DUMBARTON OAKS PAPERS
NUMBER THIRTY-TWO

Dumbarton Oaks Papers

NUMBER THIRTY-TWO

Dumbarton Oaks

Center for Byzantine Studies

Trustees for Harvard University

Washington, District of Columbia

1978

Distributed by
J. J. Augustin, Publisher
Locust Valley, New York

Dumbarton Oaks Papers is published by the Editorial Staff at Dumbarton Oaks under the supervision of the Senior Fellows of the Center for Byzantine Studies; Miss Julia Warner, Associate Editor; Dr. Fanny Bonajuto, Research Associate for Publications (retired); Mrs. Nancy Rogers Bowen, Assistant Editor; and Dr. Timothy Miller, Editorial Assistant.

Library of Congress Catalogue Card Number 42–6499; ISBN 0–88402–081–9
Printed in Germany *at* J. J. Augustin, Glückstadt

CONTENTS

NOTES

ILLUSTRATIONS

(*Following Page 28*)

Cyril A. Mango and Ihor Ševčenko: SOME RECENTLY ACQUIRED BYZANTINE INSCRIPTIONS AT THE ISTANBUL ARCHAEOLOGICAL MUSEUM

(*Facing Page 145*)

Lennart Rydén: THE DATE OF THE *LIFE OF ANDREAS SALOS*
Monacensis gr. 443, fol. IV^v, *Life of Andreas Salos*, 749 B-C

(*Following Page 192*)

Jeffrey C. Anderson: COD. VAT. GR. 463 AND AN ELEVENTH-CENTURY BYZANTINE PAINTING CENTER

(Following Page 216)

ILLUSTRATIONS

DUMBARTON OAKS PAPERS
NUMBER THIRTY-TWO

SOME RECENTLY ACQUIRED BYZANTINE INSCRIPTIONS AT THE ISTANBUL ARCHAEOLOGICAL MUSEUM

Cyril Mango and Ihor Ševčenko

LIST OF ABBREVIATIONS

(See also *List of Abbreviations Used in this Volume*, at end of volume)

Delatte, *Anecdota* A. Delatte, *Anecdota Atheniensia*, I (Liège, 1927)

Fiebiger-Schmidt, *Inschriftensammlung* O. Fiebiger and L. Schmidt, *Inschriftensammlung zur Geschichte der Ostgermanen*, DenkWien, Phil.-hist.Kl., 60,3 (Vienna, 1917)

Förstemann, *Namenbuch* E. Förstemann, *Altdeutsches Namenbuch*, 2nd ed., I (Bonn, 1900)

Grégoire, *Recueil* H. Grégoire, *Recueil des inscriptions grecques chrétiennes d'Asie Mineure* (Paris, 1922)

Herrmann, *Ergebnisse* P. Herrmann, *Ergebnisse einer Reise in Nordostlydien* (Vienna, 1962)

Keil-Premerstein, *Bericht* (1908) J. Keil and A. Premerstein, *Bericht über eine Reise in Lydien*, DenkWien, Phil.-hist.Kl., 53,2 (Vienna, 1908)

Keil-Premerstein, *Bericht* (1911) J. Keil and A. Premerstein, *Bericht über eine zweite Reise in Lydien*, Denk-Wien, Phil.-hist.Kl., 54, 2 (Vienna, 1911)

Keil-Premerstein, *Bericht* (1914) J. Keil and A. Premerstein, *Bericht über eine dritte Reise in Lydien*, DenkWien, Phil.-hist.Kl., 57,1 (Vienna, 1914)

Preisendanz, *Pap. Gr. Mag.* K. Preisendanz, *Papyri graecae magicae*, I–II (Berlin-Leipzig, 1928–31)

Wessel, *Inscr. Gr. Chr.* C. Wessel, *Inscriptiones graecae christianae veteres Occidentis* (Halle, 1936)

IN the following pages we are publishing thirty-three Byzantine inscriptions which entered the collections of the Istanbul Archaeological Museum between the years 1961 and 1973 (excluding the group from Karakilise near Yalova). We recorded them in connection with our projected *Corpus of Dated Byzantine Inscriptions* for which we are reserving one or two securely dated specimens which otherwise would have a place in this article. The inscriptions are arranged according to their accession numbers.[1] In view of the limited amount of time we have spent in the vast storerooms and gardens of the Museum, we cannot claim that our coverage is complete, and we have deliberately limited our commentary to a minimum.

As an Appendix (No. 34), we are publishing Inv. No. 5930, a pagan inscription of the year 201–2. It is related to the group which entered the Museum of Manisa in recent years.

For permission to work in the Istanbul Museum, a privilege we have enjoyed for several years, we are particularly grateful to its then Director, Bay Necati Dolunay, and to our friend of many years, the present Director, Dr. Nezih Fıratlı*. We also wish to thank Dr. Nuşin Asgari, the present Keeper of the Museum's Greek, Roman, and Byzantine Collections, for her assistance. Health and circumstances permitting, we hope to continue publishing Byzantine inscriptions acquired by the Museum in 1973 and subsequent years.[2]

1. Inv. No. 5471 (fig. 1)

Marble tombstone broken in two.
Provenance: Istanbul, Şehremini; found in 1961 near a hypogaeum at Cevdet Paşa Caddesi.
Dimensions: Maximum height 0.26 m.; width of two fragments combined 0.30 m.; thickness 0.03 m.; height of letters 0.02–0.04 m.; interlinear spaces 0.02–0.035 m.
Text: ενθαδε κα-
 τακι-cross-τε Επ-
 ιφανις
Translation: "Here lies Epiphani(o)s."
Date: *Ca.* sixth century.

* We record with sorrow the untimely death of Dr. Nezih Fıratlı in March 1979.
[1] Until 1971, the Museum's accessions had a *numerus currens*. From 1971 on, the first two digits of the accession number are the last two digits of the year of accession. The present article was completed in June 1973. Some revisions were made in January 1979.
[2] In June 1978 Ihor Ševčenko revisited the storerooms and gardens of the Istanbul Archaeological Museum and, again owing to the generous help of Dr. Fıratlı and Dr. Asgari, was able to take down about thirty-five inscriptions accessioned between 1973 and 1978. He was able to photograph only a few of them.

2. Inv. No. 5472 (fig. 2)

Bottom part of marble tombstone.
Provenance: Same as that of No. 1 (Inv. no. 5471).
Dimensions: Maximum height 0.365 m.; width 0.235 m.; thickness 0.035 m.; height of letters 0.02–0.0375 m.
Text:
υλ..........
αυτου
ινδ(ικτιωνος) ιβ'
Translation: ".....indiction twelve."
Date: *Ca.* sixth century.

3. Inv. No. 5669 (fig. 3)

Four fragments of the lid of a sarcophagus. The lid was slightly gabled and had bosses at the corners. Each of the sloping sides of the lid is decorated with a large cross. Inscription in a *tabula ansata*.
Provenance: Istanbul, Kocamustafapaşa. Found in 1964 next to a large sarcophagus.
Dimensions: Length 0.865 m.; width 0.65 m.; thickness 0.035 m.; height of letters 0.03–0.04 m.; interlinear spaces 0.015–0.02 m.
Text: + ενθαδε κατα-
κε[ι]ται η δουλη του
θεου Ουνουτζου +
Translation: "Here lies the [female] servant of God Ounoutzou."
Date: Fifth–sixth century.
Commentary: The name of the deceased woman is Turkic, presumably Hunnic. -τζου reflects -çi, -çı, -çu, a very common suffix of *nomina agentis* or *auctoris* in Turkic, including Khazar, North-Caucasian Hunnic, and Protobulgarian. The name is not listed by Moravcsik, *Byzantinoturcica*, II (Berlin, 1958), who does, however, list several names ending in -τζού: 'Αλατζού, 'Αλμαλτζού, Πεγλερτζού, all of them Tartar, hence late. The only Hunnic name with a similar termination listed by Moravcsik is Βουλγουδοῦ.

4. Inv. No. 5832 (fig. 4)

Small fragment of red stone. Letters outlined with double incisions; top edge original.
Provenance: Istanbul, Yeşildirek, Çorapcı Cafer Sokağı (1965).
Dimensions: Height 0.08 m.; width of face 0.13 m., width of back 0.15 m.; thickness 0.03 m.; height of letters 0.025–0.03 m.
Text: ενθ]αδε ανα[πα-
υε]τε δουλ[ος or -η
Translation: "Here rests the servant [of God]...."
Date: Ninth century? This date is given with caution.

5. Inv. No. 5867 (fig. 5)

Marble tombstone with gabled top. Lines ruled at top and bottom.
Provenance: Istanbul, Şehremini sewage works (1967).
Dimensions: Height 0.44 m.; width 0.20 m.; thickness 0.04–0.07 m.;
 height of letters 0.02–0.025 m.; interlinear spaces 0.015 m.

Text: +

 ενθαδε κα-

 τακιτε Θε-

 οφοβιος

 πιστος Πλε-

5 υρηνος

Translation: "Here lies the Christian Theophobios from Pleura."

Date: *Ca.* sixth century.

Commentary: In pagan inscriptions, πιστός, *fidelis*, is a laudatory epithet
 meaning "trustworthy, reliable." In Christian inscriptions (such as
 ours), it has the technical meaning of "faithful," i.e., baptized
 Christian. Cf. C. M. Kaufmann, *Handbuch der altchristlichen Epi-
 graphik* (Freiburg im Breisgau, 1917), 61 and note 1, 64 (from
 Fenerbahçe–Hieria), 228–29; M. N. Tod, "Laudatory Epithets in
 Greek Epitaphs," *BSA*, 46 (1951), 189 (at least one Christian
 inscription, *IG*, XIV, 1610 [Rome]); L. Robert, in *Hellenica*, 13
 (1965), 36 and note 1.

 For Istanbul and its environs, cf. G. Curtis, in Ἑλλ.Φιλολ.Σύλλ,
 Suppl. 17 (1886), nos. 87, 89, 91, 92, 98; cf. *ibid.*, Suppl. 19 (1890),
 38; *ibid.*, Suppl. 18 (1888), 615 (Büyükada), 618; and *ibid.*, vol. 30
 (1908), 216 (Erenköy); cf., furthermore, several fifth/sixth–century
 funerary inscriptions containing Germanic names, Fiebiger–
 Schmidt, *Inschriftensammlung*, nos. 274–76. For Bithynia, cf.
 J. Pargoire, in *EO*, 9 (1906), 216; for Lydia, cf. Keil–Premerstein,
 Bericht (1914), no. 114; for Phrygia, cf. *MAMA*, VII (1956),
 no. 104b; VIII (1962), nos. 325–326e; in Syria, the Christian use
 of the word is infrequent, cf. *IGLSyr*, nos. 746A and 2173 (possibly
 Christian). For the West, cf. Wessel, *Inscr. Gr. Chr.*, nos. 60, 138,
 158, 172a (no. 67 has πιστεύων ἐν Χριστῷ as an explicit equivalent of
 πιστός); R. Egger, *Forschungen in Salona*..., II (Vienna, 1926),
 76, no. 85 (ἐντελέως πιστή at the age of over two years); M. Cagiano
 de Azevedo, in *La Chiesa Greca in Italia dall' VIII al XVI secolo*,
 III (Padua, 1973), 1947–81: ἐ]νθάδε κῖτε Μικκίνα πιστή.... The
 editor mistook ΔΥΩΒ at the end of the inscription for the date of
 4472 = 710 A.D. (In fact, Mikkina died at the age of two [δύω, β'],
 probably in the sixth century). For Africa, cf. P. Monceaux, in
 Bulletin de la Société Nationale des Antiquaires de France, (1908),
 262–64: Μαρία πιστή (Carthage; date: early seventh century?);
 E. Marec, in *Libyca*, 3 (1955), 163–66: a) *Aprilia fidelis*; b) *Jobius
 vir clarissimus fidelis* (Hippo; date: 557 and 553 respectively).

For other occurrences of πιστός in inscriptions in the present article, cf. Nos. 10, 14, 30, 31, 33 below.

Lines 4–5. Pleura is unknown to us. Πλευρών in Aetolia would give Πλευρώνιος or Πλευρωνεύς as the name of an inhabitant of the city.

6. Inv. No. 5891 (fig. 6)

Central part of cruciform marble tombstone. The indentations left by the crossarms (which must have been very short) are visible at the level of the first and last lines of writing. Right-hand edge original.

Provenance: Unknown; purchased in 1967.

Dimensions: Height 0.245 m.; width 0.32 m.; thickness 0.065 m.; height of letters 0.03 m.; interlinear spaces 0.01 m.

Text: [+ ενθα-]
 δε κα-
 τ]ακιτε Τανδ-
 ηλας πριμι-
 5 κ]ιρις τελευ-
 τ]α μη(νι) Μαρτι(ου)
 .]ε′ η(μερα) δ′ ινδ(ικτιωνος) ϛ′

Translation: "Here lies Tandị̣las the primicerius. He died on the (.)fifth of March, a Wednesday, indiction five (?)."

Date: Fifth–sixth century. Note the form of delta in the last line.

Commentary: Lines 3–4. The reading of the name of the deceased is problematic. In any case, the name is Germanic because of its ending, -ila or -ilo; cf. Ulfila, Totila: Förstemann, *Namenbuch*, 989–91, lists 339 masculine names with this termination. For parallels to our Tandị̣las, cf. Förstemann, *Namenbuch*, 1403 (Tancila, fifth century, occurring in Cassiodorus, *Variae* II, ep. 35; Tenchilo; Danchilo), 1393 (Tadilo), 403 (Tantula, eighth century; Tenzil, ninth century).

Lines 4–5. Given without a qualifying noun, the title of *primicerius* is vague: it denotes the superior officer, one whose name was entered first on the "wax tablet," i.e., the list of members of a military, civilian, or ecclesiastical unit. In view of Tandị̣las' Germanic name, he was probably a military *primicerius*, either an aide-de-camp of a tribune, or a top petty officer assisting the *comes* of a *schola*, or a top petty officer of some other military unit. On *primicerii*, especially the military ones, cf. W. Ensslin, in *RE*, Suppl. 8 (1956), 614–16 (best treatment); E. Stein, *Histoire du Bas-Empire*, I (Paris–Bruges, 1959), 427–28; R. Guilland, *Recherches sur les institutions byzantines*, I (Amsterdam, 1967), 301.

For other early epitaphs of *primicerii*, cf. *REG*, 3 (1890), 79 (near Pessinus); *BCH*, 5 (1881), 93 (northern Greece).

7. Inv. No. 5892 (fig. 7)

Left arm of cruciform marble tombstone. Lines ruled at top and bottom.

Provenance: Unknown; purchased in 1967.

Dimensions: Maximum height 0.29 m.; width 0.30 m.; thickness 0.03 m.; height of letters 0.02–0.05 m.; interlinear spaces 0.02 m.

Text:

 α.... [φοιδερ-

 ατ(ου) δεσποτ[ικου..

 μη(νι) ὠκτοβρι(ου) ιβ' η(μερα) β' [τελευ-]

5 τα δε ετω(ν) γ̄‹ +

Translation: "[Here lies...] of *foederatus*, devoted to his Overlord.... [He (or she) died] on the twelfth of October, a Monday, at the age of three and one-half."

Date: *Ca.* fifth–sixth century. Note the form of delta in the last line.

Commentary: Lines 2–3. For [φοιδερ]άτου δεσποτ[ικοῦ, cf. C. Curtis, in Ἑλλ.Φιλολ.Συλλ., suppl. 17 (1886), no. 89, cf. no. 91; cf. also φεδεράτου δεσποτικοῦ in Fiebiger–Schmidt, *Inschriftensammlung*, no. 275. For δεσποτικός, "devoted to his Overlord," *ibid.*, nos. 274 and 278 (ὑπὸ δεσποτίαν Βαδουαρίου).

On the Gothic *foederati*, cf., e.g., A. M. Schneider, "Gotengrabsteine aus Konstantinopel," *Germania*, 21,3 (1937), 175–76 and 175 note 2.

Line 5. On the abbreviation ‹, "one half," in inscriptions, cf., e.g., *CIG*, IV, no. 9301; *IG*, XII, 2 (1899), no. 646a line 6, cf. p. 138. It is routine on papyri and wooden tablets, cf., e.g., F. Preisigke and F. Bilabel, *Sammelbuch griechischer Urkunden aus Ägypten*, III (Strasbourg, 1926), no. 6219.

8. Inv. No. 5965 (fig. 8)

Marble tombstone slab. Lines ruled at top and bottom.

Provenance: Küçükçekmece (Rhegion), found in 1966.

Dimensions: Height 0.29 m.; width 0.25 m.; thickness 0.025 m.; height of letters 0.02–0.025 m.; interlinear spaces 0.01 m.

Text: + + +

 ενϑα-

 δε κατα-

 κιτε Ευ-

 φροσυ-

5 νη

Translation: "Here lies Euphrosyne."

Date: *Ca.* sixth century. Note form of rho with open loop, resembling Latin R, in line 4.

9. Inv. No. 5988 (fig. 9)

Top portion of marble funerary slab with large cross in the middle. Lines of writing and width of crossarms marked by incisions. Top edge original.

Provenance: Istanbul. Found in 1966 in laying the foundations of Cerrah-paşa hospital.

Dimensions: Maximum height 0.27 m.; width 0.27 m.; thickness 0.02 m.; height of letters 0.03 m.; interlinear spaces 0.015 m.

Text: ενϑ-cross-αδε κ-
αταк-cross-ιτε τ(ου)
της-cross-μακα-
[ριας] μνημη-
5 ς].........

Translation: "Here lies.... of X of blessed memory...."

Date: *Ca.* sixth century.

10. Inv. No. 5989 (fig. 10)

Top portion of marble funerary slab in several fragments joined together.

Provenance: Same as that of No. 9 (Inv. no. 5988).

Dimensions: Maximum height 0.24 m.; width 0.255 m.; thickness 0.02 m.; height of letters 0.025–0.03 m.; interlinear spaces 0.01 m.

Text: + ενϑαδε
κατακι-
τε Ανασ-
τασια
5 [π]ιστι

Translation: "Here lies the Christian Anastasia."

Date: *Ca.* sixth century.

Commentary: Line 5. For πιστή, cf. Commentary to No. 5 above.

11. Inv. No. 6000 (fig. 11)

Graffito on uneven piece of marble.

Provenance: Unknown; purchased in 1967.

Dimensions: Height 0.21 m.; width 0.10 m.; thickness 0.025 m.

Text: Or, in conventional spelling:

υ κ	υ κ
πρεσβε	πρέσβε-
βε αγυε Κ[η	υε ἅγιε Κ[ή-
ρηκ(αι) του ϑεο[υ	ρυκε τοῦ ϑεοῦ
5 ελευϑυνε	5 ἐλεηϑῆναι
τας ψυχα	τὰς ψυχὰ-
ς υμων τω[ν	ς ἡμῶν τῶ[ν
ησε	εἰς σὲ
προστρεχ[ον	προστρεχ[όν-

10 των σκ(αι)πε 10 των· σκέπε

φρουρυ φυλα[ττε φρούρει φύλα[ττε

+ τ[ο]ν ... τόν ...

Translation: "Intercede for us, O God's Saint Kerykos(?), that the souls of us who have recourse to thee should find mercy. Shelter, guard protect"

Date: Tenth century.

Commentary: The invocation may be addressed to the infant Saint Kerykos (the spelling varies, Κύρικος being the most frequent; cf., e.g., *MAMA*, I [1928], no. 323, eastern Phrygia; Keil–Premerstein, *Bericht* (1908), no. 209, Larisa in Lydia), son of St. Julitta; both were martyred at Tarsus. They do not appear, however, to have enjoyed much of a cult at Constantinople. The *synaxis* of these Saints was celebrated on July 15 in the church of Archangel Michael in the Adda quarter, cf. *Synaxarium CP*, 821, and R. Janin, *La géographie ecclésiastique de l'Empire byzantin*, III. *Constantinople. Les églises et les monastères* (Paris, 1969), 350. On a monastery of St. Kyrikos at Constantinople, cf. *ibid.*, 303. There was a second St. Kerykos (a *hosios pater*) at Apros (Germeyan Köyü) in Thrace: *Synaxarium CP*, 563. The stone could have come from the latter locality.

On the other hand, it is possible to interpret κήρυκε τοῦ θεοῦ in the sense of "herald of God," in which case it would refer to St. Paul or another apostle.

Lines 10–11. σκέπε – φύλαττε: For a similar formula in an invocation addressed to Saints Julitta and Kerykos, cf. the inscription on a marble iconostasis beam in the Museum of Izmir, ed. A. K. Orlandos, in Ἀρχ.Βυζ.Μνημ.Ἑλλ., 3 (1937), 147: τὸν ἐνδόξον μαρτύρον Κυρήκο[υ] καὶ Ἰουλήτας· σκέπε· σόζε· φύλαττ(ε) τὴν δ(ού)λη(ν) σ(ου) Ἀρετή[ν].

In the Passion of Saints Cyricus and Iulitta (*ActaSS*, July 16, vol. IV [1867], 28C), the Saint, just before suffering a martyr's death, implores God that, whoever would worship or invoke his name, should obtain a good reward and remission of sins: *et qui coluerit vel invocaverit memoriam nominis mei, da eis mercedem bonam et si habuerint peccata...absolvantur*. The author of our inscription may have been acting upon this passage of the *Passio*.

12. Inv. No. 6049 (fig. 12)

Upper left corner of marble (funerary?) slab. Top and left edges original.

Provenance: Topkapı Sarayı, first court, near the laboratory of the Archaeological Museum (1967).

Dimensions: Height 0.27 m.; width 0.15 m.; thickness 0.06 m.; height of letters 0.025–0.04 m.; interlinear spaces 0.025 m.

Text: Ομιλ....
ηθῶν ο....
δὲ μουσ....
κὼν ακ....
5 .(ου)σβᾳ....
Date: Thirteenth century?

13. Inv. No. 6082 (fig. 13)

Right-hand fragment of marble slab. Lines of writing ruled at top and
 bottom.
Provenance: Unknown; purchased in 1968.
Dimensions: Height 0.47 m.; width 0.17 m.; thickness 0.05 m.; height of
 letters 0.025–0.03 m.; interlinear spaces 0.01 m.
Text: ταφ]ων τουτων
 κα]τακρισιν α-
 ιτ]ω τυς κληρω-
 νο]μ(ου)ς μ(ου) ει τι-
5 ς α]νανεωσ[ει
 .ο καθος εγ[ω
 επ]υεισα αυ[τη or -τος
 ε]χι προς τω
 ονο]μα το φωβ-
10 ερ]ον κ(αι) τιν μερι-
 δ]αν τ(ου) ειπο⟨ν⟩τ-
 ος] αρον αρον
 [σταυρωσον αυτον]
Translation: "... this gra[ve] (?), I call condemnation upon my heirs: if
 any of them changes anything contrary to my actions, may such a
 person have to count with the Terrible Name, and may he share
 the lot of him who said, 'Away with him, away with him, [crucify
 him].'"
Date: Sixth–seventh century.
Commentary: Line 3. The stone reads τυς [= τοῖς]; the sense, however,
 remains that of τούς.
 Line 7. For ἐπ]ύεισα = ἐποίησα, cf., e.g., L. Moretti, *Inscriptiones
 graecae urbis Romae*, II (Rome, 1972), no. 443 lines 4–5: επυησεν;
 cf. also an inscription (fifth-century?) over the entrance of the former
 Medikion monastery Tirilye-Zeytinbağı, published by C. Mango and
 I. Ševčenko, *DOP*, 27 (1973), 275–76 and fig. 150: επυησα.
 Line 8–10. ἔχει πρὸς τὸ ὄνομα τὸ φοβερόν ⟨of God⟩ is, like the ex-
 pressions ἔξει [or ἔχει] πρὸς τὴν τριάδα, πρὸς τὴν αἰωνίαν κρίσιν, πρὸς
 τὸν μέλλοντα κρίνειν ζῶντας καὶ νεκρούς, τὸ κρίμα ἀπὸ τοῦ θεοῦ (for these,
 see *JRS*, 14 [1924], 86–87, and *MAMA*, I, nos. 160, 168–69; IV,
 no. 577), a variant of the formula ἔχει πρὸς τὸν θεόν, concerning
 which cf. No. 15 below.

For ὄνομα τὸ φοβερόν, cf. ἔσται αὐτῷ πρὸς τὸ μέγα ὄνομα τοῦ Θεοῦ in an inscription coming from Eumeneia (Işıklı) in Phrygia, cf. P. Le Bas and W. Waddington, *Inscriptions grecques et latines de la Syrie*, III (Paris, 1870), no. 740 [= *CIG*, III, no. 3902].

Lines 12–13. ἄρον, ἄρον, [σταύρωσον αὐτόν]: This is a quotation from John 19:15; the exclamation is attributed to a single person (τοῦ εἰπό⟨ν⟩τος), while the Gospel attributes it to the Jews in general. Cf. M. Pierart, in *BCH*, 98 (1974), 789–91: ... τὴν] μερίδα αὐτοῦ μετὰ τῶν λεγόντων ἄρον[ἄρον σταύρωσον αὐτ]όν (Argos; date not given, photograph suggests fifth-sixth century). Furthermore, John 19:15–17 (starting after our quotation) occurs on an ostrakon, cf. G. Lefebre, in *BIFAO*, 4 (1904), 15; in our inscription, however, the quotation functions as an imprecation, while in the case of Lefebre's ostrakon, we seem to deal with a poor man's lectionary. Cf. Jalabert, in *DACL*, III,2 (1914), 1751.

14. Inv. No. 6086 (figs. 14 **a** and **b**)

Fragment of marble tombstone or sarcophagus inscribed on both sides. Two holes have been cut through the slab, which is eroded from prolonged immersion in water. Inscription **b** represents a reuse.

Provenance: Unknown; purchased at Istanbul in 1967.

Dimensions: Height 0.47 m.; width 0.30 m.; thickness 0.04 m.; height of letters (inscription **b**) 0.02 m.; interlinear spaces 0.01–0.015 m.

Text **a**: large cross

 [ενθα]δε κα-

 [τακι]τε̣ Φ....

Translation: "Here lies Ph...."

Text **b**: [ε]νθαδε [κα-

 τ]ακι̣[τ]ε̣ ΣΤΕ

 η Σε[..]ινα π̣-

 ι]στη δουλι

5 το]υ θεου θυγα-

 τ]ερ γεναμεν[η

 Σανβατιου +

 large cross

Translation: "Here lies Se..ina, faithful servant of God, the daughter of Sambatios."

Date: *Ca.* sixth century.

Commentary: Lines 2–3. The name of the deceased is unclear. It is also possible to read Στε[φα|ν]ης, i.e., Στεφανίς.

Line 3. For πιστή, cf. Commentary to No. 5 above.

Lines 5–6. For ε instead of η in θυγάτερ, cf., e.g., W. Calder, in *JRS*, 14 (1924), 85, no. 1 (Αὐρέλιος); Preisendanz, *Pap. Gr. Mag.*, 195 = P 7 ('Ιεσοῦ), and E. Peterson, Εἷς Θεός (Göttingen, 1926), pp. 11 (βοεθõν, ἀμέν) and 67 (μενός). Cf. also No. 19 line 3 below.

Line 6. For the form γεναμένη, cf., e.g., I. Ševčenko, in *Byzantion*, 35 (1965), 565–66.

Line 7. Σανβάτιος is the Armenian Smbat.

15. Inv. No. 6092 (fig. 15)

Marble funerary slab.

Provenance: Unknown; purchased at date unknown.

Dimensions: Height 0.465 m.; width 0.25 m.; thickness 0.065 m.; height of letters 0.02–0.035 m.; interlinear spaces 0.01–0.015 m.

Text: ει-cross-τις
 τολμησ-
 ι αριν το
 λιθαριν
 5 ⌜ε⌝χη προς
 τον θεον
 και λαβη
 την θλιψι-
 ν της μητ-
 10 ρος μου

Critical note: Line 5. The stone has ΣΧΗ.

Translation: "If anyone dares to remove this stone, may he have to settle accounts with God and have upon himself my mother's grief."

Date: *Ca.* sixth century.

Commentary: Lines 5–6. ἔχει πρὸς τὸν θεόν: σχῇ would be possible (cf. εἴσχι below), but all the other examples known to us of the formula with the verb ἔχειν have ἔχει or ἔξει, and L. Robert, in *Hellenica*, 11–12 (1960), 402, no. 7 quotes an example with ἔχῃ (from Galatia). The early Christian formula ἔχει or ἔξει πρὸς τὸν θεόν or τὴν τριάδα occurs in Asia Minor. For examples from Konya and Ladik (Laodicea Combusta in Pisidia), cf. Buckler–Calder–Cox or Calder alone, in *JRS*, 14 (1924), 37, no. 19 (with bibliography); 85 (further bibliography); 85–88, nos. 1, 2, 4, 5; *MAMA*, I (1928), no. 161; VII (1956), no. 96 (εἴσχι πρὸς τὸν θεόν); from Cilicia, cf. Keil–Wilhelm, *MAMA*, III (1931), nos. 196, 347, and J. and L. Robert, "Bulletin épigraphique," *REG*, 85 (1972), no. 547. L. Robert, in *Hellenica*, 11–12 (1960), 401–405, gives seventeen examples of the formula. However, this formula survived in Byzantine times as well: it occurs in the form νὰ ἔχι πρὸς τὸν θ(εὸ)ν in an inscription dated to the year 1181 and found either at the Seraglio Point in Istanbul or at Galata (at present, the inscription is in the laboratory of the Istanbul Museum). Cf. K. Bittel and A. Schneider, in *Archäologischer Anzeiger*, 58 (1943), 252–53. The other most frequent imprecation formula on Phrygian funerary monuments is

ἔσται αὐτῷ πρὸς τὸν θεόν; on this, cf., e.g., F. Cumont, in *MélRome*, 15 (1895), 252–55; G. Mendel, in *BCH*, 33 (1909), 342–48 (Synnada, with further bibliography); and *MAMA*, VI (1939), nos. 223–33, 235 (Apamea). Cf. also Commentary to No. 13 above.

16. Inv. No. 6114 (fig. 16)

Right-hand arm of cruciform, marble tombstone. Lines of writing ruled at top and bottom. Parts of top, right-hand, and bottom edges original.

Provenance: Kalamış, near Greek church (1965).

Dimensions: Height 0.21 m.; maximum width 0.315 m.; thickness 0.065 m.; height of letters 0.02 m.; interlinear spaces 0.01 m.

Text: ---δο]μεστικου οι-

 ---]πατρος των προς

 ---]οπηδιων Σευηρου

 ---τ]ελευτησαντος ιν(δικτιωνος)

 5 ---]ουαριω κ'

Translation: Impossible, in view of the fragmentary character of the inscription.

Date: Fifth–sixth century?

Commentary: Line 1 οι-: οπ- is also possible.

 Line 3. ---]οπηδιων may be τ]ὸ παιδίον; cf. το πηδιον in an inscription from the Medikion monastery (Tirilye–Zeytinbağı), cf. C. Mango and I. Ševčenko, in *DOP*, 27 (1973), 275 and fig. 150; cf. also No. 28 lines 3–4 below.

17. Inv. No. 6115 (fig. 17)

Marble funerary slab in three pieces. Lines of writing ruled at the bottom.

Provenance: Küçükçekmece (Rhegion) at a place called Kanarya. Purchased in 1968.

Dimensions: Height 0.55 m.; width (complete) 0.355 m.; thickness 0.03 m.; height of letters 0.028–0.03 m.; interlinear spaces 0.003–0.005 m.

Text: ειδε]ς παροδι-

 τα το]ν ηλιον

 ον αναλ-

 [αμψα]ντα κ(αι) δυ-

 5 [σαν]τα ευξ(ου)

 [υπε]ρ εμ(ου) εν-

 θαδε γαρ κα-

 τακιμε Θεωδο-

 ρα η της μακα-

 10 ριας μνημης

ϑυγατηρ Αλυ-
πι(ου) πρε(σβυτερου) ετελιο-
ϑην ετων: ε':
ημ(ερα): δ': μη(νι) Ι(ου)λι(ου)
15 αι ενδ(ικτιωνος): γι': βα-
[σιλ(ειας) Ηρακ]λι-
[ου]

Translation: "[You saw (?)], O passer by, the sun that had [barely] risen when it set again. Pray for me, for here I lie, Theodora of blessed memory, daughter of Alypios the presbyter. I died aged five, on a Wednesday, July 11 ⟨or 14⟩, indiction thirteen in the reign of Heraclius (?)."

Date: 610–41? 625?

Commentary: Line 14. Note the abbreviation $\overset{H}{M}$ functioning both for the day and for the month.

Line 14. δι, i.e., fourteen, is also possible. Note the inversion of numerals in day of month and indiction. This inversion is frequent, even outside of the Semitic area (or of inscriptions done by or for Semitic speakers), especially in pagan inscriptions from Lydia. Cf. also Ἑλλ.Φιλολ.Σύλλ., Suppl. to vol. 17 (1886), 94 (Panion in Thrace, date: 882) and *IG*, X, 2, 1 (1972), no. *804, an inscription from Thessalonica (date: 535): ἰνδ(ικτιῶνος) δι'; finally, for Crete, cf. A. C. Bandy, *The Greek Christian Inscriptions of Crete* (Athens, 1970), no. 56 (sixth century), no. 75 (sixth century), no. 104 (seventh–eighth centuries). Cf. also No. 30 below.

Lines 16–17. The restitution is tentative, for the lettering seems to point to an earlier date. We assume an abbreviation in the word βασιλείας. If the emperor is Heraclius, and the day of the month the eleventh, then the date of the inscription would be 625.

18. Inv. No. 6144 (fig. 18)

Marble funerary slab in three pieces.
Provenance: Found in the course of the restoration of Yedikule. Entered the Museum in 1968.
Dimensions: Height 0.40 m.; width 0.635 m.; thickness 0.04 m.; height of letters 0.03 m.; interlinear spaces 0.015–0.02 m.
Text:τῶν ἐμῶν] φως ομμάτων
.συντριμ]μὸν καρδίας *v.* ἰδοῦ
[ϑανου]σα π[ατ]ερ ἡρετισάμην *v.* σῶν
εγγυς ὀστῶν τὴν ἐμην κεῖσϑαι κόνιν:
5 σὺ δ' αλλ' ὁ τύμβους καϑορῶν τούτ(ου)ς
ξένε *v.* εὔχ(ου) μοναχὴν Εὐγενειανὴν
Ξένην: τῷ Πατρὶ συσκηνοῦν με
τρυφῆς εν χ[λ]όη:

Translation: "...O light of my eyes...[contri]tion of the heart. Behold, O father, I have chosen, now that I am dead, that my dust should lie close to your bones. But you, O stranger, who are beholding these tombs, pray that I, the nun Xene Eugeniane, should dwell with the Father in the grassy garden of delectation."

Date: Fourteenth century.

Commentary: The inscription is in dodecasyllables, separated either by two points or by a space.

Line 2. The restitution συντριμ]μὸν is given *exempli gratia*. For the expression, cf. Theophanes continuatus, Bk. V, in *Vat. gr.* 167, fol. 99ᵛ, συντριμμοῦ καρδίας, where the Bonn ed., p. 285, 8, has the wrong συντριβῆς.

Line 3. π[άτ]ερ refers here to Xene's father according to the flesh next to whom she was buried. Πατρί in line 7 may designate either that same father or God the Father.

Lines 6–7. Eugeniane is a family name, made illustrious by the romance writer of the twelfth century, Nicetas Eugenianos; Xene is a name frequently taken by nuns upon entering orders. Cf. the horizontal bar over Xene to indicate that it is a proper name.

19. Inv. No. 6153 (fig. 19)

Marble tombstone.
Provenance: Unknown; acquired in 1968.
Dimensions: Height 0.36 m.; width 0.295 m.; thickness 0.037 m.; height of letters 0.025–0.04 m.; interlinear spaces 0.015 m.
Text: εν9-cross-αδε
 κατακιτ(αι)
 ε δουλη
 του 9εου
5 Νοννις

Translation: "Here lies the [female] servant of God Nonnis."
Date: Fifth–sixth century.
Critical note: Line 1. The letters 9 and α are faintly scratched in on either side of the cross. They may not be contemporary with the inscription.
Commentary: Line 3. For ε instead of η, cf. Commentary to No. 14, text **b**, lines 5–6. But perhaps the verb ending -αι was rendered twice.

20. Inv. No. 6234 (figs. 20 **a**, **b**, and **c**)

Fragment of marble column shaft. The inscription, of which the major part is lost, was written all round.
Provenance: Found in 1969 east of the Archaeological Museum in the course of construction of the Museum annex.

Dimensions: Height 0.21 m.; width 0.29 m.; thickness 0.11 m.; height of
letters 0.015 m.; interlinear spaces 0.005–0.01 m.

Text: ———]ο[———
 ———]ν[. . .]ατουδε[———
 ———]νμησα[. . .]κ[.]ιαλ[———
 ———]ηναμην[. .]υ[.]σ[. .]εφελ[———
5 ———Μιχα]ηλ Γαβριηλ Ουριηλ[.]α[———]ηλ[———
 ———]ς Ιακοβος Ζαβαι[———]α[.]αβασ[———
 ———]ου μη παρελε[υ]σ[ε]τ[αι]το ͞ποτηριον το[υτο———
 ———]ι Θ(εο)ν και ερημ[———

Translation: "———] cloud (?) [———] Michael, Gabriel, Uriel [———] James
⟨son of⟩ Zeb[edee (?) [———] this cup will not pass away (?) [———."

Date: *Ca.* sixth century.

Commentary: To place our damaged inscription in context, we should
consider the following combination of its elements: the mention
of the Archangel Uriel (whose name does not occur in the Scrip-
tures, but who is frequently invoked in apocryphal and magical
texts; the apparent mention of the Apostle James; and the apparent
quotation from Matth. 26:39 (or, at least, the use of a New Testa-
ment phrase, οὐ μὴ παρέλθη, (cf. Matth. 5:18, 24, 34–35; Mark 13:30;
Luke 21:32) in line 7.

Our inscription belongs to the category of Christian magic
prayers, exorcisms, and invocations. Most of the relevant texts
have been preserved in papyri, manuscripts, or on metal amulets
and phylacteries; for an epigraphical example, cf. Grégoire, *Recueil*,
I no. 341 *ter* (exorcism of hail from the area of Alaşehir [Phila-
delphia]). Cf. also L. Robert, in *Hellenica*, 11–12 (1960), 429–35.

Line 3. Μησα[ηλ is possible; i.e., Μισαήλ, another angel whose
name occurs in pagan and Christian exorcism; also in conjunction
with three other angels, cf. Preisendanz, *Pap. Gr. Mag.*, I (1928),
128, and Delatte, *Anecdota*, 249 line 17; or one of the Three
Hebrews (Ἀνανίας, Ἀζαρίας, Μισαήλ), who are invoked along with
the archangels: *ibid.*, 31 line 15; 424 line 19.

Line 4. ἀμ]ὴν ἀμήν is possible, as well as ἵνα μὴ. For ἀμήν repeated
three times in magical texts, cf. Delatte, *Anecdota*, 465, line 28.

]εφελ[——— suggests νεφελ- or clouds with which the archangels
were associated.

Line 5. The Archangels Michael, Gabriel, and Uriel (or "Uruel")
often appear in apocryphal texts and incantations in this sequence
and are usually followed by the fourth archangel, Raphael. Random
examples: Andrew of Caesarea, *Commentary on the Apocalypse*,
PG, 106, col. 300D; Apocalypse of Esdra, ed. C. Tischendorf, *Apo-
calypses Apocryphae* (Leipzig, 1866), 31 (and five other angels "of
the end of the world"); Karl Wessely, *Ephesia Grammata*, Zwölfter
Jahresbericht über das k. k. Franz-Joseph Gymnasium in Wien

(Vienna, 1886), 18, nos. 113–16; A. Vasil'ev, *Anecdota Graeco-By-zantina*, I (Moscow, 1893), 326, 334, 343; C. C. McCown, *The Testament of Solomon* (Leipzig, 1922), § XVIII, 5–8; R. Reitzenstein, *Poimandres* (Leipzig, 1904), 294, 296–98; Epistle of the Apostles (Coptic), trans., e.g., M. R. James, *The Apocryphal New Testament* (Oxford, 1924), 489; E. Peterson, Εἷς Θεός (Göttingen, 1926), 84 no. 6, 121; Delatte, *Anecdota*, 31 lines 5–6; 36 lines 10–11; 89 lines 15–16; 92 line 12; 99 line 17; 117 lines 23–24; 118 lines 9–10; 119 lines 21–22; 123 lines 17–18; 125 lines 7–8 and 28–29; 230 line 4; 231 lines 11–12; 232 line 6; 245 lines 2–3; 249 lines 14–15; 424 lines 9–10; 429 lines 12–13; 623 lines 3–4; 624 line 5; Preisendanz, *Pap. Gr. Mag.*, I, 128; C. Bonner, *Studies in Magical Amulets* (Ann Arbor, 1950), 170, 214.

For the sequence Michael, Gabriel, Raphael, Uriel or "Uruel," cf. R. Hercher, *Astrampsychi oraculorum decades CIII*, Jahresbericht über das Königl. Joachimstalsche Gymnasium (Berlin, 1863), 3; Wessely, *op. cit.*, 18, no. 115; and L. Delatte, *Un office byzantin d'exorcisme*, Acad. Royale de Belgique, Mémoires, 52, 1 (Brussels, 1957), 67 line 31. For further examples (esp. from the Apocalypses of Enoch, Esdras, and Moses), and studies on Uriel, cf. P. Perdrizet, in *SemKond*, 2 (1928), 241–76 (classic); K. Preisendanz, in *RE*, IX, A, 1 (1961), 1011–23 (best), and J. Michl, in *RAC*, 5 (1962), 254–56.

As Raphael appears quite regularly in the company of the other three great archangels, one might read [Ρ]α[φα]ηλ in line 5.

Line 6. Ἰάκωβος is sure. Ζαβ[points to James, son of Zebedee, one of the apostles. The name of that apostle's father is regularly spelled Ζεβεδαῖος, but the forms Ζαβαδαίας, -δίας, Ζαβδαῖος do occur in the Old Testament Apocrypha, and Ζαβδαῖος is attested on a papyrus; cf. F. Preisigke, *Sammelbuch griechischer Urkunden aus Ägypten*, I (Strasbourg, 1915), no. 681, lines 29 and 69. In Christian magic incantations, the Apostles are invoked along with the four archangels, cf., e.g., Vasil'ev, *op. cit.*, I, 326: ὁρκίζω σε κατὰ τῶν τεσσάρων ἀρχαγγέλων Μιχαὴλ Γαβριὴλ καὶ Οὑριὴλ καὶ Ῥαφαήλ...ὁρκίζω σε κατὰ τῶν δώδεκα ἀποστόλων; cf. also F. Pradel, *Griechische und südital. Gebete* (Giessen, 1907), 22 line 26; Delatte, *Anecdota*, 89 lines 15–18: ἀρχάγγελοι τοῦ Θεοῦ, Μ. καὶ Γ., Οὑρουὴλ καὶ Ῥ., βοηθήσατε ἐν τῇ ὥρᾳ ταύτῃ· ἅγιοι ἀπόστολοι, ἅγιε Ἰωάννη Πρόδρομε, ἅγιε Ἰωάννη Θεολόγε, βοηθήσατε; cf. *ibid.*, 99 lines 17–20; 119 lines 21–25.

[.]αβας[---: [σ]αβαω[Θ is also possible. For a combination of Sabaoth with the names of the four archangels, cf. Delatte, *Anecdota*, 230 lines 4–5, 623 lines 2–4.

Line 7. παρελξ[υ]σ[ε]τ[αι] is conjectural. The verb is surely παρελθεῖν. The combination of this verb with ποτήριον points to Matth. 26:39.

Line 8. ερημ[---: Θρην[--- is also possible.

21. Inv. No. 6237 (fig. 21)

Marble funerary slab. Left edge original.

Provenance: In 1906, the slab was immured in the outer wall of a house situated in the Cami Kebir quarter of Alaşehir (Philadelphia); cf. Keil–Premerstein, *Bericht* (1908), 43, no. 89. In 1969 it was purchased by the Museum from the Manisa antiquities dealer, Cemil Lambaoğlu.

Dimensions: Height 0.30 m.; width 0.32 m.; thickness 0.10 m.; height of letters 0.02 m.; interlinear spaces 0.005 m.

Text: [+ ε]νθαδε κιτ[ε
 το παιδειον η κορ[η
 Φιδηλεια θυγατηρ
 Φιδηλιας της κοσμιο[τ(ατης)
 5 και Αθηναι(ου) κομητο[ς
 τελε[υ]τα επιβασα
 ετων γ′ ινδ(ικτιωνος) θ′
 μη(νι) Γορπιε(ου) κη′
 βασιλιας
 10 Ιουστινιαν(ου)

Translation: "Here lies the infant girl Phidelia, daughter of Phidelia, the most decorous, and of Athenaios the *comes*. She died upon reaching the age of three, in indiction nine, on the twenty-eighth of the month Gorpiaios [July–August], in the reign of Justinian."

Date: 531, 546, or 561. Note form of delta in line 7.

Commentary: The inscription was published by Keil–Premerstein, *Bericht* (1908), 43 no. 89, with a facsimile drawing, from which the slight deterioration of the stone between 1906 and 1969 is apparent; it was published with a short commentary (parallels to ἐπιβᾶσα ἐτῶν and to κοσμιο[τ(άτης); faulty dating). It was republished by Grégoire, *Recueil*, no. 343 (dating corrected).

 Line 3. Φιδηλία — for the name and spelling Φιδήλιος in Justinian's time, cf., e.g., *CIG*, 9276 (date: 533). The name of the one-time *quaestor* of Athalarich was spelled Φιδέλιος, cf. *RE*, 6 (1909), 2228.

 Line 5. κόμητος — The rank of *comes* was created by Constantine the Great. In the late Empire *comes* was a title given to a military or civil official of some importance. The *comitiva*, however, could be bestowed upon a deserving individual who did not exercise an official function. The *comitiva* gave one access to senatorial rank, but by the fifth century the *comitiva* of the third grade was bestowed upon city people of humble degree. Cf., e.g., A. Berger, *Encyclopedic Dictionary of Roman Law* (Philadelphia, 1953), 397 (with succinct bibliography); A. H. M. Jones, *The Later Roman Empire*, II (Oxford, 1964), 528, 544–45. For a *comes* in a sixth-century inscription from Salona, cf. Wessel, *Inscr. Gr. Chr.*, nos. 117, 132.

22. Inv. No. 6261 (figs. 22 **a** and **b**)

Marble water spout in the shape of a lion's head. The inscription is on
the lion's forehead.

Provenance: Possibly Eskişehir. Acquired from dealer M. Kolaşin in 1969.

Dimensions: Height 0.31 m.; length 0.40 m.; width 0.32 m.; height of
letters 0.015–0.02 m.

Text: υπερ ευχης, Κοσταν-
τιν[(ου)] πρησμονος

Translation: "In fulfillment of the vow of Constantine the sawyer.(?)"

Date: *Ca.* sixth century.

Commentary: Line 1. On the formula ὑπὲρ εὐχῆς, cf., e.g., I. Ševčenko,
in *DOP*, 17 (1963), 394–95.

Line 2. If read correctly, the strange form πρησμονος is a genitive
of an unattested nominative πρήσμων, i.e., πρίσμων, "sawyer ⟨of
marble?⟩"; Constantine would thus give his profession. The normal
form is πρίστης, "cutter of marble"; cf. L. Robert, in *JSav* (Janu-
ary–June, 1962), 5–43.

23. Inv. No. 7316 (fig. 23)

Terracotta tile with raised rim on three sides. Upper right corner missing.

Provenance: Unknown; purchased in 1969.

Dimensions: Height 0.47 m.; width at top 0.33 m., at bottom 0.285 m.;
thickness 0.022 m., including rim 0.045 m.

Text: κ(υ)ρ(ι)ε φωηϑ-
η των δουλω⟨ν⟩
σο⟨υ⟩ Ηοανη το α-
ργων τω Στο-
5　μοπατα το
δορκαρηο ω α-
δεφως +

Translation: Uncertain. Perhaps "Lord help Thy servant John the idle (?),
who is nicknamed Stomopatas (?), ⟨and is⟩ the brother of (?) a
shieldmaker (?)."

Date: Seventh–ninth century.

Commentary: The meaning of the inscription shall remain unclear as
long as we do not know whether it was done in all seriousness or
was a graffito made in jest.

Lines 1 and 3. Horizontal lines over κρε and ιοανη assure the
reading κύριε and Ἰωάννη or Ἰωάννη⟨ν⟩.

Line 1. Note φ for β in φωήϑη. Was the writer non-Greek
speaking?

Lines 3–4. We take αργων to mean ἀργόν, "idle, do-nothing";
a proper name or nickname Ἄργος is also possible.

Line 4. The proposed στομοπατᾶς—mouth-treader (perhaps "standing in the middle of the ranks," i.e., "coward"?) is unattested, but conceivable. The suffix -ᾶς denotes a trade or an undesirable characteristic.

Line 6. The unattested δορκαρίῳ we take to mean "leather-shield maker" or "leather-shield bearer." Cf. Constantine Porphyrogenitus, *De administrando imperio*, ed. G. Moravcsik and R. Jenkins (Washington, 1967), 110 line 31 and 250 line 83, where δόρκα means "leather shield." For a similar formation, cf. κλιβανάριος, "wearer of a coat of mail."

Lines 6–7. ω αδεφως should be ὁ ἀδελφός. The grammar is simply not there.

24. Inv. No. 71.91 (fig. 24)

Fragment of carved marble entablature. Above the inscribed band is an
 interlace ornament with an upright vine leaf within each loop.
 Below the inscription is a row of smaller leaves with vertical veins.
Provenance: Istanbul. Found in 1968 between Kocamustafapaşa and
 Silivrikapı.
Dimensions: Height 0.50 m.; length 1.67 m.; thickness 0.61 m.; height
 of letters 0.09 m.
Text: ⌣πρ]ος 9(εο)ν νευουσαν ευσεβει τροπ[ω
Translation: "...her, who is inclined towards God in pious manner."
Date: Sixth century.
Commentary: This was part of the dedicatory inscription of a church,
 like those of SS. Sergius and Bacchus and St. Polyeuctus, composed
 on behalf of a female donor. The inscription is in twelve-syllable
 iambic verse, with the *Binnenschluss* after the seventh syllable.

25. Inv. No. 72.12 (fig. 25)

Fragment of marble tombstone.
Provenance: Unknown; purchased from an antiquities dealer in 1972.
Dimensions: Height 0.23 m.; width 0.24 m.; thickness 0.09 m.; height of
 letters 0.025–0.03 m.; interlinear spaces 0.01 m.
Text: [ε]ν̣θαδε κ[α-
 τ]ακιτε Βρ̣[.
 .]ενημ(ης) ο της
 μακαριας
5 μνημης υι-
 ος Ουνιγια
Translation: "Here lies Vr[.]ẹnim(is) (?) of blessed memory, the son of
 Ounigias."
Date: Sixth century.

Commentary: Lines 2–3. Βρ[. .]ενημ(ης) is suggested *exempli gratia*. In view of the name of his father (or possibly mother), the name of the deceased, too, should be Germanic.

Line 6. We postulate Οὐνιγίας as a nominative masculine. The name is certainly Germanic, cf. Förstemann, *Namenbuch*, 1479: Unigis, a *spatharius* at the court of Theodoric (in Cassiodorus); Unigius, bishop of Avila in Spain, in 683; *ibid.*, 1614: Winigis, frequent occurrences in the fifth and eighth centuries; Unichis (fifth century). It is also possible that the inscription mentions the mother of the deceased. If so, one should read Οὐνιγία[ς].

26. Inv. No. 72.22 (fig. 26)

Marble block, presumably from the walls of Istanbul. Letters originally filled with lead, holes for the attachment of which are visible.
Provenance: Found in the course of grading operations in the third court of Topkapı Sarayı near Arz Odası.
Dimensions: Height 0.17 m.; length 1.20 m.; thickness 0.25 m.; height of letters 0.13 m.
Text: ...μεγιστος ευσεβ[ης...
Translation: "...the exalted and pious [emperor]...."
Date: Ninth or tenth century.

27. Inv. No. 73.18 (fig. 27)

Square marble tombstone with a cross in center.
Provenance: Unknown; a gift to the Museum. Entered the Museum on 16 February 1973.
Dimensions: Height 0.30 m.; length 0.304 m.; thickness 0.05 m.; height of letters 0.025–0.035 m.; interlinear spaces 0.005–0.025 m.
Text: μνημη
Ιρηνης
ασκητρη-
ας
Translation: "Memorial of the nun Irene."
Date: Fifth–sixth century.
Commentary: Note the use of ἀσκήτρια, "nun." For ἀσκήσας possibly meaning "was a Christian" or "a penitent," cf. Wessel, *Inscr. Gr. Chr.*, no. 31. For the use of ἀσκοῦσα and related forms for *nun* in a hagiographical text written about 900, cf. *Žitie i podvigi sv. Feodory Solunskoj*, ed. Bishop Arsenij (Jur'ev, 1899), pp. 4, 6; 5, 9; 20, 34; 23, 39; 26, 45; 30, 51.

28. Inv. No. 73.19 (fig. 28)

Marble tombstone broken off at left and lower end.
Provenance: Unknown; a gift to the Museum.

Dimensions: Height 0.36 m.; length 0.18 m.; thickness 0.045 m.; height
 of letters 0.03–0.04 m.; interlinear spaces 0.01–0.03 m.

Text: ε + ν-
 θαδε
 κατακ-
 ιτη Μ-
 5 αξιμο-
 ς
 α + ω

Translation: "Here lies Maximos."

Date: Fifth–sixth century.

Commentary: Lines 3–4. Cf. η for αι in κατάκιτη. For parallels, cf. Com-
 mentary to No. 16 line 3, above.
 Line 7. The letters α and ω under the transverse arm of the
 cross imitate the same letters suspended from metal crosses. This
 would firmly date the practice of suspending letters from crosses
 to the fifth–sixth centuries.

29. Inv. No. 73.28 (fig. 29)

Tombstone of Proconnesian marble, broken at lower end.

Provenance: Istanbul – Ataköy, in excavations for a new apartment
 house. Entered the Museum on 26 April 1973.

Dimensions: Maximum height 0.755 m.; length 0.375 m.; thickness
 0.06 m.; height of letters 0.025 m.; interlinear spaces 0.005–
 0.008 m.

Text: + + +
 + ενθαδε κατα-
 κιτε ο της ευλ⟦α-⟧
 βως μνημης Αμα-
 ντις διακονος
 5 του Θεολογου ε-
 τελιωθη μηνι Οκ-
 τοβριω αρχη ινδ(ικτιωνος)
 ιγ′ +

Translation: "Here lies Amantios of pious memory, deacon of ⟨the Church
 of St. John⟩ the Theologian. He died in the month of October,
 at the beginning of the thirteenth indiction."

Date: Fifth–sixth century.

Critical note: Line 2. Originally, the stonecutter carved ευλβ, omitting
 the alpha.

Commentary: Lines 2–3. ευλαβως stands for εὐλαβοῦς.
 Lines 3–4. 'Αμάντις: for the name in the East, cf. the quarter
 τὰ 'Αμαντίου in Constantinople, R. Janin, *Constantinople byzantine.
 Développement urbain et répertoire topographique*, 2nd ed. (Paris,

1964), 307, who refers to other persons of this name in the fourth–fifth centuries.

Lines 4–5. Judging by the place at which the tombstone was found (Ataköy near Bakırköy), Amantios was deacon of the famous Church of St. John the Evangelist at the Hebdomon (at Bakırköy, cf. Janin, *La géographie ecclésiastique* [*supra*, p. 9], 278). The church existed by the year 400, cf. *ibid.*, 275.

30. Unnumbered A (fig. 30)

Marble tombstone in two fragments. Lines of writing ruled.
Provenance: Unknown.
Dimensions: Height 0.37 m.; width 0.197 m.; thickness 0.04 m.; height of letters 0.025–0.045 m.; interlinear spaces 0–0.01 m.
Text:

α πισ[τη
εν Χ[(ριστ)ω
απεγε-
5 νητο μη(νι) Μ-
αρτι(ου) ζι′
ημερα ς′
ινδ(ικτιωνος) ια′ +

Translation: "[Here lies] ...a, faithful in Christ. She departed on the seventeenth of March, Friday, indiction eleven."
Date: Fifth–sixth century. Note form of delta in the last line.
Commentary: Line 2. For πιστή, cf. Commentary to No. 5 above.

Lines 4–5. ἀπεγένετο, "died," is frequent; cf., e.g., ἀπογεν(ομέν)ου ἐτῶν ιδ′ in an inscription of the year 208 from 'Ināk (southern Syria), last edited by Otto Fiebiger, in *Inschriftensammlung zur Geschichte der Ostgermanen*, Zweite Folge, Akademie der Wiss. Wien, Phil.-hist. Klasse, Denkschriften, 72,2 (Vienna, 1944), no. 20.

Line 6. Note inversion of numerals in the day of the month, as in No. 17 above.

31. Unnumbered B (fig. 31)

Marble tombstone. Two upper corners knocked off.
Provenance: Unknown.
Dimensions: Height 0.36 m.; width 0.34 m.; thickness 0.065 m.; height of letters 0.025–0.027 m.; interlinear spaces 0.01 m.
Text: +
ενθαδ[ε κα-
τακιτε Αυ-
ξωνια πισ··
τη

Translation: "Here lies the Christian Auxonia."
Date: *Ca.* sixth century. Note forms of nu and xi.
Commentary: Line 3. For πιστή, cf. commentary to No. 5 above.

32. Unnumbered C (fig. 32)

Fragment of brick with stamped inscription and carved decoration consisting of a mask between two columns and a fish above.
Provenance: Unknown.
Dimensions: Maximum height 0.27 m.; width 0.20 m.; thickness 0.04 m.; inside measurements of stamp 0.115 × 0.065 m.
Text: [+] Κ̣ωνστ-
αντιν(ου)
Date: Sixth century.
Commentary: This is, to our knowledge, a unique piece. The inscription Κωνσταντίνου (whether it refers to a person or to a municipal brickyard) is the commonest Byzantine brickstamp found at Istanbul. Cf., e.g., C. Mango, "Byzantine Brick Stamps," *AJA*, 54 (1950), 24–25. We have not, however, seen another specimen with carved decoration.

33. Unnumbered D (fig. 33)

Marble tombstone with two crosses.
Provenance: Unknown
Dimensions: Height 0.57 m.; length 0.39 m.; thickness 0.06 m.; height of letters 0.03–0.04 m.; interlinear spaces 0.005–0.015 m.
Text: ενθ-cross-αδε
κα-cross-τα-
κι-cross-τε
η τις-cross-μακα-
5 ριας μνημης
Θεωδορα{ς}
πιστη χορι-
ου Υνιασις
cross
Translation: "Here lies the faithful Theodora of blessed memory; ⟨she was⟩ from the village of Oiniasis (?)."
Commentary: Line 7. For πιστή, cf. the Commentary to No. 5 above.
Line 8. The name of the village is unknown to us. Cf. Oinaion (modern Ünye) on the Black Sea coast.

APPENDIX

34. Inv. No. 5930 (fig. 34)

Marble funerary stele with a gable, acroteria, and a foot.

Provenance: Unknown; bought from antiquities dealer Yusuf Karakuş in 1967. In view of parallels (cf. Commentary below), the probable provenance of the stele is Lydia, most likely the cemetery at Icikler (next to ancient Saittai) or Kula (both in east Lydia).

Dimensions: Maximum height 0.69 m.; maximum length 0.385 m.; thickness 0.055 m.; height of letters 0.02 m.; interlinear spaces 0.005 m.

Text: ἔτους σπϛ' μη(νὸς) Ὑπερ-
βερτέου ϛ' ἀ(πιόντος) Καρποφ-
όρον ἡ γυνὴ Τρύφα-
ινα ἐτείμησαι
5 ζή(σαντα) ἔτ(η) λ'

Translation: "In the year 286, on the sixth of the month of Hyperberetaios [August] counting from the month's end, Tryphaina, his wife, honored Karpophoros, who died at the age of thirty."

Date: Assuming — as is reasonable — that our inscription is dated by the Sullan Era, the year 286 corresponds to 201–2.

On the Sullan Era (starting in the fall of 85 B.C.) and its application in Lydia, especially in Saittai (Icikler), Maionia (Menye), and Iulia Gordos (Gördes), cf. W. Kubitschek in *RE*, I (1894), 638–39; *idem, Grundriss der antiken Zeitrechnung* (Munich, 1928), 76; A. E. Samuel, *Greek and Roman Chronology* (Munich, 1972), 247 note 8 (of little help here); P. Herrmann, *Ergebnisse*, 10, and *idem*, "Überlegungen zur Datierung der 'Constitutio Antoniniana,'" *Chiron*, 2 (1972), 526–28.

Commentary: A close parallel to our inscription is provided by the stele of the year 192, brought to Trieste from Izmir (but not necessarily found there) *ca.* 1887; cf. P. Sticotti, in *Jahreshefte des Österreichischen Archäologischen Institutes in Wien*, 2 (1899), Suppl., 103. The stele has almost the same shape, dimensions, formulae, abbreviations, and a similar ornament (a wreath): ἔτους σοϛ' μη(νὸς) Δεσίου ϛ' Τυχικὸς Σωτηρίδα τὴν γυνѣκα ἐτείμησεν ζή(σασαν) ἔτ(η) ιη'.

Herrmann, *Ergebnisse*, 14 note 50, attributes this stele to Saittai. Indeed, the funerary stelai originating from the necropolis of Saittai are remarkably similar to our stele. Cf. Keil–Premerstein, *Bericht* (1911), nos. 216–17; P. Herrmann and K. Z. Polatkan, "Grab- und Votivstelen aus dem nordöstlichen Lydien im Museum von Manisa," *AnzWien*, 98 (1961), no. 16: cf. p. 122, no. 5 and p. 123, no. 10; and Herrmann, *Ergebnisse*, esp. p. 15, no. 8 and p. 17, no. 13. On the site, see L. Robert, in *Opera minora selecta*, I (Amsterdam, 1969), 422–28, and Herrmann, *Ergebnisse*, 12–14.

Other similar stelai come from Kula south of Icikler, cf. Keil–Premerstein, *Bericht* (1908), nos. 184–87.

Another parallel is the funerary stele of the year 300 found in Uşak; it is dated by the Sullan Era and contains the expression ἐτείμησαν and the abbreviation for ζή(σασαν) ἔ(τη). Cf., finally, E. Gibson, "The Rahmi Koç Collection, Inscriptions, Parts II and III," *Zeitschrift für Papyrologie und Epigraphik*, 31 (1978), esp. 237–40 and fig. XII, who published two grave stelai dated by the Sullan Era (to 182–83 and 259–60 respectively); both display the formula ἐτ(ε)ίμησαν. According to the editor, they both come from northeast Lydia.

Lines 1–2. For the form Ὑπερβερτέου, cf. Ὑπερβερταίου and possibly Ὑπερβετε[ου in Keil–Premerstein, *Bericht* (1908), nos. 81, 144, 160, 181, 184, 185, 191; *idem*, *Bericht* (1911), nos. 148, 170, 239; Ὑπερβερτέου in K. Buresch, *Aus Lydien. Epigraphisch-geographische Reisefrüchte* (Leipzig, 1898), 54; Herrmann, "Grab- und Votivstelen," no. 4; *idem*, *Ergebnisse*, no. 8; Gibson, "The Rahmi Koç Collection," no. 2, p. 240.

Line 2. ϛ′ ἀπιόντος — The stigma is "underdeveloped," but the reading is sure on account of close parallels in Keil–Premerstein, *Bericht* (1911), no. 161; Herrmann, "Grab- und Votivstelen," no. 2, and esp. *idem*, *Ergebnisse*, no. 13, and H. W. Buckler, in *JHS*, 37 (1917), 101, no. 12 (Lydia), which have the same day of the month. Cf. also Keil–Premerstein, *Bericht* (1914), no. 11.

Lines 2–3. Καρποφόρον — For the occurrence of this name in the region, cf. Keil–Premerstein, *Bericht* (1911), no. 102.

Lines 3–4. Τρύφαινα — For the occurrence of this name in the region, cf., e.g., Keil–Premerstein, *Bericht* (1908), no. 138, and Herrmann, *Ergebnisse*, no. 55.

Line 4. As a funerary formula, ἐτίμησε is characteristic for areas of Phrygia and Lydia, cf., e.g., L. Robert, in *Hellenica*, 6 (1948), 92. Almost every one of the nineteen funerary stelai from Saittai, published by Herrmann in "Grab- und Votivstelen" and *Ergebnisse*, contains the formula.

For providing us with some bibliography pertinent to the discussion of this inscription, we are indebted to Dr. T. Drew-Bear.

INDEX

(Numbers refer to number and line of inscription.)

1. PROPER NAMES AND TITLES

Ἀθηναῖος	21.5	Κωνσταντῖνος	32.1–2
Ἀλύπιος	17.11–12	Κοσταντῖνος	22.1–2
Ἀμάντις	29.3–4	Μάξιμος	28.4–6
Ἀναστασία	10.3–4	Μάρτιος, month	6.6, 30.5–6
Ἄργος (?) Ἄργων acc. sg.?	23.3–4	Μιχαήλ	20.5
ἀσκήτρηα	27.3–4	μοναχή	18.6
Αὐξωνία	31.2–3	Νοννίς	19.5
βασιλεία	17.15–16, 21.9	Ὀκτόβριος	29.6–7
Βρ..ενημης	25.2–3	Ὠκτόβριος	7.4
Γαβριήλ	20.5	Ουνιγιας	25.6
Γορπιέος, month	21.8	Ουνουτζου	3.3
διάκονος	29.4	Οὐριήλ	20.5
δομέστικος	16.1	Ζένη	18.7
δορκάρηος (?)	23.6	Πλευρηνός	5.4–5
Ἐπιφάνις	1.2–3	πρεσβύτερος	17.12
Εὐγενειανή	18.6	πρήσμων (?)	22.2
Εὐφροσύνη	8.3–5	πριμικίρις	6.4–5
Ζαβαι-, i.e., Ζαβαι[δαῖος] (?)	20.6	Σανβάτιος	14b.7
Ἠοάνης	23.3	Σε..ινα	14b.3
Ἡράκλειος (?)	17.16–17	Σευῆρος	16.3
Θεολόγος, i.e., John the Evangelist	29.5	Στομοπατᾶς (?)	23.4–5
Θεοφόβιος	5.2–3	Τανδηλας	6.3–4
Θεωδόρα	17.8–9, 33.6	Τρύφαινα	34.3–4
Ἰάκοβος	20.6	Υνιασις (χωρίον)	33.8
Ἰούλιος, month	17.14	Ὑπερβερτέος, month	34.1–2
Ἰουστινιανός	21.10	Φιδηλία	21.4
Ἰρήνη	27.2	Φιδηλεία	21.3
Καρποφόρος	34.2–3	φοιδεράτος	7.2–3
Κήρηκος	11.3–4	Χριστός	30.3
κόμης	21.5		

2. DATED INSCRIPTIONS

A.D. 201/02	34
531, 546, or 561	21
610–41 (?), 625 (?)	17

PLATES

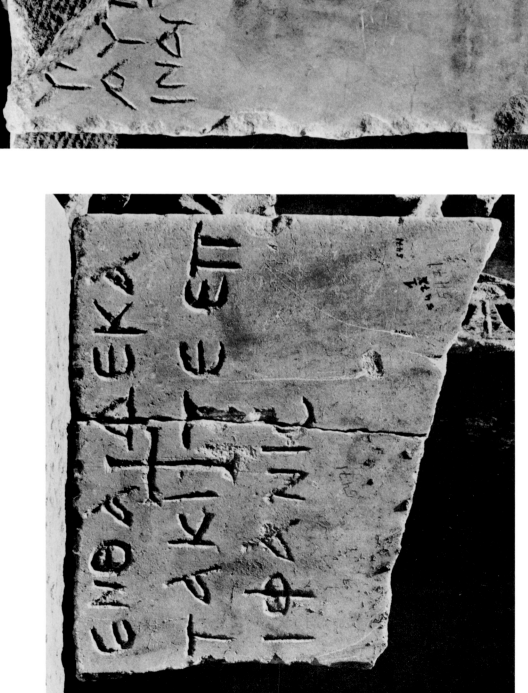

1. Inv. no. 5471

2. Inv. no. 5472

Istanbul, Archaeological Museum

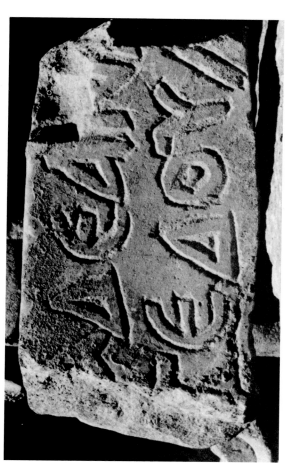

4. Inv. no. 5832

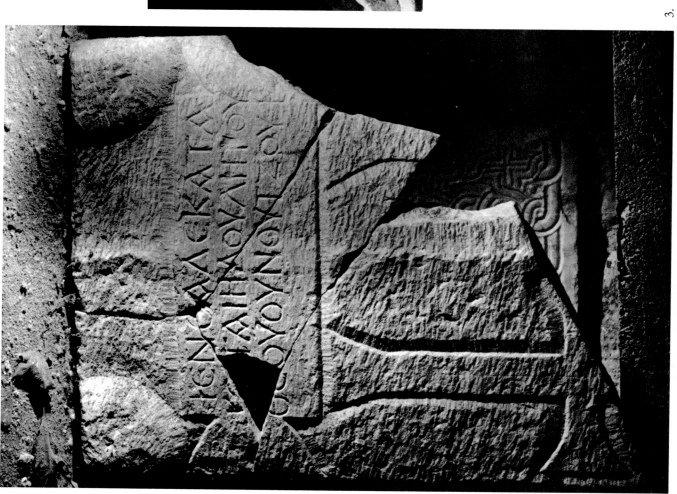

3. Inv. no. 5669

Istanbul, Archaeological Museum

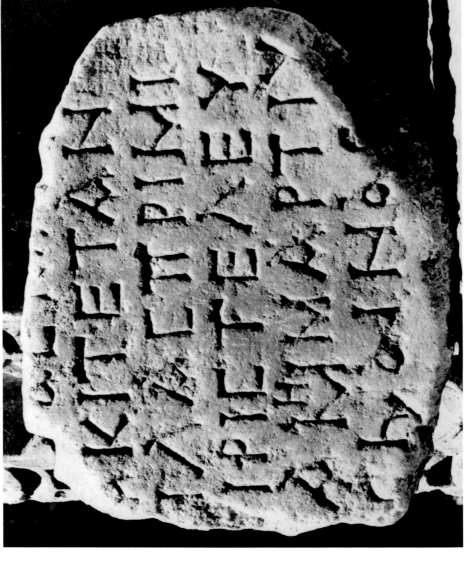

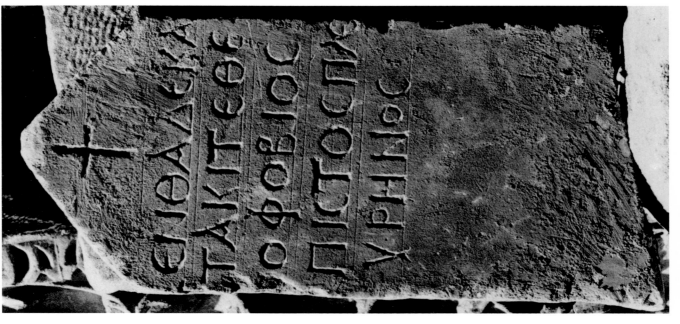

6. Inv. no. 5891

5. Inv. no. 5867

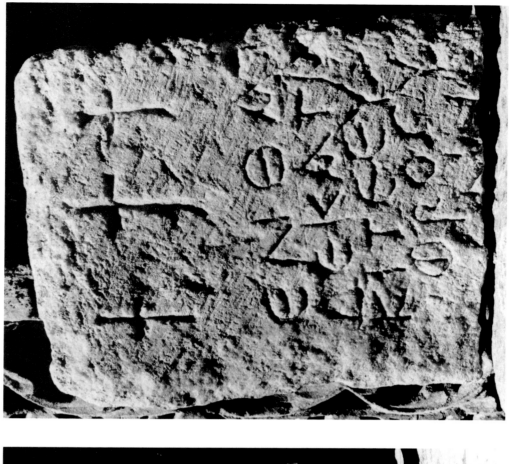

7. Inv. no. 5892

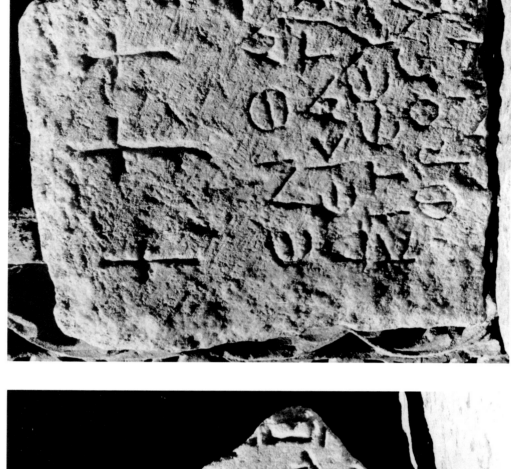

8. Inv. no. 5965

Istanbul, Archaeological Museum

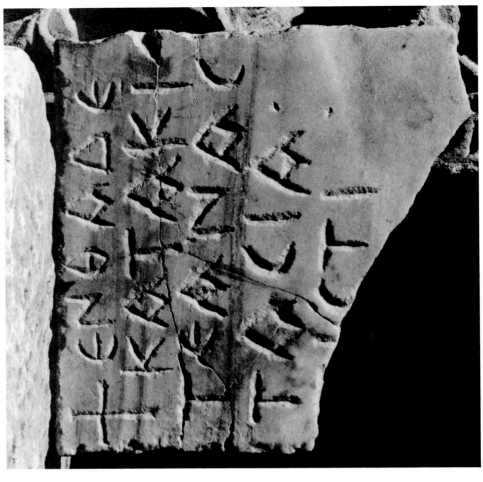

10. Inv. no. 5989

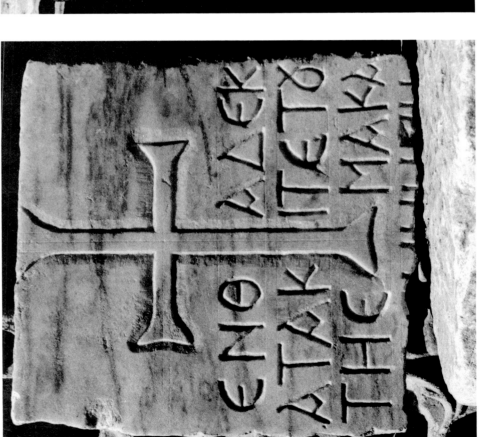

9. Inv. no. 5988

Istanbul, Archaeological Museum

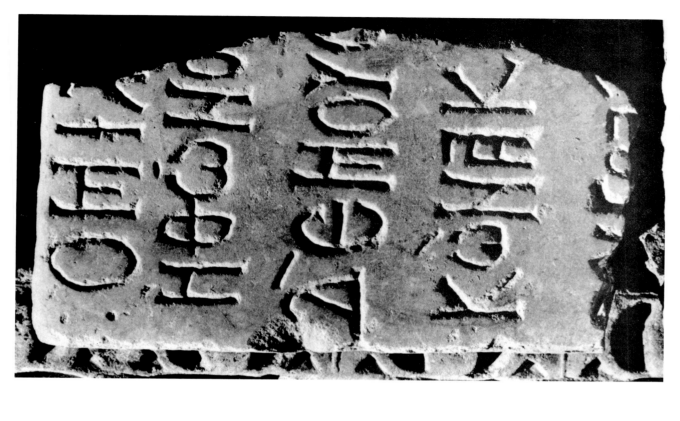

12. Inv. no. 6049

Istanbul, Archaeological Museum

11. Inv. no. 6000

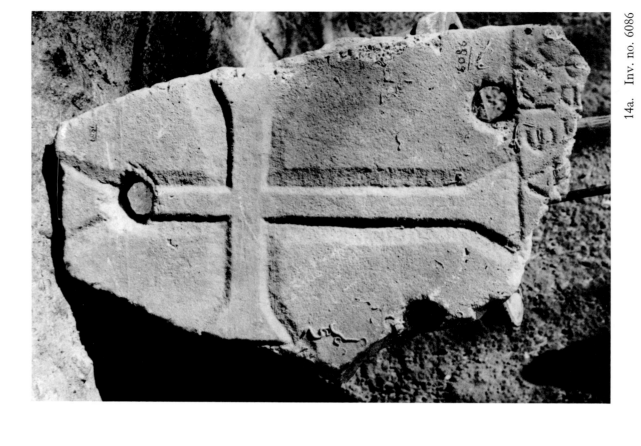

14a. Inv. no. 6086

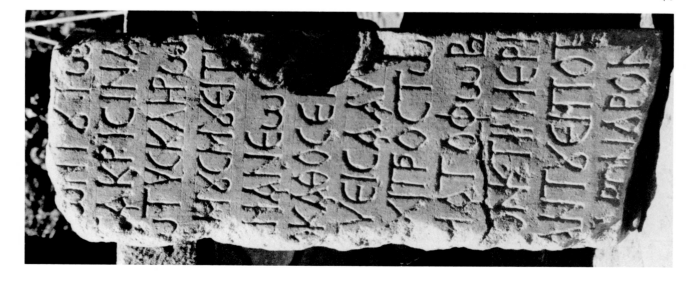

13. Inv. no. 6082

Istanbul, Archaeological Museum

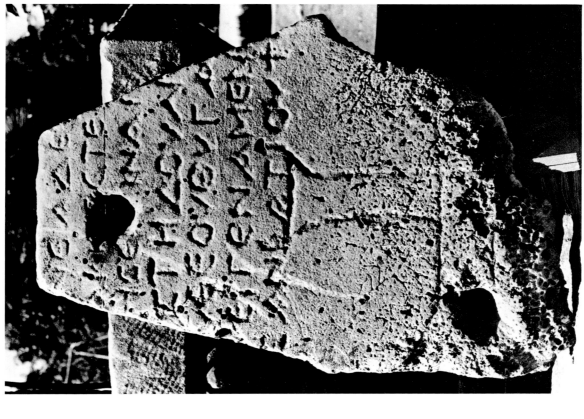

14b. Inv. no. 6086

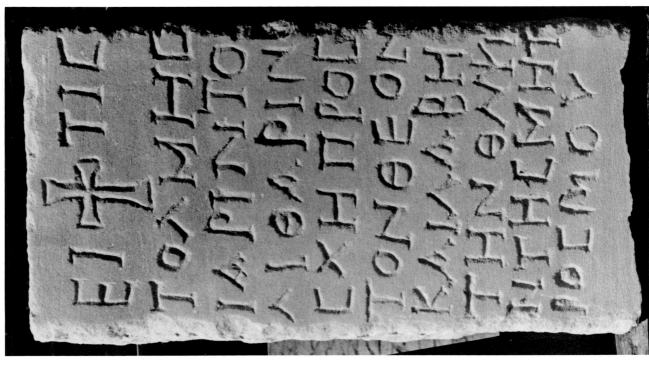

15. Inv. no. 6092

Istanbul, Archaeological Museum

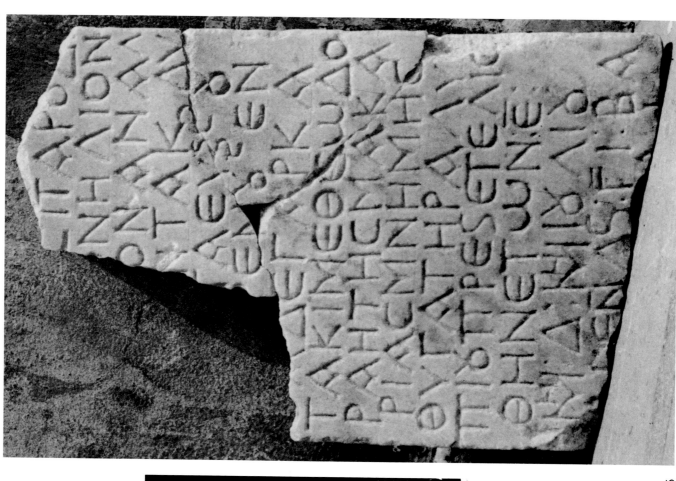

16. Inv. no. 6114

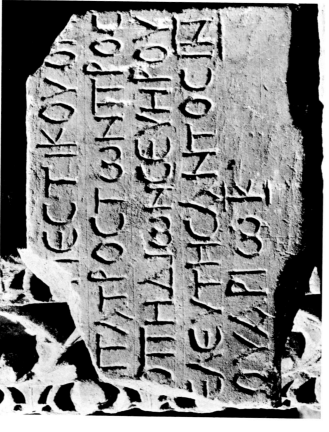

17. Inv. no. 6115

Istanbul, Archaeological Museum

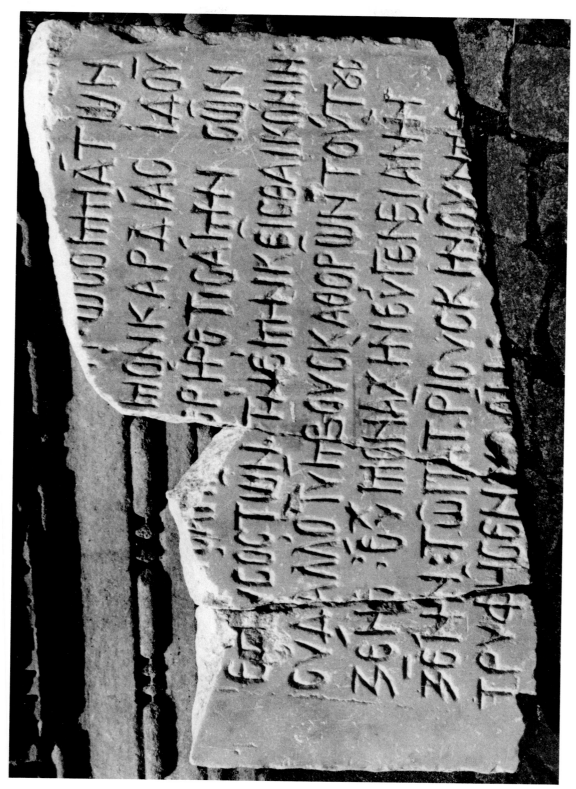

18. Istanbul, Archaeological Museum, Inv. no. 6144

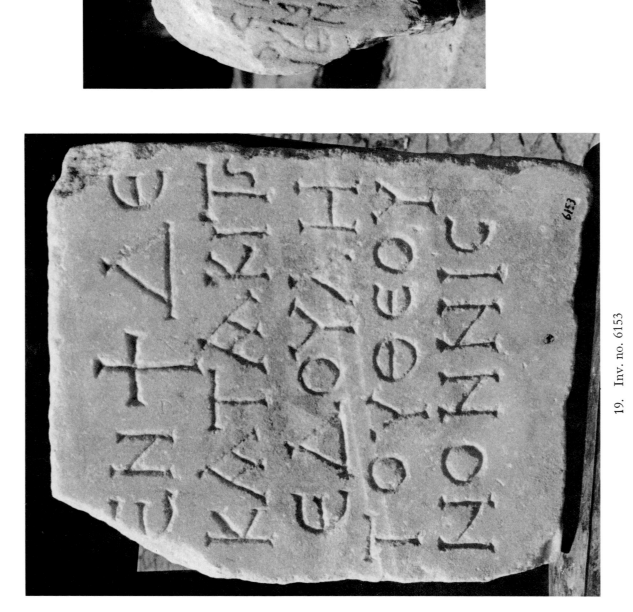

19. Inv. no. 6153

20a. Inv. no. 6234

Istanbul, Archaeological Museum

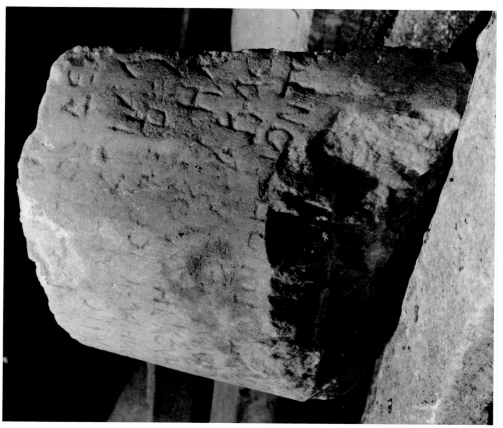

20c.

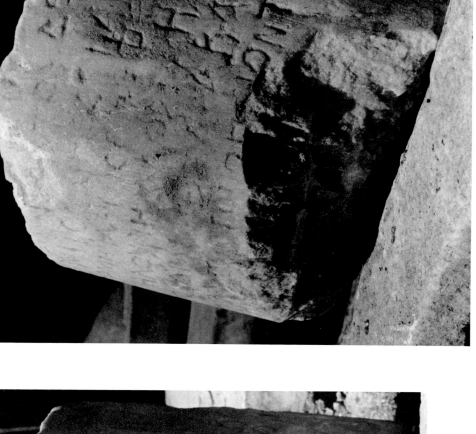

20b.

Istanbul, Archaeological Museum, Inv. no. 6234

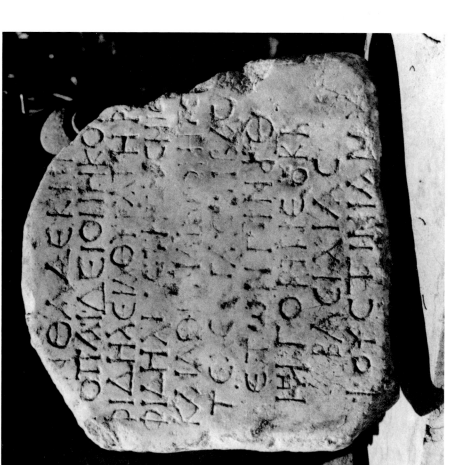

21. Inv. no. 6237

22a. Inv. no. 6261

Istanbul, Archaeological Museum

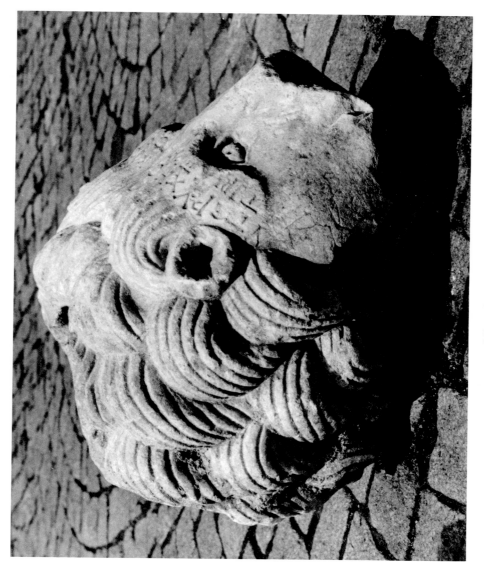

22b. Inv. no. 6261

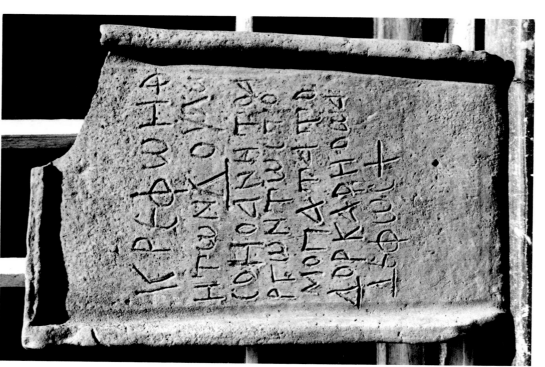

23. Inv. no. 7316

Istanbul, Archaeological Museum

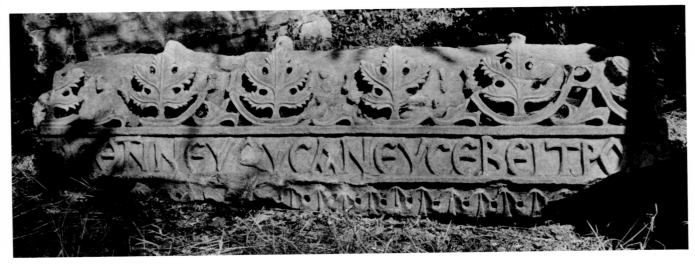

24. Inv. no. 71.91

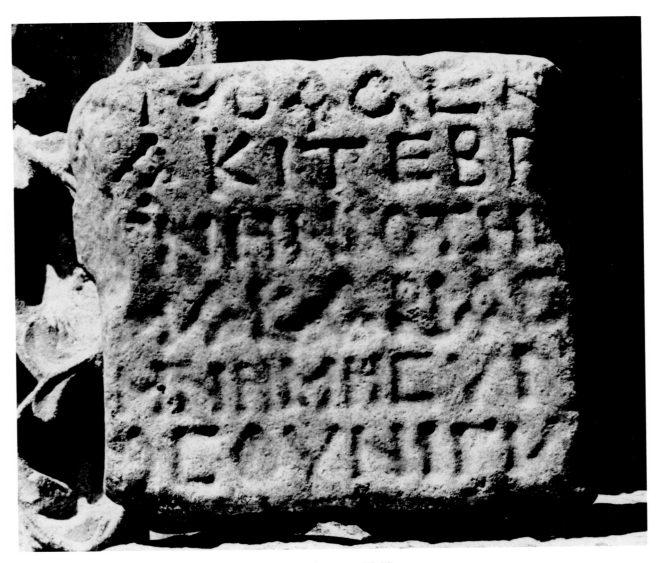

25. Inv. no. 72.12

Istanbul, Archaeological Museum

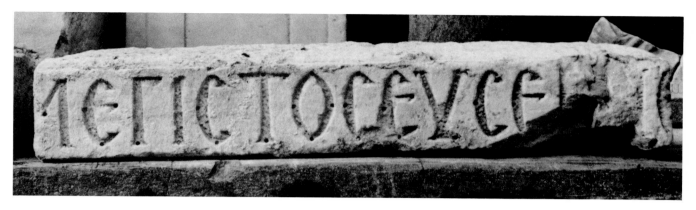

26. Inv. no. 72.22

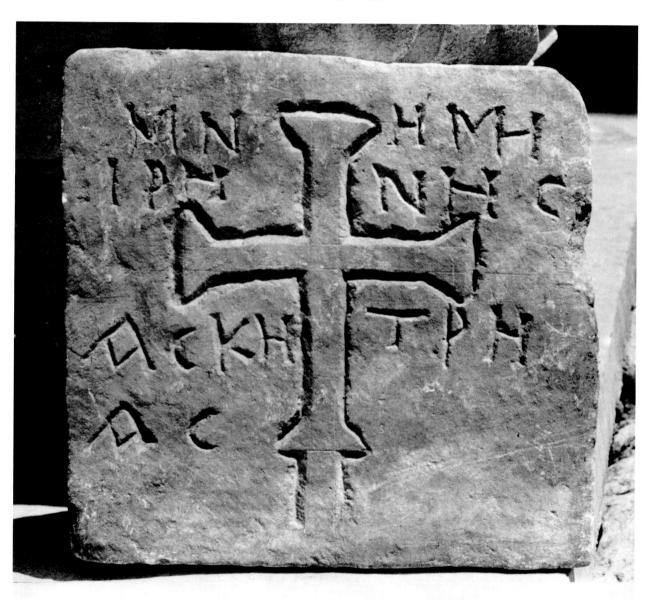

27. Inv. no. 73.18

Istanbul, Archaeological Museum

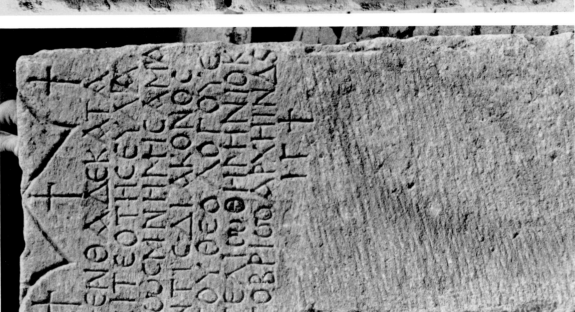

30. Unnumbered A

29. Inv. no. 73.28

Istanbul, Archaeological Museum

28. Inv. no. 73.19

32. Unnumbered C

Istanbul, Archaeological Museum

31. Unnumbered B

33. Unnumbered D

34. Inv. no. 5930

Istanbul, Archaeological Museum

THE TITLE ΒΑΣΙΛΕΥΣ
IN EARLY BYZANTINE
INTERNATIONAL RELATIONS

Evangelos K. Chrysos

This paper was prepared at the Dumbarton Oaks Center for Byzantine Studies during my stay there in the fall of 1976. I would like to thank the faculty, research and library staffs, and the visiting fellows for their help and advice, especially Prof. Philip Grierson, who kindly discussed the numismatic material. I would also like to thank Nancy Rogers Bowen for editing this study for publication.

INTRODUCTION

In the *intitulatio* of a Novel promulgated by Heraclius and his son Heraclius New Constantine on March 21, 629, L. Bréhier discovered in 1905 the first instance for the assumption of the title βασιλεύς in protocols of official imperial documents: Ἡράκλειος καὶ Ἡράκλειος νέος Κωνσταντῖνος πιστοὶ ἐν Χριστῷ βασιλεῖς.[1] Bréhier concluded that this instance could possibly be not only the first known case, but the actual date of the official introduction of the title into the Byzantine protocol.[2] Forty-three years later, during which time this conclusion was either ignored, misunderstood, or rejected by almost all scholars who dealt with the history of Byzantine imperial titles, Bréhier restated his opinion in a refined version: "Ce fut Héraclius, après sa victoire sur la Perse, qui modifia le premier le protocole impérial et lui donna la forme définitive qu'il conserva, avec peu de variantes, jusqu'à la fin de l'Empire.... Pour la première fois le mot basileus devient le titre légal du souverain et il semble bien que dans la pensée d'Héraclius, ce changement soit comme la consécration de la victoire qu'il a remportée sur celui que se targuait jusque-là d'être le grand roi, l'unique basileus."[3]

J. B. Bury was the first to make use of this discovery, in a lecture on "The Constitution of the Later Roman Empire."[4] However, Bury did not make fair use of Bréhier's article. For, after referring to the discovery, he states curiously that Bréhier failed to see the reason for this change of style, "but the significant date A.D. 629 supplies the explanation."[5] What follows is the explanation that Bury missed (!) in Bréhier's article: "In that year Heraclius completed the conquest of Persia. Now, the Persian king was the only foreign monarch to whom the Roman Emperors conceded the title Basileus; except

[1] C. E. Zachariae von Lingenthal, *Jus Graeco-Romanum*, III (Leipzig, 1857), 44; cf. Zepos, *Jus*, I (Athens, 1931), 36; L. Bréhier, "Le protocole impérial depuis la fondation de l'empire Romain jusqu'à la prise de Constantinople par les Turcs," *CRAI* (1905), 177–82, esp. 179. However, Bréhier investigated the subject more thoroughly in his article, "L'origine des titres impériaux à Byzance—Βασιλεύς et δεσπότης," *BZ*, 15 (1906), 172–73.

[2] *Idem*, "L'origine des titres," 173. Recently, N. Oikonomides reconstructed the *intitulatio* of a letter sent by Heraclius to the Great King of Persia Kavadh-Siroe in 628 as follows: Αὐτοκράτωρ Καῖσαρ Φλάβιος Ἡράκλειος πιστὸς ἐν Χριστῷ βασιλεὺς Ῥωμαίων: "Correspondence Between Heraclius and Kavath-Siroe in the Paschal Chronicle (628)," *Byzantion*, 41 (1971), 273. This proposal does not affect Bréhier's argument because the letter of Heraclius is dated after the battle of Ninevah. However, the title βασιλεύς seems to have been added to current imperial titles by other emperors before Heraclius. Cf. H. Grégoire, *Recueil des inscriptions grecques chrétiennes d'Asie Mineure* (Paris, 1922), no. 107 (for Justinian); and J.-P. Sodini, "Une titulature faussement attribuée à Justinien Iᵉʳ," *TM*, 5 (1973), 373–84 (for Tiberius). See Appendix, *infra*, p. 72f.

[3] L. Bréhier, *Les institutions de l'empire byzantin* (Paris, 1949), 49–50. In this second statement Bréhier avoided combining the assumption of the title with the restitution of the Holy Cross, because he realized that this event most probably occurred in 630; cf. *idem*, *Vie et mort de Byzance* (Paris, 1947), 52.

[4] *The Creighton Lecture, University College, London, November 12, 1909* (Cambridge, 1910); repr. in *idem*, *Selected Essays*, ed. H. Temperley (Cambridge, 1930), 99–125.

[5] *Ibid.*, 109.

the Abyssinian king, who hardly counted. So long as there was a great independent Basileus outside the Roman Empire, the Emperors refrained from adopting a title which would be shared by another monarch. But as soon as that monarch was reduced to the condition of a dependent vassal and there was no longer a concurrence, the Emperor signified the event by assuming officially the title which had for several centuries been applied to him unofficially."[6] The argument in Bury's explanation, that "Heraclius completed the conquest of Persia" and that the Persian monarch "was reduced to the condition of a dependent vassal," is so obviously erroneous that for its rejection it would be sufficient to refer to what Bury himself had written twenty years earlier, namely that after the battle of Ninevah Heraclius did not conquer Persia, but concluded peace with Chosroes' son Kavădh-Široe![7] It was, therefore, an easy task for Ernest Stein[8] to upset this argument when he reviewed the *History* of A. A. Vasiliev, who had adopted Bury's explanation literally and without any reference to Bréhier.[9] It is important to notice, however, that for Stein, Bury's (and Vasiliev's) explanation is unacceptable, not so much because the Persian king was not really reduced to the condition of a vassal,[10] but because even in this condition he continued to be recognized officially as βασιλεύς, and therefore it would be unreasonable for the Roman emperor to share the same title with his vassal. Thus, it was due to Bury's failure to present his and Bréhier's theory in a reasonable way that later scholars rejected it.

Looking for another, more probable explanation, Stein suggested that "es dürfte sich vielmehr lediglich um eine (vielleicht schon wenige Jahre vor 629 erfolgte) zweckmässige Vereinfachung der Kaisertitulatur handeln, die zugleich der fast vollendeten Gräzisierung der Staates Rechnung trug."[10a] G. Ostrogorsky, without mentioning Stein (!), fully accepted this opinion, changing only the sequence of the two factors: the assumption of the title of βασιλεύς was a result of the *Gräzisierung* of the Byzantine state and meant a simplification of the imperial title.[11]

In a long footnote Ostrogorsky repeated Stein's conclusion concerning Bréhier's and Bury's theory. However, he added a further argument of decisive importance which had not been produced by Stein: "...the use of the title of Basileus for foreign rulers before its official adoption by the Byzantine Emperor was of little significance. Basileus had at that time the

[6] *Ibid.*, 109. Cf. O. Treitinger, *Die oströmische Kaiser- und Reichsidee* (Jena, 1938; repr. Darmstadt, 1956), 186; and E. Kornemann, *Doppelprinzipat und Reichsteilung im Imperium Romanum* (Leipzig-Berlin, 1933), 156.

[7] J. B. Bury, *A History of the Later Roman Empire* (London, 1889), II, 242f.

[8] Cf. *BZ*, 29 (1930), 353.

[9] As early as 1917 in the Russian edition, *Lektsii po istorii Vizantii*, I (Petrograd, 1917), 186; cf. the first English edition, *History of the Byzantine Empire*, I (Madison, Wisc., 1928), 241. Vasiliev does not speak of a conquest of Persia, but rightly only of "the successful outcome of the Persian war." However, he quotes Bury, who writes of the "dependent vassal."

[10] ... der (*angebliche*) Klientelfürst: *op. cit.*, 353.

[10a] *Ibid.*, 353.

[11] *Geschichte des byzantinischen Staates* (Munich, 1963), 89. Cf. W. Ennslin, in *CMH*, IV,2 (Cambridge, 1966), 1f.; and D. Zakythenos, Βυζαντινὴ Ἱστορία (Athens, 1972), 144.

same meaning as *rex* and in the early Byzantine period, when the Byzantine ruler had the official title of *Imperator*, it was used not only for the Persian monarch, but for such as Attila and the kings of Armenia and Ethiopia, and sometimes, alternating with other designations, for the Germanic rulers and even the leaders of the Abasgi and Zechi...."[12]

In order to support this argument concerning the imperial title βασιλεύς, Ostrogorsky refers to the evidence collected by Rudolf Helm.[13] However, the material supplied by Helm does not support Ostrogorsky's far-reaching conclusion. As a matter of fact, the accurate examination of the references produced by Helm without commentary, clarification, or classification[14] does not upset but testifies to the fundamental conclusion already established by A. Gasquet in the last century: that there is a sharp distinction to be made between the literary sources, with their current but not necessarily official terminology, and the imperial documents, which preserve the official usage of titles; and that in the latter we should not expect to find the title *basileus* conceded to any ruler, short of the Roman emperor and the Persian monarch.[15]

On the grounds of this basic distinction, the primary aim of this study is to reconsider the evidence concerning the official titles of the rulers of the neighboring states of the Byzantine Empire, for some of whom Ostrogorsky alleged the conferment of the title βασιλεύς. These states can be divided into four groups: I. The states whose sovereignty was never questioned by Byzantium; as we shall see, there was only one such state, Sasanid Persia. II. The national kingdoms located on the periphery of the Empire, in the East; to these belong Armenia, the kingdoms of the Causasian area and the shores of the Black Sea (Iberia, Lazica, Abasgia, Bosporus), and the kingdoms of East and North Africa (the Ethiopian, Nubian, and Blemyan kingdoms). III. The autonomous satrapies and phylarchies on the periphery but inside the Byzantine frontier, such as the Armenian satrapies and the nomadic Arabic phylarchies of the Syrian desert. IV. The numerous national kingdoms of the barbarian nations of the *Völkerwanderung*, who succeeded in establishing themselves temporarily or permanently on the soil of former Roman provinces with imperial consent; to these belong the Visigoths, the Ostrogoths, the Vandals, the Franks, the Burgundians, the Heruls, and the Lombards, as well as the Huns.

[12] G. Ostrogorsky, *History of the Byzantine State*, trans. J. Hussey, 2nd ed. (New Brunswick, N.J., 1969), 106 note 2. Cf. I. Shahid, "The Iranian Factor in Byzantium During the Reign of Heraclius," *DOP*, 26 (1972) (hereafter Shahid, "The Iranian Factor"), 299f.

[13] "Untersuchungen über den auswärtigen diplomatischen Verkehr des römischen Reiches im Zeitalter der Spätantike," *AUf*, 12 (1932), 383 note 2.

[14] In a book review of Helm, "Untersuchungen," G. Ostrogorsky pointed out that the collected material is supplied in too short a way, mainly in the footnotes: "Stellenweise erreicht allerdings die Kürze einen Grad, bei dem sie aufhört eine Tugend zu sein"; cf. *BZ*, 36 (1936), 442.

[15] A. Gasquet, "L'empire d'Orient et l'empire d'Occident. De l'emploie du mot βασιλεύς dans les actes de la Chancellerie byzantine," *RH*, 26 (1884), 281–302. Cf. Th. Nöldeke, *Die Ghassânischen Fürsten aus dem Hause Gafna's*, AbhBerl (Berlin, 1887) (hereafter Nöldeke, *Die Ghassânischen Fürsten*), 12f.; Th. Mommsen, "Ostgothische Studien," *NA*, 14 (1889), 541 (*idem, Gesammelte Schriften*, VI [Berlin, 1910], 482).

For the occasion of a Symposium on "Byzantium and Sasanian Iran," held at Dumbarton Oaks in 1970, I. Shahid made a thorough study of the assumption of the title *basileus* by Heraclius.[16] Shahid rejects both Bury's[17] and Ostrogorsky's[18] theories. According to him, the formal assumption of this title mirrors a "constitutional change"[19] for the Empire. It is "related not so much to remote Hellas or foreign Persia as to...Christianity...."[20] Nevertheless, it intends to bring "the two empires [Rome and Persia] nearer to each other on the ground of a common concept of sovereignty deriving from kingship...."[21] Furthermore, Shahid supposes that Heraclius was inspired by his Armenian origin and his affiliations with the Arsacid royal family of Armenia.[22]

Shahid's theory is based on an erudite study of several aspects of the subject. However, I cannot accept some of his conclusions. For instance, in spite of the growing impact of Christian ideals on the image of Byzantine "kingship" and political ideology, I hesitate to accept that the assumption of the title may derive from Heraclius' Christian concept of *basileia*. Moreover, the assertion that the title *basileus* was of any help for the development of a Roman-Persian concept of sovereignty should be proposed in the opposite sequence, namely that the mutual recognition of the two states' sovereignty and equality of political rank has eased the process of assimilation of the Persian concept of kingship by the Byzantine emperors. On the other hand, even if one were to accept Shahid's suggestion that Heraclius was of Armenian origin—his argumentation on this point is less than convincing—it seems to me very improbable that the emperor could be influenced by the memory of a local kingship which had been abolished at Byzantine initiative 250 years before.[23]

More important is Shahid's proposal to assign to the assumption of βασιλεύς a "constitutional" meaning. I fail to see any constitutional change at work after the battle of Ninevah and think that we should take seriously the fact that no such change has been recorded in the contemporary sources.[24] However, the assumption of the title cannot be explained merely as a reduction and simplification of the imperial titles, or as an insignificant novelty in the practice of the imperial chancery; Shahid, therefore, is certainly right in calling our attention to more essential reasons that might have caused or resulted in the assumption of the title βασιλεύς. This problem is discussed in the last part of this study.

[16] "The Iranian Factor," 295–320. For a short report on the Symposium, see R. Frye, in *DOP*, 26, pp. 361–62.

[17] Bury's theory is challenged with the argument that it was not only the Persian king who was conceded the title βασιλεύς: Shahid, "The Iranian Factor," 296–99; however, see *infra*, pp. 59–60.

[18] The theory of Hellenistic influence is rejected as a too narrow (linguistic) phenomenon, whereas the explanation that the new title represents a simplification of former titles is found insufficient to explain the change of titles, because "much more is involved in this change": *ibid.*, 300–2.

[19] *Ibid.*, 313.

[20] *Ibid.*, 302.

[21] *Ibid.*, 306.

[22] *Ibid.*, 308–12.

[23] See infra, pp. 36–39.

[24] Shahid, "The Iranian Factor," 313–17.

I. The Titles of the Great King of Persia

There can be no doubt that Byzantine-Persian legal relations were established on the grounds of mutual equality and recognition of state sovereignty. Moreover, emperor and Great King respected each other's position as head of state and did not challenge each other's sovereignty even during or after victorious wars.[25]

The Persian monarch, whose official title was *shahanshah* (king of kings), was officially addressed by the emperor with the title βασιλεύς (in Latin, *rex*), while the emperor was constantly addressed by the Sasanid ruler as *quaisar i Rum*,[26] until Chosroes II rendered to Emperor Mauricius the title βασιλεὺς Ῥωμαίων.[27]

The fact that the Romans avoided the full title "king of kings" for the Persian monarch is certainly not due to any hesitation in recognizing him as the sovereign of the Iranian state, although the simple form they used was shared by a large number of other "kings" within Persia who were subordinate to the Great King. However, it implies the Roman rejection of the Oriental imperialistic ideology involved in the exclusive title.[28] It was therefore only under the pressure of the day that the Senate of Constantinople felt obliged in 615 to render to Chosroes II, who had taken Jerusalem, the title ἀρχιβασιλεύς, a necessary concession in order to avoid his proper title, βασιλεὺς βασιλέων. The Senate could not possibly use this title because in the genitive plural βασιλέων would include also Emperor Heraclius, who in the same letter is referred to as βασιλεύς.[29]

On the other hand, the Persian practice of using the title καῖσαρ for the emperor, even after βασιλεύς had prevailed as the main imperial title of address, was certainly not intended to diminish his sovereign position in the Empire. The title βασιλεύς had to be avoided, not only because it was not in official use, since it was repulsive to the Romans, but also because, used in connection with the exclusive title βασιλεὺς βασιλέων of the Persian monarch, it would degrade the emperor to the legal status of the many "kings" who

[25] See E. Chrysos, "Some Aspects of Roman-Persian Legal Relations," *Kleronomia*, 8 (1976), 1–56. Cf. K.-H. Ziegler, *Die Beziehungen zwischen Rom und dem Partherreich* (Wiesbaden, 1964), 141–53; and also K. Güterbock, *Byzanz und Persien in ihren diplomatisch-völkerrechtlichen Beziehungen im Zeitalter Justinians* (Berlin, 1906), 4–36. Cf. further S. Verosta, "International Law in Europe and Western Asia Between 100 and 650 A.D.," in *Recueil des cours, Académie de droit international*, 113,3 (1964), 524.

[26] Καῖσαρ, οὕτω γὰρ τὸν Ῥωμαίων βασιλέα καλοῦσι Πέρσαι: Procopius, *Bella* II.21,9. Cf. Güterbock, *op. cit.*, 6f.; Bréhier, *Les institutions* (note 3 *supra*), 283 note 4.

[27] Theophylactos Simocattes, *Historia* IV.11, ed. C. de Boor, Teubner (1887), 169. This was repeated by Kavădh-Široe, *Chronicon Paschale*, ed. L. Dindorf, Bonn ed. (1832), 735. For this novelty, see *infra*, pp. 70–71.

[28] That the imperialistic ideology was expressed through the exclusive title is shown in the speech of the Persian representative at the Fifty Years' Peace negotiations, who argued that ὡς κατὰ τὸ προσῆκον καὶ οὐκ ἀπεικὸς αὐτῷ [i.e., Chosroes] ἡ ἐπωνυμία κεκόμψευται τὸ βασιλέα προσαγορεύεσθαι βασιλέων: Menander, frag. 11, *Excerpta de legationibus*, ed. C. de Boor (Leipzig, 1903), 177 lines 8–10. The use of this title was impossible in the Christian era because all similar exclusive titles were attributed to the Christian God; E. Chrysos, "The Date of Papyrus SB 4483 and the Persian Occupation of Egypt," *Dodone*, 4 (1975), 344f.

[29] *Chronicon Paschale*, ed. Dindorf, I, 708.

were under the authority of the Great King. It was therefore necessary that Chosroes II and Kavădh-Široe refrain from using their exclusive title βασιλεύς βασιλέων when they rendered the title βασιλεύς to the Emperors Mauricius and Heraclius respectively.[30] Moreover, the preference for the title *caesar* instead of the other, more distinctive imperial titles, *imperator* and *augustus*, perhaps was meant to express the hereditary legitimation of the emperor, which was in fact expressed with the *cognomen*;[31] this aspect of hereditary succession was fundamentally important for the Persian concept of monarchical legitimacy.

II. The Client Kingdoms of the Empire in the East

1. *Armenia*

Armenia was divided into two partial kingdoms under Persian and Byzantine political influence respectively, due to the agreement between the Great King Shapor II and Emperor Valens in 378, until some years later the Armenian kingship was completely abolished.[32] It is therefore the period before the abolition of the Armenian kingship to which Ostrogorsky probably refers when he supposes that the Armenian kings were conceded the title βασιλεύς.[33] I. Shahid, who supports Ostrogorsky's argumentation on this point, attributes great importance especially to the nomination of Hannibalianus to the Armenian royal throne by his uncle, Constantine the Great, in 335/36, taking for granted that he was "designated 'king of kings'" and given Armenia and the Pontus.[34]

There is no doubt that Hannibalianus was nominated *rex* of Armenia. This is witnessed by official coins struck in 336/37 in Constantinople with the inscription FL ANNIBALIANO REGI,[35] and is testified also by trustworthy sources like Ammianus Marcellinus, who mentions him with the title *rex*.[36] However, there is no evidence available that Hannibalianus was ever officially addressed with the title *basileus*, and therefore we should not hasten to take it for granted, although the nomination of Hannibalianus must have taken place according to the Roman tradition of *appellatio regis*[37] which included

[30] Cf. *supra*, note 2; and *infra*, pp. 70–71.

[31] Dio Cassius, *Roman History* LIII.18,2: Ἡ γὰρ τοῦ Καίσαρος...πρόσρησις δύναμιν μὲν οὐδεμίαν αὐτοῖς οἰκείαν προστίθησι, δηλοῖ δ' ἄλλως τὴν τοῦ γένους σφῶν διαδοχήν. Cf. Th. Mommsen, *Römisches Staatsrecht*, 4th ed., II,2 (Tübingen, 1952), 770f.; cited by J. Straub, "Dignatio Caesaris," in *Regeneratio Imperii. Aufsätze über Roms Kaisertum und Reich im Spiegel der heidnischen und christlichen Publizistik* (Darmstadt, 1972), 36–63. Cf. John Lydus, *De magistratibus*, III.4: Τὸ γὰρ Καίσαρος ὄνομα γένους ἐστὶ δεικτικὸν ἀπὸ τοῦ πρώτου Καίσαρος, ὥσπερ Φλαβίων καὶ Κορνηλίων καὶ Φλαβίων καὶ 'Ανικίων, τούτου πρότερον παρὰ βαρβάροις ηὑρημένου. Αἰγύπτιοι μὲν γὰρ ἀπὸ τοῦ πρώτου Φαραῶνος τοὺς σφῶν βασιλέας ἐπεφήμιζον Φαραῶνας, καὶ Πτολεμαίους ἀπὸ τοῦ πρώτου.

[32] On the partition of Armenia, see Chrysos, "Some Aspects," 37. On the abolition of kingship, see K. Güterbock, "Römisch-Armenien und die römischen Satrapieen im vierten bis sechsten Jahrhundert," in *Festgabe Johann Theodor Schirmer* (Königsberg, 1900), 20 ff.

[33] *History* (note 12 *supra*), 106 note 2.

[34] "The Iranian Factor," 298–99.

[35] P. M. Bruun, *The Roman Imperial Coinage*, VII (London, 1966), 584, 589–90; cf. J. Maurice, *Numismatique Constantinienne*, I (Paris, 1908), 128–32.

[36] *Rerum Gestarum* XIV.1,2: *Hannibaliano regi.*

[37] O. F. Winter, "Klientelkönige im römischen und byzantinischen Reich," *JÖBG*, 2 (1952), 36.

the conferment of the title βασιλεύς.[38] Nevertheless, the only Greek source that mentions Hannibalianus with his royal title, while describing the ceremony of his investiture, calls him, significantly, not βασιλεύς but ῥήξ.[39]

The case of Hannibalianus has inspired far-reaching conclusions concerning Byzantine state theory and international relations. Thus, E. Kornemann argued that the appointment of Constantine's nephew to the Armenian throne is the first application of the doctrine that the so-called client kingdoms are part of the Empire, i.e., *reichsangehörig*,[40] while O. Seeck suggested that the appointment was the first step in Constantine's plan to conquer Persia and to establish his nephew in Ctesiphon as "Great King" of a *Secundogenitur* empire.[41] These conclusions are based on the erroneous information supplied by the *Excerpta Valesiana* that Hannibalianus was appointed not *rex* but *rex regum*, and the supposition that this title is the programmatic manifestation of his claim over the rights of the Sasanid Great King.

The unknown author of the *Excerpta* states in fact that Constantine *Annibalianum data ei Constantiana filia sua* regem regum [emphasis mine] *et Ponticarum gentiam constituit*.[42] J. C. Rolfe translated this passage as follows: "Hannibalianus he [Constantine] created King of Kings and ruler of the Pontic tribes,"[43] supposing that Constantine's nephew was a) designated "king of kings," i.e., he was given the supreme title of Oriental sovereignty, and b) appointed ruler of the client kingdoms of the Pontus. However, Polemius Silver seems to have understood this sentence more historically when he quoted it without *et*: *Hannibalianum regem regum Ponticarum gentium constituit*,[44] meaning obviously that he was given royal authority over the kings of the client tribes of the Pontus.

Hannibalianus' appointment to the Armenian throne is certainly connected with the Roman-Persian hostilities in 335 and Constantine's plans for an

[38] When Nero crowned Tiridates king of Armenia in Rome in A.D. 66, he spelled the words: βασιλέα (σὲ) τῆς 'Αρμενίας ποιῶ: Dio Cassius, *Roman History* LXII.5,3; cf. Ziegler, *op. cit.* (note 25 *supra*), 74.

[39] 'Αννιβαλιανὸν ῥῆγα προχειρισάμενος ἐνέδυσε κοκκηρὰν χλαμύδα καὶ κατὰ Καισάρειαν τῆς Καππαδοκίας ἀπέστειλεν: *Chronicon Paschale*, ed. Dindorf, I, 532; *Chronica minora*, ed. Th. Mommsen (Berlin 1892–98), I, 235, 335 line 2. The investiture with the red (not purple) chlamys mentioned in the Chronicle is probably connected with Hannibalianus' promotion to the rank of *nobilissimus*, as it is testified by Zosimus: ...καὶ 'Αννιβαλιανὸς ἐσθῆτι χρώμενος κοκκοβαφῆ καὶ περιχρύσῳ, τῆς τοῦ λεγομένου νωβελισσίμου παρ' αὐτοῦ Κωνσταντίνου τυχόντες ἀξίας αἰδοῖ τῆς συγγενείας: II.39,2, ed. L. Mendelssohn, Teubner (1887), 97 lines 18–21; and ed. F. Paschoud, (Paris, 1971), 112. On the rank of *nobilissimus*, see W. Ensslin, *RE*, 17, col. 791 ff.

[40] "Die unsichtbaren Grenzen des römischen Kaiserreiches," in *Staaten, Völker, Männer: Das Erbe der Alten*, Ser. II, no. 24 (1934), quoted from the reprint in *idem, Gestalten und Reiche* (Leipzig, 1943), 333: "Von da an ist die neue Lehre geblieben, dass auch das Land der Reichsklienten (Föderaten) in den Grenzgebieten 'reichsangehörig' sei." See, against this theory, E. Chrysos, Τὸ Βυζάντιον καὶ οἱ Γότθοι (Thessaloniki, 1972), 30 f., 58 f.

[41] *Geschichte des Untergangs der antiken Welt*, 2nd ed., IV (Stuttgart, 1911), 7–9. See, against this theory, B. Stallknecht, *Untersuchungen zur römischen Aussenpolitik in der Spätantike (306–395 n. Chr.)* (Bonn, 1969), 37.

[42] *Pars prior* 6.35, ed. Th. Mommsen, MGH, *AA*, IX,1 (Berlin, 1892), 11 line 5.

[43] Cf. his edition of *The History* of Ammianus Marcellinus, III, Loeb (Cambridge, Mass.-London, 1939), 529.

[44] *Laterculus* 63, ed. Th. Mommsen, MGH, *AA*, IX,1 (Berlin, 1892), 522.

effective answer to Shapor's offensive policy in Mesopotamia.[45] However, we can understand the sources mentioning the nomination of Hannibalianus only if we consider the fact that they connect it with Constantine's decision to divide his empire between his three sons and two nephews.[46] While the three sons were favored with a part of the imperial territory, the emperor bestowed upon his nephews Roman interests at the periphery of the imperial territory; Dalmatius' jurisdiction consisted of the Gothic federates of the Lower Danube,[47] while his brother Hannibalianus was authorized to exercise Roman overlordship in the client kingdoms of the East. It is in this way that we have to understand the short but more correct version preserved in the *Epitome de Caesaribus* that Hannibalianus was given *Armeniam nationesque circumsocias*.[48] Hannibalianus, who was designated king of Armenia in 335 in connection with Constantine's *Ostpolitik*, but did not yet have the chance to exercise his royal rights, was given in 337 the authority over the Pontic client tribes.[49] This was a Roman appointment, not an Oriental investiture; therefore, there was no reason for the conferment of the title *rex regum*. Moreover, the fact that the official coins with Hannibalianus' effigy,[50] aiming to advertise imperial policy in the East, do not mention the title *rex regum*, but only the title *rex*, is in my opinion a very strong argument *e silentio* that this title was never given to him. Nevertheless, this does not exclude the possibility that if Hannibalianus had ever actually come to exercise the royal office, which he did not, he might have used all the traditional titles of the Oriental kings, who, in spite of their legal associations, were calling themselves *reges regum*.[51]

It is of great importance for our study to underline the fact that Byzantium was first to abolish the kingship in the Roman part of divided Armenia and instead to create a Roman province out of so-called Great Armenia, and was first to establish a new form of constitutional dependence on the emperor

[45] W. Ensslin, "Zu dem vermuteten Perserfeldzug des rex Annibalianus," *Klio*, 29 (1936), 102–10, esp. 110.

[46] *Excerpta Valesiana* I.6,35; *Epitome de Caesaribus* 41.21.

[47] Cf. Chrysos, Τὸ Βυζάντιον καὶ οἱ Γότθοι, 72.

[48] Cf. 41, ed. Fr. Pichlmayr, Teubner (1966), 168.

[49] Cf. N. H. Baynes, "Rome and Armenia in the Fourth Century," in *Byzantine Studies and Other Essays* (London, 1955), 189.

[50] Silver coins show significantly on the reverse side the river Euphrates seated on the ground holding a scepter in his right hand. The legend reads: SECVRITAS PVBLICA. The bronze coins show the Euphrates reclining at the left, with his left elbow on a water jug and holding a fish in his right and a rudder in his left hand. Here the legend reads: FELICITAS PVBLICA; see Bruun, *op. cit.* (note 35 *supra*), 584, 589–90. It is worth mentioning that on the obverse Hannibalianus wears not the royal tiara but the normal Roman laurel wreath.

[51] B. Stallknecht explained that the title *rex regum* was asserted for Hannibalianus on the basis of a similar measure which Shapor II undertook only a short time before, when he appointed his brother Narseh as king of Armenia: *op. cit.* (note 41 *supra*), 36ff. However, the alleged appointment of Narseh never took place! Stallknecht was misled by a note in Moses of Chorene's *Armenian History* III.10, according to which Shapor was "planning—but never performed his plan—to appoint Narseh to the Armenian throne"; cf. Ensslin, "Zu dem vermuteten Perserfeldzug," 110; and *idem*, *RE*, 16, cols. 1757–58, *s.v.* Narses 3. Moreover, if we accept Stallknecht's suggestion that Constantine established with his nephew what Shapor had failed to accomplish with his brother, then we have a further reason to reject the information concerning the title *rex regum*. For Shapor would never give his own title to a subordinate king, even if this king were his own brother.

by appointing a noble of Armenian origin to govern the land with the Roman title of *comes Armeniae*.[52] Beyond any practical administrative and internal reasons, which might have led to the decision to abolish the kingship in Armenia, there should be no doubt that the new constitutional form was conceived to suit better the hierarchical state order of the dominate as it was developed at the end of the fourth century in East Rome.[53] However, this form was changed again by Justinian when his conception of the state order as well as the need for more effective military protection of Armenia during his Persian war called for the transformation of Great Armenia into a Roman province.[54]

2. *The Kingdoms of the Caucasian Area*

In the small client kingdoms, which were located in the Caucasian area, we observe the same trend toward the abolition of the local kingship. However, the development was much slower in this area, no doubt due to the fact that it was too important strategically for both great powers, Persia and Byzantium, and it was therefore permanently an object of discord. Thus, every effort was made by both powers to gain or regain over these kingdoms political, cultural, religious, and, if necessary, military influence. Since, however, subordination to one of the great powers was demonstrated through the appointment and investiture of the client kings,[55] the emperors could not possibly think of touching the institution of kingship, which could happen only in periods of stability in international relations. Lazica is a characteristic example.

According to the Roman-Persian agreement of 378, which was revalidated in the time of Theodosius I, Lazica, the old Colchis, located in the western part of Georgia and on the eastern coast of the Black Sea, was made a client kingdom of East Rome.[56] Whenever the royal throne of Lazica was vacant, the legitimate heir would come to Constantinople to express his loyalty and receive from the hands of the emperor the insignia of his dignity.[57]

In the time of Emperor Leon and Great King Perôz, i.e., after 457, Lazica seems to have shifted to Persian domination under conditions unknown to us.[58] However, things changed again in 522, when the legitimate heir to the throne of Lazica, Tzathes I, came to Constantinople, where he was baptized, married to a Byzantine girl of noble birth, and invested by Justin I.[59] His

[52] See Güterbock, "Römisch-Armenien" (note 32 *supra*), 26 ff.

[53] See *infra*, pp. 62–63.

[54] See the detailed study of Güterbock, "Römisch-Armenien," 40–58.

[55] Cf. Winter, *op. cit.* (note 37 *supra*), 36 f.

[56] Cf. Chrysos, "Some Aspects," (note 25 *supra*), 45 ff.

[57] For the investiture of Tzathes I in 522, see Malalas, Bonn ed. (1831), 412 f.; *Chronicon Paschale*, ed. Dindorf, I, 613; and Theophanes, *Chronographia*, ed. C. de Boor, Teubner (1883–85), 168. The investiture of Tzathes II in 555 is described by Agathias III.15.

[58] This was incidentally mentioned by ambassador Petros to Chosroes I in 561: Τοῦτο τὴν ἰσχὺν ἔλαβεν ἐκ τῶν Θεοδοσίου τοῦ καθ' ἡμᾶς βασιλέως χρόνων μέχρι Περόζου τοῦ ὑμετέρου πάππου καὶ Λέοντος τοῦ καθ' ἡμᾶς: Menander, frag. 3, *Excerpta de legationibus*, ed. de Boor, 187 line 18 f.

[59] For the evidence, see *supra*, note 3. Cf. A. A. Vasiliev, *Justin the First. An Introduction to the Epoch of Justinian the Great* (Cambridge, Mass., 1950) (hereafter Vasiliev, *Justin the First*), 260 ff.; and C. Toumanoff, *Studies in Christian Caucasian History* (Washington, D.C., 1963), 255 f.

son Gabazes II, who was half Roman by birth, was holding the title of *silentiarius* at the Byzantine court when he succeeded his father to the throne.[60] In 554, during the Persian war, Gabazes was suspected of collaborating with the enemy and was assassinated. To his throne Justinian invested his brother Tzathes II,[61] who is the last known king of Lazica.[62]

The Greek sources usually apply the term βασιλεύς to the Lazic kings. Even in the official protocol of the negotiations concerning the future of Suania, which the Byzantine ambassador carried on with Chosroes I after the conclusion of the peace treaty in 561, as it is preserved by Menander, the ambassador mentioned the Lazic ruler with the title βασιλεύς.[63] However, he seems to have avoided using the same term for the kinglet of Suania, whose title was also βασιλεύς, calling him instead ἄρχων,[64] ἡγεμών,[65] or βασιλίσκος.[66] Nevertheless, no official documents are preserved to supply positive evidence that the term βασιλεύς was officially conceded to the king of Lazica by the imperial court.

However, after the end of the Persian war and the conclusion of the Fifty Years' Peace Treaty of 561, according to which Lazica was definitely assigned to the Empire, since the Great King had abandoned his claims,[67] the next we hear about this country is that the kingship was abolished and replaced by the institution of the "Presiding Prince," who had local origin but served the Byzantine Empire with the title of a Roman *patricius*.[68]

The destiny of the Lazic kingdom was shared almost at the same time by the other client states of the Caucasian area, which after the end of the great wars were assigned to the Empire. Thus in Iberia, the neighbor of Lazica in the East, the kingship was abolished in 588 when the land passed to Byzantine allegiance after a changeful history of partition between Persia and Byzantium and reunification under Persian or Byzantine protection, or even occupation.[69] Instead of having kings, Iberia was given "Presiding Princes" of local origin whose legitimation for ruling their country was based on their title of Byzantine curopalate.[70]

As far as we can see, a similar process was undergone by the other kingdoms of the Caucasus, such as Abasgia and Albania.[71] Anyway, by the end of the

[60] The evidence for his title is in Procopius, *Bella* II.29,31.

[61] For the evidence, see *supra*, note 2. Cf. B. Rubin, *Das Zeitalter Iustinians* (Berlin, 1960) (hereafter Rubin, *Das Zeitalter Iustinians*), 362f.

[62] Cf. Toumanoff, *op. cit.*, 255.

[63] Λαζῶν βασιλεῖς, Menander, frag. 3, *passim*. Although Menander seems to preserve faithfully the official version of the minutes, nevertheless the terms used during the negotiations should not be taken as expressing the official usage of the imperial court or the king's chancery. This explains how Chosroes could use the term βασιλεύς in connection with Justinian (τῷ καθ' ὑμᾶς βασιλεῖ) without breaking the tradition of not applying this term to the emperor.

[64] Ὅτι ψήφῳ τοῦ Λαζῶν βασιλέως ὁ Σουανίας ἄρξων τὸ κῦρος ἐδέχετο: Menander, frag. 3, *Excerpta de legationibus*, ed. de Boor, 184 lines 5–6; cf. 187 line 13.

[65] Λαζῶν βασιλεῖς, οἱ Σουάνων ἐχειροτόνησαν ἡγεμόνας: *ibid.*, 187 line 22; cf. 184 line 7.

[66] Οἵ γε Λαζῶν βασιλεῖς, οἵ γε βασιλίσκους ἐπέστησαν Σουάνοις: *ibid.*, 187 line 24.

[67] Güterbock, *Byzanz und Persien* (note 25 *supra*), 60f.; Rubin, *Das Zeitalter Iustinians*, 369f.

[68] For the evidence, see Toumanoff, *op. cit.*, 255 note 355; and *idem*, "Armenia and Georgia," in *CMH*, IV,1 (1966), 603.

[69] *Ibid.*, 597–603.

[70] The character of the institution of the Principate, or rule by presiding princes, is discussed in *idem, Studies*, 384–89.　　　[71] *Ibid.*, 256f.

sixth century there were no more vassal "states" under Byzantine domination in the East ruled by "kings."

3. The Bosporan Kingdom

The kingdom of the Crimean Bosporus was the last survival of the Hellenistic kingdoms of the East which for centuries were tolerated by Rome because it was considered more practical to preserve their constitutional form than to incorporate them into the imperial territory as Roman provinces.

The kings of the Bosporus were allowed to use the traditional Hellenistic title βασιλεύς on their coins,[72] while in inscriptions we also find other Oriental titles, such as βασιλεὺς βασιλέων, βασιλεὺς τοῦ σύμπαντος Βοσπόρου καὶ τῶν πέριξ ἐθνῶν, μέγας βασιλεύς, etc.[73] On inscriptions dedicated to or referring to Roman emperors, the bombastic titles are never used; instead they limit themselves to the title βασιλεύς.[74]

However, the barbarian invasions from the north (Goths) and the east (Huns) destroyed the Bosporan kingdom. The last king known to have struck coins with the title βασιλεύς is Phescaporis VI in 332.[75]

From the period of Hunnic rule over the lands of the northwestern Black Sea we hear that in the time of Justin I the citizens of the city of Bosporus decided to ask for the emperor's protection.[76] Next we hear that the Hunnic King Grod himself appeared in Constantinople and asked to be baptized. Justinian functioned as godfather and sent the new convert to his country, authorizing him to defend the Roman possessions and the Bosporus. For our subject, it is important that Malalas, our source, and Theophanes, who follows him, call the Hunnic ruler ῥήξ.[77]

Some scholars date to the time of Justinian an inscription found in Kertsch, which refers to the building of a tower in the time of King Diuptunus.[78] Gajdukevič recently went so far as to suggest that after reconquering the Crimean Bosporus, Justinian established Diuptunus as a descendent of the old royal family of the Tiberii Julii, as king of the Bosporan kingdom.[79] If Gajdukevič's theory were correct, we would have the interesting case of the restoration of a client kingdom in the sixth century. However, many old

[72] Usually Bosporan coins have the king's effigy with his name and the title βασιλεύς, and on the reverse the figure of the Roman emperor; W. Wroth, *Catalogue of Greek Coins*, XIII: *Pontus, Paphlagonia, Bithynia and the Kingdom of Bosporus* (London, 1889), 80f.

[73] V. V. Struve, *Korpus Bosporskih nadpisej* (Moscow, 1965), e.g., nos. 28–34, 39–40, 44–45, 53–56, 59, 979–80, 1008, 1010, 1048–49.

[74] In these cases they call themselves βασιλεὺς N. N. φιλοκαῖσαρ καὶ φιλορώμαιος, εὐσεβὴς (and quite often ἀρχιερεὺς Σεβαστῶν, since the kings functioned usually as high priests at the emperor's divine service); cf. *ibid.*, nos. 38, 41, 47–48, 52, 978, 1047. In Latin the titles are *Rex N. N. amicus imperatoris populique Romani*; cf. *ibid.*, no. 46. Cf. also B. Latyschev, *Inscriptiones regni Bosporani Graecae et Latinae*, II (St. Petersburg, 1880; repr. Hildesheim, 1965), no. 40.

[75] V. Gajdukevič, *Das Bosporanische Reich* (Berlin, 1971), 481.

[76] Procopius, *Bella* I.12,7–8, ed. J. Haury and G. Wirth, Teubner, I (1963), 57 lines 4–6.

[77] Malalas, Bonn ed., 431 line 16f.; Theophanes, ed. de Boor, 175 line 24f.

[78] ...ἐπὶ Τιβερίου ᾿Ιουλίου Διουπτούνο[υ] βασιλ(έως) Εὐσεβο(ῦς) φιλοκέσαρος καὶ (φ)ιλορωμέου: Latyschev, *op. cit.*, addenda, no. 49; Struve, *op. cit.*, no. 67; cf. E. H. Minns, *Scythians and Greeks* (Cambridge, 1913), 610, who dates the inscription to the second half of the fourth century.

[79] *Op. cit.*, 517.

Bosporan elements make this date for the inscription very improbable. It is written in the old style of the second to third century, it mentions public offices of the old Bosporan kingdom, such as ὁ ἐπὶ τῆς πινακίδος and ὁ ἐπὶ τοῦ πρωτεύοντος, and it is dated according to the Bosporan calendar. On the other hand, it is much more probable to regard Tiberius Julius Diuptunus as one of the members of the royal dynasty of the Bosporus of the Roman period, instead of pressing the evidence with the suggestion that he was a sixth-century descendant of the old royal family.

When at the end of the sixth century Maurice restored Byzantine domination in the Crimea, the inscriptions that were to commemorate his rebuilding activity were made by the *dux* of Cherson![80]

In the year 619 the ruler of the Huns, who lived in the area of the former Bosporan kingdom, repeated Grod's action and came to Constantinople, together with his court and his bodyguard, asking to be baptized. Emperor Heraclius received him with high honors and gifts and conceded to him the title of a Roman *patricius*. Patriarch Nicephorus, our single source, calls the Hunnic ruler precisely ὁ τῶν Οὔννων τοῦ ἔθνους κύριος καὶ ἡγεμών,[81] but not βασιλεύς.

4. The African Kingdoms

The Abyssinian king has already been mentioned by Bury as an "exception which hardly counts" to the rule that the Persian king was the only foreign monarch to whom the Roman emperors conceded the title *basileus*.[82] It is true that the majority of the Greek literary sources call the monarch of Ethiopia βασιλέα Αἰθιοπίας or Ἀξωμιτῶν,[83] as they also do the "sub"-kings dependent on the Abyssinian king.[84] However, the literary sources do not attest that the title βασιλεύς was also used officially by the imperial chancery. We do not possess any official document, or any reliable account of such a document in the sources, in which the imperial court would use this title for the Abyssinian king.[85]

[80] +Πρὸς τοῖς λοιποῖς μεγάλοις καὶ θαυμαστοῖς κατορθώμασι καὶ τόδε τὸ λαμπρὸν ἐν Βοσπόρῳ καισάριον ἀνενέωσεν Μ(αυρ)ίκιος ὁ εὐσεβέστατος καὶ θεοφύλακτος ἡμῶν δεσπότης διὰ τοῦ γνησίου αὐτοῦ δούλου Εὐπατερίου τοῦ ἐνδοξοτάτου στρατηλάτου καὶ δουκὸς Χερσῶνος, ἰνδικτιῶνος η′: *ibid.*, 518.

[81] *Historia*, ed. C. de Boor, Teubner (1880), 12 lines 20–28.

[82] See *supra*, pp. 31–32.

[83] Procopius, *Bella* I.20; Malalas, Bonn ed., 457f.; Theophanes, ed. de Boor, 244; Cosmas Indicopleustes, *Topographie chrétienne* XI.4, 7, ed. W. Wolska-Conus, SC, 197 (Paris, 1973), 321, 337.

[84] See, for instance, Procopius, *Bella* I.19,3, for the Homerite king; and Cosmas Indicopleustes XI.13, ed. Wolska-Conus, 343, for the two kings on the island of Taprorane.

[85] We have two inaccurate reports of diplomatic procedure between Constantinople and Aksum in the sixth century, but they fail to supply us with evidence for the official use of the title *basileus*. The first report is quoted by Tabari from two Arab traditions of the eighth and ninth centuries recalling an alleged audience given by Emperor Justin I to an ambassador of the Abyssinian king Elesbaas. According to Th. Nöldeke's German translation (*Geschichte der Perser und Araber zur Zeit der Sasaniden aus der arabischen Chronik des Tabari* [Leyden, 1879], 189–90), "... der *Kaiser Fürst* der Römer," said to the ambassador: "ich will für dich an den *König* von Ḥabeš schreiben So gab ihm der *Kaiser* einen Brief an den *König* von Ḥabeš mit, ... Als nun Daus Dhû Thaʻlabân mit dem Brief des *Kaisers* zum Naǧâšî, dem *Fürsten* von Ḥabeš, kam, ..." According to the French translation of H. Zotenberg (*Chronique*, II [Paris, 1869], 181–82): "L'empereur écrivit donc au Nedjâschî, le roi d'Abyssinie." It is important to note that the original Arabic text uses the words *qaisar, sàhib al-Rum* for the emperor (the traditional expression, which the Arabs took from the Persians), while the Abyssinian king is *malik* (the Semitic word for king) or *najāshi, sāhib al Habashā* (the traditional royal title in the

On the other hand, we do possess an imperial document, in which the title is clearly missing. It is the letter of Emperor Constantius II addressed to King Aizanes of Abyssinia, which is incorporated in the *Apologia ad Constantium* of Athanasius of Alexandria.[86] The *intitulatio* of the letter, as preserved by Athanasius, is Νικητὴς Κωνστάντιος Μέγιστος Σεβαστὸς ʼΑϊζανᾷ καὶ Σαζανᾷ, that is, without any titles for the Abyssinian monarch and his coregent. Only at the end of the letter Constantius calls the receivers ἀδελφοὶ τιμιώτατοι. Nevertheless, it is very interesting for our discussion that in introducing this letter, together with another letter of Constantius to the Alexandrians, Athanasius calls the leaders of Aksum τύραννοι.[87]

A. Dihle, discussing this "title" in a study on the missionary bishop of Abyssinia, Frumentius, and King Aizanes, has rightly pointed out that this word, beside its meaning of usurper, is used in the literature as a *vox media* applying to barbarian rulers, especially to those of Africa, without the meaning of usurper.[88] With this general meaning the word is used in the official bilingual inscription made in 29 B.C. by Cornelius Gallus, the first Roman governor of Egypt, on the island of Philae. In this inscription a distinction is made between the βασιλεῖς-*reges* and the τύραννοι-*tyranni*.[89] Moreover, Diodorus of Sicily describes the social life of the Troglodyte-Nubians as βίον ἔχοντες ἀπὸ θρεμμάτων νομαδικῶν κατὰ συστήματα τυραννοῦνται καὶ μετὰ τῶν τέκνων τὰς γυναῖκας ἔχουσι κοινὰς πλὴν μιᾶς τῆς τοῦ τυράννου.[90] With the same meaning the word is applied by the anonymous author of the *Periplus of the Erythraean Sea*, who is again distinguishing between the (Roman) αὐτοκράτωρ, the (Abyssinian) ἔνθεσμος βασιλεύς, and the minor τύραννοι.[91] Dihle explains the use of τύραννοι in the Apology of Athanasius

Ethiopian language); cf. *Annales quos scripsit Abu Djafar Mohammed ibn Djarir at-Tabari*, ed. M. J. de Goeje, ser. 1, vol. II (Leyden, 1881–82), 927.

On the other hand, according to the *Martyrium S. Arethae*, the emperor asked the Patriarch Timothy of Alexandria to write to Elesbaas and to suggest that he attack the king of the Homerites: Τὰ κινηθέντα εἰς τὰς ἀκοὰς τοῦ δούλου τοῦ θεοῦ ʼΙουστίνου βασιλέως Ῥωμαίων, ὃς παραυτίκα γράμματα ἐποίησεν πρὸς Τιμόθεον, τὸν ἐπίσκοπον ʼΑλεξανδρείας, ὅπως γράψῃ ἡ αὐτοῦ ὁσιότης καὶ ὑπὸ λόγον ποιήσῃ πρὸς ʼΕλεσβαὰν τὸν βασιλέα τῶν Αἰθιόπων, ὅπως στρατοπεδαρχήσας ἐξαλείψῃ πάντας τοὺς παρανόμους μετὰ τοῦ βασιλέως αὐτῶν: *ActaSS, Octobris*, X (1869), 743. In his letter to Elesbaas Timothy calls him ἡ σὴ ἀδελφότης and ἡ σὴ ὁσιότης, what Vasiliev erroneously translates as "your majesty"; cf. *Justin the First*, 294. In these reports, which cannot be considered as recalling the official terminology, it is essential to note that not only the Abyssinian but also the dependent rulers are called βασιλεῖς.

[86] Ed. J.-M. Szymusiak, SC, 56 (Paris, 1958), 125. The fact that this letter is incorporated in a treatise addressed to the emperor elevates its credentials of authenticity.

[87] Γέγραπται τοῖς ἐν ʼΑξούμει τυράννοις: *ibid.*, 121; ἃ δὲ καὶ Φρουμεντίου χάριν τοῦ ἐπισκόπου τῆς ʼΑξούμεως γέγραπται τοῖς ἐκεῖ τυράννοις: *ibid*, 124.

[88] *Umstrittene Daten. Untersuchungen zum Auftreten der Griechen am Roten Meer*, Wissenschaftliche Abhandlungen der Arbeitsgemeinschaft für Forschung des Landes Nordrhein-Westfalen, 32 (Cologne, 1965), 52–54: "Das Wort . . . verwendet man ferner gern, um einen Barbarenherrscher zu bezeichnen, ohne dass dadurch dessen Rechtmässigkeit angezweifelt würde." Nevertheless, Dihle's suggestion that this meaning is implied in the word τύραννος, used by Sozomenos, *Historia Ecclesiastica* I.19,3 and II.15,3, is not correct. In this context the word most probably means the "unworthy" monarchs who were defeated by Constantine before A.D. 325, i.e., Maxentius and Licinius.

[89] E. Bernard, *Les inscriptions grecques et latines de Philae*, II: *Haut et Bas Empire* (Paris, 1968), no. 128.

[90] *Bibliothecae historicae* III.39,1.

[91] *Periplus maris Erythraei*, ed. H. Frisk (Göteborg, 1927), chaps. 2, 14, 16, 20, 22, together with chaps. 23, 24, and 31. Cf. W. Dittenberger, *Orientis Graeci Inscriptiones Selectae*, II (Leipzig, 1905), no. 654, p. 364 note 12: *Regulos qui in Aethiopia et aliis regionibus Aegypto finitimis ita imperabant, ut superioris alicuius regis (aut populi Romani) dicioni subiungerentur*, τύραννος *appellari consuesse*

as implying the exotic character of the Ethiopian milieu. However, beyond this meaning, which seems to have been attached to the word for centuries, it later came to be used as a technical term meaning φύλαρχος (which is never applied in the sources for Abyssinian conditions, but is well documented for the Blemyan and the Arab leaders) or more often βασιλίσκος (which is actually used by the same Aizanes, the receiver of Constantius' letter, in a trilingual inscription dedicated to his victorious expeditions).[92] In this inscription Aizanes calls his enemies βασιλίσκοι, while he uses for himself the title βασιλεύς, which follows a long tradition of the Ethiopian chancery.[93]

The explanation suggested for the title τύραννος in connection with βασιλεύς, βασιλίσκος, and φύλαρχος becomes more probable when one considers the conditions existing in the "kingdoms" of the Blemyes and the Nubians in the sixth century. In a remarkable inscription set up in the time of Justinian by the king of the Nubians, Silka, to commemorate his victories over a number of enemies, he calls himself βασιλίσκος Νουβάδων καὶ ὅλων τῶν Αἰθιόπων(!), while he mentions his enemies as βασιλεῖς καὶ δεσπόται.[94] Bury does not take seriously Silko's title βασιλίσκος: "The Greek who composed the inscription," he argues, "must have smiled to himself when he introduced the diminutive βασιλίσκος, 'kinglet.'"[95] This explanation, however, is not acceptable, since it presupposes

scimus ex Periplo maris Erythraei. S. Hable-Selassie's explanation that the term is used in the *Periplus* "für jene Herrscher, die keine dynastische Sukzession haben" (*Beziehungen Äthiopiens zur Griechisch-Römischen Welt* [Bonn, 1964], 54) cannot be proved. F. Altheim understands the term τύραννος in the meaning of usurper, because he attempts to prove that the Ezana of the inscription is not identical with the recipient of Constantius' letter: *Geschichte der Hunnen* (Berlin, 1962), V, 167 f.; cf. F. Altheim and R. Stiehl, *Die Araber in der alten Welt*, II (Berlin, 1965), 296, who make the interesting suggestion that the Greek word τύραννος might be a curious translation of the Ethiopian term *makuānĕnĕt*, which in fact means the judge (-iudices); cf. also *ibid.*, IV (1967), 510 f. Here Altheim's and Stiehl's argument that Athanasius intentionally confronts the emperor's expression ἀδελφοὶ τιμιώτατοι with the τύραννοι, i.e., illegitimate rulers, can easily be upset. In his *Apology* the bishop of Alexandria would never offend the imperial ears by calling the Ethiopian rulers, who were honored by the emperor with the title ἀδελφοί, usurpers.

[92] F. Bilabel and E. Kiessling, *Sammelbuch griechischer Urkunden aus Ägypten*, V,3 (Wiesbaden, 1950), no. 8546.

[93] The Abyssinian king calls himself officially βασιλεύς, as testified by the coins (A. Kammerer, *Essai sur l'histoire antique d'Abyssinie* [Paris, 1926], 154–70) and by inscriptions (E. Littmann, *Deutsche Aksum-Expedition*, IV [Berlin, 1913]; F. Altheim and R. Stiehl, "Die Datierung des Königs ʿĒzānā von Aksūm," *Klio*, 39 [1961], 234–48, esp. 241, 244; Altheim and Stiehl, *Die Araber*, V,2 [1969], 167 ff.). Aizanes called himself βασιλεὺς βασιλέων even before he was converted to Christianity: Bilabel and Kiessling, *op. cit.*, no. 8546. For the origins of this title, see W. Vycichl, "Le titre de roi des rois—negusä nägäśt. Etude historique et comparative sur la monarchie en Ethiopie," *AnnEth*, 2 (1957), 193–203; and A. Caquot, "La royauté sacrale en Ethiopie," *ibid.*, 206 f. In the restored Abyssinian kingdom after A.D. 1270 up to the "emperor" Haile Selassie I of our days this remained the official title; cf. E. Hammerschmidt, *Äthiopien* (Wiesbaden, 1967), 151 f.

[94] Ἐγὼ Σιλκώ, βασιλίσκος Νουβάδων καὶ ὅλων τῶν Αἰθιόπων, ἦλθον εἰς Τάλμιν καὶ Τάφιν. ἅπαξ δύο [for δὶς] ἐπολέμησα μετὰ τῶν Βλεμύων, καὶ ὁ θεὸς ἔδωκέν μοι τὸ νίκημα. μετὰ τῶν τριῶν ἅπαξ ἐνίκησα πάλιν καὶ ἐκράτησα τὰς πόλεις αὐτῶν. ἐκαθέσθην μετὰ τῶν ὄχλων μου τὸ μὲν πρῶτον ἅπαξ, ἐνίκησα αὐτῶν καὶ αὐτοὶ ἠξίωσάν με. ἐποίησα εἰρήνην μετ' αὐτῶν καὶ ὤμοσάν μοι τὰ εἴδωλα αὐτῶν....ὅτε ἐγεγονέμην βασιλίσκος, οὐκ ἀπῆλθον ὅλως ὀπίσω τῶν ἄλλων βασιλέων, ἀλλὰ ἀκμὴν ἔμπροσθεν αὐτῶν....οἱ δεσπόται τῶν ἄλλων ἐθνῶν, οἱ φιλονεικοῦσιν μετ' ἐμοῦ, οὐκ ἀφῶ αὐτοὺς καθεσθῆναι εἰς τὴν σκιάν...: Bilabel and Kiessling, *op. cit.*, no. 8536; cf. G. Lefebvre, *Recueil des inscriptions grecques-chrétiennes d'Egypte* (Cairo, 1907), no. 628.

[95] *Later Roman Empire* (note 7 *supra*), II, 330 note 1. The same interpretation of the term βασιλίσκος is provided for a fifth-century reference by F. Altheim and R. Stiehl, who analyzed a passage in Palladius, *De vita Bragmanorum Narratio*, I.4 (ed. I. Duncan and M. Derrett, in *ClMed*, 21 [1960], 109: καὶ διαπλεύσας μετὰ πρεσβυτέρου ταύτην κατέλαβε πρότερον τὴν Ἀδουλήν, εἶτα μετ' ἐκείνην τὴν Αὐξούμην, ἐν ᾗ καὶ βασιλίσκος μικρὸς τῶν Ἰνδῶν ἐκεῖ καθεζόμενος). Altheim and Stiehl concluded: "Palladius ...

that Silko was not aware of the real meaning of the titles attributed to him by the Greek who composed the inscription at his order. On the other hand, if we identify Silko's enemies with the Romans, as Vasiliev did,[96] we obtain in this inscription interesting evidence for an arrogant Nubian phylarch who pretends to rule over "all Ethiopians" and still calls his Roman imperial enemies βασιλεῖς καὶ δεσπόται, while he is contented with the title βασιλίσκος.

In two other inscriptions on gazelle leather probably from the same period found in Gebelein, the king of the Blemyes calls himself also βασιλίσκος.[97] In the first inscription the terms φύλαρχος and ὑποτύραννος[98] are also used. Thus, βασιλίσκος is the ruler while φύλαρχος is the chief of a district. What is quite amazing, though, is that the man under the φύλαρχος is not called ὑποφύλαρχος but ὑποτύραννος. This implies that φύλαρχος is another term for τύραννος, the chief under the sovereign. Krall explains the term βασιλίσκος convincingly as "ein Zugeständnis an das byzantinische Staatsrecht," and as "ein Bekenntnis der Unterordnung unter eine höhere Macht."[99] This higher power must be the Empire, which had to pay annual *curatoria* to the Blemyes.

According to Procopius, the Emperor Diocletian concluded a treaty with the Blemyes and the Nubians. They promised to remain peaceful and the Empire was to pay to them annually a certain amount in gold.[100] Even if this treaty was not concluded at the time of Diocletian, but at a later date,[101] it shows the character of Byzantine-Blemyan relations and makes it very probable that Silko and his royal colleagues called themselves βασιλίσκοι as a necessary concession to Byzantium, since they belonged to the nations ὅσοι τὴν Ῥωμαίων ἀσπάζονται δεσποτείαν.[102]

These conclusions on Ethiopian royal titles in connection with the titles of the small "kingdoms" of the Nubians and the Blemyans does not mean that those rulers were considered by the Byzantines to be equal. There was certainly a very clear distinction made between the great and powerful kingdom of Aksum and the vassal phylarchies on the periphery of the Empire in Africa, whose allegiance was guaranteed through diplomatic activity, *foedera, curatoria,* and missionary work. To the latter phylarchies we should add the Maurish tribes living on the edge of the Roman provinces in North Africa. Procopius reports from the Vandal war that the Maurish chiefs went to Beli-

bezeichnet Aksum als unbedeutendes Königtum, seinen Herrscher als βασιλίσκος μικρός": *Christentum am Roten Meer,* I (Berlin-New York, 1971), 402.

[96] *Justin the First,* 286f.

[97] J. Krall, *Beiträge zur Geschichte der Blemyer und Nubier,* DenkWien, Phil.-hist.Kl., 46,4 (Vienna, 1900), 415. Cf. C. Wessely, *Studien zur Palaeographie und Papyruskunde,* VIII: *Griechische Papyrusurkunden kleineren Formats* (Leipzig, 1908; repr. Amsterdam, 1965), nos. 132, 133.

[98] Ἐγὼ Χαράχην βασιλεῖσκος τῶν Βλεμύων γράφω τοῖς τέκνοις Χαράχην Χαραπατχούρ καὶ Χαραζιὲτ ὥστε κελεύω καὶ δεδωκέναι τῆς κουρατωρίας τῆς νήσου λεγομένης Τάναρε καὶ οὐδεὶς κελεύεται κωλῦσαι ὑμᾶς ἐὰν δὲ ἀγνομονοῦσιν οἱ Ῥωμεῖς μὴ παρέχουσιν συνήθεια ὁ φύλαρχος οὐ κωλύσεται οὐδὲ ὁ ὑποτύραννος κρατῆσαι Ῥωμεῖς ἕως πληρώνεται τὰς συνηθείας τῆς νήσου μου Χαράχην βασιλείσκ(ος)...: Wessely, *ibid.,* no. 132.

[99] *Op. cit.,* 6.

[100] *Bella* I.19,29–36; cf. Vasiliev, *Justin the First,* 287.

[101] See E. Honigmann's review of Vasiliev, *Justin the First,* in *Byzantion,* 20 (1950), 347.

[102] Theodoretus, *Graecorum affectionum curatio,* PG, 83, col. 1037. Cf. A. Vasiliev, "Justin I and Abyssinia," *BZ,* 33 (1933), 67: "Byzantium considered Abyssinia a vassal state." On the importance of this passage, see Stallknecht, *Untersuchungen zur römischen Aussenpolitik* (note 41 *supra*), 27.

sarius asking for the insignia of their legitimacy as an expression of their loyalty to the emperor and their decision to support the imperial army. They maintained that to receive τὰ ξύμβολα τῆς ἀρχῆς from the Romans was an old tradition, which was broken when the Vandals occupied North Africa.[103]

III. The Roman Satrapies and Phylarchies

1. *The Armenian Satrapies*

According to the Roman-Persian peace treaty of A.D. 363 the satrapies Ingilena and Sophena remained under Roman control. After the partition of Armenia later in the fourth century, four more satrapies, Anzitena, Asthianena, Sophanena, and Balabitena, were added. These six remained under the same political conditions until Justinian created from them the province *Armenia quarta* in A.D. 536.[104]

The satrapies were political units under "princes" of hereditary succession and local origin, who were invested and recognized as "viceroys" by the emperor.[105] The satraps were recipients of imperial orders (edicts) and paid taxes in the form of *aura coronaria*.[106]

C. Toumanoff thinks that the term "satrap" was a Roman bureaucratic misnomer for the princes.[107] However, this is not true. The Persian term satrap was the official title of these ruling princes (in Greek σατράπης, in Latin *satrapes* [or -*a*]) witnessed in imperial edicts.[108] The Roman satrapies created by the Persians are no doubt the most significant example of political administrative forms which the Empire found in the East and copied.

2. *The Arab Phylarchies*

The nomadic Arab tribes living throughout the desert of Syria and Palestine, i.e., on the periphery of the southeastern Roman provinces, enjoyed the great amount of autonomy to which nomadic peoples have been accustomed, even in our own day.[109] Their chiefs had no administrative or political competence entrusted to them by the Roman state, but they were, nevertheless, recognized

[103] Νόμος γὰρ ἦν Μαυρουσίων ἄρχειν μηδένα, κἂν ῾Ρωμαίοις πολέμιος ᾖ, πρίν ἂν αὐτῷ τὰ γνωρίσματα τῆς ἀρχῆς ὁ ῾Ρωμαίων βασιλεὺς δοίη: *Bella* III.25,5.

[104] Justinian, *Novel* 31.1; cf. *Codex Justinianus* I.29,5, and Procopius, *De aedificiis*, III.1,17; Güterbock, "Römisch-Armenien" (note 32 *supra*), 29–39; A. H. M. Jones, *The Cities of the Eastern Roman Provinces*, 2nd ed. (Oxford, 1971), 244f., 445f. Cf. N. G. Garsoïan, "Armenia in the Fourth Century. An attempt to Re-Define the Concepts 'Armenia' and 'Loyalty,'" *REArm*, N.S. 8 (1971), 344, with a different understanding of the legal position of the satrapies.

[105] Güterbock, "Römisch-Armenien," 33f.

[106] *Codex Theodosianus* 12.13,6 (A.D. 387), addressed to *Gaddanae satrapae Sofanenae*.

[107] "Armenia and Georgia," *CMH*, IV,1, p. 595 note 3.

[108] Cf. the legal texts, *supra*, notes 1 and 3.

[109] From the large bibliography on the "Roman" Arabs, see Nöldeke, *Die Ghassânischen Fürsten*, 4–52; R. Devreesse, *Le Patriarcat d'Antioche depuis la paix de l'Eglise jusqu'à la conquête arabe* (Paris, 1944), 241–82; P. Goubert, *Byzance avant l'Islam*. I: *Byzance et l'Orient* (Paris, 1951), 248–72; S. Smith, "Events in Arabia in the 6th Century A.D.," *BSOAS*, 16 (1954), 425–68; I. Kawar, "The Arabs in the Peace Treaty of A.D. 561," *Arabica*, 3 (1956), 181–213; *idem*, "Procopius and Arethas," *BZ*, 50 (1957), 39–67, 362–82; R. Paret, "Note sur un passage de Malalas concernant les phylarchs arabes," *Arabica*, 5 (1958), 251–62; Rubin, *Das Zeitalter Iustinians*, 268–79 and notes on 488–95.

as the leaders of their tribes on the battlefield and in affairs included in their autonomy. In the Greek and even the Latin sources the title of the chief is φύλαρχος-*phylarchus*,[110] although sometimes he is also called στρατηγός,[111] ἐθνάρχης,[112] or simply ᾿Αράβων ἡγούμενος.[113]

Procopius is again exceptional and reports that the phylarch Arethas (al-Hāriṯ b. Jabalah) was invested by Justinian as a "king": Διὸ δὴ βασιλεὺς ᾿Ιουστινιανὸς φυλαῖς ὅτι πλείσταις ᾿Αρέθαν τὸν Γαβαλᾶ παῖδα ἐπέστησεν, ὃς τῶν ἐν ᾿Αραβίοις Σαρακηνῶν ἦρχεν, ἀξίωμα βασιλέως αὐτῷ περιθέμενος, οὐ πρότερον τοῦτο ἔν γε ῾Ρωμαίοις γεγονὸς πώποτε.[114]

Th. Nöldeke, in his important *Abhandlung* on the Ghassânic princes, holding to the truth that the title βασιλεύς was officially used within the Empire only for the emperor, rejected Procopius' information and pointed out that the evidence preserved in inscriptions and literary sources for Arethas and his successors gives them only the titles of *phylarch* and *patricius*.[115] Thus, R. Devreesse does not discuss Procopius' trustworthiness on this point. Nevertheless, considering the unanimous evidence against him, he avoids mentioning Arethas with the royal title.[116]

I. Kawar, in his numerous and extensive articles on the "Roman" Arabs of the sixth century, sees the conferment of βασιλεία on Arethas, however, not as the recognition of his sovereignty, since Arethas remained functionally a phylarch, but as meant to serve a very special purpose among the Arabs in Syria, namely as a counterbalance to Laḥmid Moundhir.[117] For this explanation he abandons Nöldeke's basic point that the title was officially preserved only for the emperor,[118] and, in this way, his only problem is to interpret Procopius' statement that οὐ πρότερον τοῦτο ἔν γε ῾Ρωμαίοις γεγονὸς πώποτε. He finds, therefore, an intelligent explanation: Procopius is purposely wrong,

[110] Sextus Rufus, *Breviarium* chap. 14: *phylarchi Saracenorum* (in the time of Lucullus' expedition, 69–67 B.C.). For further references, see Paret, *op. cit.*, 252 note 2. In order to distinguish the "Roman" phylarch from his Persian opposite, Malalas calls him φύλαρχος ῾Ρωμαίων: *Chronographia*, Bonn ed., 434 line 23.

[111] W. H. Waddington, *Recueil des inscriptions grecques et latines de la Syrie* (Paris, 1870), no. 2112.

[112] *Ibid.*, no. 2196.

[113] Evagrius, *Historia Ecclesiastica* IV.12, ed. J. Bidez and L. Parmentier (London, 1898), 162 line 27; VI.2, p. 223 line 21; Theophylactos Simocattes, *Historia* III.17,7, ed. de Boor, 146 line 10.

[114] *Bella* I.18,47, ed. Haury and Wirth, I, 90 lines 12–16.

[115] *Die Ghassânischen Fürsten*, 12–15. In addition to the inscriptions of Arethas' son Moundhir, quoted by Nöldeke, which call him Φλ(άβιος) ᾿Αλαμούνδαρος ὁ πανεύφημος πατρίκ(ιος) καὶ φύλαρχος (Waddington, *op. cit.*, nos. 2562c, 2110), D. Schlumberger discovered an inscription at the Qasr el-Heir monastery dated to A.D. 559, speaking of the φυλαρχία τοῦ εὐδοξοτάτου ᾿Αρέθα...πατρικίου: "Les fouilles de Qasr el-Heir el-gharbi," *Syria*, 20 (1939), 368–72.

[116] "Pour eux, à quoi correspondait exactement cet ἀξίωμα βασιλέως conféré par Justinien à Hârith? Nous ne pouvons traduire que par 'royauté,' mais en ajoutant immédiatement que dans les documents quasi officiels restés à notre disposition, le patriciat et la phylarchie sont seuls mentionnés": *Le Patriarcat d'Antioche*, 277f. This is almost the explanation E. Stein gave to the investiture of Arethas. He drops the story of the royal rank and speaks of the subordination of the Arab tribes under the Ghassânid: "titular kam dies dadurch zum Ausdruck, dass Charet den Patriziat erhielt": *Studien zur Geschichte des byzantinischen Reiches* (Stuttgart, 1919), 40.

[117] I. Kawar, "Procopius on the Ghassânids," *JAOS*, 77 (1957), 79–87, esp. 84f.; *idem*, "Procopius and Arethas," esp. 366–69; *idem*, "The Patriciate of Arethas," *BZ*, 52 (1959), 321–43, *passim*; *idem*, "Procopius and Arethas Again," *Byzantion*, 41 (1971), 313–38, esp. 315–16.

[118] He refers for this to the single example of the king of Palmyra, Odenathus. On Odenathus' title, see *infra*, pp. 51–52.

because with this statement he exercised his famous *Kaiserkritik*: his purpose was to show that the emperor's decision was fatal, since Arethas turned out to be a traitor.[119]

B. Rubin, the only scholar who has made use of the material collected by O. F. Winter on the *Roman* tradition of appointing kings,[120] does not hesitate to accept Procopius' information.[121] He even understands it in terms of the Roman tradition of the *appellatio regis* and does not bother about the lack of evidence for this title of Arethas on the ground that Procopius uses in the same connection the same title for the "Persian"-Arab phylarch of Ḥīra al-Moundhir.[122] As a matter of fact, Procopius states explicitly that Arethas was made super-chief of a number of tribes, an "ἀρχιφύλαρχος" of the "Roman" Arabs, in order to face the super-chief of the "Persian" Arabs, Laḥmid Moundhir, who βασιλέως ἀξίωμα ἔχων ἁπάντων μόνος τῶν ἐν Πέρσαις Σαρακηνῶν ἦρχε.[123] It is clear, therefore, that the ἀξίωμα βασιλέως of Arethas was meant to confront the βασιλέως ἀξίωμα of Moundhir. Thus, if we want to understand the royal dignity of Arethas, as Procopius wants us to, we have to see the "constitutional" position of the Laḥmid phylarch, on the other side of the *limes*, in his relation to the Persian Great King.

Except Procopius, who twice calls Moundhir βασιλεύς,[124] Theophanes, Evagrius, and Menander call him φύλαρχος; once each, Theophanes[125] and the *Martyrium Sancti Arethae* use the diminutive βασιλίσκος. Nevertheless, the Syrian and the Arab sources use *malik* as the title of the Laḥmid phylarchs, and there is no doubt that these "kings" were in fact part of the large community of kings functioning under the "king of kings" of Iran and Non-Iran, the Persian *shahanshah*. As A. Christensen defines their role: "Les membres de la première classe dans l'État sassanide portaient le titre de rois, ce qui justifiait le titre officiel du roi d'Iran, celui de 'Roi des Rois.' Cette classe comprenait d'abord les princes vassaux qui régnaient dans les extrémités de l'empire, les roitelets qui s'étaient mis sous la protection du roi d'Iran, et à qui le grand roi avait assuré, en revanche, la royauté pour eux et leurs successeurs, avec l'obligation de mettre leurs troupes à la disposition de leur suzerain et, peut-être, de payer un certain tribut... *Parmi ces rois vassaux on comptait les rois arabes de Ḥīra* [italics mine]."[126] From this lesser position of king in relation to the Persian king of kings, Moundhir calls himself, according to Procopius, ὁ τῶν Σαρακηνῶν βασιλεύς, while for the Persian monarch he uses the vocative: ὦ βασιλέων βασιλεῦ.[127] On the other hand, this position is indicated when Theophanes and the *Martyrium S. Arethae* call him βασιλίσκος τῶν

[119] Kawar, "Procopius and Arethas," 366–69. On the notorious treachery of Arethas, see V. Christides, "Saracens' *Prodosia* in Byzantine Sources," *Byzantion*, 40 (1970), 5–13. Cf. *infra*, note 140.
[120] On Winter's dissertation, see *infra*, note 166.
[121] "Die Verleihung des Titels steht natürlich fest": Rubin, *Das Zeitalter Iustiniens*, 493 note 825.
[122] *Ibid.*, 276.
[123] *Bella* I.18,45, 46.
[124] *Ibid.* I.17,30, I.18,45.
[125] Ed. de Boor, 178 line 9.
[126] A. Christensen, *L'Iran sous les Sassanides*, 2nd ed. (Copenhagen, 1944), 101.
[127] *Bella* I.17,30, 33.

Σαρακηνῶν, not in order to underrate his actual power, but to characterize his real legal position in relation to the Persian monarch, when he is called only βασιλεύς τῶν Περσῶν. We can, therefore, assert that Moundhir was a *shah* in juxtaposition to the *shahanshah*, or a βασιλίσκος when the Persian monarch was called simply βασιλεύς.[128]

Are we justified, then, in classifying the appointment of Arethas, whatever Procopius wants us to understand, as an *appellatio regis*? Rubin, who recalls this Roman tradition, fails to distinguish between the appointment of a prince to an existing throne, on the one hand, and the designation of a chief as king of a kingdom that does not yet exist on the other.[129] If Arethas was really appointed king, then automatically the organization of his tribe must have been transformed into a kingdom, and there is no evidence to support such an explanation of what happened in or around 530 with the Roman Arabs. Justinian, according to Procopius, put all (or most) of the nomadic tribes under one phylarch, and it seems that for the first time on this occasion a united leadership, or an ἀρχιφυλαρχία, was established.[130] If the ἀρχιφυλαρχία was not established as a βασιλεία, and there is indeed no evidence to suggest it, then what remains, if we want to make use of Procopius' information, is that he either gave him the title of a king, without making him a real king, or he invested him with such honors and insignia that he could be regarded as the equal counterpart of King Moundhir.

The first possibility does not seem probable. In a relevant official document, Justinian's *Novel* 102 on the duties of the *moderator Arabiae* from the year 536, Arethas is referred to only with the title φύλαρχος, while there is no other evidence that he ever officially held the title βασιλεύς.[131] As a matter of fact, even Procopius, as R. Paret has already pointed out, does not suggest the conferment of the title but only of the royal dignity.[132] We shall, therefore, have to content ourselves with the second choice, that Arethas was invested (περιθέμενος) with royal honors and insignia to be the counterpart of Moundhir.

[128] A. Vasiliev missed this point in thinking that "some Greek sources contemptuously call this man 'a little king of the Saracens,' but his contemporary Procopius highly praises his talents": *Justin the First*, 277.

[129] This distinction is necessary, however, for if Rome seems to have found content in the role of a king-maker we still have no reason to see her as a "kingdom"-maker. She has preserved some kingdoms for a while, when their incorporation into the provincial system did not seem or prove to be profitable, but she did not establish new kingdoms.

[130] Cf. Nöldeke, *Die Ghassânischen Fürsten*, 12; and G. Olinder, *The Kings of Kinda of the Family of Ākil al-Murār* (Lund-Leipzig, 1927), 66: "Before the year 529 there was probably no common ἀρχιφύλαρχος over the Arabs of the Romans."

[131] Μήτε τῷ περιβλέπτῳ δουκὶ μήτε τῷ φυλάρχῳ μήτε τινὶ τῶν δυνατῶν οἴκων.... *Novel* 102, chap. 1, ed. R. Schöll and G. Kroll (Berlin, 1929), 423 line 39. Kawar's supposition that in this passage there is a breviloquence (he reads τῷ περιβλέπτῳ δουκὶ...τῷ περιβλέπτῳ φυλάρχῳ) is very weak support for his artificial attempt to reconstruct Arethas' *cursus honorum* from the clarissimate (over the spectabilate and the illustrate) to the gloriosissimate: "The Patriciate of Arethas" (note 117 *supra*), 323–29. Arethas was possibly *clarissimus* before 530, as the φύλαρχοι are called in Justinian's *Edict* IV (chap. 2: τοῖς περιβλέπτοις δουξὶ τοῖς λαμπροτάτοις φυλάρχοις: ed. Schöll and Kroll, 762 line 31), and he was *gloriosissimus* when he was made Roman *patricius*. But there is no reason to assume that at some time between 530 and 559 he received the other honors. As a matter of fact, he was made *patricius* (and *gloriosissimus*) as early as 530; see *infra*, p. 64.

[132] "Ce qui strictement ne signifie pas la collation du titre de basileus": Paret, *op. cit.* (note 109 *supra*), 255.

Anyway, from the time of Arethas our sources record only that he was a *patricius*, and we shall have to examine the real meaning of his patriciate in comparison with the other national chiefs or rulers who held this title in the period under discussion.

From the time of Arethas' son and successor we hear about the crown of the "Roman" phylarchs. John of Biclar reports that when Moundhir visited Constantinople officially in 580 *cum stemmate suo Tiberio principi cum donis barbariae occurrit.*[133] We read about the size and value of the crown in the *Ecclesiastical History* of John of Ephesus, who preserves important information on the Ghassânid's visit to the capital. According to John, "...he was received with great pomp, and endless honours conferred upon him by the merciful king Tiberius, who made him large presents and royal gifts, and did for him all that he desired, and gave him everything he asked, even bestowing military titles on the two sons, whom he had with him, *and giving him leave to wear a royal crown* [italics mine]."[134] John of Ephesus explains the issue on the permission "to wear a royal crown" in chap. IV.42: "...Tiberius dismissed him with great honours, and kingly presents of gold and silver, and magnificent dresses, and saddles, and bridles of gold, and armour. And besides all this, *he also gave him a royal crown* [italics mine], the right of wearing which had never hitherto been conceded to any of the chiefs of the Arabs, but only leave to put on their heads a simple circle."[135] From these two passages it is easy to put aside the oriental *topoi* and get the concrete information: the Ghassânid Moundhir, like all his predecessors, obviously including Arethas, had only the right to wear "a simple circlet," until in 580 Tiberius allowed him to wear "a royal crown." The "circlet," in Syriac *kelil*, is now identified with the *corona-aurea*, while the "royal crown," in Syriac *tağ*, is thought to be the proper διάδημα.[136] Ch. Clermont-Ganneau has noticed that the same word *tāghâ*, or *tâğ*, is used in the inscription of Nemâra for Imrou'l-Qais, the Persian vassal king "of all the Arabs" (dated to A.D. 328) and came to the conclusion: "Il est à présumer que c'est sur les sollicitations mêmes de Alamoundaros que Tibère se décida à lui conférer *cette distinction extraordinaire qui, aux yeux des Arabes, constituait la grande investiture royale à la mode perse* [italics mine]."[137] We shall have to conclude that when Arethas was made "βασιλεύς," he may have received with the rank of *patricius* only the royal-like "circlet," not the "crown."

In this connection we should examine the importance of the real royal crown presented to Arethas' son Moundhir for his "constitutional" position. Was it this time meant to be a conferment of a higher royal rank? If, on the grounds of Clermont-Ganneau's conclusion that it was an investiture *à la*

[133] MGH, *AA*, XI; in *Chronica minora*, ed. Mommsen (note 39 *supra*), II, 214 line 19, the chronology, "ca. 575," is wrong.

[134] *Ecclesiastical History* IV.39, trans. R. Payne Smith, *The Third Part of the Ecclesiastical History of John Bishop of Ephesus* (Oxford, 1860), 298.

[135] *Ibid.*, 304–5.

[136] Nöldeke, *Die Ghassânischen Fürsten*, 25f.

[137] "Le *tâdj-dâr* Imrou'l-Qais et la royauté général des Arabes," *Recueil d'Archéologie Orientale*, 7 (1906), 167–70, esp. 169; cf. Paret, *op. cit.*, 257f.

mode perse, we examine the history of the "Persian" Arabs, the Laḥmids, in the same period, we should take note of the information preserved in the Arabic chronicles of Aǧânî and Tabarî: on the occasion of the enthronement of the Laḥmid King Nuʿmân III, the Great King Hormizd IV presented him with a diadem (tâǧ) which cost 6,000 Dirhen, and this event is echoed throughout Arabic poetry in the title "the crown holder"—dû at-tâǧ, attributed to this king.[138] It is revealed how relevant this information is to our discussion when we recall that Nuʿmân III succeeded his father Moundhir IV to the Laḥmid leadership most probably in 580, i.e., the year of the Ghassânid Moundhir's visit to Constantinople.[139]

We shall, therefore have to assume that in or about 580 the Persian monarch decided to emphasize the position of his vassal king among the Arabs and presented him with a "royal crown"; whereupon Tiberios either was asked to or thought it wise to react in a similar way, and offered to his vassal phylarch what his Arabs, who knew the Persian ceremonies, would recognize as a royal crown.

For the purposes of this study the conclusion should suffice that the title *basileus* was not conceded to the Arab phylarchs, nor was it assumed by them, although their title in Arabic was *malik* (king).

Excursus

The Titles of Odenathus of Palmyra

I. Kawar-Shahid asserts that before the Ghassânid Arethas another Saracen, King Odenathus of Palmyra, was conferred the title βασιλεύς, because he was officially nominated "king of kings."[140] However, there is no evidence whatsoever that Odenathus was actually recognized as "king of kings" by the Roman emperor. According to the sources he became tyrant of his native city of Palmyra, which, in the middle of the third century, was not only the most important trade and communication center of eastern Syria but also the only serious military power for protecting trade activities and caravans and for defending the Euphrates border.[141] During the Roman-Persian war, Emperor Gallienus authorized Odenathus to command the Roman troops of the East and gave him the military title of *dux Romanorum*, and later *corrector*

[138] Cf. G. Rothstein, *Die Dynastie der Lahmiden in al-Hira. Ein Versuch zur arabisch-persischen Geschichte zur Zeit der Sasaniden* (Berlin, 1899), 128f.

[139] *Ibid.*, 111. This connection of Moundhir's permission to carry a royal crown with the "coronation" of his counterpart Nuʿmân in the same year has not been pointed out before, although Rothstein, *ibid.*, 129, mentions the evidence in John of Ephesos for the Ghassanid's title as cited by Nöldeke.

[140] "Arethas Son of Jabalah," *JAOS*, 75 (1955), 212f.: "The Romans had conferred the title not only of king but also 'king of kings' on one of Arethas' predecessors in the service of Rome, namely Odenathus, of whom Procopius certainly knew"; see further *idem*, "Procopius and Arethas" (note 117 *supra*), 367; *idem*, "Procopius and Arethas Again" (note 117 *supra*), 316, answering Christides, who regards the reference to Odenathus as not wrong but "irrelevant, since for Procopius the activities of Odenathus take place in the remote past": *op. cit.* (note 119 *supra*), 6 note 1. Rubin accepts Kawar's reference to Odenathus: *Das Zeitalter Iustinians*, 495 note 830.

[141] Jones, *op. cit.* (note 104 *supra*), 265f.

totius Orientis.[142] This strong position of Odenathus is described by the *Scriptores Historiae Augustae*: *Odenathus rex Palmyrenorum optinuit totius Orientis imperium.*[143] This description defines the actual position of Odenathus in A.D. 264,[144] but is nevertheless erroneous, if the term *imperium* is used in the technical sense of "being *imperator*," i.e., of assuming the imperial power.[145]

The assertion that Odenathus was conferred the title "king of kings" is probably made on the ground of a Palmyrenian bilingual *miliarium*[146] from the time of Odenathus' son and successor Vaballathus Athenodorus (A.D. 268–70), i.e., from the period after Odenathus' death, during which his famous wife Zenobia, being the actual ruler of Palmyra, initiated an independent imperial policy, usurped the title *augusta* for herself, and occupied such imperial lands as Syria and Egypt.[147] According to the Palmyrenian version of the inscription, Athenodorus and Odenathus hold the title "king of kings." This title for father and son is, no doubt, an understandable novelty for a period of war with the Persian monarch, the "king of kings of Iran and Non-Iran," but there is no evidence to prove that it was conferred by Rome or assumed on Roman approval and recognition. For Rome conferred no titles to Odenathus and his son short of the Roman military ones.

IV. THE KINGDOMS OF THE *VÖLKERWANDERUNG*

1. *The Germanic Kingdoms*

The Germanic nations of the Völkerwanderung established themselves in the course of the fourth to the sixth century on the soil of the former Roman provinces. In their individual development they underwent quite a variety of constitutional forms, all of which resulted in monarchical leadership. This leadership was called by the Latin term *regnum* and in every case the ruler's official title was *rex*. So it was with the Visigoths,[148] the Ostro-

[142] Cf. Ch. Clermont-Ganneau, "Odeinat et Vaballat rois de Palmyre, et leur titre romain de *corrector*," *RBibl*, 29 (1920), 394. [143] *Vita Gallieni* 10.1, ed. E. Hohl (Berlin, 1971), II, 88 line 16.
[144] Ziegler, *op. cit.* (note 25 *supra*), 144.
[145] Cf. *Vita Gallieni* 3.3: *Totius prope igitur Orientis factus est Odenatus imperator*; cf. also *Tyranni Triginta* 15.1–8, ed. Hohl, II, 115.20–116.23. Cf. J. G. Février, *Essai sur l'histoire politique et économique de Palmyre* (Paris, 1931), 72 ff.
[146] *Corpus Inscriptionum Semiticarum* II, no. 3271. The Palmyrenian version reads in Latin translation: *Pro salute et [victoria] Septimii Vahballathi Athenodori, illustrissimi regis regum et correctoris totius Orientis, filii Septimii [Odaenathi regis] regum; et pro salute Septimiae Batzabbai, illustrissimae reginae, matris regis regum filiae Antiochi.* The proposed restitution of the destroyed Greek version is: [Ὑπὲρ σωτηρίας καὶ νείκης Ἰουλίου Αὐρηλίου Σεπτιμίου Οὐαβαλλάθου Ἀθηνοδώρου τοῦ λαμπροτάτου βασιλέως καὶ ἐπανορθωτοῦ πάσης ἐπαρχίας κ]α[ὶ ὑπέρ σω]τηρίας Σεπτιμίας Ζηνοβίας τῆς λαμπροτάτης βασιλίσσης μητρὸς τοῦ βασιλέως...; cf. Clermont-Ganneau, "Odeinat et Vaballat," 394f.
[147] Cf. A. Alföldi, "The Crisis of the Empire (A.D. 249–270)," *CAH*, XII (1939; repr. 1961), 174–80.
[148] On the Visigothic kingdom of Toulouse, see L. Schmidt, *Die Ostgermanen* (Munich, 1941; repr. 1969) (hereafter Schmidt, *Die Ostgermanen*), 510. On the kingdom of Toledo, see E. A. Thompson, *The Goths in Spain* (Oxford, 1969), 252f.; and K. F. Stroheker, "Das spanische Westgotenreich und Byzanz," *BJb*, 163 (1963), 252–74, esp. 264f., repr. in *idem, Germanentum und Spätantike* (Zürich-Stuttgart, 1965), 228f. On the early underdeveloped kingdom in the fourth century, see Schmidt, *Die Ostgermanen*, 243f.; and E. A. Thompson, *The Visigoths in the Time of Ulfila* (Oxford, 1966), 43–55. On the early Germanic kingship, see J. M. Wallace-Hadrill, "Germanic Kingship and the Romans," in *idem, Early Germanic Kingship in England and on the Continent* (Oxford, 1971), 1–20. On the problem of the titles of the barbarian rulers, see H. Wolfram, *Intitulatio I. Lateinische Königs- und Fürstentitel bis zum Ende des 8. Jahrhundets*, MittIÖG, Suppl. 21 (1967).

goths,[149] the Vandals,[150] the Burgundians,[151] the Franks,[152] and the Lombards.[153]

The royal chanceries applied further additional titles for their rulers; the kings of the Visigoths, the Vandals, the Burgundians, and the Franks received the titles *dominus* or *dominus noster*,[154] or even the title *princeps*. Nevertheless, before A.D. 800 none of the Germanic kings ever assumed the official titles of the Roman emperor, i.e., *imperator*[155] and *Augustus*.[156]

As an exception, one which has been taken very seriously by many scholars,[157] we shall have to examine the fact that on coins struck by the Frankish King Theodebert I (534–48) we find on the reverse *Victoria Augusti* (or *Augustorum*), and on the obverse of a single coin the titles *pp. Aug.* On this issue I am very pleased to incorporate verbatim a note written by Professor Philip Grierson at my request:

> The vast bulk of the pseudo-imperial coinage struck by the Germanic peoples and their rulers in the fifth to seventh centuries has copied mechanically the *Victoria Aug.* and *Victoria Augustorum* formulae of the originals, and often retain these after they have begun to place their own names on the obverses of the coins, but they never use the title of *Augustus* themselves with such epithets as *rex*, *victor*, and *DN* (for *dominus noster*) and so forth. The one apparent exception to this rule is a solidus of the Frankish king Theodebert I with an inscription DN THEIDEB ERTIPPAUC, and the authenticity of this cannot be regarded as assured. Only a single specimen is known, formerly in the Voillemier Collection, and now in Berlin.[158] The style of the obverse bust and the standing angel on the reverse correspond

[149] *Rex Gothorum*: cf. the index to Cassiodor's *Variae*, ed. Th. Mommsen, MGH, *AA*, XII (Berlin, 1894), *s.v. rex*. On the titles of the Ostrogothic kings of Italy, see Schmidt, *Die Ostgermanen*, 360f., 371f.

[150] *Rex Wandalorum et Alanorum*: L. Schmidt, *Geschichte der Wandalen* (Munich, 1942), 148f., 156f.

[151] *Rex Burgundionum*: *idem*, *Die Ostgermanen*, 176. For the period of the underdeveloped kingship (the phylarchs), see *ibid.*, 167f.

[152] *Rex Francorum*: E. Zöllner, *Geschichte der Franken bis zur Mitte des sechsten Jahrhunderts* (Munich, 1970), 120. For the later period, see B. Krusch, *Studien zur fränkischen Diplomatik. Der Titel der fränkischen Könige*, AbhBerl, Phil.-hist.Kl., 1937 no. 1 (Berlin, 1937).

[153] *Rex Langobardorum*: Schmidt, *Die Ostgermanen*, 616.

[154] See the evidence in the works mentioned *supra*, notes 148–53. The obvious fact that this title is borrowed from the Roman emperors does not mean that it characterizes the sovereignty of the ruler in his relationship to the Roman emperor, as Schmidt, *Die Ostgermanen*, 510 note 3, suggests, but merely the absolute form of rule in the relation of the monarch to his subjects. Even the nonreigning members of the Burgundian royal family are addressed with the title *dominus*; cf. *ibid.*, 172.

[155] Only the Maurish kinglet Masties (*ca.* 535) was not contented with his Roman title *dux* and added to his name the title *imperator* (!); cf. Ch. Courtois, *Les Vandales et l'Afrique* (Paris, 1955), 333 and Appendix II note 132.

[156] Unique is the private inscription set up by the Roman senator Caecina Mavortius Basilius Decius, who styled the Ostrogothic King Theoderic *rex Theodericus victor ac triumphator semper Augustus*: H. Dessau, *Inscriptiones Latinae Selectae*, I (Berlin, 1892), no. 827. J. M. Wallace-Hadrill's conclusion from this inscription is erroneous: "Imperial practice in the bestowal of titles of honour on barbarian rulers seems not to have been governed by hard and fast rules, and it is hardly surprising that western commentators sometimes gave misleading accounts, particularly of insignia": *The Long-Haired Kings and Other Studies in Frankish History* (London, 1962), 175 note 4. Just the opposite is true.

[157] See, e.g., Bréhier, *Les institutions* (note 3 *supra*), 294: "L'effigie impériale figurait parfois sur les monnaies, frappées au poids et au titre légal de l'Empire: la disparition de cette effigie indiquait l'émancipation d'un vassal. Exemple du Mérovingien Théodebert, fils de Clovis." Cf. A. Gasquet, *L'empire byzantin et la monarchie franque* (Paris, 1888), 171–78; Zöllner, *op. cit.*, 122f.

[158] A. de Belfort, *Description générale des monnaies mérovingiennes*, IV (Paris, 1894), no. 5467, citing Dr. Voillemier, "Des premières monnoies d'or mérovingiennes, et spécialement de quelques-unes de Théodebert Ier," *RN* (1841), 119–20, no. 7, pl. IV,7. The coin was then in his collection. For a photograph, see A. Suhle, *Deutsche Münz- und Geldgeschichte von den Anfängen bis zum 15. Jahrhundert*, 3rd ed. (Munich, 1964), 17.

closely to one of the Italian issues of Justinian's reign, and the coin is what we could expect of an Italian issue of Theodebert. But the weight (4.14 g.) is abnormally low. Theodebert's coins regularly spell him Theodibertus, with an "o" and in the nominative,[159] and not Theudeberti with a "u" and in the genitive, and the normal title on the coins is *rex* or *victor*, not *augustus*. Although the coin was published as long ago as 1841, the forging of Merovingian coins had begun as early as the seventeenth century, and in my view the coin is too doubtful for any weight to be attached to it.

If Theodebert's coin is a forgery, and therefore is not to be considered, we can conclude that there is no exception to the rule that the Germanic kings never used the imperial titles. There should be no doubt that the barbarian rulers avoided the titles of the Roman emperor not because it would be an unwelcome innovation to their national traditions, but mainly because they recognized the sovereignty of the Roman state over the territory of their establishment. This was the legal reality which they agreed to share by virtue of the *foedus* they concluded with the Empire. This reality was respected even in times when, due to the current constellation of power, it appeared to be more a fiction than to possess any political validity.

The usage of titles in the royal chanceries is imitated by the Latin literary sources of this time. The papal chancery, the Acts of the western synods, Cassiodorus, Jordanes, Ennodius, *Excerpta Valesiana*, and the *Liber Pontificalis*, to mention the most important sources, call the Germanic kings *reges* and preserve the title *imperator* only for the Byzantine emperor.[160] As late as 799 Alcuin praised Charlemagne in regarding his *regalis dignitas* as being third after the pope's *apostolica sublimitas* and the Roman emperor's *imperialis dignitas*.[161]

On the other hand, the evidence introduced by Helm shows in fact that the majority of Greek literary sources mention the Germanic kings in several cases with the title βασιλεύς.[162] It is worth mentioning, however, that, as Vetter points out, according to Malalas all the western kings (the Germans and the Huns) are only ῥῆγες,[163] although he does not hesitate, of course, to call the western emperors βασιλεῖς. Moreover, a historian like Olympiodorus, who had served several times as ambassador to the court of barbaric monarchs, calls them ῥῆγες or φύλαρχοι, but never βασιλεῖς, a title that he attributes only to the Roman emperor.[164] Letters of Roman emperors addressed to Germanic

[159] See the index in de Belfort, *op. cit.*, V (1895), 121–22. The triens which he cites as no. 5488 with *Theudbertus* is misread; see M. Prou, *Les monnaies mérovingiennes* (Paris, 1892), no. 43. The spelling *Thuodibertus*, *ibid.*, no. 53, is irregular.

[160] See the list made by G. Vetter, *Die Ostgoten und Theoderich* (Stuttgart, 1938), 109, at note 128. For the Latin sources of the Germanic states, see F. Haenssler, *Byzanz und Byzantiner. Ihr Bild im Spiegel der Überlieferung der germanischen Reiche im früheren Mittelalter* (Bern, 1960).

[161] Alcuini, *Ep. ad Carolum*, ed. E. Dümmler, MGH, *Ep.*, IV (Berlin, 1895), 288 line 17 ff.: *Nam tres personae in mundo altissime fuerunt: id est apostolica sublimitas. Alia est imperialis dignitas. Tertia est regalis dignitas.*

[162] *Op. cit.* (note 13 *supra*), 383 note 2. Cf. also the material collected by Vetter, *op. cit.*, 110, at note 133, for the use of βασιλεύς and ῥής in Malchus, Eustathius, Procopius, Malalas, and Theophanes.

[163] Vetter, *op. cit.*, 54. Cf. W. Ensslin, in *BZ*, 40 (1940), 173.

[164] *FHG*, IV, 57–68. On Vetter's argumentation on the fact that Procopius avoids the term ῥής (except in special cases: see *infra*, pp. 56–57) and calls all monarchs βασιλεῖς, see the answer of Ensslin, *op. cit.*, 173: "Prokop als Purist vermeidet es möglichst nichtgriechische Wörter zu gebrauchen."

rulers are not preserved in Greek.[165] However, the *deperdita* found in literary sources testify, as far as I can see, to the statement that the Roman court never used the title βασιλεύς in connection with any Germanic king.[166] There is one exception: Procopius quotes from two letters written by Justinian to Gelimer, who in 530 overthrew the Vandal king Ilderic and became himself *rex Vandalorum*. In these letters, Justinian calls Ilderic βασιλέα Βανδάλων, and the Vandal monarchy βασιλεία.[167] However, the explanation is to be found, in my opinion, in the fact that these two letters were written originally in Latin, and the "purist" Procopius contented himself with translating the terms *rex* and *regnum* of the original into βασιλεύς and βασιλεία.[168]

As exceptional evidence I shall have to mention the famous passage in Gregory of Tours' *Histories* on the investiture of the Frankish king Clovis as *ex consule* through the ambassadors of Emperor Anastasius in 508, which ends with the information that "from this day on he was called 'consul or augustus'": *Igitur ab Anastasio imperatore codecillos de consulato accepit et in basilica beati Martini tunica blathea indutus at clamide, imponens vertice diademam. Tunc ascenso equite, aurum argentumque in itinere illo, quod inter portam atrii et ecclesiam civitatis est, praesentibus populis manu propria spargens...ab ea die tamquam consul aut augustus est vocitatus.*[169] During the lively discussion on the meaning of this passage, which reached its climax in the years after 1933 when B. Krush understood it to testify to the first imperial coronation

[165] For the period up to 476, see O. Seeck, *Regesten der Kaiser und Päpste für die Jahre 311 bis 476 n. Chr.* (Stuttgart, 1919; repr. Frankfurt, 1964). For the period after 565, see F. Dölger, *Regesten der Kaiserurkunden des oströmischen Reiches*, I (Munich, 1924). I am preparing a *Regesten* volume covering the period between 476 and 565. In a single case, in the inscription of the letter of Maurice to Childebert preserved in Latin (*ibid.*, 83) the Frankish king is called *Childeberthus vir gloriosus rex Francorum*: MGH, *Ep.*, III (Berlin, 1892), no. 42, p. 148 line 24.

[166] This observation is backed by the results of Winter, *op. cit.* (note 37 *supra*), 35–50, esp. 42, namely that the Roman policy of *reges appellare* was not adapted to the Germanic rulers. Cf. *idem, Antike Königserhebungen und ihre Weiterbildung durch das byzantinische Kaisertum* (Diss. University of Vienna, 1941 [unpub.]), summarized in Rubin, *Das Zeitalter Iustinians*, 493–95.

[167] *Bella* III.9,10–19: Ούχ ὅσια ποιεῖς οὐδὲ τῶν Γιζερίχου διαθηκῶν ἄξια, γέροντά τε καὶ ξυγγενῆ καὶ βασιλέα Βανδίλων....μήτε οὖν ἐργάσῃ περαιτέρω κακὸν μήτε τοῦ βασιλέως ὀνόματος ἀνταλλάξῃ τὴν τοῦ τυράννου προσηγορίαν, βραχεῖ προτερεύουσαν χρόνῳ ἀλλὰ τοῦτον μὲν, ἄνδρα ὅσον οὔπω τεθνηζόμενον, ἔα φέρεσθαι τῷ λόγῳ τὴν τῆς βασιλείας εἰκόνα, σὺ δὲ ἅπαντα πρᾶττε ὅσα βασιλέα πράττειν εἰκός.

[168] If he had preferred to transcribe *rex* as ῥήξ he would have had difficulties translating *regnum* to an adequate Greek word, different from βασιλεία. This is the way H. B. Dewing understood the meaning of Procopius' quotation. In his English translation the βασιλεὺς Βανδίλων is "king of the Vandals," the εἰκὼν τῆς βασιλείας is "form of royal power," while the βασιλεία 'Ιουστινιανοῦ is rightly Justinian's "imperial power": Procopius, Loeb, II (London-New York, 1916), 87. On the method used by Procopius in incorporating letters into his *Histories*, see F. Dahn, *Prokopius von Cäsarea* (Berlin, 1865), 89–104, esp. 93f. On the authentic letters quoted by Procopius (among them are the two letters under discussion), O. Veh comments: "Indessen tragen auch sie [the authentic letters] in ihrer Schlichte nicht das rhetorische Gewand der byzantinischen Kanzlei, sondern die Ausdrucksweise Prokops, der vielleicht manches Dokument wie z.B. die zwischen dem ostgotischen bezw. vandalischen Höfen und Byzanz gewechselten Briefe aus dem Lateinischen erst übertragen musste": *Zur Geschichtsschreibung und Weltauffassung des Prokop von Caesarea*, I, Wissenschaftliche Beilage zum Jahresbericht 1950/51 des Gymnasiums Bayreuth (Bayreuth, 1951), 16. That in Greek Geiseric's title was ῥήξ we see in Theophanes: ῥῆγα καλέσας ἑαυτὸν γῆς τε καὶ θαλάσσης: ed. de Boor, 101 line 19. On the *superscriptio* of Gelimer's letter to Justinian (Βασιλεὺς Γελίμερ 'Ιουστινιανῷ βασιλεῖ: Procopius, *Bella* III.10,20), see Wolfram, *op. cit.* (note 148 *supra*), 134f.

[169] *Historiarum* II.38, ed. B. Krusch, MGH, *ScriptRerMerov*, I, 1,1 (Hannover, 1936), 88 line 15–89 line 5.

of a German king,[170] K. Hauck reached the most satisfactory interpretation in translating the verb *vocitare* with *acclamare*, and so translating the passage "from this day on he was acclamated (*voces* = *acclamationes*) as a consul of the emperor."[171]

Since this passage is by no means to be taken anymore as referring to an imperial title *augustus*, there is for our discussion no need to look for any further explanation.[172] Nevertheless, in my opinion it could be fruitful to reconsider the evidence for the possible patriciate of Clovis combined with royal (not consular) acclamations and *donativa* in the sense of an *ingressus regis*, and to reexamine the possibility that Gregory of Tours a) relies for this passage on *topoi*,[173] and b) absorbs the aspirations of the clergy of Tours, as Courcelle anticipated.[174]

It can be stated, therefore, that the imperial titles *imperator* and *augustus* were never usurped by the Germanic kings.

Finally, we have to examine two cases in which Procopius uses the term ῥήξ. The first is the story of the Heruls who assassinated their king because they decided to live without one.[175] If the purist Procopius uses ῥήξ this time, there is possibly no other reason than his intention to emphasize the weak

[170] *Die erste deutsche Kaiserkrönung in Tours, Weihnachten 508*, SBBerl, Phil.-hist.Kl., 1933 (Berlin, 1933), 1060 ff. H. Günther disagreed, in "Der Patriziat Chlodwigs," *HJ*, 54 (1934), 468–75. Günther's suggestion that in 508 Clovis was designated Roman *patricius* was rejected by L. Schmidt, "Nochmals der Patriciat Chlodwechs," *HJ*, 55 (1935), 552f.; while W. Ensslin, "Nochmals zu der Ehrung Chlodowechs," *HJ*, 56 (1936), 499–507, esp. 507, conjectured the expression *aut augustus* into *ut augustus*, with the meaning "he was called consul like the Emperor." Cf. Wallace-Hadrill, *The Long-Haired Kings* (note 156 *supra*), 175 note 1; and the German translation of Gregory of Tours by R. Buchner, *Zehn Bücher Geschichten*, I (Darmstadt, 1970), 134: "Von diesem Tag an wurde er *wie der Kaiser* [italics mine] konsul genannt."

[171] "Von einer spätantiken Randkultur zum karolingischen Europa," *Frühmittelalterliche Studien. Jahrbuch des Instituts für Frühmittelalterforschung der Universität Münster*, 1 (1967), 1–93, esp. 30 ff. This explanation is anticipated by P. Courcelle, *Histoire littéraire des grandes invasions germaniques* (Paris, 1948), 203: "Il est exclu que l'empereur ait accordé à Clovis une investiture quelconque; le proclamer auguste, ç'aurait été le désigner comme collègue à l'empire! Si les lignes ont un sens et correspondent à des faits, Clovis, à la suite de cette cérémonie, a été acclamé 'auguste' par le peuple." Cf. the extensive discussion of this subject, *ibid.*, 4th ed. (Paris, 1964), 242–50.

[172] Mr. Grierson has called attention to the difficulty created by one of Gregory's incidental touches, the assertion that Clovis, on the occasion of his consular procession, threw gold *and silver* coins to the people, for at that time there were no silver coins regularly circulating in the West. In the late fifth and early sixth centuries the Franks did indeed sometimes strike minuscule silver coins (cf. Prou, *op. cit.* [note 159 *supra*], xcvif.; J. Lafaurie, "Monnaie en argent trouvé à Fleury-sur-Orne. Essai sur le monnayage d'argent franc des Vᵉ et VIᵉ siècles," *Annales de Normandie*, 14 [1964], 173–222), but they were too tiny to be suitable for distribution in this fashion, and although the contents of Childric's tomb show that earlier Roman silver coins, presumably from recently discovered hoards, were much prized, they would scarcely have been numerous enough to serve as *Auswurfsmünzen*; cf. R. MacMullen, "The Emperor's Largesses," *Latomus*, 21 (1962), 159–66; and, in the specific consular context, H. Stern, *Le Calendrier de 354. Etude sur son texte et ses illustrations* (Paris, 1953), 152f. and pl. XIV. For a general survey, cf. N. L. Rasmusson, "Auswurfsmünzen," *Atti del Congresso internazionale di numismatica, Roma 1961*, II (Rome, 1965), 623–36, Clovis at p. 625.

[173] For the *topoi* in the description of the *pompae* of the Emperors Gallienus and Aurelianus by the *Scriptores Historiae Augustae*, see E. Merten, *Zwei Herrscherfeste in der Historia Augusta, Untersuchungen zu den pompae der Kaiser Gallienus und Aurelianus* (Bonn, 1968).

[174] *Op. cit.*, 204.

[175] Ἔρουλοι τὸ τοῦ τρόπου θηριῶδές τε καὶ μανιῶδες ἐνδειξάμενοι ἐς τὸν αὐτῶν ῥῆγα (ἦν δὲ οὗτος ἀνὴρ Ὄχος ὄνομα) ἐξαπιναίως τὸν ἄνθρωπον ἀπ' οὐδεμιᾶς αἰτίας ἔκτειναν, ἄλλο οὐδὲν ἐπενεγκόντες ἢ ὅτι ἀβασίλευτοι τὸ λοιπὸν βούλονται εἶναι. καίτοι καὶ πρότερον ὄνομα μὲν αὐτοῖς ὁ βασιλεὺς εἶχεν, ἰδιώτου δὲ ὁτουοῦν οὐδέν τι σχεδὸν ἐφέρετο πλέον: *Bella* VI.14,38–39, ed. Haury and Wirth, II (1963), 214 lines 4–11.

position of the kinglet, who had the title of king but in fact did not differ from the common men.[176] Later the Heruls changed their minds, and after some unsuccessful attempts to get a king from their native country in Scandinavia they asked the Emperor Justinian to choose and send one. Procopius, who tells the story, avoids again the use of βασιλεύς, except for the emperor, and calls the king to be elected an ἄρχων.[177]

In the second case, the purist Procopius uses the term ῥήξ when he defines Theoderic's rule in Italy: Καὶ βασιλέως μὲν τοῦ Ῥωμαίων οὔτε τοῦ σχήματος οὔτε τοῦ ὀνόματος ἐπιβατεῦσαι ἠξίωσεν, ἀλλὰ καὶ ῥὴξ διεβίου καλούμενος (οὕτω γὰρ σφῶν τοὺς ἡγεμόνας καλεῖν οἱ βάρβαροι νενομίκασι) τῶν μέντοι κατηκόων τῶν αὑτοῦ προὔστη ξύμπαντα περιβαλλόμενος ὅσα τῷ φύσει βασιλεῖ ἥρμοσται.[178]

This is not the proper place to study this significant passage for Theoderic's "constitutional" position, as it was understood in Constantinople. Nevertheless, we must examine the distinction between the terms ῥήξ and βασιλεύς.[179]

Although Procopius' determinative expression βασιλέως τοῦ Ῥωμαίων leaves room for other βασιλεῖς, who could be not Roman, it is obvious that the φύσει βασιλεύς to whom Theoderic is compared is not a "king," but the emperor.[180] The ὄνομα βασιλέως, which Theoderic did not usurp, is, therefore, not only *imperator* in Latin, but also that same title βασιλεύς in Greek.[181]

A few lines further on, Procopius gives a remarkable definition of Theoderic's position: Ἦν τε ὁ Θευδέριχος λόγῳ μὲν τύραννος, ἔργῳ δὲ βασιλεὺς ἀληθὴς τῶν ἐν ταύτῃ τῇ τιμῇ τὸ ἐξ ἀρχῆς εὐδοκιμηκότων οὐδενὸς ἧσσον.[182]

Again, the comparison of the βασιλεύς to those "who have distinguished themselves in this office from the beginning" shows that the moral and political image of the true ruler, which Procopius attributes to Theoderic, is not that of a "king," but that of the Roman emperor.[183] In this final evaluation of Theoderic's character and rule the historian thinks it necessary to state that his favorite ruler λόγῳ was not a βασιλεύς, i.e., he did not have the title nor the legal status of a βασιλεύς.

[176] On the Herulian kingship, see Schmidt, *Die Ostgermanen*, 554.

[177] Πέμψαντες οὖν ἐς Βυζάντιον βασιλέως ἐδέοντο ἄρχοντα σφίσι πέμψαι, ὃν ἂν αὐτῷ βουλομένῳ εἴη: *Bella* VI.15,31; cf. also VI.15,36: καὶ βασιλεὺς [i.e., Ἰουστινιανὸς] πάσῃ δυνάμει κατάγων ἐς τὴν ἀρχὴν αὐτὸν ἐν σπουδῇ ἐποιεῖτο.

[178] *Ibid.* V.1,26, ed. Haury and Wirth, II, 8 line 8.

[179] I am preparing a study on "Theodericus rex: Τύραννος or βασιλεύς?"

[180] Cf. Dewing's translation: "And though he did not claim the right to assume either the garb or the name of emperor of the Romans, but was called 'rex' to the end of his life (for thus the barbarians are accustomed to call their leaders), still, in governing his own subjects, he invested himself with all the qualities which appropriately belong to one who is *by birth an emperor* [italics mine]," and his footnote: "the title 'rex' was current among the barbarians to indicate a position inferior to that of a βασιλεύς or 'imperator'": *op. cit.*, III, 11 and note 2.

[181] Procopius does not know of any exclusive imperial titles in Greek. He uses the equivalent of *imperator*, αὐτοκράτωρ, in its old Greek meaning; e.g., *Bella* V.5,4: στρατηγὸς αὐτοκράτωρ ἐφ' ἅπασι Βελισάριος ἦν. See the index of the edition of Haury and Wirth, IV (1964), 342 *s.v.*

[182] *Bella* VI.29. On Procopius' classical models, see Rubin, *Das Zeitalter Iustinians*, 436 note 486, 495 note 850.

[183] The reason Procopius gives for his positive picture of Theoderic, namely his care for his subjects, Goths and Italians, and their unanimous love for him (VI.29–31), is well explained in terms of the *Kaiserkritik*, as F. Dahn (*op. cit.* [note 168 *supra*]) and B. Rubin (in *RE*, 23,1 [1957], col. 429) have pointed out. This shows again that Procopius' *Fürstenspiegel* is that of the "true emperor."

2. *Attila and the Hunnic "Kingdoms"*

Attila is mentioned by R. Helm as the first example of those rulers of national "kingdoms" who are referred to in the Greek sources with the title βασιλεύς.[184] However, the evidence supplied by Priscus Panites, the most reliable source for the history of Attila and his Huns, proves that in spite of the current use of this term the historians were conscious of its function as the official and exclusive title of the Roman emperor.

Priscus does not hesitate to use the title, not only for Attila but even for the chiefs of the Hunnic tribes united under his authority.[185] On the other hand, the same historian provides us with positive evidence that Attila, whatever he was called in the literature, even by Priscus himself, was not officially conceded the title *basileus*. He reports a conversation that took place in 449 at the court of Attila among the Roman ambassadors, who were waiting to be received for an audience with the king. During their conversation about whether it would be wise to try to direct the greediness of the Huns toward Persia, in the hope of rescuing the Empire from their excessive demands, Comentiolos, a Roman native of Pannonia, expressed his fear that if Attila should succeed in subduing the Persians he would demand much more. Thus, he would not tolerate being deprived of his proper rank and would no more be satisfied with the title of a Roman *magister militum* (a fiction used by the imperial government to cover the annual tribute paid to him as his salary for his service as general) and would force the Empire to render him the title βασιλεύς![186]

There should be no doubt that Attila, even at the zenith of his power, had to accept the fact that the Romans were "depriving" him of his dignity as βασιλεύς.[187]

In a previous chapter we have seen how the Hunnic rulers of the Black Sea were bestowed with great honors and titles of high Byzantine rank, as recogni-

[184] *Op. cit.* (note 13 *supra*), 383 note 2.

[185] Speaking of the gifts which the Emperor Theodosius II sent to the chiefs he speaks of τῶν βασιλέων τοῦ ἔθνους, who are συμβασιλεύοντες of Attila: *Exc. de leg.*, ed. C. de Boor (Berlin, 1903), p. 130 line 13 ff. Cf. Altheim, *Geschichte der Hunnen* (note 91 *supra*), IV, 275. Altheim's interpretation of συμβασιλεύοντες is erroneous: Priscus' ἑκάστῳ should not be read as ἑκατέρῳ. Cf. *cuiusque gentis regis*, in the Latin translation of C. Cantoclarus, in *FHG*, IV, 82f.

[186] Οὐκ ἔτι 'Ρωμαίων ἀνέξεσθαι τὴν αὐτοῦ νοσφιζομένην ἀρχήν, ἀλλὰ θεράποντας περιφανῶς ἡγησάμενον χαλεπώτερα ἐπιτάξεων καὶ οὐκ ἀνεκτὰ ἐκείνοις ἐπιτάγματα, ἣν δ'⟨ἣ⟩ ἀξία, ἧς ὁ Κωνσταντίολος ἐπεμνήσθη, στρατηγοῦ 'Ρωμαίων, ἧς χάριν ὁ 'Αττήλας παρὰ βασιλέως ἐδέδεκτο τὸ τοῦ φόρου ἐπικαλύπτοντος ὄνομα, ὥστε αὐτῷ σιτηρεσίου προφάσει τοῦ τοῖς στρατηγοῖς χορηγουμένου καὶ συντάξεις ἐκπέμπεσθαι. ἔλεγεν οὖν μετὰ Μήδους καὶ Πάρθους καὶ Πέρσας τοῦτο τὸ ὄνομα ὅπερ αὐτὸν βούλονται 'Ρωμαῖοι καλεῖν, καὶ τὴν ἀξίαν, ἣ αὐτὸν τετιμηκέναι νομίζουσιν, ἀποσεισάμενον ἀναγκάσειν σφᾶς ἀντὶ στρατηγὸν βασιλέα προσαγορεύειν (*Exc. de leg.*, p. 142 lines 4–15). Priscus was an eyewitness, and therefore his trustworthiness is beyond any doubt.

[187] The meaning of this passage has been overestimated by E. A. Thompson, who interprets the statement of Comentiolos as follows: "If Persia were to collapse, the outlook for the Roman Empire would be very black, for he doubted if Attila would allow them to maintain an independent existence once Persia had fallen": *A History of Attila and the Huns* (Oxford, 1948), 115. On the question of Attila holding the office of στρατηγός (= *magister militum*), according to Priscus' evidence, see Seeck, *Geschichte* (note 41 *supra*), VI (1920), 290. Cf. Al. Demandt, in *RE*, suppl. 12 (1970), col. 753, *s.v. magister militum*. This question deserves further investigation in order to date Attila's "promotion" and to uncover the real reason for similar gestures of the Roman government toward other "barbarian" rulers before and after Attila.

tion of their loyal service to the Empire.[188] Nevertheless, they were not conceded the imperial title in Greek: βασιλεύς!

V. State Sovereignty and International Relations

A. Gasquet, Th. Nöldeke, and Th. Mommsen have long ago pointed out that when we study the titles of emperors and kings it is very important to examine separately the literary sources on the one hand, and the official imperial documents on the other.[189] This distinction has hitherto been made only when the imperial titles were studied, and it was upon this distinction that the title *basileus*, found in official use in 629, was considered significant, although in the literary sources the same title was unofficially used for the emperors as early as the first century B.C. However, this distinction has not been made in the study of the regnal titles of the rulers of countries neighboring Byzantium. As we can see now, it was in failing to do this that George Ostrogorsky came to the conclusion that the title *basileus* was used in Byzantium before Heraclius for foreign rulers. As a matter of fact, for most of these rulers we do find this title used by the Early Byzantine literary sources. Nonetheless, the study of all available documents issued from the imperial chancery in the period from Constantine the Great to Heraclius has shown that, with the exception of the Persian King of Kings, in no case was any foreign ruler ever officially conceded or acknowledged to hold legitimately the title *basileus*. This is true even for those Oriental kings subordinate to the emperor, whose elevation to their national throne was due to imperial recognition and investiture with the regnal insignia.

Of course, it can be argued that only a few imperial documents have been preserved from the Early Byzantine period. However, it is not very probable that new evidence might lead us to modify this statement, for a very simple but also very important reason: most probably none of the rulers concerned were expecting the emperor to address them with the exclusive regnal title. They themselves refrained from using this title in their own official presentations, that is, in documents, inscriptions, and coins. On the contrary, from what has been preserved of these we can say that the titles which the emperors used when addressing these rulers were the same ones which they ordinarily used for themselves. From the information we have we must come to the conclusion that, with the exception of the Sasanian *shahanshah* and the Ethiopian *nagusa*, who for some time usurped the titles of the Persian monarch, no ruler of this period ever officially used the title *basileus* for himself.

As an example of Oriental rulers it is worth mentioning that the rulers of the Nubians and the Blemyans in Africa, in the inscriptions commemorating their victories over their enemies, including the Romans, are called not kings (βασιλεῖς) but kinglets (βασιλίσκοι), the title we find in use in other sources for

[188] See *supra*, p. 41.
[189] See *supra*, p. 33.

rulers of this part of the world.[190] On the other hand, the Germanic rulers, the Visigoths, Ostrogoths, Franks, Vandals, Burgundians, and Lombards, who were constantly addressed by the Byzantine emperors as *reges* and never as βασιλεῖς, *imperatores*, or *Augusti*, consciously refrained from using these imperial titles for themselves. We have seen that the Ostrogothic King Theoderic the Great "did not attempt to arrogate either the garb or the name of emperor of the Romans but was called *rex* to the end of his life (for thus the barbarians consider proper to call their rulers)."[191]

As for the Hun ruler Attila, whom Ostrogorsky included in his list as having been conceded the title βασιλεύς by the Roman emperor, we have seen that even at the zenith of his power this title was consciously withheld from him and that he was unsatisfied with this situation.[192] But he did not change it.

Thus, we can conclude that the Empire did not concede to the neighboring rulers the title βασιλεύς and used other titles instead. Furthermore, this usage did not contradict but corresponded to the official attitude of the neighboring rulers, who consciously refrained from arrogating the exclusive title. This principle remained unchanged after the official assumption of the title βασιλεύς by the Byzantine emperor at the beginning of the seventh century. The title was used by Western rulers only after Charlemagne's coronation in Rome on Christmas day in 800, which was regarded as the "coup d'état of St. Peter's basilica" until the title was officially conceded to him in 812; and in the East, the first to claim the right to assume the title was the Bulgarian Tsar Symeon in the early tenth century.

What are the implications of all these facts for the international relations of the Mediterranean world, and especially for the attitude of the Early Byzantine state? On the basis of modern scholarship one is inclined to regard the principle I have just described as an expression of the Byzantine idea that the emperor rules the whole world, that he pretends to be and is recognized as the *dominus totius mundi*, master of all the peoples of the world, and therefore the use of the imperial and regnal titles is an expression of Byzantine universalism, which is considered the absolute form of imperialism. However, if we study more closely the international relations of Byzantium, we might have reason to modify this opinion. In studying this question it is important to make a distinction between the nations that had been living in the East for centuries when the Romans arrived during their rapid expansion in the second and the first centuries B.C., and those nations that appeared at the northern and western frontiers of the Empire in the course of the third to the sixth centuries, invaded the Roman provinces, and eventually settled there.

I shall survey the Germanic nations first. These nations had kings who were elected by the free, national council to lead the people in their migration. Thus, the kings were *Volksführer*, leaders of the people, not lords of the country they had settled, and their royal authority did not include any territorial

[190] See *supra*, p. 44.
[191] See *supra*, p. 57.
[192] See *supra*, p. 58.

sovereignty. In this sense they remained *reges Gothorum, Francorum*, etc., never *reges Italiae, Franciae* (or *Galliarum*). When a peace treaty was concluded with them, the imperial government approved their settlement on the soil of Roman provinces; they became *foederati*, and the national kings were recognized officially as leaders of autonomous political units within the Empire, on the condition that they recognize the sovereignty of the emperor. This was expressed through the bestowal of imperial court titles, in the first stage military titles, such as *comes* or *magister militum*,[193] and, later, political titles, such as *exconsul* and *patricius*,[194] and in some cases through the *adoptio per arma*.[195]

Of course, the fact that the Germanic nations "belonged" to the Empire (they were *reichsangehörig*) did not affect their political independence; the Byzantines were usually quite realistic in adapting themselves to this situation. On the other hand, there should be no doubt that the kings acknowledged the "constitutional" reality to which they belonged. We have already seen that Theoderic was cautious not to infringe upon the emperor's titles and emblems. He was also cautious in more serious matters; for instance, he did not promulgate laws (*leges*), because this was the right of the imperial government.[196]

Another Germanic ruler, the Burgundian king Sigismund, assured the emperor at the same time that *patria nostra vester orbis est*, and that the royal administration "does not reduce your sovereignty in your provinces."[197] I think that whatever the practical reasons were for this strong expression of fidelity, Sigismund's words reveal that he knew the institutional framework within which he was exercising his royal authority.[198] If we understand in this context

[193] These titles not only served to satisfy the barbarians' vanity—we know notorious cases of national leaders who joked about their Roman titles—but also, more importantly, demonstrated to all sides that the kings were enrolled in imperial service. Furthermore, the annual subsidies, which the Empire very often had to pay to these leaders by virtue of the *foedus*, was in this way camouflaged as the ordinary salary for their service: Chrysos, Τὸ Βυζάντιον καὶ οἱ Γότθοι (note 40 *supra*), 156–64.

[194] On the new rank of *patricius* as established by Constantine, see W. Heil, *Der Konstantinische Patriziat*, Basler Studien zur Rechtswissenschaft, 78 (Basel, 1966), 54 ff. For the *patricii* of the sixth century, see R. Guilland, "Les patrices byzantines du VIᵉ siècle. Contribution à l'histoire des institutions et à la prosopographie de l'empire byzantin," *Palaeologia*, 7 (1959), 271–305. On the conferment of the Byzantine titles, see also Gasquet, *L'empire byzantin* (note 157 *supra*), 134–58, whose conclusions have often been neglected.

[195] Cf. P. E. Pieler, "L'aspect politique et juridique de l'adoption de Chosroès proposée par les Perses à Justin," *RIDA*, 19 (1972), 428f.

[196] See A. H. M. Jones, "The Constitutional Position of Odoacer and Theoderic," *JRS*, 52 (1962), 126–30.

[197] The letter of Sigismund was published and perhaps also composed by Avitus of Vienna, *Alcimi Ecdicii Aviti Viennensis episcopi opera quae supersunt*, ed. R. Peiper, MGH, *AA*, VI,2 (Berlin, 1883), 100: *Vester quidem est populus meus, et plus me servire vobis quam illi praeesse delectat. Traxit illud a proavis generis mei apud vos decessoresque vestros semper animo Romana devotio, ut illa nobis magis claritas putaretur, quam vestra per militiae titulos porrigeret celsitudo, cunctisque auctoribus meis semper magis habitum est, quod a principibus sumerent, quam quod a patribus attulissent. Cumque gentem nostram videamur regere, non aliud nos quam milites vestros credimus. Implet nos gaudiorum munere vestra prosperitas: quidquid illic pro salute omnium curatis, et nostrum est. Per nos administratis remotarum spatia regionum, patria nostra vester orbis est, tangit Galliam, Scythiam lumen Orientis et radius, qui illis partibus oriri creditur, hic refulget.*

[198] I believe that Schmidt fails to understand this framework when he describes the wording of the letter of Sigismund as "unwürdige Sprache": *Die Ostgermanen*, 161.

Justinian's wars of the reoccupation of Africa and Italy, we must come to the conclusion that, although these wars were premature and politically shortsighted, they were fought on the basis of a constitutional commonplace, which we miss completely if we characterize Justinian's policy in the West as universalistic or even imperialistic.

I admit that it is very difficult to distinguish between the ideological claims to universal rule, which survive in many Byzantine literary sources, and what we regard as valid legal reality. On the other hand, it is very easy and even modern, but still wrong, to define the legal aspect as a fiction in absolute contradiction to the political reality, which alone should count. If the above-mentioned letter of Sigismund were not sent to the Byzantine Emperor Anastasius, but were instead the letter of a Burgundian lord sent three centuries later to a Carolingian emperor, we would have no difficulty in declaring it homage, typical of medieval feudal Europe. But how far are the two realities from each other? How far is the Early Byzantine type of *foedus*, applied to the legal arrangements for the settlement of newcomers to the Empire, from the *feudum* of medieval legal dependencies? These questions have not yet been seriously discussed, although much has been written explaining the origins of the feudal system and the etymology of the word *feudum*.[199] These questions are not asked because we are accustomed to regard the legal aspects of the settlement of the Germanic kingdoms as belonging to the realm of fiction. In medieval Europe the principle was voiced that the king was an emperor in his realm: *rex imperator in regno suo*.[200] According to Walter Ullmann, "the meaning attached to it was that within his kingdom the king was sovereign, and this idea could be expressed suitably only in the language of the Roman law according to which the emperor was the supreme, 'superior' authority."[201] It seems to me that somewhere between the Roman law and its actual political expression in Early Byzantium we might find a further link between Late Antiquity and the Middle Ages regarding the constitutional development of the latter.

Let us now look at Early Byzantine policy in the East. In order to understand it properly we have to review briefly the policy of Rome toward the kingdoms of the East.[202] The republican senatorial government of Rome was reluctant to conquer the eastern kingdoms and transform them into Roman provinces. It was considered enough to control their foreign policy by making them Roman allies. During the so-called Roman revolution of the first century B.C., however, the powerful political leaders tried to impose their political will in Rome, carrying thence their glory and booty from victories against remote enemies and the transformation of these enemy states into Roman

[199] The current etymology of *feudum* is from Old German *fief*. However, the etymology from Latin *foedus* is not only possible but quite probable. Cf. V. Brömdal, "Moyen-latin feudum," *Donum natalicium Schrijnen* (Nijmegem, 1929), 447 ff.; I owe this reference to R. Schieffer, Munich.

[200] See G. Post, *Studies in Medieval Legal Thought* (Princeton, 1964), 453–82.

[201] W. Ullmann, *A History of Political Thought: The Middle Ages* (Baltimore, 1965), 196.

[202] See Winter, *op. cit.* (note 37 *supra*), 35–50.

provinces. For the kingdoms which survived within the annexed territories, the political leaders usurped the Senate's right to appoint the client kings. It is significant that Caesar was the first to do so. Augustus decided to end the policy of perpetual aggrandizement and consolidated Roman authority in the East, accepting as the outermost limit of the Roman Empire the Parthian and Armenian borders. In the course of the first century A.D. the kingdoms still existing in the territory of the eastern Roman provinces were eventually abolished. Since these kingdoms were located in so-called imperial provinces, which were constantly increasing at the expense of the senatorial provinces, the royal authority of the absorbed kingdoms was assumed by the emperor, who legally exercised the king's rights in the former kingdoms through his procuratorial officials, and consequently was regarded by the subjects of the former kings as their new king, *basileus*. From the second century on, kingdoms dependent on Rome existed only beyond the official Roman frontier. The characteristic elements of the constitutional form of their kingship, which was similar to and influenced by the monarchical form of the Persian kingship, were first, the hereditary succession to the throne within the same royal family, and second, the feudal system of local nobility consisting of the landed proprietors who supported the king but at the same time limited his power. From the fourth century onward we notice a change in the Roman attitude toward the eastern client kingdoms. The first known cases are the Roman satrapies. When after the Roman-Persian peace treaty of 363 the northwestern part of Mesopotamia (the districts of Ingilena and Sophena) remained under Roman control, it was not incorporated into the provincial organization but continued to form an autonomous political unit under "princes," called satraps, not kings, who nonetheless were local nobles, invested by the emperors with the traditional emblems of their authority which they exercised as a kind of viceroy.[203] After the division of Armenia into two parts, one Roman and one Persian, in 387 or perhaps 378, the southern part was transformed into four satrapies, Anzitena, Asthianena, Sophanena, and Palabitena, in addition to those I just mentioned. In the main part of Roman Armenia the kingship was abolished soon afterward. However, the country was not transformed into a province, but it was arranged that it be governed by an Armenian noble who was given the Roman title of *comes Armeniae*.[204] We can observe the same policy toward all the other client kingdoms of the East. The kingdom of the Crimean Bosporus suffered much destruction and numerous foreign occupations between the fourth and the sixth centuries. However, whenever this country emerges from obscurity during the sixth or the seventh centuries, we no longer find any kings ruling it, but we do hear of a *dux* exercising political authority.[205]

The kingdoms of Lazica and Iberia in the Caucasian area shared the same destiny. In the fourth quarter of the sixth century the kingship was abolished

[203] Cf. *supra*, p. 46.
[204] Cf. *supra*, pp. 38–39.
[205] Cf. *supra*, p. 42.

there, too, and was replaced by the institution of the Presiding Prince of local origin, who exercised political authority while holding the Byzantine title of a *patricius* in the case of Lazica, and of *curopalates* in the case of Iberia.[206] During his Persian war Justinian incorporated Great Armenia into the provincial system, abolishing the ducate.[207] However, he did not do the same with the Gashanid Arabs. On the contrary, he united the phylarchies under one phylarch, the famous Al-Harit (Arethas), who was granted the title of a Byzantine *patricius*.[208]

Thus, it can be said that Byzantine policy toward the eastern client kingdoms from the fourth to the sixth century is a policy of gradual incorporation in one form or another. When direct annexation was necessary for military reasons and was politically opportune, the territory of the kingdom was incorporated into the provincial system. Otherwise, the administration was more effective and much less problematic when it remained in the hands of local nobles, who were appointed to carefully chosen ranks in the imperial service, and who exercised the emperor's authority as his viceroys.

The transformation of the client kingdoms into subordinate principalities no doubt inflicted the loss of their sovereignty. For their legal relations with the Empire were no longer based on *amicitia* or *societas*, the traditional Roman forms of clientele, which guaranteed the ally's territory and respected, at least in theory, his sovereignty.[209] Now the emperor was accepted as the κύριος, the *dominus*, the lord—no longer the overlord—of the principality.

It is obvious that this concept of legal relations is not Roman. But if this is true, where did the concept come from? And how did it fit into the Roman constitutional tradition? Many aspects of this question are still to be elaborated, but the main line of development can be drawn.

It can be argued that if the emperor was considered sovereign over the above-mentioned principalities, it should follow that he was also sovereign over his own empire. But did Roman state sovereignty lie with the emperor? This is a perplexing question which has interested Roman lawyers since the second and third centuries A.D. It has been argued that even in the imperial centuries of the dominate and through the Byzantine period Roman sovereignty was with the *populus Romanus*, who delegated this sovereignty to the emperor and withdrew it if they thought he was not worthy of it.[210] Quite recently, H.-G. Beck, in his stimulating attempt to "de-ideologize" Byzantine constitu-

[206] Cf. *supra*, p. 40.

[207] Cf. *supra*, p. 39.

[208] Cf. *supra*, pp. 46–51.

[209] On these forms of Roman international relations, see esp. P. C. Sands, *The Client Princes of the Roman Empire* (Cambridge, 1908), 88 ff.; B. Paradisi, "L'amitié internationale. Les phases critiques de son ancienne histoire," *Recueil des cours, Académie de droit international*, 78 (Paris, 1952), 329; W. Dahlheim, *Struktur und Entwicklung des römischen Völkerrechts im dritten und zweiten Jahrhundert v. Chr.* (Munich, 1968), 163 ff.; M. Lemosse, *Le régime des relations internationales dans le Haut-Empire romain* (Paris, 1967), 20 ff.

[210] From the large bibliography on this matter, see S. Brassloff, "Fürstensouveränität und Volkssouveränität in den justinianischen Rechtsbüchern," *WSt*, 36 (1914), 351–54; G. Bagnani, "Divine Right and Roman Law," *Phoenix. The Journal of the Classical Association of Canada*, 3 (1949), 51–59; J. Karayannopulos, "Der frühbyzantinische Kaiser," *BZ*, 49 (1956), 369–84 (repr. in *Das byzantinische Herrscherbild*, ed. H. Hunger [Darmstadt, 1975], 235 ff.).

tional history, correctly suggested that the Senate and the citizens of Constantinople were much more important constitutional factors than the ideological dressing of our evidence admits.[211] However, it seems to me that we would abandon Byzantine legal reality if we tried to view the political power of the Senate and the populace of Constantinople as a constitutional factor in terms of being the source of the imperial authority.[212] The key sentence as far as legal texts are concerned is that with which the Roman lawyer Ulpian explained the legislative authority of the emperor: "What the Emperor has determined has the force of a statute; seeing that, by the *lex regia* which was passed on the subject of his sovereignty, the people [*populus*] transfer to him and confer upon him the whole of their own sovereignty and power."[213]

As a matter of fact, Ulpian's statement that the authority of the emperor is derived from the fact that the people have, by the *lex regia*, conferred upon him all their authority is strictly in harmony with the political theory of all previous lawyers. We also find the same theory in Justinian's Constitution, prefixed to the Digest, where Justinian himself is referring in explicit terms to the ancient law by which the Roman people transferred all their authority and power to the emperor.[214] However, it would be wrong, in my opinion, to interpret this juridical *topos* documenting the people's sovereignty as the source of imperial authority. This would be true only if the *lex regia* mentioned in Ulpian's sentence were to be understood as a constitutional act, part of the procedure of the emperor's proclamation and coronation, so that it would have to be repeated as the actual transfer of the people's authority to the emperor. But such an act is unknown to our sources.[215] Therefore, I am inclined to understand Ulpian's reference to the *lex regia* as a reminiscence of the decision of the Roman Senate to bestow upon Augustus his *auctoritas* over the *respublica* in 27 B.C.

[211] *Senat und Volk von Konstantinopel. Probleme der byzantinischen Verfassungsgeschichte*, SBMün, Phil.-hist.Kl., 1966, no. 6 (Munich, 1966).

[212] Beck, *op. cit.*, 71f., concludes: "Es ist es wohl nicht übertrieben, im Senat und im Volk von Konstantinopel Bestandteile und Triebkräfte des politischen Lebens zu sehen, die im Gesamt der byzantinischen Verfassung den Platz von *Verfassungsorganen* einnehmen, sofern man die Flüssigkeit des Begriffes 'Verfassungsorgan' innerhalb einer Konstitution, die als solche aus der irrationalen Sphäre des römischen Prinzipats stammt, nicht verschleiert." Cf. J. Karayannopulos, in *Hellenica*, 23 (1970), 123–26. For a juridical correction, see P. E. Pieler, "Zum Problem der byzantinischen Verfassung," *JÖB*, 19 (1970), 55f.

[213] *Quod principi placuit, legis habet vigorem: utpote cum lege regia, quae de imperio eius lata est, populus ei et in eum omne suum imperium et potestatem conferat*, cited in Justinian, *Digest* I.4,1, trans. Ch. H. Monro, *The Digest of Justinian*, I (Cambridge, 1904), 23. The authenticity of this passage is questioned by Bagnani, *op. cit.*, 55f. Cf. also U. von Lübtow, *Das römische Volk. Sein Staat und sein Recht* (Frankfurt, 1955), 466.

[214] See R. W. Carlyle and A. J. Carlyle, *A History of Mediaeval Political Theory in the West*, 3rd ed., I (Edinburgh-London, 1950), 64–70.

[215] The *lex de imperio* as the Senate's legal act of conferring the *imperium*, known from the so-called *lex de imperio Vespasiani* (for the text, cf. S. Riccobono, *Fontes iuris Romani anteiustiniani*, I [Florence, 1941], 154–56), ceased to be promulgated before the end of the third century. According to von Lübtow, *op. cit.*, 407, "erst Carus hat bei seiner eigenen Erhebung und der seiner Söhne bewusst auf jede Mitwirkung des Senats verzichtet und dessen Recht ausgeschaltet. Bei diesem verfassungswidrigen Novum ist es in der Folgezeit geblieben, mochte sich auch ein 'recht kläglicher Rest' der Bestallungsvollmacht in der durch die Kaiser erfolgenden Wahlanzeige mit anschliessender Akklamation des Senats erhalten."

I believe that this was also the way Justinian understood this alleged law when he referred to it in his above-mentioned Constitution: "Considering indeed that by an ancient enactment, the so-called *lex regia*, all legal authority and all power vested in the Roman people were transferred to the Imperial Government, and we do not attribute our collective legislatorial sway to this and that source, but desire that it should be all our own, how can antiquity interfere with our legislation?"[216] We see that Justinian was interested in showing that preexisting legal principles derived from former legislation should not have prohibiting power over his own legislation. Against this background the *lex regia* is considered the basic constitutional act with which in the remote past the Roman people transferred their sovereignty to the imperial government. Thus, it is no longer mentioned to explain how the emperors assumed the right of promulgating *constitutions* as the principal form of legislation, but in order to prove that the emperor's legislation is not necessarily bound to conform to the ancient laws.[217] However, if this is the meaning of the *lex regia* we are dealing with a constitutional form which in the essential question of sovereignty has moved away from the Roman tradition of the *maiestas populi Romani*. Furthermore, it is not difficult to recognize in this constitutional form the main characteristic of Hellenistic and/or Oriental kingship, which was the legal authority of the king over his subjects.

As a matter of fact, the people of Rome and of the East acknowledged this reality by calling the new constitutional form by its name. The Romans defined it ironically as *regnare sine regio insigni*, while in the East "the Greeks with their keen sense of reality, although they used the word *autokrator* for the new ruler as a formal title, soon preferred for everyday convenience to employ a term which indicated summarily what his position was, that is *basileus*."[218] This was also the way the Greek historians of Rome evaluated the establishment of the principate. Thus, according to Dio Cassius, in 27 B.C.

[216] *Codex Justinianus* I.17,1,7: *Cum enim lege antiqua, quae regia nuncupabatur, omne ius omnisque potestas populi Romani in imperatoriam translata sunt potestatem, nos vero sanctionem omnem non dividimus in alias et alias conditorum partes, sed totam nostram esse volumus, quid possit antiquitas nostris legibus abrogare?* Cf. Monro, *op. cit.*, xv.

[217] Analyzing a passage from the sixth-century *Treatise on Political Science* (ed. A. Mai, *Scriptorum veterum nova collectio*, II [Rome, 1827], 599) and a parallel passage from John Lydus (*De magistratibus* II.2, ed. R. Wünsch, Teubner [1903], 56 lines 24–26), F. Dvornik came to the following conclusion: "The first law of kingship, as defined by the Anonymous and supplemented by Lydus, represents the final stage in the growth of the Byzantine view on the origin of the Christian *basileia*. The Byzantines finally succeeded in reconciling two apparently contradictory principles: the divine origin of kingship and God's election of the candidate on the one hand, and the people's sovereignty freely conferred on their chosen leader on the other": *Early Christian and Byzantine Political Philosophy: Origins and Background*, DOS, IX (Washington, D.C., 1966), II, 716. However, both the anonymous author of the *Treatise* and John Lydus refer merely to the proclamation of the emperor and his assumption of the imperial insignia, and not to the people's delegation of their sovereignty to him. Cf. A. Pertusi, "I principi fondamentali della concezione del potere a Bisanzio. Per un commento al dialogo 'Sulla scienza politica' attribuito a Pietro Patrizio," *BISI*, 60 (1968), 13–15; H.-G. Beck, *Res publica Romana. Vom Staatsdenken der Byzantiner*, SBMün, Phil.-hist.Kl., 1970,2 (Munich, 1970), 18. F. Dvornik anticipated a millennium's political thinking which resulted in the modern distinction between state and society and the modern conception of the people's sovereignty. For the danger of interpreting medieval political ideas in the framework of modern political theory, see O. Brunner, *Land und Herrschaft*, 3rd. ed. (Brünn-Munich-Vienna, 1943).

[218] M. P. Charlesworth, "Pietas and Victoria: The Emperor and the Citizen," *JRS*, 33 (1943), 1.

"the power of both people and senate passed entirely into the hands of Augustus, and from this time there was, strictly speaking, a monarchy...the name of monarchy, to be sure, the Romans so detested that they called their emperors neither dictators nor kings nor anything of the sort; yet since the final authority for the government devolves upon them, they must be called kings."[219]

Augustus refrained from assuming the royal titles but ruled the Roman Empire as a monarch for forty-one years, and people were stricken at his death. Only some years before, however, his uncle, Julius Caesar, who was actually ruling Rome as a monarch, tried to obtain the royal title; for this reason he was assassinated[220] and his murderers were celebrated as tyrannicides.[221] We shall have to examine why the Romans were so reluctant to grant the royal title, hoping that this will bring us back to our main subject.

The first and principle reason would seem to be the traditional hatred of the Romans for the kingship, which was the first stage of their constitutional development, and which, according to tradition, had ended when the cruel tyrant *rex* Tarquinius Superbus was exiled. So, for the Romans, *rex* was synonymous with tyrant.[222] However, in the course of time the Romans learned from the Greeks that not every kingship is necessarily a tyranny. None less than Cicero, speaking of Tarquinius in his *Republic*, absorbed the Greek distinction and made the following statement: "Do you not see, therefore, how a king was transformed into a despot, and how a good form of government was changed into the worst possible form through the fault of one man? For here we have a master over the people, whom the Greeks call a tyrant; for they maintain that the title of king should be given only to a ruler who is as solicitous of the welfare of his people as is a father for his children, and maintains in the best possible conditions of life those over whom he is set."[223] This distinction between kingship and tyranny was quite common during the imperial centuries and protected the Roman principate from being identified with tyranny.

It is interesting that the distinction appears again in a remarkable way in John Lydus. In his survey of the constitutional forms which Rome had under-

[219] Dio Cassius, *Roman History* LIII.17,1–2: Οὕτω μὲν δὴ τό τε τοῦ δήμου καὶ τὸ τῆς γερουσίας κράτος πᾶν ἐς τὸν Αὔγουστον μετέστη, καὶ ἀπ' αὐτοῦ καὶ ἀκριβὴς μοναρχία κατέστη...τὸ μὲν γὰρ ὄνομα αὐτὸ τὸ μοναρχικὸν οὕτω δή τι οἱ Ῥωμαῖοι ἐμίσησαν ὥστε μήτε δικτάτορας μήτε βασιλέας μήτ' ἄλλο τι τοιουτότροπον τοὺς αὐτοκράτοράς σφων ὀνομάζειν· τοῦ δὲ δὴ τῆς πολιτείας τέλους ἐς αὐτοὺς ἀνακειμένου οὐκ ἔστιν ὅπως οὐ βασιλεύονται. The translation is taken, with slight alterations, from E. Cary, VI (London, 1917), 235f. Cf. also Appian, *proem*. VI: Καὶ ἔστιν ἤδη ἡ ἀρχὴ μέχρι νῦν ὑφ' ἑνὶ ἄρχοντι, οὓς βασιλέας μὲν οὐ λέγουσιν, ὡς ἐγὼ νομίζω, τὸν ὅρκον αἰδούμενοι τὸν πάλαι, αὐτοκράτορας δὲ ὀνομάζουσιν, ὃ καὶ τῶν προσκαίρων στρατηγῶν ὄνομα ἦν· εἰσὶ δὲ ἔργῳ τὰ πάντα βασιλεῖς.

[220] On Caesar's monarchy and attempted kingship, see D. Felber, "Caesars Streben nach der Königswürde," in F. Altheim and D. Felber, *Untersuchungen zur römischen Geschichte*, I (Frankfurt, 1961), 211–84; A. Alföldi, *Studien über Caesars Monarchie* (Lund, 1953); G. Dobesch, *Caesars Apotheose zu Lebzeiten und sein Ringen um den Königstitel. Untersuchungen über Caesars Alleinherrschaft* (Vienna, 1966); St. Weinstock, *Divus Julius* (Oxford, 1971).

[221] On the idea of the tyrannicide, see R. MacMullen, *Enemies of the Roman Order* (Cambridge, Mass., 1966), 1–46.

[222] See L. Wickert, "*Princeps*," in *RE*, 22 (1954), col. 2110.

[223] *Republic* II.26 (47), trans. C. W. Keyes, Loeb (London, 1928), 157.

gone since the days of Romulus, he comes to the conclusion that the best form of government is the *basileia*, which is the opposite of regnal monarchy (τὸ ῥήγιον ὄνομα) and better than emperorship (τὸ Καισάρων ἤγουν αὐτοκρατόρων ἀξίωμα). Thus, he first defines the ῥήγιον ὄνομα as a tyrannical form of government and therefore repulsive to the Romans, and argues that it is wrong to attribute to the Roman *reges* of olden times the title βασιλεύς;[224] for the *reges* were tyrants and therefore by definition they could not be βασιλεῖς.[225]

Then John describes the "caesarian" form of state based on the definition of *imperare* and points out that this form is different from both the βασιλεία and the tyranny.[226] Now, it is striking that between the principate and the βασιλεία John Lydus introduces another constitutional form, which he calls δομινατιών. According to John this form appeared when Diocletian transformed the principate into a tyrannical form of government by assuming royal insignia and introducing antipopular measures (heavy taxation, etc.).[227] Finally, John Lydus describes the βασιλεία as the ideal constitutional form and argues that the βασιλεύς preserves the state, properly administers the law in agreement with the best of the citizens, and takes care of his subjects like a father. In so doing the βασιλεύς is the opposite of the τύραννος, who rules arbitrarily following only his vices without respect for the law.[228]

John Lydus' definitions of βασιλεύς and τύραννος are obviously taken from the old philosophical and rhetorical tradition, the Discourses on Kingship, the "mirrors of princes," etc. Among many other authors, John definitely knew Synesius of Cyrene, who is the closest to him in time. Thus, he quoted verbatim from Synesius the remark that βασιλέως μὲν τρόπος ὁ νόμος, τυράννου δὲ νόμος ὁ τρόπος.[229] However, John Lydus goes beyond Synesius when he dis-

[224] *De magistratibus* I.3: Ὄνομα δὲ τῆς ἀρχῆς αὐτῶν [i.e., Romulus et Remus] ὃ Ἰταλοὶ λέγουσι ῥήγιον οἷον τυραννικόν· οὐδὲ γὰρ βασιλείας Ῥωμαϊκῆς ἐννόμου ἐστὶ σημαντικόν, ὡς τινες ὑπολαμβάνουσι τὸ ῥήγιον ὄνομα· ὅθεν οὐκέτι μετὰ τὴν ἐκβολὴν τῶν ῥηγῶν παρὰ Ῥωμαίοις καίτοι βασιλευομένοις ἐχρημάτισεν. ἕτερον γὰρ τὸ τῆς ἐννόμου βασιλείας καὶ ἕτερον τὸ τυραννίδος καὶ ἄλλο τὸ τῆς αὐτοκρατορίας ἀξίωμα.... *Ibid.* I.5: ...ὥστε τύραννος ἦν ὁ Ῥωμύλος.

[225] This idea is clearly expressed in Diogenes' answer to Alexander the Great's question on how one could be the best king, as narrated by Dio Chrysostom, *The Fourth Discourse on Kingship* 24: Ἀλλ᾽ οὐδέ ἐστιν, ἔφη, βασιλεύειν κακῶς οὐ μᾶλλον ἢ κακῶς ἀγαθὸν εἶναι. ὁ γὰρ βασιλεὺς ἀνθρώπων ἄριστός ἐστιν, ἀνδρειότατος ὢν καὶ δικαιότατος καὶ φιλανθρωπότατος καὶ ἀνίκητος ὑπὸ παντὸς πόνου καὶ πάσης ἐπιθυμίας... καθάπερ οὖν οὐκ ἔστι κυβερνᾶν μὴ κυβερνητικῶς, οὕτως οὐδὲ βασιλεύειν μὴ βασιλικῶς.

[226] Τὸ γὰρ τῶν Καισάρων ἤγουν αὐτοκρατόρων ἐπώνυμον οὐδὲ βασιλείας ἀλλ᾽ οὐδὲ τυραννίδος ἐστὶ σημαντικόν, αὐταρχίας δὲ μᾶλλον καὶ αὐθεντίας τοῦ διοικεῖν τοὺς ἐξανισταμένους κατὰ τῶν κοινῶν θορύβων ἐπὶ τὸ κάλλιον ἐπιτάττειν τε τῷ στρατεύματι, πῶς ἂν δέοι μάχεσθαι τοῖς ἐναντίοις. imperare γὰρ τὸ ἐπιτάττειν παρ᾽ Ἰταλοῖς λέγεται, ἔνθεν ἰνπερατόρων. ὅτι δὲ βασιλείας οὐκ ἔστι σημαντικὸν τὸ αὐτοκράτορος ἢ Καίσαρος ὄνομα, δῆλον ἄντικρυς τῷ καὶ τοὺς ὑπάτους καὶ μετ᾽ ἐκείνους τοὺς Καίσαρας τὸ τῶν λεγομένων ἰνπερατόρων ⟨ὄνομα⟩ ἀξίωμα τῆς ἐπωνυμίας λαβεῖν. οὐδὲ γὰρ ἐπισήμοις τυραννικοῖς φαίνεται χρησαμένη ἡ τῶν Καισάρων ἀρχή, ἀλουργίδι δὲ μόνῃ τὴν Ῥωμαίων βουλὴν ἀναβαίνουσα καὶ τὰς ἐν ὅπλοις δυνάμεις αὐτοκρατῶς, ὡς ἔφην, ἰθύνουσα. ταύτῃ καὶ πρίγκιπας αὐτοὺς ἐκάλεσαν Ῥωμαῖοι, οἱονεὶ πρώτην κεφαλὴν τῆς πάσης πολιτείας: *De magistratibus* I.4.

[227] Ἐφυλάχθη οὖν παρὰ Ῥωμαίοις ἡ τοιαύτη τῶν Καισάρων εὐταξία ἄχρι Διοκλητιανοῦ, ὃς πρῶτος στέφανον ἐκ λίθου τιμίας συγκείμενον τῇ κεφαλῇ περιθεὶς ἐσθῆτά τε καὶ τοὺς πόδας ψηφώσας ἐπὶ τὸ βασιλικόν, ἢ τἀληθὲς εἰπεῖν ἐπὶ τὸ τυραννικὸν ἔτρεψεν, ἀνεμετρήσατό τε τὴν ἤπειρον καὶ τοῖς φόροις ἐβάρυνεν: *ibid.* I.4. καὶ δῆλον ἄντικρυς, ὅτι Ῥωμαίοις ἔθος dominos τοὺς τυραννήσαντας ἀποκαλεῖν, ὡς δὴ Σύλλαν καὶ Μάριον, καὶ δομινατιῶνα τὴν τυραννίδα: *ibid.* I.6. As far as I can see, the term δομινατιών is in Greek ἅπαξ λεγόμενον. [228] *Ibid.* I.3.

[229] *Ibid.* I.3; cf. Synesius, *On Kingship* VI D, ed. N. Terzaghi (Rome, 1944), 15 lines 7–8. Synesius must have been the source of John Lydus, for no other discourse on kingship contains this remark. The closest is Dio Chrysostom, *Discourse on Kingship* III.43–44.

cusses the titles which he considered proper for the emperors of his time. Synesius had praised the emperors of the fourth century for refraining from using the title βασιλεύς in their own official documents.[230] In opposition to that, John Lydus speaks in favor of the title βασιλεύς instead of the titles δεσπότης[231] and *dominus*,[232] both of which are properly used only for the tyrants. Thus, we can see that John Lydus presents Justinian's regime as a sort of enlightened kingship. This form preserves the merits of the Principate, excluding its deterioration and degeneration, i.e., the dominate, which is rejected as a tyrannicide; on the other hand, it is purified from the faults of *regnum*, and is supposed to respect the law and take care of the people. A perceptive βασιλεύς preserves the tradition and the law and takes care of the state and the citizens, not as a *dominus* but as a father: this is the ideal kingship which is praised and defined by John Lydus under the experience and with the terminology of his time. This constitutional form can best be expressed by the βασιλέως ὄνομα.

We should expect that John Lydus' preference for *basileia* would lead him to propose that this should replace the traditional Roman "emperorship" (τὸ Καίσαρος ἀξίωμα). However, he is aware of a fact that prevents him from doing so. He sees the necessity of continuing to call his ideal constitutional form an emperorship, because with this title the emperors have been able to appoint kings (βασιλέας) to the other (client) nations.[233]

In his *Res gestae* Augustus praised himself, stating *inter alia* that in his triumphs nine kings or royal children preceded him.[234] The way in which he mentions the many kings who in one way or another paid homage to him during his rule[235] expresses in ideological terminology the superiority of the Roman emperor over the kings of the world. Thus, the emperor could not assume the title of a king because he was above all kings, and in many cases he was the actual king-maker, since it was in his power to recognize and invest the client kings.[236] This idea appears again in John Lydus, not with ideological implications but as a real obstacle for the assumption of the title βασιλεύς by the emperor: the emperor cannot call himself officially a βασιλεύς as long as

[230] Ἐπεὶ καὶ τοὔνομα αὐτό σοι δείξω τοῦ βασιλέως ὄψιμον, ἐκλιπὲς Ῥωμαίοις γενόμενον ἀφ' οὗ Ταρκυνίους ὁ δῆμος ἐξήλασεν. ἀπὸ τούτου γὰρ ἡμεῖς μὲν ὑμᾶς ἀξιοῦμεν καὶ καλοῦμεν βασιλέας, καὶ γράφομεν οὕτως· ὑμεῖς δέ, εἴτε εἰδότες εἴτε μή, συνηθείᾳ δὲ συγχωροῦντες, τὸν ὄγκον τῆς προσηγορίας ἀναδυομένοις ἐοίκατε. οὔκουν οὔτε πρὸς πόλιν οὔτε πρὸς ἰδιώτην οὔτε ὕπαρχον γράφοντες οὔτε πρὸς ἄρχοντα βάρβαρον ἐκαλλωπίσασθέ ποτε τῷ βασιλέως ὀνόματι· ἀλλ' αὐτοκράτορες εἶναι ποιεῖσθε: *On Kingship* chap. 17, ed. Terzaghi, 38 line 16–39 line 6. Cf. Ch. Lacombrade's commentary, in *Le Discours sur la Royauté de Synésios de Cyrène à l'empereur Arcadios* (Paris, 1951), 142.

[231] Μισητὸν γὰρ καὶ Ῥωμαϊκῆς ἐλευθερίας ἀλλότριον δεσπότας, ἀλλὰ μὴ βασιλέας, τοὺς κρατοῦντας ὀνομάζειν: *De magistratibus* I.6.

[232] *Ibid.* I.6.

[233] Κρεῖττον δὲ βασιλείας τὸ Καίσαρος ἀξίωμα, ὅτι καὶ δοῦναι βασιλέας πάλαι τοῖς ἔθνεσιν ἐπ' ἐξουσίας εἶχε: *ibid.* I.6.

[234] *Res gestae divi Augusti* 4.3, ed. V. Ehrenberg and A. H. M. Jones, *Documents Illustrating the Reigns of Augustus and Tiberius*, 2nd ed. (Oxford, 1955), 4–5: *In triumphis ducti sunt ante currum meum reges aut regum liberi novem.*

[235] *Ibid.* 27, 31, 32, 33.

[236] Cf., for instance, *ibid.* 27: *Armeniam maiorem interfecto rege eius Artaxe cum possem facere provinciam, malui maiorum nostrorum exemplo regnum id Tigrani regis Artavasdis filio, nepoti autem Tigranis regis, per Ti. Neronem tradere.*

other client rulers are appointed by him as βασιλεῖς. It was therefore only after the abolition of kingship in the client kingdoms neighboring Byzantium in the fourth quarter of the sixth century that the title βασιλεύς could be assumed officially by the emperors.

We have seen that the constitutional development from Augustus to Justinian was the gradual transformation of the Roman Principate to the Hellenistic *basileia*. On the other hand, the Early Byzantine policy of abolishing the kingship in the client states of the East had come to an end by the last years of the sixth century. Nevertheless, when this was accomplished still another factor, Roman relations with the other great power of the East, the Sasanian Great Kings, prevented the assumption of the title βασιλεύς. We do not have to analyze these relations *in extenso*. Nonetheless, it is necessary to remember first, that the King of Kings recognized the emperor's sovereignty over the Empire and its client states on the condition that the emperor recognized his sovereignty over the Persian Empire and its clients; and second, that this recognition of equal sovereignty was expressed through the official titles. The Sasanian monarch was recognized as King of Kings (βασιλεύς βασιλέων), while the emperor was addressed as *quaisar i Rum* (Caesar of the Romans). It is obvious that these titles were exclusive. There was only one Caesar, the Roman, and on the other hand there could be only one King of Kings, the Sasanian. If the Byzantine emperor assumed the title *basileus* he would be indicating his submission to the *basileus basileon*, while the assumption of the whole exclusive title would mean an open claim to the Sasanian throne.[237]

This barrier was removed again at the end of the sixth century. When Emperor Maurice supported Chosroes II in regaining his throne in 591 a new Byzantine-Persian peace treaty was concluded, which restored Byzantine rule in northeastern Mesopotamia to the *status quo ante* A.D. 363. On this occasion Chosroes sent an official letter to his protector Maurice, in which he made for the first time in Roman-Persian relations a significant concession: he dropped from the inscription the exclusive title βασιλεύς βασιλέων, and called himself Περσῶν βασιλεύς while at the same time he conceded the emperor the title βασιλεύς Ῥωμαίων.[238] This is the first known case of the use of this title in an official document of the international, highly sophisticated world of diplomacy in the sixth century. However, it was not only a gesture of diplomatic courtesy on the part of the young Persian prince. It was also a concession which enabled the Byzantine emperor to call himself what he already had been for centuries: βασιλεύς τῶν Ῥωμαίων. On the other hand, the same concession strengthened the Roman-Persian peace on the basis of the balance of the two Great Powers, no doubt at the cost of the smaller and client nations. This is expressed at the beginning of the above-mentioned letter of Chosroes to Maurice: "The divinity has from the beginning ordered from heaven that two eyes should shine over

[237] See *supra*, pp. 35–36.
[238] Theophylactos Simocattes, *Historia* IV.11, ed. de Boor, 169.

the world, the most powerful emperorship [βασιλεία] of the Romans and the most perceptive scepters of the Persian state. Through these two greatest powers the disobedient and warlike nations are winnowed and the management of mankind is regulated and ruled forever."[239]

After the publication of A. Alföldi's classic articles on the imperial representation and ceremonies we have learned to be careful not to attribute to Persian influence the elements which characterize the Late Roman and Byzantine court.[240] However true and helpful Alföldi's conclusions have been to the scholarship of the last forty years, there are several references in the sources which cannot be interpreted merely as anti-Persian topology, since there are some aspects of the constitutional theory and the political life of Early Byzantium which can be explained more easily as influences from the neighboring Great Power of the East than can be traced back to ancient Roman forms. This study of the Empire's attitude toward the client kingdoms should be considered one of these aspects. It has been stated above that the Roman system of appointing and investing kings is derived from the Persian (formerly Parthian) policy toward the client kingdoms within and without that vast state. It is the policy of the *shahanshah*s toward the local *shah*s. This influence is obvious in the Byzantine policy of appointing "satraps" for the Mesopotamian and Armenian districts which in the fourth century were under Roman control; does not the word "satrap" say everything? That the investment of Arab phylarchs with the insignia of the *malik*s of the desert was carried out in exactly the same way as the Persian king carried out the investment of the Lahmid phylarchs is another obvious example which marks the next chronological step in the assimilation process. Finally, the abolition of kingship and the replacement of the local kings by local princes in imperial service copied the Sasanian system of appointing *marzbân*s and other Persian dignitaries to administer the subordinate countries in the name of the King of Kings.[241]

The official protocol of the peace negotiations which took place at the Persian monarch's palace in Ctesiphon in 561 offer a lively picture of how the two Great Powers were speaking the same language not only in their political and military aspirations and their ideological presentation, but also in their attitude toward the powerless countries whose future was entirely decided by them. The negotiations concerning the future of the small kingdom of Suania in the Caucasus illustrates this attitude. The Byzantine ambassador had put forth decisive arguments that the small country should be returned

[239] Δύο τισὶν ὀφθαλμοῖς τὸν κόσμον καταλάμπεσθαι πάντα ἄνωθεν καὶ ἐξ ἀρχῆς τὸ θεῖον ἐπραγματεύσατο, τοῦτ' ἔστι τῇ δυνατωτάτῃ τῶν Ῥωμαίων βασιλείᾳ καὶ τοῖς ἐμφρονεστάτοις σκήπτροις τῆς Περσῶν πολιτείας. ταύταις γὰρ ταῖς μεγίσταις ἀρχαῖς τὰ ἀπειθῆ καὶ φιλοπόλεμα ἔθνη λικμίζονται, καὶ ἡ τῶν ἀνθρώπων διαγωγὴ κατακοσμεῖται καὶ κυβερνᾶται διὰ παντός: *ibid.* IV.11.

[240] A. Alföldi, "Die Ausgestaltung des monarchischen Zeremoniells am römischen Kaiserhofe," *RM*, 49 (1934), 1–118; and *idem*, "Insignien und Tracht des römischen Kaisers," *ibid.*, 50 (1935), 1–171; both repr. in *Die monarchische Repräsentation im römischen Kaiserreiche* (Darmstadt, 1970).

[241] Christensen, *op. cit.* (note 126 *supra*), 97 ff.

to Byzantine control, and he provided a list of Suanian kings who were invested by the emperors in the past. The King of Kings Chosroes, lacking counterarguments, suggested that the people of Suania be asked to choose their master, and he promised to accept their decision if they voted for their submission to Byzantium. The Byzantine ambassador, quite embarrassed by this proposal, wanted to know if the Great King was really thinking of asking the Suanians to decide their future. For he had no doubt that if conditions would allow they would choose self-determination. Thereupon, the Great King appeased the ambassador with a clear answer: Listen, he said, I am definitely not thinking of asking the Suanians anything concerning Suania, for it would not be pious or just to leave the country to the dangerous decision of its slaves![242] The result was that Suania remained with the Persians.

E. Stein and G. Ostrogorsky explained the assumption of the title βασιλεύς in terms of the *Gräzisierung* of the Byzantine state in the seventh century. If we take the *Gräzisierung* as a historical process, including the Hellenistic legacy which survived in Byzantium but was also inherited by the Parthian monarchs, then we must expect the Sasanian empire to be much closer to and have greater impact on the neighboring empire in the West than the language and the religious barrier allows us to acknowledge. In these terms the assumption of the title βασιλεύς expressed the fact that the Roman emperorship had absorbed enough elements of the Hellenistic kingship to be given its name officially. Thus, beyond all other elements of "Hellenization," which became dominant in the seventh century, it was the Hellenistic idea of kingship, which had been experienced in the Sasanian empire, that prevailed in Byzantine *basileia*.[243]

APPENDIX

THE DATE OF INSCRIPTIONS LBW 2770 FROM KYTHREA, CYPRUS, AND GREGOIRE 107 FROM EPHESOS

Inscription no. 2770 of the Collection of Le Bas and Waddington,[244] which was supplied with two other fragments found and published by Mitford,[245] contains the *intitulatio* of an imperial edict beginning with the title βασιλεύς. Unfortunately, the name of the emperor who promulgated the edict is erased in the inscription. Le Bas and Waddington as well as Mitford assigned the edict and the inscription to Justinian I. Quite recently J.-P. Sodini studied the imperial titles included in the existing fragments and proposed that the emperor's name was not Justinian but Tiberius II.[246] He reads the first three lines in all three fragments as:

[242] Menander, frag. 11, *Excerpta de legationibus*, ed. de Boor, 186–88.

[243] G. Rösch has written a dissertation on ONOMA ΒΑΣΙΛΕΙΑΣ. *Studien zum offiziellen Gebrauch der Kaisertitel in spätantiker und frühbyzantinischer Zeit*, to be published as vol. X of Byzantina Vindobonensia. I wish to thank Otto Kresten, who allowed me to see the proofs of this remarkable book, although it was too late to make use of it for the present study.

[244] P. Le Bas and W. Waddington, *Voyage archéologique en Grèce et en Asie Mineure* (Paris, 1847).

[245] T. B. Mitford, "Some New Inscriptions from Early Christian Cyprus, 7. A New Fragment of Justinian's Rescript from Kythrea," *Byzantion*, 20 (1950), 128–32.

[246] J.-P. Sodini, "Une titulature faussement attribuée à Justinien Ier. Remarques sur une inscription trouvée à Kythréa, Chypre," *TM*, 5 (1974), 373–84.

† βασ[ι]λεὺς [Φλάβιος Τιβέριος Κωνσ-]
[ταντῖνος] π[ιστὸς ἐν Χριστῷ ἡμερώ-]
τατος μέ[γιστ]ος εὐ[εργέτης καὶ].²⁴⁷

In my opinion there are some serious objections to this identification. Sodini finds an easy explanation for the erasure of the name of Emperor Tiberius. He suggests that the name was erased by some Cypriot who objected to the emperor's decision to transfer Armenian war prisoners to Cyprus in 578.²⁴⁸ However, this explanation is not very probable. First, Sodini seems to disregard the difference between war prisoners and refugees. For, as opposed to the refugees, the war prisoners in Cyprus would have been welcome as cheap labor.²⁴⁹ On the other hand, the year 578 as the date of the transfer is based on Hill's *History of Cyprus*: "towards the end of the reign of Justin II or more probably soon afterwards, the already very composite population of the island received an admixture of a large number of captives, who had been taken in Arzanene in Great Armenia by Maurice."²⁵⁰ However, there are two errors in Hill's statement. The transferred people were not peasants from Roman Great Armenia but war prisoners captured in Arzanene in Persarmenia. According to Theophylactos Simocattes, our main source for this war, φόνον τε πολὺν τῇ Περσῶν πολιτείᾳ ἐνεπορεύσαντο· ζωγρήσαντές τε τοῦ Περσικοῦ ἐνενήκοντα πρὸς ταῖς δέκα χιλιάσις....²⁵¹ On the other hand, this did not happen during the reign of Tiberius, but in the last year of Justin's reign before Tiberius was proclaimed emperor on October 6, 578. Again, Simocattes says that τούτων τὴν τρίτην ἀπόμοιραν Μαυρικίῳ τῷ Ῥωμαίων στρατηγῷ οἱ τοῦ ὁπλιτικοῦ δωρησάμενοι, οὐκ ἀνήκεστα τοῦ πολέμου τὰ ἐπίχειρα ἐπεποίηντο. ὁ μὲν οὖν στρατηγὸς τῶν ζωγρηθέντων τὴν ἐνδημίαν παρεδήλου τῷ Καίσαρι, ὁ δὲ Καῖσαρ ἀνὰ τὴν Κύπρον τὴν λείαν διέχεεν.²⁵² From this evidence we must conclude that Tiberius was still holding the title of Caesar when this event took place in the summer of 578, some months before he was proclaimed emperor.²⁵³ Thus, even if the Cypriots were not satisfied with the captives, the name they would erase would be Justin's and not Tiberius', since the latter was not yet emperor when this occurred in the summer of 578.

It seems to me that every attempt to date the inscription from Kythrea must start from the fact that the emperor for whom we are looking suffered the *damnatio memoriae*, regardless whether this happened officially as the Senate's decision or occasionally after his deposition and assassination.

The only emperor who is known to have been condemned officially in the period between Justinian and Heraclius is the tyrant Phocas. We know that when Heraclius came to Constantinople as a liberator Phocas was executed, and his statue in the Hippodrome was overturned and publicly burnt as a kind of symbolic *damnatio memoriae*.²⁵⁴

²⁴⁷ *Ibid.*, 384.

²⁴⁸ *Ibid.*, 382.

²⁴⁹ According to Evagrius, *Ecclesiastical History* V.19, ed. Bidez and Parmentier, 215 lines 19–22: τὰ σαγηνευθέντα αἰχμάλωτα ὁλοκλήρους νήσους καὶ πόλεις, ἀγρούς τε ἐρημωθέντας τῷ χρόνῳ ἐξοικῆσαι τήν τε γῆν ἐνεργὸν καταστήσασθαι πάντῃ πρώην ἀγεώργητον οὖσαν.... Cf. P. Charanis, "The Armenians in the Byzantine Empire," *Byzantinoslavica*, 22 (1961), 198.

²⁵⁰ G. F. Hill, *A History of Cyprus*, 2nd ed., I (Cambridge, 1949), 281.

²⁵¹ Theophylactos Simocattes, *Historia* III.15,14–15, ed. de Boor, 143 lines 6–8. On the number 10,090, see Hill, *op. cit.*, 281 note 4.

²⁵² Theophylactos Simocattes, *Historia* III.15,15, ed. de Boor, 143 lines 8–12. According to John of Ephesos, the captives were Persarmenian Christians: *Ecclesiastical History* III.vi,15, trans. E. W. Brooks, CSCO, 106, *Scriptores Syri*, 55 (Louvain, 1936), 236; cf. also *ibid.* III.vi,34, trans. Brooks, 257.

²⁵³ It is in failing to see this clear indication that Hill dated this event after the death of Justin II: *op. cit.*, 281 note 3. His reference to Bury is irrelevant, since Bury does not date Maurice's expedition in Arzanene after Justin's death, although he is inclined to accept the year 578 rather than 577: *Later Roman Empire*, II, 104 note 1. Cf. Goubert, *op. cit.* (note 109 *supra*), 74–78.

²⁵⁴ See A. N. Stratos, *Byzantium in the Seventh Century*, I (Amsterdam, 1968), 90f. If the identification with Phocas is correct, perhaps we can come even closer to the date of the erasure of his name. Studying the coins struck in Cyprus in 609 and 610 with the legend ERACLIO CONSVLI, Philip Grierson has elucidated that Heraclius himself or his general Nicetas came to Cyprus in A.D. 609,

However, I cannot exclude another emperor whose name could also have also been erased on the inscription. This is Phocas' predecessor Maurice, who lost the imperial throne after a successful uprising against him. On Grégoire's inscription no. 111 the name of Maurice is erased,[255] most probably in the course of the persecution suffered by Maurice, his reputation, and his family in the time of Phocas' regime.[256]

Sodini, who knows that the official assumption of the title βασιλεύς in imperial documents is not testified before Heraclius, explains the use of this title in the inscription of Kythrea so many years before A.D. 629 "par un contrôle, moins rigoureux en province, de l'exactitude des titulatures, surtout si l'on prend en considération que l'on désignait couramment l'empereur du titre de βασιλεύς."[257] However, if the isncription contained the text of an imperial edict—and there is no doubt about that—I cannot see how the most "sacred" part of it, the *Intitulatio*, could be dealt with by "un contrôle moins rigoureux."

Sodini refers to another inscription, attributed by Grégoire to Justinian and dated to A.D. 535–36, in order to show that the use of the title βασιλεύς was possible in a provincial inscription before Heraclius.[258] However, it is very doubtful that this inscription belongs to Justinian's time. Grégoire reads this inscription from Ephesos as follows:[259]

['Εν ὀνόματι τοῦ δε]σπ(ότου) ἡμῶν Ἰησοῦ Χριστοῦ βασιλεύ[ς]
['Ιουστινιανὸ]ς Ἀλαμανικούς Γοτθικούς Γερ-
[μανικούς] Εὐανδαλικούς ἔνδοξος
[νικητὴς τρ]οπεοῦχος ἀεισέβαστος Αὔγουστ(ος).
5 ['Επειδὴ ταῖς ἐκκλ]ησίαις τῆς ὀρθοδόξου πίστεως τὴν
[δέουσαν πρ]οσήκει τιμὴν προσάγεσθαι, κα[ὶ]
[τῷ ἁγίῳ καὶ] σεβασμίῳ οἴκῳ τοῦ ἀποστόλου
['Ιωάννου τῷ ἐν 'Εφ]έσῳ διακειμένῳ κατὰ τὴν δύνα-
[μιν ἡμ]ῶν προνοίᾳ τοῦτο μέν τοῦ μακαριωτάτου
10 [πατριάρχου 'Επι]φα[νί]ου τοῦτο δὲ τοῦ περιβλέπτου
[κόμητος τῆς "Εω] . . .

From Grégoire's note on line 10 it is clear that he had doubts about the essential evidence for the date 535–36.[260] For we can restore Justinian's name in line 2 only if we read πατριάρχου 'Επιφανίου in line 10 and identify the Epiphanios of the inscription with the patriarch of Constantinople of the same name.[261] Nevertheless, the alternative reading which Grégoire suggested for the five crucial letters ϽΛΡΟΥ in line 10 seems preferable to me. Therefore, in the first half

after taking Egypt on the liberation army's way from Carthage to Constantinople. The coins show that Heraclius no longer recognized Phocas, although he hesitated to let his army proclaim him emperor: P. Grierson, "The Consular Coinage of 'Heraclius' and the Revolt against Phocas of 608/610," *NC*, ser. 6, vol. 10 (1950), 71–93. Cf. *idem, Catalogue of the Byzantine Coins in the Dumbarton Oaks Collection and in the Whittemore Collection*, II, *Phocas to Theodosius III (602–717)* (Washington, D.C., 1968), 41, 208f. Cf. also W. Hahn, *Moneta Imperii Byzantini von Justinus II. bis Phocas (565–610) einschliesslich der Prägungen der Heraclius-Revolte* (Vienna, 1975), 86f. It seems quite probable that during Heraclius' or his general's stay in Cyprus the official inscriptions of the tyrant were destroyed and his name erased.

[255] Grégoire, *op. cit.* (note 2 *supra*), 39. For a photograph of the fragment with the erased name, see R. Heberdey, "Vorläufiger Bericht über die Grabungen in Ephesus 1905/06, VIII," *ÖJh* (1907), suppl., col. 67. For the date of the inscription, see Ch. Diehl, "Note sur deux inscriptions byzantines d'Ephèse," *CRAI* (1908), 207ff.

[256] Stratos, *op. cit.*, 52f.

[257] "Une titulature" (note 246 *supra*), 377.

[258] *Ibid.*, 377.

[259] *Op. cit.*, no. 107, p. 35.

[260] "L. 10. Restitution douteuse; les traces de lettres ϽΛΡΟΥ doivent sans doute s'interpréter ΦΑΝΙΟΥ à moins qu'il ne faille lire [προέδ]ρου": *ibid.*, 35.

[261] *Ibid.*, 35.

of line 10 I would suggest the reading: [τῆς Ἐφεσίων προ]έδρου.²⁶² This suggestion takes into consideration the fact that after the ecclesiastical dignity mentioned in line 10 there does not follow the *praefectus praetorio Orientis*, who would be a ἐνδοξότατος (*gloriosissimus*), but only a lower dignity, perhaps the *comes Orientis* with the title περίβλεπτος (*spectabilis*).²⁶³ Furthermore, in the inscription from Ephesos the imperial title *Caesar* is omitted, which leads necessarily to a time when the title βασιλεύς had replaced all other imperial titles, including the title *Caesar*.

²⁶² The title μακαριώτατος, attributed in line 9 to the ecclesiastical of line 10, is found in numerous imperial documents to be attributed to Metropolitans. For the evidence, see E. Chrysos, *Die Bischofs-listen des V. Ökumenischen Konzils (553)* (Bonn, 1966), 66 note 79.

²⁶³ On these titles, see P. Koch, *Die byzantinischen Beamtentitel von 400 bis 700* (Jena, 1903). Cf. also E. Hanton, "Lexique explicatif du Recueil des inscriptions grecques-chrétiennes d'Asie Mineure," *Byzantion*, 4 (1927), 116f., *s.v.* περίβλεπτος.

A *PHILORHOMAIOS ANTHROPOS*: METROPOLITAN CYPRIAN OF KIEV AND ALL RUSSIA (1375–1406)

DIMITRI OBOLENSKY

The following paper is substantially the same as that de-
livered at a public lecture at Dumbarton Oaks on 3 May 1977.

IT has become a commonplace of Late Byzantine studies to comment on the striking contrast during the last century of the Empire's existence between its growing impotence as a political body and the astonishing vitality of its culture, exemplified in the achievements of Byzantium in art, scholarship, and theology. The "last Byzantine Renaissance" was indeed, in the words of a contemporary scholar, a time when "the State was collapsing but learning never shone more brightly."[1] This light was visible far beyond the political boundaries of the now greatly shrunken Empire. Indeed, except for Constantinople, Mt. Athos, Mistra, and, during the periods when the Empire held it, Thessalonica, the fairest flowers of this late Palaeologan blossoming were to be found in the non-Greek-speaking lands of Orthodox Eastern Europe—in Serbia, Bulgaria, Rumania, and Russia. Except for the two centuries between 850 and 1050, the spread of Byzantine culture throughout Eastern Europe was never so marked, nor so successful, as during the last hundred years of the Empire's history.

This cultural expansion was, of course, part of a wider network of multiple relations—political, diplomatic, economic, and ecclesiastical—established for centuries past between Byzantium and the peoples of Eastern Europe. These relations owed their origin to two convergent impulses: the needs, usually defensive, of the Empire's foreign policy; and the desire of those East European peoples who were drawn into the Empire's orbit to "reach out" for the fruits of its civilization, and to tap the sources of its technological expertise.

This paper is concerned with the life of a man who played a crucial role in this encounter, a role which, I believe, has not yet been sufficiently appreciated. During the last quarter of the fourteenth century and the opening years of the fifteenth, when the Byzantine Empire was on the verge of collapse, when only its ecclesiastical arm—the ecumenical patriarchate—remained to champion its interests abroad, and when it seemed that it might lose the allegiance even of its East European satellites, he strove to withstand the local forces of separatism and nationalism, to gain friends for the Empire in its hour of need, and to unite the Slav Orthodox peoples through a newly found loyalty to their mother church of Constantinople. Successively a Bulgarian monk trained on Mt. Athos, a confidential agent of the Byzantine patriarch, the latter's representative as metropolitan in Kiev, a victim of the political rivalry between Muscovy and Lithuania, and, in the end, the unchallenged incumbent of the see of Moscow which had eluded him for so long, Kyprianos, or Kiprian, or Cyprian, epitomizes in his far-flung journeys, in the breadth of his mental horizon, and in his multiple loyalties the rich cosmopolitan culture which flourished in Eastern Europe during the late Middle Ages. It is strange that no comprehensive monograph has yet been published on the career of

[1] S. Runciman, *The Last Byzantine Renaissance* (Cambridge, 1970), vii.

this remarkable man.[2] The present paper cannot, of course, fill this gap; it is no more than a very preliminary sketch.

THE FORMATIVE YEARS
(ca. 1330–ca. 1370)

The first forty years or so of Cyprian's life are poorly documented. In text books, unfortunately, the early phase of his biography is often recounted with quite spurious precision. In fact, very little is known for certain. We can probably accept the general view that he was born about 1330.[3] He was certainly a Bulgarian, for his distinguished contemporary Gregory Tsamblak, a reliable source, says so explicitly.[4] It was once commonly believed that Cyprian was Gregory's uncle, on the sole evidence of a passing remark in Gregory's Church Slavonic encomium on Cyprian that "he [i.e., Cyprian] was the brother of our father."[5] The Tsamblaks were a distinguished family with branches in Bulgaria and Byzantium,[6] and historians have supposed that the young Cyprian's career was advanced by his highly placed family connections. These agreeable possibilities, however, have little basis in fact. In 1968, in a paper presented to the International Congress of Slavists in Prague, the German scholar Johannes Holthusen argued cogently that the words "the brother of our father" should be understood in a spiritual, not a physical, sense: the "brotherly" relationship was that between two episcopal colleagues, Cyprian, head of the Church of Russia, and his contemporary, the Patriarch Euthymius, primate of Bulgaria. To a Bulgarian churchman such as Gregory, Euthymius would indeed have been "our father."[7] There can be

[2] See, however, the brief but perceptive study by A.-A. Tachiaos, Ὁ μητροπολίτης Ῥωσίας Κυπριανὸς Τσάμπλακ, in Ἀριστοτέλειον Πανεπιστήμιον Θεσσαλονίκης, Ἐπιστημονικὴ Ἐπετηρὶς τῆς Θεολογικῆς Σχολῆς, VI (Thessaloniki, 1961) (hereafter Tachiaos, Ὁ μητροπολίτης Κυπριανός). Except for the first paragraph, it is reprinted in idem, Ἐπιδράσεις τοῦ ἡσυχασμοῦ εἰς τὴν ἐκκλησιαστικὴν πολιτικὴν ἐν Ῥωσίᾳ (Thessaloniki, 1962) (hereafter Tachiaos, Ἐπιδράσεις).

[3] E. Golubinskij, Istorija russkoj cerkvi, II,1 (Moscow, 1900), 298–99 note 2; P. A. Syrku, K istorii ispravlenija knig v Bolgarii v XIV věkě, I (St. Petersburg, 1899; repr. London, 1972), 254; Tachiaos, Ὁ μητροπολίτης Κυπριανός, 172; idem, Ἐπιδράσεις, 70.

[4] Pohvalno slovo za Kiprijan, in B. St. Angelov, Iz starata bǔlgarska, ruska i srǔbska literatura (Sofia, 1958), 181: егѡ же убо наше ᲅчᲅво изнесе. Cyprian is described as a Serb in two Russian sixteenth-century chronicles: Patriaršaja ili Nikonovskaja Lětopis', s.a. 1407, in PSRL, XI (St. Petersburg, 1897), 194; and Kniga Stepennaja Carskogo Rodoslovija, in PSRL, XXI,2 (1913), 440. Attempts have been made to explain the reasons for this mistaken attribution; see Afonskij Paterik (Moscow, 1889), II, 188; Tachiaos, Ἐπιδράσεις, 62 note 1; idem, Ὁ μητροπολίτης Κυπριανός, 164 note 1; and, for the most extensive discussion of this problem, J. Ivanov, "Bǔlgarskoto knižovno vlijanie v Rusija pri Mitropolit Kiprian (1375–1406)," Izvestija na Instituta za bǔlgarska literatura, 6 (1958) (hereafter Ivanov, "Bǔlgarskoto knižovno vlijanie"), 29–37.

[5] Ibid., 185: братъ бѣаше нашему оᲊцю.

[6] G. I. Theocharides, Οἱ Τζαμπλάκωνες, in Μακεδονικά, 5 (1961–63), 125–83.

[7] J. Holthusen, "Neues zur Erklärung des Nadgrobnoe Slovo von Grigorij Camblak auf den Moskauer Metropoliten Kiprian," Slavistische Studien zum VI. Internationalen Slavistenkongress in Prag 1968, ed. E. Koschmieder and M. Braun (Munich, 1968), 372–82. Holthusen's arguments may find further support in the fact that on two occasions Cyprian, then metropolitan of Kiev and Lithuania, referred to the recently deceased Alexius, primate of Muscovy, as "my brother"; see Cyprian's letter to St. Sergius of Radonež and Theodore, abbot of the Simonov monastery: Russkaja Istoričeskaja Biblioteka, VI (St. Petersburg, 1880), cols. 173–86. Ivanov ("Bǔlgarskoto knižovno vlijanie," 36) doubted whether Cyprian belonged to the Tsamblak family, but his view that the fathers of Cyprian and Gregory were half-brothers is not supported by the sources.

little doubt that Holthusen is right and that Cyprian must therefore be stripped of the surname Tsamblak, so confidently given him by most historians (myself included). We must be prepared to admit that we know nothing about his family background. We do not even know his baptismal name, for Cyprian was his name in religion.

The same uncertainty surrounds the time and place of his monastic profession. We know from a Byzantine document that in 1373 Cyprian was a monk who enjoyed the close confidence of the Patriarch Philotheos of Constantinople, and was the patriarch's οἰκεῖος καλόγηρος.[8] Presumably, to have gained such a position of trust, he must have been in Philotheos' immediate entourage for at least a few years, which pushes the date of his arrival in Constantinople, and probably of his monastic profession as well, at least as far back as *ca.* 1370.[9] We may, though with less certainty, go back even further. We possess a letter, written by the Patriarch Euthymius of Bulgaria and addressed, in the words of its superscription, "to the monk Cyprian, who lives on the Holy Mountain of Athos."[10] It contains Euthymius' replies to various questions of a disciplinary and liturgical nature which this monk had addressed to him. The identification made by the letter's editor and by modern scholars of the addressee as our Cyprian seems to me to raise chronological difficulties. Euthymius was patriarch of Bulgaria from 1375 to 1393. During those years Cyprian was commuting between Constantinople, Lithuania, and Muscovy, and could not conceivably have "lived on the Holy Mountain of Athos." So we must conclude that if Euthymius wrote the letter during his patriarchate (as the superscription in the manuscript says that he did) it must have been addressed to another Cyprian. It is possible, however, that the words "Patriarch of Trnovo" were appended to Euthymius' name by the fifteenth-century scribe,[11] and that Euthymius, in fact, wrote the letter before he became patriarch. If so, we must look for a time when he could have written the letter and when Cyprian could have been on Mt. Athos. Between about 1365 and 1371 Euthymius was himself on Mt. Athos,[12] and would obviously have had no need to write this letter; and by 1371 Cyprian was presumably already in Constantinople. If we assume that the letter was indeed addressed to our Cyprian, we may conclude that it was probably written before 1363 (the date of Euthymius' departure from Bulgaria to Constantinople), at a time when its writer was a monk in the famous monastery of Kilifarevo in northern Bul-

[8] *Acta et diplomata Graeca medii aevi sacra et profana. Acta Patriarchatus Constantinopolitani,* ed. F. Miklosich and J. Müller, II (Vienna, 1862) (hereafter *APC*), 118.

[9] A number of scholars believe that Cyprian had spent some time in Constantinople before going to Mt. Athos, and that he worked for Philotheos during his second stay in the city. See Syrku, *op. cit.,* 254; E. Turdeanu, *La Littérature bulgare du XIVᵉ siècle et sa diffusion dans les pays roumains* (Paris, 1947) (hereafter Turdeanu, *La Littérature bulgare*), 115; Tachiaos, Ἐπιδράσεις, 71; L. A. Dmitriev, "Rol' i značenie mitropolita Kipriana v istorii drevnerusskoj literatury (k russko-bolgarskim literaturnym svjazjam XIV–XV vv.)," *TrDrLit,* 19 (1963) (hereafter Dmitriev, "Rol' i značenie"), 216; I. Dujčev, "Centry vizantijsko-slavjanskogo obščenija i sotrudničestva," *ibid.,* 113. There is no evidence to support such an early visit by Cyprian to Constantinople.

[10] *Werke des Patriarchen von Bulgarien Euthymius (1375–1393),* ed. E. Kałužniacki (Vienna, 1901; repr. London, 1971), 225–39.

[11] Vladislav the Grammarian: see *ibid.,* ciii; Turdeanu, *La Littérature bulgare,* 115–19.

[12] See Turdeanu, *ibid.,* 68; *Istorija na bŭlgarskata literatura,* I, ed. P. Dinekov et al. (Sofia, 1962), 286.

garia.[13] This seems a perfectly acceptable solution: the letter's tone and contents show that there was a strong spiritual bond between writer and recipient; Cyprian and Euthymius were compatriots; and we know from Gregory Tsamblak's encomium that the relationship between them was indeed a close one.[14] We have the best possible reason for knowing that Cyprian did go to Athos: in a letter he wrote much later to the Russian monk Afanasij Vysockij, Cyprian mentions "the Holy Mountain, which I have seen myself."[15]

We may thus conclude with a fair degree of certainty that by the time Cyprian entered the inner ranks of the patriarch's civil service he had been a monk for some years, and that he received his monastic training on Mt. Athos.[16] Both conclusions will help us understand his subsequent outlook and career. In the fourteenth century Mt. Athos underwent a great spiritual and cultural renaissance. The revival of contemplative prayer, the cultivation of Christian learning, and the newly acquired prestige of the theology of Gregory Palamas attracted men in search of the spiritual life from all parts of the Orthodox world. Many were Slavs; and through them the theory and practice of Byzantine hesychasm spread between 1350 and 1450 to the farthest confines of Eastern Europe.[17] Another feature of this Athonite world of the late Middle Ages was its cosmopolitanism: in the cenobitic houses of Athos Slavs and Rumanians lived and worked alongside their Greek companions, studying, copying, and translating Greek spiritual (and sometimes secular) writings and relaying the new Slav versions back to their native countries. It proved of great importance to Cyprian's future development that these two features of fourteenth-century Athos, allegiance to the hesychast tradition of contemplative prayer and a broad cosmopolitan outlook, were imprinted upon him so early in life. Both were soon reinforced by his move to Constantinople and by his association with the Patriarch Philotheos.

THE YEARS OF STRUGGLE
(ca. 1370–90)

If Cyprian's biographer suffers from a dearth of information regarding the first period of his life (i.e., until 1370), he may justly complain of a superabundance regarding the second (the next twenty years). It is hard not to

[13] Different dates for Euthymius' letter have been proposed: between 1360 and 1369: Archimandrite Leonid, "Kiprijan do vosšestvija na moskovskuju mitropoliju," *Čtenija v Imperatorskom Obščestvě Istorii i Drevnostej Rossijskih pri Moskovskom Universitetě*, 1867, pt. 2, p. 19; between 1372 and 1375: Syrku, *op. cit.*, 575 note 2; between 1371 and 1373: Turdeanu, *La Littérature bulgare*, 115. The last two of these datings are obviously too late. Tachiaos, 'Επιδράσεις, 75 note 50, is unwilling to commit himself.
[14] Gregory uses the possessive pronoun to describe the relationship between Cyprian and Euthymius: своего же и великаг(о) Еνθиміа; cf. *Pohvalno slovo za Kiprijan*, ed. Angelov (note 4 *supra*), 184.
[15] *Russkaja Istoričeskaja Biblioteka*, VI, col. 263.
[16] It is widely believed that Cyprian had earlier been a monk in the Bulgarian hesychast monastery of Kilifarevo; cf. V. Sl. Kiselkov, *Sv. Teodosij Tŭrnovski* (Sofia, 1926), 34; Turdeanu, *La Littérature bulgare*, 115; Tachiaos, 'Επιδράσεις, 68; and *idem*, Ὁ μητροπολίτης Κυπριανός, 170. Others believe this view is probable; cf. Syrku, *op. cit.*, 253; Dmitriev, "Rol' i značenie," 216. In the absence of any evidence, this cannot be regarded as more than a possibility.
[17] See Dujčev, *op. cit.*, 121–26; *idem*, "Le Mont Athos et les Slaves au Moyen Âge," in *idem*, *Medioevo Bizantino-Slavo*, I (Rome, 1965), 487–510.

feel overwhelmed by the plethora of contemporary evidence, often highly tendentious, derived from the acts of Church councils, chronicles, pamphlets, biographies, and letters. Sometimes the sources give diametrically opposite versions of the same event, and modern historians, taking up these medieval cudgels, have tended to divide into rival parties, often defined on national lines, in accordance with their own ethnic prejudices. No wonder that, faced with this welter of passion and bias, the prospective biographer of Cyprian must at times have felt discouraged.

It would need more than one lecture to explore this forest of conflicting testimony. My aim in this paper is simply to look at some of the evidence with a critical eye and, as far as possible, to consider Cyprian's career against the background of the ecclesiastical, political, and cultural history of his time.

In the early 1370's, it will be recalled, Cyprian was residing in Constantinople as an οἰκεῖος καλόγηρος of the Patriarch Philotheos. The epithet οἰκεῖος, applied to him in an official Byzantine document, seems significant. In Late Byzantine society it had become something of a technical term. The οἰκεῖοι were trusted and influential officials who served the emperor or sometimes other highly placed persons, and who were bound to their employers by a particularly close professional relationship.[18] There can be no doubt that in his capacity of patriarchal οἰκεῖος Cyprian would have been entrusted with confidential and important missions. Though, for lack of evidence, we must resist the temptation, to which several historians have succumbed,[19] to suppose that he took part in the negotiations which led in 1375 to the restoration of full communion between the Byzantine patriarchate and the Churches of Serbia and Bulgaria, we can certainly accept that by 1375, when he was appointed envoy to Kiev, Cyprian enjoyed the reputation of an able and experienced diplomat. Both his hesychast training on Mt. Athos and the experience he had gained as Philotheos' *homme de confiance* were a good preparation for this mission. In the fourteenth century, as the imperial government proved increasingly impotent in its foreign policy, the Byzantine patriarchate assumed the role of chief spokesman and agent of the imperial traditions of East Rome. The hesychast patriarchs of the second half of the fourteenth century were particularly determined and successful champions of these traditions; and among them Philotheos was preeminent.[20]

[18] On the οἰκεῖοι, see J. Verpeaux, "Les 'Oikeioi.' Notes d'histoire institutionnelle et sociale," *REB*, 23 (1965), 89–99; G. Weiss, *Joannes Kantakuzenos—Aristokrat, Staatsmann, Kaiser und Mönch—in der Gesellschaftsentwicklung von Byzanz im 14. Jahrhundert* (Wiesbaden, 1969), 143–45 and *passim*; Lj. Maksimović, *Vizantijska provincijska uprava u doba Paleologa* (Belgrade, 1972), 14–15, 18–19, 33, 35, 117.

[19] See, in particular, P. Sokolov, *Russkij arhierej iz Vizantii* (Kiev, 1913), 434–35, who advances the fanciful suggestion that in 1366 Cyprian was the abbot of the monastery of Brontocheion at Mistra; and Tachiaos, Ἐπιδράσεις, 100 note 66. It is by no means impossible that Cyprian took part in the negotiations which led to the healing of the schism between the Serbian Church and the Byzantine Patriarchate: during part of the time when these negotiations were proceeding he was an *oikeios* of the Patriarch Philotheos; and a key figure in these negotiations, Metropolitan Theophanes of Nicaea, seems to have been a close friend of Cyprian. See Tachiaos, *ibid.*, 100, 115; and *infra*, p. 90. But here again direct evidence simply does not exist.

[20] See O. Halecki, *Un empereur de Byzance à Rome. Vingt ans de travail pour l'union des Eglises et pour la défense de l'Empire d'Orient 1355–1375*, Rozprawy Historyczne Towarzystwa Naukowego Warszawskiego, VIII (Warsaw, 1930), 235–42; J. Meyendorff, "Alexis and Roman: A Study in Byzantino-Russian Relations (1352–1354)," *Byzantinoslavica*, 28 (1967), 278–88.

In this period the patriarchate's ecumenical claims were often defined in documents issued by its chancellery as κηδεμονία πάντων (literally "solicitude for all" or "guardianship of all"). Save for a larger dose of rhetoric and the patriarchate's manifest inability to enforce this doctrine for more than brief spells, there was little to distinguish it, *mutatis mutandis*, from the more forceful declarations of papal supremacy which emanated from the Roman Curia. Here is a sample, among many: "God," wrote the Patriarch Philotheos to the princes of Russia in 1370, "has appointed our Mediocrity (τὴν ἡμῶν μετριότητα) as the leader (προστάτην) of the Christians in the whole world and the guardian (κηδεμόνα) and curator (φροντιστήν) of their souls; all are dependent on me, as the father and teacher of all. Since, however, it is not possible for me to go myself the round of the cities and countries of the earth and to teach the word of God therein...our Mediocrity chooses the best men most distinguished in virtue, and appoints and consecrates them pastors and teachers and bishops, and sends them to the different parts of the world."[21]

Naturally enough it was to the Slav churches of Eastern Europe that the efforts of the patriarchate to maintain and strengthen its authority were primarily directed in the fourteenth century. For centuries these churches had maintained a wavering yet real loyalty to their mother Church; and it was hoped in Constantinople that the rulers of these lands could be persuaded to provide money or troops to the embattled Empire. The patriarchate's chosen instruments in this imperial and pan-Orthodox policy were mostly monks, not a few of them Slavs, who by conviction and training could be counted upon to propagate throughout Eastern Europe the belief that Orthodox Christendom was a single body whose spiritual head was the ecumenical patriarch. One of their tasks was to resist the growth of local forms of ecclesiastical nationalism. It is not surprising to find that the leaders of the pro-Byzantine "pan-Orthodox" parties in the different Slav countries in the second half of the fourteenth century all belonged to the hesychast movement. Of this movement I will attempt no comprehensive definition beyond suggesting that it drew its spiritual force from the Athonite tradition of contemplative prayer, was sustained on the administrative level by the "ecumenical" policy of the Byzantine patriarchate, had a wide impact upon the cultural life of Eastern Europe in the late Middle Ages, and was fostered by an international brotherhood of men with close personal links with each other and a strong loyalty to Byzantium.[22] It was the hesychasts who healed the schism which in the third quarter of the fourteenth century had separated the churches of Bulgaria and Serbia from the Byzantine patriarchate. Their most promising opportunities, however, seemed at that time to lie further north, in Russia. Of all the ecclesiastical satellites of Byzantium, the Russians had been consistently the most loyal since the early Middle Ages. And now that the Empire was

[21] *APC*, I (1860), 521; cf. Meyendorff, *op. cit.*, 280; *idem*, "O vizantijskom isihazme i ego roli v kul'turnom i istoričeskom razvitii Vostočnoj Evropy v XIV v.," *TrDrLit*, 29 (1974), 302–3.

[22] See A.-A. Tachiaos, "Le Mouvement hésychaste pendant les dernières décennies du XIVe siècle," Κληρονομία, 6,1 (1974), 113–30; D. Obolensky, "Late Byzantine Culture and the Slavs. A Study in Acculturation," *Acts of the Fifteenth International Congress of Byzantine Studies* (forthcoming).

facing financial ruin and, with the Ottoman invasions, beginning to fight for its very life, aid, whether in money or in kind, from the populous and rich Russian lands was becoming almost a necessity. However, the political situation in that sector presented the patriarchate and the imperial government with an awkward dilemma.

In the second half of the fourteenth century, in the area between the Carpathians and the upper Volga, two states had emerged competing for the allegiance of the Eastern Slavs: the grand duchy of Lithuania and the principality of Moscow. The former had gradually absorbed the greater part of western Russia: by 1375 the grand dukes of Lithuania had replaced the Tatars as overlords of the middle Dnieper valley and had advanced their eastern frontier to within a hundred miles of Moscow. Muscovy, still the lesser of the two states, was emerging as the leader of the principalities of central Russia and was claiming to embody the political and cultural traditions of early medieval Kievan Rus'. The most potent symbol of this continuity was the metropolitan-primate of Russia. Though his residence had been moved from Kiev to Vladimir in 1300 and thence to Moscow in 1328, he still retained his traditional title of "metropolitan of Kiev and All Russia." In practice, most of the fourteenth-century metropolitans, whether they were native Russians or Byzantine citizens, tended to identify themselves with the policies and aspirations of the princes of Moscow. This was scarcely to the liking of the grand dukes of Lithuania, Moscow's rivals for political hegemony in Eastern Europe, who naturally sought to deprive their opponents of the considerable advantages derived from the presence within their city of the chief bishop of the Russian Church. Their best hope lay in persuading the Byzantine authorities either to transfer the seat of the metropolitan to Lithuania, or at least to set up a separate metropolitanate in their country.

The dilemma which faced the Byzantines was the following: could the authority of the patriarchate best be maintained by the traditional policy of keeping the Russian Church under the jurisdiction of a single prelate appointed from Constantinople? And if so, should he reside in the historic see of Kiev, which from the early 1360's was in Lithuanian territory, or in Moscow? Or alternatively, on a realistic assessment of the power structure in eastern Europe, should there now be two separate metropolitanates, one in Moscow and the other in Kiev?[23]

Most of the hesychast patriarchs of Constantinople in the second half of the fourteenth century favored a unified pro-Muscovite solution, none more so than Philotheos, who in June 1370 wrote a spate of letters to Moscow fulsomely praising its primate, Metropolitan Alexius of Kiev and All Russia. He went as far as to solemnly excommunicate several princes of Russia who, breaking their agreements with the prince of Moscow, allied themselves against him with Olgerd, the pagan grand duke of Lithuania,[24] and in so doing

[23] See Meyendorff, "Alexis and Roman," 281. D. Obolensky, *The Byzantine Commonwealth* (London, 1971), 262–63.
[24] *APC*, I, 516–25.

acted against "the holy commonwealth of Christians" (τῆς ἱερᾶς πολιτείας τῶν χριστιανῶν).[25]

By 1371, however, Philotheos began to have second thoughts about the wisdom of supporting Alexius. Serious complaints about the metropolitan's behavior had begun to reach the patriarchate. Michael of Tver', a Russian prince at loggerheads with Muscovy, had been treacherously arrested in Moscow, undoubtedly with the metropolitan's connivance, after having been promised safe conduct; he now wished to cite Alexius before the patriarch's tribunal in Constantinople.[26] More ominous still was a letter received by Philotheos from the grand duke of Lithuania, in which he bitterly accused Alexius of showing no interest in his western Russian dioceses and of inciting the Muscovites to attack his subjects. In peremptory tones Olgerd demanded a separate metropolitan for the Orthodox of the Grand Duchy.[27]

Philotheos was caught on the horns of a dilemma: to accede to Olgerd's request was to divide the Russian Church in two and to risk the displeasure of the prince of Moscow. To ignore the request might result in the Patriarchate losing control over the Church of Lithuania. So he decided to play for time. He wrote to Alexius, rebuking him for never visiting his Lithuanian dioceses and reminding him that "when we consecrated you, we consecrated you metropolitan of Kiev and All Russia, not of one part, but of all Russia."[28] However, since his repeated injunctions were having no effect, Philotheos decided in 1373 to send to Russia a confidential envoy charged with restoring peace between Muscovy and Lithuania and with persuading Alexius to visit the western Russian part of his metropolitanate. This envoy was Cyprian.[29]

Probably during the winter of 1373–74 Cyprian arrived in Kiev and established contact with the Lithuanian authorities. These then sent an embassy to Constantinople, reiterating their former request for a separate metropolitan, independent of Moscow. Philotheos could no longer sit on the fence; he hit on an ingenious solution which, though of dubious canonical propriety, at least satisfied Olgerd's immediate demands without sacrificing the principle of the unity of the Russian metropolitanate. He appointed Cyprian metropolitan of Kiev and Lithuania, with the proviso that after Alexius' death he would reunite under his authority the whole Russian Church.[30] Cyprian's consecration took place in Constantinople on 2 December 1375.[31]

[25] *Ibid.*, 524.

[26] *Ibid.*, 582–86. As A. S. Pavlov rightly noted, the letter addressed to the Metropolitan Alexius (*ibid.*, 320–21) was wrongly ascribed to the Patriarch Kallistos I (1350–53, 1355–63) by the editors of the *Acta Patriarchatus*. In reality it was written by Philotheos and belongs to the collection of letters which he sent to Russia in 1371: *Russkaja Istoričeskaja Biblioteka*, VI, Appendix, cols. 155–56. For two other letters wrongly ascribed to the Patriarch Kallistos, see J. Darrouzès, *Le Registre synodal du Patriarcat byzantin au XIVe siècle* (Paris, 1971), 105.

[27] *APC*, I, 580–81. [28] *Ibid.*, 321. [29] *APC*, II, 118.

[30] *Ibid.*, 14, 120. The sources disagree over the title granted to Cyprian in 1375. According to the Acts of the Patriarchal Synod of 1380 it was μητροπολίτης Κυέβου καὶ Λιτβῶν (*APC*, II, 14). The Acts of the Synod of 1389, on the other hand, give it as μητροπολίτης Κυέβου, ʽΡωσίας καὶ Λιτβῶν (*APC*, II, 120). F. Tinnefeld ("Byzantinisch-russische Kirchenpolitik im 14. Jahrhundert," *BZ*, 67 [1974], 375) believes the evidence of the Synod of 1380; I put more trust in that of the Synod of 1389.

[31] There can be little doubt that Cyprian's appointment as prospective successor of Alexius was uncanonical. The Acts of the Patriarchal Synod of 1380, so frequently at variance with the truth,

This much regarding Cyprian's first mission to Russia is uncontroversial. The rest, and notably his own role in these events, provides the student of medieval documents with an interesting exercise in textual criticism. Our knowledge of these events is derived mainly from two Byzantine sources, the Acts of the Patriarchal Synods held in Constantinople in 1380 and 1389. They are in total disagreement on every point of substance. The Synod of 1380, presided over by the Patriarch Neilos, painted Cyprian as a villainous intriguer who wormed his way into Olgerd's confidence, grossly deceived Alexius, and himself wrote and delivered to Constantinople the letter in which the Lithuanian authorities requested his appointment as their primate.[32] In the Acts of the Synod of 1389, convened by the Patriarch Antony, the blame is laid squarely on the shoulders of Alexius, who as acting regent of the Muscovite realm forsook the government of the Church for politics, provoked Olgerd by his aggressive behavior, and wholly neglected his Lithuanian dioceses. Cyprian, on the other hand, is said to have done his best to reconcile Olgerd and Alexius, and is described as "a man distinguished in virtue and piety."[33]

It stands to reason that at least one of these Synodal Acts is blatantly lying. Most Russian Church historians, apparently unwilling to admit any blemish in the character of Metropolitan Alexius, a national hero and a popular saint, prefer to believe the Synod of 1380. Hence, even if they occasionally tone down the harshness of the Synod's strictures on Cyprian (who, incidentally, was also canonized by the Russian Church), their description of his behavior is less than edifying.[34] Time unfortunately does not allow a proper *Quellenkritik*. I will say, however, that a careful study of these two documents has convinced me that the Synodal Act of 1380 contains far too many evasive statements, inconsistencies, and factual distortions to merit

rightly point this out: τὴν αὐτοῦ [Κυπριανοῦ] δὲ χειροτονίαν, ὡς ζῶντος ἔτι τοῦ μητροπολίτου Ἀλεξίου γεγενημένην, ἀκανόνιστον ἡγουμένη (*ibid.*, 15). Even the signatories of the Synodal Act of 1389, who were entirely favorable to Cyprian, sounded uncomfortable when referring to his appointment in 1375 as Alexius' successor: they appointed him, they state, as metropolitan of All Russia "as though beginning afresh" (ὡς ἐξ ἄλλης ἀρχῆς: *ibid.*, 128). This prospective appointment was certainly a far-reaching example of the exercise of ecclesiastical *oikonomia*. However, it was not wholly unprecedented: Philotheos' predecessor, the Patriarch Kallistos, soon after Alexius' appointment as metropolitan of Kiev and All Russia, seems to have consecrated in 1354 a Lithuanian candidate in terms sufficiently vague to enable him to claim jurisdiction over at least some of Alexius' dioceses: see Meyendorff, "Alexis and Roman," 284–87. Only a small fragment of the Synodal Act of 1375 by which Cyprian was appointed has survived, cited in the Act of 1389: *APC*, II, 120. For modern views on the uncanonical nature of Cyprian's appointment in 1375, see N. Glubokovskij, "Kiprian," in *Pravoslavnaja bogoslovskaja enciklopedija*, X (St. Petersburg, 1909), col. 42; C. Mango, "A Russian Graffito in St. Sophia, Constantinople," *Slavic Word*, 10,4 (1954), 437.

[32] *APC*, II, 12–18.

[33] *Ibid.*, 116–29.

[34] Cf. Metropolitan Makarij, *Istorija russkoj cerkvi*, IV,1 (St. Petersburg, 1886), 59–63; Glubokovskij, in *Pravoslavnaja bogoslovskaja enciklopedija*, X, col. 42; Golubinskij, *Istorija russkoj cerkvi*, II,1, 211–15; and A. V. Kartašev, *Očerki po istorii russkoj cerkvi* (Paris, 1959), I, 321–23. A more fair and convincing picture of Cyprian's actions in 1375–78 is given by I. N. Šabatin, "Iz istorii Russkoj Cerkvi," *Vestnik russkogo zapadno-evropejskogo Patriaršego Ekzarhata*, 13, no. 49 (1965), 42–44. Another, earlier exception to this chauvinistic bias against Cyprian is the judgment of Archimandrite Leonid, *op. cit.* (note 13 *supra*), 28 note 28.

serious credence.[35] There is reason to believe that in several respects the Synod echoed the view of official Muscovite circles, which the government of John V and Manuel II, having regained power in Constantinople the previous year, was concerned to placate.[36] By contrast the Synodal Act of 1389, though not wholly free of disingenuousness and special pleading,[37] gives an account that is coherent and convincing, and which in several particulars agrees with the evidence of other sources. I believe there are no valid grounds for imputing any dishonorable action to Cyprian during the events of 1373–75.

The first three years of his tenure of the See of Kiev seem to have been uneventful.[38] In a letter he later wrote to St. Sergius of Radonež he listed some of his achievements, which were no more than one would except of a competent and conscientious administrator.[39] However, Cyprian's life soon entered a new phase filled with variety and drama, beginning with the death of the Metropolitan Alexius on 12 February 1378 and lasting for twelve years.

You will recall that in 1375, when Cyprian was appointed metropolitan of Kiev and Lithuania, it was stipulated that, on Alexius' death, he would reunite under his authority the Lithuanian and the Muscovite parts of the metropolitanate and become primate of All Russia. Trusting in this promise, Cyprian set out for Moscow as soon as the news of Alexius' death reached him.

[35] Here are a few samples: (1) The Act of 1380 alleges that on one occasion when Alexius was visiting his Lithuanian dioceses he was arrested on Olgerd's orders and almost killed (*APC*, II, 12). This allegation is contradicted not only by the Act of 1389, which states that by 1373 Alexius had not set foot in his Lithuanian dioceses for nineteen years (i.e., since his appointment as metropolitan of Kiev and All Russia in 1354) (*ibid.*, 118), but also by the Patriarch Philotheos' letter of 1371, in which he rebukes Alexius for refusing to visit both Kiev and Lithuania (*APC*, I, 321; see note 26 *supra*). (2) The statement that in 1379 the Russian envoys asked the patriarchate to appoint Pimen as metropolitan (*APC*, II, 15) is outrageously disingenuous. For the true facts, see *infra*, p. 90. (3) The Act of 1380 claims that the Orthodox Church of Lithuania had so many bishops that there was no need for Alexius to come to Kiev, and simultaneously that Alexius considered it unnecessary to undertake this journey for "the small remains (μικρὸν λείψανον) of his Kievan flock" (*ibid.*, 13)—a remarkable instance of the wish to have one's cake and eat it! (4) Cyprian is accused of establishing close relations with Olgerd upon his arrival in Kiev (*ibid.*, 13–14), as though it were not his plain duty to do this.

[36] See G. M. Prohorov, *Povest' o Mitjae-Mihaile i ejo literaturnaja sreda* (Diss. Institut Russkoj Literatury [Puškinsky Dom], Leningrad, 1968), 10.

[37] Thus the Synod seems unduly concerned with whitewashing the Patriarchs Makarios and Neilos by minimizing the extent to which Makarios acted under pressure from Moscow over the acceptance of Michael-Mitjaj's candidature (*APC*, II, 120–21) and by alleging that Neilos acted innocently in consecrating Pimen (*ibid.*, 121; cf. *infra*, p. 90).

[38] In one passage of the sixteenth-century *Nikonovskaja Lětopis'* (*s.a.* 1376: PSRL, XI, 25), it is alleged that soon after his arrival in Kiev Cyprian went to Moscow in an attempt, thwarted by Prince Dimitri, to seize and occupy Alexius' metropolitan see. This would have been an act as senseless as it was uncanonical; and a later passage in the same Chronicle (*s.a.* 1380: *ibid.*, 49) makes it clear that until Alexius' death in 1378 Cyprian resided in Kiev and made no attempt to go to Moscow. See also *Voskresenskaja Lětopis'*, *s.a.* 1376, in PSRL, VIII (1859), 25. There can be no doubt that Cyprian did not go to Moscow before 1378; see Golubinskij, *Istorija russkoj cerkvi*, II,1, 214 note 2; A. E. Prěsnjakov, *Obrazovanie velikorusskago gosudarstva* (Petrograd, 1918), 316 note 1. Nevertheless, somewhat inconsequentially, both Golubinskij (*ibid.*, 212–15) and Kartašev (*Očerki po istorii russkoj cerkvi*, 322) accuse Cyprian of unlawfully attempting to seize Alexius' see. The most Cyprian can be accused of is an attempt, soon after his arrival in Kiev, to detach the Novgorod archdiocese from Moscow and to establish his own jurisdiction over it. The Novgorodians, who were then on good terms with Moscow, replied that they would accept Cyprian's jurisdiction if he were first acknowledged as primate of Russia by the grand prince of Moscow; cf. *Voskresenskaja Lětopis'*, *loc. cit.* Šabatin ("Iz istorii Russkoj Cerkvi," no. 49, pp. 43–44; *ibid.*, no. 50, p. 110) has convincingly rebutted the charge that Cyprian intrigued against Alexius. Cf. Dmitriev, "Rol' i značenie," 226–27.

[39] *Russkaja Istoričeskaja Biblioteka*, VI, cols. 181–83.

He seems to have had some intimation of trouble ahead, for on the way he wrote to two distinguished Muscovite abbots on whose support he clearly counted. One of them was St. Sergius of Radonež, and the other was Sergius' nephew Theodore, abbot of the Simonov monastery. When he reached Muscovite territory he realized that he was, in the eyes of the government, an undesirable alien. Prince Dimitri of Moscow had placed armed guards on the road to the capital, with orders not to let him through. By a roundabout route Cyprian managed to reach Moscow. He was promptly arrested, subjected to gross indignities, and expelled from Muscovy. We learn these facts from Cyprian's own vivid account in a letter he wrote to Sergius and Theodore on his way back from Moscow in June 1378, while still under the emotional shock of his experience. He sternly rebukes the Russian abbots for failing to stand up before the Muscovite authorities for their lawful metropolitan, and announces his intention of going to Constantinople to seek defense before the Byzantine authorities. They, he adds with a note of bitterness, "place their hope in money and the Franks [i.e., the Genoese]. I place mine in God and in the justice of my cause."[40]

The reason for Prince Dimitri's hostility to Cyprian can be inferred from the latter's letter to Sergius and Theodore. "He imputes it to me as a crime," he complained, "that I was in Lithuania first."[41] Since Cyprian had resided in Kiev for the past two years the Muscovite government no doubt chose to regard him as little more than a Lithuanian agent. Although the hated Olgerd had died in the previous year, the political relations between Muscovy and Lithuania were still tense. And Dimitri had little use for the idea of a single metropolitanate of All Russia unless he could control it himself. In his eyes the patriarchate's decision of 1375 to sever western Russia from Alexius' jurisdiction and to place it under Cyprian's authority was a breach of faith and an act of gross pro-Lithuanian favoritism. This explains the complaint in Cyprian's letter that the Muscovites "were abusing the Patriarch, the Emperor and the Great Synod: they called the Patriarch a Lithuanian, and the Emperor too, and the most honorable ecumenical Synod."[42]

Cyprian traveled to Byzantium across the Rumanian lands and his native Bulgaria. His reception in the Bulgarian capital of Trnovo, probably early in 1379, is described in conventionally rhetorical terms in Gregory Tsamblak's encomium of him.[43] In Constantinople a fresh disappointment awaited him.

[40] *Ibid.*, cols. 173–86; G. M. Prohorov, *Povest' o Mitjaje. Rus' i Vizantija v èpohu Kulikovskoj bitvy* (Leningrad, 1978) (hereafter *Povest' o Mitjaje* [1978]). Cyprian states that after his arrest he was insulted, mocked, robbed of his possessions, locked up hungry and naked for a whole night, and on the evening of the next day brought out of prison, not knowing whether he was being led to his execution. He complains of still suffering from the effects of that freezing night. It is interesting that, no doubt for security reasons, several passages of this letter are written in cipher; see *ibid.*, col. 173 note 3, col. 175 note 1, col. 183 note 4, col. 186 note 3. Cf. N. S. Borisov, "Social'no-politiceskoe soderžanie literaturnoj dejatel'nosti mitripolita Kipriana," *Vestnik Moskovskogo Universiteta*, Ser. 9, 1975, no. 6, pp. 60–62; and Prohorov, *op. cit.*, 56–59.

[41] *Russkaja Istoričeskaja Biblioteka*, VI, col. 182.

[42] *Ibid.*, col. 185.

[43] *Pohvalno Slovo za Kiprijan*, in Angelov, *op. cit.* (note 4 *supra*), 183–85.

The new Patriarch Makarios, under pressure from the Muscovite authorities and no doubt from his patron, the Emperor Andronikos IV, declined to honor his predecessor's pledge to Cyprian and declared his intention of appointing the Russian cleric Michael (Mitjaj), the candidate of the grand prince of Moscow, to succeed Alexius.[44] The outcome of this deal was one of the most sordid and disreputable episodes in the history of Russo-Byzantine relations. Michael, the Muscovite candidate, died on board ship within sight of Constantinople. His Russian escort, thoughtfully provided by the prince of Moscow with blank charters adorned with his seal and signature and with a considerable sum of money, used the charters to substitute the name of one of their party, the Archimandrite Pimen (Ποιμήν), for that of the deceased Michael and distributed the money as bribes to officials in Constantinople.[45] With the help of these forged documents they persuaded Makarios' successor, the Patriarch Neilos, to appoint Pimen as "metropolitan of Kiev and Great Russia,"[46] while Cyprian, by the Synod's special "condescension" (συγκαταβάσει),[47] was allowed to retain jurisdiction over the Orthodox Church of Lithuania. This was the very decree which, as I suggested earlier, so blatantly tampered with the truth and dishonestly slandered Cyprian.

When the Synod issued the decree in June 1380, Cyprian had already left Constantinople for Kiev. We can imagine his anger and frustration: to judge from his letter to St. Sergius, written after his expulsion from Moscow, he was a man easily roused to anger. Slowly, however, things began to move in his favor. He had influential friends in Constantinople; one of them was Theophanes, metropolitan of Nicaea, who did not hesitate to express to the Synod his view that Cyprian was fully entitled to the See of Kiev and All Russia which he was promised in 1375. It is significant that Theophanes was a noted hesychast who had been used by Philotheos to restore communion with the Serbian Church.[48] Cyprian's chances were improving in Muscovy, too. His former enemy, the Grand Prince Dimitri, was falling increasingly under the influence of the group of Russian hesychast monks who were strong supporters of Cyprian.[49] Their leaders were his former correspondents, St. Sergius of Radonež and his nephew, the Abbot Theodore, who was now the grand prince's confessor. Their influence probably became greater still after Dimitri's victory over the Tatars at the battle of Kulikovo in September 1380, which finally established Moscow's hegemony among the central Russian

[44] *APC*, II, 120–21.

[45] *Ibid.*, 121. Cf. Golubinskij, *Istorija russkoj cerkvi*, II,1, 242–47; Kartašev, *Očerki po istorii russkoj cerkvi*, 328–29; Tachiaos, 'Επιδράσεις, 113–15; *idem*, 'Ο μητροπολίτης Κυπριανός, 215–17; cf. Prohorov, *Povest' o Mitjaje* (1978), 82–101.

[46] *APC*, II, 12–18.

[47] *Ibid.*, 17.

[48] *Ibid.*, 16–17. On Theophanes of Nicaea, see H.-G. Beck, *Kirche und theologische Literatur im byzantinischen Reich* (Munich, 1959), 746; and note 19 *supra*. Cf. Prohorov, *Povest' o Mitjaje* (1978), 97–98.

[49] See Prěsnjakov, *Obrazovanie velikorusskago gosudarstva*, 360; Šabatin, "Iz istorii Russkoj Cerkvi," no. 50. p. 110; G. M. Prohorov, "Etničeskaja integracija v Vostočnoj Evrope v XIV veke (Ot isihastskih sporov do Kulikovskoj bitvy)," *Doklady Otdelenija Etnografii*, II (Leningrad, 1966), 104–6; *idem, Povest' o Mitjaje* (1978), 101–5.

principalities. In the spring of 1381 Theodore was sent to Kiev to invite Cyprian to take over the leadership of the Muscovite Church.[50]

When Cyprian entered Moscow on 23 May 1381 there was much popular rejoicing, if the Russian chronicles are to be believed;[51] it seemed that justice had finally prevailed and the policy of his late mentor and protector, the Patriarch Philotheos, had at last been vindicated. Except for Galicia on the northeastern slopes of the Carpathians, which in deference to the wishes of its new sovereign, the Polish king, had been given a metropolitan of its own in 1371,[52] the entire Russian Church was now united under Cyprian's authority. Yet his relations with Prince Dimitri remained uneasy. The Muscovite sovereign may have tempered the rigor of his views under the influence of the Russian hesychast monks; but he remained at heart an unrepentant nationalist interested in the aggrandizement of his domains and in freeing his country from Tatar rule. He could not be expected to entertain much sympathy for the opinions of his primate, who believed that the Church should be independent of secular control and that the metropolitanate of Kiev and All Russia was not a national institution, let alone an instrument of Muscovite state policy, but a constituent part of the ecumenical patriarchate. No doubt feeling the need to strengthen his position in Moscow, Cyprian took to the pen. It was probably in 1381 that he wrote his *magnum opus* in Church Slavonic, the life of his predecessor but two, the Metropolitan Peter (1308–26).[53] It is a work of considerable sophistication, both literary and ideological. Although it is based on an earlier, anonymous biography of Peter, as much as Cyprian's letter to the abbots Sergius and Theodore it affords us more than a glimpse of its author's personality, motives, and outlook. It was noticed long ago that Cyprian's Life of St. Peter of Moscow has strong autobiographical overtones.[54] In order to detect them it is scarcely necessary to read between the lines. The careers of the two prelates had indeed a number of striking similarities: both had close connections with western Russia; each had a rival who tried to supplant him unlawfully; both were slandered by their Russian enemies before the authorities in Constantinople; both eventually overcame these obstacles and were enthroned as metropolitans in Moscow. Cyprian, without naming himself, pointedly highlights these similarities. He repeatedly eulogizes the city of Moscow and what he calls "the high throne of the glorious metropolitanate of Russia"; and, the better to drive home his message to Prince Dimitri and his government, he paints an idyllic picture of the relations between the Metropolitan Peter and the Muscovite ruler of the time, and condemns attempts by laymen to divide the Russian metropolitanate and to interfere in ecclesiastical appointments.

[50] M. D. Priselkov, *Troickaja letopis'* (Moscow-Leningrad, 1950), 421.

[51] *Ibid.*, 421; the *Nikonovskaja Lětopis'* (PSRL, XI, 41) misdates the event to 1378.

[52] *APC*, I, 577–80.

[53] Published in Angelov, *op. cit.* (note 4 *supra*), 159–76; and Prohorov, *Povest' o Mitjaje* (1978), 204–15. For a discussion of the dating, see Dmitriev, "Rol' i značenie," 251–52.

[54] See V. Ključevskij, *Drevnerusskija žitija svjatyh, kak istoričeskij istočnik* (Moscow, 1871), 82–88; Dmitriev, "Rol' i značenie," 236–50, who provides a detailed analysis of the work.

If the autobiographical element is latent in Cyprian's Life of Peter of Moscow, it is quite explicit in his encomium to the same saint, probably also written in 1381.[55] He writes of his own initial appointment as metropolitan of Russia in 1375; of his ill-fated attempt to come to Moscow in 1378 when he was so brutally treated on the prince's orders—an event over which he slides, with tactful euphemism, by merely saying "something adverse happened, on account of my sins"; of his failure to obtain justice in Constantinople at the patriarchal court of "the wickedly appointed senseless Makarios"; and of his stay in Constantinople in 1379–80, which lasted for thirteen months because, he says, "it was not possible to leave the imperial city: for the sea was held by the Latins [an allusion to the Chioggia War between Venice and Genoa, fought mainly in Byzantine waters from 1377–81] and the land by the godless Turks." This autobiography, which ends with an account of his second, triumphant arrival in Moscow in 1381, includes a lengthy eulogy of the Patriarch Philotheos. The encomium and also the Life of St. Peter of Moscow are indeed precious documents for Cyprian's biographer. Mgr. Louis Petit once wrote: "A Byzance, un hagiographe qui se respecte ne manque jamais de parler un peu de lui."[56] One can only add that Cyprian went a good deal further in this direction than was normally considered proper in that age.

These tactful literary exercises, however, availed him little in the short run. Another severe trial lay in store for him. In August 1382 the army of Tohtamyš, a Mongol vassal of Tamerlane, approached Moscow, and before the Tatars captured and looted the city Cyprian slipped out and made his way to the town of Tver'. The circumstances of his departure from Moscow remain obscure, as the Russian chronicles give discordant versions.[57] It is possible, though not certain, that he displayed a certain failure of nerve and leadership. Whether because Cyprian had behaved pusillanimously or, more probably, because he had sought refuge in Tver', Moscow's traditional enemy, Prince Dimitri was furious. Cyprian was again expelled from Muscovy, and returned to Kiev. The egregious Pimen, fraudulently appointed metropolitan in Constantinople and then imprisoned by Dimitri on his return to Russia, was hauled out of jail and solemnly deposited on the primate's throne in October 1382. There is reason to believe that this was done under pressure from Constantinople, where the Patriarch Neilos had been whipping up a campaign in favor of Pimen and consistently maligning Cyprian in his letters to the Muscovite government.[58]

These discreditable maneuvers were almost at an end. In 1385, after Pimen had been abandoned by Moscow and excommunicated by the patriarch,[59]

[55] *Velikija Minei Četii*, December 21 (Moscow, 1907), cols. 1642–46.

[56] *Vie et office de Michel Maléinos, suivis du Traité Ascétique de Basile le Maléinote*, Bibliothèque hagiographique orientale, IV, ed. L. Clugnet (Paris, 1903), 3. I owe this reference to the kindness of Professor Ihor Ševčenko.

[57] See L. V. Čerepnin, *Obrazovanie russkogo centralizovannogo gosudarstva v XIV–XV vekah* (Moscow, 1960), 636–37.

[58] *APC*, II, 121–22.

[59] In 1384 Prince Dimitri of Moscow, having withdrawn his support from Pimen, sent the Russian Archbishop Dionysius of Suzdal' to Constantinople, apparently with the intention of persuading the

Cyprian was summoned to Constantinople for a final decision on his future. While awaiting the outcome, he lived in the monastery of Stoudios which, along with Mt. Athos, was then a prominent center of scholarly collaboration between Byzantine and Slav monks. A note in a manuscript of St. John of the Ladder in Cyprian's own hand states: "On 24 April 1387 this book was completed [i.e., copied] in the Studite monastery by Cyprian, the humble metropolitan of Kiev and All Russia."[60] It is worth noting that, despite all his misfortunes, he still regarded himself as the lawful incumbent of that see. The same year he was sent to Lithuania by the Emperor John V on a political mission (διὰ δουλείας βασιλικάς).[61] We do not know its purpose, but it is hard to resist the impression that it was connected with the personal union concluded between the Grand Duchy of Lithuania and the Kingdom of Poland in the previous year (1386), which threatened to jeopardize the entire future of the Orthodox Church in the Grand Duchy. Whatever its purpose, Cyprian's imperial mission is evidence of the esteem in which he was then held by the Byzantine government. In February 1389, under the new Patriarch Antony IV, the Synod met to decide the future of the Russian Church and to put an end to the disgraceful anarchy of the past ten years. The Acts oft he Synod admit that the Russians were pouring on the Byzantines a flood of "insults...and reproaches and accusations and grumblings" (ὕβρεις πολλὰς...καὶ μώμους καὶ κατηγορίας καὶ γογγυσμούς).[62] This was no doubt an understatement. After the villainy perpetrated by their envoys in Constantinople and the brutalities and vacillations of Prince Dimitri, the Russians for their part had scarcely a better press in Byzantium. The Synod wisely opted for reconciliation. It appointed Cyprian metropolitan of Kiev and All Russia, and decreed that the unity of the Russian metropolitanate be maintained for all times (εἰς τὸ ἐξῆς εἰς αἰῶνα τὸν ἅπαντα).[63]

THE YEARS OF ACHIEVEMENT
(1390–1406)

Early in 1390, after a stormy passage on the Black Sea in which he nearly lost his life, Cyprian, escorted by a retinue of Byzantine and Russian prelates, made his solemn entry into Moscow via Kiev.[64] Prince Dimitri had died the previous year and his son and successor, Basil I, seems to have accepted his new primate readily. For fifteen years Cyprian had reached out for the metropolitanate of All Russia, this glittering prize promised him by his patron

patriarch to consecrate him metropolitan. Neilos declined to be forced into hasty action, and sent a commission of inquiry to Moscow with power to appoint Dionysius if it thought fit; cf. *ibid.*, 122–24. Before any decision was reached, however, Dionysius was arrested in Kiev by Olgerd's son, Prince Vladimir, and died in prison on 15 October 1385; cf. Priselkov, *Troickaja Letopis'*, 427–29; *Nikonovskaja Lětopis'*, PSRL, XI, 86. The two Russian Church historians distinguished by their bias against Cyprian, Golubinskij (*Istorija russkoj cerkvi*, II,1, 253) and Kartašev (*Očerki po istorii russkoj cerkvi*, 332) do not hesitate to charge him with this crime, though there is no evidence of his involvement in it. Šabatin ("Iz istorii Russkoj Cerkvi," no. 50, p. 115) comes somewhat hesitantly to Cyprian's defense.

[60] Ivanov, "Bŭlgarskoto knižovno vlijanie," 48; Mango, *op. cit.* (note 31 *supra*), 437.
[61] *APC*, II, 124. [62] *Ibid.*, 123. [63] *Ibid.*, 128.
[64] Priselkov, *Troickaja Letopis'*, 435–36; *Nikonovskaja Lětopis'*, PSRL, XI, 101, 122.

Philotheos and so rudely denied him by Dimitri of Moscow and by Philotheos'
two successors on the patriarchal throne. Now, with the final obstacles removed,
he could at last put into practice the program for Eastern Europe he and
Philotheos had devised together in the early 1370's: its aim was to attach
the South Slav and Russian Orthodox Churches more firmly to the ecumenical
patriarchate by the concerted action of a group of men, bound to each other
by ties of friendship or discipleship and owing a common loyalty to the
hesychast tradition and to the Mother Church of Constantinople. The linchpin
of this program of ecclesiastical diplomacy was the undivided metropolitanate
of Kiev and All Russia, with its effective center in Moscow. Though we lack
detailed information about these last sixteen years of Cyprian's life, there is
reason to think that they were not unproductive.

Much of his administrative work during those years is of little interest to
anyone save the historian of the Russian Church.[65] Two areas of his activity,
however, impinged on the wider field of European history. The first was
Lithuania. In 1386 one of the most fateful marriages in the history of Eastern
Europe took place when Olgerd's son Jagiełło, grand duke of Lithuania,
married Queen Jadwiga of Poland. Jagiełło, who had earlier undertaken to
marry the daughter of Prince Dimitri of Moscow and to become a member of
the Orthodox Church,[66] had to promise to convert his subjects to the Roman
faith and to unite his Grand Duchy with the Kingdom of Poland. Fortunately
for the Orthodox, who formed the majority of the population of the Grand
Duchy, Jagiełło was unable to enforce this conversion to Rome. His cousin
Witold, who became grand duke of Lithuania under Jagiełło's suzerainty in
1392, was an Orthodox and the father-in-law of the grand prince of Moscow.
A period of peaceful relations thus began between Muscovy and the Polish-
Lithuanian federation, which lasted until 1406.

There can be no doubt that Cyprian played a major role in fostering this
rapprochement. According to the Russian chronicles, he paid two further
visits to Lithuania—in 1396[67] and in 1404[68]—and each time stayed there for
some eighteen months. On both occasions he met Witold, and in 1405 he had
a long and very friendly encounter with King Jagiełło.[69] He must have got to

[65] For Cyprian's ecclesiastical activity between 1390 and 1406, see Golubinskij, *Istorija russkoj
cerkvi*, II, 1, 302–56; Prěsnjakov, *Obrazovanie velikorusskago gosudarstva*, 363–73; Kartašev, *Očerki po
istorii russkoj cerkvi*, 333–38; Šabatin, "Iz istorii Russkoj Cerkvi," no. 51, pp. 192–94, no. 52, 237–57.

[66] See F. Dvornik, *The Slavs in European History and Civilization* (New Brunswick, N.J., 1962),
221–22.

[67] The date of Cyprian's first visit varies in the different chronicles: 1396: *Voskresenskaja Lětopis'*,
PSRL, VIII, 69; 1397: *Nikonovskaja Lětopis'*, PSRL, XI, 166; 1398: Priselkov, *Troickaja Letopis'*,
449. The correct date is presumably 1396, since in January 1397 the Patriarch Antony wrote both
to Cyprian and to King Jagiełło in reply to their joint proposal for a church council, no doubt made
after a personal meeting (see *infra*). It was doubtless in 1396 that Cyprian wrote to the patriarch from
Lithuania complaining of overwork. In his reply dated January 1397, the patriarch refers to Cyprian's
"many exertions and travels" (τῶν πολλῶν κόπων καὶ περιόδων) and attempts to console him by
pointing out that they are but the professional duty of every true bishop (*APC*, II, 282).

[68] Priselkov, *Troickaja Letopis'*, 458; *Voskresenskaja Lětopis'*, 77; *Nikonovskaja Lětopis'*, 191.

[69] This summit meeting took place in the Lithuanian town of Miloljub, lasted for a week, and was
also attended by the Grand Duke Witold: Priselkov, *Troickaja Letopis'*, 459; *Voskresenskaja Lětopis'*,
77; however, *Nikonovskaja Letopis'*, 192, claims that the meeting lasted for two weeks.

know him on an earlier occasion, for in a letter written to Cyprian in January 1397 the Patriarch Antony IV remarks: "as you have written yourself, the King [of Poland] is a great friend of yours" (φίλος σου πολὺς ἔνι ὁ κράλης).[70] It was doubtless in 1396 that Cyprian and Jagiełło thought up their remarkable scheme for the reunion of the Byzantine and Latin churches, to be effected at a council, presumably on Lithuanian soil. Both sent their written proposals to the patriarch, who showed a cautious interest in the project but pointed out in his replies, dated January 1397, that "Russia" (i.e., presumably Lithuania) was an unsuitable venue for such a council, and that in any case the blockade of Constantinople by the Turkish armies of Bayazid made its summoning inexpedient. Let the kings of Hungary and Poland organize another crusade against the Turks; then, said the patriarch, a council could be held, for the roads would be open. As for Cyprian, it was his bounden duty to use his influence with the Polish king to secure this desirable end.[71] It is with justice that John Barker, commenting on Antony's letter to Jagiełło, remarks: "This passage makes clear that the Byzantines regarded union as the cart and aid as the horse, and that they had very strong opinions as to which should come first."[72]

The second aspect of Cyprian's activity which is of general interest is the role he played as a representative of the Byzantine authorities in Russia. There has been some otiose speculation about his attitude to the notorious decree of Basil I ordering the deletion of the Byzantine emperor's name from the commemorative diptychs of the Russian Church, on the grounds that in Russia "we have the church but not the emperor." The Patriarch Antony, in a letter he wrote to the Muscovite ruler in 1393, roundly rebuked him for this nationalistic revolt against the authority of "the universal emperor," "the Lord and Master of the *oikoumene*."[73] He makes it clear that Basil actively "prevented" (ἐμποδίζεις) his metropolitan from commemorating the emperor. In my view it is inconceivable that Cyprian would have complied with such an order except under the strongest protest and duress.[74] He seems,

[70] *APC*, II, 283. [71] *Ibid.*, 280–85.

[72] J. W. Barker, *Manuel II Palaeologus (1391–1425): A Study in Late Byzantine Statesmanship* (New Brunswick, N.J., 1969), 150–54. On this project of union, see also Golubinskij, *Istorija russkoj cerkvi*, 337–39; Prěsnjakov, *Obrazovanie velikorusskago gosudarstva*, 370; O. Halecki, "La Pologne et l'Empire byzantin," *Byzantion*, 7 (1932), 49; Kartašev, *Očerki po istorii russkoj cerkvi*, 336–37; Tachiaos, Ἐπιδράσεις, 127–30; *idem*, Ὁ μητροπολίτης Κυπριανός, 229–32; Šabatin, "Iz istorii Russkoj Cerkvi," no. 52, pp. 250–52.

[73] *APC*, II, 188–92; abridged English trans. E. Barker, *Social and Political Thought in Byzantium* (Oxford, 1957), 194–96; and J. W. Barker, *op. cit.*, 105–10. For the correct dating of this letter to 1393, not 1394–97 (as G. Ostrogorsky, *History of the Byzantine State* [Oxford, 1968], 554 note 1, argued), see J. W. Barker, *op. cit.*, 109–10 note 31; and Darrouzès, *Le Registre synodal*, 125 note 34.

[74] There are no valid grounds for accepting the view, implied in Hildegard Schaeder's book (*Moskau das dritte Rom*, 2nd ed. [Darmstadt, 1957], 1–12), that Cyprian sympathized with Basil I's revolt against the emperor's suzerainty, or Šabatin's belief ("Iz' istorii Russkoj Cerkvi," no. 52, pp. 238–39) that he agreed to drop the emperor's name from the Russian diptychs as the price for the grand prince's noninterference in Church affairs. Much more convincing are the arguments advanced by Tachiaos to show that Cyprian could not possibly have countenanced Basil I's attitude in this matter (Ἐπιδράσεις, 130–39; Ὁ μητροπολίτης Κυπριανός, 232–41). There is no evidence to support the opinion of Sokolov (*op. cit.* [note 19 *supra*], 572–73) and Prěsnjakov (*Obrazovanie velikorusskago gosudarstva*, 365 note 1) that it was not Basil I but his father, Prince Dimitri, who discontinued the practice of commemorating the emperor's name in Muscovy.

in any case, to have persuaded the Russian monarch fairly rapidly to recognize once more the emperor's nominal suzerainty over the Muscovite realm; for in a letter written by Cyprian between 1395 and 1406 to the clergy of Pskov he states explicitly that the emperor is commemorated liturgically in the churches of Moscow.[75]

As a Byzantine agent in Russia, Cyprian was also useful as a fund raiser. His good offices were repeatedly sought by the Byzantine government and Church during the Turkish siege of Constantinople which lasted from 1394 to 1402.[76] According to Russian sources, in 1398 he helped collect a considerable sum of money which, perhaps surprisingly, reached Constantinople safely.[77] The patriarchal archives preserved the draft of a letter addressed to Cyprian and dated to 1400, in which the Patriarch Matthew urged him, "as a Byzantine-loving man" (ὡς φιλορρώμαιος ἄνθρωπος), to start another fund-raising campaign; he was to assure his Russian flock that it was more meritorious to contribute money for the defense of Constantinople than to build churches, to give alms to the poor, or to redeem prisoners. "For this holy city," wrote the patriarch, "is the pride, the support, the sanctification, and the glory of Christians in the whole world."[78]

Cyprian's efforts as a φιλορρώμαιος ἄνθρωπος should not obscure his services to his country of adoption during this last and more serene period of his life. There is time to enumerate them only briefly. In 1375, when the armies of Tamerlane were approaching Moscow, Cyprian had the famed icon of Our Lady of Vladimir, Russia's palladium, transferred to Moscow in order to instill courage in the inhabitants of the threatened city. On that very day, according to a Russian chronicle, Tamerlane ordered a general retreat.[79]

Cyprian has also a secure and not undistinguished position in the history of Russian letters. I have already referred to some of his writings. Russian archival collections have preserved manuscripts copied by him, mostly Church Slavonic translations from the Greek. Among them are the Psalter, St. John Climacus' *Ladder*, and works of the Pseudo-Dionysius.[80] He inserted into the Russian version of the Synodikon for the Sunday of Orthodoxy the new articles of the Byzantine Synodikon which endorsed the theological teaching of the hesychasts, thus contributing to the subsequent spread of hesychasm

[75] *Russkaja Istoričeskaja Biblioteka*, VI, col. 239. This commemoration appears to have been the imperial *polychronia* which formed part of the Synodikon for the Sunday of Orthodoxy. See J. Gouillard, "Le Synodikon de l'Orthodoxie. Edition et commentaire," *TM*, 2 (1967), 93–95, 253–56. Cf. F. Uspenskij, *Očerki po istorii vizantijskoj obrazovannosti* (St. Petersburg, 1891), 109–45.

[76] On the siege of Constantinople, see J. W. Barker, *op. cit.*, 123–99.

[77] *Troickaja Letopis'*, 448; *Nikonovskaja Lětopis'*, 168; *Sofijskaja vtoraja lětopis'*, PSRL, VI (1853), 130; *Voskresenskaja Lětopis'*, 71. Cf. F. Dölger, *Regesten der Kaiserurkunden des oströmischen Reiches*, V (Munich-Berlin, 1965), 85 (no. 3267). Neither the Byzantine appeal for help nor the Russian response merit the epithet "supposed" (J. W. Barker, *op. cit.*, 153 note 45).

[78] *APC*, II, 361.

[79] See G. Vernadsky, *The Mongols and Russia* (New Haven, 1953), 275–76; Čerepnin, *op. cit.* (note 57 *supra*), 673–78.

[80] For general studies of Cyprian's literary work, see Ivanov, "Bŭlgarskoto knižovno vlijanie," 25–79; Dmitriev, "Rol' i značenie," 215–54. Cyprian's literary, liturgical, and historical work fall outside the scope of this article, and merit a separate study.

in Russia.[81] He also played an important role in the development of Russian liturgical practice,[82] making new translations into Church Slavonic of Greek liturgical texts, introducing into Russia the *ordo* of the liturgy of St. John Chrysostom in current use in late medieval Byzantium,[83] issuing detailed instructions on liturgical problems,[84] and generally attempting to bring the ritual of the Russian Church fully into line with Constantinopolitan practice of the late fourteenth century.[85] Finally, he is believed to have played an active part in the compilation of the first comprehensive Muscovite chronicle, which included material collected from different parts of the country and which was completed in 1408, two years after his death.[86]

A modern scholar has attributed to Cyprian the following statement: "I seek peace and ecclesiastical unity between north and south."[87] I have not been able to find these exact words in any of Cyprian's published works, though I believe them to be a none-too-faithful rendering of something he did, in fact, write in one of his letters to St. Sergius.[88] Genuine or not, this quotation seems an appropriate epitaph for a man who, drawing his spiritual and intellectual inspiration from the hermitages of Athos and the example of his mentor, the Patriarch Philotheos, devoted the greater part of his active life to the task of keeping together the disparate fragments of the Byzantine commonwealth. He fought hard, and in the end achieved a large measure of success.

A Russian chronicle, in its account of Cyprian's death, tells us that his favorite place of residence was his country estate near Moscow. "The place," we are told, "was quiet, silent and free from noise, between two rivers ...

[81] *Russkaja Istoričeskaja Biblioteka*, VI, cols. 239, 241.

[82] The standard work on Cyprian's liturgical activity is still the very thorough study by I. Mansvetov, "O trudah Mitropolita Kiprijana po časti bogosluženija," *Pribavlenija k izdaniju tvorenij svjatyh otcev v russkom perevodě*, 19 (1882), 152–205, 413–95; *ibid.*, 30 (1882), 71–161. Cf. Ivanov, "Bŭlgarskoto knižovno vlijanie," 37–47, 52–67.

[83] This was the Διάταξις τῆς θείας λειτουργίας, attributed to the Patriarch Philotheos; see P. N. Trembelas, Αἱ τρεῖς λειτουργίαι κατὰ τοὺς ἐν Ἀθήναις κώδικας (Athens, 1935), 1–16. Cf. Beck, *op. cit.* (note 48 *supra*), 726. Cyprian made available in Russia the Church Slavonic translation of this διάταξις, made by the Patriarch Euthymius of Bulgaria: *Werke des Patriarchen von Bulgarien Euthymius (1375–1393)*, ed. E. Kałužniacki (Vienna, 1901; repr. London, 1971), 283–306.

[84] *Russkaja Istoričeskaja Biblioteka*, VI, cols. 235–70.

[85] The contrast is worth noting between the high praise meted out to Cyprian in a Russian document dated 1403 for his "correction of the [Church] books" (cf. A. I. Sobolevskij, *Perevodnaja literatura Moskovskoj Rusi XIV–XVII vekov* [St. Petersburg, 1903], 12–13 note 3) and the storm that broke over a similar issue in Russia three centuries later, when the decision of the Russian Patriarch Nikon to enforce upon his Church the liturgical texts and practices of the contemporary Greek Church caused millions of "Old Believers" to go into schism. In this area also it is remarkable how the hesychast, pro-Byzantine party was able in the late Middle Ages to offer a viable alternative to the growth of religious nationalism.

[86] See M. D. Priselkov, *Istorija russkogo letopisanija XI–XV vv.* (Leningrad, 1940; repr. The Hague, 1966), 128–40; *idem, Troickaja Letopis'*, 3–49; D. S. Lihačev, *Russkie letopisi i ih kul'turno-istoričeskoe značenie* (Moscow-Leningrad, 1947), 296–97; Dmitriev, "Rol' i značenie," 226–28.

[87] Archimandrite Leonid, *op. cit.* (note 13 *supra*), 29.

[88] "I seek neither glory, nor riches, but my metropolitanate, which the holy Great Church of God [i.e., the Patriarchate of Constantinople] entrusted to me": *Pravoslavnyj Sobesednik*, 1860, pt. 2, p. 104. Prohorov, *Povest' o Mitjaje* (1978), 202.

beside a pond, and there was much forest around.''[89] There he would retire to pray, read, and indulge in his favorite pastime, the copying of manuscripts. One is reminded of Peter the Venerable's account, written to Héloïse, of the last years of Abélard's life: *libris semper incumbebat*.[90] There he died, probably in his late seventies, on 16 September 1406. Four days before his death, seriously ill, he dictated a farewell letter to his friends and his enemies, begging forgiveness and sending to all his ''peace and blessing and last embrace.'' He asked that it be read at his funeral, while his body was being lowered into the coffin. The Russian chronicler, who cites in full the text of the letter, tells us that many were in tears as they heard it read.[91]

We may perhaps best take leave of Cyprian in the quiet surroundings of his Russian country home which he loved so much. A southerner by birth, he must have found the scenery very unlike the rolling hills of his native Bulgaria and the dark blue sea, the sun-baked cliffs, and the chestnut groves of Mt. Athos. It is pleasant to think that in his adopted northern home, where in the autumn and on long summer days the translucent sky falls gently on the silent waters, he may have found peace at last.

Dumbarton Oaks
May 1977

[89] *Nikonovskaja Lětopis'*, 194–95.

[90] *The Letters of Peter the Venerable*, ed. G. Constable, I (Cambridge, Mass., 1967), 307 (Letter 115).

[91] Priselkov, *Troickaja Letopis'*, 462–64; *Nikonovskaja Lětopis'*, 194–97. Two sixteenth-century chronicles state that some of Cyprian's successors on the metropolitan throne had the text of his letter read at their funeral and placed in their coffins: *Nikonovskaja Lětopis'*, 197; *Kniga Stepennaja Carskogo Rodoslovija*, PSRL, XXI,2 (1913), 443–44.

MENANDER PROTECTOR

BARRY BALDWIN

LITTLE has been written, in English or any other language, on Menander Protector,[1] yet his fragments are among the most considerable of those preserved in the *Excerpta de legationibus* of Constantine Porphyrogenitus. He is, of necessity, a major source of information for the diplomatic and military history of the reigns of Justin II and Tiberius. He also merits attention as a relatively neglected member of the sequence of Byzantine *Profanhistoriker* that stretches from Eunapius to Theophylact Simocatta.[2]

There are very few external *testimonia* to the existence of Menander. Theophylact briefly commends his account of the siege of Sirmium (1.3,5). Along with Procopius, Agathias, and Hesychius, he is adduced (with some chronological inaccuracy, as will be seen) by Constantine Porphyrogenitus on a matter of provincial nomenclature (*De them.* 1.2, Bonn ed. [1840], p. 18). The epigram he dashed off on the martyrdom of Isbozetes, the Persian magus who converted to Christianity (frag. 35), is included in the *Anthology* (*AP* 1.101). His absence from the *Bibliotheca* of Photius is worth remarking.[3]

What little we know of Menander is owed to the extract from his own Preface preserved in the *Suda* (ed. Adler, M 591). It may be suggestive that the compiler contents himself almost entirely with verbatim quotation, adding only the obvious fact that Menander was a historian.

Menander's father was a certain Euphratas, a native of Constantinople and a man quite devoid of formal education. There was also a brother named (nicely enough) Herodotus, who was a dropout from law school. With such familial examples, it is perhaps not surprising that Menander himself became unruly for a while; not, however, before studying law, which was proper, or so he says. His study of law is a theme which could well have been polished up later in retrospect, intended at least partly as homage to his model Agathias. A striking linguistic debt[4] may enhance such an interpretation, as might his admitted aversion to the onerous life of a lawyer, a standard complaint indulged in also by Agathias (3.1,4).

It is obvious that Menander is here engaging in studied and favorable comparison between himself and his father and brother. How good a student he actually was is discreetly concealed; we are told that he concluded his studies ὡς μοι ὑπῆρχε δυνατόν.[5] Even after due allowance for the convention of modesty

[1] The only significant studies are: M. Apostolopoulos, Μένανδρος Προτέκτωρ μιμητὴς Ἀγαθίου (Athens, 1894); V. Valdenberg, "Le idee politiche di Procopio e di Menandro Protettore," *StB*, 4 (1935), 65–85; O. Veh, *Beiträge zu Menander Protektor* (Fürth-Beirut, 1955).

[2] Especially in the light of the outstanding study of Agathias by Averil Cameron, *Agathias* (Oxford, 1970); cf. esp. 125–26, 136 for valuable remarks on Menander.

[3] Not that anything should be made of this: Eunapius, Olympiodorus, Malchus, Procopius, and Theophylact are listed; Priscus and Agathias are not.

[4] Both Agathias (2.15,7) and Menander speak of education πρὸς τῶν νόμων. There has been a good deal of debate over the merits of πρός or πρό; cf. Cameron, *Agathias*, 140–41; and B. Baldwin, "Four Problems in Agathias," *BZ*, 70 (1977), 295–305.

[5] It is clear from Agathias, *AP* 1.35, that four years was the usual length of legal training, but the rhetorical preliminaries must also be taken into account; cf. Cameron, *Agathias*, 2 note 1.

in an author's preface, it may not be altogether cynical to suspect that his performance was not the best.

Regardless of his scholarly performance, Menander became a young man about town. He enjoyed the Hippodrome, cultivated the theater, and frequented the palaestra, none of which implies a career of spectacular debauchery. It is evident from the poems of Agathias, Leontius Scholasticus, and other contributors to the *Cycle* that the circus and actresses were numbered among the permitted pleasures of the capital. Whether involvement in the θόρυβοι τῶν χρωμάτων connotes any serious political activity is now very much open to question.[6]

Worst of all, in Menander's own view, was his devotion to the palaestra, where along with his cloak were stripped off all shame and sense. This could hint at sexual escapades: wrestling is a regular term in erotic description.[7] However, emphasis on the evils of nudity carries a clear suggestion of Christian condemnation of the old Hellenic ways. This is consonant with the evidence of the other fragments: Menander was without any doubt a Christian, and, as I shall show, one with a taste for sermonizing.[8]

Menander was redeemed by the advent of the Emperor Maurice, who was a patron of the arts, particularly poetry and history. Better still, he was amenable to subsidizing the efforts of novice practitioners, which inspired Menander to turn from the paths of idleness and apply himself to historiography.

So much for the content of this first fragment. Some of the Preface is literary convention.[9] The autobiographical *sphragis*, for example, was the usual practice of historians, according to Agathias (*Praef.* 14). The modesty over his credentials as a historian (frag. 2) or his Attic virtuosity (frag. 12) is trite enough.[10]

Nevertheless, there are some distinctive features. At least we are spared the tedious accounts in Agathias and other writers of being compelled to historiography by the pleas of friends. Menander cheerfully admits to making up his own mind for reasons that are frankly opportunistic. Also striking is his candor *de vita sua* and the deficiencies of his relatives; could this be something of a deliberate burlesque of the *sphragis*?

[6] See Alan Cameron, *Circus Factions* (Oxford, 1976), *passim*.

[7] It is hardly necessary to document this at length: Paulus Silentiarius, *AP* 5.259 (with Viansino's note), will serve as an example for Menander's own age. Lucian (?), *Asinus* 10, is perhaps the *locus classicus* (with bludgeoning humor, the heroine is named Palaestra); Domitian's *mot* on *clinopale* may also be recalled from Suetonius, *Dom.* 22.

[8] In the present bout of confessional, notice the expression τὸ νουνεχές, an idiom perhaps peculiar to Menander, or at least one that is distinctively his. *LSJ* cites it only from an anonymous passage in the *Suda* (ed. Adler, A 2394); see *infra* for the probability that this passage is in fact from Menander. The phrase recurs in Menander, frag. 60, which is the only reference given in G. W. H. Lampe, *A Patristic Greek Lexicon* (Oxford, 1961). The expression is neglected by E. A. Sophocles, *Greek Lexicon of the Roman and Byzantine Periods* (New York [n.d.]). Its presence in the fragment under discussion may emphasize the sincerity of Menander's effusion.

[9] For the conventions, see Cameron, *Agathias*, 145–46.

[10] As far as we can tell from the fragments, Menander is less prolix on the subject of his own shortcomings as historian than Agathias. Mock modesty is not an ubiquitous vice in the relevant writers, as is evidenced by the pugnacity of Eunapius, frag. 1. Menander himself appears confident enough in frag. 11 when arguing the need to reproduce the exact text of a document.

Conceivably, although there is another explanation. Evagrius (*HE* 6.1) thought it appropriate to salute Maurice for (according to Gibbon) expelling from his mind the wild democracy of passions. It is notable that such a thing could be said in a work composed in the twelfth year of Maurice's reign: the image of a reformed sinner was clearly congenial to the Emperor. Hence, the admission of a wild past is a neat way for Menander to suggest his own similarity to Maurice, especially when it is allied to praise of that ruler for pointing the way to rehabilitation.[11]

Not much can be offered by way of a biography of Menander Protector. He obviously produced his historical work during the reign of Maurice (582–602). The statement of Constantine Porphyrogenitus that he wrote under Justinian is probably carelessness of memory or expression, understandable since Menander's narrative begins in this Emperor's reign. The same error is made, for analogous reasons, in the case of Agathias.

A man completely lacking in education might be presumed neither rich nor important in Constantinople, yet there was clearly enough money to finance two sons in legal studies (albeit Menander's brother soon gave up). An advantageous marriage might be divined, or perhaps Menander and his father did not get on: lack of learning is a common charge in the language of ancient vituperation.

References to Menander in the sources call him only protector and historian. There is no suggestion that he was a sophist as, for instance, Priscus and Malchus had been. His own Preface guarantees that he did not emulate Agathias and become a lawyer. One would like to know more about his poetry, of which the only extant example is the aforementioned epigram on the martyr Isbozetes. Was this his sole effort, or one of many?

Most likely there were other poems, for the combination of poet and historian would be far from unique. His immediate predecessor Agathias is the obvious case in point. Olympiodorus of Thebes should also be cited: according to Photius (*Bibl.*, cod. 80) he was a professional poet who also wrote history. Olympiodorus and Menander are the only two ancient historians whom we know to have burst into verse of their own composition.[12] By his own account, Menander took up history because Maurice patronized it. Since the emperor equally favored poetry, it is a fair assumption that Menander would have sought to make himself known in that genre also. There were established types of poetry through which a man could earn wealth and recognition;[13] it is enough to cite John Lydus, whose encomium on the prefect Zoticus earned him recompense at the rate of one gold piece a line (*De mag.* 3.27).

[11] It is worth noting that Evagrius has been thought to have used Menander. For references, see E. Gibbon, *The History of the Decline and Fall of the Roman Empire*, ed. J. B. Bury, V (London, 1898), 496, where the notion is rejected; cf., however, *ibid.*, IV (1901), 518, where Bury had accepted it without comment.

[12] In his seminal paper, "Olympiodorus of Thebes," *CQ*, 38 (1944), 45, E. A. Thompson wrongly gave Olympiodorus a monopoly on this. The oversight was corrected by Alan Cameron, "Wandering Poets: A Literary Movement in Byzantine Egypt," *Historia*, 14 (1965), 490 note 127. The phenomenon can be seen in other genres; Diogenes Laertius, as an awful example, frequently inflicts his own epigrams upon the reader. [13] See Cameron, *ibid.*

One has the impression from his prefatory fragments that Menander was able to be both roué and writer without wanting or having to pursue a career. Although it is hazardous to assume sense or system on the part of the *Suda*, its entry for Menander would surely have given more on his professional activities, had there been any.

Nowhere in the fragments of his historical narratives is there any overt reference to personal experience or autopsy of any kind. There is no indication of diplomatic travel of the sort engaged in by Olympiodorus, Priscus, or Nonnosus, for example.[14] It is explicit (frag. 12) that he had to rely on the official texts and the versions of key participants such as Peter the Patrician.

Inferences are, of course, always possible, but one should be extremely cautious. Impressive looking displays of topographical description often turn out, on inspection, to be rhetorical set pieces culled from sources or schoolroom. This is most notoriously true in the case of siege descriptions (see *infra*), but it can apply to all forms of "learning." In fragment 20, for instance, a passage replete with curious lore concerning barbarians, there is a brief discussion of the peculiarities of Turkish wine. What Menander offers may or may not be correct. The point is, the item does not imply any firsthand knowledge. Such topics were commonplaces; Priscus (frag. 8, to which the present passage of Menander is very similar in subject and content) has a parallel observation on Hunnic beer.[15] By the same general token, when Menander boasts (frag. 10) that he will not flatter the great it means nothing for his own status; he is but airing one of the most venerable of all historiographical clichés.[16]

There is one other basic and pertinent matter that warrants a special word. In the *Excerpta de legationibus* and the *Suda*, Menander is cited as Menander Protector, which is his modern appellation. The usual view is that he was able to afford membership of the *protectores domestici*, on whose toy-soldier qualities Procopius (*Anecd.* 24.24) waxes notably sarcastic. This may very well have been the case, and I have no theories on other matters concerning Menander that would be helped by the demolition of the tradition. Hence it is not special pleading but neutral observation to point out that there is no mention of protectorate status in fragment 1. Naturally, one cannot be confident when dealing with fragments, but what we do have looks like a full and unabridged confessional. Menander says that he gave up serious pursuits, chose the worst way, and κεχηνὼς περιενόστουν, which tells us nothing.

It is impossible to be sure just what the term protector connotes in Byzantine Greek of this period. In its transliterated form the word occurs only in inscriptions and papyri in the fourth and fifth centuries.[17] John Lydus employs it

[14] For Nonnosus, see Photius, *Bibl.*, cod. 3 (Müller, *FHG*, IV, 178–80); this historian's father and grandfather were also diplomats under Anastasius and Justin I.

[15] Cf. E. A. Thompson, "Notes on Priscus Panites," *CQ*, 41 (1947), 63.

[16] Menander betrays none of the sourness evinced by Agathias (*Praef.* 16–20) on this subject; cf. Cameron, *Agathias*, 6, 34.

[17] The word surfaces as a new one in the Supplement to *LSJ*. See the examples in H. J. Mason, *Greek Terms for Roman Institutions* (Toronto, 1974), 82; cf. A. Cameron, "Latin Words in the Greek Inscriptions of Asia Minor," *AJP*, 52 (1931), 255.

(*De mag.* 1.46) as a synonym for *primoscutarius*. The definition offered by the *Suda* (ed. Adler, P 2884) suggests diversity of meaning: εἶδος ἀξιώματος Ῥωμαϊκοῦ. καὶ φυλάττει.

Menander himself uses the word only once in the extant fragments. In a rarely cited passage (frag. 60),[18] a character is described as τῶν μεθορίων λεγόμενος προτίκτωρ (δηλοῖ δὲ παρὰ Ῥωμαίοις τὸν ἐς τοῦτο καταλεγόμενον). He supervised the preparation of ambassadorial lodgings, τοῦτο γὰρ τὸ λειτούργημα ἄνωθέν τε καὶ ἐξ ἀρχῆς τῷ προτίκτωρι ἐπιτέτραπται. This presumably has to do with the duties of a *protector deputatus*. The passage obviously does not imply that Menander himself underwent such service. Given the various nuances of the term, to say that Menander idled around the capital as a *protector domesticus* is to state not a fact but an inference.

Menander would have referred to himself as protector somewhere in his Preface, judging from the fact that the only time he is so styled by the *Suda* is at the very beginning of fragment 1; elsewhere he is plain Menander. The title is confirmed by its presence in the *Excerpta*. If it relates to a period of dissipation as a guard in the capital it is not one by which the historian would have wanted to be remembered; not that he could control how posterity would refer to him. However, it is at least possible that he was a protector in a way that involved some genuine activity as a soldier. If so, this would most likely have happened in the reign of Maurice.

Müller published seventy-six fragments, of which the great bulk derive from the *Excerpta de legationibus*. How unrepresentative they are of the whole work is a matter for subsequent comment. A few (frags. 2, 10, 12, 30, 35a, 44, 59, 61) come from the *Excerpta de sententiis*. The final sixteen emanate from the *Suda*[19] (frags. 1, 7, 31, 53, 56, 58, 67, 68, 69, 70, 71, 72, 73, 74, 75, 76).

These last are inevitably the least reliable. All of them have the name Menander attached, save for fragment 56, a flattering character sketch of Maurice, which Valesius plausibly ascribed to our historian. Yet aside from the first fragment the reference is to plain Menander, which can obviously cause trouble. Hemsterhuis and Bernhardy, in their editions of the *Suda*, and Meinecke, in his edition of Menander, wished to transfer fragment 7 to Menander of Ephesus. Müller cautiously rejected this, but in an addendum (*FHG*, IV, 670) was inclined to reassign fragment 73 to the same Menander of Ephesus.[20]

Nor is this all. The attachment of an author's name does not guarantee that it is the right one. Just as the *Suda* thrice assigned extracts from Theophylact Simocatta to Eunapius,[21] it also gives to Menander items that belong respectively to Theophylact (ed. Adler, P 1245) and Appian (E 3835).

[18] It is not adduced in the best accounts of the *protectores*: E. Stein, *Histoire du Bas-Empire*, I (Paris, 1949), 57–58; A. H. M. Jones, *The Later Roman Empire, 284–602* (Oxford, 1964), 53–54, 636–40; *RE*, suppl. XI, col. 1113f.

[19] The *Suda* also reproduces parts of the *Excerpta* fragments, ed. Adler, *Index Auctorum, s.v.* Menander.

[20] Since frag. 73 follows Agathias 3.5,9 (which it clearly imitates) in the *Suda* entry (ed. Adler, S 901), there is *prima facie* evidence for its being from the pen of Menander.

[21] See Alan Cameron, "An Alleged Fragment of Eunapius," *CQ*, 13 (1963), 232.

For all we know, some of the fragments printed by Müller are wrongly labeled. This is a caveat that will have to be applied to any generalization about the work of Menander.

A related admonition is equally in order. Various anonymous passages in the *Suda* have been credited by different scholars to Menander Protector, largely on the basis of their content, in correlation with passages in the *Excerpta*. However, it will not do to assume that any unassigned quotation in the *Suda* dealing with the period 558–82 has to derive from Menander. At least two other historians covered much the same ground: Theophanes of Byzantium and John of Epiphaneia.[22] Some of our items may belong to them. Linguistic analysis can sometimes be suggestive; in general, however, the Byzantine historians share the same repertoire of stylistic tricks and flourishes to a degree that makes ascription of anonymous passages exceedingly hazardous.

Bearing all of the above qualifications constantly in mind, we may proceed to consider the major features of Menander's work. Its title is given in the *Excerpta* as plain *History*, which is probably right. The same unadorned heading is attached to the narratives of Malchus, Candidus, and Agathias. Priscus of Panium was a little more colorful (or precise): the *Suda* reports his title as *Byzantine History*. Two historians, Eunapius in the fourth century and Hesychius in the sixth, apparently preferred *Chronicle*. The pretentiousness of Theophylact in calling his work *Ecumenical History* was unique. Equally untypical, as in so many things, albeit at the other end of the scale from Theophylact, was Olympiodorus of Thebes: he dubbed his work ὕλη συγγραφῆς. Menander once (frag. 12) refers to his own book as a συγγραφή, in a discussion of his own methodology, but this need have no bearing on his title.

It is just possible that the original heading or subtitle contained something like τὰ μετὰ ᾿Αγαθίαν. That would have a precedent in the case of Eunapius, whose title acknowledged Dexippus in this way. However, this does not appear to have been a very common form of title, nor is it necessary to envisage Menander striving to honor Agathias in such a formal way. The latter was primarily a starting point for his own narratives. As it now stands, his prefatory reference to Agathias is much less honorific than that of John of Epiphaneia;[23] nor does it compare with his own praise of Procopius (frag. 35).

Menander commenced his account in 558, where that of Agathias had been terminated by death. To judge by the *Excerpta*, it seems to have extended to the end of Tiberius' reign in 582. Given the tone of the Preface, however, one might believe that Menander at least intended to continue into the reign of Maurice. It would not follow from the virtual silence of Theophylact that he did not do so. The habits of ancient historians in the matter of acknowl-

[22] Theophanes is known to us only from Photius, *Bibl.*, cod. 64 (*FHG*, IV, 270–71); for John, cf. Evagrius, *HE* 5.24: the one remaining extract is in Müller, *FHG*, IV, 272–76.

[23] John of Epiphaneia calls Agathias the most distinguished *rhetor* in the capital. John was himself a *scholasticus*, which may be relevant to the form of praise here bestowed.

edgment of sources are well known. We know that John of Epiphaneia carried his narratives to 591, though he is never mentioned by Theophylact. It should be kept in mind that the Early Byzantine contemporary histories do not always adhere to what we might choose to think of as the rational bounds of a reign or reigns.[24] It is unlikely that the author's premature death is always the explanation.

In electing to cover a relatively small part of contemporary history in detail, Menander was of course doing nothing new. Nor was it simple emulation of Agathias. Olympiodorus is an obvious early link in the chain, with his twenty-two books on the period 407–25, but the genre is observable at least as early as the third century A.D.[25]

Even on the assumption that Menander stopped where he planned to stop, namely in 582, we do not know in how many volumes his work was cast. Fragment 7 (from the *Suda*) is formally assigned to Menander's Book One, but the item, Thracian treachery, has no chronological bearing, and its authorship is disputed. Fragment 38, which belongs to the year 575 and has to do with the first acts of Tiberius as Caesar for the now insane Justin, is ascribed in the *Excerpta* to Book Six. That would suggest an average of roughly one book for every three years. However, fragment 43, which is formally dated to the second year of Tiberius' tenure as Caesar, is assigned to Book Eight. Niebuhr's contention, in his edition of Menander, that this must be an error is generally followed. Certainly it would leave very little room for Book Seven to have any substantial contents.

No other fragment is ascribed to a particular book. One or both of the two references in the *Excerpta* might be wrong. On the other hand, if fragment 38 is correctly located in Book Six, and if the rough average of one book per three years was maintained, then we could think in terms of eight or nine books for the whole work.

These would have been big books indeed, to judge by the detailed scale of some of the passages preserved in the *Excerpta*: fragment 11, to take the most notable example, runs to a good twenty-two half-columns of Greek text in Müller. Yet in terms of chronological scope, eight or nine books for twenty-four years of history hardly compare with Olympiodorus' twenty-two books for a period of eighteen years, or, for that matter, with Agathias himself, whose five books embrace only seven years of history.

However, it is clearly hazardous to think in terms of averages. All sorts of factors influence the amount of coverage given to particular periods and events. It is certain that the exploits of Maurice under Tiberius would have received full and favorable treatment. Not every embassy, treaty, or military engagement can have been accorded equal space. A particular siege would

[24] Eunapius stopped at 404, though we know from his frag. 87 that he was still alive in 414. Olympiodorus covered the years 407–25, and Priscus the years 433–74 (in each case, the closing date is more "rational" than the opening one). Malchus is more problematic, given the discrepancy between Photius and the *Suda* (cf. B. Baldwin, "Malchus of Philadelphia," *DOP*, 31 (1977), 89–107, for efforts to disentangle it): Photius says he wrote on the period 473–80.

[25] A certain Nicostratus, for instance, covered the period 244–60; cf. *FGrHist*, 98.

have been written up at length as a rhetorical set piece; the same goes for one or two speeches. It does not follow that every siege and every speech is elaborated on the same scale. Fragment 11, with its plethora of speeches and its full account of the individual clauses of the treaty, is obviously exceptional. Here, the detailed treatment is conditioned by the presence of Peter the Patrician as both protagonist and source. Not only does Menander parade his admiration for Peter, but he also employs the latter's own version of events; this was on a scale large enough for Menander to describe it (frag. 12) as a τεῦχος μέγιστον. Hence the disproportionate size of fragment 11.

The point is clinched by sundry observations on the part of Menander himself. In fragment 11 he tells us pointedly why he records the exact text of Chosroes' words to Justinian: ὡς ἂν μὴ ὑποτοπήσοι τις ἑτέρᾳ φράσει παρατετράφθαι τι τῶν ἀληθῶς.... Elsewhere, he candidly states that he is giving only a summary of a treaty's terms (frag. 12), or the gist of a royal letter (frag. 54). The latter case is instructive: we are given only the νοῦς of Tiberius' letter, but Chosroes' reply is in *oratio recta*. This may well amount to a sensible realization that the historian's own creative powers, if not the reader's patience, were finite.

Most of what survives of Menander's work has to do with Eastern affairs. This has prompted some probably unfair modern criticism to the effect that he neglected the West.[26] One has to allow for the process of selection followed in the *Excerpta*. There, Eastern items often predominate for very good and practical reasons: it was not customary for Byzantine historians in the early period to ignore the West. We ought not to be misled by the famous complaint (or excuse) of Eunapius (frag. 74) that an Eastern-based historian could not inform himself about events in the West. The fragments of other members of the sequence of *Profanhistoriker* show that they could and would look beyond the immediate affairs of Constantinople. Photius (*Bibl.*, cods. 78–79) makes a point of this in his comments on Malchus and Candidus.

The example of Agathias is surely sufficient proof of the scope of his conscious successor. Fragments 8, 24–25, 49, and 62 are overtly concerned with the Lombards. A tantalizing item involving a city with seven hills (frag. 71) most likely alludes to Rome, and fragment 72 (on Narses) should relate to the West.

Byzantium was naturally the center of Menander's own world. A feature of his style is suggestive of his feelings: he frequently alludes to Constantinople as βασιλίδα πατρίδα or πόλιν (frags. 9, 28, 43, 47, 49, 54, 63, 64). This was an expression that began to be applied to the city in fourth-century oratory, when it was replacing Rome. To some extent, then, it is a rhetorical ornament. Nevertheless, its use could connote genuine sentiment. The phrase is also used of Rome, and sometimes of Antioch.[27] The Emperor Julian was being passionate as well as rhetorical when he insisted that Rome was ἡ μὲν βασιλεύουσα τῶν ἁπάντων πόλις (*Or.* 1.4). Menander almost invariably applies the

[26] Jones, *LRE*, 303.
[27] For references, see Lampe, *Patristic Lexicon*.

phrase in contexts of people visiting or returning to the capital: Byzantium is *the* place to which one comes. In two passages (frags. 49, 62) he shows his feelings by contrasting the Queen of the East with "Old Rome."

There were few literary sources available to Menander for the actual events covered in his work. It is a moot point whether he used Theophanes or was used by him, or whether the two were independently composing their histories at about the same time.[28] That the two men were both natives of Byzantium need not suggest any sort of relationship.

There is not enough of Theophanes' work remaining to permit any real investigation; nor would detection of similarities necessarily make it clear who was following whom. For instance, in fragment 2 of Theophanes there is a "learned" allusion to the Persians calling the Turks Cermichiones οἰκείᾳ γλώσσῃ. Menander uses this same formula in the context of Turkish rites for the dead (frag. 43). But it does not follow that either of these writers drew upon the other for such exotic information. Such formulae and *flosculi* were literary conventions: a particular item might come from anywhere.

The only contemporary source cited by Menander (not that this is conclusive) is Peter the Patrician, for the Peace of 562 (frags. 11–12). As we have seen, Menander attributes a μέγιστον τεῦχος to Peter. Almost certainly, this does not refer to Peter's own historical work which seems to have terminated around the reign of Julian. His *Book of Ceremonies*, mentioned by the *Suda* in an entry that contains an extract from Menander's commendations (frag. 12), is an obvious possibility.[29] Alternatively, a special aide-mémoire or some particular account of the embassies culminating in the Peace of 562 will be thought of.

For antiquarian, ethnographical, and all such materials, Menander could have gone to any number of sources. Virtually none are formally adduced, but as I have remarked, this means little or nothing. In any case, to judge by the fragments Menander was not in the habit of larding his narratives with the names of other writers. Homer is once brought in (frag. 10), complete with quotation from *Iliad* 6.339; and there is a tortuous reference to Hesiod as the "Ascraean bard" (frag. 35).[30] This latter allusion is in the context of an admiring mention of Procopius, who, perhaps significantly, is praised for his style rather than his content. No other writers, ancient or contemporary, are named in the surviving fragments.

Fragment 12 offers a quite encouraging glimpse of Menander's approach to the writing of history. He thinks it appropriate to give the exact text of a treaty, albeit this is not possible in every case, without any Atticist rewriting. The apology is significant,[31] but it need not rob Menander of all his credit.

[28] Krumbacher, 244, thought Menander might have used Theophanes; Bury (ed. of Gibbon, V, 495) was doubtful. To judge from his terminal date, John of Epiphaneia probably wrote after both Menander and Theophanes.

[29] *Suda* (ed. Adler, P 1406); Peter's Κατάστασις was exploited more than once in the *De caerimoniis* of Constantine Porphyrogenitus.

[30] This was typically Byzantine, of course; Agathias was at it as early as *Praef.* 9, in the case of Aristotle.

[31] Cf. Cameron, *Agathias*, 136.

It is possible that he had read and appreciated Olympiodorus on the importance of content over style.

In the same passage Menander qualifies his use and eulogy of Peter the Patrician by observing that he is on guard against the natural bias of an account of vital negotiations penned by one of the protagonists. This piece of common sense is all the more cogent for being applied to a particular source, rather than being cast in the shape of a generalizing cliché about the historian's own objectivity. Elsewhere there are signs of a skeptical intelligence, of which the statement ἀκήκοα δὲ περὶ...ἐμοὶ δὲ οὐ πιστά (frag. 25) is the most striking.

However, Menander betrays many of the faults inherent in Byzantine historiography. These will be noted in their respective contexts. Apart from echoes and imitations of Thucydides and the classics, the rhetorical nature of some of Menander's narrative can perhaps be most effectively demonstrated by a comparison of his account of Justin's reception of the Avar embassy (frag. 14) with the effusion of Corippus (*Laud. Just.* 3.231–401). Structure and content are very close. In Menander's version, as also in Corippus' (266–68), Justin bids the Avars say what they please. The gifts of Justinian are recalled at the opening of the Avars' speech in Menander and at its close in Corippus (303 f.). Menander, and also Corippus (274 f.), has the barbarians boast of their Thracian conquests. Justin replies in the historian's narrative without any demonstration of his usual temper; Corippus (308–9) is again in harmony: *nulla commotus in ira/tranquillus princeps*. The Avars are struck with fear by the imperial response; the poet (399–400) concurs: *contremuit stupefactus Avar magnoque timore/diriguit*.

It is hardly likely that Menander had either the ability or the desire to read the Latin version of an African poet. The similarities are partly conditioned by the facts, to be sure, but they reflect a common rhetorical way of describing a specific type of episode.

A word may be inserted here on Menander the military historian. Relatively few of the extant fragments bear on this aspect. There are two of some little substance (frags. 31, 58), in addition to fragment 73 (on siege engines) and the exiguous fragment 70, in which a gruesome death is the subject. His account of the siege of Sirmium is commended by Theophylact (1.3,5), which is a bad sign. Sieges regularly brought out the worst in late historians.[32] And there would have been plenty of material for a set piece on Sirmium, a city that was for a long time an imperial highlight in the third and fourth centuries.[33]

Nevertheless, even here there is some cause for optimism. The *locus classicus* for imitation was Thucydides 2.75,5, which contains the words δέρρεις καὶ διφθέρας. The phrase is reproduced by Arrian (*Anab.* 2.18), Priscus (frag. 1b), and Agathias (3.5,10). However, Menander, where the opportunity arose in the opening sentence of fragment 73, eschewed it, preferring βοείοις δέρμασιν.

[32] The most notorious case is probably Priscus, frag. 1b; see E. A. Thompson, "Priscus of Panium, Fragment 1b," *CQ*, 39 (1947), 92.
[33] Cf. F. Millar, *The Emperor in the Roman World* (London, 1977), 47.

Fragment 11, the longest surviving extract, might fairly be used to exemplify some of the virtues and vices of Menander's approach. It is concerned with the delicate negotiations which led to the Peace of 562 between Justinian and Chosroes. The momentousness of this event, along with the fact that the Roman ambassador was Peter the Patrician, whose qualities Menander admired and whose version he followed, suggests that the episode was treated at disproportionate length.

This allows us to see the historian in full flight at various levels. On the darker side is the plethora of speeches. The first one, by Peter, is redolent of Thucydides, with its philosophical veneer and contrived antitheses. It should be noted that the effect is more one of mood than of linguistic pastiche: working through it with the aid of E. A. Bétant, *Lexicon Thucydideum* (Geneva, 1843; repr. Hildesheim, 1961), did not disclose any flagrant borrowings. The artificiality of the composition is betrayed rather by its indulgence in favorite Menandrian tricks of style.[34] Perhaps more revealing is the answering speech of the Persian Isdigunas, which is largely a tissue of effects repeated from Peter's oration.[35]

Another tired device is the edifying tale of Sesostris and his Tamerlane-like treatment of captive monarchs. Peter uses it to curb the arrogance of his Persian opponent. It recurs in Theophylact (6.11,10), and Sesostris is also invoked as the Colchian avatar by Agathias (2.18,5).

On the credit side is Menander's concern to give the exact words of Chosroes to Justinian, his setting down of the main clauses in the treaty, and his provision of a Greek version of the pretentious opening of the Persian ratifying document with all of the Persian monarch's titles. The presence of a *hapax legomenon* εἰρηνοπάτριος here may be a tribute to Menander's striving after accuracy: he is not, at any rate, given to neologisms.[36]

Menander's inclusion of a detailed account of the treaty terms has evoked surprise from a most expert quarter.[37] It does appear to be something of a novelty, the sort of thing one might more easily have associated with an Olympiodorus of Thebes. The explanation may simply rest upon the dominating presence of Peter the Patrician as protagonist and source, as I have mentioned. Or, paradoxically, the item can be explained as stylistic *imitatio*. In a passage replete with Thucydidean-sounding speeches, would not the detailing of treaty terms handily conjure up the exposition of the provisions of the Peace of Nicias?

Whatever else may be said, we should be grateful to Menander for his full account of the provision and exchange of Greek and Persian texts of the

[34] E.g., the figurative use of παραπέτασμα (frags. 9, 60), or πέφυκε in the sense of "is," frequent in the speeches and aphorisms of Menander but not employed in his ordinary narratives.

[35] For instance, the noun περιττολογία and the phrase πρότεροι διαλεγόμενοι occur in both; Chosroes and Justinian are advertised in much the same terms; both legates have a prepared piece on Antioch; and so on. Thematically speaking, of course, such counterpoint is realistic enough.

[36] The only other one perhaps is ἀπατωλογισμός, also in frag. 11; it is printed as one word by Müller, but as two in Migne's text of the *Excerpta*. For Chosroes' title, cf. frag. 43, where Valentinus dubs the Byzantines εἰρήνης ἐργάται.

[37] Cameron, *Agathias*, 136.

agreement between the respective parties and the associated formalities.[38] To what extent he felt his Byzantine audience needed this background information, assuming that it was normal procedure, is an interesting question. One has the uneasy feeling that many of his readers would have preferred such items as fragment 20, the visit to Dizabulus the Turk, with its exotica, "learning," and reminiscences of Priscus' account (frag. 8) of the journey to the camp of Attila.

Menander's views on the emperors can at least be glimpsed from the fragments. He seems inclined to portray Justinian in the best possible light, albeit not constrained by that emperor's living presence. For seducing the Saracens by gifts (frag. 15), he is μεγαλόφρων ἀνὴρ καὶ βασιλικώτατος, whereas Justin is ἐμβρίθης for ignoring them. His policy of purchasing Utigur aid against the Cotrigurs is narrated without comment (frag. 3). For not launching war against the Avars, Justinian is commended by the senate as ἀγχίνους, and by the historian for ἐμφρονέστατα προμηθευσάμενος, which is suggestively close to his prefatory praise of Maurice (προμηθέστατα). It is not a Freudian slip when Peter calls him δεσπότης (frag. 11): the term is variously applied to Chosroes and others (frags. 17, 18, 28), and becomes a standard Byzantine word for emperor.

Fragment 4 is the most striking. Justinian's failure to attack the Avars is excused on the grounds of old age and feeble health. This passage is clearly modeled on Agathias' handling of the same theme (5.14,1), a treatment cast in more general vein. Like Agathias, Menander takes care to remind his readers of Justinian's earlier successes in Africa and Italy. It should also be borne in mind that there is something of a *topos* involved: Menander says very much the same sort of things about Chosroes (frag. 35).

The panegyric of Corippus does not reflect later Byzantine judgments upon Justin. This ruler is generally severely handled by the Greek sources.[39] Overall, Menander may have been less harsh. There is both implied and overt approval of his cancellation of subsidies to the Avars (frags. 14, 29), though the language used by the Emperor is once categorized as μεγαληγορίᾳ πολλῇ (frag. 28). For wishing to be φοβερώτατος in the eyes of the barbarians (frag. 15) Justin is neither praised nor blamed. The Emperor's dismissal of John Comentiolus for sending envoys to Suania (frag. 16) is implicitly approved by the reference to imperial νουνεχεία, a distinctive term in the historian, in patching up the damage caused (frag. 17). The simple reference to Justin's insanity in the first sentence of fragment 37 does not permit us to see how this tragic event was handled.

When Justinian subsidized Saracens, he was βασιλικώτατος. For rejecting Avar overtures, Justin is said to have βασιλικῶς ἐχρῆτο τοῖς ῥήμασιν (frag. 29). Menander's handling of this whole question of the rival policies of subsidies and war is as fraught with inconsistencies and ambiguity as that of Agathias.

[38] For a paraphrase and comment, cf. J. B. Bury, *History of the Later Roman Empire (A.D. 395 to 565)* (London, 1923), II, 120–25.

[39] See *ibid. (395 A.D.–800 A.D.)* (1889), II, 73.

To a degree, Menander's treatment is conditioned by Agathias', at least in the case of Justinian.

"In fact, albeit unconsciously, Agathias reflects both sides of the essential duality in contemporary attitudes to Justinian. Probably, indeed, he was evading a direct judgement." These sensible remarks of Mrs. Cameron[40] may not be quite the whole story. What we see in these historians is also surely a struggle between head and heart. All patriotic Byzantines must have yearned to see old glories restored and the barbarians smashed, but they were aware of the impossibility of this dream. Hence the emotional tension reflected in the pages of Agathias and Menander.

Thus the cautious and conciliatory policies of Tiberius are frequently endorsed. His decision not to aid Italy against the Lombards because of unavoidable Eastern needs is twice discussed and apparently condoned (frags. 49, 64). His responses and policies vis-à-vis Persia are praised for their prudence and foresight (frags. 40, 46). The Emperor's restoration of royal Persian hostages to Chosroes (frag. 51) is singled out as an act particularly pleasing to God.

No ambivalence attends the surviving remarks on Maurice, the inspiration and putative hero of Menander's history. Even if fragment 56, an encomium upon the all-encompassing virtues of the Emperor, is not by Menander, which seems unlikely, what remains is still untempered compliment.

In the Preface, he is both patron of letters[41] and protector of the people. Before his own accession he was totally loyal to Tiberius (frag. 47). His old-fashioned sense of military discipline permits Menander a chance to indulge in the hackneyed business of restoring order among the soldiers by making them dig ditches and fortify camps (frag. 58). Εἰκότως is the historian's word for his decision to avenge the ill-treatment of Roman envoys by Hormisdas (frag. 55). The piety of Maurice is much stressed:[42] he is both Christian warrior (frag. 57) and Christian champion of abused taxpayers and subjects (frag. 59).[43] Not that his virtues are invariably linked to the Almighty; he is also paraded as a man as provident as any can be against the uncertainties of war (frag. 59). That is high praise from Menander, with whom the mutations of fortune and man's inability to reckon with them are something of an obsession (frags. 10, 30, 44, 61).

It is not impossible that Menander ventured some criticisms of Maurice in the manner of Theophylact. His treatment of Peter the Patrician, for instance, shows that he is not necessarily blinded by hero-worship. It is true that much of his praise of Maurice is cast in platitudinous terms, but that need not mean that it is cool or enforced: platitudes as often as not connote sincerity.

Menander's attitudes to a few other individuals can be discerned from time to time. Not only does he in his own *persona* commend Peter's learning and

[40] Cameron, *Agathias*, 126.
[41] A tribute echoed by Theophylact 8.11,13.
[42] This could lead him into excessive respect for priests: Theophylact 1.11,20.
[43] Theophylact (8.7,3), however, concedes a tendency toward avarice.

legal expertise, but he also makes Chosroes (frag. 11) and John Comentiolus (frag. 15) issue similar compliments, an effective way of suggesting how widespread Peter's fame was.

Also on the Roman side, there is a short comment on the military successes of Narses, tempered by his retreat on an unspecified (thanks to the exiguity of frag. 72) occasion. The snippet again suggests Menander's ability to keep his heroes in perspective. Needless to say, an imitator of Agathias would have derived at least some of his approval of Narses from that quarter.[44]

Fragment 37 emphasizes the major role played by Sophia at the outset of Tiberius' tenure as Caesar (the claim is repeated in the beginning of frag. 38 also). She receives the Persian envoy and sends her reply through the court doctor Zacharias, who, it is made clear, is her creature rather than a professional diplomat.

Is this to be construed as criticism of petticoat government and, by extension, censure of Tiberius? Perhaps; but we do not know enough about Menander's attitudes toward women in general or this Empress in particular to say so with any confidence.[45] And it should be noted that Zacharias recurs on similar missions for Tiberius (frag. 60).

Of the enemies of Byzantium, Hormisdas, son and successor of Chosroes, is painted in darkest colors as ἀνοσιουργὸς ὄντως ἀνήρ, whose fierceness is contrasted with the humane mildness of Tiberius (frag. 55). He is similarly condemned by Theophylact (3.16,7 f.). In the fragments of Menander, Hormisdas is the "stage Oriental" rather than old Chosroes.[46] There is one interesting point about the latter worth bringing in here. In fragment 11, as we have seen, Menander provides the Greek version of Chosroes' titles. Although he is "Giant of Giants" and such, not one of his epithets denotes a conquered race. One cannot help thinking of a passage in Agathias (1.4,3) where Theudebert objects to Justinian's penchant for such titles. Could Menander be making a subtle comment?[47]

Dizabulus, the Turkish king, is ἀγχίνους καὶ δεινός (frag. 18), a common formula of esteem that is used elsewhere of Sebochthes (frag. 36). The Persian envoy Andigas is ἐχέφρων, experienced, and wise with age (frag. 60). More condescending, and perhaps more typical, is the judgment on the Persian general Sapores (frag. 50): his fame is that of a man who was οὐκ ἀγεννής.

On barbarians and foreigners in general, Menander can sometimes be objective and discriminating on levels other than individual. The Persians are recognized as being on a par with the Romans as τὰ μέγιστα τῶν πολιτευμάτων (frag. 11). Sandilch the Utigur chieftain is allowed a sense of honor both when he lectures Justinian on the ethics of barbarians not attacking other barbarians (frag. 3) and when he stresses the common bonds between such

[44] See especially 1.16,1–2; cf. Cameron, *Agathias*, 51.

[45] The toughness and ambition of Sophia is a theme of John of Ephesus (3.7).

[46] Menander may have been unusually mild on Chosroes; Procopius was very hostile (*BP* 2.9,8–9, for instance).

[47] If so, ambiguity would return to plague us, since in *his* ratificatory document (frag. 11), Justinian indulges in no title mongering of his own.

peoples (frag. 4). It is possible that the brief surviving comment on Odigar as "the greatest of Hunnic generals" (frag. 69) originally led to some genuine praise.

By and large, however, Menander does not rise above the habits of the age. It is asserted without qualification that barbarians have an innate tendency to be fierce, foolish, and fractious (frag. 48). Foreign ambassadors are invariably arrogant when they address emperors or their Roman counterparts, whether they be Persian (frag. 11), Turk (frag. 43), or Avar (frag. 64). Ethnic discrimination is hardly possible, for boasting is a mark of φρόνημα βάρβαρον (frag. 10). Attitudes like this once led Menander into calling Persia the "Eastern Barbarian" (frag. 11).

This sweeping generalization is ubiquitous. Thracians break oaths (frag. 7); Avar treatment of envoys breaks the law of nations regarding the respect owed to diplomats (frag. 6); the Saracens are a quarrelsome race (frag. 15); and so on. One absurdity is worth pointing out: barbarians, it is alleged, cannot even row boats properly (frag. 63)!

When foreigners are approved, it is frequently with a note of condescension. Biganes, although a barbarian, prefers honor to wealth (frag. 57); a proverb may be barbarian but even so has truth (frag. 10); the luxurious trappings of Dizabulus are summed up as οὐδέν τι ἀποδέοντα τῶν παρ' ἡμῖν (frag. 20).

All of this is terribly familiar from the pages of Procopius and Agathias.[48] One final example, however, might indicate a certain, no doubt unconscious, parody of such prejudices, or at least a nice sense of dramatic irony on the part of Menander. Fragment 18 informs us that the Scythian race is παλίμβολον; this is advanced as a Persian credo. Yet in the very next sentence it is Chosroes who poisons the Turkish ambassadors' food!

It has long been debated whether Agathias was Christian or pagan. In my view, Mrs. Cameron has decisively settled that issue in favor of the former.[49] No such controversy was ever possible in the case of Menander: his aforementioned poem on the martyr Isbozetes marks him as unambiguously Christian.

It might be a fair presumption that Agathias must have been a Christian, otherwise the pious Menander would not have acknowledged him so openly as inspiration and model, especially in a preface honoring the devout Maurice. However that may be, to know that we are reading a Christian historian is valuable when studying Menander's phraseologies and use of objective formulae.

Some of his references would have looked cool, even subtly hostile, had they stood alone. For instance, the definition of Christianity as τὴν καθ' ἡμᾶς δόξαν (frag. 11) or hymns as καθὰ νενόμισται ἡμῖν in the same passage. Even such a sentiment as ὁ θεὸς ἐκόλασεν the pride of Rome (frag. 11) would not by itself have been conclusive. But there can be no doubt about the sentiment that Sebochthes was ἀγχίνους because he had Christian sympathies (frag. 36).

[48] See Cameron, *Agathias*, 116–17, for a valuable discussion.
[49] *Ibid.*, 89–111 (cf. 89 note 1 for a conspectus of scholars and opinions).

Given that we know where Menander stood, his use of such formulae as τὸ κρεῖττον (frag. 11) and τὸ θεῖον (frag. 59) serves to illuminate their meaning in Agathias. The tone of his writing suggests that Menander was enthusiastic in his beliefs. A merely conforming writer would hardly have wished to obtrude such opinions as the one that Theodorus was "wise" to say that a city defended by God cannot be taken (frag. 41). The emphatic and repetitive nature of the extracts preserved in the *Excerpta de sententiis* (see *supra*, p. 105) hints at a preachy historian. Given his hectic youth and the confessional tone of his Preface, we may be dealing with the fervor of a convert or a reformed sinner.

A miscellany of items bearing on Menander's methods and opinions may be gleaned from the surviving fragments. It is not always clear whether a remark springs from personal experience or simply a rhetorical repertoire. For instance, does the observation that all men naturally yearn for their native land (frag. 47) contain any autobiographical clue? Or could the two aphorisms on the evils of civil war and the one on tyranny (frag. 30) have any bearing on the usurpation of Phocas?

We encounter the overly familiar when we learn that wisdom comes with age (frag. 60) or that the common people are a φιλοτάραχον χρῆμα (frag. 30).[50] The noticeable iteration of the emphatic οἶμαι, not a common habit of Menander, in a passage of obtruded learning (frag. 20) may arouse a suspicion that the intent is to conceal a literary debt or borrowed erudition.[51] However, the sage observation (frag. 11) that much diplomatic rhetoric is designed solely for bluff and counterbluff, the appreciation of Suania's geographical significance as out of all proportion to its intrinsic value (frag. 15), or the comments on the strategic position of Daras (frag. 47) do a good deal to restore some respect for Menander as a historian of sense and discernment.

Enough remains of Menander to allow delineation of the main features of his style and language. He is notably capricious in the vexed area of ethnic nomenclature. Persians are sometimes Persians, sometimes Medes; similarly, the archaic Colchi is interchanged with the modern Lazi; both pairs are used indifferently within the space of two sentences in fragment 3. The presence of Assyrians in fragment 11 is notable, especially as it occurs in the peace treaty clauses.[52] Like Agathias,[53] Menander is not afraid of including Avars (frags. 4, 6, 9, etc.) without explanatory or apologetic formula; the same is true of Huns (frags. 3, 69), Slavs (frag. 47), Goths (frag. 30), and even such outright modernisms as Macrabandi and Taranni (frag. 41). The relative absence of that common Byzantine affectation, whereby contemporary tribes appear behind the mask of Scythians or Massagetae, is very welcome. Yet Turks are sometimes admitted unadorned (frags. 10, 18), whereas on other occasions Menander adds an explanatory phrase (frags. 19, 43). This same

[50] Cf. Agathias 2.11,2, 3.11,1, and elsewhere for similar time-honored banalities on the mob. The wisdom and age cliché may be compared to Menander's pejorative use of μειρακιώδης (frag. 37).

[51] The οἶμαι used to strengthen Menander's view of the childishness of Chosroes' letter (*supra*, note 50) should be taken into account.

[52] See *AP* 9.810 for an Assyrian triumph commemorated by a statue.

[53] See Cameron, *Agathias*, 82, for the procedures of Agathias in this respect.

inconsistency is manifest with some toponymns: plain Pannonia in one place (frag. 63), the same province with explanation in another (frag. 9).

Another instructive area is military terminology. Here, imprecision and a striving for variety are discernible. For instance, the leader of the Saracens is once called φύλαρχος (frag. 17), the appropriate designation of a confederate chieftain.[54] On other occasions, barbarian leaders are referred to as ἄρχων (frag. 6) or ἡγέμων (frags. 10, 11, etc.). From time to time a Turkish or Avar leader is properly called Chagan (frags. 12, 27, 63), whereas Theophylact (1.3,8) finds an explanatory formula necessary on its introduction into his narrative. It is interesting to observe the word μόναρχος applied to both a Lombard leader (frag. 24) and a Turk (frag. 43). Equally striking is the term γενεάρχης, attached to Persarmenian leaders (frag. 47) and also employed in a letter from Chosroes to Tiberius (frag. 54). Conspicuous by its absence throughout is the word ῥήξ.

This brings us to the question of objective formulae and Latinisms. As is usual with the Byzantine historians, no set principle is observable. In a purist mood, Menander will resort to cumbersome periphrases to avoid *comes* (frag. 7), *magister* (frag. 11), or prefect (frags. 15, 19, 28). Roman officers appear as *strategos* (frags. 11, 19), hyparch (frag. 28), or taxiarch (frag. 34). Transliterations of the order of δούξ are never seen.

However, μάγιστρος appears three times without apology in fragment 11 and with a formula elsewhere (frag. 55). It could be that realism supersedes formula, since these usages occur in reproductions of treaty clauses and diplomatic letters. There is a similar case with *cubicularius*, employed in the same context not long after Menander had resorted to παρευνάστηρ to avoid it. There are other signs of the influence of content on language; plain μοναστήριον crops up in a section of treaty clauses (frag. 11), while the blatant Latinism κεντηνάρια is found in a passage dealing with Italian concerns (frag. 49).

Other notable Latinisms with objective formulae include particularly ponderous references to quaestor (frag. 39) and *comes sacrarum largitionum* (frag. 46), the reiteration of *protector* with and without explanation (frag. 60), two mentions of the month of August[55] (frags. 19, 41), an explanation of *naves longae* (frag. 48), and three allusions to the word *sacra* (frag. 11). The most striking plain Latinism, albeit one by no means unique to Menander, is ἀσηκρῆτις (*a secretis*) in fragment 55. It is worth noting, finally, that Menander generally explains his words as Latin (frags. 11, 19) or Roman (frags. 46, 60) terms, eschewing such pettifoggery as τῇ νεωτέρᾳ γλώσσῃ (Theophylact 6.3,6).

Very striking, given his indisputable faith, is the avoidance of Christian terminologies, apart from the aforementioned μοναστήριον.[56] Allowance must obviously be made for the fact that relatively few of the extant fragments bear on the subject. Still, one cannot help remarking the variety of ways by

[54] Cf. Thompson, "Olympiodorus of Thebes" (*supra*, note 12), for this point.
[55] Similarly, Agathias (3.28,1) gives December (with formula).
[56] In this context, observe νεώς for church (frag. 11).

which Menander avoids saying ἐπίσκοπος: ὁ μέγιστος ἱερεύς (frag. 27); τὸν προε-
στῶτα τῶν ἱερῶν τοῦ Χριστοῦ (frag. 57, repeated with slight variant in frag. 62);
ἱερεύς, ἀρχιερεύς, and ἱερουργός (frags. 57, 62); ὁ τὴν ἀρχιερωσύνην διέπων (frag. 63).
Just as eye-catching are the phrases used to denote the Bible: τὰς θεσπεσίας
βίβλους and ταῖς ἁγίαις διφθέραις (frag. 63). All of this represents Menander's most
patent affectation, admirably illustrating the tension between style and content
in Byzantine historiography.

All the speeches in the extant fragments represent diplomatic exchanges
(frags. 3, 6, 11, 15, 17, 18, 20, 27, 29, 43, 55, 60, 64). Clearly, Menander makes
the most of the most natural context for such exercises. Looking beyond what
has been preserved, it is difficult to think that he would not have composed
some speeches for generals to deliver before battles. As to the general nature
of Menander's confections, little need be added to the earlier discussion of
Peter the Patrician's effort in fragment 11. Romans, Persians, Avars, Turks—
all are marvelously capable (as are their interpreters!) of orating in the same
style with the same repertoire of linguistic effects. This is not to say that a
speech in Menander can never have any relation to the original. Fragment 11,
for example, could well reproduce much of what was contained in the accounts
of Peter the Patrician himself. But one has only to recall the very long tradition
of including speeches in historical narratives: for the Byzantine epigones,
Thucydides was both their prime influence and chief sanction.

The display of learning or pseudolearning is very much a stylistic feature
which can take several forms. Perhaps the simplest level is a parade of
references to ancient writers. To judge from what survives, Menander did
not much engage in this: a Homeric tag (frag. 10) and a circuitous allusion
to Hesiod (frag. 35) are the only items on display. Two cognate demonstra-
tions of classical learning are the Sesostris anecdote in fragment 11, discussed
earlier, and the mention of Aeetes (frag. 3); this latter item, on inspection,
turns out to be a minimal version of the more elaborate reference in Agathias
(3.5,4).

Menander is more addicted to the exotic. Genuine interest should not be
precluded, but when he talks about such things as Persian banquet customs
(frag. 20) one suspects that his chief concern is to give the impression of a
Herodotus at work. Some effects are inspired by closer sources. We have
already seen that his account of Turkish wine (frag. 20) is paralleled by
Priscus on Hunnic beer. Similarly, the mentions of Turkish rites of the dead
(frag. 43; cf. frag. 15) are partly owed to an Agathian disquisition (2.24,10).
The repetition of effects such as the two Golden Mountains Ektag and Ektel
(frags. 20, 43) is not unreasonable since they do seem to be quite different
places,[57] but it may imply a limited store of such learning.

The quality of Menander's information is hard to assess. He seems, for
instance, to be mistaken about the Furdigan festival (frag. 15).[58] On the other

[57] See the discussion in Bury, ed. of Gibbon, IV, 540. Cf. also Gy. Moravcsik, *Byzantinoturcica*, II
(Berlin, 1958), 122.
[58] According to Niebuhr, followed by Müller.

hand, there is no reason to believe that he could not have found out the correct facts concerning the type of concubine given to Zemarchus or the meaning of the term Tarchon (frag. 20).[59] The occasional item is more a piece of vague dramatic coloring than solid information: the elaborate barbarian oath of the Avar Chagan (frag. 63) falls into that category.

Apart from the description of Dizabulus' court (frag. 20), which owes a fair amount of its structure and content to Priscus on the camp of Attila,[60] Menander would appear to have kept excursuses and digressions in reasonable check. The vivid accounts of geographical and topographical hazards found in some passages (frags. 18, 21, 60) are all expressly included to explain their consequences for military strategy or the progress of a delegation, hence are quite defensible. Descriptions of the golden trappings of Turkish or Avar leaders (frags. 20, 65) or the Turkish "Devil Dance" put on before the Roman envoy Zemarchus should not be dismissed as padding or journalism, since many of Menander's readers would not have been well informed on such things. One item is worth noting as possibly indicating autopsy on Menander's part:[61] the particular knowledge displayed of the city of Theodosiopolis, including the names of its northern and southern suburbs (frag. 41).

Turning to linguistic matters, one observes the medley of Atticisms and late usages common to the historians of the period. Some items that turn up in Menander had been satirized centuries before as hyper-Attic by Lucian (*Lexiphanes* 21): ἀμῆγέπη (frag. 55), δήπουθεν (frags. 9, 11 [five times, both in speech and narrative], 18, 38, etc.), ἄττα (frags. 11, 12, 15, 17, etc.). Other noteworthy features include ἀμωσγέπως (frag. 3) and quite frequent indulgence in the dual (frags. 4, 8, 11, 12, 20, 40, 47— of both natural pairs and such couplings as pairs of envoys, kings, etc.).

Related effects are on the order of θροῦς, the Attic form of θρόος (frag. 18) and ἐν χρῷ (frag. 73). Occasionally, Menander may have been led into false purism by unreliable lexica. For instance, in fragment 27 he employs αὐθαδιάζομαι, recommended by Phrynichus for ἀναιδεύεσθαι but in reality mainly a late usage.[62] We may smile also over the conceit ἐπαλαλάζειν τὸ ἐνυάλιον καὶ παιανίζειν (frag. 31), a most unlikely occurrence in a Byzantine army (cf. Theophylact 1.9,8, and 2.16,1).

The visibly late usages are standard: οἰκεῖος as a personal pronoun (frags. 3, 6, 10, 14, etc.); ἐς with the accusative for ἐν with the dative (frag. 9); ἐν and the dative indicating motion to a place (frags. 11, 14, 16, 17, etc.); and so on. Late words unsurprisingly are not always avoided (or avoidable); some notable cases are: φορολογία (frag. 14); ἀδελφότης (frag. 11) and the related κυριότης (frag. 28); and the technical term σπαλίων (frag. 73).

Various ingredients make up Menander's style. The obvious influence of Agathias need only be noted here, since it has been abundantly documented

[59] Cf. Moravcsik, *op. cit.*, 299.

[60] The accumulation of similar details (barbarian drink, giving of women to envoys, description of royal enclosure, etc.) is ultimately suspicious.

[61] It could, of course, equally well derive from a source (written or oral).

[62] Cf. C. A. Lobeck, ed. (Leipzig, 1820; repr. Hildesheim, 1965), 66.

by Apostolopoulos (see *supra*, note 1). Classical echoes and imitations are too many to classify, and are often as much a matter of mood and tone as actual linguistic borrowings. There are poeticisms from time to time, such as the Homeric ἱππόβοτος and ἀναιμωστί, both in fragment 60; δρομάς applied to ships is another interesting item.[63] Effects such as the placing of πέρι after its noun (frags. 4, 10, 11, 12, 15, 17, etc.), or the sole extant case of dating events by the seasonal method of Thucydides[64] (frag. 41), go into making up the overall motley style.

One item may indicate some skill in reworking small points on Menander's part. In fragment 3 he has the adjective ὁμόσκευος. *LSJ* records this word only from Thucydides 2.96 and 3.95, in which it is employed in the context of barbarians and is coupled with ὅμορος, an epithet eschewed by Menander in the present extract in a sequence of three ὁμ-formations. This is not a major matter, but possibly suggestive of his methods of borrowing and adaptation.

Menander indisputably strove after style. Some little tricks and flourishes are discernible. For example, he often gives πέφυκε in the sense of "is" but restricts it to speeches and aphorisms (frags. 3, 6, 10, 11 [on 4 occasions], 15, 27, 29, 43, 48, etc.). Certain phrases tend to recur: ἀφανίσαι ἄρδην (frags. 3, 4, 29, with slight variations), or θυμῆρες with dative of person concerned (frags. 1, 9, 12, 35) may be cited. Favorite words can also stand out, of which δορυάλω-τος|δοριάλωτος (frags. 4, 6, 11, 20, 27, 45, 46, 55) is a good example.

Certain fluctuations probably perturb the modern reader more than the ancient. Menander can, for instance, use αὐτοκράτωρ and βασιλεύς of the emperor in the same sentence, albeit that had been happening for centuries.[65] And problems with foreign nomenclature should earn some indulgence for the mutations Targitius-Targites[66] (frag. 28, in the space of two sentences) and Daurentius-Daurites (frag. 48).

Particularly distinctive of Menander's narrative is the colorful language he so often employed in diplomatic exchanges. Ammigus the Frank promises to fight on as long as he can hold a spear (frag. 8); the Turkish chieftain Silzibulus mocks the Avars for not being birds and fishes who can fly or swim away from their enemies (frag. 10); a barbarian proverb about dogs is adduced in the same extract to deter a Hun (frag. 10); a Turkish envoy boasts that his nation's enemies will die like flies (frag. 43). All of this, the opposite of the formal transactions of diplomats, interpreters, and potentates, may, one hopes, be as much a reproduction of the actual records as the result of artistic rewriting.

Ultimately, it is impossible to assess properly the worth of a historian whose work survives only in fragments, however considerable. The lack of other narratives for the period prevents us from testing the reliability of

[63] *LSJ* gives only δρομάδας ὁλκάδας, Aristophanes, frag. 470; cf. δρόμωνας, regarded by Procopius, *BV* 1.11,16, as a modernism.

[64] Cf. Cameron, *Agathias*, 62, for Procopius and Agathias in this regard.

[65] See Millar, *op. cit.* (note 33 *supra*), 499, who finds the phenomenon in Artemidorus Daldianus 5.16 "remarkable."

[66] In Corippus, *Laud. Just.* 3.258, he appears as Tergazis.

Menander's content. If what we have is a fair sample, he was at least at times a critical historian who used sources and witnesses with sense and discrimination. That the natural center and focus of his world was Byzantium did not blind him to events in the West. In such prejudices as those evinced toward barbarians he is typical of his age. With regard to religion, he appears to be a good deal more than a mere conformist.

For us, Menander is the penultimate figure in the sequence of historians from the fourth to the early seventh century. It is probably fair to conclude that, with the exception of his unambiguous Christianity (a factor that is tempered by his avoidance of Christian terminologies), Menander is a good deal closer to his predecessors than to his successor Theophylact Simocatta. In terms of style, at least, that is no small blessing.

Appendix

Some anonymous fragments ascribed to Menander Protector

The following twenty-two anonymous passages in the *Suda* have been conjecturally ascribed by various scholars to Menander. Sometimes with reason, sometimes without (as Adler twice remarks in the case of Toup). There is not usually a great deal that can be said either way, since it is a case of assigning fragments to a writer whose work itself survives only as such. The following remarks are offered in a spirit of caution and modesty.

> A 2394: Ἀνεῖτο δὲ αὐτῷ ἡ κόμη, καὶ ποτὸν ὕδωρ ἦν: ἀντὶ τοῦ ἀπολελυμένη ἦν. περὶ Σαμουὴλ τοῦ προφήτου φησίν. Ἀνεῖτο δέ, ἀντὶ τοῦ ἀνέκειτο. ἐπεὶ δὲ ὁ Ναρσῆς, ὁ τῆς Ἰταλίας στρατηγός, ἐς πάντα ξυγκατεμίγνυε τῷ μεγαλουργῷ τὸ νουνεχές, καὶ ἐκοινώνει αὐτῷ τῆς φρονήσεως ἡ ῥώμη καὶ ἅπας τῷ κρείττονι ἀνεῖτο, ταύτῃ τοι οὐ πρὸς τὸ ἐμμελὲς ἐκκλίνας, αὐτίκα καὶ ὅγε ἐπεραιώθη τὸ ῥεῖθρον σὺν τῷ ῥεῖθρῳ.

The first sentence derives from John of Antioch. It is always worth noting with which historians possible passages of Menander are transmitted in the *Suda* (cf. my earlier discussion of frag. 73, which accompanies an extract from Agathias). From ἐπεί to the end was assigned to Menander by Toup and Bernhardy.

We know from frags. 8 and 72 that Narses features in Menander's narrative. The latter passage suggests a generally approving attitude, which we would expect from the continuator of Agathias. The present extract contains the word μεγαλουργός, which is applied to Narses in Agathias 1.16,1. Notice also the distinctively Menandrian τὸ νουνεχές (see *supra*, note 8). On grounds of both content and language, this fragment is very likely by Menander.

> B 401: Βόσπορος, πόλις περὶ τὸν Ἑλλήσποντον, ἣν Βωχάνος ὁ Τοῦρκος ἐπὶ Ἰουστινιανοῦ βασιλέως ἐπόρθησε.

For the attribution, cf. E. Stemplinger, in *Philologus*, 63 (1904), 619; De Boor, in *BZ*, 23 (1914), 12.

The capture of Bosporus by Bochanus is mentioned both at the end of Menander (frag. 43) and in the opening of fragment 45. However, this event took place in the latter part of Justin's reign, when Tiberius was Caesar. Menander would not have given such a date incorrectly. Either the fragment is not his or the allusion to Justinian is a textual error for Justin.

D 579: Διακεχαραγμένος: ξίφεσι πεπληγμένος. ὁ δὲ διεσώθη εἰς τὸν Ναρσῆν δια-
κεχαραγμένος τὸ σῶμα.

The last sentence is ascribed to Menander by Bernhardy. There is a linguistic point to support this. The word here illustrated by the *Suda* occurs in the phrase ξιφειδίοις διεχαράξαντο, in Menander, fragment 43 (in the context of Bochanus and Bosporus, interestingly enough). This provides the only example of the verb in this sense in Lampe. Its presence here may constitute some sort of case for assigning the fragment to Menander; the mention of Narses neither helps nor hinders.

D 1193: Διοπτῆρες: οἱ ἐπιτηρηταί, οἱ προφύλακες. καταχεομένου τοῦ ἐξ ἐπιτεχνή-
σεως ὄμβρου τῶν Ἀβάρων καὶ συννεφοῦς ὄντος τοῦ ἀέρος καὶ ἐσέτι σκοτώ-
δους οὐχ οἷοί τε ἐγένοντο οἱ διοπτῆρες διαγνῶναι ἐπιόντας τοὺς δυσμενεῖς.

Bernhardy awarded this passage (from καταχεομένου to the end) to Menander, adducing fragment 21. The latter passage is certainly very similar, involving scouts in bad weather conditions, to an episode concerning Turks and Romans. However, the very closeness may suggest something of a standard set piece, and it does not follow that Menander should be the author of both.

E 498: Ἐκμελές: ἠμελημένον. ὁ δὲ δὴ Βῶνος οὐκ ἐς τὸ ἐκμελὲς αὐτῷ οὐδ' ἐς τὸ
ῥᾳθυμότερον ἐτράπη ὁ νοῦς, ἀλλὰ συντόνῳ τῷ τάχει πρὸς τὴν σωτηρίαν
ἐχρῆτο. καὶ τἄλλα πάθη κατὰ τὴν ἐκμελῆ λύραν ἐθεραπεύετο. φησὶν Εὐνά-
πιος. Ἐκμελὴς οὖν ἢ κακόηχος. ὅτι καὶ Θεοδόσιος ὁ βασιλεὺς ἐκμελὴς ἦν καὶ
πάσῃ ῥᾳθυμίᾳ ἐκκείμενος.

From ὁ to ἐχρῆτο was ascribed to Menander by Mai. The general Bonus features in Menander (notably frags. 27, 31). Assuming he is to be equated with the quaestor of Moesia lauded by Agathias (1.19,1), praise of Bonus by Menander would come naturally. The phrase οὐδ' ἐς τὸ ῥᾳθυμότερον ἐτράπη ὁ νοῦς is paralleled by a boast ὅμως δὲ ῥᾳθυμίᾳ τὸν νοῦν οὐκ ἐπιτρέψω given to John Comentiolus by Menander (frag. 15) as a specifically Roman quality. It is at the very least possible that for reasons of content and language the fragment is by Menander.

E 2452: Ἐπίλυσιν: ἔφοδον. ὁ δὲ πέμπει Ἰωάννην, ὡς ἂν προφυλακῇ χρήσοιτο καὶ
προκαταμάθοι τὴν ἐπίλυσιν τῶν βαρβάρων.

From ὁ to the end is assigned to Menander by Burney. There is no real clue as to authorship. The John in question might be the John Comentiolus of Menander, fragment 15 and elsewhere, but there are obviously too many Johns in the history of the period to permit any identification.

E 2470: Ἐπιμεμφόμενος· πρός γε καὶ πλεῖστα ἐπιμεμφόμενος ἦν τοῖς Πέρσαις, ἅτε
δὴ πρὸς αὐτῶν ἄδικα πεπονθώς.

Given to Menander by Gaisford, to Aelian (without any reason) by Adler. The Persian reference is no particular help, and I see no way of making even a reasonable guess as to the author.

H 42: Ἡγεμών, ἡγεμόνος καὶ ὦ ἡγεμών. ἡγεμόνας ἐδέοντο τῆς ἀτραποῦ σφίσι
ξυναποστεῖλαι, ὡς ἂν αὐτοὶ ἡγήσοιντο τούτοις ἐπὶ τὸ Σίρμιον.

From ἡγεμόνας to the end was assigned to Menander by Bernhardy. Mention of Sirmium is tempting, in view of fragments 25–27 and 63–66, but it has been shown what a large role this city played in earlier imperial history, which fatally widens the range of possible authors. For easy example, the fragment might bear on the city's capture by the Huns reported by Priscus, fragment 8.

H 424: Ἧπερ: καθότι. ἐδόκει δὲ τῷ βασιλεῖ ἀρκεῖσθαι τοῖς παροῦσι καὶ μὴ σφόδρα
ἐπαίρεσθαι· ἥπέρ ἐστιν ἄριστον πολέμῳ καὶ τοῖς ἐκ τοῦ πολέμου συμβαί-
νουσιν ὁμιλεῖν, ὡς οὐδενὸς ἐν αὐτοῖς βεβαίου καὶ πιστοῦ πάντως ὑπάρχον-
τος.

The phrase πολέμου συμβαίνουσιν ὁμιλεῖν was related to Menander by Gaisford on the basis
of πολέμοις ὁμιλεῖν (frag. 41). This is notable, though hardly cogent. However, in conjunction
with the sentiment expressed in the fragment as a whole, which is very much a favorite with
Menander (cf. my earlier remarks on this), the point may give him some claim to the fragment.

I 356: Ἱμονιά. τὸ δὲ φρέαρ ἅτε ὀρεινὸν ὂν κοῖλον ἦν καὶ βαθὺ ὥστε δεῖν ἱμονιᾶς
μακρᾶς. οἱ δὲ αὐτὸ τὸ ἀντλητήριον· παρὰ τὸν ἱμάντα.

One of Toup's wilder ascriptions. The fragment is slightly reminiscent of Menander, fragment 73
(there is a well in both, and both might be in contexts of siege), but there is no basis for any sober
ascription.

K 553: Καταθέσει: καταπαύσει, καταλήξει. ἢ λήψονται αὐτὸν ἐπὶ καταθέσει τοῦ
πολέμου.

Another of Toup's (from ἤ to the end). With regard to the word being illustrated, it may be
observed that in this sense the present passage is the only one adduced by *LSJ* (it is not in
Lampe). There is a similar use of the cognate verb with πόλεμον by Menander (frag. 11).

K 745: Καταρράκται: πέτραι ἐν τῷ Ἴστρῳ ποταμῷ, ὄρους τρόπον τινὰ ὑπὸ τῷ
ῥεύματι ἐπὶ παντὸς τοῦ πλάτους ὑποπεφυκότος, οἷς ἅπασιν ὁ ποταμὸς
ἐμπίπτων μετὰ μεγίστου πατάγου ἀνακόπτεται, καὶ καχλάζων περὶ ταῖς
πέτραις, ἔπειτα ὑπερφερόμενος ἑλιγμούς τε καὶ παλιρροίας καὶ χαρύβδεις,
κυκλουμένου τοῦ ῥεύματος, ἀποτελεῖ· καὶ τὸ σύμπαν, ὁ ποταμὸς κατὰ
ταῦτα τὰ χωρία οὐ πολὺ ἀπέοικε τοῦ κατὰ Σικελίαν πορθμοῦ.

Kuster thought that this might be by either Menander or Eunapius. I am inclined to think
the latter: in content, the fragment could be linked with Eunapius, fragment 42; as was seen
earlier, this type of digression does not seem to be typical of Menander; and the relatively high-
flown nature of the style appears more Eunapian.

K 2690: Κυμοτόμος: περὶ τὰς γεφύρας οἰκοδόμημα τρίγωνον τὸ ὀξὺ ἔχον ἔμπροσθεν
ἐν τριγώνῳ σχήματι, ὃ δὴ οἱ μηχανοποιοὶ κυμοτόμον καλοῦσιν, ἐμβόλῳ
νηὸς μακρᾶς ἀπεικασμένον· ὅπερ ὁ τῶν Ἀβάρων Χαγάνος ἐτεκτήνατο
γεφυρώσας τὸν ποταμὸν καὶ ἐς τὴν περὶ Δαρδανίαν ὄχθην διαβιβάσας
τὸν στρατόν.

Bernhardy gave this passage to Menander on the basis of fragment 63, where the Chagan of
the Avars is bridging the river Saos. One should notice the phrase νηὸς μακρᾶς, in the light of
the aforementioned long ships in Menander, fragment 48 (with objective formula). According to
LSJ, the substantival use of κυμοτόμος is unique to this passage. We hardly know enough of
Menander to say whether or not he would have such a technical piece of information.

P 47: Παλαμωμένων: χερσὶν ἐργαζομένων. τὴν ἐκ τῶν Ῥωμαίων παλαμήσασθαι
σωτηρίαν.

The ascription from τήν on is stigmatized as *temere* by Adler; but see P 2909 below.

P 456: Παρασχόν: ἐπίρρημα. εἰ δέ γε παρασχὸν οὕτω κατάδηλος γένηται δόξαι
λέγειν, ὡς παραγέγονε λέξων περὶ τῶν πρέσβεων.

Given from εἰ to the end to Menander by Bernhardy; in truth, only the reference to envoys
even hints at Menandrian authorship.

P 1109: Περιαιρεῖν: ἀφαιρεῖσθαι, ἀποκόπτειν, καθυφεῖσθαι. συγχωρηθῆναι δὲ τοῖς Κελτίβηρσιν ὑπὸ Τιβερίου πρεσβεύειν πρὸς τὴν σύγκλητον καὶ περιαιρεῖν, ἐάν τι τούτων δύνωνται παραιτεῖσθαι. οἱ δὲ παραλῦσαι ἐπρέσβευσαν τὴν σύγκλητον τῶν στρατιωτῶν καὶ τῶν φόρων.

Gaisford ascribed the passage, from συγχωρηθῆναι on, to Menander; Bernhardy was doubtful. Events involving Celtiberia certainly took place in the 570's in the reigns of both Tiberius and Maurice. Theophylact (6.3,6) instructs us that men from Celtic Iberia were now (i.e., in his day) known as Franks. On the evidence of his fragments, it is less rather than more likely that Menander would employ an absurd archaism for this people. The passage almost certainly relates to Byzantine history, though the actual reference could be a flashback to, e.g., the Celtiberian peace made by Tiberius Gracchus in 179 B.C.

P 2311: Προαλάμενος: προπηδήσας. καὶ προαλάμενος· τῆς πληθύος μετεχώρησεν ὡς Ναρσῆν. ὁ δὲ ἐνηγκαλίσατο αὐτόν.

Everything after καί is apportioned to Menander by Bernhardy. Outside patristic texts, the word under definition is very rare (only here and in Quintus Smyrnaeus 4.510). Menander is not notably given to rarities, but our evidence may mislead, and we have seen that he employs poeticisms on occasion. The form πλῆθυς seems not to have been used by Menander, albeit manuscript evidence on such a point is not worth much. The reference to Narses is suggestive, no more.

P 2909: Προὐργιαίτατον καὶ Προὐργιαίτερον: ἀναγκαιότατον. προτιμότατον. θέσθαι προὐργιαίτερον τοῦ πρὸς Ῥωμαίους πολέμου τὴν ἐξ αὐτῶν παλαμήσασθαι σωτηρίαν. ὅπερ ἕπεται φύσει ἀνθρώπου ἐν τοῖς τελευταίοις κινδύνοις τὰ σφέτερα προὐργιαίτερα τιθεμένων, ἀνεχώρησαν.

From θέσθαι to σωτηρίαν belongs to Menander, according to Toup. Again temere, in Adler's opinion. However, the phrase παλαμήσασθαι σωτηρίαν occurs in P 47, his other "rash" ascription. It may well be that whoever wrote one wrote the other. And the next sentence in this fragment is very Menandrian in sentiment and phraseology: fragment 10 has the similar phrases ἐν τοῖς μεγίστοις κινδύνοις and φύσει ἕπεται. The last sentence in the Suda passage may well have been influenced by Thucydides 3.109,2: τὸ ἑαυτῶν προὐργιαίτερον ἐποιήσαντο. If so, that would be suggestive, though not necessarily of Menander.

S 588: Σκήψας: ἐπιβάλλων, ἐπιφέρων. Σοφοκλῆς· ἐν δ' ὁ πυρφόρος θεὸς σκήψας ἐλαύνει λοιμὸς ἔχθιστος πόλιν.
καὶ σκηψαμένων τινῶν προδοσίαν ὁμογλώσσων τοῖς Σκύθαις, τοῖς καλουμένοις Γρουθίγγοις.

Adler thought that from καὶ σκηψαμένων on could be from either Menander or Priscus. I would prefer Priscus or an earlier historian. For although, in terms of content, the fragment could relate to Justinian's campaigns, the term Gruthungi (equivalent to Ostrogoths) seems to relate to an earlier period. They occur, for instance, in Dexippus, Ammianus, and later in Claudian, but not apparently after the fifth century (cf. RE, VII, cols. 1872–73).

Y 583: ὑποστάς: πορευομένων δὲ αὐτῶν καὶ γενομένων κατὰ τὸν στενωπόν, προῄει μὲν ὁ Οὔλιθ, ὑποστὰς δὲ ὁ Ἀναγάστης, τῷ δῆθεν ῥαδίως ἑκάτερον αὐτῶν διεξελθεῖν, τὸν ἀπὸ τῆς κεφαλῆς πῖλον ἀνέλαβε.

Ascribed under the influence of fragment 43 to Menander by Bernhardy. I have nothing to add to the cogent reassignment of this fragment to Priscus of Panium by A. F. Norman (CQ, 3 [1953], 171), though I would caution against that part of his argument which sees barbarian nomenclature of the -ith or -ich types as "in the best tradition of Priscus": Menander has such forms as Apsich (frag. 6), Maniach (frag. 20), and Koch (frag. 70).

Υ 743: Ὑψαγόρας: ὑψιλόγος. ἐχρῆτο δὲ κομπολογίαις καὶ ὑψηγόρας τις ἦν καὶ τραχύς. ὁ δὲ Βῶνος κατ' οὐδὲν τοῖς ῥήμασιν ὑποχαλάσας ἀνεμίμνησκε τῆς ἐν Σκυθίᾳ μάχης.

Assigned to Menander from ἐχρῆτο on by Toup. Bonus has already been discussed in a similar context. The language of this fragment is very Menandrian; for the adjective in question, cf. fragment 43: ὑψαγόρας γάρ τις ἀνήρ (also frags. 6, 37, etc., for the simple epithet); for other ingredients of the present passage, cf. fragment 11: κομπολογίᾳ χρωμένου; fragment 15: βαρβάρων φρονήματι ἥκιστα ὑποχαλῶν. This accumulation may make the ascription plausible.

φ 715: Φριμασσομένη: χρεμετίζουσα, ἀγριουμένη· ἢ ἀτάκτως πηδῶσα. ἡ δὲ ἵππος ὀπισθόρμητα φριμασσομένη ἐχώρει καὶ ἀδύνατα εἶχεν ἐς τὰ ἄδενδρα ἐπιβῆναι. καὶ αὖθις· κτύπου τῶν ὅπλων καὶ φριμαγμοῦ τῶν ἵππων κατακούοντες ἐξεπλήσσοντο.

The words ὀπισθόρμητα φριμασσομένη ἐχώρει were attributed to Menander by E. L. de Stefani, in *Studi Italiani de filologia classica*, 18 (1910), 439. There is obviously no real clue to be had from such a snippet (cf. ed. Adler, V, 37, for the item).

THE DATE OF THE
LIFE OF ANDREAS SALOS

Lennart Rydén

THE chronological data contained in the *Life of Andreas Salos*[1] are contradictory. The author, who introduces himself as Nicephorus, priest at St. Sophia, pretends to be a contemporary of Andreas Salos. According to the beginning of the *Vita*, Andreas came to Constantinople during the reign of Leo the Great, i.e., Leo I (457–74). Yet Nicephorus speaks of Symeon Salos, a sixth-century saint, as a man of the distant past.[2] Because of this and other chronological difficulties, C. Janning, followed by many later scholars, assumed that Andreas Salos lived not under Leo I but under Leo VI (886–912),[3] whereas I. Sreznevskij suggested that an original *Vita*, written in the sixth century, had been revised in the tenth.[4] Most of the contradiction, however, disappeared as it became clear that the *Vita* is a piece of historical fiction,[5] written in the ninth or tenth century by an author who, for reasons that have never been properly examined, deliberately dated his hero and himself to the second half of the fifth and the first half of the sixth century. Thus, the question is no longer whether Andreas came to Constantinople in the reign of Leo I or in the reign of Leo VI, or whether Nicephorus lived in the fifth–sixth century or in the ninth–tenth, but when exactly in the ninth–tenth century the *Vita* was written,[6] and why it was given the form of an Early Byzantine document. Let us begin with a brief examination of the *Life of Andreas Salos* as a piece of historical fiction and see how consistent its historical character is.

[1] *BHG*³, 115z ff. My references are to the *Vita S. Andreae sali*, PG, 111, cols. 628C–888D (hereafter cited only by column number). This is a reprint of C. Janning's *editio princeps* in *ActaSS*, May, vol. VI (1688). For cols. 852C–873A and 848C–849A, see also L. Rydén, "The Andreas Salos Apocalypse. Greek Text, Translation, and Commentary," *DOP*, 28 (1974), 197–261, esp. 201–14; and *idem*, "The Vision of the Virgin at Blachernae and the Feast of Pokrov," *AnalBoll*, 94 (1976), 63–82, esp. 64–65. For cols. 744C–760A, see also S. Murray, *A Study of the Life of Andreas, The Fool for the Sake of Christ* (Borna-Leipzig, 1910) (hereafter Murray), 85–100.

[2] The author is called Nicephorus, priest at St. Sophia: 888C. Nicephorus is a contemporary of Andreas Salos: 637A, 648B, 660A ff., 677B, 837B, 873A, 881B, and 888C. Symeon Salos is a man of the past: 648A.

[3] See Janning's *Commentarius praevius*, reprinted in PG, 111, cols. 621–28. As late as 1946, A. A. Vasiliev regarded it as an established fact that the name Leo that occurs in the *Life* is that of the Emperor Leo VI (*The Russian Attack on Constantinople in 860* [Cambridge, Mass., 1946], 162), although it is hard to see how this can be reconciled with his view that Andreas' prophecies refer to the reign of Michael III.

[4] I. Sreznevskij, "Žitie Andreja Jurodivago," *Sbornik Otdelenija Russkago Jazyka i Slovesnosti Imperatorskoj Akademii Nauk*, XX, 4 (St. Petersburg, 1879), 149–84, esp. 157.

[5] Cf. H. Gelzer, *Leontios' von Neapolis Leben des Heiligen Johannes des Barmherzigen Erzbischofs von Alexandrien* (Freiburg i. B.-Leipzig, 1893), intro., 13: "Der Tractat ist keine Geschichte, sondern Dichtung, gewissermassen ein historischer Roman."

[6] Several more or less precise dates have been suggested: ninth or tenth century, and more probably the ninth (Murray, 33); end of the ninth century (G. da Costa-Louillet, "Saints de Constantinople aux VIIIᵉ, IXᵉ et Xᵉ siècles. 1. Vie de S. André Salos," *Byzantion*, 24 [1954], 179–214); ca. 900 (A. P. Rudakov, *Očerki vizantijskoj kul'tury po dannym grečeskoj agiografii* [Moscow, 1917], 228; J. Grosdidier de Matons, "Les thèmes d'édification dans la Vie d'André Salos," *TM*, 4 [1970], 277–328, esp. 278); not long before the date of the oldest extant MS (tenth century) (H.-G. Beck, *Kirche und theologische Literatur im byzantinischen Reich* [Munich, 1959], 568); after 920 (J. Wortley, "The Political Significance of the Andreas-Salos Apocalypse," *Byzantion*, 43 [1973], 248–63); middle of the tenth century (A. Ehrhard, in Krumbacher, 194); ca. 1000 (P. Maas, review of Murray, in *BZ*, 21 [1912], 317). These suggestions, however, are based on rather general observations. The aim of this paper is to provide evidence for a more reliable dating of the *Vita*.

I. The *Life of Andreas Salos* as Historical Fiction

Like many other *Vitae*, the *Life of Andreas Salos* starts with an indication of place and time: Constantinople in the reign of Leo the Christ-loving and Great (629D). The emperor whom Nicephorus has in mind is certainly Leo I, who was designated as "the Great," i.e., the elder, when his grandson Leo II became coemperor.[7] Being a strong supporter of the Chalcedonian creed, he could with good reason be called φιλόχριστος by an orthodox writer. Nicephorus mentions Leo twice again (640A and 744A), thus reminding the reader of the chronological frame indicated at the beginning. In the former of these passages Nicephorus says that, because of his supposed madness, Andreas was sent to the church of the martyr Anastasia "which the pious Leo Makelles had built."[8] This is not quite correct since this building is older, but Nicephorus may refer to the fact that it did not receive the relics of St. Anastasia until the reign of Leo I.[9] In the latter passage he speaks of Daniel Stylites (d. 493) as a contemporary of Andreas, saying that Andreas had a vision in which he went to see Daniel at Anaplous just as Leo and his Augusta used to do.[10] Later on, he tells the story of how the protective force of the Virgin's *maphorion* was revealed to Andreas during a nocturnal doxology in the Holy Soros at Blachernae (848Cff.).[11] This seems to be part of the historical setting as well, for it was in the time of Leo I, people said, that the *maphorion* was discovered and deposited in the Holy Soros at Blachernae, which Leo had built especially for this purpose. Andreas' intimate friend Epiphanius, a pious young man of noble birth, plays a particularly important role in the chronological structure of the *Vita*. On three occasions, 657B, 729B, and 884D, Andreas predicts that Epiphanius will become bishop of Constantinople, and at the end of the work Nicephorus mentions Epiphanius τοῦ γεγονότος ἐνθάδε ἀρχιερέως as his source of information for things he has not seen with his own eyes (888C). No doubt Nicephorus has the Epiphanius in mind that became bishop of Constantinople in 520.

Nicephorus also refers to a number of people who lived before Leo I, namely, Julian the Apostate (877A), St. Hippolytus (865C), St. Athanasius (684C), St. Basil the Great (873B), Arius (824B), the martyr Babylas (877A), and Theodore, a young man from Antioch who was tortured by Julian the Apostate (877Bff.).[12] These names fit the historical setting without contributing to an

[7] J. B. Bury, *History of the Later Roman Empire from the Death of Theodosius I to the Death of Justinian* (London, 1923; repr. 1958), I, 323 note 1.

[8] The variant reading in Janning's note agrees with the text of the best MSS.

[9] Theophanes, *Chronographia*, ed. C. de Boor, I (Leipzig, 1883), 111 lines 7–9; see also L. Rydén, "A Note on Some References to the Church of St. Anastasia in Constantinople in the Tenth Century," *Byzantion*, 44 (1974), 198–201.

[10] St. Neophytus (d. 1214) seems to refer to the *Life of Andreas Salos*, and especially to this passage, when he says that Gennadius I, bishop of Constantinople (458–71), was in the prime of life under Leo the Great, when Daniel stood on his pillar at Anaplous and Andreas Salos played the fool; see Neophytus' encomium on Gennadius in the edition of H. Delehaye, in *AnalBoll*, 26 (1907), 221–28, esp. 221 line 29 ff., with Delehaye's remarks on p. 295.

[11] For a commentary on this episode, see Rydén, "The Vision of the Virgin" (*supra*, note 1).

[12] See, e.g., Theophanes, *op. cit.*, 52 line 29.

exact dating. The same applies to the fact that Nicephorus mentions a number of public places, secular buildings, monuments, and churches which had been created before the middle of the fifth century and thus existed in the days of Leo I: the Forum of Constantine the Great (712B, 748C, 749A, 837C, 868B); the Forum of Bous (688A); the Neorion[13] (776C); the Great Palace (800Cf.); the Hippodrome (780C, 849B); the Senate House (748C); the column of Constantine the Great (837C, 868B); the weather vane of Theodosius I[14] (749A); St. Sophia (781B, 788D, 864C, 868B, 888C); the churches of the martyrs Acacius[15] (841Cff.), Agathonicus[16] (804B), and Thyrsus[17] (833Aff.); and the chapel of SS. Peter and Paul,[18] built by Constantine the Great, people said (740B). The churches of St. Mary in Chalkoprateia and of St. John the Baptist, also mentioned in the *Vita* (785A and 844A), appear to be closely connected with the period in which Andreas is supposed to have lived, although Nicephorus does not exploit them for the purpose of dating. The former was built in the middle of the fifth century. It may even have been dedicated by Leo's wife, Verina.[19] The latter may be identical with the famous Studios church, completed in 463 or, perhaps more likely, with St. John the Baptist ἐν τῇ Ὀξείᾳ, built, it is said, by Anastasius I (491–518).[20] The Staurion (749B) and the Artopoleia (648C, 657A, 708B) may not have been known as topographical names as early as the fifth century, but, on the other hand, it is not likely that Nicephorus' contemporaries found them anachronistic. The Artopo-

[13] The oldest harbor of Constantinople; see R. Janin, *Constantinople byzantine. Développement urbain et répertoire topographique*, AOC, 2nd ed., IVa (Paris, 1964), 235f., 396f.; H. Ahrweiler, *Byzance et la mer. La marine de guerre, la politique et les institutions maritimes de Byzance aux VIIe–XVe siècles* (Paris, 1966), 430.

[14] Built by Theodosius the Great; see C. Mango, *The Art of the Byzantine Empire 312–1453. Sources and Documents* (Englewood Cliffs, N. J., 1972), 44 note 114. The name Anemodoulion, however, which Nicephorus uses in the *Vita*, does not seem to be the original. See *infra*, p. 136.

[15] Known from 359 on; see G. Prinzing and P. Speck, "Fünf Lokalitäten in Konstantinopel," in *Studien zur Frühgeschichte Konstantinopels*, ed. H.-G. Beck (Munich, 1973), 179–227, esp. 189.

[16] In the tenth century, St. Agathonicus was supposed to have been built by Constantine the Great, but presumably it was built somewhat later; see R. Janin, *La géographie ecclésiastique de l'Empire byzantin*, I. *Le siège de Constantinople*, 3: *Les églises et les monastères* (Paris, 1953), 11f.; G. Dagron, *Naissance d'une capitale. Constantinople et ses institutions de 330 à 451* (Paris, 1974), 396.

[17] Janin, *Eglises*, 257, thinks that Nicephorus here mentions an otherwise unknown church, situated near the portico called *ta Maurianou* in the tenth century. However, Nicephorus does not say that the church of St. Thyrsus was standing near *ta Maurianou*. He simply says that it was St. Thyrsus' Day and that Andreas was near *ta Maurianou* when he happened to see a man returning from the church of this Saint. There is no reason to doubt that Nicephorus has in mind the usual church of St. Thyrsus, which stood close to the Helenianae palace and was built *ca.* 400. See Janin, *Eglises*, 256; and V. Tiftixoglu, "Die Helenianai nebst einigen anderen Besitzungen im Vorfeld des frühen Konstantinopel," in *Studien*, ed. Beck, 49–120, esp. 57f.

[18] According to Andreas' prophecy (741A/B), a pious ruler will reconstruct this chapel and provide it with five domes. Nicephorus seems to have in mind the church of the Holy Apostles, which was changed in this way by Justinian I, although it was not just a chapel but a large basilica and was not called Peter and Paul; cf. Grosdidier de Matons, *op. cit.* (*supra*, note 6), 307 note 104. See also *infra*, pp. 140–41.

[19] Janin, *Eglises*, 246.

[20] Th. Preger, *Scriptores originum Constantinopolitanarum*, I–II (Leipzig, 1901–7; repr. New York, 1975), 235. St. John the Baptist ἐν τῇ Ὀξείᾳ was situated near the church of St. Acacius, which appears in the same context, and it was also close to the church of the martyr Anastasia mentioned above. It is therefore more in line with the topographical context than the Studios church, although it does not fit the chronological frame of the *Vita* quite as well.

leia appear in the *Parastaseis*,[21] compiled during the reign of Constantine V (741–75). The Staurion appears in the stories of the translation of the body of St. Stephen, the first martyr, and in the *Vita* of the martyr Acacius, to whom one of the oldest churches of Constantinople was dedicated.[22]

Nicephorus says that he had known Andreas Salos and Epiphanius personally, thus pretending that the *Vita* was written in the sixth century. In this way he could make the *Vita* more credible and prevent embarrassing questions, such as: "How do you know all this about a saint that lived hundreds of years ago?" As everyone knows, Early Byzantine books were written in uncial script, whereas books produced during the Macedonian period, in which Nicephorus actually belonged, were normally written in minuscule script. Did Nicephorus consider this fact when he chose the sixth century as the fictitious date of composition of the *Vita*? I think he did, since otherwise the contrast between the historical fiction and the form of the autograph would have been too obvious. My guess is that Nicephorus used the same device as Photius, who was supposed to have invented a noble pedigree for Basil I and prophesied that Basil should reign happier and longer than any of his predecessors. According to Nicetas Paphlago,[23] Photius wrote the prophecy and Basil's genealogy on old papyrus leaves with Alexandrian, i.e., uncial letters, carefully imitating the ancient handwriting. He provided the leaves with old covers taken from an old book and put the whole thing in the imperial library.[24] In the same way, it seems to me, Nicephorus pretended that he had discovered a hitherto unknown document in a library where old books were kept, ideally in the patriarchal library. At any rate, among the hundred or so extant MSS containing the *Life of Andreas Salos* there is an uncial fragment consisting of eight parchment leaves appearing as flyleaves in Monacensis gr. 443, a paper codex of the fourteenth century. The fragment was discovered by A. Ehrhard, who dated it to the tenth century and identified the text as the section 745B–757C of our *Vita*. He also assumed that the MS originally contained the whole *Vita* and no other text.[25] If this assumption is correct, it is a fair guess that the surviving fragment was the tenth quire of a codex consisting of twenty quires or 160 folios, judging from the size of the preserved section and its place in the *Vita*. The writing can be studied on the photo reproduced here, as well as on a photo of two pages of the fragment added at the end of Sara Murray's study.[26] It may be classed as a variant of the archaizing Coptic or Alexandrian uncial used in headings, indices, and other special cases after the minuscule had been introduced in the ninth century. The individual letters seem to have been formed with relative ease, but taken as a whole the writing looks coarse and irregular, as if the author

[21] *Ibid.*, 44 ff.

[22] Prinzing and Speck, *op. cit.*, 182, 188; Dagron, *op. cit.*, 393–95, 404–5.

[23] *Vita Ignatii*, PG, 105, cols. 565C–568A.

[24] For a paleographical commentary on this interesting passage, see G. Cavallo, Γράμματα ᾿Αλεξανδρῖνα, *JÖB*, 24 (1975), 23–54.

[25] A. Ehrhard, *Überlieferung und Bestand der hagiographischen und homiletischen Literatur der griechischen Kirche*, I, TU, 50 (Leipzig, 1937), 81–82.

[26] *Op. cit.* (*supra*, note 1).

was accustomed to writing single uncial letters but not to using them in continuous script. The quality of the text is better than that of any minuscule MS of the *Vita* so far known to me. The context is clear. There are no obvious additions or omissions. One can hardly escape the impression that the codex to which the remaining leaves belonged was the autograph of Nicephorus. It is true that the orthography is irregular; e.g., in the two columns reproduced here, β stands for υ (Σταβρίω), ε for αι (διανεῖμε), ο for ω (ὄν, ἡττόμενος, βλέπον), ω for ο (διωρατικῶ), ι for η (εἰρικῶς) and ει (φιδωλός), and η for ι (πολητῶν) and ει (βιώση, πάθη). It is also true that the text of the fragment does not always conform with traditional grammar. In the same two columns, κινοῦντας appears instead of κινοῦντα, ἐν instead of ἐπί (ἐν εὐλαβείᾳ ἐπευφημιζόμενον), and ἐπί instead of ἐν (ἐπὶ τῇ βιώσει αὐτοῦ εὐλαβὴς ὑπῆρχεν). In column 1 ἐπευφημιζόμενον is unexpectedly coordinated with κινοῦντας, and in column 2 the coordination of μαινόμενος and βλέπων is equally unexpected. In the other folios of the fragment there are similar cases in which καί and τε are used superfluously.[27] There are also cases in which the accusative appears instead of the nominative[28] or the dative,[29] and the dative instead of the accusative.[30] But, as is well known, such orthographical and grammatical peculiarities are typical of lowbrow texts. Far from making the uncial fragment dubious, they show that it is written in a language that agrees with the general character of the *Vita*. Furthermore, two passages which at first seemed corrupt have proved to be acceptable on closer inspection. The first is on the reproduced folio, in the middle of the first column. The context requires that the words μεθ' ἑτέρου τινός should be connected with λόγον κινοῦντας, yet they appear to be connected with ἐπευφημιζόμενον and separated from where they actually belong by a colon and a καί. The difficulty disappears if one keeps in mind that the καί stands between two participles and that the author often inserts a meaningless καί in such cases.[31] The second is 753B (Murray, 99 line 1): προέλαβεν ἔν τινι τόπῳ δι' ἧς ἔμελλεν ὁ μοναχὸς διέρχεσθαι, where ἧς seems to refer to a masculine antecedent. In this case, the difficulty is explained by Luke 19:4–5: καὶ (Ζακχαῖος) προδραμὼν εἰς τὸ ἔμπροσθεν ἀνέβη ἐπὶ συκομορέαν, ἵνα ἴδη αὐτόν (τὸν Ἰησοῦν), ὅτι ἐκείνης (v. l. δι' ἐκείνης) ἤμελλεν διέρχεσθαι. καὶ ὡς ἦλθεν ἐπὶ τὸν τόπον....[32] Evidently, this passage served as a model for the passage in the *Vita*. It shows that ἧς does not refer to τόπῳ but to the way which the monk was going to pass. A third

[27] Cf. 749C (Murray, 94 line 1): ἐκεῖσε παραγενόμενος τῷ διορατικῷ τε χαρίσματι κοσμούμενος ἐθεάσατο; 752C (Murray, 96 line 11): ἀποκριθεὶς...καί φησιν.

[28] Cf. 756A (Murray, 100 line 12): ἔδυς ὡς νύκτα καχέσπερος.

[29] Cf. 748C (Murray, 91 line 1): τὸν διάβολον...θυσίαν προσφέροντα; 749A (Murray, 92 line 5) εἶπεν αὐτὸν ὁ ὅσιος; 752D (Murray, 97 line 6): ὁ νομοθετῶν τοὺς υἱοὺς τῶν ἀνθρώπων κρίνειν δίκαια; 756A (Murray, 100 line 6): θλίψις με...καθέστηκεν; 757A (Murray, 102 line 16): οἱ δουλεύοντες αὐτόν; 757B (Murray, 103 line 7): ἐντελοῦμαι τοῦτον.

[30] Cf. 752A (Murray, 95 line 3): μάτην παρεδρεύεις τῷ μοναχῷ καὶ φυλάττεις αὐτῷ; 756B (Murray, 101 line 12): οὕτως ἠρνήσω κόσμον καὶ τοῖς ἐν κόσμῳ.

[31] A case in point is 748C (Murray, 90 line 3): ἦν ὁ ὅσιος παίζων ἐν τῷ τοῦ φόρου πλακώματι καὶ ὡς ἔθος ἔχων ποτὲ μὲν τρέχειν ποτὲ δὲ σάσσειν, γενόμενος κατέναντι τῆς μεγάλης πύλης τοῦ σινάτου κατεσκόπει τοὺς ἐκεῖσε ὄντας λωρόποδας. Here, one would expect the καί to appear before γενόμενος rather than before ὡς ἔθος ἔχων.

[32] I owe this reference to Professor Jerker Blomqvist.

passage at 756B (Murray, 101 line 3) is perhaps more likely to be corrupt. It runs as follows: τί θέλεις σὺ τὸ χρυσίον, ὅπερ καὶ μετὰ θάνατόν σου οἷς οὐ θέλεις ἢ καὶ ἐχθροί σου τοῦτο κληρονομήσουσιν. Here, either a verb like ἔσται or ἐλεύσεται is missing before οἷς, or οἷς is subject of κληρονομήσουσιν as well as object of θέλεις, the dative being used in a rather loose way.[33] Although I cannot give a quite satisfactory explanation of this difficulty,[33a] it does not seem to me to be so serious as to require emendation. It is also remarkable that the author of the fragment has corrected himself in three other cases[34] but not in this. Did he not regard it as an error, or did it simply escape his notice? However that may be, it obviously carries far less weight than the fact that in all other respects the fragment corresponds to what one would expect of the autograph. Moreover, there would seem to be little point in assuming that the fragment is nothing more than a good copy of an uncial model. In the tenth century, uncial MSS were not copied in uncial hand but transliterated into minuscule. Why should a scribe stick to the uncial writing in this particular case? Because he wanted people to believe that the copy had been made before the introduction of minuscule script in the ninth century?[35] But whereas Nicephorus had good grounds for trying to deceive his contemporaries by pretending that he had discovered a hitherto unknown document, there was no reason why a copyist should try to repeat this trick. On the contrary, once "the old document" had been "discovered," the trick could hardly be repeated without harming the credibility of the Vita. For if there were more than one ancient-looking copy, people would naturally wonder why this interesting text had not been known before. For the mere multiplication of the Vita, on the other hand, the minuscule script must have appeared much better suited than the uncial.[36]

[33] The MSS most closely related to the uncial fragment have εἰ instead of οἷς, but this does not solve the problem.

[33a] After this article was sent to the editor, I noticed a passage in the Life of St. Philaretus, version BHG³, 1512, which seems to explain the difficulty. St. Philaretus, being on his death bed, recommends to his offspring that they give away their riches to the poor and so lay up treasure for themselves in heaven. "Do not leave riches behind you when you die," he says, "ἵνα μὴ ἐν τοῖς ὑπάρχουσιν ὑμῖν ἀγαθοῖς τρυφήσουσιν ἀλλότριοι· ἔστι πολλάκις καὶ οἷς οὐ θέλετε τοῦτον (= τὸν πλοῦτον) ἐᾶτε." (Ed. A. A. Vasiliev, IRAIK, 5 [1900], 81 lines 32–33). The parallel shows that Nicephorus has forgotten to insert the verb ἐᾷς, or ἐάσεις, after οἷς οὐ θέλεις. As in the preceding case, the error evidently derives from a badly integrated literary borrowing. Vasiliev's edition is based on Parisinus gr. 1510, which was written in the tenth century. There are also other striking similarities between this revised version of the Vita Philareti and the version of our Vita that is most closely related to the uncial fragment. These similarities I hope to discuss eleswhere.

[34] Fol. IX, col. 1 (748A; Murray, 89 line 4): ἀλληνάλλως; fol. IV, col. 2 (749A; Murray, 92 line 9): βλέπεις; fol. VIIᵛ, col. 1 (753C; Murray, 99 line 7): νενομισμένης. The author originally wrote ἀλληνάλως, βέπεις, and νενομισμένη.

[35] Sara Murray, who realized the importance of the uncial fragment, suggested that the reason for the uncial writing might be that the copyist "was a man who clung to ancient traditions of writing," or that he "had before him as his original a valuable manuscript, the archetypon of the text, the value of which he sought to make known to future readers by making his manuscript uncommon" (Murray, 120f.). She did not, however, make any serious effort to solve the problem which, in her opinion, was insoluble.

[36] I am consequently basing the edition of the Vita which I am preparing mainly on those MSS which are most closely related to the uncial fragment (cf. the references given in note 1). I do not agree with Maas, who in his review of Murray's study, op. cit. (supra, note 6), 317–19, argued that, on the whole, all the surviving MSS are equally good or bad.

However, in spite of the allusions to the reign of Leo I and the patriarchate of Epiphanius, the uncial MS, and the prophecies *ex eventu*, which automatically characterize Andreas as a man who lived long ago, the historical atmosphere of the *Vita* is rather thin. To begin with, although it is historically correct to speak of a fifth-century *salos*, it seems somewhat anachronistic to describe him as living in Constantinople. The *saloi* of the Early Byzantine period did not appear in the capital but in Egypt, Palestine, and Syria, as Grosdidier de Matons' survey shows.[37] Nicephorus' credibility is further harmed by the fact that Andreas is not mentioned in the *Synaxaria* until 1301,[38] whereas Symeon Salos appears in the *Synaxarium* of Constantinople already in the ninth–tenth century,[39] as well as in the *Ecclesiastical History* by Evagrius,[40] written *ca.* 600, and in the *Life of Symeon Salos*,[41] written by Leontius of Neapolis in the middle of the seventh century. As for Epiphanius, he is no doubt a historical person, but Nicephorus' portrait of him is rather vague, and Nicephorus is also vague on the relation between Epiphanius and himself. He seems to be pretending that he is older than Andreas (cf. 637A, where he plays the role of Andreas' adviser), and consequently much older than Epiphanius. Yet, at the end of the *Vita*, he indicates that he did not write it until Epiphanius was dead (τοῦ γεγονότος ἐνθάδε ἀρχιερέως 888C). This would imply that the author was born before the middle of the fifth century and wrote the *Life of Andreas Salos* after 535, which is unlikely. Theognostus, the *protospatharios* and future general of the East mentioned at the beginning of the *Vita*,[42] does not even seem to be a historical figure. He is supposed to have been *magister militum per Orientem*, it would seem, but no *magister militum per Orientem* called Theognostus is recorded for the second half of the fifth century or the beginning of the sixth.[43] Furthermore, Nicephorus seems to have read the *Life of Daniel Stylites*,[44] but he does not exploit very much of the material offered there to strengthen the historical atmosphere of his own work. He does not mention the successors of Leo I, under whom Andreas must have lived if he came to Constantinople in Leo's reign. Nor does he mention Gennadius I, who was bishop of Constantinople under Leo I. He does not mention the theater, or the chariot races in the Hippodrome, although these played such an important part in the life of common people during the early history of Constantinople. He also disregards the fact that St. Sophia in the fifth century was quite different from Justinian's magnificent building.

[37] *Op. cit.* (*supra*, note 6), 279 ff.

[38] *Synaxarium CP*, col. 713, line 53, cod. Mc, written 1301. The *Synaxarium Chiffletianum*, which contains a notice of Andreas Salos, was not written by Patriarch Sergius II (1001–19), as Murray thought (Murray, 31); it was compiled closer to the fourteenth century. See F. Halkin, "Distiques et notices propres au synaxaire de Chifflet," *AnalBoll*, 66 (1948), 5–32, esp. 5.

[39] *Synaxarium CP*, cols. 833 line 5–834 line 19.

[40] Ed. J. Bidez and L. Parmentier (London, 1898; repr. Amsterdam, 1964), 182 line 26–184 line 23.

[41] *BHG³*, 1677.

[42] Στρατηλάτης ἐν τοῖς τῆς ἀνατολῆς (v. l. ἀνατολικοῖς) μέρεσιν (632A).

[43] Cf. R. Guilland, "Les termes désignant le commandant en chef des armées byzantines," Ἐπ.Ἑτ.Βυζ.Σπ., 29 (1959), 35–77; *idem, Recherches sur les institutions byzantines*, I (Berlin, 1967), 385 ff.; A. Demandt, *RE*, Suppl. XII (1970), 790.

[44] *BHG³*, 489; cf. *supra*, p. 130.

Even in his imitation of a sixth-century MS (granted that I have understood the role of the uncial writing correctly) Nicephorus is rather careless. He accentuates the uncial script regularly, although an author of the sixth century would hardly have done so. He even puts in some double accents,[45] a feature that did not come into use until the ninth century.[46] The heading and the initial of chapter 32 on folio IV^v, reproduced here, are of a type that seems to derive from early minuscule MSS. It is possible that Nicephorus succeeded in deceiving some of his contemporaries in this way, readers who were looking for other qualities than historical accuracy, but to the modern scholar the fake is obvious, as the datings of the manuscript catalogues show.

He also weakens the historical credibility by committing more serious anachronisms. That he speaks of Symeon Salos as a man of the past has already been mentioned. In the eschatological section, he has Andreas predict that Illyricum and Egypt will be restored to the Roman Empire (856A), as if these provinces had already been lost in the fifth century. He also seems to allude to Iconoclasm (837A). He mentions a *chartoularios plôimôn* (849B), although this office was not introduced until the ninth century.[47] He refers to the Virgin's chapel in the portico of the Forum of Constantine the Great (712B) and to the Myrelaion (721A), although these churches are not heard of before the reigns of Basil I (867–86) and Romanus I (920–44), respectively.[48] The Anemodoulion as the name of the weather vane of Theodosius I, and the topographical names Heptascalon (841D), *ta Maurianou* (832D), and Antiphorus (856B), do not appear in our sources before the middle of the tenth century.[49] None of them is likely to have been used in the fifth–sixth century. All these inconsistencies bring us to the question of the real date of the *Vita*.

II. THE *Life of Andreas Salos* AND THE *Ekphrasis* OF CONSTANTINE OF RHODES

Among the references just mentioned, the church of Myrelaion gives the latest terminus post quem. It seems to have been built in the early twenties of the tenth century.[50] As far as we can see now, there are no open references to any later buildings, persons, institutions, or other circumstances. If we

[45] E.g., fol. IV^v, col. 2, line 9; see photo.

[46] M. Reil, "Zur Akzentuation griechischer Handschriften," *BZ*, 19 (1910), 476–529, esp. 482f.

[47] Ahrweiler, *op. cit.* (*supra*, note 13), 74. The man is introduced as εἷς τῶν μεγάλων. Nicephorus may be thinking of him as he would have appeared in the mid-tenth century, when the prestige of the imperial navy was at its height.

[48] Maas, *op. cit.* (*supra*, note 6), 318; R. Janin, "Notes d'histoire et de topographie," *REB*, 26 (1968), 171–84, esp. 178–84.

[49] The name Anemodoulion seems to appear for the very first time in the *Life of Andreas Salos*; cf. Janin, *Constantinople byzantine* (*supra*, note 13), 100. The Antiphorus of Constantinople I have only found mentioned in Constantine Porphyrogenitus, *De caeremoniis*, Bonn ed. (1829), 165 line 17 (*Constantin Porphyrogénète, Le livre des cérémonies*, ed. A. Vogt, I [Paris, 1935; repr. 1967], 154 line 3); there was, however, an *antiphorus* also at Edessa (Procopius, *De aedificiis* II.7,6) and at Antioch (Evagrius, *Ecclesiastical History* III.28; Malalas, Bonn ed. [1831], 397 line 23). For Heptascalon, see Janin, *Constantinople byzantine*, 229; for *ta Maurianou*, *idem*, "Etudes de topographie byzantine: Ἔμβολοι τοῦ Δομνίνου, τὰ Μαυριανοῦ," *EO*, 36 (1937), 129–56.

[50] Janin, "Notes d'histoire."

want to go further, we must therefore turn to other, dated, literary works to see if they offer any clues. Even if the *Life of Andreas Salos* is a literary forgery, it is reasonable to think that Nicephorus' choice of historical material as well as his handling of this material reflect the outlook and predilections of his contemporaries. Thus there seems to be a certain affinity between the selection of buildings and works of art mentioned in the *Vita* and the Early Byzantine wonders described in the *Ekphrasis* of Constantine of Rhodes,[51] written sometime between 931 and 944.[52]

Constantine's poem consists of 981 iambic trimeters. The first half is mainly devoted to a description of the seven θαύματα of Constantinople, forming a kind of prologue to the main theme of the poem, the *ekphrasis* of the church of the Holy Apostles. According to the poet, the seven wonders of Constantinople were the column of Justinian I, the column of Constantine the Great, the Senate House at the Forum, a cross-bearing column of uncertain identity, a monumental weather vane erected by Theodosius I, the column of Theodosius I, and the column of Arcadius. As in the case of the seven wonders of the world, the seven wonders of Constantinople varied with the interests of the authors. In the *Parastaseis*,[53] compiled in the middle of the eighth century, there is a set of wonders of Constantinople quite different than in Constantine's *Ekphrasis*.[54] The monuments described as wonders in the *Parastaseis* do not appear in the *Life of Andreas Salos*. There is, however, a certain correspondence between the topographical setting of the *Vita* and the wonders of the *Ekphrasis*. Of the six monuments that fit the chronological frame of the *Vita* (the column of Justinian would have been anachronistic, except in a prophecy *ex eventu*), three are mentioned; namely, the column of Constantine the Great (837C, 868B), the Senate House at the Forum (748C), and the weather vane of Theodosius I (749A). The second of these is particularly interesting. It is mentioned in the following context. Andreas was standing in the Forum contemplating the λωρόποδες, represented on the great door of the Senate House, when a passerby slapped him on his back and said: "You imbecile, what are you looking at?" Andreas, knowing that the man was a great sinner, answered: "You fool! I am looking at the visible idols, but you are a spiritual λωρόπους, and a serpent, and of the viper's brood. Your soul's axles and your heart's spiritual legs are twisted and going to hell. Hell has opened its mouth to devour you, for you are a fornicator and an adulterer and you sacrifice to the devil every day."[55] In the poem of Constantine of Rhodes a considerable

[51] Ed. E. Legrand, "Description des œuvres d'art et de l'église des Saints Apôtres de Constantinople. Poème en vers iambiques par Constantin le Rhodien," *REG*, 9 (1896), 32–65; with archeological commentary by Th. Reinach, *ibid.*, 66–103.

[52] Reinach, *op. cit.*, 67; G. Downey, "Constantine the Rhodian: His Life and Writings," in *Late Classical and Mediaeval Studies in Honor of A. M. Friend, Jr.* (Princeton, 1955), 212–21, esp. 214.

[53] Ed. Preger (*supra*, note 20), 39–51.

[54] As pointed out by Reinach, *op. cit.*, 69 note 2.

[55] ...γενόμενος κατέναντι τῆς μεγάλης πύλης τοῦ Σινάτου κατεσκόπει τοὺς ἐκεῖσε ὄντας λωρόποδας. Εἰς δὲ τῶν διερχομένων ἰδὼν τὸν ὅσιον τούτοις ἐντρανίζοντα δίδωσιν αὐτῷ κόσσον κατὰ τοῦ αὐχένος λέγων· "Σαλέ, τί ἵστασαι βλέπων;" Ὁ δὲ μακάριος ἔφη πρὸς αὐτόν· "Ἔξηχε τῷ νοΐ, τῶν εἰδώλων τοῖς αἰσθητοῖς ἐντρανίζων ἕστηκα. Καὶ γὰρ καὶ αὐτὸς νοητὸς λωρόπους καθέστηκας καὶ ὄφις καὶ γέννημα ἐχιδνῶν· οἱ γὰρ

portion of the section on the Senate House (vv. 90–162) is devoted to a description of the great bronze door (vv. 125–52). The poet says that it was Constantine the Great who brought it to Constantinople from the temple of Artemis at Ephesus, where it had been in use ὅτ' ἦν ζόφωσις εἰδώλων πλάνης (v. 129). The door was decorated with a Gigantomachy in relief in which you could see Zeus with his thunderbolts, Poseidon with his trident, Apollo with his bow, and Hercules in his lion's skin:

> καὶ τοὺς Γίγαντας ὡς δράκοντας τοὺς πόδας
> κάτωθεν ἐνστρέφοντας ἐσπειρημένους,
> ῥιπτοῦντας ὕψει τῶν πετρῶν ἀποσπάδας (vv. 139–41).

It appears from these lines that the legs of the giants ended as snakes, which was the usual way of representing the giants in postclassical art.[56] The expression λωρόπους ("with legs that are like thongs" or "whips"), which appears in the *Life of Andreas Salos*, is an obvious reference to the snake-like legs of the giants.[57] Andreas likens the sinful man to a snake-legged giant who fights against God but is bound to lose.

It is worth noting that Nicephorus alludes to the Gigantomachy a second time at 864D, where he says that the wicked apocalyptic woman will try to fight with God, εἰς ὕψος ἐμπτύουσα καὶ λίθους πέμπουσα. The last words are clearly reminiscent of the last of the lines just quoted from Constantine's poem. I find it hard to believe that a man like Nicephorus, who evidently had a deep dislike for the "exterior" learning and secular art, was so familiar with the history and meaning of the Gigantomachy represented in relief on the bronze door of the Senate House that he could use it directly as a source for the *Life of Andreas Salos*.[58] It seems much more likely that he got his information from a literary source; not, however, from Themistius,[59] or from a mythological handbook,[60] or a learned *ekphrasis* of ancient art, written by an erudite humanist (this kind of *ekphrasis* did not appear between the reign of Justinian

ἄξονες τῆς ψυχῆς σου καὶ τὰ νοητὰ διαβήματα τῆς καρδίας σου διεστραμμένα εἰσὶν καὶ ἐπὶ τὸν ᾅδην βαδίζοντα· ἰδοὺ γὰρ ἔχανεν ὁ ᾅδης καὶ καταπιεῖν σε ἐκδέχεται πορνεύοντα καὶ μοιχεύοντα καὶ τὸν διάβολον καθ' ἑκάστην θυσίαν προσφέροντα." (Text of the uncial fragment, which covers this passage.)

[56] According to Cedrenus, Bonn ed. (1838), 565, the door had been given to the Artemision by Trajan.

[57] As Murray, 29, rightly suggests.

[58] On the Gigantomachy in the miniatures, see K. Weitzmann, "The Survival of Mythological Representations in Early Christian and Byzantine Art and Their Impact on Christian Iconography," *DOP*, 14 (1960), 43–68, esp. 50: "Only within a circle of erudite Byzantine humanists who moved in the atmosphere of the patriarchal and imperial palaces were miniatures like the Gigantomachy produced and fully appreciated. [...] as soon as they had lost their physical association with the explanatory text, their proper meaning was quickly lost [...]."

[59] *Themistii Orationes*, ed. W. Dindorf (Leipzig, 1832), Or. XIII, 176D: Ἔστιν ἐν τῷ ἄστει τοῦ Κωνσταντίνου τῆς μάχης τῆς πρὸς τοὺς θεοὺς τῶν γιγάντων εἰκὼν ἐν χαλκῷ πεποιημένη ἀντὶ κρηπῖδος τοῦ βουλευτηρίου. ἐν οὖν τῇ εἰκόνι ταύτῃ πρὸς μὲν τοὺς ἄλλους θεοὺς οἱ γίγαντες ἀνταίρουσι καὶ ἐξορμῶσιν οἱ μὲν πέτρας, οἱ δὲ δρῦς κτλ. (= *Themistii orationes quae supersunt*, ed. G. Downey, I [Leipzig, 1951], 253 lines 7–11). A little later in the same text, the giants are called dragons, which obviously alludes to their snake-formed legs. Thus, Themistius offers the basic material. Nevertheless, it seems unlikely that this source was known to Nicephorus. He was certainly not the man to study the works of pagan rhetoricians.

[60] In the Middle Byzantine period, Byzantine scholars seem to have been familiar with Apollodorus' *Bibliothēkē*; see K. Weitzmann, *Greek Mythology in Byzantine Art* (Princeton, 1951), 83.

and the middle of the twelfth century[61]), but from a literary work like Constantine's poem, which deals with monuments sponsored by Christian emperors and excludes pagan art, except when it had been adopted by a Christian emperor and was given a Christian reinterpretation. The buildings and monuments which Constantine of Rhodes describes all belong to the Early Byzantine period. If the *Ekphrasis* was written before the *Vita*, it may have attracted the attention of Nicephorus, who needed material for the historical setting of the *Vita*. It seems significant that Constantine mentions the fire that blackened the Senate House:

ὅταν Λέων κατῆρχεν ὁ πρώην ἄναξ,
Λέων ἐκεῖνος τῆς Βηρίνης εὐνέτης (vv. 108–9)

The fact that Leo I was mentioned in connection with the Senate House may have helped to attract Nicephorus' attention.

The weather vane of Theodosius I is described by Constantine (vv. 178–201). It had the shape of a female figure and was placed on top of a high pyramid, the four sides of which were decorated with reliefs representing naked Erotes playing in a rural and pastoral landscape; boys with trumpets symbolized the four winds. According to the *Patria*,[62] compiled at the end of the tenth century, the monument had been erected by Leo III (717–41), but the character of the decoration shows that the attribution to Theodosius I (379–95) is much more likely.[63] Nicephorus obviously believed that it existed in the reign of Leo I. He calls it τὸ Ἀνεμοδούλιον (749A; Murray, 92 line 3), a name that Constantine does not use, perhaps because it did not fit the iambic trimeter (although Constantine is not strict on this point), or because he found it too folkloristic. There is no reason to doubt that Nicephorus has in mind the same monument as Constantine. First, Nicetas Choniates uses the name Anemodoulion of the same monument.[64] Second, Cedrenus, whose description of the monument is based on the poem of Constantine of Rhodes, speaks of it as τὸ τετρασκελὲς τέχνασμα ὃ δῆριν λέγουσιν ἀνέμων, i.e., "the battle of the winds."[65] The δῆρις ἀνέμων seems to be a paraphrase of the dissimilated form Ἀνεμοδοῦριν,[66] which appears in the MSS of the *Life of Andreas Salos* as well as in the *Patria*. Third, the context fits the description in Constantine's *Ekphrasis* perfectly. Andreas came to the part of the Forum where women are selling "those costly feminine embellishments" (τὸν πολυτελῆ κόσμον ἐκεῖνον). He looked at the wares and exclaimed: "Oh! Chaff and dust!"[67] As he stood contem-

[61] C. Mango, "Antique Statuary and the Byzantine Beholder," *DOP*, 17 (1963), 53–75, esp. 67.

[62] Ed. Preger (*supra*, note 20), 253.

[63] Mango, *The Art of the Byzantine Empire* (*supra*, note 14), 44 note 114.

[64] *Nicetae Choniatae Historia*, ed. I. A. van Dieten, CFHB, XI,1 (Berlin, 1975), 332 line 35, 648 line 56.

[65] Bonn ed. (1838), 565 line 20.

[66] Cf. St. B. Psaltes, *Grammatik der byzantinischen Chroniken*, 2nd ed. (Göttingen, 1974), § 156. J. Compernass, in *RQ*, 22 (1908), 55 ff., suggests that the original form of the name was ἀνεμοειδωλεῖον, which through ἀνεμο-μοδουλεῖον became Ἀνεμοδούλιον, but this etymology seems too complicated to be likely.

[67] Cf. LXX, Job 21:18.

plating all the buying and selling that took place in the Forum, an old man passed by and said: "You fool! Why do you shout chaff and phantoms? If you are selling chaff, go to the Anemodoulion and sell it there!" The man's suggestion is a joke. Chaff is associated with winds: if you are selling chaff, the appropriate place to do it is by the weather vane.[68]

Also, the second and main part of the poem, the *ekphrasis* of the church of the Holy Apostles, is reminiscent of the *Life of Andreas Salos*. Constantine of Rhodes says that the church of the Holy Apostles had not always been so large and splendid as it was in his time. The original church, built on the fourth and largest of Constantinople's seven hills, had been rather small:

> Ἀλλ' οὖν κατ' ἀρχὰς οὐ τόσος μορφὴν πέλεν (v. 472)
>
> . . .
>
> ἀλλὰ μικράν πως τὴν κατάστασιν φέρων,
> Κωνσταντίνου[69] τὸ πρῶτον ἐκ θεσπισμάτων
> λαβόντος ἀρχὴν τοῦδε παγκλύτου δόμου... (vv. 476–78).

However, Justinian I tore down the old church and erected a completely new building. Justinian's church is very large:

> εὐρὺς γάρ ἐστιν, εὐροσύνθετος λίαν (v. 461).

It is like a heaven with five stars, forming a cross:

> ὥσπερ τις ἄλλος ἀστροσύνθετος πόλος,
> πενταστρόμορφος, συγκροτούμενος κάραις
> τρισὶ μὲν ὀρθαῖς, ταῖς δυσὶ δ' ἐγκαρσίαις (vv. 457–59),

or like a cover that protects the whole city with its five domes:

> πεντάστεγός τις σφαιροσύνθετος σκέπη
> πᾶσαν περικλείουσα τῷ δοκεῖν πόλιν (vv. 503–4).

The architect made the central dome bigger than the others, for it was destined to be the throne of the Lord and to protect his image:

> μέλλουσαν εἶναι δεσπότου μέγαν θρόνον
> τῆς εἰκόνος τε τῆς ὑπερτίμου σκέπην
> τῆς ἐγγραφείσης ἐν μέσῳ κλεινοῦ δόμου (vv. 628–30).

It is remarkable that Nicephorus does not mention Justinian's reconstruction of St. Sophia, although he introduces himself as a priest of this church. Instead he, like Constantine of Rhodes, dwells upon the history of the Holy Apostles. One night, he says, Andreas got stuck in a hole in the ground near

[68] Compernass, *loc. cit.*, thinks that the Anemodoulion was "ein freier Platz, auf welchem Marktwaren feilgeboten werden durften," which was named after the monument. But you cannot sell chaff and dust on the market.

[69] The unique MS has Κωνσταντίου; see G. Downey, "The Builder of the Original Church of the Apostles at Constantinople. A Contribution to the Criticism of the *Vita Constantini* Attributed to Eusebius," *DOP*, 6 (1951), 53–80, esp. 55 note 8 and fig. 13. On this point, Nicephorus follows another tradition than Constantine of Rhodes. According to him, "οἱ τῆς πόλεως" said that the original chapel had been built by Constantine the Great.

a chapel belonging to the Apostles Peter and Paul. Andreas prayed to the Apostles for help. At once there appeared from the chapel a shining cross and two beautiful men, presumably Peter and Paul, who helped him out of the pit. The Apostles disappeared again, but the shining cross remained and showed the way to the portico. Then it rose above the middle of the city, as if lifted by golden wings. When he could no longer see it, he discovered that the chapel of the archapostles had become a large and splendid five-domed church. He also saw the Lord sitting on a throne in the middle of the church, surrounded by Cherubim and Seraphim and the whole host of the heavenly powers. According to this vision Andreas predicted the rebuilding of the church, saying: "As time goes on, a pious emperor will rebuild it the way I saw it."[70]

Janin[71] does not think that Nicephorus had the Holy Apostles in mind, remarking that this church was not dedicated to Peter and Paul alone and that it had never been a mere εὐκτήριον. These objections, however, would not seem to be decisive. With regard to the first difficulty, Grosdidier de Matons[72] points out that a tendency to let Peter and Paul represent all twelve apostles appears in other sources as well. The second difficulty is easily explained if we remember that Constantine of Rhodes says that the original church was μικράν πως τὴν κατάστασιν φέρων. The identification is also supported by the fact that Nicephorus says that the cross rose κατὰ τὸ μέσον τῆς πόλεως, which suggests the site of the Holy Apostles. I think the correspondences between the two texts indicate that the *Life of Andreas Salos* was written after the *Ekphrasis*, i.e., after 931, even if it is hard to know for certain that Nicephorus had actually seen Constantine's poem. In any case, it is not usual for hagiographers to be ahead of their time.

III. THE *Life of Andreas Salos* AND THE *Vita Basilii*

In certain respects, the *Life of Andreas Salos* is reminiscent of the *Vita Basilii*, Constantine Porphyrogenitus' famous biography of his grandfather Basil I (867–86).[73] According to Constantine, Basil belonged to a family of Armenian Arsacids who had come to Byzantium in the reign of Leo I.[74] The

[70] In the MSS most closely related to the uncial fragment, the relevant passage reads as follows: ...συνέβη εὑρεθῆναι αὐτὸν πλησίον εὐκτηρίου τινὸς τῶν ἁγίων καὶ κορυφαίων ἀποστόλων Πέτρου καὶ Παύλου, ὅπερ ἔφασκον οἱ τῆς πόλεως τὸν ἐν ἁγίοις Κωνσταντῖνον τὸν βασιλέα οἰκοδομῆσαι....εἶδε καὶ ἰδού· [the cross] καθάπερ πτέρυξι διαχρύσοις εἰς τὸ ὕψος ἤρθη κατὰ τὸ μέσον τῆς πόλεως....ἰδού, τὸ εὐκτήριον ἐκεῖνο τῶν κορυφαίων ἀποστόλων νεύσει θεοῦ μετασκευασθὲν πεντακόρυφος ναὸς ἐγεγόνει περικαλλής τε τῷ μεγέθει καὶ τῷ εἴδει ἀμίμητος. Εἶδε δὲ τὸν κύριον ἐν μέσῳ τοῦ ναοῦ ἐπὶ θρόνου καθήμενον καὶ Χερουβὶμ καὶ Σεραφὶμ κύκλῳ αὐτοῦ σὺν πάσῃ τῇ στρατιᾷ τῶν ἐπουρανίων δυνάμεων φόβῳ καὶ τρόμῳ παριστάμεναΚατὰ τὴν ὥραν οὖν ἐκείνην προεῖπε τοῦ ναοῦ τὴν ἐπὶ τὸ κρεῖττον βελτίωσιν, φήσας ὅτι "Καιρῷ προβαίνοντι ἀναστήσει αὐτὸν εὐσεβὴς βασιλεία καθ᾿ ὃν τρόπον ἐθεασάμην αὐτόν" (740B–741B).

[71] *Eglises* (*supra*, note 16), 415.

[72] *Op. cit.* (*supra*, note 6), 307 note 104.

[73] *Vita Basilii* constitutes Book V of Theophanes Continuatus, Bonn ed. (1838), 211–353. For the much discussed question whether Basil was Constantine's real grandfather, see C. Mango, "Eudocia Ingerina, the Normans, and the Macedonian Dynasty," *ZVI*, 14/15 (1973), 17–27.

[74] *Vita Basilii*, 213 lines 9–10: Λέων ἦν ὁ μέγας τηνικαῦτα τὴν Ῥωμαϊκὴν διέπων ἀρχήν, ὁ Ζήνωνος πενθερός.

Arsacids were well received at Constantinople, but, for political reasons, Leo moved them to Nike in Thrace. In the reign of Heraclius (610–41) they settled definitely at Adrianople in Thrace, the future capital of the Macedonian theme. Here Basil was born at the beginning of the ninth century, to judge from the internal chronology of the *Vita Basilii*. His mother, who was a Macedonian, claimed to be a descendant of Alexander the Great on her father's side and of Constantine the Great on her mother's. Thus, royal blood from East and West combined in Basil's person. In 813 Adrianople was taken by Krum. The captives, among them Basil and his parents, were deported to the Bulgarian territory north of the Danube. When peace was made in 815 they returned to Adrianople. After his father's death Basil, now a young man, ἄρας ἐκ Μακεδονίας τῆς Θράκης (223 line 5), went to Constantinople to try his luck. There a certain Theophilus, a distinguished man related to Michael III and Caesar Bardas, liked to surround himself with strong, fine looking, and beautifully dressed young men, apparently to compensate for his unimpressing stature (he was nicknamed Θεοφιλίτζης, Θεοφιλίδιον, Θεοφιλίσκος, and described as ὁ μικρὸς ἐκεῖνος Θεόφιλος). Basil joined this circle, and Theophilus, who found him stronger and braver than all the others, soon made him his πρωτοστράτωρ. One day Antigonus, the son of Caesar Bardas, gave a dinner for Bardas, Theophilus, and a number of other important persons. Bardas was accompanied by some Bulgarians who were bragging that they had among them a wrestler who had never been beaten in a fight. Theophilus suggested a wrestling match between the Bulgarian and Basil. The fight had hardly begun before it ended. Basil lifted the Bulgarian as easily as a hay bundle and flung him on the table. Then Basil was noticed by Michael III who made him *his* πρωτοστράτωρ.[75] When Basil eventually became coemperor of the Byzantine Empire (866), a 350-year-old prophecy came true, for about the time when Basil's ancestors left Armenia, Isaac, an Armenian priest who was himself of Arsacid blood, had predicted that after 350 years a descendant of Arsakes would ascend the Roman throne.[76] The Romans were happy, for now they had obtained exactly what they had been praying for: an emperor who came from a poor family and knew the distress of the humble.[77] Emperor Basil is depicted as an ideal ruler. He studies the *Lives* of great men, saints as well

[75] Basil's career in Constantinople shows that he cannot have been born as early as Constantine Porphyrogenitus suggests.

[76] *Vita Basilii*, 241 lines 17 ff.: τότε δὲ καὶ ἡ πρὸ πεντήκοντα καὶ τριακοσίων ἐτῶν πρόρρησις καὶ προφητεία τὸ τέλος ἐλάμβανεν Ἰσαὰκ τοῦ διορατικωτάτου τῶν ἱερέων καὶ μοναχῶν, ὃς ἐξ Ἀρσακιδῶν καὶ αὐτὸς καταγόμενος δι' ὁράματος ἔμαθεν ὅτι μετὰ τοσοῦτον χρόνον τὸν μεταξὺ ἐκ τῶν ἀπογόνων Ἀρσάκου μέλλει τις ἐπὶ τὰ τῆς Ῥωμαϊκῆς βασιλείας σκῆπτρα ἀναβιβάζεσθαι.

[77] *Vita Basilii*, 242 lines 3–6: πάντες γὰρ ἐπιστῆναι τοῖς πράγμασιν ηὔχοντο ἄνδρα καὶ τῆς ἐλάττονος τύχης πεῖραν δεξάμενον καὶ ἐγνωκότα τοὺς κατὰ τῶν πενήτων ὑπὸ τῶν ὑπερεχόντων κονδυλισμοὺς καὶ τὰς ἀδίκους ἐξ αὐτῶν ἀφαιρέσεις κτλ. In a mosaic in the Καινούργιον, a church erected by Basil, his children were shown saying: εὐχαριστοῦμέν σοι, λόγε τοῦ Θεοῦ, ὅτι ἐκ πτωχείας Δαυϊτικῆς ἀνύψωσας τὸν πατέρα ἡμῶν (*ibid.*, 335 lines 2–3). Cf. also Liudprand, *Antapodosis* I.8: *Basilius imperator augustus, avus huius* (i.e., of Constantine Porphyrogenitus), *Macedonia humili fuerat prosapia oriundus, descenditque Constantinopolin* τῆς πτωχειας, *tis ptochias, quod est paupertatis iugo* etc. (Freiherr vom Stein-Gedächtnisausgabe. Ausgewählte Quellen zur deutschen Geschichte des Mittelalters, ed. R. Buchner and F.-J. Schmale, VIII [Darmstadt, 1971], 254).

as generals and emperors, and endeavors to imitate them.[78] He is generous, just, and pious. He converts Jews[79] and Russians[80] to Christianity and sends bishops and an archbishop to the Bulgarians, and, thanks to them and the work of the monks, the Bulgarians are definitely Christianized.[81] New churches are built, and the old ones are repaired.[82] Hitherto unknown treasures appear from under the surface of the earth.[83] The enemies of the Empire are defeated. Among his generals is a certain Andreas from Scythia, Ἀνδρέας ἐκεῖνος ὁ ἐκ Σκυθῶν, described as clever, pious, and orthodox, although the emperor does not appreciate his ability as much as it deserves.[84]

It seems to me that Nicephorus was familiar with the *Vita Basilii* and borrowed from it in at least two different ways. First, Andreas' career is, *mutatis mutandis*, a copy of that of Basil. Nicephorus says that in the reign of Leo I there was at Constantinople a certain *protospatharios* Theognostus. This man had many οἰκέτας, and later he bought others still. Among the new boys there was a handsome Scythian called Andreas. This boy soon became Theognostus' favorite. He learned reading and writing and rose to be a secretary. His master heaped gifts upon him and dressed him in fine clothes from his own wardrobe. But Andreas was more interested in the *Passions* of the martyrs and the *Lives* of the saints than in the matters of this world. He dreamed of imitating the holy men, and eventually he decided to become a *salos*. He made this decision under the influence of a vision in which he found himself defeating an Ethiopian wrestler who had never been beaten before. The Ethiopian of course represents the Devil, but he also corresponds to the Bulgarian wrestler in the *Vita Basilii*. At last Andreas left his mortal master and became a servant of Christ.[85]

As I have already remarked,[86] Theognostus does not seem to be a historical person. Instead, there is reason to believe that he is a fictitious figure, made on the model of Theophilus ὁ Μικρός in the *Vita Basilii*. He may even have received the first half of his name from this person. That Andreas is said to be a Scythian, i.e., a barbarian from the North, corresponds, on a lower social level, to what Constantine Porphyrogenitus says of Basil: namely, that he was brought up in Macedonia and spent part of his childhood in Bulgarian captivity. As Nicephorus had created Andreas himself, he could give him any name he liked. I would think that he first conceived him as a Scythian, and then looked for a suitable name. St. Andreas was the apostle of the Scythians.

[78] *Vita Basilii*, 314 line 6 ff.; cf. P. J. Alexander, "Secular Biography at Byzantium," *Speculum*, 15 (1940), 194–209.

[79] *Vita Basilii*, 341 line 8–342 line 6.

[80] *Ibid.*, 342 line 20–343 line 2: Ἀλλὰ καὶ τὸ τῶν Ῥῶς ἔθνος δυσμαχώτατόν τε καὶ ἀθεώτατον ὂν χρυσοῦ τε καὶ ἀργύρου καὶ σηρικῶν περιβλημάτων ἱκαναῖς ἐπιδόσεσιν εἰς συμβάσεις ἐφελκυσάμενος, καὶ σπονδὰς πρὸς αὐτοὺς σπεισάμενος εἰρηνικάς, ἐν μετοχῇ γενέσθαι καὶ τοῦ σωτηριώδους βαπτίσματος ἔπεισε καὶ ἀρχιεπίσκοπον παρὰ τοῦ πατριάρχου Ἰγνατίου τὴν χειροτονίαν δεξάμενον δέξασθαι παρεσκεύασεν κτλ.

[81] *Ibid.*, 342 lines 7–19.

[82] *Ibid.*, 321 line 17 ff.

[83] *Ibid.*, 256 line 23–257 line 1.

[84] *Ibid.*, 284 line 9 ff.

[85] Cf. 629 D ff.

[86] *Supra*, p. 135.

Andreas was also the name of the able Scythian general mentioned in the *Vita Basilii*. So he naturally called him Andreas.

Second, Andreas' prophecy of the last reigns of the Roman Empire is in part parallel to Isaac's prophecy as mentioned in the *Vita Basilii*. Isaac's prophecy was made, it is said, 350 years before Basil's elevation, i.e., at the beginning of the sixth century.[87] This fits the internal chronology of the *Life of Andreas Salos*. Nicephorus says that Andreas came to Constantinople as a boy in the reign of Leo I (457–74) and that he lived for sixty-six years (888C), and he makes him prophesy on the end of the world toward the end of the *Vita*, i.e., we may conclude, at roughly the same time as Isaac is said to have predicted Basil's accession to the Roman throne. Moreover, Andreas' prophecy begins with the description of an emperor that is similar to the portrait of Basil I in the *Vita Basilii*. Like Basil, this emperor will rise from poverty;[88] in his days "all gold, wherever it is hidden, will be revealed before his majesty at the instigation of God";[89] he will "tame the fair-haired peoples"[90] and persecute the Jews;[91] he will "raise up holy churches and rebuild destroyed altars";[92] and he will make righteousness, moderation, and orthodoxy prevail. In short, he will restore Church and Empire to their former splendor. Like Basil in the *Vita Basilii*, he is a portrait of the ideal Christian emperor.

Parts of this material may also be found in other sources. Of Isaac's vision there was a Greek as well as an Armenian version. Actually, it was a forgery from the latter half of the ninth century, made, it would seem, to support Byzantine interests in Armenia, and perhaps also to strengthen the legitimacy of the Macedonian dynasty.[93] In the *Vita Ignatii*,[94] Photius is said to have invented a similar prophecy and to have smuggled it into the palace library.[95] The prophecy predicted that, after a certain number of generations, the Roman throne would be occupied by an offspring of Tiridates the Great, who was king of Armenia at the time of St. Gregory the Illuminator. That this offspring should be identified with Basil I was clearly indicated in the prophecy, as Photius, according to the *Vita Ignatii*, could demonstrate. In this way Photius is supposed to have ingratiated himself with the emperor and prepared his return to the patriarchate.[96] Obviously, Isaac's vision and Photius' forgery are closely related to each other, although it is not quite clear whether Photius

[87] Actually, Isaac, or Sahak, the last Arsacid patriarch of Armenia, to whom the prophecy was ascribed, died in 439.

[88] Cf. 853B: Ἐν ταῖς ἐσχάταις ἡμέραις ἀναστήσει κύριος ὁ θεὸς βασιλέα ἀπὸ πενίας.

[89] Cf. 856B: Ἐν τοῖς καιροῖς γὰρ ἐκείνοις πᾶς χρυσὸς ὅς ἐστιν ἐν οἱῳδήποτε τόπῳ κρυπτόμενος νεύσει θεοῦ ἀποκαλυφθήσεται τῇ βασιλείᾳ αὐτοῦ.

[90] Cf. 856A: ἡμερώσει τὰ ξανθὰ γένη.

[91] Cf. 856B: τοὺς Ἰουδαίους καταδιώξει.

[92] Cf. 856B: ἀναστήσει ναοὺς ἁγίους καὶ ἀνοικοδομήσει συντετριμμένα θυσιαστήρια.

[93] P. Garabed Der Sahaghian, "Un document arménien de la généalogie de Basile Iᵉʳ," *BZ*, 20 (1911), 165–76; N. Adontz, "L'âge et l'origine de l'empereur Basil I (867–886)," *Byzantion*, 8 (1933), 475–500; *ibid.*, 9 (1934), 223–60.

[94] The *Vita Ignatii* was probably written between 907 and 910; see R. J. H. Jenkins, "A Note on Nicetas David Paphlago and the *Vita Ignatii*," *DOP*, 19 (1965), 241–47.

[95] Cf. *supra*, p. 132.

[96] PG, 105, cols. 565C–568B.

ΤΑ ΕΙΡΙΚΩC· ΑΡΟΜΑΙ ΕΞΑΓΟΡΕΥΟΝΤΕC
ΩC ΤΩΝ ΕΚΕΙ ΑΝΕ ΤΑC ΑΜΑΡΤΙΑC ΑΥ
ΧΩΡΗCEN ΚΑΙ ΕΝ ΤΩΝ. ΠΑΡΕΙΧΟΝ
ΤΩ CΤΑΒΡΙΩ ΠΑΡΕ ΑΥΤΩ ΙΚΑΝΗΝ
ΓΕΝΕΤΟ: ΠΕΡΙ ΤΟΥ ΧΡΥCΙΟΥ ΠΟCΟΤΗ
ΜΟΝΑΧΟΥ ΤΟΥ ΕΝ ΤΑ ΤΟΥ ΔΙΑ ΝΕΙΜΕ
ΤΩ CΤΑΒΡΙΩ ΤΟΙC ΠΕΝΗCΙΝ· Υ
ΝΟC CΩΟΥΝ ΤΟΙC Ε ΠΕΡ ΨΥΧΙΚΗC CΩΤΗΡΙΑC
ΚΕΙCE ΕΠΕCΤΗ ΕΥ ΑΥΤΩΝ· Ο ΔΕ ΤΩ
ΡΕΝ ΜΟΝΑΧΟΝ ΤΙ ΠΑΘΗ ΤΗC ΦΙΛΑΡ
ΝΑ ΕΝ ΕΥΛΑΒΕΙ CE ΓΥΡΙΑC ΗΤΤΩΜΕ
ΠΕΥΦΗΜΙΖΟΜΕΝΟ ΝΟC. ΟΥΔΕΝΙ ΕΞ ΑΥ
ΜΕΘ ΕΤΕΡΟΥ ΤΙΝΟC· ΤΩΝ ΠΑΡΕΙΧΕΝ
ΚΑΙ ΩC ΑΛΗΘΕΝ ΠΕΡΙ ΤΙΝΙ· ΑΛΛΑ ΠΑΝ
ΩΦΕΛΕΙΑC ΨΥΧΗC ΤΑ ΕΙC ΤΟ ΝΙCΟΡΒΑ
ΛΟΓΟΝ ΚΙΝΟΥΝ ΝΑΝ ΕΤΑΜΙΕΥΕ
ΤΑC ΕΠ ΑΛΗΘΕΙΑC ΤΟΙC ΜΟΥ ΤΩ CΗ
ΓΑΡ ΕΠΙ ΤΗ ΒΙΩ CΗ ΩC ΑΤΕ ΤΩ ΒΙΩ
ΑΥΤΟΥ· ΕΥΛΑΒΗC ΖΩΝ ΑΥΤΩ ΧΩ
ΥΠΗΡΧΕΝ ΚΑΙ ΕΥ ΟΥΤΩ ΤΗ ΦΙΛΑΡΓΥ
CΕΒΗC· ΠΑΝΤΑ ΕΡ ΡΙΑ ΜΑΙΝΟΜΕΝΟC
ΓΑΖΟΜΕΝΟC ΤΑ ΚΑΙ ΒΛΕΠΩΝ ΕΑΥ
ΤΟΙC ΜΟΝΑΧΟΙC ΕΥ ΤΟΝ ΠΛΗΘΥΝΟ
ΑΡΜΟCΤΑ· ΕΝ ΤΟΥ ΜΕΝΟΝ· ΗΓΑΛΛΕ
ΤΟΙC ΜΟΝΟΝ CΦΑΛ ΤΟ· Ο ΟΥΝ ΜΑΚΑΡΙ
ΛΟΜΕΝΟC· ΦΙΛΑΡ ΟC ΑΝΔΡΕΑC ΕΚΕΙCE
ΓΥΡΟC ΩΝ· ΤΙΝΕC ΔΙ ΠΑΡΑΓΕΝΟΜΕΝΟC·
ΤΩΝ ΠΟΛΙΤΩΝ ΤΩ ΔΙ ΩΡΑΤΙΚΩ

Monacensis gr. 443, fol. IV*v*, *Life of Andreas Salos*, 749 B–C

should be regarded as the original author or not.[97] However that may be, nothing indicates that Nicephorus had seen these forged documents with his own eyes, although he probably knew the *Vita Ignatii*.[98] Much related material is also contained in the funeral oration on Basil delivered by Leo VI in 886 or 887.[99] Like Constantine, Leo says that Basil was an Arsacid, that he came from a poor family, that he rejuvenated the Empire[100] and defeated and punished the Arabs,[101] that he ordered buildings to be erected and embellished,[102] and that in Basil's reign the Golden Age seemed to have reappeared.[103] On the other hand, Leo does not mention the vision of Isaac, nor does he mention Theophilitzes or Basil's fight with the Bulgarian. These elements Nicephorus cannot have obtained from Leo's funeral speech. Nor does Nicephorus seem to be relying on the section dealing with Basil I in Genesius' history.[104] There, too, important details, such as Isaac's vision, are missing, although Genesius offers more of the legendary and narrative material than Leo does. The *Vita Basilii* seems to be the only single text that contains all the relevant material. It is therefore more likely than any other text to have been Nicephorus' source for Andreas' date and background. It is also very likely to have influenced the description of the first eschatological ruler.

The *Vita Basilii* was written *ca.* 950.[105] Thus, there is reason to advance the terminus post quem for the composition of the *Life of Andreas Salos* to the middle of the tenth century.

IV. Epiphanius

After Andreas, the most important person in the *Vita* is Epiphanius. Nicephorus no doubt had in mind the man who was bishop of Constantinople from 520 to 535.[106] To the modern historian, Bishop Epiphanius appears as a rather shadowy figure. Nothing is known of his family. According to Theophanes he was presbyter and syncellus in the Church of Constantinople before he became the successor of John II.[107] He seems to have been "a quiet,

[97] Garabed Der Sahaghian, *op. cit.*, 175, points out that, if his dating of the vision to the patriarchate of Basil's son, Stephen I (886–93), is correct, the vision is hostile to Photius.

[98] If Nicephorus used uncials in order to give the autograph an ancient look, this was a forgery of the same kind as the one described in the *Vita Ignatii*; cf. *supra*, p. 132.

[99] *Oraison Funèbre de Basil I par son fils Léon VI le Sage*, ed. A. Vogt and I. Hausherr, *OC*, 26,1 (Rome, 1932).

[100] *Ibid.*, 56 lines 10–15: οἷόν τι γῆρας ἀτερπὲς τὸ σχῆμα, ἐν ᾧ τέως ἑωρᾶτο τὰ πράγματα, ἵνα μὴ λέγω ἡ κακία, ἀπεσκευάζετο, καὶ πρὸς καινὴν καὶ εὔτακτον μεταβολὴν... ἐξανίστατο.

[101] *Ibid.*, 56 lines 16–21.

[102] *Ibid.*, 60 lines 27–29: οἴκων ὧν μὲν ἐκ βάθρων οἰκοδομαί, ὧν δὲ ἐπισκευῆς ἠξιωμένων πρὸς κάλλος μεταποίησις.

[103] *Ibid.*, 58 lines 26–28: ...ὡς ἐκεῖνα, ἅ ποτέ φασι χρυσᾶ ἔτη ἡ παλαιότης ἀνατεῖλαι, εἰς ταῦτα δοκεῖν αὐτὴν καταστῆναι.

[104] Bonn ed. (1834), 107 line 14–128 line 23. Genesius wrote his history sometime between 944 and 959; see Gy. Moravcsik, *Byzantinoturcica*, I (Berlin, 1958), 318. There may be some reason to believe that the work was written in the earlier half of this period; see F. Tinnefeld, *Kategorien der Kaiserkritik in der byzantinischen Historiographie von Prokop bis Niketas Choniates* (Munich, 1971), 91, with further references.

[105] Moravcsik, *op. cit.*, 380.

[106] Cf. *supra*, p. 130.

[107] Theophanes (*supra*, note 9), 166.

prudent, complaisant person, living unobtrusively in stirring times, exactly the character to submit gracefully to the ecclesiastical activity of his emperor."[108] Since there was no biography of Epiphanius, we have no reason to believe that Nicephorus knew more about him than we do. When he adds otherwise unknown details, such as that Epiphanius' father was called John (688A), or that after his father's death he was to become a monk and change his name (884C/D), I doubt that he is depending on historical facts. John was such a common name that Nicephorus may have borrowed it from anywhere, e.g., from Epiphanius' predecessor John II. Whether Bishop Epiphanius was a monk or not we do not know, nor is there any indication that Nicephorus knew either. Janning[109] and da Costa-Louillet[110] think that the change of name indicates that the Epiphanius of the *Vita* should be distinguished from the bishop of the same name. But the change of name is probably of little importance in this context. In the *Vita Evaristi*,[111] written in the first half of the tenth century, the holy man is called Evaristus right from the beginning, although at one moment[112] we are told that his original name was Sergius and that Evaristus was the name he got when he renounced the world. In the same way, Nicephorus calls Andreas' young friend Epiphanius, although he thinks that this is his monastic name, which he did not receive until after Andreas was dead.

Information on Bishop Epiphanius being scanty, Nicephorus probably turned to other models in order to get some more material for his portrait of this character. When he describes Epiphanius as a pious youth of noble Constantinopolitan stock, as περιφανὴς ἐν σοφίᾳ (684A), as a future monk, patriarch, and ὁμολογητής (884C/D), he may be using his contemporary, Patriarch Polyeuctus (956–70), as a model. Especially what Andreas says of Epiphanius' future in 884D seems to be a little too strong to have been inspired by the shadowy figure of the sixth-century bishop. Andreas' words are: καὶ τῆς ἁγίας ταύτης ἐκκλησίας χηρευσάσης, σε ἐγερεῖ κύριος φωστῆρα καὶ ὁδηγὸν καὶ ποιμένα τῶν πεπλανημένων ψυχῶν ἐμπειρότατον. μέλλεις δὲ καὶ εἰς ὁμολογίαν περὶ ὀνόματος τοῦ Χριστοῦ ἔρχεσθαι καὶ σὺν ἁγίοις γενήσεται ὁ κλῆρός σου.[113] This prediction seems more appropriate to Polyeuctus than to Epiphanius. Having been a monk for many years, Polyeuctus succeeded the worldly patriarch Theophylactus in April 956. As a patriarch he was independent and outspoken to the extent that Constantine Porphyrogenitus is said to have repented his promotion.[114] It may further be noted that Polyeuctus is said to have been advanced in years at the time of the death of Romanus II (963).[115] This certainly means that his youth coincided with the reign of Leo VI, which would give a good parallel to the story of young Epiphanius under Leo I. On the whole, the

[108] W. Smith and H. Wase, *A Dictionary of Christian Biography*, II (London, 1880), 157.

[109] *Commentarius praevius* (*supra*, note 3), col. 622.

[110] *Op. cit.* (*supra*, note 6), 180.

[111] *BHG*³, 2153.

[112] *Vita Evaristi*, ed. C. van de Vorst, *AnalBoll*, 41 (1923), 302 line 36.

[113] Text according to the recension most closely related to the uncial fragment (cf. 884D).

[114] Scylitzes, *Synopsis historiarum*, ed. J. Thurn (Berlin, 1973), 244.

[115] Leo Diaconus, *Historia*, Bonn ed. (1828), 32 lines 23–24.

moralizing, strictly orthodox tendency of the *Vita*[116] is well in line with Polyeuctus' austere, moralizing character. The fictitious writer of the *Vita* is supposed to belong to the clergy of St. Sophia (888C). If this reflects the position of the *real* author, it is a fair guess that he knew Polyeuctus and was impressed by his strong personality. On the other hand, as he also seems to have had a high opinion of Constantine Porphyrogenitus (cf. *infra*), I would not go as far as Janning, who simply identified Epiphanius with Polyeuctus, or, alternately, with Antonius (974–79), whose character was similar.[117] In my view, we should limit ourselves to saying that the portrait of Epiphanius *may* contain some features that derive from Polyeuctus. If so, the *Life of Andreas Salos* may not have been written until 956 or later, although I cannot find any *reliable* terminus post quem after *ca*. 950.

V. "CONSTANTINE THE GREAT"

Since the terminus post quem seems to fall within the reign of Constantine Porphyrogenitus (945–59), it might be worth seeing if Constantine VII can be compared to any of the Byzantine emperors described in the eschatological section of the *Vita*.[118] If the answer is yes, we may also be able to find the terminus ante quem. It is not as unreasonable to look for such a connection as I once thought. According to Nicephorus, the reign of the first eschatological ruler will be happy. In his time, men will enjoy themselves, unaware of the approaching disaster. Nicephorus seems to be writing in the reign of a successful emperor, indirectly warning his contemporaries that the current prosperity might be deceptive. The extremely moralizing tone of the *Vita* agrees with this message. Now, although the Byzantine Empire enjoyed relative prosperity during Constantine's reign, we know that the apocalyptic feeling was still there. A certain Gregory, author of the *Vita Basilii iunioris*,[119] written, it would seem, between 956 and 959,[120] thinks that he is writing ἐν ταῖς ἐσχάταις ἡμέραις.[121] Toward the end of the same *Vita* Christ is heard saying: Ἰδοὺ ἐγὼ παραγίνομαι καὶ ὁ μισθός μου ἅμα ἐμοί, καὶ αἱ ἡμέραι ἐγγὺς τῆς ἐμῆς πρὸς ἡμᾶς (read ὑμᾶς) δευτέρας ἐλεύσεως, καὶ μακάριοί ἐστε ἐὰν ἑτοίμους καὶ γρηγοροῦντας εὑρήσω ὑμᾶς.[122] Thus, in Constantine's reign, pious men kept warning that the end was drawing near.

A look at the eschatological section of our *Vita* shows that the final drama will begin with the succession of five different emperors, the first of whom will be good and will reign for thirty-two years. The two following emperors

[116] See Grosdidier de Matons' excellent analysis, *op. cit.* (*supra*, note 6).

[117] *Commentarius praevius* (*supra*, note 3), cols. 623–24.

[118] 853B–860C. For the text, see *supra*, note 1.

[119] *BHG*³, 263–64; see also Rydén, "The Church of St. Anastasia" (*supra*, note 9), 198 note 2.

[120] H. Grégoire and P. Orgels, "L'invasion hongroise dans la 'Vie de Saint Basile le Jeune'," *Byzantion*, 24 (1954), 147–54.

[121] Ed. S. Vilinskij, *Žitie sv. Vasilija Novago v' russkoj literaturě*. II, Zapiski imperatorskago novorossijskago universiteta, istoriko-filologičeskago fakul'teta (Odessa, 1911), 311 line 16, 316 line 35.

[122] Ed. A. Veselovskij, "Razvskanija v' oblasti russkago duhovnago stiha," *XVIII-XXIV, Sbornik' otdělenija russkago jazyka i slovesnosti imperatorskoj akademii nauk'*, LIII, no. 6, suppl. (St. Petersburg, 1891), 169.

will be evil, one being an incarnation of Antichrist and the other a convert to paganism. The fourth and the fifth will be good again. The former will come from Ethiopia and reign in peace for twelve years, whereas the latter will come from Arabia and reign for only one year. At the end of his reign he will go to Jerusalem and surrender the imperial power to God. As I have tried to show elsewhere,[123] the first, second, third, and fifth of these emperors represent the legendary history of the first four Byzantine emperors, i.e., the history of Constantine the Great, Constantius, Julian the Apostate, and Jovian, put into future tense. Between the third and the fifth emperor, Nicephorus has inserted a ruler reminiscent of Alexander the Great. Now, if Nicephorus describes the beginning of the end of the world as a repetition of the earliest history of the Byzantine Empire, it seems unlikely that he also has a succession of later Byzantine emperors in mind. If there is any correspondence between Nicephorus' eschatological system and later Byzantine history, I think it is restricted to a parallel between the first eschatological ruler ("Constantine the Great") and the emperor in whose reign the *Vita* was written.

As we have already seen, "Constantine the Great" is remarkably similar to Basil I as he is portrayed in the *Vita Basilii*. The reason for this similarity cannot be that Nicephorus regarded Basil's reign as the beginning of the end. Nicephorus lived more than half a century later than Basil I. Thus, if "Constantine the Great" stands for Basil I, "Constantius" stands for Leo VI, "Julian" for Alexander, "Alexander the Great" and "Jovian" for Constantine Porphyrogenitus and Romanus I; and this is, of course, extremely improbable.[124] The reason is rather that Nicephorus knew the *Vita Basilii* and borrowed certain features from it for his portrait of the first eschatological ruler. He did not confine himself, however, to simply copying Constantine Porphyrogenitus' picture of his grandfather. As Paul J. Alexander has demonstrated, the Byzantine theory of kingship as expressed in the *Vita Basilii* is derived from Constantine the Great and his circle.[125] Nicephorus seems to have been aware of this connection. At any rate he went beyond the portrait of Basil I and depicted the first eschatological ruler as an incarnation of Constantine the Great himself. In so doing, he reinterpreted Isaac's prophecy and gave it an up-to-date meaning: the emperor of the prophecy was no longer Basil but Constantine the Great, i.e., I think, Constantine Porphyrogenitus in the guise of Constantine the Great.

One reason why Constantine VII portrayed his grandfather as the ideal Christian emperor and even claimed that he was a descendant of Constantine the Great on Basil's mother's side was certainly that he wanted to strengthen the legitimacy of the Macedonian dynasty. Constantine also seems to have

[123] "Zum Aufbau der Andreas Salos-Apokalypse," *Eranos*, 66 (1968), 101–17.

[124] Passages such as Constantine Porphyrogenitus, *De thematibus*, ed. A. Pertusi, ST, 160 (Vatican City, 1952), 75 line 2: ἐπὶ τῶν χρόνων τοῦ μακαρίτου καὶ ἁγίου μου πατρός, show how absurd it would be to compare Leo VI to an evil apocalyptic ruler.

[125] P. J. Alexander, "The Strength of Empire and Capital as Seen Through Byzantine Eyes," *Speculum*, 37 (1962), 339–57, esp. 348–54. For the same theory appearing in the *Life of Andreas Salos*, see Rydén, "The Andreas Salos Apocalypse" (*supra*, note 1), 239–41.

referred to Constantine the Great in his dealings with foreign nations. In the famous thirteenth chapter of the *De Administrando Imperio*,[126] he tells his son Romanus not to accept the demands of the barbarians for imperial crowns and dresses, for Greek fire, and for marriage alliances with the imperial family, and recommends that he refer his refusal to the authority of Constantine the Great. The crowns and the dresses had been sent to Constantine the Great by God Himself, Constantine says, and, following the will of God, Constantine the Great had put them in the sanctuary of St. Sophia, whence they could not be taken away except temporarily on certain occasions. God had also confided to Constantine the Great the secret of the Greek fire, and he (Constantine the Great) had therefore ordered a curse to be inscribed on the altar of St. Sophia "that he who should dare to give of this fire to another nation should neither be called a Christian, nor be held worthy of any rank or office."[127] In the same way the curse of Constantine the Great befell any emperor who allied himself in marriage "with a nation of customs differing from and alien to those of the Roman order," the Franks excepted, "because he himself drew his origin from those parts."[128] Constantine Porphyrogenitus doubtless knew that these excuses were anachronistic,[129] but in his vision of the Byzantine Empire he combined past and present without scruple. He thus created a timeless, ideal picture of the empire which he could use to his advantage in his dealings with foreign nations.[130] It is also interesting to note that Liudprand, who visited Constantinople in 949, says that the part of the imperial palace called Porphyra, in which Constantine Porphyrogenitus was born, had been built by Constantine the Great.[131] According to Liudprand, it was Constantine the Great who had expressed the wish that his offspring should be born there and be called Porphyrogeniti. In the opinion of many, Liudprand adds, Constantine Porphyrogenitus was in fact descended from Constantine the Great. This seems to be just another example of Constantine

[126] Greek text ed. Gy. Moravcsik, English translation R. J. H. Jenkins, DOT, I (Washington, D. C., 1967). According to the internal evidence, the *De Administrando Imperio* was written between 948 and 952 (cf. intro., 11).

[127] *Ibid.*, 69f. These anachronisms are in line with the fact that neither Nicephorus nor Constantine of Rhodes dwell upon the history of St. Sophia.

[128] *Ibid.*, 71.

[129] As Alexander, "The Strength of Empire," 347, observes, Constantine Porphyrogenitus says in chapter 48 of the same work that the Greek fire was invented in the reign of Constantine IV Pogonatus (668–85). Cf. also C. Neumann, *Die Weltstellung des byzantinischen Reiches vor den Kreuzzügen* (Heidelberg, 1894), 3.

[130] There is a similar anachronism in the well-known mosaic representing the Virgin and Child, surrounded by Justinian I and Constantine the Great, in the southwest vestibule of St. Sophia. It shows Justinian I bringing a model of St. Sophia and Constantine the Great bringing a model of Constantinople to the Virgin. In reality, St. Sophia was dedicated to the Divine Wisdom, i.e., to Christ, whereas Constantinople was dedicated to Constantine the Great himself; for the latter, see Dagron, *op. cit.* (*supra*, note 16), 42. The Virgin did not become the particular protectress of Constantinople until the seventh century. The exact date of the mosaic is unknown. Estimates range from the middle of the tenth century to the first quarter of the eleventh. To me a date around 950 seems likely, since it would fit the exploitation of the name of Constantine the Great in the *De Administrando Imperio*. It would also fit the words "for she (the City) has been given to the Mother of God and no one will snatch her out of her hands" in the prelude to the prophecy of the end of the world in the *Life of Andreas Salos* (853B).

[131] Liudprand, *Antapodosis* (*supra*, note 77) I.6–7.

Porphyrogenitus' anachronistic references to Constantine the Great, especially as the Porphyra does not appear in our sources until the eighth century.[132]

Furthermore, as Constantine Porphyrogenitus in his portrait of Basil I alluded to the image of Constantine the Great, so Constantine himself was compared to the first Christian emperor. He was even found to be his superior, as we learn from the preface to the *Geoponica*, an encyclopedic work that almost certainly was compiled on the initiative of Constantine Porphyrogenitus. The anonymous author addresses himself to τὸ τερπνὸν τῆς πορφύρας ἀπάν-Ξισμα, i.e., no doubt, to Constantine Porphyrogenitus, and says, among other things: "Disdaining the pursuits of the other emperors, you have competed with the first emperor of the Christians, with Constantine, the founder and protector of this city, whom you have left far behind you, thanks to your beautiful works, your triumphs, your victories, and your other achievements."[133] Now, if the compiler of the *Geoponica* could compare Constantine Porphyrogenitus to Constantine the Great, Nicephorus can certainly be supposed to have drawn the same parallel. Constantine's successors, Romanus II (959–63), Nicephorus Phocas (963–69), John Tzimisces (969–76), and Basil II (976–1025), are much less likely to have inspired a comparison with Constantine the Great. Unlike Constantine, they did not carry the same name as the first Christian emperor. They did not share his interest in history, nor did they have the same reason to support their legitimacy by claiming to be descendants of the founder of Constantinople. On the other hand, it seems utterly unlikely that Nicephorus would have depicted any of these emperors as a new Constantius, who is presented as an incarnation of Antichrist because he was an Arian, or as a new Julian the Apostate. Thus, if we accept the idea that there is a connection between Nicephorus' eschatological vision and the reign of Constantine Porphyrogenitus, we must conclude that the *Life of Andreas Salos* was written before Constantine died in November 959. To my mind, the paragraph on "Constantine the Great" is a kind of prophecy *ex eventu*; with "Constantius" the real prophecy begins.

VI. THE *Life of Andreas Salos* AND THE HEBREW *Vision of Daniel*

This interpretation is supported by a Hebrew version of the *Vision of Daniel* discovered in Cairo and recently translated into English by A. Sharf.[134] The anonymous author of this vision says that in the reign of Chosroes, King of Persia, the Archangel Gabriel appeared to Daniel and revealed to him what would happen at the end of days. In those days, he said, there will arise a blasphemous king who will mock priests and anger the Most High by his

[132] Cf. Janin, *Constantinople byzantine* (*supra*, note 13), 121.

[133] Σὺ γὰρ μικρὰ τὰ τῶν ἄλλων βασιλέων σπουδάσματα λογισάμενος πρὸς μόνον ἐκεῖνον ἡμιλλήθης τὸν πρῶτον Χριστιανῶν βασιλέα, Κωνσταντῖνόν φημι τὸν ταύτης οἰκιστήν τε καὶ πολιοῦχον, ὃν καὶ πολλῷ τῷ μέσῳ παρήλασας ἔργοις παλλίστοις (read καλλίστοις) καὶ τροπαίοις καὶ νίκαις καὶ τοῖς λοιποῖς ἀριστεύμασιν· *Geoponica*, ed. H. Beckh (Leipzig, 1895), 1 lines 10–15.

[134] A. Sharf, "A Source for Byzantine Jewry under the Early Macedonians," *BNJbb*, 20 (1970), 302–18, esp. 303–6.

deeds. But God will slay him for the evil of his doings and set another king in his place, a king whose tribe will be exalted from its former state. The sign of his name will be the two B's. He will enrich his kingdom with great riches, he will conquer nations and bring peoples under his sway. He will baptize the Jews by force. He will die in his bed in great agony and pass his scepter to his son, whose name will be the sign of royalty for beasts. Together with him there will reign two uncrowned men, one after the other, the first being a dark one who will reign peacefully for twenty-two seasons, the second being an Arab who will give the king bad advice but not succeed. After him there will arise a king who will reign with four other crowned kings, all from the same family. But he, too, will die, and from the same house (as the king with the lion's name) there will reign a king whom many foes will try to ensnare, but they will not succeed, for he will be worthy of (divine) protection. At the beginning of his reign his kingdom will prosper and be exalted to the skies, but in the last days it will be destroyed. This dynasty will not fall, i.e., I understand, the dynasty of the king of the two B's will be the last Christian dynasty. It will enjoy its possessions peacefully and the land will be filled with good things. Then the son of wickedness will appear from the North and rule over the land of Aftalopon[135] three seasons and a half season. He will commit sins, the like of which have not been committed from the creation of the world to its end, for he will join in marriage sons with their mothers, brothers with their sisters, and daughters with their fathers, and so forth.

It should appear from this summary of Sharf's translation that, as Sharf and the commentators quoted by him have observed, the anonymous apocalyptist is referring to Byzantine history from Michael III to Constantine VII. His message evidently is that Constantine VII will be the last Christian emperor. At the end of this emperor's reign, Antichrist will appear from the North, i.e., from the land of Gog and Magog, and the tribulations will begin. This indicates that the author is writing between 945 and 959.[136] Like Nicephorus he seems to be relying on the *Vita Basilii* for certain details. As Isaac, according to the *Vita Basilii*, made his prophecy 350 years before the elevation of Basil I, so Gabriel appeared to Daniel in the reign of Chosroes, King of Persia—presumably Chosroes I (531–79). Like the Macedonian dynasty in the *Vita Basilii*, the tribe of the king of the two B's will be "exalted from its former state." The contrast between the king of the two B's and his predecessor corresponds to the contrast between Michael III and Basil I in the *Vita Basilii*.

There are also other signs that, somehow, the Hebrew *Vision of Daniel* and the *Life of Andreas Salos* are related to each other. Speaking of Con-

[135] Aftalopon (Έπτάλοφος) is Constantinople, not Rome, as Sharf thinks. There is no indication that the capital will be moved from Constantinople at this stage of the drama.

[136] Sharf, *op. cit.*, 316 note 80, assumes that the apocalypse was written not long after the death of Constantine VII, since he is the last Byzantine emperor mentioned. But apocalyptic texts are normally supposed to be written *before* the death of the last ruler they refer to. The fact that Messiah, according to the anonymous author, will reign in Byzantium can hardly be understood as an allusion to the victories of Nicephorus Phocas and John Tzimisces, as Sharf suggests (*ibid.*, 317).

stantine VII, Gabriel says that "many foes will gather about him to ensnare him but their counsel will be frustrated for he will be worthy of (divine) protection." This looks like a summary of the words with which Andreas begins his prophecy of the end of the world: "About our city you shall know: Until the end she will fear no nation whatsoever, for no one will entrap or capture her, not by any means, for she has been given to the Mother of God and no one will snatch her out of her hands. Many nations will break their horns against her walls and withdraw with shame, receiving from her gifts and great wealth." Very remarkable is the similarity between Leo's two uncrowned coregents in the *Vision* and the fourth and fifth rulers in the prophecy of the *Vita*. In the *Vita* "the man from Ethiopia" is followed by a ruler from Arabia, and in the *Vision* "a dark one" is followed by an Arab. "The man from Ethiopia" is an incarnation of Alexander the Great, and as such, it is said, he will reign for twelve years. One would expect "the dark one" to reign for twelve years as well, and not for twenty-two, but the anonymous author seems to have mixed up the number of Alexander's years with the number of dirty peoples which Alexander, according to tradition, had shut up in the North. In both the *Vita* and the *Vision* the former of the two figures has been badly integrated into the context. In the *Vita*, "Alexander the Great" is an intruder into the series "Constantine the Great," "Constantius," "Julian," and "Jovian." In the *Vision*, "the dark one" does not seem to correspond to any historical figure, whereas the Arab can easily be identified with Leo's well-known chamberlain Samonas, who was an Arab.[137] Also, the second ruler in the *Vita* ("Constantius") and the ruler following upon Constantine VII in the *Vision* are very similar. Both are described as forerunners of Antichrist. They will reign for three years and a half. In their days father will have intercourse with daughter, son with mother, and brother with sister. God will send thunder and lightning and the cities will burn. In those days happy are those who live in Rome, Riza, Armenopetra, Strobilos, and Karioupolis (*Vita*, 857B), or "in Rome and in Salonica, in Sicily and in Beroia, in Shtriglion and in Ashiniad, in Aram and in Istambolin" (?) (*Vision*).

The writer of the *Vision* is quite explicit about his belief that, after Constantine VII, the eschatological drama will begin. By describing five easily identifiable emperors, starting with Michael III and ending with Constantine VII,[138] he clearly demonstrates when he thinks that the end will come. In comparison with the prophecy *ex eventu*, he devotes little space to his real prophecy. In the eschatological section of the *Vita*, on the other hand, the prophecy *ex eventu* is much shorter than the real prophecy. Instead of preparing his readers with a series of clearly recognizable emperors, Nicephorus mentions only the last real emperor, whom he disguises as Constantine the Great so that he becomes hard to identify. I think, however, that the similarities between the *Vision* and the *Vita* show that Nicephorus is using the

[137] To Sharf and the authorities quoted by him (*ibid.*, 312 and note 55) the man from Arabia is as mysterious as "the dark one." They do not consider the possibility of identifying him with Samonas.
[138] References to Alexander (912–13) are lacking.

same material as the author of the *Vision* (a current version of the *Vision of Daniel*[139] and the historiography of Constantine VII and his circle) and expresses the same view (after Constantine VII the end will begin). To my mind, this in turn indicates that he is writing at the same time.

VII. THE UNCIAL FRAGMENT

It has been suggested above[140] that the uncial fragment contained in the Monacensis gr. 443 is the surviving tenth quire of the original MS in which Nicephorus tried to support the historical fiction of the *Vita* by imitating sixth-century writing. It has also been mentioned that the imitation is inconsistent. It is obviously not the result of a careful study of a real sixth-century codex. What Nicephorus is in fact imitating is rather the archaizing Coptic uncial of the tenth century. For certain details his models may very well have been the elegant minuscule MSS produced at Constantinople in the middle of the century. The breathings are comparatively small and mostly of the cursive round type, less often angular, and rarely in the form of one half of the letter H. As is well known, this mixture of round and angular breathings is typical of many MSS written in the middle and the second half of the tenth century, when round breathings become increasingly frequent. The characteristic left hook that terminates the vertical stroke of the letters Ρ, Φ, and Ψ also appears in the semimajuscule headings of Mt. Athos, Dionysiou 70, written in 955 by the *notarius* Nicephorus for Constantine Porphyrogenitus' brother-in-law Basil.[141] The number and heading of chapter 32 on folio IV[v], reproduced here, are red, as are the starlike ornament at the end of the heading and the initial E of the first word of the chapter. Both the star and the initial are very simple. Nevertheless, they are strikingly similar to the stars and initials in the luxurious Hippiatrika-MS in Berlin, Phill. 1538, written for Constantine Porphyrogenitus, it would seem,[142] and in the famous Gospel Book Parisinus gr. 70, probably written in 964.[143] The star also appears, e.g., in Vaticanus gr. 124, written at Constantinople in 947,[144] and the initial also in the MS written by the *notarius* Nicephorus mentioned above.[145]

It cannot be proved on paleographical grounds alone that the uncial fragment was written at Constantinople in the fifties of the tenth century. It may be said, however, that both the writing and the ornamentation fit the date and provenance which the observations made in the previous sections imply.

[139] Cf. Liudprand, *Legatio* (*supra*, note 77), chap. 39: *Habent Greci et Saraceni libros, quos* ὁράσεις *sive visiones Danielis vocant, ego autem Sibyllanos, in quibus scriptum reperitur, quot annis imperator quisque vivat; quae sint futura eo imperante tempora, pax an simultas, secundae Saracenorum res an adversae.*

[140] *Supra*, p. 132.

[141] K. and S. Lake, *Dated Greek Minuscule Manuscripts to the Year 1200*, III (Boston, 1935), pl. 154.

[142] K. Weitzmann, *Die byzantinische Buchmalerei des IX. und X. Jahrhunderts* (Berlin, 1935), 16f.

[143] *Ibid.*, 14.

[144] A. Diller, "Notes on Greek Codices of the Tenth Century," *TAPA*, 78 (1947), 184–88, pl. 1. For the provenance, see J. Irigoin, "Pour une étude des centres de copie byzantins (suite)," *Scriptorium*, 13 (1959), 177–209, esp. 195.

[145] Lake, *loc. cit.*

VIII. Other Observations

It would seem that the general character of the *Vita* is in support of a date within the reign of Constantine VII. The *Vita* is an unusually long and comprehensive work. In its way it is surprisingly learned. It not only tells us about the deeds and behavior of Andreas Salos, it also asks and answers a series of questions of a quasi-scientific kind such as: from where do the clouds get their rain? Why is the snow white? What is the soul made of? How is Paradise? What is hell like? When will the world come to an end, and how? Thus the *Life of Andreas Salos* is not only a saint's *Life* but also a kind of encyclopedia corresponding to the different encyclopedic enterprises instigated by Constantine Porphyrogenitus. On a popular level it seems to me to reflect the intellectual atmosphere radiating from the imperial palace in his reign.

There is also an unmistakable affinity between the *Life of Andreas Salos* and the *Vita Basilii iunioris*.[146] They are both long, comprehensive texts, written in unpretentious Byzantine Greek and showing the same characteristic mixture of saint's *Life* and apocalyptic treatise. The moralizing element is strong in both cases. Andreas is a *salos*, and Basil is sometimes said to behave like a *salos*. They both live and die in Constantinople, although their origins were far away, Scythia in the case of Andreas, the backwoods of Asia Minor in the case of Basil the Younger. The author of the *Vita Basilii iunioris*, a certain Gregory, is not known outside the frame of this text, nor is Nicephorus known otherwise than through the *Life of Andreas Salos*, although it seems likely that the authors of these extensive texts also wrote other works. It appears from their publications as we know them, however, that they belonged to the same intellectual milieu and had similar interests. They both knew Constantinople well, and they both seem to have been familiar with the hagiographical works of Leontius of Neapolis.[147] As Germaine da Costa-Louillet says, the *Life of Andreas Salos* and the *Vita Basilii iunioris* "semblent baigner dans la même atmosphère."[148] It has already been mentioned that the latter appears to have been written between 956 and 959.

Finally, a brief remark on the name of the author. According to 888C, the fictitious author of the *Vita* was a priest at St. Sophia called Nicephorus. Is this applicable to the real author too? At least as far as the name is concerned, there is room for doubt. The historical fiction implies that the real author denied authorship of the *Vita* and pretended that he had discovered a hitherto unknown Early Byzantine document. The credibility of this document would have suffered if the discoverer had been the fictitious author's namesake. People would have wondered at such a coincidence. For practical reasons, I have called the real author by the name of the fictitious one, but it should be borne in mind that his true name probably was different.[149]

[146] *Supra*, note 119.
[147] Da Costa-Louillet, *op. cit.* (*supra*, note 6), 202 note 2.
[148] *Ibid.*, 182. She also points out that these two saints' *Lives* sometimes appear in the same MSS.
[149] Cf. Maas, *loc. cit.* (*supra*, note 6).

IX. Conclusion

On the basis of these observations, it may be concluded that the *Life of Andreas Salos* was written between the time of the composition of the *Vita Basilii* and the death of Constantine VII Porphyrogenitus, i.e., in the sixth decade of the tenth century. The fictitious date of the *Vita* seems to derive from the story of Isaac's vision and the Armenian origin of the Macedonian dynasty.

THE VERSIONS
OF THE *VITA NICONIS*

DENIS F. SULLIVAN

I. INTRODUCTION

THE *Vita Niconis* (*BHG*³, 1366, 1367) has been characterized as "eine der wichtigsten Quellen für die innere Geschichte Griechenlands im 10. Jahrhundert."[1] St. Nikon *Metanoeite* was born in the Pontus Polemoniacus *ca.* 930. At some point in the 950's he began preaching his message of repentance in Asia Minor. When Nicephorus Phocas recaptured Crete from the Arabs in the spring of 961, Nikon journeyed there and spent the next seven years re-Christianizing the island.[2] After brief periods in Athens, Euboea, Thebes, and other cities and villages of Hellas and the Peloponnese, he came to Lacedaemonia, probably in the early 970's,[3] where he remained until his death toward the end of the century. His *Vita* recounts numerous details of his activities during these periods and also provides a variety of insights into social customs and monastic practices as well as *obiter dicta* on historical events of the time.

The *Vita Niconis* is preserved in two manuscripts, Barberini gr. 583 and Koutloumousi 210. The Barberini text has never been edited, although a Latin translation (at times only a paraphrase) was made directly from the manuscript by Jacques Sirmond *ca.* 1600. The Koutloumousi text was edited by Spyridon Lampros in 1906. There are considerable differences between these two texts, but as yet their relationship has not been established. In the following remarks, which derive from a projected edition and translation of the *Vita*, I would like to address this issue. I believe that new external evidence on the anonymous author's method of composition, as well as a comparison of some of the significant variations between the texts, shows that the Barberini manuscript contains the earlier form of the *Vita*.

II. THE MANUSCRIPTS

The *Vita Niconis* was first known in printed form in the Latin translation of Jacques Sirmond, who worked in Rome from 1590 to 1608, collaborating with Cardinal Baronius on the *Annales Ecclesiastici*.[4] His translation was published in excerpts by Baronius, who remarks that Sirmond worked from materials *ex Sfortiana bibliotheca*.[5] This Sforza manuscript used by Sirmond

[1] H.-G. Beck, *Kirche und theologische Literatur im byzantinischen Reich* (Munich, 1959), 577.

[2] See E. Voulgarakis, "Nikon Metanoeite und die Rechristianisierung der Kreter vom Islam," *Zeitschrift für Missionswissenschaft und Religionswissenschaft*, 47 (1963), 192–204, 258–69.

[3] On the dating, see R. J. H. Jenkins and C. Mango, "A Synodicon of Antioch and Lacedaemonia," *DOP*, 15 (1961), 238.

[4] C. Baronius, *Annales Ecclesiastici, a Christo Nato ad Annum 1198*, 12 vols. (Rome, 1580–1607). I have used the edition published by L. Guerin, 37 vols. (Barri-Ducis, 1864–83).

[5] Baronius, *Annales Ecclesiastici*, XVI, 114. The complete translation was published by E. Martene and U. Durand, *Veterum Scriptorum ... amplissima collectio*, VI, (Paris, 1729), 837–87.

can be identified with that now in the Barberini collection of the Vatican Library, Barberini gr. 583 (formerly VI,22).[6] Pages 611–83 contain a *Vita Niconis* which corresponds closely with the Latin translation of Sirmond, and Delehaye has shown that this must be the manuscript from the Sforza library.[7] Barberini gr. 583 (hereafter B) is a large paper codex, .38 × .28 m., written in two columns and consisting of 1026 pages. It is a collection of saints' lives and homilies, copied by various hands generally attributed on palaeographical grounds to the fifteenth century.[8] The provenance of the manuscript prior to its use by Sirmond is unknown.

Another text of the *Vita Niconis* was found in 1880 in Koutloumousi cod. 210, folios 106a–181b, by Spyridon Lampros. He published a Greek edition in 1906 based solely on this manuscript.[9] Koutloumousi 210 (hereafter K) is a paper codex written in single columns and consisting of 181 folios.[10] The scribe and date of the codex are known precisely from a note at the end of the manuscript: Ἐτελειώθη τὸ παρὸν διὰ χειρὸς ἐμοῦ τοῦ ταπεινοῦ Παρθενίου ἐπισκόπου κατὰ τὸ ‚αχλ´ ἔτος τὸ σωτήριον (= 1630). This Parthenius has been identified as the bishop of Bresthene[11] who is known from other sources.

The *Vita Niconis*, then, is contained in these two manuscripts. The Greek text has been edited *in toto* only from the Koutloumousi codex, although Lampros later published a brief discussion of Barberini gr. 583, noting some of the differences between B and K.[12] Galanopoulos reprinted Lampros' text of K in 1933, adding some readings derived from the Barberini manuscript.[13] Neither editor, however, attempted to establish the relationship between the two texts, and each was quite selective in his use of B.

A comparison of B and K quickly reveals that, although the two texts have many passages in common, there are a number of important discrepancies. In some cases these can be attributed to a scribal error, e.g., small omissions or slight changes. Others, however, are more interesting. They might be characterized as: (1) lengthy sections which are similar, but show substantial rewording in both grammar and vocabulary; (2) large sections which appear in B, but are absent in K; and (3) passages of some length which are completely different. None of these can be explained by the

[6] For a description and inventory of the manuscript, see H. Delehaye, "Catalogus codicum hagiographicorum graecorum Bibliothecae Barberinianae de Urbe," *AnalBoll*, 19 (1900), 107–14.

[7] *Idem*, "La Vie d'Athanase, Patriarche de Constantinople (1289–1293, 1304–1310)," *MélRome*, 17 (1897), 40 note 1.

[8] See *idem*, "Catalogus," 107. N. Vees, "Vie de Saint Théoclète, Evêque de Lacédémone," *Vizantijskoe Obozrenie*, 2 (1916), Suppl. I, p. 4, notes the common ascription to the fifteenth century but suggests that the portion of the manuscript containing the *Vita Niconis* may be fourteenth-century.

[9] Ὁ βίος Νίκωνος τοῦ Μετανοεῖτε, ed. S. Lampros, in Νέος Ἑλλ., 3 (1906), 132–228.

[10] For a description and inventory of the manuscript, see S. Lampros, *Catalogue of the Greek Manuscripts on Mount Athos*, I (Cambridge, 1895), 297.

[11] See M. Galanopoulos, Ὁ Λακεδαιμόνιος βιβλιογράφος ἐπίσκοπος Βρεσθένης Παρθένιος, in ᾽Επ.῾Ετ.Βυζ.Σπ., 12 (1936), 259–60.

[12] S. Lampros, Ὁ Βαρβερινὸς κῶδιξ τοῦ βίου τοῦ Νίκωνος, in Νέος Ἑλλ., 5 (1908), 301–4[8].

[13] M. Galanopoulos, Βίος, πολιτεία, εἰκονογραφία, θαύματα καὶ ἀσματικὴ ἀκολουθία τοῦ ὁσίου καὶ θεοφόρου πατρὸς ἡμῶν Νίκωνος τοῦ Μετανοεῖτε (Athens, 1933).

mechanics of transmission.[14] Rather, they suggest that one of the texts must be a rewriting of the other. The problem is to establish which is the earlier version.

III. The External Evidence

One solution to this problem lies, I believe, in the relationship of the *Vita Niconis* to earlier hagiographic and patristic literature, especially the *Vita Lucae Junioris* (BHG[3], 994). The *Life of Saint Luke* (890–953) was written by a younger contemporary of that saint shortly after Luke's death and may thus be attributed to the third quarter of the tenth century.[15] It must, therefore, precede the *Life of St. Nikon*, who did not die until late in the tenth century. A comparison of these two *Lives* suggests very strongly that the author of the *Vita Niconis* knew the *Vita Lucae* quite well and used portions of it in composing his own work.[16] The *Vita Lucae* opens with a prologue in which the choice of Luke as a subject is justified. It continues with a description of Luke's childhood, adult life, and death, and concludes with a series of posthumous miracles and an epilogue. The *Vita Niconis* follows the same format, which in itself is hardly startling. Yet certain similarities of thought and wording in each of these sections are so striking as to put a definite connection almost beyond doubt. In the following pages I shall illustrate this relationship by a comparison of various passages from the two *Lives*, using the edition of the *Vita Lucae* by P. Kremos[17] and the Barberini version of the *Vita Niconis*.[18] The similar passages will be presented in parallel columns with brief introductions to set the context. Where K differs from the passages of B cited below, I will give the variants. Where no variant is noted, B and K are in agreement. In order to clarify the argument, however, I will reserve discussion of these variants until after I have completed the comparison of the Barberini text to the *Vita Lucae*.

[14] I do not, in this paper, consider the stemmatic relationship of the two manuscripts, but rather the relationship between the two versions they contain. And of course the fact of revision complicates any attempt to arrive at a stemma. A careful examination of the areas in which there does not appear to be any revision, however, suggests that each manuscript is a witness of independent value for these sections.

[15] On the dating, see G. Da Costa-Louillet, "Saints de Grèce aux VIIIe, IXe, et Xe siècles," *Byzantion*, 32 (1961), 331–32.

[16] Certain connections between the two saints apparently existed prior to the composition of the *Vita Niconis*. Nikon himself had visited Thebes *ca.* 970, before he went to Lacedaemonia. More significant still, when Hosios Lukas was constructed, a mosaic of Nikon was included in the catholicon (M. Chatzidakis, "A propos de la date et du fondateur de Saint Luc," *CahArch*, 20 [1969], 127–50 has proposed a date of 1011; E. Stikas, "Nouvelles observations sur la date de construction du catholicon et de l'église de la Vierge du monastère de saint Luc en Phocide," *CorsiRav*, 1972, pp. 311–30, opposes Chatzidakis and argues that the catholicon dates from the time of Constantine IX Monomachos, probably 1042–45). O. Demus, *Byzantine Mosaic Decoration* (London, 1947), 57, comments on the inclusion of this mosaic in relation to the "monastic and local provincial character" of the church.

[17] Ed. P. Kremos, in Φωκικά, I (Athens, 1884), 25–62.

[18] I have used a microfilm of the Barberini manuscript.

Vita Lucae	*Vita Niconis*
The prologue of the *Life of Luke* begins: Οὐ χρόνος ἦν ἀληθῶς ὁ τοῦ καλοῦ βίου καὶ τῆς περὶ τὴν ἀρετὴν σπουδῆς αἴτιος, ἀλλὰ γνώμη μόνη καὶ ἡ τὰ χρηστὰ φιλοῦσα προαίρεσις.[19]	The prologue of the *Vita Niconis* begins: Εἰ οὐ τόπῳ ἢ χρόνῳ, γνώμῃ δὲ μᾶλλον στερρᾷ καὶ προαιρέσει τά τε μέγιστα τῶν κατορθωμάτων καὶ τὴν εἰς τὸ ἀκρότατον τῆς ἀρετῆς ἐπίδοσιν δεῖ ἐπιγράφειν...[20] (Εἰ...ἐπιγράφειν deest in Κ).
The author continues by remarking that this can be seen from other men who ...βίον ἄληπτον τοῖς πολλοῖς ἐπιδειξαμένων....[21]	Later the author speaks of the glory of those ...βίον ἄληπτον τοῖς πολλοῖς ἐπιδειξάμενοι...(βίον...ἐπιδειξάμενοι deest in Κ).[22]
Luke, however, the subject of his biography, has ...τὸ τραχὺ καὶ ἀνώμαλον τῆς πρὸς αὐτὴν φερούσης καὶ τοῖς πολλοῖς ἄβατον οὐ τῇ φύσει ταύτης ἔδειξε περιόν, ἀλλὰ τῇ γνώμῃ μᾶλλον καὶ προαιρέσει τῶν τὰ καλὰ μέν, ἐπίπονα δὲ διὰ ψυχῆς ἀσθένειαν καὶ μαλακίαν παραιτουμένων.[23]	Finally it is said that Nikon ...τὸ τραχὺ καὶ ἄναντες τῆς πρὸς αὐτὴν ἀγούσης, τοῖς δὲ πλείουσι (Κ πλείοσι) καὶ ἄβατον, οὐ τὸ τῇ φύσει (Κ οὕτω τὴν φύσιν) ταύτης ἔδειξε περιόν (Κ περιών)...ἀλλὰ τῇ γνώμῃ μᾶλλον καὶ τῇ τὰ χρηστὰ φιλούσῃ προαιρέσει..., and that Nikon was an example to τοῖς...προαιρουμένοις μὲν τὰ ἀμείνω, δι' ἀσθένειαν δ' ἐσθ' ὅτε ψυχῆς καὶ μαλακίαν παραιτουμένοις (τοῖς...παραιτουμένοις deest in Κ).[24]

In the prologues of these two *Lives*, then, one can see four passages in which the thought and the wording are quite close. A contrast of χρόνος with γνώμη and προαίρεσις opens the *Vita Lucae*. A similar juxtaposition occurs in the *Vita Niconis* (B), with the addition of τόπος to complement χρόνος. The similarity increases with the reference to those who have "displayed a life not attainable by the majority," and this close verbal resemblance continues in the contrast of φύσις and γνώμη, and in the passage on the "weakness and softness of the soul." In these final three examples almost direct quotations are used, while in the first the author of the *Life of Nikon* seems to have elaborated on and expanded the contrast found in the *Vita Lucae*. One might also note that the phrase ἡ τὰ χρηστὰ φιλοῦσα προαίρεσις, which occurs in the opening passage of the earlier *vita*, is represented only by προαίρεσις in the opening of the *Vita Niconis* but is picked up in full later in the prologue.

[19] Ed. Kremos, 25.
[20] MS Barberini gr. 583, page 611.
[21] Ed. Kremos, 25.
[22] MS Barberini gr. 583, page 611.
[23] Ed. Kremos, 25.
[24] MS Barberini gr. 583, pages 611–12; ed. Lampros (*supra*, note 9), 132 lines 22 ff.

Thus the apparent imitation is not slavish, even though the degree of similarity suggests a connection. Some phrases have been altered or used in a slightly different context, and their presentation in the *Vita Niconis* (B) is more complex. Overall, however, the thought and wording of the two introductions are quite similar.

The resemblance between the prologues of these two works is not an isolated phenomenon. Similarities can be found in a number of other areas. In each *Life* the saint's death is described and then followed by a series of posthumous miracles. In both there is a transition passage which indicates the approach the author will follow in narrating these miracles.

Vita Lucae

This transition passage in the earlier *Life* reads:

Ὥρα δὲ καὶ τῶν μετὰ θάνατον τοῦ σοφοῦ θαυμάτων μνήμην ποιήσασθαι, οὐ πάντων ἀκριβῶς οὐδὲ καθεξῆς, πῶς γὰρ τῶν τοσούτων καὶ ἃ νάμασι ποταμίοις ἐπίσης ῥέουσι καὶ μάλισθ' ὅτι μηδὲ μέχρι καὶ νῦν ἐκεῖνα τῆς ῥοῆς ἔστησαν; ὀλίγα δὲ τούτων ἀπολαβόντες εἰς δόξαν θεοῦ καὶ ὑμῶν ὠφέλειαν τῶν εἰς τοῦτο συνειλεγμένων διηγησόμεθα.[25]

Vita Niconis

The corresponding passage in the *Vita Niconis* has:

Ἀλλ' ὥρα (Κ ὅρα) καὶ τῶν μετὰ τὴν κοίμησιν τοῦ ὁσίου θαυμάτων τε καὶ χαρισμάτων, ὧν ἠξιώθη ἐκ τοῦ ἀγαθοῦ Πνεύματος, μνήμην ποιεῖσθαι, εἰ καὶ μὴ πάντων ἀκριβῶς οὐδὲ καθ' ἑξῆς. Πῶς γὰρ, τοσούτων ὄντων, ἃ δὴ καὶ ποταμίοις ἐπίσης ῥέουσι νάμασι, καὶ μάλισθ' (Κ μάλιστα) ὅτι μηδὲ μέχρι καὶ νῦν ἐκεῖνα τῆς ῥοῆς ἔστησαν; Ὀλίγα δὲ τούτων ἀπολαβόντες εἰς δόξαν θεοῦ, τοῦ οὕτω δοξάζοντος ὡς ἡ ὑπόσχεσις τοὺς αὐτοῦ θεράποντας, τὰ πλείω τοῖς εἰδόσι παραπέμψωμεν.[26]

The similarities here are obvious. Finally, some examples from the epilogues of these two *Lives* will complete our survey of the correspondences between the structural frameworks.

Vita Lucae

The epilogue of Luke's *Life* begins:

Ἀλλὰ πῶς ἄν τις τὰ ἐκείνου λέγων φιλοτιμούμενος μὴ καὶ ἀδυνάτοις ἐπιχειρεῖν δόξειεν ὥσπερ ἀστέρων πληθὺν ἢ ψάμμον παράλιον ἢ χώρας θαλαττίους ἐθέλων ἀπαριθμεῖν....[27]

Vita Niconis

In the epilogue of the *Vita Niconis* we read:

Ῥᾷον γὰρ ἀστέρων πληθὺν ἀριθμεῖν καὶ ψάμμον παράλιον ἢ καὶ κυάθῳ πέλαγος (Κ πέλαγος κοτύλῃ) ἐκμετρεῖν ἢ καὶ ἄλλο τι ἐπιχειρεῖν τῶν ἀνηνύτων (τῶν ἀνηνύτων ἐπιχειρεῖν transp. Κ) ἢ τὰ ἐκείνου πάντα λέγειν καὶ διηγεῖσθαι....[28]

[25] Ed. Kremos, 54.
[26] MS Barberini gr. 583, page 653; ed. Lampros, 184 lines 11 ff.
[27] Ed. Kremos, 61.
[28] MS Barberini gr. 583, page 682; ed. Lampros, 221 lines 4 f.

Vita Lucae	*Vita Niconis*
At another point the epilogue of the *Vita Lucae* has: Αὐτὸς δέ μοι ἄνωθεν εἴης προστάτης τοῦ βίου καὶ τῆς ζωῆς, ἱερὲ Λουκᾶ, τὸ ἐμὸν ἐντρύφημα καὶ καλλώπισμα.... [29]	In the same passage Nikon's biographer prays: Εἴης δέ μοι καὶ προστάτης ἄνωθεν τῆς μονῆς, ἱερὲ Νίκων, τὸ ἐμὸν ἐντρύφημα (Κ τρύφημα) καὶ καλλώπισμα.... [30]

The *Vita Niconis*, then, is articulated by a prologue, a central transitional passage, and an epilogue all of which contain sections bearing a marked resemblance to their counterparts in the *Vita Lucae*. That this relationship also pervades the body of the work can be shown by a number of examples.

Vita Lucae	*Vita Niconis*
Luke was his parents' third child ...ὃς ἔτι τὴν πρώτην μετιὼν ἡλικίαν καὶ εἰς παῖδας ἐξεταζόμενος οὐδὲν κατὰ παῖδας ἐποίει. [31]	The young Nikon ...Τὴν πρώτην ἔτι μετιὼν ἡλικίαν καὶ εἰς παῖδας ἐξεταζόμενος (Β ἐξηταζόμενος; Κ ἐξισαζόμενος) οὐ κατὰ παῖδας εἶχε τὸ φρόνημα.... [32]
The author of the *Vita Lucae* says of Luke's eating habits: ὅτι μηδενὶ πρὸς ταῦτα διδασκάλῳ καὶ ὁδηγῷ χρησάμενος, ἀλλ' οἴκοθεν καὶ παρ' ἑαυτοῦ πρὸς ἅπαν μὲν τὸ τῇ γαστρὶ χαριζόμενον ἐκπολεμωθείς, πόνους δὲ καὶ ἔνδειαν καὶ εἴ τι ἄλλο τὸ τὴν σάρκα λυποῦν ἐκ ψυχῆς ἀσπασάμενος. [33]	Nikon's biographer says: Λίαν γὰρ ἐκπολεμηθεὶς πρὸς ἅπαν τὸ τῇ γαστρὶ χαριζόμενον, πόνους διηνεκεῖς καὶ ἔνδειαν καὶ εἴ τι ἕτερον τῶν τὴν σάρκα λυπεῖν εἰδότων ἐκθύμως ἠσπάζετο. And below that ...μηδενὶ πρὸς ταῦτα παιδευτῇ καὶ ὁδηγῷ χρησάμενος, οἴκοθεν καὶ παρ' ἑαυτῷ Nikon began his ascetic contests. [34]
When Luke is tonsured it is said that the abbot ...τῇ καλλίστῃ χορείᾳ τῶν ἀδελφῶν ἐγκρῖναι.... [35]	In the *Vita Niconis* one reads that the abbot ...τῇ καλλίστῃ χορείᾳ τῶν ἀδελφῶν ἐγκρίνει (Κ τῇ καλλίστῃ χορηγίᾳ ἐγκρίνει). [36]
In another passage Luke cures a man near death, μόνῳ δὲ ἄσθματι τὸ νεκρὸν εἶναι μὴ πιστευόμενον. [37]	In the *Vita Niconis* the saint comes to the home of John Blabenterios in Argos and finds the man and his daughter τῷ ἄσθματι δὲ μόνον νεκροὺς εἶναι μὴ πιστευομένους. [38]

[29] Ed. Kremos, 62.
[30] MS Barberini gr. 583, page 683; ed. Lampros, 221 lines 23 ff.
[31] Ed. Kremos, 27.
[32] MS Barberini gr. 583, page 612; ed. Lampros, 133 lines 24 f.
[33] Ed. Kremos, 27.
[34] MS Barberini gr. 583, page 615; ed. Lampros, 137 lines 14 ff.
[35] Ed. Kremos, 29.
[36] MS Barberini gr. 583, page 615; ed. Lampros, 136 line 27.
[37] Ed. Kremos, 44.
[38] MS Barberini gr. 583, page 634; ed. Lampros, 160 line 28.

Vita Lucae

We are told of Luke's sleeping habits:
Εἶτα μικρόν τι τοῦ ὕπνου παραγευόμενος, εὐθὺς ἀνεπήδα καὶ τῷ Δαβὶδ συνεφθέγγετο, "Προέφθασα ἐν ἀωρίᾳ καὶ ἐκέκραξα"· καὶ αὖθις, "Προέφθασαν οἱ ὀφθαλμοί μου πρὸς ὄρθρον τοῦ μελετᾶν τὰ λόγιά σου."[39]

When Luke wished to live apart from the monastery as an anchorite, the abbot ...καὶ οὐκ ἠνείχετο τὴν διάζευξιν, ἐπεὶ καὶ δριμεῖς τῶν κατὰ θεὸν φιλούντων οἱ πόθοι καὶ τῶν φυσικῶν ἰσχυρότεροι.[41]

Luke's biographer explains the saint's decision to go to Kalamion as follows:
Τούτων ὁ θαυμάσιος ἀκούσας Λουκᾶς τῶν τοῦ Ἰωαννίτζη μερῶν ἀφίσταται καὶ πρός τι χωρίον Καλάμιον οὕτως ἐπιχωρίως καλούμενον μεταβαίνει, ὃ μὴ μόνον εὖ ἔχον ἡσυχίας, ἀλλὰ καὶ ἀέρος ἐν καλῷ κείμενον σφόδρα ἐκεῖνος ἠσπάσατο ἐν αὐτῷ τε διάγων ἠγάλλετο τὴν ψυχήν.[43]

In the *Vita Lucae* one posthumous miracle ends with the cured man's return home ...Τελείας οὖν ὁ ἄνθρωπος ἐπιτυχὼν τῆς ἐλευθερίας οἴκαδε ἐπανῄει, χαίροντας ἰδὼν τοὺς οἰκείους χαίρουσιν ὀφθαλμοῖς, while in another the person healed ἐγερθεὶς τοῦ ὕπνου καὶ τὸ ὄναρ μὴ ἀγνοήσας φανερὰν ὑπάρχειν ἀλήθειαν πᾶσί τε διηγεῖτο καὶ σὺν αὐτῷ πάντας εἶχε θεὸν καὶ τὸν αὐτοῦ θεράποντα μεγαλύνοντας.[45]

Vita Niconis

Nikon's biographer tells us that he rivaled Arsenios in going without sleep and that ...διὰ τὴν ἀνάγκην τῆς φύσεως μικρὸν τοῦ ὕπνου καὶ ἀδρανὲς καὶ οἷον (Κ οἱονεὶ) διεψευσμένον (Κ διαψευσάμενον) παραγεύεσθαι, εὐθὺς ἀνεπήδα, τὰ τοῦ Δαβὶδ ᾄδων καὶ λέγων "Προέφθασα ἐν ἀωρίᾳ καὶ ἐκέκραξα," καὶ τὰ ἐξῆς.[40]

When Nikon learned that his father was looking for him, he told the abbot that he must flee, but τὴν διάζευξιν οὐκ ἠνείχετο.
And both he and the abbot wept; λίαν γὰρ δριμεῖς τῶν κατὰ θεὸν φιλούντων οἱ πόθοι καὶ τῶν φυσικῶν ἰσχυρότεροι.[42]

When the abbot becomes concerned lest Nikon's austere life-style endanger his health he ...οἰκίσκον δὲ αὐτῷ προσαποτάξας πρὸς ἡσυχίαν εὖ ἔχοντα... (Κ οἰκίσκον δέ τινα πρὸς ἡσυχίαν εὖ ἔχοντα δειμάμενος....). And Nikon agreed to live there: ἦν γὰρ ἐν καλῷ (Κ ἐν λάκκῳ) κείμενον ἡσυχίας τὸ δωμάτιον....[44]

In the *Vita Niconis* one posthumous miracle narrates the cure of a child and ends ...ὁ πατὴρ χαίρουσιν ὀφθαλμοῖς χαίροντας ἑώρα τοὺς οἰκείους, καὶ σὺν αὐτῷ πάντας εἶχε θεὸν ὁμοῦ καὶ τὸν αὐτοῦ θεράποντα μεγαλύνοντας (Κ ὁ πατὴρ χαίνουσιν ὀφθαλμοῖς ἑώρα τοὺς οἰκείους· καὶ ἀπελθὼν οἴκαδε χαίρων, ὁλοψύχως θεὸν ἐδόξαξε καὶ τὸν αὐτοῦ θεράποντα ἐμεγάλυνεν).[46]

[39] Ed. Kremos, 35.
[40] MS Barberini gr. 583, page 616; ed. Lampros, 138 lines 3 ff.
[41] Ed. Kremos, 32.
[42] MS Barberini gr. 583, page 619; ed. Lampros, 142 lines 26 ff.
[43] Ed. Kremos, 45.
[44] MS Barberini gr. 583, page 617; ed. Lampros, 139 lines 9 f. and 17 f.
[45] Ed. Kremos, 57 and 60.
[46] MS Barberini gr. 583, page 674; ed. Lampros, 205 lines 24 ff.

Vita Lucae

In the *Vita Lucae* Pothos, the *strategos* of Hellas, desires to return to Constantinople to be with his wife after the death of their son. Yet, because of the dangerous atmosphere in the imperial court, he is afraid. He consults Luke, who tells him to go without fear that the emperor will be favorable to him. His reaction is described in the following words: Ταῦτα ὁ στρατηγὸς ὡς ἐκ προφητικῆς καὶ θεοπνεύστου γλώττης ἀκούσας καὶ μηδὲν ἐφ' οἷς ἀκήκοεν ὅλως ἐπιδοιάσας, ὁδοῦ εἴχετο.[47]

In the *Vita Lucae* one of the posthumous miracles concerns a certain John of Terbenia. Being too ill to ride, he is unable to come to the saint's shrine to seek a cure. Instead he takes a different approach: φθάνει τὸν τόπον τῇ διανοίᾳ, τοῖς τῆς πίστεως διαθέει πτεροῖς· αὐτῆς ψαύει τῆς σοροῦ τοῖς χείλεσι· καλεῖ, καὶ σώματι μακρὰν ὤν, τὸν ἐγγὺς παρεῖναι μὴ ἀποροῦντα διὰ τῆς χάριτος....[49]

Finally, Luke's biographer reports, among that saint's posthumous miracles, the cure of a blind man. The story is worth quoting in full: Ὁ τοῦ μέλλοντος ῥηθήσεσθαι θαύματος ἀπολαύσας οὔτε τὴν πόλιν ὅθεν ἐστὶν οὔτε τὸ ὄνομα ὃ κέκλητο δῆλος ἡμῖν καθίσταται ἢ ὅτι τὰς τῶν ὀμμάτων εἶχε βολὰς ἀμαυράς, τοὺς τοῦ σώματος ἀμφοτέρους ἀπέσβετο λύχνους, τοῦ γλυκυτάτου πᾶσιν ἐστερεῖτο φωτός. Οὗτος ἀπάσης τῆς ἐξ ἀνθρώπων ἀπογνοὺς βοηθείας, ὡς κρεῖττον ὂν τὸ πάθος ἢ κατὰ ἀνθρωπίνην καὶ τέχνην καὶ

Vita Niconis

In a similar scene in the *Vita Niconis* John Malakenos, a wealthy Laconian, is falsely accused of treason and summoned to appear before the emperor. He consults Nikon who tells him to go without fear since the emperor will recognize his innocence and honor him with a position in the senate. His reaction is described as follows: Ὁ τοίνυν Μαλακηνός, ὡς ἐκ προφητικῆς γλώσσης καὶ θεοπνεύστου ταῦτα ἀκηκοὼς καὶ μηδὲν ὅλως τούτοις ἐπιδοιάσας, παρεκλήθη οὔτι μετρίως.[48]

In the *Vita Niconis* a certain young novice named Luke is in a similar situation. His solution is like that of John of Terbenia: Φθάνει τῇ διανοίᾳ τὸν θεῖον καὶ ἱερὸν οἶκον τοῦ μάκαρος ... καὶ τοῖς τῆς πίστεως πτέροις, αὐτῆς (Κ αὐτοῖς) ψαύει τῆς σοροῦ τοῖς χείλεσι, καὶ καλεῖ (καλεῖ om. Κ) σώματι πόρρω διεστηκώς, τὸν ἐγγὺς παρεῖναι μὴ ἀποροῦντα (ἤλπισε add. Κ) διὰ τῆς χάριτος.[50]

In the *Vita Niconis* a certain monk, Procopius, is cured of blindness. Here, too, a lengthy citation is in order: Ἀλλὰ προσεκτέον. Ὀφθήσεται γὰρ καὶ τὸ μέλλον ῥηθῆναι διὰ βραχέων καινὸν καὶ παράδοξον καὶ διηγήσεως ἄξιον. Ἀνὴρ γάρ τις τῶν ἔτι (Κ ἐν) τῷ βίῳ περιόντων καὶ τῷ πολλάκις δηλωθέντι μετοχίῳ τῆς μονῆς (Κ add. τοῦ μάκαρος) τὰς οἰκήσεις ποιούμενος, ὑγρότητος δριμυτάτης ἐπιρροῇ (Κ ἐπιρροῆς) ποτε λώβην τῶν ὀφθαλμῶν ὑποστὰς οὐ τὴν τυχοῦσαν καὶ ὑπόχυσιν (Κ

[47] Ed. Kremos, 49.
[48] MS Barberini gr. 583, page 649; ed. Lampros, 178 lines 24 ff.
[49] Ed. Kremos, 58.
[50] MS Barberini gr. 583, page 669; ed. Lampros, 209 lines 8 ff.

Vita Lucae

θεραπείαν, ἐπὶ τὸν ἅγιον καταφεύγει καὶ τὸν αὐτοῦ ναὸν εἰσελθὼν χεῖράς τε ἅμα καὶ τὰ τῆς διανοίας ὑψώσας ὄμματα, "Λῦσόν μου τὸ σκότος ὁ τοῦ ἀληθινοῦ φωτός, ἔλεγε, παραστάτης καὶ κληρονόμος· ἀπάλλαξόν με τῆς κατεχούσης νυκτός· ἴδω σου τὴν εἰκόνα· προσβλέψω τὴν θήκην· τὸ σεμνεῖον θεάσωμαι· τοῦ τεμένους κατατρυφήσω· κηρύξω πᾶσι καὶ διηγήσωμαι τὰ θαυμάσιά σου, πλησθέντος μοι χαρᾶς τοῦ στόματος καὶ τῆς γλώττης ἀγαλλιάσεως." Οὕτως ἐκεῖνος δεόμενος, ἐπείπερ ὁ ἅγιος τὴν ἴασιν ἀνεβάλλετο, ῥαθυμίας ἡττηθεὶς οἴκαδε ἀνεχώρει, δευτέραν θέμενος μικροψύχου θελήματος τὴν ἐλπίδα τῆς θεραπείας· πλὴν ἀλλὰ καὶ οὕτως οὐχ ὑπερεῖδεν αὐτὸν ὁ τοῦ θεοῦ ἄνθρωπος καὶ περὶ τὸ συμπαθεῖν ἑτοιμότατος, ἀλλ' ὁδεύοντι καὶ ἔτι ὁδοῦ ἐχομένῳ τὰ τῆς εὐχῆς ἐκπληροῖ καὶ τὸ λίαν διψώμενον χαρίζεται φῶς· οὐ μὴν ἀθρόαν οὐδὲ παραχρῆμα τὴν ὅλην αὐγὴν δίδωσιν, ἀλλὰ κατὰ μικρὸν ὑφαπλουμένην αὐτῷ καὶ τρανουμένην τῇ τοῦ λυπηροῦ σκότους ὑποχωρήσει. Ἀμέλει καὶ δυσπιστεῖν εἶχε τὸ πρῶτον καὶ οὐκ ἀληθὲς τὸ πρᾶγμα ἐνόμιζεν· ἐπεὶ δὲ σαφεῖς ἐδέχετο τὰς τῶν ὁρατῶν ἀντιλήψεις καὶ πᾶσιν ὁμοίως ἑώρα τοῖς καλῶς βλέπουσι, χαρᾶς πλησθεὶς μετὰ θαύματος τῷ θείῳ Λουκᾷ τὴν εὐχαριστίαν καὶ δι' αὐτοῦ τῷ θεῷ καὶ τοῖς πᾶσι τὸ θαῦμα δίδωσι, τρανωθεὶς μετὰ τῶν ὀφθαλμῶν καὶ τὴν γλῶτταν τῇ περιουσίᾳ τῆς ἡδονῆς.[51]

Vita Niconis

λώβην ὑποστὰς κατὰ τῶν ὀφθαλμῶν, τοῦ βλέπειν ἐστέρητο, καὶ) ἀμαυρὰς εἶχε (Κ ἔχων) τὰς τῶν ὀμμάτων βολάς, καὶ (Κ om. καὶ) τοὺς λύχνους τοῦ σώματος ἀθλίως οὕτω (Κ add. σκότους) πεπήρωτο (Κ πεπλήρωτο) καὶ τοῦ πᾶσιν ἡδυτάτου φωτὸς παντάπασιν ἀπεστέρητο. Comparison is made to a New Testament miracle and then, the ailment being incurable, we are told that the man ...τῶν ἄλλων πάντων καὶ οὗτος ὑπεριδὼν καὶ πάσης τῆς ἐξ ἀνθρώπων ἀπογνοὺς θεραπείας, πρὸς τὸν κοινὸν καὶ ἄμισθον ἰατρὸν ἔγνω δεῖν καταφεύγειν. Καὶ δῆτα καὶ (Κ om. καὶ) ἀνακλίνας (Κ κατακλίνας) ἑαυτὸν εἴσω τοῦ ἐν τῷ μετοχίῳ, ἱδρυμένου ἐπ' ὀνόματι τοῦ ὁσίου, ἱεροῦ εὐκτηρίου, ἔμπροσθεν τῆς ἐκεῖσε θείας καὶ θαυματουργοῦ εἰκόνος τοῦ μάκαρος χεῖρας τε ἅμα καὶ ὄμματα τῆς διανοίας ὑψώσας, Λῦσόν μου, ἔλεγε, τὸ σκότος ὁ τοῦ (Κ om. τοῦ) πρώτου καὶ ἀληθινοῦ φωτὸς κληρονόμος· λύτρωσόν (Κ λύτρωσαί) με τοῦ πιέζοντος πάθους· ἀπάλλαξόν με τῆς κατεχούσης νυκτός· ἴδω σου τὴν σεβάσμιον εἰκόνα· κατατρυφήσω τοῦ θείου τεμένους· κηρύξω πᾶσι κἀγὼ καὶ διηγήσομαί σου τὰ θαυμάσια. Οὕτως οὖν τῷ Προκοπίῳ. Nikon appears to Procopius in a dream and cures him. When the monk awakens, he...τὸ λίαν διψώμενον φῶς καὶ τὴν ὅλην αὐγὴν παραχρῆμα (Κ παρὰ χρῆμα) ἀπελάμβανε, καὶ καθαρῶς ἑώρα πᾶσιν ὁμοίως τοῖς καλῶς βλέπουσιν. Ἐπὶ δὲ τῷ παραδόξῳ τούτῳ θαύματι χαρᾶς πλησθεὶς καὶ θυμηδίας, δόξῃ τῇ πρὸς θεὸν ἐχρῆτο καὶ τῇ πρὸς τὸν ἅγιον εὐχαριστίᾳ, τρανωθεὶς ἐπὶ τοῖς ὀφθαλμοῖς καὶ τὴν γλῶτταν, καὶ κῆρυξ ὢν διαπρύσιος (Κ κηρύττων διαπρυσίως) μέχρι καὶ τήμερον τῆς εἰς αὐτὸν γενομένης παραδοξοποιίας (Κ add. οὐ παύεται).[52]

[51] Ed. Kremos, 58.
[52] MS Barberini gr. 583, page 670; ed. Lampros, 210 lines 14 ff.

A number of other comparisons might be made,[53] but the examples given are sufficient to show the relationship between the *Vita Niconis* (B) and the *Vita Lucae*. The anonymous author of Nikon's biography appears to have used portions of the earlier work as a model, both for the basic structure of his own composition and for the details of some individual incidents. Admittedly, Byzantine hagiographic texts are highly traditional in format and phraseology. The possibility, however, that the similarities cited above result from independent use of common ideas and phrases is quite remote. The similar structural passages and direct quotations make this clear. Moreover, a perusal of the two models of Byzantine hagiography, Athanasius' *Vita Antonii* and Gregory Nazianzenus' *In Laudem Basilii Magni*, as well as a variety of other *Lives*, especially those of the tenth, eleventh, and twelfth centuries,[54] reveals none which contain such precise and numerous similarities. Similar ideas do occur, e.g., in the descriptions of a saint's childhood, but not to the extent detailed above.

The Barberini version of the *Vita Niconis*, then, seems in part to have been written using the *Vita Lucae* as a model. This method of composition is interesting in itself. The author, who was abbot of Nikon's monastery in Sparta, must have worked directly from a copy of the *Vita* of St. Luke of Phocis. But more significant still is the light this discovery throws on the relationship between the B and K versions. To this point I have compared only the Barberini version to the *Vita Lucae*. A brief survey of these same passages in K is instructive for the question of the priority of the versions.[55] First, the Koutloumousi text contains many of the same quotations from the *Vita Lucae* as B. The whole transitional passage, portions of the epilogue, and a number of narrative passages are virtually the same as those in B.

[53] In the *Vita Lucae* (ed. Kremos, 34), Luke's assumption of the μέγα σχῆμα has a number of verbal similarities to the comparable scene in the *Vita Niconis* (MS Barberini gr. 583, page 635). Luke's years of service to a stylite near Corinth (ed. Kremos, 39) are described in terms that closely resemble Nikon's service in the monastery of Chryse Petra (MS Barberini gr. 583, page 615). It is notable in this passage that, while both the *Vita Lucae* and B contain the phrase ...ταύτην ταπείνωσιν...ζηλῶν, K has ...ταύτην ταπείνωσιν...μιμούμενος (ed. Lampros, 137 lines 3–4). Later Luke (ed. Kremos, 39) is the object of abusive treatment in a scene that resembles the story of Nikon and John Aratos (MS Barberini gr. 583, pages 639–40). Here, too, there are a number of similar phrases, and the turning point of both scenes comes with a quote from Psalm 75:8, ὁ Θεὸς ἐξ οὐρανοῦ ἠκούτιζε κρίσιν. Finally, Crinites, who held the ἀρχή of Hellas (ed. Kremos, 49), is drawn to consult Luke just as Basil Apocaucos, the praetor at Corinth, is drawn to seek Nikon's aid (MS Barberini gr. 583, page 645).

[54] I have looked for similarities in the *Lives* of Daniel the Stylite (d. 493), Theodore of Sykeon (d. 613), John the Almsgiver (d. 620), Athanasius of Methone (ninth cent.), Theocletus (d. *ca.* 870), Peter of Argos (d. *ca.* 922), Michael Maleinos (d. 961), Nilus of Grottaferrata (d. 1004), Athanasius the Athonite (d. *ca.* 1004), Symeon the New Theologian (d. 1022), Meletios (d. 1105), and Cyrill of Philea (d. 1110). In none have I discovered anything approaching the degree of similarity found in the two *Lives* compared above. In fact, only in the *Life* of Athanasius the Athonite have I found even a few similar phrases, and these were not the kind of precise quotations seen in the *Vita Niconis*. I might also note that N. Vees, Συμβολὴ εἰς τὴν ἱστορίαν τῶν μονῶν τῶν Μετεώρων, *Byzantis*, 1 (1909), 220–21, found a close resemblance between the prologue of the *Life* of Athanasius of the Meteora (d. 1383) and that of the *Vita Lucae*. This *vita* was of course written long after that of Nikon and its dependence on the *Vita Lucae* does not affect the argument presented above. Rather, its anonymous author seems to have used the *Vita Lucae* just as the author of Nikon's biography did, but less extensively.

[55] See *supra*, pp. 162–67.

This suggests that the borrowings from the *Vita Lucae* must have been present in the original version of the *Vita Niconis*. On the other hand, K is also missing a number of such borrowings which B preserves. Portions of the prologue in B which closely resemble the prologue of the *Vita Lucae* are not present in K, which has a completely different introductory passage. Then in the description of Nikon's childhood K has the reading ἐξισαζόμενος, while both B and the *Vita Lucae* have ἐξεταζόμενος (to be counted in the number of[56]). In the tonsure scene K reads τῇ καλλίστη χορηγίᾳ ἐγκρίνει..., again at odds with both B and the *Vita Lucae* which have τῇ καλλίστη χορείᾳ τῶν ἀδελφῶν ἐγκρίνει. In the description of the δωμάτιον K has ἐν λάκκῳ, at variance with the ἐν καλῷ of both B and the *Vita Lucae* and the sense of the passage. The δωμάτιον is "well situated for hesychia" and not "situated in a ditch." In the passage concerning the cure of the child B and K differ substantially. B's ending for the miracle appears to bring together almost verbatim the endings of two miracles in the *Vita Lucae*. This correspondence is lost in K where the passage seems to have been deliberately rewritten. Finally, the story of the young novice Luke shows B and the *Vita Lucae* agreeing with the reading καλεῖ, while K has the clearly intentional change to ἤλπισε.

These variants in K show that, while both versions contain borrowings from the *Vita Lucae*, K preserves them less faithfully and less fully than B. In perhaps two instances the differences might be attributed to transmission problems, but in most cases they are clearly the result of deliberate alterations. And whenever B and K differ in these borrowings, B is always closer to the *Vita Lucae*. I conclude that the Barberini version is the original and the Koutloumousi a revision. The borrowings from the *Vita Lucae* were the work of the original author, essential parts of the composition. Some of these borrowings were lost when the revision preserved in K was written. The reviser responsible for the Koutloumousi version may not have been aware of the model on which the original was based. At any rate, he altered it in ways which took it away from this model.

Before concluding this section, I would like to consider one other difference between B and K which reinforces my contention that the Barberini version is the original one. In the Koutloumousi version the description of Nikon's birth begins with the following passage:

Τούτῳ τοίνυν τῷ μακαρίῳ πατρὶς μὲν ἡ πρώτη καὶ θειοτέρα καί, ὥσπερ εἰπεῖν οἰκειότερον, ἡ ἄνω Ἰερουσαλήμ, ἐν ᾗ, κατὰ τὸν θεῖον φάναι Δαβίδ, διεπλάσθη, πρὸς ἣν καὶ ἀπετίθετο διηνεκῶς τὸ πολίτευμα, καὶ πρὸς ἣν ἀεὶ ἔσπευδεν ἀναβὰς ἐν τῇ καρδίᾳ ὅσαι ὧραι τιθέμενος καὶ τὸν νοῦν ἀνάγων πρὸς θεωρίαν τῆς ἡλιακῆς ἀψῖδος ὑπεριπτάμενον.[57]

The Barberini version here reads ...ἀεὶ ἔσπευδε ἀναβάσεις ἐν τῇ καρδίᾳ ὅσαι ὧραι τιθέμενος καὶ τὸν νοῦν ἀνάγων πρὸς θεωρίαν τῆς ὑλικῆς δυάδος ὑπεριπτάμενον[58]. The noun ἀναβάσεις is preferable to the participle ἀναβάς. The later participle τιθέμενος requires an object, and it seems best to read "making ascents hourly

[56] See H. G. Liddell, R. Scott, and H. S. Jones, *A Greek-English Lexicon* (Oxford, 1940), 592.

[57] Ed. Lampros (*supra*, note 9), 133 lines 8–13.

[58] MS Barberini gr. 583, page 612.

in his heart." The second difference between B and K is more significant. Either the saint's mind is "flying beyond the sunny arch," or "flying beyond the material duality." Again recourse to external evidence seems to provide an answer. In section two of Oration 21 (*In Laudem Athanasii*),[59] Gregory Nazianzenus says: μακάριος οὗτος, τῆς τε ἐντεῦθεν ἀναβάσεως, καὶ τῆς ἐκεῖσε θεώσεως, ἣν τὸ γνησίως φιλοσοφῆσαι χαρίζεται, καὶ τὸ ὑπὲρ τὴν ὑλικὴν δυάδα γενέσθαι. Earlier in the same passage he states that such a man achieves union with God διὰ λόγου καὶ θεωρίας.[60] The number of verbal similarities between this passage in Gregory and that in the *Vita Niconis* (μακάριος, ἀναβάσεις, θεωρία, and ὑπὲρ τῆς ὑλικῆς δυάδος), as well as the general similarity of thought, suggests that the author of the *Vita Niconis* was aware of Gregory's definition of μακάριος and incorporated it into his description of Nikon. The reference to ἡ ὑλικὴ δυάς, preserved only in B, is an essential part of this definition.[61] The fact that both B and K preserve the other similarities while only B preserves this phrase is indicative. It must have been part of the original version and been corrupted in K. The change to τῆς ἡλιακῆς ἀψῖδος might be explained on paleographical grounds, but given what we have already seen of K's relationship to the *Vita Lucae*, it is perhaps more likely that the reviser was unaware of the origin of the phrase and altered it to something more readily understandable to him. In either case, B is again seen to preserve a correct reading in a passage derived from an earlier piece of hagiography.

IV. INTERNAL EVIDENCE

In the preceding section I have argued for the priority of the version of the *Vita Niconis* contained in the Barberini manuscript by reference to external evidence. I would like now to compare the sequences of posthumous miracles found in B and K. I believe that certain significant differences between the two reveal, solely on the basis of internal evidence, that the sequence found in the Barberini version is the earlier and correct one.

One of the major differences between B and K lies in the order of presentation of the miracles which occurred after Nikon's death. Each version reports twenty-six of these, introduced by the transition passage drawn from the *Vita Lucae*. To facilitate the argument which follows, I list the miracles, identified where possible by the name or residence of the person cured, together with any specific chronological indications. The order given is that of the Barberini version.[62]

[59] PG, 35, cols. 1081–1128.

[60] *Ibid.*, col. 1084C.

[61] I also find the phrase in the *Life* of Athanasius the Athonite; cf. I. Pomialovskij, *Žitie Prepodobnago Afanasija Afonskago* (St. Petersburg, 1895), 15 lines 4–5. It is said that Athanasius traveled to Athos with no material possessions and without fear of robbers, τῷ ὑπὲρ τὴν ὑλικὴν ἤδη δυάδα γενέσθαι. Thus the phrase must have had some currency in the eleventh-twelfth century. In the *Life* of Athanasius, however, the context does not suggest a direct knowledge of the passage in Gregory Nazianzenus, as is the case in the *Vita Niconis* (B).

[62] The posthumous miracles in B are found on pages 653–83.

1. John, son of Sabbatius (at Nikon's funeral)
2. Basil Apocaucos (. . . τὴν τοῦ πραίτωρος ἀρχὴν διοικήσας)
3. Man from Elos
4. Man from Plagia, near Corinth
5. Woman from Sparta
6. Autochthonous woman
7. Second man from Elos
8. Monk from Kalamata
9. Cataclysm at Kalamata (during Nikon's lifetime)
10. The Abbot Gregorius and the *kubikularios*
11. Antiochus, dux of the Ethnikoi
12. Michael Choirosphaktes
13. Milengoi
14. The novice Luke (ὃς καὶ μέχρι τῆς δεῦρο ζῶν)
15. Procopius (τῶν ἔτι τῷ βίῳ περιόντων)
16. Michael Argyrometes (ὃς ἔτι ἐν τοῖς ζῶσίν ἐστι)
17. Image of Nikon on the πλὰξ λιθίνη
18. Stephan (ζῶν γὰρ ἔτι καὶ οὗτος καὶ περιών)
19. Gregorius, son of Stephan (ὀλίγαις ὕστερον ἡμέραις)
20. Manuel (in the same year the author became abbot)
21. Author himself cured
22. Girl kidnapped from *metochion*
23. John (ὁ πρὸ μικροῦ γεγένηται)
24. Aquilaean traders (ἄρτι . . . ἐγχωριάσαντες)
25. Young boy in the monastery (τὴν πρὸ βραχέος τελεσθεῖσαν)
26. General statement on Nikon's aid to Lacedaemonians, especially sailors.

The presentation of these miracles in K contains some major differences.[63] The stories of the novice Luke, Procopius, and Michael Argyrometes (B, nos. 14, 15, and 16) are placed as a group later in the sequence, following the author's own cure (B, no. 21), so that in K they become nos. 19, 20, and 21, with nos. 17–21 moving up to become nos. 14–18 in K. This arrangement also involves substantial differences in the introductions to the stories of Luke and the πλὰξ λιθίνη. In B this Luke is said to be a novice in a monastery of St. Nicholas near Sparta, while the πλὰξ λιθίνη is said to be situated in the church built by Nikon at Sparta. In K the novice Luke is placed in the shrine of a *metochion* of Nikon's monastery, while the πλὰξ λιθίνη is in the monastery of St. Nicholas. Thus, in addition to the difference in the sequence of the miracles, there is also a factual discrepancy between the two versions. Two factors, I believe, indicate that this error lies in K.

First, the twenty-six miracles seem to follow a rudimentary chronological order. Although the author states in the transition passage that he will not

[63] See ed. Lampros (*supra*, note 9), 184 line 11–220 line 33.

narrate them καθ' ἑξῆς, this phrase has been appropriated from the *Vita Lucae* and is quickly disregarded. In fact, after the digression on the cataclysm at Kalamata (B, no. 9), which is prompted by the preceding story of a monk from Kalamata, the author returns to his narrative with the words: ὁ δὲ λόγος καθ' εἱρμὸν καὶ αὖθις ὁδευέτω, τέρπων ἀκοὰς φιλοθέους ἐπὶ τῇ καθ' ἑξῆς διηγήσει τῶν τῷ ἁγίῳ καθ' ἑκάστην θαυματουργουμένων.[64] Thus, he openly admits the digression and states in his own words his desire to proceed "in order." It is also notable that the list of miracles given above seems to divide chronologically into two groups of thirteen. In the second group (B, nos. 14–26) ten of the stories are definitely contemporary with the author, as the references show. The remaining three stories in this group (B, nos. 17, 22, and 26) contain less specific indications that they too are contemporary. Moreover, within this second group there appears to be an internal chronological order. B begins in sequence with the stories of men who are said to be "alive *even* to this day," or to be "*still* alive," mentions an experience of the author himself and ends with a group of events described progressively as πρὸ μικροῦ, ἄρτι, and πρὸ βραχέος. The first thirteen miracles, on the other hand, contain no such references and are clearly earlier. The first two, in fact, may be placed at or shortly after Nikon's funeral, while the Abbot Gregorius (B, no. 10) is definitely a predecessor of the author.

Given this apparent chronological order, we may ask which sequence, that of B or K, is more logical. The final thirteen in B begin with the miracle of the novice Luke, "who is alive even to this day." This Luke was a νεανίας[65] when his miracle took place, but the author knows him as a man with gray hair (τῆς ἤδη ἐπανθούσης αὐτῷ πολιᾶς[66]). A considerable span of time separates the occurrence of the miracle from the date at which the author is writing, a fact which he stresses by describing Luke as καὶ μέχρι τῆς δεῦρο ζῶν. In K, which contains the same chronological references to this novice Luke, the miracle appears nineteenth in sequence, instead of fourteenth, and comes after the story of the author's own cure. It is arguable, I believe, that the sequence in B is the more logical chronologically. The miracle experienced by Luke as a νεανίας should be the earliest of those associated with contemporaries of the author. In B it occupies this position, although in K it follows the story of the author's own cure, a position which seems to violate the chronological relationship between the two men as well as that of the whole sequence of posthumous miracles.

One other factor also supports the correctness of the sequence in B. In miracle no. 18 in B a certain Stephan is described as ζῶν γὰρ ἔτι καὶ οὗτος καὶ περιὼν,[67] a phrase which appears in the text of K also. The first καὶ here is used to limit οὗτος, so that the phrase may be rendered "for this one *too* is still alive and surviving." In this context the καὶ suggests that there has

[64] MS Barberini gr., page 659; ed. Lampros, 191 lines 17 ff.
[65] Ed. Lampros, 208 line 13; MS Barberini gr. 583, page 668.
[66] Ed. Lampros, 208 line 16; MS Barberini gr. 583, page 668.
[67] Ed. Lampros, 203 line 23; MS Barberini gr. 583, page 672.

already been at least one previous reference to a living contemporary of the author in the sequence of posthumous miracles. If we accept the sequence of B, this condition is met, since the novice Luke is said to be ζῶν and Procopius and Michael Argyrometes are also characterized as being still alive. In K, however, the story of Stephan precedes these three miracles, and the καί has no point of reference. Again, therefore, internal evidence suggests that the sequence of the Barberini version is the correct one.

V. Summary and Conclusions

The foregoing argument might be summarized as follows. The texts of the *Vita Niconis* contained in MSS Barberini gr. 583 and Koutloumousi 210 are different versions of the *Life*, one a rewriting of the other. Evidence presented here indicates that the original version is that contained in B; this judgment is based primarily on external evidence derived from the *Vita Lucae Junioris*. I have suggested that the original author of the *Vita Niconis* was well acquainted with the *Vita* of Luke of Phocis and incorporated portions of it into his own work. I have then shown that the relationship of the *Vita Niconis* to the *Vita Lucae*, although found in both the Barberini and Koutloumousi versions, is more fully and precisely preserved in B. This has led to the conclusion that B contains the original version and that K is a revision by someone who was probably unaware of the intentional borrowings from the *Vita Lucae* and who made changes which diminished and obscured the relationship. This conclusion is further strengthened by a comparison of the differing sequences of posthumous miracles found in B and K. Analysis of the order of these miracles reveals that only B's sequence is chronologically consistant.

The Barberini version, therefore, is the original. As I indicated at the outset, this paper originated from research undertaken to evaluate the need for a new critical edition of the *Vita Niconis*. It is now clear that such an edition is necessary. That of Lampros, based solely on K, has only limited value. Obviously the heretofore unedited Barberini manuscript must serve as the basis of such an edition. K may provide some valuable readings, but wherever there is evidence of revision, the text of B will be closer to what the original author wrote.[68]

University of Maryland

[68] In the process of preparing this paper I have profited much from the suggestions and criticism of Professor Nicolas Oikonomides of the University of Montreal and of Dr. John W. Nesbitt of Dumbarton Oaks.

COD. VAT. GR. 463 AND AN ELEVENTH-CENTURY BYZANTINE PAINTING CENTER

JEFFREY C. ANDERSON

THE study of Byzantine manuscript painting has mainly involved problems of classification. Works have been more or less roughly divided into periods or centuries by style and into iconographical families according to significant compositions. Certain issues can now be formulated as the next generation of problems awaiting study. As a general statement of these issues we cannot do better than to recall Alphonse Dain's succinct characterization of the state of paleographical research when he wrote over two decades ago: "La notion de *scriptorium*, si commune dans le monde médiéval latin, est encore mal définie dans le domaine grec, sauf dans des cas trop rares. La détermination des centres de copie et les écoles de calligraphie d'époque byzantine est le dernier grand problème qui reste à résoudre dans l'ordre de la paléographie grecque."[1] For art historians, the identification of the centers of book decoration will be a major step toward the answers to a number of fundamental and largely unexplored questions, such as how painters were trained, how they were organized, whether they were mainly laymen or predominantly monks, and which were the leading centers. Two ways are open in the persuit of information bearing on these problems; one is through the compilation and analysis of written testimony, and the other through the accumulation of a body of empirical evidence. The following study of three Middle Byzantine manuscripts is intended as a contribution to the latter method. The basic assumption is that after the amateurish or technically incompetent work has been set aside, there remains a body of manuscripts that cannot be divided among more than a handful of organized groups of artisans. From this assumption I have presumed that the possibility exists of demonstrating that certain illustrated manuscripts were produced in the same centers.

The three works that I believe were made by the same group of artisans are all known; they are Vat. gr. 333 and gr. 463, and Venice, Bibl. Marc., gr. 479. I intend to establish the relationships between them by showing that all or part of the illustrations of each are the autograph work of two anonymous painters who, with two colleagues (whose hands appear in only one of the manuscripts), form the staff of the center. The means of making the attributions is stylistic analysis as it is commonly applied to Western works of art. Certain habits of painting as revealed in particular physiognomic types, patterns of drapery articulation, and methods of drawing are used in preference to those aspects of a painter's work, like iconography or composition, that might be more useful in establishing provenance on a more general level. The difficulties in making such attributions are well recognized. A case

[1] "La Transmission des textes littéraires classiques de Photius à Constantin Porphyrogénète," *DOP*, 8 (1954), 35. I wish to express my gratitude to Dr. Gary Vikan and Professors David Wright and Kurt Weitzmann for their suggestions.

To compensate for loss of color and detail in the reproduction process, in this paper the miniatures appear uniformly enlarged 25%.

can sometimes be strengthened by similarities in the styles of ornament and script and by records of ownership, but these matters are of no assistance here. Two of the manuscripts contain little or no ornament, and the script of one must be disqualified from consideration. The remaining sample, given the perils of attribution based on the Middle Byzantine "liturgical" hand, is too small to permit a demonstration that there was an immediate relationship and, as a consequence, that the center was a scriptorium, which is my belief. Finally, records of provenance offer no clues. I have therefore confined this study to identifying the painters, showing where they worked, as indicated by general aspects of style, and offering two final observations which challenge commonly held notions of Byzantine painting. Throughout, I use the term "center," or "painting center," to denote the organization to which the painters belonged because it is less specific than "workshop" or "scriptorium," which have meanings or connotations that cannot be supported by fact or inference.

One of the three manuscripts contains a dated colophon; it is Vat. gr. 463,[2] an illustrated text of the so-called "liturgical homilies" by the fourth-century Church Father Gregory of Nazianzus. On the last leaf of the manuscript with text, folio 469[v], is the colophon written by the scribe in carmine half-uncial:[3]

αὕτη ἡ βίβλος πέφυκε Θεοδώρου (μον)αχ(οῦ) πρεσβυτέρου καὶ προεστῶτος τῆς τῶν Γαλακρηνῶν μονῆς, πόθῳ πολλῷ καὶ ἐπιμελείᾳ ἐξ οἰκείων αὐτοῦ, μᾶλλον δὲ τῶν τοῦ Θ(εο)ῦ, δωρεῶν κατασκευασθεῖσα καὶ κοσμηθεῖσα· γραφεῖσα δὲ τῇ αὐτοῦ προτροπῇ χειρὶ Συμεὼν (μον)αχ(οῦ) τοῦ αὐτοῦ μαθητοῦ, καὶ τελειωθεῖσα μη(νὶ) δεκεμβρίῳ ἰνδ(ικτιῶνος) πρώτης ἐν ἔτει τῷ ͵σφοα' βασιλεύοντος τοῦ εὐσεβεστάτου Κωνσταντίνου τοῦ Δούκα καὶ Ἐβδοκίας τῆς αὐγούστης.

This book belongs to Theodore the monk, presbyter and abbot of the Galakrenai monastery, having been made and adorned with great affection and care from his own, or rather God's, gifts. It was written at his request by the hand of Symeon the monk, his pupil, and finished in the month of December of the first indiction, in the year 6571 [= 1062] in the reign of the most pious Constantine Ducas and Eudocia the augusta.[4]

The colophon indicates that the abbot Theodore of the Galakrenai monastery[5] had his pupil Symeon write the text of the Gregory manuscript, a task certainly carried out in the monastery itself. The text is written in a handsome minuscule that attests to Symeon's training. The homilies are in the large minuscule

[2] R. Devreesse, *Codices Vaticani graeci*, II, *Codices 330–603* (Vatican City, 1937), 231–33; illustrations completely published by G. Galavaris, *The Illustrations of the Liturgical Homilies of Gregory Nazianzenus*, Studies in Manuscript Illumination, VI (Princeton, 1969) (hereafter Galavaris, *Gregory Nazianzenus*), figs. 78–93.

[3] K. and S. Lake, *Dated Greek Minuscule Manuscripts to the Year 1200*, VIII, 2 (Boston, 1937), pl. 530. The assertion by F. Dölger, in his review of this fascicle of the Lakes' corpus (*BZ*, 40 [1940], 121), that the colophon of Vat. gr. 463 is not by the hand of the scribe, strikes me as being based more on the colophon's content than on the style of writing. I find no reason to doubt that it is a scribal colophon.

[4] I am indebted to Professor John Duffy for bringing to my attention the proper punctuation and reading (which significantly alter the traditional interpretation) of this colophon.

[5] For this monastery, see the various publications of R. Janin: "La Banlieue asiatique de Constantinople," *EO*, 22 (1923), 294; *Constantinople byzantine*, AOC, IVa (Paris, 2nd ed., 1964), 497–98; *Les Eglises et les monastères des grands centres byzantins* (Paris, 1975), 40–41.

used for service books, while the commentary and subsidiary texts are written in a smaller, slightly more cursive manner, but there are no apparent stylistic changes that would suggest more than one scribe.[6] The decoration of the manuscript, however, was not done in the monastery. Theodore paid for the decoration, as he says "...from his own, or rather God's, gifts." Whether this was actual cash payment or remuneration by some other means we do not know; but it is certain that he would not have been obliged to pay for work done in the very monastery in which he was abbot. The date—December 1062—specifically refers to the completion of the text, as is usual in Byzantine colophons. Since, in addition, it makes mention of the decoration, the colophon may have been appended after the painting was finished. Even if it could be proven that it was written before the addition of the decoration, the gain in knowledge would be minimal, for observation shows that the manuscript was planned from the start to receive the headpieces and initials. In either case, the painting was surely done immediately after the completion of the text, in late 1062 or early 1063. Further implications of the colophon are best left until the illustrations of this manuscript and those of the two related ones have been examined.

The decoration of Vat. gr. 463 consists of one full-page miniature, a series of figural initials, and nonfigural letters and headpieces. The figural initials have been published by G. Galavaris, who implies that they were all executed by the same painter.[7] An examination of their style, however, indicates the collaboration of two artisans. The first initial, on folio 4, to Oration 38 (*In Theophania*), is a *chi*,[8] now so flaked as to render it useless for stylistic analysis. The next initial, though, is relatively well preserved; it is the *epsilon* on folio 22 with a portrait of Basil the Great (fig. 1) beginning Oration 43 (*In laudem Basilii Magnii*). The Saint is represented almost full-length with his right arm outstretched to form the cross-stroke of the letter. There is no shading, on either his off-white *sticharion* or his olive-brown *phelonion*, to indicate the specific limbs or the overall plasticity of the forms. Instead, thin lines of chrysography outline the sleeve of the *phelonion* and define the shallow folds of the material. In general, chrysography—which I use here to denote not simply "writing in gold," but also the same technique employed by painters in the articulation of drapery and flesh—is conceived of as a rational system of highlights intended to create the illusion of light reflected from the irregular surface of a simple geometric form. In the portrait of Basil, though, the lines

[6] For page facsimiles, see Lake, *op. cit.*, pls. 528–30; and H. Follieri, *Codices graeci bibliothecae Vaticanae selecti*, Exempla scripturarum, IV (Vatican City, 1969), pl. 26. One irregularity should be pointed out: quires I (α') through XXIX (κθ') are numbered at the bottom left corner of the first leaf. A new set of quire numbers begins on fol. 230, but the first few of these have been trimmed away by a binder so that the first preserved after the change is on fol. 262 to quire V (ε'); these are placed in the top right corner of each first leaf of a new quire. Since there is no accompanying change in the style of the script, there is no obvious reason for the change. The eleventh-century Gospel Lectionary Vat. gr. 1162 also has the quires numbered in two parts, but in this case the break coincides with the division between the *synaxarion* and the *menologion* (as well as with certain changes in the type of illustration). In my experience such renumbering is rare.

[7] *Gregory Nazianzenus*, 252.

[8] *Ibid.*, fig. 80 (with the left part of the letter omitted from the illustration).

of gold seem indecisively applied; they are generally short, curved, and at times almost tentative in appearance, and as a result, the drapery appears agitated yet flat. It is outlined by a thin black line, while the hand and arm are outlined in carmine, which served as the underdrawing for gold. The individual fingers are indicated by the same dense black that the painter uses elsewhere.

Basil's face presents other hallmarks of this painter's style. The flesh, once outlined in gold, is a flat shade of unnaturalistic pink with no shading along any of the surfaces. The mouth is indicated by a line of gold and the other features by short black lines. The Saint's hair, mustache, and beard are also black, but with surprisingly indistinct outlines. In the following initial on folio 107 (Oration 39, *In sancta lumina*), a letter *pi* with the Baptism of Christ (fig. 2), this painter's peculiar palette is again apparent. The flesh of the nude Christ at the left is rendered in the same unrelieved pink color as that of Basil's face in the previous letter; there is no internal shading and the limbs are indicated only by chrysography. Christ's facial features, like those of the Baptist to the right, are drawn completely in black with exceptional crudeness, and both he and John have their mouths delineated in a noticeable frown. In this composition, the painter has also used white lines here and there to show highlights. On John's face there is one above the left eye and another on the side of the face. These highlights, like the black used elsewhere, are not worked into the base tone; rather, they were quickly applied after the pink had set.

The subject of the composition on folio 107 naturally dictates that John be shown striding, but the painter is constrained by the shape of the letter to show him in a more or less upright posture. He has settled on a rather willowy figure with bent knees. John's tunic, now almost completely flaked away, was originally the same slightly greenish cream color as that in the letter on folio 22, while his himation is olive-brown. The lines of chrysography indicating the crests of the drapery folds are again spread in an overall network of short, curving strokes. The drapery is outlined in black and the limbs in gold.

The work of this first painter, Painter I, seems barely informed by a developed concept of an organic figure motivating the rise and fall of drapery. There is no shading along the sides of limbs, or even on entire figures. Painter I relies on certain graphic conventions, which at times he appears not to comprehend fully. The uniformly intense pink of feet, arms, hands, and faces is regularly outlined in gold, while the internal details like fingers, noses, or eyes are in black. Occasionally, he uses white highlights which familiarity with Byzantine painting tells us indicate brow ridges or cheekbones. Apart from the unusual color used for the flesh and the rather dull shades for the drapery, this painter's work is marked by the pigment layers themselves. Painter I often applies his colors in thick layers that have in time been lost. In itself, this may not seem to count as a particularly noteworthy trait, especially in light of the notorious Byzantine fondness for heavy, and there-

fore fragile, layers of enamel-like pigment; but in regard to the techniques of Painter I's associates, this becomes significant. In all, this man's hand, as defined by style and technique, is apparent in six of the fourteen initials, those on folios 4, 22, 107, 127, 184, and 319.[9] Except for the *alpha* on folio 319, the initials in this style are consecutive within roughly the first half of the homilies text.

The initial *alpha* on folio 192 (to Oration 21, *In laudem Athanasii*), showing St. Athanasius (fig. 3), is executed in a manner manifestly different from that of the letters attributed to Painter I. Athanasius leans to the right, gesturing forcefully in a way similar to that of John the Baptist who signals the tree at whose roots the ax has been laid, a familiar Gospel illustration. In contrast to the representation of Basil on folio 22 (fig. 1), one notes how the line describing the left side of the Saint's body curves over the shoulder, then moves in toward the waist, finally swelling out gently over the calf and ankle. The impression is of loosely fitting vestments, which through their own weight conform to the contours of the Saint's body as he leans sharply to his left. The full-sleeved *phelonion* is ochre and is worn over a light blue *sticharion*; their descriptive lines of chrysography are relatively wide and have been applied with a sure touch in long parallels. Finally, the face of the Saint is rendered differently from those in any of the six letters attributed to Painter I. The hair gives the impression of being a soft mass which, due to the fine shading around the face and the emphasis of the thin black hairline, appears to rise plastically from the head. Athanasius' hair is grey, not the strong black regularly used by Painter I.[10] The flesh is a creamy shade of warm ochre with red used to indicate the lips. Soft areas of white are carefully blended into the base tone to give the forehead and bridge of the nose an appearance of plasticity. Only the eyes and nose are actually outlined, and this is done with a brown line considerably less insistent than the black used by Painter I. The subtlety of this second painter's approach to portraiture is demonstrated by the knit brow of St. Gregory in the initial on folio 230 (to Oration 42, *Supremum vale*),[11] a letter with an overall height of only about three and one-half centimeters.

Painter II, as he will henceforth be called, uses a thin black line, but, as with the chrysography, in a markedly different manner from that of Painter I. Painter II outlines his figures in black, although the impression is considerably softened by overlapping the line with the color of the garment itself. This is clearly a conscious device because both painters, as one can tell from flaked or smeared letters, use carmine for the basic underdrawing, not black. Painter II also uses black along with gold in the articulation of drapery. In the figure of Habakkuk on folio 324 (to Oratio 45, *In sanctum Pascha* II) the gold and black are mixed and effectively suggest the rise and fall of the cloth (fig. 4).

[9] For those not reproduced here, see *ibid.*, figs. 80, 84, 88.

[10] There are only two instances in which Painter I departs from this practice: the personification of the river Jordan on fol. 107 and Adam on fol. 319.

[11] Galavaris, *Gregory Nazianzenus*, fig. 86.

One notes particularly the illusion of depth in the area between Habakkuk's legs created by the buildup of dark lines. Never does Painter II use black or gold to indicate either the outline of limbs or specific facial features; for these purposes he regularly uses brown. The color schemes also divide the figural initials into two groups. The difference in flesh tones is obvious; but, in addition, the ochre, light blue, and pink used in the draperies on folios 192, 230, 324, and 411 seem clearer than the sometimes murky tones in letters attributed to Painter I. Finally, the pigment layers of the figures of Athanasius and Habakkuk are intact. It is only in the initials on folios 230 and 411 that there are any losses. These traits are common to eight initials, those on folios 192, 230, 295, 324, 359, 371, 391, and 411.[12] Except for the Anastasis by Painter I, all the figural initials in the second part of the manuscript are painted by the second hand.

When the figural initials of Vat. gr. 463 are analyzed compositionally, there are no objective grounds for dividing them into two groups. At their most basic level, letters attributed to Painter I reflect narrative models (folios 4, 107, 127, 319), portraits (folio 22), and genre compositions (folio 184). Similarly, Painter II's work encompasses both narrative scenes (folios 192, 230, 371, 411) and portraiture (folios 192, 391). Neither is there any difference in the compositional modes; all the compositions are fairly lively, but typical of Middle Byzantine book illustration. Thus, the only factors dividing the letters into two groups are the treatment of individual forms and color schemes, which are traits of individual painters that probably would not be subject to close copying. If one agrees with Galavaris that Vat. gr. 463 is a copy of another illustrated Gregory manuscript,[13] then the division of these letters by style of execution becomes even more convincing.

As an aid in establishing the painters' working methods the nonfigural ornament deserves consideration. Common sense suggests that as each painter added the initial he also completed the headpiece and gold title of the leaf he was working on at the time. An examination of this ornament shows that it falls into two groups, but the distribution does not exactly coincide with that of the figural initials. The consecutive headpieces on folios 4, 22 (fig. 1), 107 (fig. 2), 127 (fig. 5), and 184 present a homogeneous style that might be termed the "precise style." In each case the colors are strong and saturated, and the designs are executed with considerable care. The lines of highlight, drawn over the base tone to articulate the outlines of flower petals or the centers of vines, are thin and carefully painted. In addition, each title within this series is in gold uncials drawn with a precision matching that of the headpiece ornament. The first change in style of this ornament, to what I will call the "broad style," is on folio 192 (fig. 3), coinciding with the change in initials from Painter I to Painter II. Here the color scheme is slightly different; this is most noticeable in the shade of blue which is clearly lighter than that used in all the previous headpieces. Also, the highlight lines are wider and less

[12] For those not reproduced here, see *ibid.*, figs. 86, 87, 90–93.
[13] *Ibid.*, 177–92.

carefully painted, so that the forms appear slightly rougher than those of the first series. Finally, the title is written in half-uncial, and the letters themselves, often failing to conform exactly to the underlying carmine, appear to be applied almost haphazardly.

The title form proves to be an accurate index of the two styles, for each time the title is written in uncial the colors and style remain constant, and vice versa. The two styles of the headpieces may be compared most conveniently with those of the initials in tabular form (P = precise; B = broad; NF = nonfigural initial; U = uncial; H-u = half-uncial):

Folio	Initial	Headpiece	Folio	Initial	Headpiece
4	I	P/U	319	I	P/U
22	I	P/U	324	II	P/U
107	I	P/U	359	II	P/U
127	I	P/U	371	II	P/U
184	I	P/U	391	II	P/U
192	II	B/H-u	411	II	B/H-u
230	II	P/U	428	NF	B/H-u
256	NF	B/H-u	444	NF	B/H-u
295	II	B/H-u			

There is a pattern behind this distribution. Each initial by Painter I is accompanied by a headpiece in the precise style and a title in uncial letters. There are only six titles in half-uncial with headpieces in the broad style: three correspond to initials by Painter II and three to nonfigural initials; none correspond to initials executed by Painter I. The three nonfigural initials, those on folios 256, 428, and 444 (to Orations 14, *De pauperum amore*; 19, *Ad Iulianum tributorum*; and 12, *Ad patrem*, respectively), are within the section of letters painted by the second hand. This concentration suggests either a model lacking in figural initials or adaptable miniatures for these homilies, or a cycle devised *ad hoc* wherein one painter was unable or unwilling to consistently devise figural compositions that would meet the requirements of the text. Whatever the model(s) may have been for Vat. gr. 463, the concentration of these three initials in one section of the manuscript and their correspondence with broad style headpieces suggests that they are the work of Painter II. At this point some interpretation is necessary. The working method was probably as follows. The manuscript was divided into two parts for decoration. The parts were not equal, since clearly the greater share went to the artisan with the more accomplished figure style, Painter II.[14] Painter I, after he had finished all the leaves apportioned to him, completed the headpieces and titles to some of the leaves with initials by his colleague, who, in fact, seems to have had less patience with such ornament. This distribution may suggest that Painter I was an assistant to Painter II.

[14] The one full-page miniature, the portrait of Gregory on fol. 3ᵛ (*ibid.*, fig. 78), is also the work of Painter II. This portrait, originally on a single leaf, has been remounted.

The style of Painter I of Vat. gr. 463 is important in relation to the second illuminated manuscript, the Vatican Book of Kings (Vat. gr. 333),[15] a work of capital importance in the history of narrative illustration. Its cycle was certainly in existence by preiconoclastic times, as is attested by those scenes excerpted from it to serve as illustration for the supernumerary psalm. It is primarily the evidence of the similarity between the scenes from the life of David in the Paris Psalter (Paris. gr. 139) and those of the seventh-century Cyprus plates that indicates a preiconoclastic origin.[16] Vat. gr. 333, however, is the only densely illustrated Book of Kings to have survived. Various dates in the eleventh and twelfth centuries have been proposed for it.[17] Most recently, J. Lassus, who has done extensive work on this manuscript, has suggested the eleventh century, a date that would probably meet with general approval.

In the course of his study of the Book of Kings, Lassus has twice commented on the differences in style in the miniature cycle. In his first publication of the manuscript in 1929 he observed a two-part stylistic division, the first part extending from the beginning of the cycle to folio 51v, the second from folio 53 to the end.[18] This change, he wrote, was due to the participation of two different painters, but he left open the possibility that the first part as well was the work of more than one painter. At that time, Lassus felt it reasonable to suggest that some of the stylistic differences, if not most of them, should be accounted for by the use of different models. In his most recent publication on this subject (1973), his divisions of the cycle are generally the same, but he has rejected the argument that it was somehow pieced together from sources of varying styles.[19] Instead, he decides in favor of a single model and is, therefore, compelled to confront the variations in the first part of the cycle, the miniatures to folio 51v. Some of his attributions are made *en passant* in the section of commentary on the iconography of the miniatures, while others are mentioned briefly in the introduction.[20] In sum, Lassus does not offer a systematic division of hands for Vat. gr. 333; he is content to say that it is the work of various painters, any of whom may have worked with assistants. The significant shift registered in Lassus' writings on the Book of Kings is in the attitude toward the model in relation to the obvious stylistic

[15] Devreesse, *op. cit.* (note 2 *supra*), 4–5; illustrations completely published by J. Lassus, *L'Illustration byzantine du Livre des Rois, Vaticanus graecus 333*, Bibliothèque des Cahiers archéologiques, IX (Paris, 1973) (hereafter Lassus, *Livre des Rois*).

[16] K. Weitzmann, "Prolegomena to a Study of the Cyprus Plates," *Metropolitan Museum Journal*, 3 (1970), 97–111. Weitzmann has also argued for the use of an illustrated Book of Kings as a source of models for certain scenes in the synagogue at Dura-Europos, a relationship that would date the invention of the Book of Kings cycle to at least the first half of the third century A.D.; see *idem*, "Zur Frage des Einflusses jüdischer Bilderquellen auf die Illustration des Alten Testaments," *Mullus: Festschrift Theodor Klauser* (= *JbAChr*, Suppl., 1 [1964]), 404–5 (reprinted in English translation in *Studies in Classical and Byzantine Manuscript Illumination*, ed. H. Kessler [Chicago-London, 1971], 79–80).

[17] A date in the twelfth century is proposed, e.g., by V. Lazarev, *Storia della pittura bizantina* (Turin, 1967), 254 note 21 (hereafter Lazarev, *Storia*).

[18] "Les Miniatures byzantines du Livre des Rois d'après un manuscrit de la Bibliothèque Vaticane," *MélRome*, 45 (1928), 41–44.

[19] *Livre des Rois*, 16–18.

[20] *Ibid.*, 17.

differences between the painted miniatures. It seems reasonable, I think, to suppose that even though Vat. gr. 333 is the only surviving work of its type, it is a copy of a similarly illustrated work; its cycle was not pieced together from disparate sources.

All the miniatures up to folio 27ᵛ are the work of a single painter, to whom I shall refer as Painter A. The demonstration, however, is complicated by two factors. The first is that from the beginning of the manuscript up to folio 11 the miniatures are often heavily abraded. The second is that the miniatures of the first quire (folios 5 to 12) are very small; the one on folio 8, for example, is only 2.6 cm. high.[21] From the start of the second quire (folios 13 to 19) the miniatures become appreciably larger, and this change in scale has an effect on certain aspects of the painter's style. Two well-preserved miniatures in the first quire, those on folio 12 (figs. 6a–b), exhibit several traits that are, upon examination, discernible in other miniatures in this as well as subsequent quires. In the first miniature (I Sam. 8:1) the heads of Samuel's two sons are slightly too large for their stocky bodies (fig. 6a). Both have skin that is a light cream color with a definite green cast to it. Their faces are carefully shaded with red on the cheeks and the centers of the foreheads and with brown elsewhere, as around the sharply slanting brows that give them a melancholy appearance. Their hair is a deep brown and is outlined in black with hairlines receding at the temples, but dipping low in the center of the forehead. The expression suggested by the eyes paralleled by the hairline is heightened by the brothers' perceptible frowns. Mouths and other facial features, like the eyes themselves and the outlines of the nose, are drawn with a brown line. The same physiognomic type, as well as individual stylistic traits, are seen in earlier miniatures of the cycle, for example, those on folios 6ᵛ, 10ᵛ, and 11.[22]

In painting the drapery of Samuel's two sons on folio 12, Painter A uses a method not unusual in Byzantine illumination. The son at the left wears a creamy yellow tunic articulated by thin black lines, over which is a rich brown cape articulated with red. The second brother, the figure in the center, wears a cool, light lavender tunic and a medium brown cape over it. In both cases the painter uses a deeper tone for whole sections of drapery covering parts of the figure farther away from the beholder. Over this he then draws the fine lines of appropriate darker colors to indicate the individual folds, and adds white for highlight areas. Occasionally, the major change from one plane to another is marked by an entirely different color. In the second miniature on folio 12 (fig. 6b) Samuel wears a yellow mantle that changes to a deep brown as it describes the part of the body farther away from the viewer.

In both illustrations on folio 12 Samuel's proportions are different from those of the other figures: his leonine head is better balanced by a body that seems taller and more imposing. In addition, the painter exercises considerable care in delineating this one figure. Samuel's drapery, each time a light blue

21 *Ibid.*, fig. 8.
22 *Ibid.*, figs. 5, 15, 16.

himation over a pale yellow tunic, is somewhat more detailed than the garments of the other figures. His face is a rich tan, carefully shaded. One especially appreciates the expert handling of the transitional passage from the highlighted cheekbone to the sunken hollow of the cheek itself. There is, therefore, a tendency to single out the most important figure in a composition not simply through increased stature, but also through greater attention to the details of drapery articulation and facial modeling. Such distinctions may occasionally appear distracting to our eyes, as in the miniature on folio 16v.[23]

The style described above remains constant through each leaf of the next two quires. In these larger miniatures the emphasis on the heads is diminished in favor of depicting figures with more natural proportions, as in the scene of the anointing of David (I Sam. 16:13) on folio 22v (fig. 7). Here, in the representation of the brothers, one notes the physiognomic type for stock figures used by Painter A; they have broad foreheads and often slanting brows, as do the sons of Samuel in the miniatures on folio 12 (figs. 6a–b). The change in figure proportions is not the only one accompanying the enlargement of the miniatures at the start of the second quire. The speed at which Painter A worked was apparently also affected, for the colors in the second and third quires lack the miniature-to-miniature homogeneity of those of the first quire. Yet the clustering of miniatures with like color schemes is not progressive through any one quire; rather, it suggests that the scenes were executed one *bifolium* at a time. This suspicion is confirmed by the distribution of hands in the fourth quire, folios 27 to 34. Clearly, all the miniatures on the outside, or first, sheet of quire four, folios 27 + 34, were executed by Painter A. It is with the second *bifolium*, folios 28 + 33, that a noticeable change in the painting style occurs, but as with the change in style in Vat. gr. 463 there is no accompanying change in format or compositional style.

On folio 28 (fig. 8) there is a scene illustrating part of the story of David and Jonathan (I Sam. 20:35–41). At the far right the two figures of David and Jonathan embracing are unquestionably the work of Painter A. David's face may be compared in its manner of execution and physiognomic type with that of the stock crowd figure second from the right in the miniature on folio 16.[24] It is the three figures to the left in the composition on folio 28 that are by the second hand, Painter B.[25] The most striking is the youth in the center who bends down to pick up the arrow. His tunic is a single, flat blue with no shading; there are only short, curved lines of chrysography to indicate the fold patterns of the garment. In the miniature on the verso of this leaf,[26] illustrating I Sam. 21:1–6 and 10–15, Painter A executed the figures of Ahimelech and David, while the three "young men" at the left and Doeg peering over the hill are the work of Painter B. These

[23] *Ibid.*, fig. 27.
[24] *Ibid.*, fig. 26.
[25] *Ibid.*, 17: Lassus argues simply for a change of painters in this miniature; clearly, however, it is a case of collaboration.
[26] *Ibid.*, fig. 52.

secondary figures are portrayed with their garments outlined with a thin black line. Their exposed flesh, however, is outlined in chrysography. Painter A never outlines flesh or figures in gold; he uses it only as decoration on shoes or to indicate patterns of embroidery on patrician garments.

The faces of Painter B's figures on the sheet 28 + 33 are all heavily flaked, but those of the miniature on folio 30 are well preserved (fig. 9). This sheet, like 28 + 33 and 29 + 32, represents the collaboration of the two painters. In the upper zone of the miniature (I Sam. 22:18) Painter A was responsible for only the kneeling figure of Ahimelech; the others are by Painter B. Each figure's flesh, except that of Ahimelech, is represented by a strong, dense pink with no shading whatsoever. The hair of these figures is a uniform dark brown and is, like the faces and arms, outlined in gold in a manner that seems rather careless, as it often falls within the actual outline of the area of color it is meant to delineate. The internal drawing of facial features is done with a dense black line, although gold may also occasionally be used. The contrast with the face of Ahimelech could hardly be greater. His skin is a warm brown, smoothly shaded. The physiognomic type is related to that of Painter A's Samuel, as, for instance, in the miniatures on folios 17v[27] and 22v (fig. 7). In the lower zone of the miniature (fig. 9) the same criteria apply: the figures of David and Abiathar are the work of Painter A, while those of David's bodyguards are the contribution of Painter B. In terms of the general conception of the figure, as well as the means employed in its execution, the gulf between the work here attributed to a Painter A and a Painter B is so great that to my mind it is unthinkable as the conscious effort of one individual or the result of a change in the model.

The collaboration of A and B continues through the three surviving sheets of the fifth quire (folios 35 to 40) and one sheet, folios 44 + 45, of the sixth. In each miniature the pattern of collaboration is the same. Since the style of the backgrounds does not appear to change, even after Painter B begins to assist, the working procedure was probably as follows: Painter A first did the carmine underdrawing and painted the backgrounds and the most important figures of the miniatures on a single *bifolium*, which he then gave to Painter B for the addition of all the secondary figures. This method of working is simply an extension of the esthetic underlying Painter A's own work in the first three quires of the manuscript.

I think it can be argued convincingly that Painter B of the Vatican Book of Kings is identical with Painter I of Vat. gr. 463. The two blindfolded priests who stand to the left in the miniature on folio 30 of Vat. gr. 333 (fig. 9) may be compared with the figure of John the Baptist on folio 107 of Vat. gr. 463 (fig. 2). In both manuscripts the figures are flat in appearance; their garments are outlined in black and their flesh in gold. In both, the dull colors of the garments are articulated with short lines of chrysography, but with virtually no change in the basic tone of the garment itself; the flesh is painted in the same harsh pink with the facial features summarily indicated by black lines.

[27] *Ibid.*, fig. 29.

The mouths of the priests, framed by dark brown beards and mustaches, curve downward in a deep frown, as does that of John in the initial in Vat. gr. 463. Painter I's figure of the Baptist in the initial on folio 127 of Vat. gr. 463 (to Oration 40, *In sanctum baptisma*) (fig. 5) may also be compared with that of Nabal (I Sam. 25: 5–12) on folio 33 of the Book of Kings (fig. 10). In this miniature Painter A executed only the figure of David, now badly flaked, seated on a shield at the far left; the remainder of the two-part miniature was left to Painter B, including Nabal, the major participant in the scene at the right. He is dressed in a long green tunic outlined in black and articulated with short strokes of chrysography. In this example the painter's conception of the figure is particularly apparent, and is exceptionally close to that of the painter of John the Baptist. Both John and Nabal wear tunics that are rather long and close-fitting, and, while both figures are shown in motion, the sides of their garments remain almost parallel from shoulder to hemline. The tunic utterly fails to suggest the form of the body beneath it. Contrast this figure type with Painter A's Samuel on folio 22v of the Book of Kings (fig. 7). Samuel's himation—apart from its having a surface articulated in folds that, no matter how stereotyped and formalized, are rationally conceived—has an outline that clearly reveals the shoulder, elbow, waist, and knee. Even the diminutive figure of Habakkuk in Painter II's initial on folio 324 of Vat. gr. 463 (fig. 4) is painted so as to suggest the major limbs and joints of the body. Both John and Nabal have their left arms hidden beneath their tunics, and here again the painter is content with little more than a perfunctory suggestion; he uses gold and black lines to show a disturbance in the material that hardly evokes the impression of the garment falling over an arm. Nabal's face, including physiognomy, color, and details of drawing, is quite close to that of John the Baptist; note, for example, the placement of the prominent dot for the pupil of the eye in both figures. Thus, on a general and on a particular level, there are grounds for confidently maintaining that Painters I and B are the same individual, whose work stands out from that of his colleagues as well as from that of Byzantine painting in general. His secondary role in the illustration of Vat. gr. 333 is similar to the one he played in the decoration of Vat. gr. 463, and suggests that his strengths (ornament) and weaknesses (figures) were recognized by his fellow painters.

The participation of Painter I–B in these two manuscripts indicates that they were painted in the same center, and thereby enables more accurate dating of the Book of Kings than has hitherto been possible. Before considering the dating, it would be best to finish the examination of the Kings cycle. Lassus has twice stated that the major stylistic break in Vat. gr. 333 occurs with the miniature on folio 53; this is the point of the second format change in the manuscript, when the frames and blue backgrounds are discontinued. That the painter responsible for this miniature is neither A nor I–B strikes me as a correct observation. I should like to question whether this is the first miniature painted by a third hand. In the sixth quire of the

manuscript the first sheet, folios 41 + 48, is mainly the work of A, while the fourth sheet, folios 44 + 45, is a collaboration of A and I–B. The second and third sheets, folios 42 + 47 and 43 + 46, however, contain miniatures in a style sufficiently different from those of the others to suggest that they are the work of a different hand.

The miniature on folio 42ᵛ (fig. 11) contains two scenes by Painter C, the upper one illustrating II Sam. 3:7, Ishbosheth Reproaching Abner, and the lower one, II Sam. 3:15–16, Michal Sent to David.[28] In the upper right is the commanding figure of Abner standing in a convincing *contrapposto* and oratorically gesturing toward the seated Ishbosheth. Abner, like most of the figures in this miniature, is a stocky fellow with a large head. His physiognomic type clearly is a departure from any used by Painters A or I–B. The head is a simple oval whose outline is interrupted only by the indentation for the orbit of the right eye. The hairline is low and effectively emphasizes the curve of the brow ridge. This device is occasionally used by Painter A, but never with the same sense of the decorative interplay of concentric arcs; nor are the head types drawn by A ever so simple. In the scene below, Painter C depicts David with the same physiognomy; in fact, there is a certain homogeneity to the facial types in this miniature that seems at odds with Painter A's attempts to vary the types in his miniatures. Contrast, for example, Painter A's figures in the miniature on folio 22ᵛ (fig. 7), where the faces vary somewhat from figure to figure, although in general they tend to be long and occasionally they have foreheads that seem to jut out strongly. Each face on folio 42ᵛ (fig. 11) has a carefully blended, but prominent, red circle on the cheek, fine shading along the line of the jaw, and subtle highlights on the brow ridge and nose. These basic features of facial articulation are all present in the work of Painter A, but Painter C uses them with more economy; and because his forms are more geometrically simple there is a gain, not a loss, in the degree of apparent plasticity. Abner's flesh is a warm tan and David's a cool cream, colors that alone would prevent an attribution of the miniature to Painter I–B. The subsidiary figures here, although somewhat flaked, are unquestionably in the style of the two main ones. Painter C, in fact, works alone, never collaborating with A or I–B on individual miniatures or, with one exception, even on single *bifolia*. The one exception is the miniature on folio 41ᵛ, showing David with his wives and children (II Sam. 3:2).[29] In this miniature the pigment layer is uncharacteristically thick and some areas are lost, but the figures, especially that of David, appear to be the work of C. The miniature in the left column, however, is by A. This is the only example of individual scenes by these two painters appearing on the same leaf.

From the start of quire seven (folios 49 to 55), Painter C's miniatures become consecutive, continuing to the end of the manuscript. His framed miniature on folio 50 (fig. 12) depicting Uriah slain at the siege of Rabbah

[28] *Ibid.*, 36: in his commentary on this miniature Lassus writes, "On peut croire à l'intervention d'une autre main."

[29] *Ibid.*, fig. 78/79.

(II Sam. 11:17) shows the same youthful type as that in the miniature on folio 42ᵛ (fig. 11). This miniature also contributes two examples of the profile view habitually used by Painter C. It is the type of Uriah at the bottom of the miniature, as well as of one of the soldiers inside the fortified city, and is characterized by the low forehead, stubby nose, sunken mouth, and prominent chin. In addition, this profile type is often depicted with unruly hair. These two facial types virtually exhaust Painter C's repertory; his figures lack the range of expressions and physiognomies displayed by those of Painter A.

The absence of a frame and a background in the miniature on folio 53 does not, upon closer inspection, constitute quite as dramatic a break as it might seem at first. Painter C's miniatures in the sixth quire of the manuscript are framed exactly as are those of his colleagues. These frames consist of three lines, a gold one in the center set off at either side by vermilion. Painter C's miniatures on folio 50 (fig. 12) and 50ᵛ, the leaf conjugate with folio 53, has only a single, carmine line. He may, therefore, have decided to drop the frame and background with the first miniature of the seventh quire, only to return later and add them. Whether they were added as an afterthought, and if so, why, cannot be determined; one certainty is that the frame is a constraint upon Painter C: when he drops it certain elements of his style are given freer rein. The slight differences can be seen in his unframed miniature on folio 71ᵛ (fig. 13), which illustrates the anointing of Solomon (I Kings 1:39). The figures are somewhat taller and thinner than those of the framed miniatures (compare figs. 11 and 12). The colors of faces and drapery, no longer needing to stand out against a strong blue background, are slightly paler, although they remain fairly close to the colors used by Painter A. Primarily, Painter C can now simplify the drapery patterns to just a few lines here and there generally applied over an unmodulated base tone. For drapery articulation he still uses both black and chrysography, as he did in the framed miniatures. For the faces the same proportions prevail: the forehead is low, the nose long and straight, and the mouth fairly small. The color schemes are also the same. Ochre and light tan approaching a cool green are the base tones, which he occasionally alternates decoratively for faces in a group but usually employs logically, reserving the lighter shade for women and youths and the darker for older men. In the unframed miniatures a softer shading is used around the jawline and eyes, but the technique for drawing the eye, that is, two short strokes that do not meet, remains the same. Thus, in the one quire where his miniatures would appear together with those of his colleagues, Painter C adjusts to the framed format by intensifying his palette, increasing the thickness of the pigment layer, and slightly altering his figure canon to suit the reduced format. Since the unframed miniatures represent a conscious departure from the format established in the first quire, and maintained throughout most of the scenes, we may assume that they more closely correspond to Painter C's stylistic ideal.

In Vat. gr. 463 the low density of illustration and the participation of only two painters presented few problems in the division of labor. The case of

Vat. gr. 333, however, is more complex, and the attributions deserve to be summarized graphically. All the miniatures in the first three quires are the work of Painter A alone and all those after the sixth the work of Painter C. It is with the second *bifolium* of the fourth quire that the collaboration of Painters A and B begins:

Quire IV (δ')

Quire V (ε')

One quire, the sixth, contains miniatures by all three painters, yet there is only one *bifolium* with miniatures by both Painter A and Painter C:

Quire VI (ς')

The careful organization of the work of painting the Book of Kings supports the attribution of the miniatures to three different hands.

The work of Painter C is important in relation to a third illustrated manuscript, cod. Marc. gr. 479, the *Cynegetica* of the Pseudo-Oppian.[30] The *Cynegetica* is a didactic poem written by Oppian of Apamea, probably in the early third century A.D.[31] The Venice copy has generally been considered to date from the late tenth or early eleventh century. It contains, even in its slightly defective state, more than 150 miniatures painted by the same hand. The majority are unframed and have no backgrounds, like the work of Painter C in Vat. gr. 333. In fact, only a few comparisons are necessary to show convincingly that Painter C and the Master of the Venice Pseudo-Oppian are the same individual.

The miniature on folio 13ᵛ (fig. 14), illustrating *Cyn*. I.358–63, depicts an expectant Laconian woman, at the top left, looking at representations of ancient heroes (the contemplation of which, the author tells us, has a salutary influence on the appearance of the Laconian offspring). The first of these heroes, Nireus, standing nearest the woman, may be compared with the figure of Abner on folio 42ᵛ of Vat. gr. 333 (fig. 11). In the unframed *Cynegetica* miniature, Nireus is somewhat taller and thinner in appearance than Abner, but note the similarity of their head types. Both are regular ovals with an indentation for the eye sockets. The hairlines are similar as well and serve to draw attention to the large eyes. The style of indicating specific facial features with a brown line, or of lightly shading the jawline, is the same in both figures. A better comparison with this *Cynegetica* miniature might be the unframed miniature on folio 71ᵛ of Vat. gr. 333 (fig. 13). In this case the proportions of the figures are closer, as is the method of painting the garments. In both miniatures there is a single underlying drapery tone over which the painter draws the lines indicating the individual folds. The Pseudo-Oppian Master's fondness for long, sweeping folds that run from the shoulder to the waist, creating the illusion of a loosely fitted tunic firmly belted at the waist, is apparent in both miniatures.

In the *Cynegetica* miniature on folio 23 (fig. 15), illustrating the sea battle of *Cyn*. II.62–68, there is the same linear detail on the armor as in the miniature on folio 50 of Vat. gr. 333 (fig. 12), or even as on the cloth tunics of the figures acclaiming Solomon on folio 71ᵛ (fig. 13). Noteworthy is this painter's use of hatching, mostly on sleeves but also elsewhere, instead of a darker base tone. One of the principal contributions of this miniature, though, lies in the examples it offers of the Pseudo-Oppian Master's profile view of the face (compare figs. 12 and 13). The type is the same in both manuscripts, but only in the work of this one painter; it is not used by Painters I–B, II, or A, and so must be a personal trait. Over the course of the Pseudo-Oppian Master's work in the Book of Kings the actual pigment layer of his miniatures tends to become thinner. It is significant that the same tendency is also apparent in

[30] A. Zanetti, *Graeca Divi Marci bibliotheca codicum manuscriptorum* (Venice, 1740), 251; for bibliography on the miniature cycle, see Lazarev, *Storia*, 174 note 65.

[31] For discussion and bibliography, see *Oppian, Colluthus, Tryphiodorus*, ed. A. Mair, Loeb (London, 1928), xiii–xxiii.

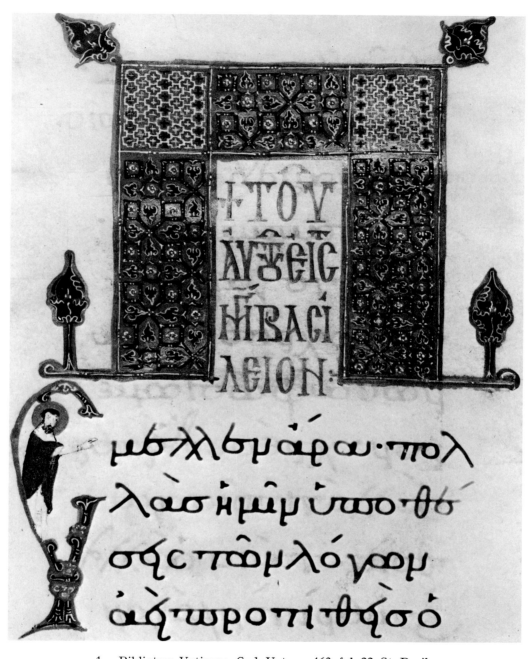

1.　Biblioteca Vaticana, Cod. Vat. gr. 463, fol. 22, St. Basil

2. Biblioteca Vaticana, Cod. Vat. gr. 463, fol. 107, The Baptism of Christ

3. Biblioteca Vaticana, Cod. Vat. gr. 463, fol. 192, St. Athanasius

4. Biblioteca Vaticana, Cod. Vat. gr. 463, fol. 324, Habakkuk

5. Biblioteca Vaticana, Cod. Vat. gr. 463, fol. 127, The Baptism of Christ

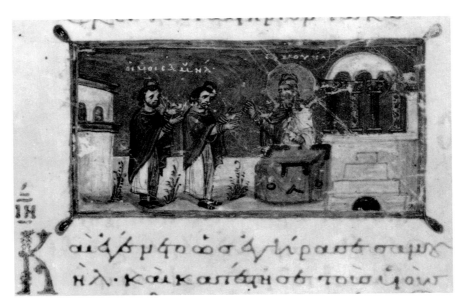

a. Samuel Appoints His Sons Judges Over Israel

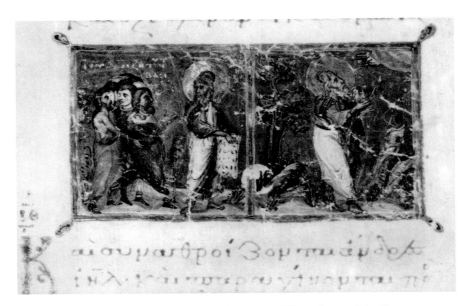

b. The Israelites Demand of Samuel a King; Samuel in Prayer

6. Biblioteca Vaticana, Cod. Vat. gr. 333, fol. 12

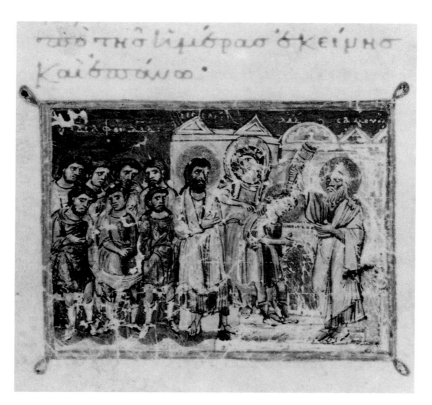

7. Fol. 22ᵛ, The Anointing of David

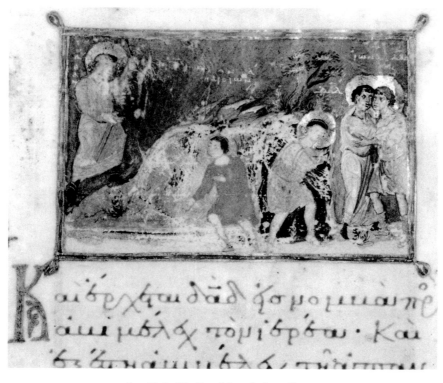

8. Fol. 28, David and Jonathan

Biblioteca Vaticana, Cod. Vat. gr. 333

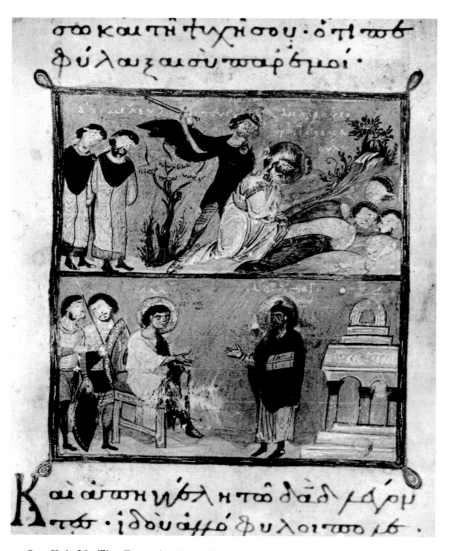

9. Fol. 30, The Decapitation of Ahimilech; Abiathar Before David

10. Fol. 33, David Sends His Messengers to Nabal

Biblioteca Vaticana, Cod. Vat. gr. 333

11. Fol. 42ᵛ, Ishboseth Confronts Abner; Michael Before David

12. Fol. 50, The Death of Uriah at Rabbah; the Messenger Before David

Biblioteca Vaticana, Cod. Vat. gr. 333

13. Biblioteca Vaticana, Cod. Vat. gr. 333, fol. 71ᵛ, Zadok Anoints Solomon

14. Biblioteca Marciana, Cod. Marc. gr. 479, fol. 13ᵛ, Laconian Woman and Ancient Heroes

15. Biblioteca Marciana, Cod. Marc. gr. 479, fol. 23, Sea Battle

16. Biblioteca Marciana, Cod. Marc. gr. 479, fol. 62, Euboeans Practicing Agricultural Arts

the *Cynegetica*. The miniature on folio 62 (fig. 16)—illustrating the story told in *Cyn.* IV.265–76 of how the Aonian women bearing the body of Dionysus arrive in Euboea, where Aristaeus taught the people shepherding, beekeeping, agriculture, etc.—serves as an example of one of the later miniatures comparable to that on folio 71ᵛ of the Book of Kings (fig. 13). In these two miniatures the Master's economy of technique is at its best. In the *Cynegetica* the garments are painted with so thin a layer of paint that the ground strip can occasionally be seen showing through.[32] The similarity of the three figures at the left of the upper zone is so close to those in the anointing of Solomon that a detailed comparison seems gratuitous. The general proportions, head shape, and details of drawing and articulation are precisely the same. In addition, both miniatures offer fine examples of the Pseudo-Oppian Master's tendency to paint his figures with rather long and unjointed arms.

The identity of the Master of the Pseudo-Oppian as Painter C links another manuscript to the Book of Kings and Vat. gr. 463. None of the three contains information relevant to where they were painted, but some speculation may be permitted. With at least four painters, the center was an active one. A further inference that may be drawn from the colophon of Vat. gr. 463 is that the center was known for its painting; Theodore, the abbot of the Galakrenai monastery, obviously knew that he could take his nearly completed Gregory manuscript to the painters for the addition of initials and headpieces. If we suppose that the center enjoyed some renown, then it is not impossible that other attributions may be made on the foundation of the three manuscripts discussed here, and that, through a process of *enchaînement*, a work may be added to the group that contains the key to provenance. (It must be stated, though, that if the center was monastic and had a name it might be possible to determine the exact location and uncover facts bearing on its history, but if the center consisted of laymen working on commissions, then it is most unlikely that any literary testimony concerning it survives.) Until further information is added, the center can be broadly located in Constantinople by showing that the style of its products is generally comparable to that of several manuscripts of Constantinopolitan origin.

The figure style of the three manuscripts is in certain respects on a level comparable to that of the Theodore Psalter (Lond. Add. 19,352) made in the Studios monastery in 1066.[33] The salient feature of the figures in the Psalter is their relative incorporeality. Bodies tend to be tall and thin, the shading of individual forms is minimal, and prominent lines of chrysography emphasize simple planes, or when caught by light, splinter in a manner that subverts the illusion of solid, plastic form. The Evangelist portraits once part of the Phanar Lectionary, given in 1063 by Catherine Comnena to the monastery

[32] The Pseudo-Oppian Master's method of working, in which the backgrounds are painted first, tends to confirm the assumed steps that Painters A and I–B took in their joint miniatures in Vat. gr. 333.

I should like to add here that the clustering of miniatures with similar color schemes in Marc. gr. 479 suggests that the Pseudo-Oppian Master painted the miniatures consecutively.

[33] S. Der Nersessian, *L'Illustration des psautiers grecs du moyen âge*, II, *Londres, Add. 19.352*, Bibliothèque des Cahiers archéologiques, V (Paris, 1970).

of the Holy Trinity at Chalke, exhibit elements of the same trend in metropolitan painting.[34] The major aspects of this trend become particularly apparent when one contrasts the style of painting in the Lectionary, the Psalter, and the three manuscripts under consideration here with illuminations from the tenth century, such as the portraits in Mt. Athos, Stauronikita, cod. 43,[35] or with ones dating from the turn of the tenth to the eleventh century, such as the miniatures in the Menologium of Basil II (Vat. gr. 1613).[36] Over the course of time from the tenth century to the middle of the eleventh, landscape backgrounds were replaced by gold or were simply disregarded, and shaded drapery gave way to a less plastic, more linear treatment.[37] While no single technique or figure type specifically relates the three manuscripts under study with the Theodore Psalter or the Phanar Lectionary, they all evince the same change in sensibility, which is dramatically revealed in the work of Painter I–B's acceptance by his colleagues. The Pseudo-Oppian Master's method of rendering drapery is essentially linear, and his figures are somewhat two-dimensional; in painting faces he relies on thin layers of wash in a manner similar to that used by the painter of the Theodore Psalter. The headpiece on folio 22 (fig. 1) of the only manuscript of the group with extensive non-figural decoration, Vat. gr. 463, is of the same pattern as that on folio 100 of the Theodore Psalter.[38] Of significance is the way these patterns have been rendered. Both headpieces suggest a certain freehand informality; the lines that serve as articulation for the leaves and flower petals are wide and painted in a contrasting lighter tone. Again, a return to tenth-century works like Mt. Athos, Dionysiou, cod. 70 (anno 955)[39] or Stauronikita cod. 43,[40] with their exacting and occasionally sensitive style of ornament, underlines the similarity between the work of the painter of the Theodore Psalter and that of the painters of Vat. gr. 463. Thus, the style of the three manuscripts is similar to, and synchronous in its development with, certain Constantinopolitan manuscripts to a greater extent than might be expected in works from a provincial center.

The parallels that support localization of the center in Constantinople also provide some aid in establishing the relative chronology of the manuscripts. All three certainly fall within a quarter-century, most likely with a midpoint of roughly 1062. I am inclined to consider both the Book of Kings and the

[34] C. Diehl, "Monuments inédits du onzième siècle," *Art Studies*, 5 (1927), 9, figs. 3–6. At least three, and possibly all four, of the Evangelist portraits have been cut out of the Phanar Lectionary; two are now in the Cleveland Museum of Art (acc. nos. 42–1511, 42–1512). See the recent remarks by H. Kessler, in *Illuminated Greek Manuscripts from American Collections*, ed. G. Vikan (Princeton, 1973), 84–87, figs. 22–24.

[35] K. Weitzmann, *Die byzantinische Buchmalerei des 9. und 10. Jahrhunderts* (Berlin, 1935), figs. 169–72.

[36] *Il menologio di Basilio II*, Codices e Vaticanis selecti, VIII (Turin, 1907).

[37] K. Weitzmann, "Byzantine Miniature and Icon Painting in the Eleventh Century," *Proceedings of the 13th International Congress of Byzantine Studies*, ed. J. Hussey, D. Obolensky, and S. Runciman (London, 1967), 207–11 (repr. in *Studies*, ed. Kessler [note 16 *supra*], 271–74).

[38] Der Nersessian, *op. cit.*, fig. 163.

[39] Weitzmann, *Byzantinische Buchmalerei*, figs. 160–65.

[40] *Ibid.*, figs. 176–78.

Cynegetica as somewhat earlier than Vat. gr. 463. In comparison with the work of Painter II in Vat. gr. 463, that of Painter A in the Book of Kings displays a degree of corporeality, care in rendering the facial features, and canon of relatively natural proportions that suggests more the style of late tenth- or early eleventh-century manuscripts like the Menologium of Basil II. The *Cynegetica* is perhaps also slightly earlier than 1062 or 1063. The Pseudo-Oppian Master's style is virtually identical in both works, and since I consider the Book of Kings to date sometime after the middle of the century, I would place the *Cynegetica* around the same time.

I should like to conclude by offering two observations on aspects of the painter's styles; the first concerns the relationships among the painters. While certain workshop techniques may be common to all four painters, the strongest impression of their output is one of variety. There is none of the homogeneity associated with, for example, the painters of the Menologium of Basil II.[41] The Pseudo-Oppian Master appears to have had some influence on Painter A, but not of the sustained sort that the word implies. Painter A's representations of David on folios 24ᵛ (right column miniature) or 30ᵛ[42] of the Book of Kings clearly contain suggestions of the facial type habitually used by the Pseudo-Oppian Master. The work of Painter I–B, on the other hand, certainly remains untouched by any of the refinements which his colleagues bring to their work. It is important to note, therefore, that a uniform style was not maintained in every painting center in Byzantium.

The second point concerns the relationship of the painter to his model. Our evidence, both pictorial and literary, indicates that from the time of the reinstitution of icon worship the cardinal rule of image making in Byzantium was extreme fidelity to the model. This practice was so pervasive that it often seems that a work exhibits more stylistic features of its model than of the individual who executed it. One particular class of examples revealing the influence of this practice is illustrated texts of a non-Christian nature whose images have no iconic or dogmatic force. The Venice *Cynegetica* is often regarded as a faithful copy of a late antique work, a pronouncement that has a certain undeniable appeal, the basis for which may easily be analyzed. The New York Dioscurides (Morgan Lib., cod. M 652) is a compilation of several illustrated, late antique herbals, one of which was quite probably the famous early sixth-century Anicia Codex (Vind. med. gr. 1).[43] On folio 225ᵛ of the New York Dioscurides is a figure of a man pouring oil from a bowl into a large jar for processing;[44] his general proportions and head type are rather reminiscent of those of figures painted by the Pseudo-Oppian Master. The type is short, stocky, and has a prominent head, like the figures in the sixth-century Vienna Genesis (Vind. theol. gr. 31), a work with a number of miniatures that are unframed and lacking in any background other than

[41] See the discussion in I. Ševčenko, "The Illuminators of the Menologium of Basil II," *DOP*, 16 (1962), 243–76.

[42] Lassus, *Livre des Rois*, fig. 56.

[43] See the recent remarks by A. van Buren, in *Illuminated Greek Manuscripts*, ed. Vikan, 68.

[44] *Ibid.*, fig. 9; and *Pedanii Dioscuridis Anazarbaei de Materia medica* (Paris, 1935), II, 225ᵛ.

required topographical elements.[45] That the general similarities in figure type point to a late antique exemplar for the *Cynegetica* is seemingly confirmed by the absence of painted headpieces and initial ornament. Had the Venice *Cynegetica* been the only surviving work by the Pseudo-Oppian Master, its status as a reflection of an earlier manuscript could hardly be challenged, but the presence of these very same late antique traits in his work in the Book of Kings seriously calls this assumption into question.[46] The lack of significant variation in his style from one work to the other indicates that the Pseudo-Oppian Master is a painter with a strong personal style; he impresses it upon every miniature he paints and thereby obscures that of his models. His style is, however, an idiosyncratic one that seems based on a particularly keen appreciation of an earlier fashion. The style of the Master's colleagues, though, are more typical of the eleventh century; and taken together, the work of all four constitutes an instructive episode in Middle Byzantine painting.

The George Washington University

[45] H. Gerstinger, *Die Wiener Genesis* (Vienna, 1931).

[46] It has been suggested by K. Weitzmann (*Greek Mythology in Byzantine Art*, Studies in Manuscript Illumination, IV [Princeton, 1951], 147–51) that only the core of the illustrations in the Venice *Cynegetica* is based on an early model; the others, he argues, were added in the Middle Byzantine period, some even adapted from Christian sources. His arguments are attractive ones which might now receive further attention using the information which has been gained through the study of the Master's style. In fact, the cycles of both the *Cynegetica* and the Book of Kings should now be re-examined in light of the stylistic and technical information herein established.

CHRIST AS MINISTRANT AND THE PRIEST AS MINISTRANT OF CHRIST IN A PALAEOLOGAN PROGRAM OF 1303

THALIA GOUMA-PETERSON

THE cycle of Christ's Ministry gained new prominence in Byzantine monumental painting during the late thirteenth and early fourteenth centuries. This is in keeping with the general and prevalent tendency of the early Palaeologan period to decorate churches with multiple and varied cycles.[1] The majority of these cycles are not, however, primarily narrative in intent; their function is to convey vividly and tangibly the esoteric and symbolic complexities of theological precepts, and to make these an immediate and understandable reality. During a period of religious unrest and doubt when, according to contemporary witnesses, many no longer attended church or baptized their children, theologians found it necessary to stress the importance and reality of the sacraments and the real presence of Christ within the Church. This intent was conveyed to the painters who were advised on the overall layout of the cycles and on the sequence of events to be included within them. This is corroborated by a survey of Ministry cycles which shows that the choice and arrangement of the events within most was determined not by narrative chronology but by themes of liturgical and sacramental symbolism which stress the role of Christ as ministrant and as the ultimate prototype of the Orthodox priest.

This double intent is central in the Ministry Cycle of the parekklesion of St. Euthymios (figs. 1–4, 6), a chapel of the basilica of St. Demetrios in Thessaloniki, dedicated to St. Euthymios of Melitini (377–473), the founder of Palestinian monasticism, and renovated in 1303 by the Protostrator Michael Glavas Tarchaneiotes, a leading general of the period, and his wife Maria.[2] The dedication of the parekklesion to St. Euthymios, its architectural association with St. Demetrios, and the relation of its liturgical functions to those of the large church are unusual. The reasons that governed these choices are complex and are related to the broader political and cultural milieu of the first three decades of the reign of Andronikos II (1282–1328).[3] A primary

[1] By early Palaeologan I mean the period from *ca.* 1261 to *ca.* 1320, i.e., the reign of Michael VIII and Andronikos II up to the civil war.

On the complexity and variety of Palaeologan Church decoration, see S. Dufrenne, "L'enrichissement du programme iconographique dans les églises byzantines du XIIIᵉᵐᵉ siècle," *L'Art byzantin du XIIIᵉ siècle: Symposium de Sopoćani 1965* (Belgrade, 1967), 35–46; and articles by S. Der Nersessian, J. Lafontaine-Dosogne, and P. A. Underwood, in *The Kariye Djami*, IV, *Studies in the Art of the Kariye Djami and its Intellectual Background* (Princeton, 1975).

Early Palaeologan churches of *ca.* 1290–1320 that contain Ministry Cycles are the following: St. Clement (church of the Virgin Peribleptos), Ohrid, 1294–95 (henceforth St. Clement); Protaton, Karyes, Mt. Athos, *ca.* 1300–5 (henceforth Protaton); the Metropolis, Mistras, *ca.* 1304–10; St. Catherine, Thessaloniki, *ca.* 1300–10 (henceforth St. Catherine); St. Nikita, near Čučer, *ca.* 1307–10 (henceforth St. Nikita); St. George Staro Nagoričino, *ca.* 1312–18 (henceforth Staro Nagoričino); St. Nicholas Orfanos, Thessaloniki, *ca.* 1315–20; church of the Virgin, Gračanica, *ca.* 1321 (henceforth Gračanica); Katholikon of the monastery of Chilandari, Mt. Athos, *ca.* 1310–12 (henceforth Chilandari); Kariye Djami (monastery of Christ in Chora), Constantinople, *ca.* 1312–15 (henceforth Kariye Djami).

[2] This information about the Parekklesion is provided by a dedicatory inscription in the north aisle. For the text and meaning of the inscription, see T. Gouma-Peterson, "The *Parecclesion* of St. Euthymios in Thessalonica: Art and Monastic Policy Under Andronicos II," *ArtB*, 58 (1976) (hereafter Gouma-Peterson, "The *Parecclesion*"), 168.

[3] *Ibid.*, 168–82.

reason was the intent to honor a great monk, St. Euthymios, in conjunction with one of the most important military saints, St. Demetrios. That the donor was a general very close to the emperor further underlined the honor and respect paid to monasticism, and the dedication of the parekklesion should be seen as part of the general pro-monastic policy of the emperor and his officials.

The small chapel, though architecturally an annex of the large basilica (fig. 1), was treated in its decoration as an independent unit and was given the full iconographic program of a major church.[4] Within this program Christ's Ministry was given special prominence through its placement immediately below the Festivals on the spandrels of the south and north arcades in the nave (figs. 3, 4, 6), a position usually reserved for the Passion. The cycle begins on the south (east) wall on a very narrow surface between The Communion of the Wine and the easternmost arch (an area equivalent to half a spandrel) with Christ Reading in the Synagogue (fig. 5). It continues on the spandrels of the south arcade (from east to west) with Christ Teaching in the Temple (fig. 8) and The Expulsion of the Merchants from the Temple (fig. 12). The scene on the westernmost spandrel has been almost entirely destroyed. The sequence is interrupted by The Dormition of the Virgin on the west wall and continues on the north wall (west to east) with The Healing of the Man with Dropsy (fig. 15), The Healing of the Paralytic at Bethesda (fig. 16), and The Healing of the Woman with the Curved Back (fig. 16) on the wall above the second arch, and Christ and the Samaritan Woman (fig. 21) and The Healing of the Blind Born (fig. 24) on the surface between the third arch and The Communion of the Bread.

The practice of separating the miraculous healings and other events of Christ's public life from the principal cycle of the Great Festivals and grouping them in an independent cycle is characteristically Byzantine and goes back at least to the twelfth century.[5] Usually the cycle was placed in a subsidiary spatial unit (side aisle or transept arm), and this practice continued during the Palaeologan period. Its prominent placement in the nave of St. Euthymios immediately below the Festivals remains unusual, though it does occur in two other early Palaeologan churches.[6]

[4] For a more detailed discussion of the reasons for this unusual treatment, see *ibid.*, 170–73. The cycles in St. Euthymios are briefly described by G. and M. Soteriou, Ἡ Βασιλικὴ τοῦ Ἁγίου Δημητρίου Θεσσαλονίκης, I (Athens, 1952), 213–14. Most of the paintings in the Parekklesion came to light during the removal of the Turkish whitewash after the fire of 1917, which severely damaged the basilica of St. Demetrios. The paintings of the parekklesion also sustained extensive damage. The present roof is new (fig. 2), and in all the scenes on the upper wall area of the nave (the Festivals) a section from eight to twelve inches is missing along the upper border (fig. 5). The prothesis has been completely rebuilt and the paintings on the outer south wall are almost destroyed. Most of the scenes on the upper walls of the nave (Festivals and Ministry) and the images of saints on the soffits of the south arcade were affected by the flames and heat. The paintings have faded considerably during the last twenty years.

[5] E. Kitzinger, *The Mosaics of Monreale* (Palermo, 1960), 30–31. Examples of this practice are the Sicilian churches and the SS. Anargyroi at Kastoria (see S. Pelekanidis, Καστορία, I. Βυζαντιναὶ τοιχογραφίαι [Thessaloniki, 1953], pl. 30).

[6] The Passion is placed above the Ministry, in closer proximity to the Festivals, in many early Palaeologan churches, as for example: in St. Nikita (R. Hamann-Mac Lean and H. Hallensleben, *Die Monumentalmalerei in Serbien und Makedonien vom 11. bis zum 14. Jahrhundert* [Giessen, 1963], plans 27–28; and G. Millet and A. Frolow, *La Peinture du Moyen Âge en Yougoslavie*, III [Paris, 1962],

The scenes usually included in the Ministry Cycle in Byzantine churches do not conform to a fixed order because there was nothing traditionally canonical in the selection and grouping of these events.[7] As Underwood has observed, theoretically a Ministry Cycle could comprise any event from the adult life of Christ preceding His Passion. When all four Gospels are taken into consideration the number of subjects becomes very sizable.[8] Dionysios of Fourna cites sixty-four subjects in his Painter's Guide (Hermeneia) that could be part of a Ministry Cycle.[9] The list in the Hermeneia is the most complete in existence and is rather theoretical since no church could possibly accommodate that many scenes in one cycle. Of extant pictorial cycles the one in the Kariye Djami comes closest to the Hermeneia in scope with about half the number of events.[10]

In St. Euthymios not only is Christ's Ministry given a prominent position but it also has an added significance, for, through its placement and through the correspondence of specific events, it underlines the parallelism between the ministry of Christ and the ministry of St. Euthymios, the patron saint of the chapel whose life is represented in the north aisle (figs. 6, 26–28). This parallelism expresses pictorially beliefs central to the thought of two of the most influential prelates of the period, Bishop Theoleptos of Philadelphia (1283–ca. 1322/24) and Patriarch Athanasios I of Constantinople (1289–93,

pl. 37,2), at Chilandari (G. Millet, *Monuments de l'Athos* [Paris, 1927] [hereafter Millet, *Athos*], pl. 64,2) and in St. Nicholas Orfanos (see A. Xyngopoulos, Οἱ τοιχογραφίες τοῦ ῾Αγίου Νικολάου ᾿Ορφανοῦ Θεσσαλονίκης [Athens, 1974], pls. III and IV). In the latter the Ministry is placed in the south aisle of the U-shaped ambulatory. In St. Clement, where the zone below the Passion is occupied by the Life of the Virgin, the Ministry is placed in the northwest and southwest corner bays. In the Protaton, a basilica, the Festivals are in the nave, the Passion in the transept, and the Ministry in the side aisles (fig. 13). In two other churches, Staro Nagoričino and Gračanica, whose frescoes date some ten to eighteen years later than those of St. Euthymios, the Ministry is placed immediately under the Festivals (Hamann-Mac Lean and Hallensleben, *op. cit.*, plans 32–36), with the Passion immediately below the Ministry. The Soterious, *op. cit.*, 24, have suggested that the Passion was represented in St. Euthymios in the south aisle. This seems most probable, even though the cycle would have had to be reduced, since a large part of the south wall is taken up by three windows (figs. 1, 2).

[7] The late Paul Underwood ("Some Problems in Programs and Iconography of Ministry Cycles" [hereafter Underwood, "Some Problems"], in *The Kariye Djami*, IV, 245–48) dealt for the first time with the principles underlying the organization of Ministry Cycles. I had, in many instances, reached similar conclusions independently, but I did profit from being permitted to read this article prior to publication. For this I wish to thank Professor Kitzinger. I wish also to thank Mrs. Fanny Bonajuto for her courtesy and friendly exchange of ideas while I was at Dumbarton Oaks in the summer of 1970. On Christ's Ministry, see also G. Millet, *Recherches sur l'iconographie de l'Evangile* (Paris, 1916) (hereafter Millet, *Recherches*), 57–65.

[8] Underwood, "Some Problems," 246.

[9] Dionysios of Fourna devotes the third section of his *Hermeneia* to the life of Christ and divides it into three parts. See Dionysios of Fourna, ῾Ερμηνεία, ed. A. Papadopoulos-Kerameus (St. Petersburg, 1909), 85–113. The events of Christ's Ministry are included in the first parts ("How to represent the Festivals of the Lord and other acts and miracles of Christ," *ibid.*, 85–103), which lists a total of sixty-four events that could be included in a Ministry Cycle. Clearly, this is too large a number to represent within the confines of any church, especially a Palaeologan church, since they tended to be rather small. The sequence of events in the *Hermeneia* is based on the Gospel of Matthew, and whatever events were missing from that Gospel were taken from the others and interspersed in the appropriate chronological sequence. On this see also Underwood, "Some Problems," 247–51 and note 8.

[10] *Ibid.*, 246–47; and *idem, The Kariye Djami*, I (New York, 1966), 108–51. The *Hermeneia* and two manuscripts published by Papadopoulos-Kerameus as Appendices, and which he suggests served as sources to Dionysios, do not agree in either the number or the sequence of events (*op. cit.*, 85–103, 265, 278).

1303–9), that is, the importance of the priest as an extension of Christ and as a preserver of the sacramental reality of the Church. Both men stressed participation in the Church through baptism and the Eucharist, and both drew an analogy between the religious profession and baptism. According to Theoleptos, "If you come to an Orthodox priest you come to Christ, you honor Christ, you receive Christ. In receiving Christ, through him you also receive the Father and the Holy Spirit."[11] This is one of the central themes of the Ministry Cycle in St. Euthymios. It is clearly stated through the opening scene, which represents Christ Reading in the Synagogue at Nazareth (fig. 5) on the Sabbath (Luke 4:16–30, Matt. 13:53–58, Mark 6:1–6), and is reiterated throughout the cycle.

Because of the limited space, the first scene was reduced to the standing figure of Christ at the left reading from an open book on a lectern. Possibly there was a figure behind the lectern (over the curve of the arch) representing the attendant who handed "the scroll of the prophet Isaiah" (Luke 4:17) to Christ. Behind and above Christ there seems to be a semicircular structure, or more probably a ciborium.[12] This scene occurs frequently in early Palaeologan churches, though it was rarely depicted in Byzantine churches prior to this period. The two main variants, Christ and the attendant or Christ and a group of seated Jews, appear to be an abbreviated form of a more narrative sequence of two scenes which occurs in illuminated manuscripts from the eleventh century onward.[13] The better preserved fresco in St. Clement

[11] J. Meyendorff, *A Study of Gregory Palamas* (London, 1964), 20; S. Salaville, "Deux documents inédits sur les dissensions religieuses byzantines entre 1275 et 1310," *REB*, 5 (1947), 128–29, esp. 125. For a more complete discussion of Athanasios and Theoleptos and bibliography, see Gouma-Peterson, "The *Parecclesion*," 178–80. See also A.-M. M. Talbot, *The Correspondence of Athanasius I, Patriarch of Constantinople: Letters to the Emperor Andronicus II, Members of the Imperial Family, and Officials* (Washington, D.C., 1975).

[12] This scene is not mentioned by the Soterious. Generally, their discussion of this cycle is brief and deals mainly with stylistic aspects (*op. cit.*, 217). At present, only the figure of Christ can be barely distinguished from ground level.

[13] Two scenes occur in an eleventh-century Gospel Book, Paris, Bibl. Nat., cod. gr. 74; see H. Omont, *Evangiles avec peintures byzantines du XI^e siècle*, II (Paris, 1908) (hereafter Omont, *Evangiles*), 2 and pl. 101. They follow the sequence of the narrative of the Gospel according to Luke. The first scene is identical with those in St. Clement and St. Euthymios, and the second represents Christ seated, holding the book and explaining the passage he has just read to a group of Jews. In a thirteenth-century Gospel Book, Berlin, State Library, Q 66, the episode is illustrated in one scene, but it includes the group of seated Jews opposite the standing Christ; see E. J. Goodspeed, D. W. Riddle, and H. R. Willoughby, *The Rockefeller McCormick New Testament* (Chicago, 1932), III, 166, pl. LVIII. For the more recently proposed thirteenth-century date of the manuscript, see R. Hamann-Mac Lean, "Der Berliner Codex Graecus Quarto 66 und seine nächsten verwandten als Beispiele des Stilwandels im frühen 13. Jahrhundert," *Studien zur Buchmalerei und Goldschmiedekunst des Mittelalters* (= *Festschrift für Karl Hermann Usener*) (Marburg, 1967), 225–50. A sequence of two scenes also occurs in the Rockefeller McCormick New Testament, dated 1265–70 (University of Chicago). Here in the first scene the standing Christ is flanked by two seated figures, and in the second the seated Christ teaches a group of standing Jews (Goodspeed, et al., *op. cit.*, I, 13–16; fols. 62^v and 63^r: III, 166–68). In an eleventh-century lectionary, Morgan 639, fol. 294, and an eleventh-century Gospel Book, Florence, cod. Plut. VI.23, fol. 109^v, only The Teaching of Christ in the Synagogue, after He had read from the book of Isaiah (Luke 4:20), is represented, and is given almost the same iconography as the scene of Christ Teaching in the Temple (John 7:14–36) which follows in the Ministry Cycle in St. Euthymios (fig. 8). For the scenes in the latter two manuscripts, see K. Weitzmann, "The Constantinopolitan Lectionary Morgan 639," in *Studies in Art and Literature for Belle da Costa Greene*, ed. D. Miner (Princeton, 1954), 368–69, figs. 319–20. The only difference from the usual iconography of Christ Teaching in the Temple is that the enthroned Christ is returning the book of Isaiah, which He holds

(fig. 7) has also been restricted to Christ, the book on the lectern, and the young attendant (possibly included in St. Euthymios). On the book are inscribed the opening lines of the passage from Isaiah read by Christ: "The Spirit of the Lord is upon me, because he anointed me" (Luke 4:18, Isa. 61:1–2).[14]

This episode, though related in all the Synoptic Gospels, is given a special significance in Luke through the lengthy account of Christ's teaching, and is placed at the beginning of Christ's Ministry. Only in Luke is the passage from Isaiah, especially appropriate as the opening scene of a Ministry Cycle, introduced:

> The Spirit of the Lord is upon me because he has anointed me;
> he has sent me to announce good news to the poor,
> to proclaim release for prisoners and recovery of sight for the blind;
> to let the broken victims go free,
> to proclaim the year of the Lord's favor (Luke 4:18–19).

> Today, he said, in your very hearing this text has come true (4:21).

This passage establishes the central themes of the cycle: the manifestation of Christ's Divinity, the importance of His Ministry among men as a transmission of the Spirit of the Lord and as a source of physical and spiritual healing, and the importance of the Sabbath as the day of regeneration (Luke 4:16, Mark 6:2).

The next scene (fig. 8), Christ Teaching in the Temple at Jerusalem on the Sabbath during the Jewish Feast of the Tabernacles (John 7:14–36), parallels the first one. The event occurs at a decisive time in Christ's life, at the beginning of the Great Controversy when He comes to Jerusalem to confront the Jews. It takes place during a festival and in a holy place, and again Christ reveals Himself as the Redeemer and the Son of God. Finally, the Sabbath issue is clearly raised as a point of controversy: "Once only have I done work on the Sabbath and you are all taken aback...why are you indignant with me for giving health on the Sabbath to the whole of a man's body?" (John

n His left hand, to the attendant. In a miniature of the late tenth- or early eleventh-century Menologion of Basil II, Vatican, cod. gr. 1613, Christ is represented standing frontally on a footstool and holding the open book, with a group of Jews on either side bowing in devotion; see K. Weitzmann, *Illustrations in Roll and Codex* (Princeton, 1970), 180–81, fig. 189. According to Weitzmann, in this case the compositional scheme was based on that of the "Mission of the Apostles" and should be considered an exceptional type. For a proposed early eleventh-century date for Vat. gr. 1613, see I. Ševčenko, "On the Pantaleon Painter," *JÖB*, 21 (1972), 241–49.

14 Other early Palaeologan examples of the scene occur at Chilandari, where two scenes corresponding to two different moments of the narrative are represented: Christ Reading in the Synagogue and Christ Teaching the Jews (Millet, *Athos*, pls. 76,1, 77,1); in the Protaton (fig. 11), where Christ is shown Teaching the Jews, standing frontally under a ciborium and holding the open Book in front of his chest (this iconography echoes that of the Menologion of Basil II); in St. Nikita, Staro Nagoričino, and Gračanica, Christ is shown Reading in the Synagogue in much the same way as in St. Euthymios and St. Clement (D. V. Ajnalov', "Novyj ikonografičeskij obraz' Hrista," *SemKond*, 2 [1928], 19–24). To my knowledge the scene does not occur in Byzantine church decoration prior to the Palaeologan period.

7:21–24). This statement is a direct reference to The Healing of the Paralytic at Bethesda, which occurs later in the cycle.[15]

In the Teaching scene Christ, framed and isolated by a monumental throne, is represented blessing and holding a scroll. Behind Him is a semicircular structure with columns. He is flanked on each side by a seated Elder who gestures in astonishment and by a number of other figures, shown over the arches. The iconography of this scene in Byzantine art is similar to that of Christ Among the Doctors (Luke 2:41–49), except that in the latter Christ and the Elders are usually seated on a common bench and Christ is represented beardless.[16] It occurs in the eleventh-century frescoes of the New Church of Toqale, and its iconography is almost identical with that of the late thirteenth- and early fourteenth-century examples.[17] The Palaeologan representations in St. Euthymios (fig. 8), St. Clement (fig. 10), St. Nikita (fig. 9), and Staro Nagoričino are iconographically similar, except for minor differences such as the type of throne, the use of the ciborium, and the grouping of the Jews.

The Expulsion of the Merchants from the Temple (fig. 12), which follows on the next spandrel, is related in all four Gospels (Matt. 21:12–13, Mark 11:15–19, Luke 19:45–46, John 2:13–22). During the Jewish Passover Jesus went to Jerusalem and entered the temple. Finding it full of money changers and merchants "that sold oxen and sheep and doves," He "made a scourge of cords" (a detail mentioned only in John 2:15) and cast them out of the temple. Christ is represented pushing a money changer with His left hand and brandishing the scourge with His right. Beneath His feet are an upturned table and a number of sheep and goats, and behind Him is a ciborium. A group of merchants and money changers is crowded over the curve of the arch at right. The iconographic type of this scene was more or less firmly fixed by the ninth century[18] and occurred frequently in early Palaeologan churches.

[15] See infra, p. 205–6 and fig. 16.

[16] The Soterious, op. cit., 217, identify the scene in St. Euthymios as Christ among the Doctors. The iconography of these two subjects was closely related and is easy to confuse, and in fact the scenes were occasionally confused by the artists themselves; see G. de Jerphanion, Une nouvelle province de l'art byzantin. Les Eglises rupestres de Cappadoce, Text vol. I,2 (Paris, 1932), 332–33. The similarity of the account of the two events in the Gospels probably contributed to the confusion (compare Luke 2:42–47 with John 7:10–15). One determining factor is whether Christ is represented as a bearded adult, as given in John. In St. Euthymios the largest part of Christ's face has been destroyed, but traces of the beard are evident upon close investigation. Christ is also represented with long hair reaching to His shoulders and not with short hair reaching only to ear level, as in the scene when derived from Luke, such as, for example, in the Protaton (Millet, Athos, pl. 35,2). Often in the scene from Luke Christ's parents were included, e.g., at Sopoćani (Millet and Frolow, La Peinture, II [1957], pl. 9,3). For a recent discussion of representations of the mid-Pentecost, see G. Babić, "O prepolovljeny praznika," Zograph, 7 (1977), 22–27, which appeared after this article had gone to press.

[17] For the fresco at Toqale, see Jerphanion, op. cit., Text vol. I,2, pp. 332–33, Plate vol. II (Paris, 1928), pl. 76,1. The passage from John (7:14–51) is illustrated as a single scene in eleventh- and twelfth-century lectionaries, such as Dionysiou cod. 587m, fol. 19v. It is also represented in a series of eight scenes in Paris. gr. 74; see Omont, Evangiles, 8, pls. 156–59. In most of these scenes Christ is either enthroned or stands under a ciborium and teaches the Jews. None of the scenes is identical with the type used in Byzantine churches.

[18] According to O. Demus, The Mosaics of Norman Sicily (London, 1949) (hereafter Demus, Mosaics), 279, the apostles and often a group of Pharisees were also included. The detail of the scourge seems to have appeared for the first time in a ninth-century miniature of the Chludov Psalter. To this general type belong both the miniature in the Paris. gr. 74 (Omont, Evangiles, pl. 148) and the mosaic at Monreale (Demus, op. cit., pl. 91a).

Minor differences involve the type of Christ's gesture, the number and grouping of the merchants, and the type of architectural setting. The ciborium occurs in most scenes, but not at St. Clement (fig. 14). In St. Nikita (fig. 13) and the Protaton (fig. 11) a holy table with a book or scroll on it is placed under the ciborium.

The Expulsion of the Merchants is given greater prominence and a more symbolic interpretation in the fourth Gospel. John also places the event at the beginning of Christ's Ministry immediately after The Wedding at Cana. Within this context it acquires new significance, symbolizing at the beginning of Christ's public life the things to come, and representing the first public manifestation of Christ's authority to judge and chastise. The detail added by John, the scourge of cords, is significant as a symbol of divine authority. John was given precedence over the other evangelists both by Byzantine liturgists, for it is John's account that is read on the Friday of the first week after Easter, and by Byzantine artists, who always included the scourge (figs. 11–14).[19] The symbolic content given to this event in the fourth Gospel is in keeping with the context of the total cycle in St. Euthymios. The first three scenes are in fact variants of the same symbolic themes which reach a climax in The Expulsion of the Merchants, where Christ equates His body with the Temple of the Lord.

Little remains of the scene represented on the westernmost spandrel of the south arcade, but traces of a large table in the central area of the spandrel suggest that it most likely was an abbreviated version of The Wedding at Cana. This miracle, related only in the fourth Gospel, immediately precedes The Expulsion of the Merchants in the text (John 2:1–11). It was the first public manifestation of Christ's miraculous powers and was considered by theologians as His first authentic miracle and as a symbol of the Eucharistic "Transubstantiation."[20] If included in the parekklesion, the scene would reiterate the epiphanic theme of the three previous scenes, would develop the Eucharistic theme introduced in The Expulsion of the Merchants, and would provide a transition to the miracles which follow on the north wall.

The first miracle, The Healing of the Man with Dropsy (fig. 15), refers to the episode when Christ, in the house of a ruler of the Pharisees, on a Sabbath healed "a certain man that had the dropsy" (Luke 14:1–6). The main issue is not the miracle itself but the question raised by Christ: "Is it permitted to cure people on the Sabbath, or not?" This question refers to a theme introduced in the second scene of the cycle which will be repeated in the three miracles which follow on this wall.

Christ is seated on the left, whereas usually in this scene He is shown standing (an adjustment to the architectural projection of the doorway molding). He raises His right hand in a gesture of blessing. The sick man, dressed in a loin cloth, faces Christ, supports himself on a cane, and gestures in amazement.

[19] In the miniatures of Paris. gr. 74 The Expulsion of the Merchants is illustrated only in the fourth Gospel (Omont, *Evangiles*, pl. 148), where the miniature immediately follows The Wedding at Cana.

[20] On this miracle, its symbolism, and its iconography, see Underwood, "Some Problems," 265, 280–85. See also E. B. Smith, *Early Christian Iconography and a School of Ivory Carvers in Provence* (Princeton, 1918), 85; and L. Réau, *Iconographie de l'art chrétien*, II (Paris, 1957), 363–64.

Behind him stand two Jews, one of whom helps to support the invalid. In its main elements the iconography of this scene was well established from the ninth century on, and during the eleventh century a number of apostles and a group of Jews were added to the two protagonists.[21] Subsequently the iconographic variations involve mainly the number of secondary figures and the gestures given to Christ and the dropsical man. In early Palaeologan monuments no two examples are exactly alike (figs. 13, 15, 17).[22]

The next miracle, The Healing of the Paralytic near the Pool of Bethesda in Jerusalem (fig. 16), again occurred on the Sabbath during the Jewish festival (John 5:2–15). In keeping with the symbolic nature of the miracles in the fourth Gospel the actual healing is of lesser importance than its sacramental symbolism. Equally important is the ensuing dialogue between Christ and the Jews (John 5:19–47), in which He equates Himself with God and refers to the resurrection and judgment of the dead.

Contrary to common practice, Christ is represented seated, an adjustment to the curvature of the arch. Behind Him is a group of four apostles; opposite Him stands the paralytic lifting his bed with both hands over his head and shoulders. Above Christ and the paralytic appear the five vaults of the pool of Bethesda (John 5:2) and behind them, on a lower level, a section of the pool. The iconographic origins of this scene are rather problematic because it has often been confused with The Healing of the Paralytic at Capernaum (Mark 2:1–12, Matt. 9:2–8, Luke 5:18–26).[23] The locale of each miracle is important in establishing the identity of the scene since The Healing at Capernaum took place in a house, whereas that at Bethesda took place near a pool by the sheep market in Jerusalem.[24] According to the Gospel the pool

[21] The bearded Christ and the sick man dressed in a loincloth appear in a miniature of the Homilies of Gregory of Nazianzus, Paris, Bibl. Nat., cod. gr. 510, dated 880–83, where the scene is reduced to the two main figures; see H. Omont, *Miniatures des plus anciens manuscrits grecs de la Bibliothèque Nationale du VIe au XIVe siècle* [Paris, 1929], pl. xxxvi). In Paris. gr. 74 three apostles stand behind Christ and a rather large group of Jews stand behind the sick man (*idem, Evangiles*, pl. 122), but the protagonists are isolated from the secondary figures. In the New Church of Toqale Christ is followed by two apostles and the sick man is supported by a companion and holds his swollen abdomen with both hands (Jerphanion, *op. cit.*, Text vol. I,2, pp. 340–41, Plate vol. II, pl. 79,1).

[22] In the late twelfth-century mosaic of Monreale Christ holds the hand of the sick man (Demus, *Mosaics*, pl. 90a). In St. Clement and St. Nikita (fig. 13) the invalid stands alone supporting himself on one crutch and with his free hand gestures in amazement. In St. Clement Christ is shown blessing, whereas in St. Nikita he touches the swollen abdomen of the man. At Staro Nagoričino (fig. 17) Christ is blessing, and the sick man supports himself on one crutch and is helped by a companion; he does not gesture in amazement (Millet and Frolow, *La Peinture*, III, pl. 82,4). In the Kariye Djami a fairly large group of lawyers and Pharisees accompanies the man. The figures of Christ, his disciples, and the dropsical man are destroyed (Underwood, *Kariye Djami*, I, 130–31, II, pls. 250, 252). In St. Nicholas Orfanos a large group of lawyers and Pharisees, two of whom give assistance, accompanies the dropsical man who supports himself on two crutches (Xyngopoulos, *op. cit.* [*supra*, note 6], fig. 85).

[23] The iconographic problems of the two healings of a paralytic have also been observed by Underwood, "Some Problems," 289–97. He is, to my knowledge, the first to discuss extensively the origins and iconographic variants of The Healing at Bethesda and The Healing at Capernaum. Both scenes occur in the mosaics of the Kariye Djami. See also Goodspeed, et al., *op. cit.*, II, 218–20. Other authors discuss the iconographic evolution of The Healing of The Paralytic as though it were one and the same event; see, for example, Smith, *op. cit.*, 102; and Réau, *op. cit.*, II, 376–78.

[24] Underwood, "Some Problems," 290–91. In the sixth-century mosaics of San Apollinare Nuovo in Ravenna The Healing at Capernaum occurs in a house, whereas The Healing at Bethesda takes place outdoors in no specific locale and simply shows the paralytic carrying his bed; see F. W. Deichmann, *Frühchristlichen Bauten und Mosaiken von Ravenna* (Baden-Baden, 1958), pls. 175, 179.

had five colonnades; in early Palaeologan churches it was represented as a columnar structure with five domical vaults, a type that first occurs in St. Clement and is used in more or less the same form in St. Euthymios (fig. 16), St. Catherine (fig. 18), St. Nikita (fig. 19), and elsewhere.[25] The Palaeologan type, with Christ and the apostles, the pool and vaulted structure, and the paralytic lifting up his bed, is one of several variants and represents an abbreviation of a narrative sequence. Both a narrative type, as in St. Catherine (fig. 18) and the Kariye Djami, and an extremely abbreviated type without pool or vault, as in the Protaton (fig. 11), were used concurrently in early Palaeologan churches.[26]

The Healing of the Paralytic at Bethesda is related to the preceding scenes in the Ministry Cycle as a scene of healing and of deliverance from infirmity. It is a fulfillment of the passage from Isaiah read by Christ in the Synagogue at Nazareth: "He has sent me to proclaim release for prisoners.... To let the broken victims go free" (Luke 4:18–19); and it is also a Sabbath miracle that incited another confrontation with the Jews. But the scene also introduces a new symbolic theme, that of the Sacrament of Baptism, which recurs in two other miracles on this wall. There is a direct reference in the Gospel to the "waters of Baptism" (John 5:16–18), and it appears that from earliest times this scene was given a baptismal interpretation.[27]

The Healing of the Woman with the Curved Back (fig. 16), another Sabbath miracle (Luke 13:10–17), occurred while Christ was teaching in one of the synagogues and saw a woman "possessed by a spirit that had crippled her for eighteen years. She was bent double and quite unable to stand up straight." Christ's healing of the woman angered the Jews. His answer, "And here is this woman...who has been kept prisoner by Satan...was it wrong for her to be freed from her bonds on the Sabbath?" (Luke 13:16), is again a fulfillment of the passage from Isaiah: "He has sent me to proclaim release for prisoners" (Luke 4:18).

[25] A five-vaulted structure also occurs at Monreale, but the architectural type is different (Demus, *Mosaics*, 277, 280, pls. 66,c, 87,a). In St. Clement, Christ followed by Peter stands on the right and the pool has five vaults. A. Stojaković, "Une contribution à l'iconographie de l'architecture peinte dans la peinture médiévale serbe," *XIIᵉ Congrès International des Etudes Byzantines, Résumés* (Belgrade-Ochrid, 1961), 101–2, has suggested that the origins of this clearly formulated architectural type used in Palaeologan painting should be sought in the actual structure of the pool, as corroborated by the excavations of 1873 which showed that the pool had five porticoes.

[26] The narrative sequence, showing the paralytic seated on his bed, the paralytic carrying his bed, and the Jews questioning him, occurs in the mosaics of the Kariye Djami; see Underwood, "Some Problems," 291–93. It also occurs in manuscripts, as for example Paris. gr. 74 (Omont, *Evangiles*, pls. 103, 152), and the Gospel Book Iviron 5, which contains a sequence of two events (A. Xyngopoulos, Ἱστορημένα Εὐαγγέλια Μονῆς Ἰβήρων Ἁγ. Ὄρους [Athens, 1932]; and S. M. Pelekanidis, P. C. Christou, Ch. Tsioumis, S. N. Kadas, *The Treasures of Mount Athos*, II [Athens, 1975], 49, fig. 35).

[27] Underwood, "Some Problems," 258–61, 292, 296, has suggested that in the numerous instances in which the episode is reduced to a portrayal of Christ and the paralytic carrying his bed, as for example in the Protaton (fig. 11), the miracle is that of the Paralytic at Bethesda because of the very important liturgical symbolism of this scene. He observes that the passage from John 9:1–38 was read in connection with the preparation of the catechumens for baptism as early as the fourth century. The Healing of the Paralytic at Bethesda was included in the decoration of the baptistery of Dura-Europos in the third century (see C. H. Kraeling, *The Christian Building, The Excavations at Dura-Europos, Final Report*, VIII,2 [New Haven, 1967], 177–203).

Christ is represented at the left in a gesture of blessing. The woman, extremely bowed, supports herself on a cane and implores Christ. This iconography follows a type that was current from the eleventh century on and was frequently used in early Palaeologan painting.[28] Because of space limitations, the scene was represented on the narrow surface above the arch immediately following The Healing of the Paralytic at Bethesda and, by necessity, was confined to the figures of the two protagonists. Since this is the only scene represented on the wall area above the arches it indicates that its inclusion was considered necessary for the theological completeness of the cycle.

The following scene (fig. 21) shows Christ and the Samaritan Woman at Jacob's well near the city of Sychar (John 4:5–30). During His conversation with the Samaritan, Christ revealed Himself as the Messiah and the source of living water and proclaimed the universal character of the new religion. The meeting concluded with the conversion of the inhabitants of Sychar. The scene in St. Euthymios includes two sequential moments of the Gospel narrative: Christ's conversation with the Samaritan and the woman's subsequent report of this meeting to the inhabitants of Sychar. Jacob's well is represented below the two protagonists in the form of a cruciform baptismal font with three steps, an allusion to the baptismal symbolism of this event which, like the Baptism, was considered an act of illumination. Christ Himself refers to the Baptism by living water (John 4:11–14). The woman is shown a second time in the background, talking to the Samaritans in front of the city of Sychar and pointing at Christ.

This sequence of two events was derived from an earlier narrative version which included as many as four episodes.[29] The secondary episode in St. Euthymios refers to the passage in the Gospel: "The woman put down her water-jar and went away to the town, where she said to the people, 'Come and see a man who has told me everything I ever did. Could this be the Messiah?'" (John 4:28–29). These words of the Samaritan woman resulted in the conversion of the inhabitants of Sychar: "Many Samaritans of that town came to believe in Him because of the woman's testimony..." (John 4:39). The inclusion of the secondary episode, which remains exceptional in early Palaeologan painting, was intended to stress the conversion and baptism of the "non-

[28] The scene occurs in Paris. gr. 74. Here the two main figures are essentially the same as in St. Euthymios, except that Christ is followed by a group of apostles and a group of Jews stands behind the woman (Omont, *Evangiles*, pl. 121). The same type occurs in the mosaics of Monreale (Demus, *Mosaics*, 279, pls. 89a, 90a), except that in this case the group of Jews is led by the ruler of the Synagogue. The abbreviated type used in St. Euthymios also occurs at Chilandari (Millet, *Athos*, pl. 64), in St. Nikita (fig. 20), and in St. Nicholas Orfanos (Xyngopoulos, Οἱ τοιχογραφίες [*supra*, note 6], fig. 84), except that in these three examples two or three apostles accompany Christ.

[29] Millet, *Recherches*, 602–4, has postulated an older narrative sequence in four episodes: the woman holding her pitcher finds Christ alone and He asks for a drink (John 4:7); with empty hands she listens to the Messiah while the apostles return (John 4:26–28); she announces to the Samaritans that she has met the Messiah (John 4:28–29); the Samaritans come out of the city and ask Christ to stay with them (John 4:30–40). In his opinion two differently abbreviated versions of this narrative sequence occur in the miniatures of Paris. gr. 74 and the mosaics of St. Mark's in Venice. Demus (*Mosaics*, 281–82), on the other hand, believes that the simple type belongs to the Hellenistic tradition of the metropolis, whereas the more narrative version, e.g., in Paris. gr. 74 (see Omont, *Evangiles*, pls. 150–51) belongs to the oriental tradition.

believers." The abbreviated type, which includes only Christ and the Samaritan and occasionally a few apostles, was the one current in early Palaeologan Church decoration (figs. 22, 23).[30]

The last scene in this cycle, The Healing of the Blind Born near the pool of Siloe (fig. 24), is both a Sabbath miracle and a symbol of baptism (John 9:1–8). The baptismal symbolism is clearly expressed in the scene in St. Catherine (fig. 25), where the pool has been represented as a cruciform baptismal font. Theologians interpreted this miracle as symbolic of the healing of the human race, blind from its birth because of Adam's sin, and enlightened through baptism by the grace of the Redeemer who from the dark called us into His light.[31] Christ reveals Himself in this episode as the source of light: "While I am in the world, I am the light of the world" (John 9:5), or "It is for judgment that I have come into this world—to give sight to the sightless and to make blind those who see" (John 9:39). In these words we find again a direct reference to the passage from Isaiah which Christ read in the synagogue at Nazareth: "He has sent me...to proclaim...recovery of sight for the blind" (Luke 4:18). Because of the limited space the scene has been reduced to the two main figures. Christ, at right, places His hand upon the eyes of the blind man, who is shown in front of a rectangular structure, possibly the pool. The figure of the man, which emerges at waist level from the curve of the arch, is very damaged. This abbreviated type appears to have been current *ca.* 1300, for it also occurs in St. Clement, the Protaton (fig. 11), and the Kariye Djami.[32]

Unlike other examples of this scene and the other scenes in this cycle, the figure of Christ is placed here on the right, a reversal used to close the cycle. If Christ had been placed on the left, the observer's eye, following the course

[30] The abbreviated type occurred as early as the sixth century in San Apollinare Nuovo (Deichmann, *op. cit.*, pl. 166). It continued in use during the eleventh and twelfth centuries, e.g., at Sant'Angelo in Formis (G. de Jerphanion, *La Voix des monuments* [Paris, 1903], pl. IV,1) and Monreale (Demus, *Mosaics*, pl. 67,a). In Paris. gr. 510 even the apostles have been eliminated (Omont, *Miniatures*, pl. XXXIX). In early Palaeologan art the type occurs frequently, e.g., at St. Clement (fig. 22), the Protaton (fig. 23), St. Nikita (Millet and Frolow, *La Peinture*, III, pl. 39,4), Staro Nagoričino, St. Nicholas Orfanos (Xyngopoulos, Οἱ τοιχογραφίες, figs. 89–90), Chilandari (Millet, *Athos*, pl. 77,1). To my knowledge the only other Palaeologan fresco which includes the secondary event is a late example in the church of the Archangels at Lesnovo of *ca.* 1341–49; cf. G. Millet and T. Velmans, *La Peinture du Moyen Âge en Yougoslavie*, IV (1969), fig. 34.

[31] Underwood, "Some Problems," 258; Réau, *op. cit.*, II, 372.

[32] According to the iconographic grouping proposed by P. Singelenberg, "The Iconography of the Etschmiadzin Diptych and the Healing of the Blind Man at Siloe," *ArtB*, 40 (1958), 108–12, the scene in St. Euthymios belongs to the type which represents Christ touching or about to touch the eyes of the blind man. The most extensive treatment of this event occurs in Paris. gr. 74, where the whole narrative is represented in a sequence of ten scenes (Omont, *Evangiles*, 159–61). This, however, is an exceptional case. In Early Christian examples Christ is usually accompanied by one or more disciples. In some instances, e.g., the Rossano Gospel, a second episode was included: the blind man washing his eyes at a fountain, observed by a group of witnesses. In later Byzantine examples both the apostles and the group of witnesses were often eliminated, e.g., in Paris. gr. 510, but in some instances the apostles were included, e.g., at Monreale. For illustrations, see Singelenberg, *op. cit.*, 7, 9, 10, 11. Both the secondary episode and the group of apostles were included in some Palaeologan churches, e.g., at Chilandari (Millet, *Athos*, pl. 73,2), and miniatures, e.g., the Gospel Book Iviron 5 (Pelekanidis et al., *Treasures of Mount Athos*, II, 51; and Xyngopoulos, Ἱστορημένα Εὐαγγέλια, 49). For the mosaic of the Kariye Djami, see Underwood, *The Kariye Djami*, II, pl. 257.

of the action from left to right in the rest of the scenes, would be inclined to continue its movement. The reversal provides a conclusive end.

Clearly the Ministry Cycle in St. Euthymios was carefully planned. All the events are bound by symbolic themes which recur in several variants throughout the cycle and are introduced in the opening scene through the passage from Isaiah read by Christ in the Synagogue. The narrative or chronological sequence of events was completely disregarded in favor of symbolic unity. If, as I have suggested above, Christ Reading in the Synagogue (fig. 5) was based on the Gospel of Luke (4:16–30) and The Expulsion of the Merchants from the Temple (fig. 12) was based on the Gospel of John (2:12–22), then the cycle is derived primarily from John (five scenes) with the addition of three events from Luke (see Chart, *infra*). The events derived from Luke are of a highly symbolic nature, and are completely consonant in meaning with the more symbolic character of the fourth Gospel.

Millet has observed that the miracles performed by Christ in Judea (treated in much greater detail by Luke) were mainly incidents in the conflict between Christ and the Pharisees.[33] Through these miracles it was Christ's intention to manifest Himself as equal with His Father, as, for example, in The Healing of the Man with Dropsy and of the Woman with the Curved Back. These narratives, of a primarily symbolic nature, belong with the two complementary miracles from John, The Healing of the Paralytic at Bethesda and of the Blind Born. The four also form the group of Sabbath miracles which, as theologians emphasized, roused the anger of the Jews.[34] Regardless whether the selection and grouping of events in Ministry Cycles was based on chronological (i.e., early vs. late) or geographical grounds (Galilee vs. Judea or Jerusalem), the late miracles, performed mainly in Judea and Jerusalem, are those in which Christ openly confronted the Pharisees, proclaimed the divine origin of His powers, and called Himself the Son of God.[35] To this group belong the five miracles on the north spandrels which parallel and complete in meaning the three teaching scenes on the south.

But the scenes in the Ministry Cycle of St. Euthymios are also related in terms of Byzantine ritual, for they roughly follow a sequence of lections read between Easter and Pentecost, except that the lesson for Mid-Pentecost (Wednesday of the fourth week after Easter) is placed at the beginning—out of turn—and the miracle from Luke is interpolated among the lessons from John read on the three middle Sundays.[36] The following chart clarifies these relationships.

[33] Millet, *Recherches*, 62–63.

[34] *Ibid.*, 65. The same sequence of events as in the five scenes on the north spandrels in St. Euthymios occurs in the north aisle of the Metropolis at Mistra.

[35] Millet, *ibid.*, 62–63, emphasizes the geographical division, whereas Underwood, "Some Problems," 252–54, stresses the chronological difference. Basically, both authors make much the same point about the meaning and intention of the selection.

[36] For the sequence of lections between Easter and Pentecost, see any modern Greek edition of the *Pentekostarion*. See also E. C. Colwell and D. W. Riddle, eds., *Prolegomena to the Study of the Lectionary Text of the Gospels*, Studies in the Lectionary Text of the Greek New Testament, I (Chicago, 1933), 87f. For The Citation of Christ in the Synagogue as the first lesson of the calendar year, see also Weitzmann, *Illustrations* (*supra*, note 13), 180; for its citation as the lesson for the Mid-Pentecost, see Millet,

Christ Reading in the Synagogue (Galilee, Nazareth)	Luke 4:16–30 (also briefly Matt. 13:53–58, and Mark 6:1–6)	First lesson of the calendar year (September 1) cited by one manual as the lesson for the Mid-Pentecost (Sabbath)
Christ Teaching in the Temple (Judea, Jerusalem)	John 7:14–31	Mid-Pentecost (Wednesday of the fourth week)—Sabbath
The Expulsion of the Merchants (Jerusalem)	John 2:12–22 (also in the Synoptic Gospels)	Friday of the first week
The Wedding at Cana (?) (Galilee)	John 2:1–11	Monday of the second week
The Healing of the Man with Dropsy (on way to Jerusalem)	Luke 14:1–6	_____ (Sabbath Miracle)
The Healing of the Paralytic at Bethesda (Jerusalem)	John 5:1–15	Fourth Sunday (Sabbath Miracle)
The Healing of the Woman with the Curved Back (on way to Jerusalem)	Luke 13:10–17	_____ (Sabbath Miracle)
Christ and the Samaritan Woman (on way to Galilee, in Samaria)	John 4:5–42	Fifth Sunday
The Healing of the Blind Born (Jerusalem)	John 9:1–38	Sixth Sunday (Sabbath Miracle)

Among these scenes the group that stands out as a liturgical unit are the Sundays of the Paralytic, the Samaritan, and the Blind Born. Clearly these three events were arranged in a liturgical sequence, for Christ's encounter with the Samaritan Woman is placed after The Healing of the Paralytic (figs. 21, 16) even though it occurs earlier in the Gospel account.[37] There

Recherches, 35; and Dionysios of Fourna, Ἑρμηνεία (*supra*, note 9), 278. For the Wedding at Cana, see also Millet, *Recherches*, 35; and Jerphanion, *Les Eglises rupestres* (*supra*, note 16), Text vol. I,2, pp. 337–38, Plate vol. II, pl. 77,3.

[37] The liturgical relation of the three events from John (Paralytic, Samaritan, Blind Born) has been discussed by Underwood, "Some Problems," 258–61; and Millet, *Recherches*, 33–39. In the Kariye Djami, where the three are grouped together, the sequence is that of the Gospel (i.e., Samaritan, Paralytic, Blind Born). At Monreale the Paralytic and Blind Born are together in the upper zone of the west wall of the southern transept and the Samaritan follows in the second register of the east end ot the south wall; see W. Krönig, *Il Duomo di Monreale e l'architettura normanna in Sicilia* (Palermo, 1965), pls. 37, 46; and Kitzinger, *op. cit.* (*supra*, note 5), pl. XIII. In the Gospel Book Iviron 5, only these three events are illustrated between the fourth and tenth chapters of John's Gospel: Samaritan (fol. 371), Paralytic (fol. 377), Blind Born (fol. 405); cf. Xyngopoulos, Ἱστορημένα Εὐαγγέλια, 47–49. Millet, *Recherches*, 8–9, cites this manuscript as one in which the illustrations are chosen because of their liturgical symbolism. Here also, however, the sequence is chronological in accordance with Gospel narrative. The three miracles are illustrated in a liturgical sequence in Byzantine lectionaries, as, for example, in the marginal illuminations of a twelfth-century Constantinopolitan lectionary in the Pierpont Morgan Library (M 692), correlated with the text of the lessons from John, between fols. 22ᵛ and 38ʳ. Not only are the four Sundays illustrated, but the scene of Christ Reading in the Temple (Mid-Pentecost) is inserted between the Fourth and Fifth Sundays. The sequence of the scenes in this manuscript is as follows: The Healing of the Paralytic at Bethesda (Fourth Sunday), fol. 22ᵛ,

is, however, a second important reason for grouping together these three miracles from John: their association with the Sacrament of Baptism, which goes back to the earliest years of Christianity.[38] That this meaning was clearly understood by the persons responsible for the arrangement of the cycle in St. Euthymios is evident in the representation of the cruciform well in the scene of the Samaritan Woman (fig. 21), which is an exact replica of the font in a scene of baptism (fig. 27) from the life of St. Euthymios in the north aisle of the parekklesion.

The sacramental emphasis in the Ministry Cycle in St. Euthymios and its stress on illumination of the human being through baptism and on the healing of the whole of man's body on the Sabbath is consonant with contemporary religious thought, especially with that of Theoleptos of Philadelphia and Athanasios I. Both men placed great emphasis on baptism, and on the urgent need for the faithful to participate in the life of the Church through the sacraments. Athanasios went so far as to urge the emperor to force the people to go to church by imperial decree. Both Theoleptos and Athanasios were distressed at the laxity of Christians, who did not go to church, did not partake of the Body and Blood of Christ, and many of whose children died without baptism.[39]

However, the thought of Theoleptos provides an even more direct and striking parallel to the content and organization of the Ministry Cycle in St. Euthymios, for he wrote a homily on each of the three Sundays between Easter and Pentecost (of the Paralytic, the Samaritan, and the Blind Born). These homilies have been grouped together in a liturgical sequence in the Codex Ottobonianus (gr. 405) in the Vatican, a manuscript compiled during the fourteenth century, probably during the lifetime of Theoleptos.[40] It is clear that Theoleptos intended the three homilies to be

near the text of John 5:5–6; Christ Teaching in the Temple (Mid-Pentecost), fol. 25ᵛ, near John 7:14; Christ and the Samaritan Woman (Fifth Sunday), fol. 29ᵛ, near John 4:5; The Healing of the Blind Born (Sixth Sunday), fol. 38ʳ, near John 9:1. I am engaged in a study of the very important marginal illuminations of this manuscript, which have not as yet been thoroughly examined. For the most complete recent discussion, see G. Vikan, ed., *Illuminated Greek Manuscripts from American Collections: An Exhibition in Honor of Kurt Weitzmann* (Princeton, 1973), 134–35.

[38] See Underwood, "Some Problems," 258–61, for the history of the baptismal association of these scenes and further bibliography. The Paralytic and the Samaritan were included in the third-century Christian baptistery at Dura Europos (cf. Kraeling, *op. cit.* [*supra*, note 27], 177–203), and according to some scholars all three miracles were included in the late fourth-century decoration of the octagonal dome of S. Giovanni in Fonte at Naples; see J.-L. Maier, *Le Baptistère de Naples et ses mosaïques. Etude historique et iconographique* (Fribourg, 1964), 57. On the intentional parallelism between events in the life of Christ and certain sacramental, liturgical feasts in the fourth Gospel, see O. Cullmann, *Urchristentum und Gottesdienst* (Zurich-Stuttgart, 1962); and Underwood, "Some Problems," 260.

[39] Salaville, *op. cit.* (*supra*, note 11), 121–22, 124; and V. Laurent, *Les Regestes des actes du Patriarcat de Constantinople.* I, *Les Actes des Patriarches*, fasc. IV, *Les Regestes de 1208 à 1309* (Paris, 1971), 460–61, 517–18.

[40] The Codex Ottobonianus, gr. 405, in the Vatican contains the best collection of the writings of Theoleptos of Philadelphia. It is unfortunate that this important collection remains as yet unpublished. The homilies on the three Sundays after Easter are at the end of the manuscript (the Paralytic: fols. 174ᵛ–183ʳ; the Samaritan: fols. 183ʳ–188ᵛ; the Blind Born: fols. 188ʳ–193ᵛ). It appears that the copyist was a woman (Irene Choumnos?) and that the manuscript was compiled during Theoleptos' lifetime. See S. Salaville, "Un directeur spirituel à Byzance au début du XIVᵉ siècle: Theolepte de Philadelphie," *Mélanges Joseph de Ghellinck*, II (Gembloux, 1951), 877–87.

arranged in a liturgical sequence, for after each title he cited the Sunday on which it was to be read. The sequence of the three homilies concludes with one devoted to the Pentecost, an arrangement that corresponds with the relationship of the three events in the Ministry Cycle in St. Euthymios to the Pentecost, placed on the same level, in the soffit of the triumphal arch (fig. 4).[41] Of the twenty-four homilies in the Codex Ottobonianus only five others are based on events from the life of Christ. One of these, among the longest homilies in the codex, deals with the "Symbolism of the Miracle of the Healing of the Woman with the Curved Back," the only event represented over the curve of an arch in St. Euthymios (fig. 16).[42] These rather striking parallels may be no more than expressions of the overriding theological concerns of the age. However, as I have pointed out elsewhere, the channels through which Theoleptos could have influenced the decoration of this prestigious chapel were many.[43]

The Ministry Cycle in St. Euthymios is impressive, both because of its conciseness and unity and because of its theological cohesion and complexity. The importance of contemporary religious thought is clearly evident in the sacramental, baptismal, and eucharistic emphasis, and is in agreement with the emphasis placed on sacramental realism by Theoleptos and Athanasios, who, as Meyendorff has shown, in their religious and monastic ideals emerge as the leaders of the Hesychast movement of ca. 1300.[44] Theoleptos not only stressed participation in the Church through baptism and the Eucharist, but also drew an analogy between the religious profession and baptism; a similar parallel was drawn by Athanasios in one of his letters. According to both men, the religious profession reinforced through a life of voluntary penitence the union with Christ contracted by the sacrament.[45]

Seen in this light, the life of St. Euthymios in the parekklesion becomes doubly meaningful, for it not only illustrates this "union with Christ" but also provides a parallel to the Ministry of Christ. As Christ healed, purified, enlightened, and baptized, so did St. Euthymios. And even though the textual accounts of the Saint's life are largely devoted to his monastic life, his search for *hesychia* (spiritual rest and silence), his founding of lavrae, and his teaching, the frescoes emphasize the worldly and sacramental aspects of his life as presbyter, healer, and converter.[46] It is no accident, I believe, that the major

[41] Codex Ottobonianus, fols. 194ʳ–196ᵛ. This is the last homily in the collection and is unfinished.

[42] The homily on the miracle of "The Healing of the Woman with the Curved Back" runs from fols. 67ᵛ to 79ʳ. The other christological homilies in this collection are: "On the Feast of the Transfiguration" (fols. 80ʳ–83ʳ), "On the Nativity of Christ and Religious Life" (fols. 137ʳ–141ʳ), "Easter Sunday and the Death of Brother Leo" (fols. 168ʳ–170ʳ), and "Sunday of the Myrophores: on Joseph of Aremathea" (fols. 170ʳ–174ʳ).

[43] See Gouma-Peterson, "The *Parecclesion*," 181–82.

[44] J. Meyendorff, "Spiritual Trends in Byzantium in the Late Thirteenth and Early Fourteenth Centuries," in *Art et société à Byzance sous les Paléologues* (Venice, 1971), 62; repr. in *The Kariye Djami*, IV, 95–106.

[45] S. Salaville, "Formes ou méthodes de prière d'après un byzantin du XIVᵉ siècle, Théolepte de Philadelphie," *EO*, 39 (1940), 1–25; Laurent, *op. cit.*, 454, 515, 518–19.

[46] For a more detailed discussion of the Life of St. Euthymios and its textual sources, see Gouma-Peterson, "The *Parecclesion*," 173–78.

acts performed by St. Euthymios in the seven scenes on the north wall parallel acts performed by Christ in the miracles on the north spandrels: The Healing of Terevon (fig. 27), the paralytic child of Aspebetos, the Greek leader of the Saracens in the desert area of Koutila in Palestine, with The Healing of the Paralytic at Bethesda (fig. 16); The Baptism of Aspebetos and The Conversion of the Saracens (fig. 27) with Christ's Meeting with the Samaritan Woman (the baptismal font of the former scene and the well of the latter are identical) and the conversion of the inhabitants of Sychar (fig. 21); The Healing of the Demoniac (fig. 28) with Christ's Healing of the Blind Born (fig. 24). Though the latter two scenes are not of the same subject, they both show acts of purification and deliverance from darkness. This parallelism was stressed by the sequential and spatial correspondence of the scenes (fig. 6). Clearly the life of St. Euthymios, and through it the vocation of the priest, was shown as an extension of the Ministry of Christ, and became a pictorial illustration of the words of Theoleptos: "it was Christ the first teacher who sent the human apostle; the grace of his pastoral mission he [the human apostle] received it from Christ who told His disciples: 'Go and teach all the nations'" (Matt. 28:19). Further on in this passage Theoleptos urged the faithful to unite themselves with God through His intermediary, the priest.[47]

Meyendorff has observed that Theoleptos in many ways "appears as the precursor of the sacramental realism and mysticism of Palamas and Nicholas Cabasilas, which are based upon the belief that God is present in the church neither symbolically nor subjectively, but in all reality, and that Christian spirituality, like every other Christian religious act, must reflect this objective Presence."[48] Palamas himself informs us that the Hesychast tradition was transmitted to him personally by Theoleptos and Athanasios.[49] Central to the stand taken by Palamas against the Calabrian monk Barlaam is the belief that man is one living and indivisible unity, that supernatural grace was "granted to the whole man and not to the mind only," and that the senses, "transformed by grace, also participate in the supreme drama for which man was created, that is union with God."[50] This is one of the central themes in the Ministry Cycle of St. Euthymios, and is raised in the second scene in the words spoken by Christ in the Temple (John 7:21–24): "...why are you indignant with me for giving health on the Sabbath to the whole of man's body?" It is also the central theme of the four Homilies of the Codex Ottobonianus, in which Theoleptos repeatedly stresses the unity of soul and body and the release and illumination of the whole human being, senses and intellect (διάνοια), body and soul, through Christ, the source of Divine Light.[51]

In these Homilies Theoleptos continuously anticipates the views of Gregory Palamas. It is clear that he, as Palamas, regarded man "as one living and

[47] Salaville, "Deux documents" (*supra*, note 11), 125.
[48] Meyendorff, "Spiritual Trends," 59.
[49] *Ibid.*, 58.
[50] Meyendorff, *Palamas* (*supra*, note 11), 171.
[51] I wish to thank Professor James Helm of Oberlin College for his help with the textual analysis of Theoleptos' Homilies in the Codex Ottobonianus.

indivisible unity." He constantly emphasizes the cause and effect relationship in the way sinfulness and grace affect the body and the soul. In his Homily on the Woman with the Curved Back (fols. 67ᵛ–79ʳ) he observes that the soul of the woman was bent toward the pleasures of the flesh and as a result the body, contrary to its upright shape, bent toward the earth. Her body suffered the same as her soul so that, from the apparent infirmity of the body, the soul might perceive the true nature of its illness. In healing the woman Christ was unconcerned about the criticism of the Pharisees, for he was looking toward the true Sabbath. He came to release the human being from the double bond of the senses and the intellect (διάνοια). He made salvation possible through a sacrifice of praise; in other words, through the sacrifice of the pleasures of the flesh and through the continuous prayer of the mind. Theoleptos clearly is referring to the "monological prayer" or prayer of the mind (νοερά προσευχή) so important to fourteenth-century Hesychasts.[52] He stresses that fulfillment of the Divine wishes is achieved through the constant presence of Divine hymns in one's mouth and through the completion of the prayer of the mind. In the Homily on the Blind Born (fols. 188ʳ–193ᵛ) he observes that Christ healed the eyes of the blind man as He opens the eyes of one's soul to the knowledge of His remarkable power. The renewal of sight to the eyes of the body also became the renewal of the eyes of the soul. The blind man, because of his physical blindness, could not see the physical light and, because of the disability of his soul, was ignorant of the Divine Light. He parallels the physical sun with the sun of righteousness, and the Son of God who opened the eyes of man's body and gave light to the eyes of his soul. He considered man worthy of knowing the divinity of Him who healed him. Palamas carried these beliefs one step further. In his view the intelligence and senses transformed by Grace participate in the union with God.[53]

This state of total illumination and union with God is illustrated in one of the most significant and unusual scenes in the life of St. Euthymios; the Saint is shown miraculously Enveloped by a Heavenly Fire (fig. 26) while reading the prayer which was recited at the beginning of the Great Entrance in a low voice by the priest during the hymn of the Cherubicon. The scene shows that St. Euthymios, while performing the monological prayer, has reached the level of *hesychia* which allows him direct communion with God. As a result of this communion, he is being transformed by the power of the spirit and as a whole man shares in the divine light.[54] His state of being is the ultimate fulfillment of Christ's intention in the events of the Ministry Cycle. It is also a perfect pictorial illustration of the views of Theoleptos and Athanasios I on the role of the priest as an extension of Christ, and on the parallel between the religious profession and baptism. Finally, the scene illustrates the concept of deification formulated by Palamas thirty years later

[52] Meyendorff, "Spiritual Trends," 57; Gouma-Peterson, "The *Parecclesion*," 181.

[53] Meyendorff, *Palamas*, 175, and 176–84 for a further discussion of Palamas' views on the relation of Christ and deified humanity.

[54] For a more detailed discussion of the meaning of this scene in relation to Theoleptos' definition of prayer, see Gouma-Peterson, "The *Parecclesion*," 180–81.

and provides the perfect rebuttal to the views of Barlaam.[55] This correspondence between the cycles in the parekklesion and contemporary and subsequent Hesychast thought clearly indicates a product of the same milieu, dominated by the late thirteenth-century monastic revival which was seen by many as the most hopeful sign for the survival of the Empire.[56]

In conclusion, the carefully thought out Ministry Cycle in the parekklesion, its close correlation with the life of St. Euthymios, the parallel of Christ and the presbyter Euthymios as ministrants, and the emphasis in both cycles on the sacramental reality of the Church express the beliefs of the most influential prelates of the first two decades of the reign of Andronikos II. This suggests that they, or their representative, played an active role in formulating the concise and subtle iconographic program of this chapel. St. Euthymios is, I believe, only one instance of the widespread influence of clerics, in the role of theological advisers, on the formulation of the varied and complex programs of Palaeologan monumental painting.

[55] Meyendorff, *Palamas*, 169.

[56] *Idem*, "Spiritual Trends," 56; and *idem*, "Society and Culture in the Fourteenth Century. Religious Problems," *XIVᵉ Congrès International des Etudes Byzantines, Rapports*, I (Bucharest, 1971), 51–56. See also A. E. Laiou, *Constantinople and the Latins. The Foreign Policy of Andronicus II, 1282–1328* (Cambridge, Mass., 1972), 32–39. For the relationship of Michael Glavas and his wife Maria with this monastic milieu, see Gouma-Peterson, "The *Parecclesion*," 182 and notes 75–76.

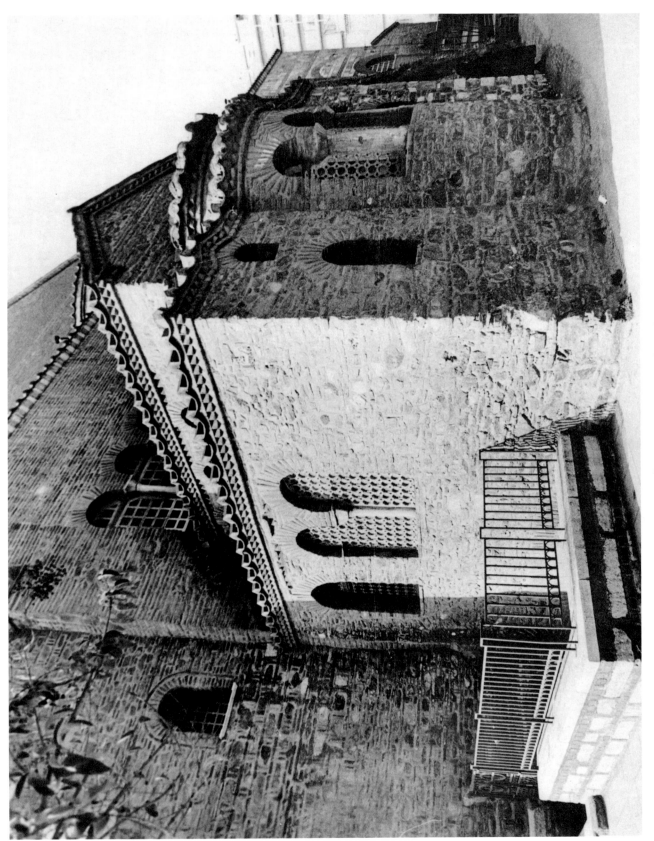

1. Thessalonica, St. Euthymios, View from Southeast

3. Section

2. Plan

Thessalonica, St. Euthymios

4. Thessalonica, St. Euthymios, Nave

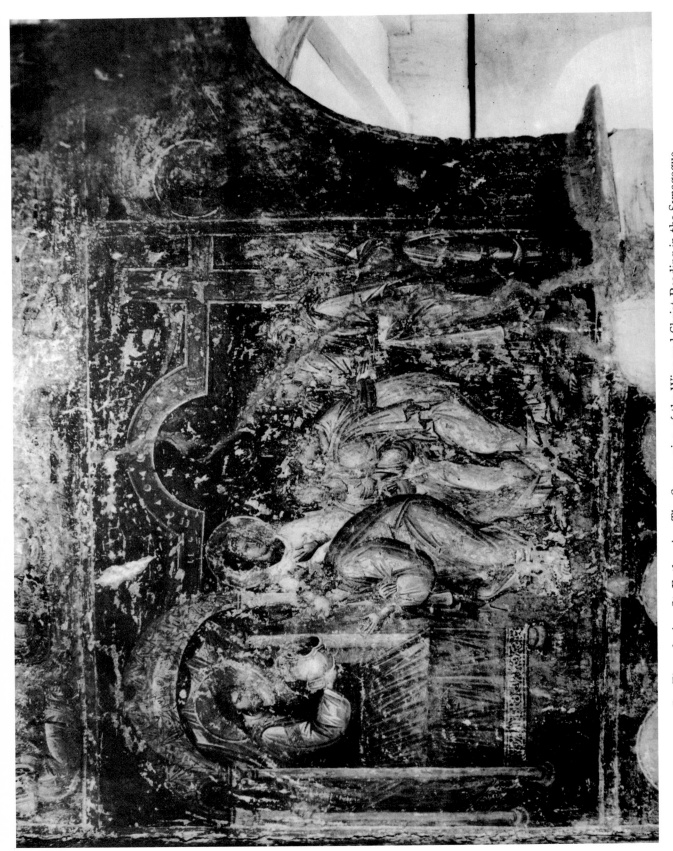

5. Thessalonica, St. Euthymios. The Communion of the Wine and Christ Reading in the Synagogue

7. Ohrid, St. Clement. Christ Reading in the Synagogue

6. Thessalonica, St. Euthymios, North Aisle

8. Thessalonica, St. Euthymios. Christ Teaching in the Temple

10. Ohrid, St. Clement

9. Near Čučer, St. Nikita

Christ Teaching in the Temple

11. Mount Athos, Protaton. The Ministry of Christ

12. Thessalonica, St. Euthymios. The Expulsion of the Merchants from the Temple

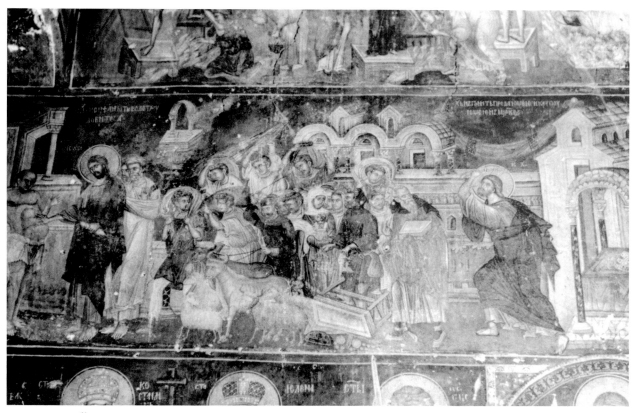

13. Near Čučer, St. Nikita. The Expulsion of the Merchants from the Temple and The Healing of the Man with Dropsy

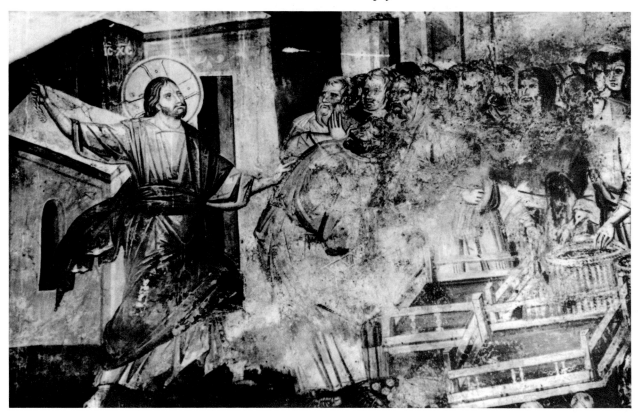

14. Ohrid, St. Clement. The Expulsion of the Merchants from the Temple

15. Thessalonica, St. Euthymios. The Healing of the Man with Dropsy

16. Thessalonica, St. Euthymios. The Healing of the Paralytic and The Healing of the Woman with the Curved Back

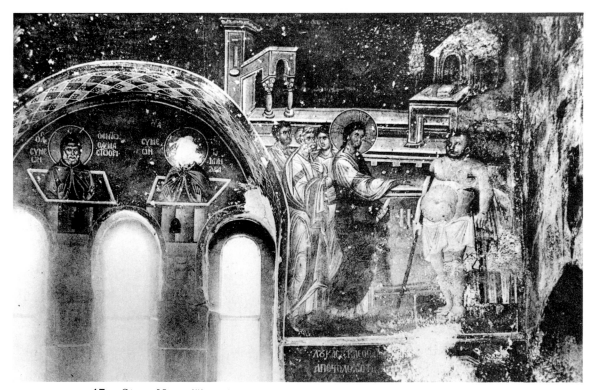

17. Staro Nagoričino, St. George. The Healing of the Man with Dropsy

18. Thessalonica, St. Catherine. The Healing of the Paralytic

19. The Healing of the Paralytic

20. The Healing of the Woman with the Curved Back
Near Čučer, St. Nikita

21. Thessalonica, St. Euthymios. Christ and the Samaritan Woman

23. Mount Athos, Protaton

22. Ohrid, St. Clement

Christ and the Samaritan Woman

24. Thessalonica, St. Euthymios. The Healing of the Blind Born and The Communion of the Bread

26. Thessalonica, St. Euthymios. The Descent of the Heavenly Fire

25. Thessalonica, St. Catherine. The Healing of the Blind Man

27. Thessalonica, St. Euthymios. The Healing of Terevon and The Baptism of Aspebetos

28. Thessalonica, St. Euthymios. The Healing of the Demoniac and The Dormition of St. Euthymios

ON THE TREATY OF 927 WITH THE BULGARIANS

Ivan Dujčev

INTRODUCTION

Codex 483 (*olim* 323) in the collection of Greek manuscripts in the Vatican Library,[1] consisting of one hundred and ninety-two sheets of paper and written during the late thirteenth or early fourteenth century, at first seems to contain only well-known texts of classical, patristic, and Byzantine authors. The first part of the manuscript includes one hundred thirty-five letters of Gregory of Nazianz, with six letters of Basil of Caesarea intercalated among them. Following this first group of letters comes another series of forty-four letters which are attributed to various philosophers: thirty-four letters of the cynic philosopher Crates,[2] one letter of Socrates to Plato, one letter of Aristotle to Theophrastus, one letter of Menippus of Gadara (in Coele-Syria), and letters of Heraclitus and the Scythian Anacharsis. The work of the rhetor Tiberius, *De schematibus*, fills eight sheets. This is followed by eight anonymous letters (*epistolae anonymae octo* [folios 58v–63]) on philosophy, etymology, and exegesis. On folios 64–103 we find the writings of the Byzantine author Nicephorus Blemmydes, *De anima* and *De corpore*. Next comes a large extract of the *Chronographia compendiaria* by the Byzantine chronicler Ioel. The manuscript ends with a collection of proverbs,[3] the commentary of Themistius (Sophonias), *In Aristotelis Parva naturalia*, two fragments of letters of Isidore of Pelusium, and finally some notes of minor importance.

On folios 43–51, after the letters attributed to Anacharsis, we find the only extant copy of an important Byzantine text, under the title ἐπὶ τῇ τῶν Βουλγάρων συμβάσει (*On the treaty with the Bulgarians*), which Monsignor Robert Devreesse[4] interpreted *nempe, ut videtur, sermo de pace quam anno 927 composuerunt Bulgari et Graeci*. This text attracted attention several centuries ago. Probably in the fifteenth century an unknown scribe added (fol. 1v) a note indicating the principal contents of the manuscript: *Ep(isto)le Gregorij Nazianzeni et quorunda(m) alior(um). Tractatus de Conuentione Bulgar or(um). Tyber(ii) de figuris rhetoricis*.[5] In spite of this explicit reference, however, philologists and specialists on medieval and Byzantine history disregarded the anonymous text for some time.

During Napoleon's occupation of Italy this manuscript, together with other manuscripts and antiquities of the Vatican, was transferred to Paris and for a number of years was part of the manuscript collection of the Bibliothèque Nationale. Thus, as Monsignor Devreesse observes, *f. 1 et 182 imis sigillum*

[1] Description of the MS: R. Devreesse, *Codices Vaticani graeci*. II. *Codices 330–603* (Vatican City, 1937), 290–93.

[2] Ed. F. Boissonade, "Notice des lettres de Cratès le Cynique contenues dans le manuscrit 483 du Vatican," *Notices et extraits des manuscrits de la Bibliothèque du Roi et autres bibliothèques*, XI (Paris, 1827), pt. 2, 16–46; other bibliographical references in Devreesse, *op. cit.*, 491.

[3] Devreesse, *op. cit.*, 292ff.

[4] *Ibid.*, 291.

[5] *Ibid.*, 293.

bibliothecae Nationalis Parisiensis rubrum, Vaticanae nigrum. It was probably
at this time that our manuscript came into the hands of the well-known French
Hellenist of German origin Carl Benedict Hase (1780–1864).[6] In Hase's papers,
which are preserved in the Bibliothèque Nationale as Suppl. grec 810, there is a
long note, on folio 33, which refers specifically to the anonymous text in the MS:
*Sequitur declamatio in pacem cum Bulgaris factam folio 43 recto. Titulus rubri-
catus, . . . quorsum pertineat haec oratio nondum invenire potuimus; certe non
extat inter scripta cognita Theophylacti Bulgarorum Archiepiscopi, de quo primum
cogitabamus. Commemoratur in hac declamatione rex Bulgarorum Simeon filius-
que nomine Petrus, quod decimum saeculum prodere videtur, quo post atrox
bellum cum Romanis Petrus rex Bulgarorum Simeonis filius pace facta d. VIII
octobr(is) a(nno) 928 Mariam Romani Lecapeni Augusti neptin uxorem duxit.
Vide Ducangium in Familiis Byzantinis 1680, fol. 313.*[7] Two explanatory notes,
one in Greek and one in Latin, were probably added by Hase.[8]

In the margin of the text concerning the conclusion of the peace treaty
between Byzantium and Bulgaria several notes in Greek are added, suggesting
the identification of the historical personalities referred to indirectly in the
text.

From Hase's note cited above, it is evident that our text seemed of interest
to him. He identified correctly the historical events to which the text relates,
i.e., the peace between the Bulgarians and the Byzantine Empire in 927
(erroneously given as 928!),[9] and the principal historical personalities involved.
As for the author of the text, Hase's first hypothesis was that it was the work
of Theophylact, Archbishop of Bulgaria. This hypothesis, however, is unac-
ceptable on account of the chronological discrepancy: Theophylact, head of
the Bulgarian Church between 1090 and 1107–8,[10] lived at Ohrid more than a

[6] A wealth of biographical and bibliographical indications on C. B. Hase is to be found in the studies
of I. Ševčenko, "The Date and Author of the So-Called Fragments of Toparcha Goticus," *AIEtByz,
Bulletin d'information et de coordination,* 5 (1971), 71–95, and "The Date and Author of the So-Called
Fragments of Toparcha Goticus," *DOP,* 25 (1971), 117–88, with 28 facsimiles.

[7] General description of the MS given by Hase in Cod. Suppl. grec 810, fols. 29–38ᵛ, under the indica-
tion 483; on our anonymous text, at fol. 33ʳᵛ. After the words *Titulus rubricatus,* come the Greek title,
the *incipit,* and the *desinit* of the text: title—ἐπὶ τῇ τῶν βουλγάρων συμβάσει; *incipit*—fol. 43, Εἰρήνην
ὑμνοῦμεν· εὐφράνθητε; *desinit*—fol. 51, ἐπὶ σοὶ καὶ ἡμῖν ἀθάνατον καὶ αἰώνιον. In the original redaction
of this note Hase introduced some additional corrections; thus, after *Archiepiscopi* he added *de
quo primum cogitabamus;* instead of *Meminit auctor regis,* he added *Commemoratur /.../ in
hac declamatione rex,* and other insignificant corrections. Th. I. Uspenskij, "Neizdannoe cerkovnoe
slovo o bolgarsko-vizantijskih otnošenijah v pervoj polovině X věka," *Letopis istoriko-filologičeskago
obščestva pri Imperatorskom Novorossijskom Universitete,* IV (Odessa, 1894) (hereafter Uspenskij,
"Neizdannoe cerkovnoe slovo"), 51 ff., reproduced this note of Hase, but incompletely and incorrectly.

[8] Cf. Uspenskij, "Neizdannoe cerkovnoe slovo," 51 ff. In Cod. Suppl. gr. 810, fol. 26, at the beginning
of his description of the MS, Hase gives the following indication: *483. Codex bombycinus, in 8. foliis
185 constans, in catalogo Romano No. 238* [Rasura]. *Index graecus recenti manu in foliis aliquot charta-
ceis. . . .* On the MS containing the notes of C. B. Hase, see H. Omont. *Inventaire sommaire des
manuscrits grecs de la Bibliothèque Nationale et des autres bibliothèques de Paris et des Départements,* III
(Paris, 1888), 313.

[9] For the exact chronology, see V. N. Zlatarski, *Istorija na bŭlgarskata dŭržava prěz srědnitě věkove.*
I,2. *Pŭrvo bŭlgarsko carstvo* (Sofia, 1927) (hereafter Zlatarski, *Istorija*), 518 ff. Cf. F. Dölger, *Regesten
der Kaiserurkunden des oströmischen Reiches von 565–1453. I. Regesten von 565–1025* (Munich-Berlin,
1924), 75, no. 612: "927 vor Okt. 8."

[10] Biographical and bibliographical references in G. Moravcsik, *Byzantinoturcica. I. Die Byzanti-
nischen Quellen der Geschichte der Türkvölker,* 2nd ed. (Berlin, 1958) (hereafter Moravcsik, *Byzan-*

century and a half later and cannot, therefore, be the author of the sermon delivered on events that took place at the end of 927. Hase was in error about the dates of Theophylact's life, which he put at the end of the tenth instead of the eleventh century. Thus, Hase was mistaken in identifying the author of this sermon with the Archbishop of Ohrid.[11] Nevertheless, Hase deserves credit, first of all, for ascertaining the historical importance of our text and, secondly, for proposing a precise and accurate chronology for the historical events with which our text is concerned.

While traveling in 1877 through Italy in search of sources on medieval Bulgarian history, the thirty-two-year-old Russian Byzantinist Th. I. Uspenskij (1845–1928) discovered the Vatican manuscript containing the text of the sermon.[12] This enigmatic document interested him greatly. Seventeen years later, in 1894, he published it.[13] His study remains, up to the present day, the fundamental work on this text.

This study consists of a brief introduction followed by the Greek text, a Russian translation with notes, and a general analysis of the sermon as a historical source. It will be of some interest to recapitulate this work. Uspenskij supposes that the sermon was delivered in Constantinople in the church of Hagia Sophia,[14] but the manuscript containing it must be dated at a period "not before the fourteenth century."[15] He then quotes the description of the MS: *Cod. Vatic. 483, in 8⁰ seu 4⁰ min., saec. XIV exeuntis, compendiis scripturae refertus, minutissima quidem at nitidissima littera scriptus. Folia complectitur 185, praeter folia praevia septem. Videtur bombycinus, at revera chartaceus est, ut ex pluribus foliis patet.* After giving the contents of the codex, he turns his attention to the only anonymous text in it which begins on folio 43. According to him, the author's name was lacking already in the fourteenth century, when the manuscript was compiled, and the sermon had no title, either then or for several centuries afterward, as is proved by the fact that in the Latin index of the MS it is still included among the letters of the philosopher Anacharsis.[16] On the other hand, this Latin index, which precedes chronologically the Greek one, could only be dated, according to Uspenskij, to the end of the eighteenth or the beginning of the nineteenth century. The title under which the text is known today is found for the first time in the Greek index.

As we have said above, in the margin of the text some unknown person added explanatory notes identifying the historical personages mentioned in

tinoturcica), 537–39; H.-G. Beck, *Kirche und theologische Literatur im byzantinischen Reich* (Munich, 1959), 649 ff., *passim*; P. Gautier, "L'épiscopat de Théophylacte Héphaistos archevêque de Bulgarie," *REB*, 21 (1963), 159–78; S. Maslev, "Les lettres de Théophylacte de Bulgarie à Nicéphore Mélissènos," *REB*, 30 (1972), 179–86.

[11] Cf. Uspenskij, "Neizdannoe cerkovnoe slovo," 52.
[12] Cf. Th. I. Uspenskij, *Vizantijskij pisatel' Nikita Akominat iz Han* (Saint Petersburg, 1874). Cf. also *idem, Obrazovanie vtorogo Bolgarskogo carstva* (Odessa, 1879).
[13] Uspenskij, "Neizdannoe cerkovnoe slovo," 48–123.
[14] *Ibid.*, 48.
[15] *Ibid.*, 48–49.
[16] *Ibid.*, 49. Cf. Devreesse, *op. cit.* (*supra*, note 1), 291.

it. These marginal notes and the Greek index seem to Uspenskij to have been written by the same hand; but he is ready to admit that they could have been made by Hase.[17]

The historical analysis and the interpretation of the sermon, as Uspenskij himself recognizes, are fraught with many difficulties.[18] To start with, he is inclined to interpret the sermon as a document concerning the history of the relations between Byzantium and the "Russians" either at the beginning or at the end of the tenth century. He supposes the author of the sermon to be an anonymous ecclesiastical orator, a member of the clergy at Constantinople proficient in the art of ecclesiastical rhetoric. By means of his rhetorical skill, evident in the literary quotations and allusions, the anonymous author presented historical facts in such a way that what was comprehensible for the people of his own time, who were contemporary with the events, is for us today an enigma. Here we find allusions to historical events of an entire century, presented not directly but rather conveyed by means of biblical and mythological references. Uspenskij compares the study of this text, with its rhetorical imagery and abstract contents, to the partaking of a luxurious feast, where, however, it is possible to pick up only a few crumbs. It is to be regretted, he declares, that the work is anonymous. Nevertheless he considers it opportune to publish the text of the sermon for several reasons. In the first place, the sermon gives a general survey of the relations between Byzantium and Bulgaria from the middle of the ninth to the middle of the tenth century, and this, moreover, from a special point of view, which is not usually found in the works of Byzantine annalists and historians. Secondly, because the anonymous author of the sermon possessed a very extensive literary knowledge, he quoted freely from the writings of profane and ecclesiastical authors, from mythological reminiscences, popular sayings, and diverse passages of the apocryphal literature; without him most of these quotations would have been lost irrevocably. Uspenskij points out that this kind of literature enables us to gain insight into the cultural level of this period. In the third place, the new Byzantine text throws light on Byzantine-Bulgarian relations at a time about which we possess rather limited information. Uspenskij reminds the reader that the text is preserved in only one copy containing lacunae and evident errors. In addition, he attempts to identify the numerous quotations from ecclesiastical, secular, and popular literature.

Uspenskij's introduction is followed by the edition of the Greek text based on the only extant copy, the Vatican MS. Uspenskij proposes several emendations of the text, always with reference to the *lectio* in the MS. He divides the text into paragraphs and adds a generally exact and clear Russian translation. Yet, as it will be seen, it is possible to make some corrections in the Greek text including new readings of single words or phrases and more plausible conjectures concerning certain passages, and also to identify certain quotations and allusions. Moreover, since Uspenskij's publication appeared

[17] Uspenskij, "Neizdannoe cerkovnoe slovo," 50 ff.
[18] *Ibid.*, 94 ff.

eighty-four years ago and was never reprinted, a new edition of this important historical text seems justified. It is also possible to amplify and to make essential emendations to Uspenskij's analysis and historical commentary.[19] His statements concerning the chronology of the sermon are basically correct: the sermon deals with the historical events of A.D. 927; namely, the end of the long war between Bulgaria and Byzantium and the conclusion of the treaty of peace in October 927. He rightly points out the desire of the anonymous author to take the opportunity, in presenting these occurrences, to expound the more general problem of the evils of war and the advantages of peace which permitted him to embrace in his sermon a chronologically wider range of happenings. His work actually informs us, by means of allusions and, to a lesser extent, directly, about many historical events that occurred after the middle of the ninth century; namely, those which followed the conversion of the Bulgarians to Christianity. The anonymous author never intended to speak as a historian; therefore he was not interested in presenting concrete historical facts. He spoke as an orator: a refined turn of phrase was far more important to him than factual content. On this premise, his work must be understood more as a work of literature and rhetoric than as a purely historical source.

In his commentary[20] Uspenskij analyzes both historical fact and rhetorical form in the sermon. He points out that the sermon consists of four different parts: a eulogy of the present time, i.e., a glorification of the peace between Byzantium and the Bulgarians; a chronicle of the past as an introduction and explanation of the circumstances leading to the present; the exposition of the immediately preceding events; and, finally, a prophecy on the future relations between Byzantium and the Bulgarians. According to Uspenskij's division of the text, paragraphs **5** to **10** form the first part of the sermon, the eulogy of the peace. This part of the work is more rhetorical, containing general exclamatory expressions and meditations on the benefits of peace. In the second part (pars. **11** to **17**) the anonymous author seeks to introduce us to the events and must necessarily include more concrete historical detail; for the speaker, this had been a golden age in the history of the Byzantine Empire. It is difficult to establish chronologically precise limits, but it seems probable that what the author had in mind was approximately the beginning of the reigns of the Byzantine emperor Leo VI (886–912) and of the Bulgarian prince Boris Michael (852–89), or, more exactly, the period following the official conversion of the Bulgarian people to Christianity in 865,[21] up to, and including, the Byzantine-Bulgarian conflict during the reign of King Symeon (893–927). In this second part of the sermon the anonymous author describes the historical events which occurred between 912–13 and the end of May 927— death of Symeon and beginning of the reign of his son Peter (927–69). The conclusion of the peace treaty (in October 927) constitutes the transition from

[19] *Ibid.*, 50–54, 94–123.
[20] *Ibid.*, 94 ff.
[21] *Ibid.*, 98 ff.

the second to the third part of the sermon. In the third part (pars. **18** to **20**) the orator describes the benefits of the new era—the era of peace. The fourth and last part (pars. **21** and **22**) contains admonitions on the advantages of peace and the evils of war, with advice on how to preserve peace. After this analysis of the contents, Uspenskij points out that not all sections of the sermon have identical historical importance as a source for the study of the relations between Byzantium and the Bulgarians.[22] Since the third and fourth parts are, in their contents, predominantly rhetorical, he focuses his attention on the first and second parts, which are richer in historical data.

The central idea of the sermon, as Uspenskij indicates, is in fact the peace which was the consequence of the Byzantine-Bulgarian treaty of October 927. The internal tranquillity of the Empire was only of secondary importance as compared with the establishment of peaceful relations with external adversaries.[23] The conclusion of the peace treaty with the Bulgarians was, unquestionably, a great political success for the Emperor Romanus I Lecapenus (920–44) and contributed considerably to consolidating his power.[24] A close analysis of the text of the sermon indicates that the Byzantine author was indeed concerned primarily with external enemies and, consequently, rejoiced at the conclusion of the peace with the Bulgarians. The idea of the spiritual unity between Byzantium and the Bulgarians is a reflection of the Byzantine concept of "a family of princes and peoples."[25] In accepting the Christian religion from Constantinople, the Bulgarians had become "spiritual sons" of the Byzantines, and the Bulgarian king a son of the emperor of Byzantium. These elements in the relations between Byzantium and the Bulgarians are only partially discerned by Uspenskij.

The Russian scholar then procedes to discuss Hase's hypothesis that the author of this sermon was Theophylact of Ohrid.[26] He disagrees with this conjecture, pointing out that, in the first place, no such sermon is known

[22] *Ibid.*, 97ff., 122ff.

[23] *Ibid.*, 97ff.

[24] Cf. S. Runciman, *The Emperor Romanus Lecapenus and His Reign. A Study of Tenth-Century Byzantium* (Cambridge, 1929), 71: "The Bulgarian peace of 927.... The capital was now well reconciled to Romanus's rule. He had, however, one more plot there with which to deal—one of a new significant type. He had fortified himself against the legitimate house by raising his own family; but now the members of his own family, too large to be manageable, were suffering from ambition and longing for the hegemony...."

[25] Concerning this concept, see G. Ostrogorsky, "Die byzantinische Staatenhierarchie," *SemKond*, 8 (1936), 41–61. Cf. F. Dölger, in *BZ*, 36 (1936), 495–96; *idem*, "Die 'Familie der Könige' im Mittelalter," *Festgabe f. H. v. Heckel* (= *HJ*, 60 [1940], 397–420; reprinted in *Byzanz und die europäische Staatenwelt, Ausgewählte Vorträge und Aufsätze* [Ettal, 1953], 34–69); *idem*, "Bulgarisches Zartum und byzantinisches Kaisertum," *IzvArhInst*, 9 (1935), 57–68, reprinted in *Byzanz und die europäische Staatenwelt*, 140–58; *idem*, "Die mittelalterliche 'Familie der Fürsten und Völker' und der Bulgarenherrscher," *Byzanz und die europäische Staatenwelt*, 159–182 (an abbreviated version from the *Studie Dölgers*, first published in Bulgarian translation [made by I. Dujčev] from the original German manuscript, under the title "Srednovekovnoto'semejstvo na vladetelite i narodite'i bŭlgarskijat vladetel," in *SpBAN, Klon ist.-filol.*, 66, fasc. 32 [1943], 181–222); *idem*, "Der Bulgarenherrscher als geistlicher Sohn des byzantinischen Kaisers," in *Sbornik v pamet na prof. Peter Nikov* (= *IzvIstDr*, 16–18 [1940]), 219–32, reprinted in *Byzanz und die europäische Staatenwelt*, 183–96. A. Grabar, "God and the 'Family of Princes' Presided Over by the Byzantine Emperor," *HSlSt*, 2 (1959), 117–23, reprinted in *idem, L'art de la fin de l'Antiquité et du Moyen Age*, I (Paris, 1968), 115–19.

[26] Cod. Paris. Suppl. gr. 810, fol. 26ff.; here, p. 220–21.

among the works of the Archbishop of Ohrid.[27] Moreover, both the spirit of
the work and the attitude of the author diverge from those of Theophylact
of Ohrid, a difference manifest in Theophylact's correspondence which reveals
a negative attitude toward the Bulgarians.[28] Hase's hypothesis must also be
rejected because of its chronological incongruity. Instead, Uspenskij proposes
his own hypothesis and declares that the most likely author of the sermon is
the Patriarch of Constantinople, Nicholas Mysticus (901–7, 912–25),[29] who
exchanged numerous letters with the Bulgarian Czar Symeon over a period
of more than ten years.[30] I must agree with Uspenskij when he emphasizes
the identity of ideas, literary mannerisms, and other language peculiarities
of Nicholas Mysticus with those of the author of the sermon. Yet, Uspenskij
is forced to admit the existence of "certain chronological difficulties"[31] in the
attribution of the sermon to the Patriarch. I must also agree with his statement
that the interpretation of many passages of this sermon would remain inex-
plicable without a parallel study of Nicholas Mysticus' correspondence with
Symeon of Bulgaria. It should not be forgotten, however, that these similar-
ities in ideas and literary mannerisms are traits common to the general men-
tality of the period.

Uspenskij points out that in the sermon any account of concrete facts is
absent. This lack of indisputable historical data allows for contradictory inter-
pretations, and for this reason all proposed interpretations must remain—
according to him[32]—more or less hypothetical. Seeking for an answer to the
question of the authorship, he correctly remarks that historical events, discussed

[27] Uspenskij, "Neizdannoe cerkovnoe slovo," 51 ff., 99 ff.

[28] Text of this correspondence in PG, 126, cols. 308–557; translation into Bulgarian by Metropolit
Symeon, "Pismata na Teofilakta Ohridski arhiepiskop Bŭlgarski," Sbornik na Bŭlgarskata Akademija
na naukitě, 27 (1931). Cf. I. Dujčev, in Slavia, 13.1 (1934), 124–26. Analysis of this correspondence as
historical source, in V. N. Zlatarski, Istorija na bŭlgarskata dŭržava prěz srědnitě věkove, II (Sofia, 1934),
252 ff. D. A. Xanalatos, Beiträge zur Wirtschafts- und Sozialgeschichte Makedoniens im Mittelalter,
hauptsächlich auf Grund der Briefe des Erzbischofs Theophylaktos von Achrida (Munich, 1937); cf. also
I. Dujčev. Makedonski pregled, 12.2 (1940), 134–43. Bibliographical references in Moravcsik, Byzan-
tinoturcica, 538–39. See also S. Maslev, "Za roljata i značenieto na dejnostta na Teofilakt Ohridski kato
arhiepiskop bŭlgarski," Izvestija na Instituta za bŭlgarska istorija, 23 (1974), 235–47. Serbian trans-
lation and commentary (by R. Katičić), in Fontes Byzantini historiam populorum Jugoslaviae spectantes,
III (Belgrade, 1966), 257–360.

[29] Biographical and bibliographical notes in Moravcsik, Byzantinoturcica, 455–56. See also I. Ch.
Konstantinides, Νικόλαος Α′, ὁ Μυστικός (ca. 852–925 μ. Χ.), πατριάρχης Κωνσταντινουπόλεως (901–907,
912–925). Συμβολὴ εἰς τὴν ἐκκλησιαστικὴν καὶ πολιτικὴν ἱστορίαν τοῦ α′ τετάρτου τοῦ Ι′ μ. Χ. αἰῶνος (Athens,
1967); A. Stauridou-Zaphraka, Ἡ συνάντηση Συμεὼν καὶ Νικολάου Μυστικοῦ (Αὔγουστος 913) στὰ πλαίσια
τοῦ βυζαντινοβουλγαρικοῦ ἀνταγωνισμοῦ (Thessalonica, 1972). Cf. also I. Božilov, in Bulgarian Historical
Review, 1.4 (1973), 120 ff.; M. Sjuzjumov, in Viz. Vrem., 35 (1973), 260.

[30] Text of the correspondence in PG, 111, cols. 27–392; new critical edition and English translation,
by R. J. H. Jenkins and L. G. Westerink, Nicholas I, Patriarch of Constantinople, Letters, CFHB, IV,
DOT, II (Washington, D. C., 1973). Bulgarian translation with commentary by V. N. Zlatarski,
"Pismata na carigradskija patriarh Nikolaja Mistika do bŭlgarskija car Simeona," Sbornik za narodni
umotvorenija, nauka i knižnina, 10 (1894), 372–428; 11 (1894), 5–54; 12 (1895), 121–211; new edition
of the Bulgarian translation, in Fontes Graeci Historiae Bulgaricae, IV (Sofia, 1961), 185–297; Bulgarian
translation of three letters, by I. Dujčev, "Pismo na carigradskija patriarh Nikolaj Mistika do arhiepis-
kopa na Bŭlgarija," Prometej, 3, fasc. 4 (1939), 26–28; "Dve pisma na carigradskija patriarh Nikolaja
Mistika vŭz vrŭzka s našeto minalo," Prometej, 3, fasc. 5 (1939), 23–27. For analysis of the letters,
Zlatarski, Istorija, 320 ff.

[31] Uspenskij, "Neizdannoe cerkovnoe slovo," 100.

[32] Ibid., 100 ff.

or simply mentioned in the sermon as having occurred recently, must be taken
as the terminus ante quem non for the date of the sermon itself. It follows
that, when we meet with uncertain and vague allusions in the text, the inter-
pretation will also be approximative and hypothetical. His interpretation is
based primarily on paragraph **16** of the sermon, where he sees allusions to the
meeting of the Emperor Romanus I Lecapenus with King Symeon of Bulgaria in
September 923.[33] In paragraph **17** the orator speaks of a treaty of peace, which
would be the treaty between Byzantium and the Bulgarians made after the
death of Symeon, in October 927:[34] it is this date which, in Uspenskij's opinion,
furnishes the terminus post quem for the composition of the sermon. As a
literary parallel to paragraph **17** Uspenskij names the twenty-fifth letter of
Nicholas Mysticus to Symeon.[35] As to the question of the date of earlier
historical events related by the anonymous author, Uspenskij mentions para-
graph **3**, which alludes to the "spiritual filiation" of the Bulgarians in respect
to the Byzantines. For appropriate parallels he refers again to several letters
of Nicholas Mysticus to Symeon.[36] Other parallels he finds between certain
passages in the Patriarch's letters and the orator's description of Symeon's
ravages in the vicinity of Constantinople. As another source clarifying the
sermon, the Russian scholar cites the correspondence between Romanus Leca-
penus and Symeon.[37] In his analysis of paragraph **7**, he finds references to the
war between the Byzantines and the Bulgarians after the death of Leo VI
(12 May 912). The allusion to the golden era in the history of the Byzantine
Empire, in which the words of I Par. 27f. are used, points to the reign of
Leo VI. Here the orator once again speaks of the spiritual "adoption" of the
Bulgarians by the Byzantines, brought about by their Christianization; thus
the Christian religion was a basic factor in the relations between Byzantium
and Bulgaria.

In his commentary Uspenskij further deals with the problem arising from
the author's reference to the Bulgarians as being ἀμαξόβιοι and nomads. He
takes the term ἀμαξόβιοι as evidence of the presence of a non-Slavic ethnic
element among the Bulgarian people. Nowadays this problem can be considered
as resolved, and therefore the discussion of the Russian scholar is only of
historiographical interest. In paragraph **12** Uspenskij sees proof that the
anonymous author was witness to the historical events related in his sermon
and states that the chief object of the wars waged by Symeon against the
Byzantine Empire was to seize the imperial crown (*stephos*). He also believes

[33] On this historical event, see Zlatarski, *Istorija*, 464 ff.
[34] For details, see *ibid.*, 521 ff.
[35] Uspenskij, "Neizdannoe cerkovnoe slovo," 102 ff.
[36] *Ibid.*, 103 ff.
[37] This correspondence is edited by J. Sakkelion, Ῥωμανοῦ βασιλέως τοῦ Λακαπηνοῦ ἐπιστολαί, in
Δελτ.ʿΕτ.ʿΕλλ., 1 (1883–84), 657–66; 2 (1885–86), 34–48. Bulgarian translation with commentary by
V. N. Zlatarski, "Pismata na vizantijskija imperator Romana Lakapena do bŭlgarskija car Simeona,"
Sbornik za narodni umotvorenija, nauka i knižnina, 13 (1896), 282–322; republished in *Fontes Graeci
Historiae Bulgaricae*, IV (Sofia [1961]), 298–314. Cf. Dölger, *Regesten* (*supra*, note 9), nos. 606–8;
Moravcsik, *Byzantinoturcica*, 502–3. Analysis in Zlatarski, *Istorija*, 485 ff., 830 ff. I am preparing a
new edition of these letters.

that here the author used a hitherto unknown apocryphal legend. This hypothesis is bold but unconvincing, for the expression Uspenskij is concerned with, far from being a borrowing from some unknown "poetical work," is simply a paraphrase of Homer, *Iliad* 11.500. In the sentence which immediately follows Uspenskij finds an allusion to the arbitrary appropriation by the Bulgarian ruler of the imperial title, namely, that of *basileus* of the Romans and Bulgarians. On the basis of an incorrect reading of ἀθετεῖ instead of εὐθετεῖ, his interpretation of this passage is that Symeon "casts away the father," but at the same time "confirms the spirit." As a matter of fact, this passage of the sermon should only be interpreted in the sense of the Byzantine theory of spiritual relationships and the "family of the princes and the peoples."[38] Thus, when the rhetor asserts that Symeon betrays fidelity toward the "father," he refers to this spiritual "family" of rulers and peoples. By so doing, Czar Symeon betrays also the "spirit," i.e., the established system of relations between Christian sovereigns and their peoples. Although lacking a clear conception of this Byzantine theory, Uspenskij nonetheless cites as a parallel the text of the twenty-fifth epistle of the Patriarch Nicholas Mysticus.[39] Paragraph 13 also alludes to the attitude of the Bulgarian Czar toward the Empire and to his violation of the system of spiritual relationship between Byzantium and the Bulgarians. In this same paragraph Uspenskij seeks to discover further indications of Symeon's attitude toward the Senate of Constantinople; unfortunately, the letters of the Czar addressed to the members of the Senate with the definite purpose of harming the new emperor Romanus Lecapenus and of presenting him as an usurper of the supreme power in Byzantium have not come down to us. But, on the basis of the answers of the Patriarch, it is possible to reconstruct to some extent their content or at least to understand the general concepts formulated by Symeon. Uspenskij's hypothesis[40] is that the Czar dwelled upon the significance of the imperial power and the usurpation perpetrated by Romanus Lecapenus; and that he claimed his own rights to the imperial crown of the Byzantine Empire on the ground of his spiritual adoption. The twenty-eighth letter of the Patriarch,[41] as Uspenskij points out, contains interesting information about the arguments used by Symeon.[42]

From this point onward, Uspenskij uses the correspondence of the Patriarch Nicholas Mysticus for his interpretation of the various allusions contained in the text of the sermon. Thus, to the passage regarding the question whether or not a person of non-Byzantine origin may become ruler of the Empire he sees parallels in the eighteenth and nineteenth letters of the Patriarch.[43] Nicholas Mysticus' letters also offer Uspenskij ways to interpret passages of the sermon containing evidence of the internal crisis of the Empire which

[38] See *supra*, note 25.
[39] Uspenskij, "Neizdannoe cerkovnoe slovo," 113 ff.
[40] *Ibid.*, 115 ff.
[41] PG, 111, col. 180.
[42] Uspenskij, "Neizdannoe cerkovnoe slovo," 115.
[43] PG, 111, cols. 121 and 128. Cf. Uspenskij, "Neizdannoe cerkovnoe slovo," 116.

immediately followed the death of the Emperor Leo VI and of his brother Alexander (6 June 913).

In the Vatican manuscript, where the anonymous author mentions the "new Proteus" (par. **14**), there is a marginal note identifying the latter as Constantine the Eunuch. Uspenskij considers this identification "unsatisfactory" because it contradicts the historical information concerning this personage.[44] Instead, he proposes as more probable the identification of the "new Proteus" with the Emperor Romanus Lecapenus. In paragraph **15** Romanus Lecapenus is alluded to again, but under the name of Moses. From a historical point of view the last paragraphs of the sermon are easy to interpret: they contain a narration both of the meeting of Romanus Lecapenus with Symeon and of the conclusion of the treaty of peace between Byzantium and the Bulgarians.

Uspenskij adds some remarks about the rhetor's learning and his view of the world.[45] Concrete historical references take a relatively limited space in the sermon because the author is more concerned with his own reflections and feelings about contemporary events than with the concrete events themselves. The anonymous writer is well versed not only in ecclesiastical literature but also in ancient history, mythology, philosophy, rhetorical art, poetry, and popular literature. In spite of all this, his work should not be considered merely a reflection of the ideas and literary trends of his time. On the contrary, this sermon reveals great individuality both as a literary work and as a historical source. In order to demonstrate to his audience the advantages of peace, the rhetor touches upon the realities of life and everyday affairs. In paragraph **8**, when referring to the life of domestic animals and to bees and ants, the author probably uses—as Uspenskij has pointed out[46]—the text of the Byzantine *Physiologus*.[47] In observing life and the harmony of the cosmos, especially in respect to the life of animals, he compares it with human society. As a parallel to these reflections of the Byzantine author, Uspenskij cites numerous passages from Nicholas Mysticus' letters,[49] as well as several other passages from the correspondence between Romanus Lecapenus and Symeon of Bulgaria.[50] Realistic descriptions are further found, according to Uspenskij,[51] in paragraphs **18** and **19** (on rural life) and in paragraph **21**.

As to the identification of the author of the sermon, Uspenskij calls attention to paragraph **2**; here, he asserts, is evidence that the author was a member of the Constantinopolitan high clergy,[52] while in paragraph **3** he sees evidence of his high social position. Although Uspenskij admits that this is insufficient to determine with any certainty the identity of the author of the sermon, as

[44] Uspenskij "Neizdannoe cerkovnoe slovo," 117 ff.
[45] *Ibid.*, 120 ff.
[46] *Ibid.*, 121.
[47] Critical edition of the Greek text published by F. Sbordone (Milan-Genoa-Rome-Naples, 1936).
[48] Uspenskij, "Neizdannoe cerkovnoe slovo," 121 ff.
[49] PG, 111, cols. 188, 116, 140, 141, 193.
[50] Sakkelion, *op. cit.*, 2 (*supra*, note 37), 46.
[51] Uspenskij, "Neizdannoe cerkovnoe slovo," 122.
[52] *Ibid.*, 122.

we have mentioned above he sees only one possible identification—that with the Patriarch of Constantinople, Nicholas Mysticus.[53] There remains, however, a very serious chronological discrepancy. It is generally agreed that the peace treaty between Byzantium and the Bulgarians was concluded in October 927, when Nicholas Mysticus had been dead for more than two years.[54] In an effort to resolve this difficulty, Uspenskij proposes that the conclusion of the peace between the two enemies might have taken place in two separate stages; had not some kind of peace perhaps been established before the marriage of the Czar Peter with Maria, daughter of Christophorus and granddaughter of the Emperor Romanus Lecapenus? But even assuming the possibility of two different stages in the establishment of the peace, Uspenskij is unable to reconcile these two hypothetical moments with the actual historical chronology. Utilizing his assumption, one may go so far as to admit that the conclusion of the peace and the resumption of pacific relations between Byzantium and Bulgaria may be dated to the year 926—that is, one year before the marriage of the Czar Peter and the princess Maria Lecapena, and one year after the death of the Patriarch Nicholas Mysticus; but a chronological discrepancy remains in any case. In fact, Uspenskij leaves open the question of the identification of the author. And yet, although this identification is presented by him only as a hypothesis badly in need of solid proof, some modern historians have accepted it as being beyond any doubt.[55]

Uspenskij's publication immediately attracted the attention of scholars and was the object of several book reviews. Thus, the distinguished specialist in the field of Byzantine philology and literature Eduard Kurtz (1846–1925) of Riga accepted in his detailed review[56] Uspenskij's comments on the text of the sermon, which he describes as "eine in der Sophienkirche über einen mit den Bulgaren geschlossenen Frieden gehaltene Rede, die der Vaticanus gr. 483, ein Sammelcodex aus dem Ende des 14. Jahrhunderts, ohne Überschrift und Nennung des Autors enthält; denn der jetzt in der Handschrift stehende Titel...ist, wie Uspenskij meint, erst später, in unserem Jahrhundert, hinzugefügt," and writes further: "Denselben Ursprung weist Uspenskij den historischen Notizen am Rande der Handschrift zu; dort ist nämlich der Versuch gemacht, die Persönlichkeiten, die der Redner erwähnt, aber ganz unbestimmt mit allegorischen, aus der Bibel und altgriechischen Mythologie und Geschichte entlehnten Namen andeutet, zu bestimmen und mit ihrem wirklichen Namen zu bezeichnen." At this point the reviewer adds some remarks about the sermon itself: "Die Rede, die sich auf den im J. 927 mit Petros, dem Sohne des Symeon von Bulgarien, geschlossenen Frieden bezieht, bietet in sprachlicher und sachlicher Hinsicht grosse Schwierigkeiten. Der Verfasser der Rede, der offenbar zu den Spitzen der hauptstädtischen Geistlichkeit gehört und umfassende Belesenheit und Gelehrsamkeit auf den verschiedensten Gebieten

[53] *Ibid.*, 122 f. See *infra*, p. 230.
[54] He died 15 May 925; cf. V. Grumel, *Traité d'études byzantines*. I. *La chronologie* (Paris, 1958), 436.
[55] Cf., for example, Moravcsik, *Byzantinoturcica*, 455, and, with some doubt, 223.
[56] E. Kurtz, in *BZ*, 4 (1895), 615–16.

des Wissens an den Tag legt, beherrscht vollkommen alle Mittel der rhe-
torischen Kunst, aber nach der in der byzantinischen Litteratur allgemein
verbreiteten Sitte umgeht er es ängstlich, in seiner Epideixis reale Facta und
historische Namen zu erwähnen, sondern beschränkt sich darauf, die zeit-
genössischen Ereignisse, die ihm und seinen Zuhörern ja wohlbekannt waren,
bloss anzudeuten und hinter rhetorischen Figuren und allegorischen Vergleichen
zu verstecken, so dass der heutige Leser sich in seinen dunklen Andeutungen
und Anspielungen nur schwer zurechtfinden kann"[57]

After describing the general characteristics of the anonymous work, Kurtz
emphasizes its importance as a historical source: "Trotzdem hat die Rede
nicht geringen Wert, erstens als Literaturdenkmal an sich, als interessantes
Specimen der hochentwickelten rhetorischen Kunst im Anfange des 10. Jahr-
hunderts, sodann aber auch als Beitrag zur Geschichte der bulgaro-byzanti-
nischen Beziehungen im 9. und 10. Jh., über die sich bei den eigentlichen
Geschichtschreibern, nur ziemlich dürftige Nachrichten finden...." As he
comes to the problem of the authorship of our sermon, he repeats the hypo-
thesis already formulated by Uspenskij, with the arguments *pro et contra*:
"Als den Verfasser dieser anonym überlieferten Rede glaubt Uspenskij mit
grosser Wahrscheinlichkeit den Patriarchen Nikolaos Mystikos in Anspruch
nehmen zu dürfen, aus dessen Briefwechsel mit Symeon von Bulgarien er
verschiedene Gedanken als für diese Annahme sprechend anführt; besonders
hebt er die bei beiden gleichartige Beurteilung einzelner Facta hervor,
namentlich die Verurteilung des Krieges zwischen den Griechen und den
Bulgaren als eines Bruderzwistes und die Betonung der geistlichen Sohn-
schaft, in der die Bulgaren zu Byzanz, das ihnen den christlichen Glauben
übermittelt hat, stehen...." However, he does not find the arguments well-
grounded. "Aber dies alles scheint doch nicht von so individueller Natur zu
sein, dass nicht auch eine andere Person zu jener Zeit diese Auffassung teilen
konnte, die wohl im Bewusstsein aller Zeitgenossen lag." He recalls the
chronological discrepancy: "Dazu kommt die chronologische Schwierigkeit auf
die Uspenskij selbst hinweist, dass der Patriarch Nikolaos bereits im J. 925
gestorben ist, also zwei Jahre vor dem in unserer Rede verherrlichten Friedens-
schlusse."[58]

The emendations of the text proposed by Kurtz are very important and
have been accepted in the present edition of the sermon. In some passages
Kurtz gives his own translation of the Greek text. For example, at p. 68, line 18
(ed. Uspenskij), he suggests the following translation: "als nach Salomo, dem
friedereichen und weisen, die Herde durch Jeroboam auseinandergerissen wur-
de...." At p. 70 line 6: "dass das Geschenk aus der Hand des Höchsten kommt,
das möchte wohl auch ein Blinder....einsehen." At p. 75 line 16, he proposes
the interpretation "wenn wir auch irgendwie, sowie jene [d. h. die Heiden: p. 75
line 1] vom richtigen Weg abgekommen sind [denn wir haben an der nämlichen
Schöpfung, wenn auch nicht an ihrem Irrtum, teil d.h. wir sind ja ebenso

[57] *Ibid.*, 615.
[58] *Ibid.*, 615–16.

Menschen wie die Heiden, aber freilich durch die christliche Religion erleuchtet], so mögen wir doch, auf den richtigen Weg zurückgeführt [zur Friedfertigkeit], uns nicht mehr davon abbringen lassen...." Finally he remarks: "Anderes, worin wir vom Herausgeber abweichen zu müssen glauben, müssen wir hier übergehen, weil es sich nicht gut in Kürze darlegen lässt....."[59] In short, Kurtz' critical observations have been singularly useful for the interpretation of our sermon.

Simultaneously with Kurtz, another Russian scholar, B. Melioranskij, wrote a short bibliographical note[60] in which he summarizes Uspenskij's study and points out his hesitation on the matter of the chronology of the anonymous work. The edition made by Uspenskij attracted also the attention of the great German Byzantinist Karl Krumbacher, who immediately included it in the bibliographical notes of his monumental work, adding some interesting observations: "Von einem Zeitgenossen des Nikolaos Mystikos stammt eine in der Sophienkirche gehaltene, ohne Autornamen in Cod. Vatic. gr. 483 überlieferte Rede, welche sich auf den im Jahre 927 mit Petros, dem Sohne des Symeon von Bulgarien, geschlossenen Frieden bezieht. Leider scheut sich der Verfasser nach der leidigen Sitte der byzantinischen Rhetorik von einer genaueren Bezeichnung von Tatsachen und Namen, so dass sich der historische Untergrund seiner dunkeln Andeutungen und allegorischen Vergleiche nicht mit genügender Deutlichkeit erkennen lässt."[61] From these remarks it is obvious that Krumbacher does not agree with Uspenskij as to the authorship of the sermon. While the Russian scholar proposed, not without some hesitation, the name of Nicholas Mysticus, the conjecture of the German scholar is that the work must be ascribed with greater probability to a contemporary of the Patriarch.

In 1900, about six years after the publication of the anonymous text, a detailed study by I. Kuznecov appeared.[62] The author proposed to analyze the correspondence of the Byzantine envoy to Bulgaria in the years 894–96, Leo Magister Choerosphaktes,[63] with the Bulgarian prince Symeon and that of the Emperor Romanus Lecapenus with the same Bulgarian ruler,[64] as well as the contents of our sermon. But Kuznecov's study remained incomplete. In his published work, the author gives only general information about the history of Bulgaria under Czar Symeon and about Byzantine-Bulgarian relations during this period; he mentions the correspondence between Leo Magister and Symeon and publishes the letters partly in the original

[59] *Ibid.*, 616.

[60] *VizVrem*, 2 (1895), 246–47.

[61] Krumbacher, 458–59.

[62] I. Kuznecov, "Pismata na Lŭva Magistra i Romana Lakapina i slovoto Ἐπὶ τῇ τῶν Βουλγάρων συμβάσει," *Sbornik za narodni umotvorenija, nauka i knižnina*, 16–17 (1900), 179–245.

[63] Last critical edition of this correspondence was published by G. Kolias, *Léon Choerosphactès magistre, proconsul et patrice. Biographie, correspondance (Texte et traduction)*, TFByzNgPhil, 31 (Athens, 1939). For other bibliographical information about this correspondence, see Moravcsik, *Byzantinoturcica*, 397–98.

[64] First edition by Sakkelion (*supra*, note 37). Cf. also Moravcsik, *Byzantinoturcica*, 502–3, with complementary bibliographical notices. Bulgarian translation of Lecapenus' letters to Symeon: Zlatarski, "Pismata" (*supra*, note 37); *idem, Istorija*, 830–36.

text, partly in Bulgarian translation, with his commentary. Then he continues with the history of Byzantine-Bulgarian relations at the time of the Emperor Romanus Lecapenus, adding detailed references to the correspondence of Patriarch Nicholas Mysticus as well as to some Byzantine chronicles. Contrary to the reader's expectation, since the sermon of 927 is cited in the title of his study, not a word is said on the subject. The supplementary study which one would have expected was never published.

Ten years later, the Bulgarian historian D. Zuhlev, who was interested predominantly in the history of the Bulgarian Church, examined the sermon as a historical source.[65] Disregarding the caution and hesitation of the editor, Zuhlev accepts some of Uspenskij's conjectures as historical facts; for him, the sermon is undoubtedly the work of Nicholas Mysticus. Further, he agrees with Uspenskij on the matter of the arrangements toward the marriage between the Bulgarian Czar Peter and the Byzantine princess Maria Irene; according to him, these took place after, not before, the conclusion of the peace treaty. This seems probable, for the negotiations between the two countries treated all problems concerning their relations, and it was not until after everything was settled that the peace treaty was signed and confirmed by the marriage.

In 1919 the Italian Byzantinist and patrologist Monsignor Giovanni Mercati published a short note in which he proposed some emendations to the text of the sermon.[66] Mercati dates the Vatican MS containing the text to the thirteenth-fourteenth century, while Uspenskij was inclined to attribute it to the late fourteenth century.[67] His emendation concerns the beginning of this anonymous work: "Chi ha sperimentato l'utilità degli inizi per il riconoscimento degli scritti anepigrafi e pseudepigrafi, non troverà superfluo che si dia il vero principio del discorso per la pace coi Bulgari nel 927 tenuto a S. Sofia di Costantinopoli," declares Mercati. He then quotes the *incipit* from Uspenskij's edition: Εἰρήνη ἀφ' ὕψους, σκιρτήσατε. εἰρήνην ὑμνοῦμεν, εὐφράνθητε. εἰρήνην ἐπὶ τὰς πόλεις Σιών, αἱ θυγατέρες Ἱερουσαλὴμ χορεύσατε. To this he objects, "Ma εἰρήνη è correzione dell'editore invece dell' εἰρήνην del m[anoscritto], e correzione non felice, che toglie alla prima coppia il parallelismo (per così dire) di costruzione alle due coppie seguenti. E' poi la conseguenza di un abbaglio circa il luogo preciso di un supplemento fatto dal *copista* medesimo, il quale dapprima aveva saltato le parole Εἰρήν. – σκιρτήσατε. Volendole supplire, lo fece nella riga superiore, di seguito alla rubrica (che da ciò risulta *originale*, e non già del secolo XIX, come sognò l'Uspenskij) Ἐπὶ τῇ τῶν Βουλγάρων συμβάσει, però tirando insieme una linea che parte di mezzo ad εὐφράνθητε· εἰρήνην e termina avanti all' εἰρήνην supplito, per avvertire che colà e non altrove va il supplemento." Finally Mercati conclude: "Pertanto devesi leggere: Εἰρήνην ὑμνοῦμεν, εὐφράνθητε· εἰρήνην ἀφ' ὕψους, σκιρτήσατε· εἰρήνην ἐπὶ τὰς πόλεις Σιών, αἱ

[65] D. Zuhlev, *Istorija na bŭlgarskata cŭrkva. I. Pŭrvi period (864–1186)* (Sofia, 1910), 411 note 3, 415–16.

[66] G. Mercati, "Minuzie. 31. Correzione al discorso per la pace coi Bulgari." *Bessarione*, 35 (1919), 38–39; reprinted in *idem, Opere minori raccolte in occasione del settantesimo natalizio*, IV, ST, 79 (Città del Vaticano, 1937), 57–58.

[67] Mercati, *op. cit.*, 57 note 1. On the Vatican MS, see also G. Przychocki, in *EOS*, 16 (1910), 104 ff.

θυγατέρες Ἱερουσαλὴμ συγχορεύσατε (così il ms. e non χορεύσατε, come nell' edizione)." Especially worthy of note is Mercati's opinion that the title is original, not a modern addition as Uspenskij believed.

In his detailed history of the Bulgarian state in the Middle Ages the distinguished Bulgarian historian Vasil N. Zlatarski wrote about the reign of the Czar Symeon, making use of the sermon as a source for that period. Therefore, he mentions the suggestion found in our text[68] concerning the meeting between Symeon and Romanus I Lecapenus in early September 923. He apparently accepts the evidence of the Anonymous as reliable, calling in question only the allegation made by the Byzantine author on the "corrupted Greek language" spoken by the Bulgarian Czar. Taking into consideration the fact that Symeon as a young man spent "about ten years" in Constantinople and, moreover, studied at the famous academy of Magnaura, where he learned the Greek language so well that his contemporaries nicknamed him *Hemiargos*, i.e., "Semi-Greek," such a statement does not ring true. Zlatarski sees here a rhetorical figure of speech, intentionally aimed at slighting the Bulgarian ruler.

In an attempt to solve the question concerning the initiative for the negotiations between Byzantium and Bulgaria after Symeon's death, Zlatarski once again resorts to the sermon. In some of its passages he sees allusions to the Bulgarians taking the first step toward the peace negotiations.[69] The meeting between the Emperor Romanus and Symeon's successor, Peter, Zlatarski accepts as authentic. Here he corrects a slight error in the translation of Uspenskij.[70] Finally, since he cannot find any reference in the sermon to the wedding ceremony of Peter and Maria Irene, he concludes that the sermon must have been delivered immediately after the conclusion of the peace treaty.[71] On the whole, Zlatarski does not make full use of all the evidence furnished by our source and, moreover, is very cautious in utilizing the sermon as a historical source. In all probability he thought that the text needed a thorough analysis before it could be regarded as a reliable document.[72]

After Zlatarski called attention to the sermon, other Bulgarian scholars examined it as a source of references for diverse fields of scholarship. Among others, I. Sakâzov in 1929 looked for data for the economic history of the Bulgarian people.[73] Recognizing in the anonymous author a "Geistlicher in Konstantinopel," he quotes the passage containing a reference to the abandonment on the part of the Bulgarians of the nomadic way of life: "Sie [the Bulgarians] wurden von unserem Gott als Söhne angenommen und entwöhnten sich ihrer amazonischen und nomadischen Sitten." Strictly speaking, this is

[68] Zlatarski, *Istorija*, 467 note 1.
[69] Sermon, paragraphs 16–17. Cf. Zlatarski, *Istorija*, 522 note 1.
[70] Zlatarski, *Istorija*, 524 note 1.
[71] *Ibid.*, 534 note 1.
[72] It was Professor Zlatarski, my university teacher, who suggested to me in 1930 to undertake a detailed study of this historical document and to prepare a new critical edition, which was first presented as my dissertation at the University of Sofia in 1932.
[73] I. Sakâzov, *Bulgarische Wirtschaftsgeschichte* (Berlin-Leipzig, 1929). On this publication, see my review of it in *IzvArhInst*, 7 (1932–33), 433–38.

not true, since the Bulgarian peoples had firmly settled several centuries before their official conversion in 865. The sermon is quoted again in connection with the peace treaty of 927 (the quotation is based on Uspenskij's translation):[74] "Die segensreichen Folgen des im Jahre 927 abgeschlossenen Friedens fanden in einer sehr farbenprächtigen Schilderung eines anonymen Redners aus jener Epoche ihren Ausdruck. 'Jetzt wurden die Erde und der Himmel reiner, und die Oberfläche der Erde bedeckte sich mit Blumen, jetzt geben sogar die Quellen mehr Wasser her, und die Erde und das Meer versehen uns reichlich mit ihren grösseren Geschenken; es ist, als ob in Wirklichkeit auch die Wipfel der Eichen mehr Eicheln spenden und die mittleren Zweige die Bienen nähren, die Herden tragen dickere Wolle, die Siedlungen breiten sich aus, die Menschen bauen Häuser, pflügen die Erde, setzen Pflanzen und säen Getreide, säubern die Gefässe von Spinnweben und durchkosten herrliche Hoffnungen; die Strassen füllen sich mit Reisenden und auf den Bergeshöhen spielen Lämmer und Kälber. Wie angenehm ist jetzt das Knarren der Wagen.... Jetzt werden die Kinder gross, und die Jugend arbeitet bis zur Ermüdung.... So wird alles jung und gibt sich der Freude hin und besingt und rühmt den Urheber dieses Segens." To point out the evils of war, the text of the sermon is once more quoted:[75] "Andere Schriftsteller berichten ausdrücklich, dass 'das Land ungebaut dalag, weil keine Leute zum Pflügen da waren, denn das ganze Land war unbewohnt.'"

In the historical literature of the years immediately following, no mention of the sermon is to be found. Then the Greek Byzantinist Nikos A. Bees (Vees) devoted to it a note in his study on the invasion of the Byzantine Empire by the Bulgarian Czar Symeon.[76] Without any solid arguments, the Russian scholar M. Šangin declared that the author of the sermon was the Archbishop Arethas of Caesarea.[77] Almost at the same time the eminent German scholar Franz Dölger, in his study on the Byzantine idea of "the family of princes and peoples,"[78] took into consideration, among other sources, our text. In it he finds expressed "das Verhältnis 'Sohn-Vater' sowohl zwischen dem byzantinischen Kaiser und dem jeweiligen Bulgarenherrscher als zwischen dem byzantinischen und dem bulgarischen Volke." He mentions Uspenskij's article and recalls that the latter had collected several illustrations of this idea, expressed by various Byzantine authors. But while Uspenskij had only cautiously advanced the suggestion that the author was Nicholas Mysticus, Dölger is in no doubt that the sermon was composed by this Patriarch. "Ausgabe der anonym überlieferten, mit Sicherheit aber dem Patr. Nikolaos zuzuschreibenden Rede auf den Frieden v. J. 924 [sic!]...," writes Dölger about

[74] Sakâzov, op. cit., 35–36, 64.
[75] Ibid., 85.
[76] N. A. Bees, Αἱ ἐπιδρομαὶ τῶν Βουλγάρων ὑπὸ τὸν τζάρον Συμεὼν καὶ τὰ σχετικὰ σχόλια τοῦ Ἀρέθα Καισαρείας, in Ἑλληνικά, 1 (1929), 388–89.
[77] M. Šangin, "Vizantijskij pisatel' Arefa—avtor Slova o mire s bolgarami 927," Istorik marksist, no. 3 (73) (1939), 177.
[78] Dölger, "Der Bulgarenherrscher," 226 note 2, reprinted in Byzanz und die europäische Staatenwelt (supra, note 25), 190 note 17.

Uspenskij's study.[79] Again, the "spiritual kinship" between Byzantium and the Bulgarians is the theme of another passage "aus der oben erwähnten Friedensrede d. J. 924." Where he detects an allusion to the conversion of the Bulgarians to Christianity, Dölger remarks: "Es verdient Beachtung, dass der Patriarch, der, wie man sieht, durch den ständigen Hinweis auf das Vater-Sohn-Verhältnis, welches den Fürsten Symeon sowohl an ihn selbst (Nikolaos) als auch an den Kaiser bindet, ein pietätvolles Verhalten des ungebärdigen 'Kindes' erzwingen will, auch auf die allgemeinere und auf die 'Bruderschaft in Christo' anspielende Bezeichnung 'Bruder' (d.h. 'Bruder in Christo' nach Paulus) ausweicht, wohl um die Empfindlichkeit des stolzen Bulgaren zu schonen...."[80] Since he attributes the sermon to Nicholas Mysticus, Dölger must of necessity date it before the death of the head of the Byzantine Church, namely, to 924.[81] He was wrong, however, in both instances.

In the first edition of his *Byzantinoturcica*,[82] the Hungarian scholar Gyula Moravcsik repeats uncritically the same errors: "*Anonymus de Bulgaris*: eine anonym überlieferte kirchliche Rede aus dem 10. Jh. ist wichtig für die bulgarisch-byzantinischen Beziehungen. Neuerdings wurde nachgewiesen, dass ihr Verfasser der Patriarch Nikolaos Mystikos...war, und dass es sich in dieser Rede um den Friedensvertrag vom J. 924 handelt." After the publication of the first edition of *Byzantinoturcica*, I wrote to Moravcsik, pointing out that both the attribution of the sermon to Patriarch Nicholas Mysticus and the dating of the sermon were disproved by internal evidence. Therefore, in the second edition of his useful work,[83] the author modified his former statement as follows: "Wer ihr Verfasser war, wurde noch nicht endgültig geklärt. Man dachte an Nikolaos Mystikos..., an Arethas...und an Theodoros Daphnopates (Mitteilung von I. Dujčev), und es wurde dementsprechend angenommen, dass sich die Rede entweder auf den Friedensvertrag vom Jahre 924 oder auf den vom Jahre 927 bezieht." Evidently Moravcsik could not make up his mind one way or another. The very title he gives to this historical document betrays his reluctance to commit himself.[84] More bibliographical data was added to the note in question.

In 1963, I published in the series of Greek, i.e., Byzantine, sources for the history of Bulgaria in the Middle Ages the text of the sermon and its translation in Bulgarian, accompanied by an introduction and a commentary.[85] Four years later the important study of Romilly J. H. Jenkins appeared.[86] It is undoubtedly one of the most useful contributions to the solution of the

[79] *Ibid.*, at beginning.

[80] *Ibid.*, at end.

[81] Patriarch Nicholas I Mysticus died 15 May 925; see *supra*, note 54.

[82] G. Moravcsik, *Byzantinoturcica*, I (Budapest, 1942), 110–11; cf. also 278.

[83] Moravcsik, *Byzantinoturcica* (*supra*, note 10), 223–24.

[84] *Ibid.*, 223: "Anonymus de Bulgaris."

[85] *Fontes Graeci Historiae Bulgaricae*, V (Sofia, 1963), 82–101.

[86] R. J. H. Jenkins, "The Peace with Bulgaria (927) Celebrated by Theodore Daphnopates," *Polychronion. Festschrift Franz Dölger zum 75. Geburtstag* (Heidelberg, 1966); Reprinted in: *idem, Studies on Byzantine History of the 9th and 10th Centuries* (London, 1970), no. XXI (hereafter Jenkins "The Peace with Bulgaria"), 287–303.

problems arising from our text and, because of it, more historians were attracted to the sermon. After some preliminary words on Uspenskij's publication of 1894, Jenkins remarks: "Uspenskij's edition is unsatisfactory in every way but one: for it is only fair to say that his transcription of the text, written in a late 14th-century hand, is most accurate. But the meaning of the document—the allusions which it makes to contemporary events and personalities, the significance and date of its explanatory 'key' (I mean, the marginalia), and indeed its very nature—almost wholly eluded him: and he himself very frankly admitted that this was so." Nevertheless Jenkins does not fail to note "the few occasions where he was right in his interpretation." Then he goes on, "But two of his misunderstandings must be observed at the outset. First, his title 'Tserkovnoe slovo' is a misnomer. There is no reason to suppose, and every reason to doubt, that this is the text of a sermon for delivery in church. The wealth of classical allusion, and the constant, if covert, reference to contemporary politicians, would make the oration quite unsuitable for a thanksgiving in S. Sophia. The misunderstanding arises from a passage[87] in which the audience is exhorted to *go* to the church and give thanks for the peace." For Jenkins is convinced that "the oration is delivered by the official Palace orator in the presence of the emperor (Romanus I); and is comparable with the series of palace orations delivered before Leo VI by Arethas of Caesarea a quarter of a century before."

According to Jenkins, the second misunderstanding concerns the marginal notes of the manuscript: "In the second place, the 14th-century text includes, not only the title given above, in red ink, but also some highly illuminating marginal comments, partly in red ink and partly in black. These comments are a 'key' to the identity of some of the persons disguised in the text under Biblical or mythological names." Jenkins believes that the dating of these notes proposed by the first editor of the text is wrong. "Uspenskij thought that these marginalia were additions of the 19th century, perhaps the work of Hase, who is known to have had access to the document. Hence, he thought himself free to doubt and even reject these identifications where he thought them improbable. But, in fact, these marginalia are in the same hand as the rest of the text [here, in a footnote, Jenkins refers to Mgr. Mercati, who pointed out this fact in 1919], and, what is more, are in every instance but one demonstrably correct. There can be little doubt that they go back to the 10th century and are perfectly reliable. We may add that Hase, good scholar as he was, would hardly have been capable of writing them."[88] This assertion, backed by the paleographical scrutiny to which the text was subjected by Mercati, is of particular importance for the accurate interpretation of our text.

The British Byzantinist warns, however, that, though the marginalia are of great help, "not...all the document's obscurities vanish before the eye of a modern scholar." After quoting Uspenskij's complaint about the difficulties

[87] *Ibid.*, 288 and note 3; the edition of Uspenskij is quoted (p. 64).
[88] *Ibid.*, 288.

the historian now has to cope with, he adds, reassuringly, "perhaps it is not quite so bad as all that." Then he proceeds to give a terse account of the results of his interpretation of the text: "Internal evidence shows that this oration was given in the Palace to celebrate the peace signed and ratified between Tsar Peter of Bulgaria and the Emperor Romanus I Lecapenus in October 927. Hence the oration itself may be dated to that month, or very shortly afterwards."[89] How much further than Uspenskij Jenkins has gone is quite evident. What he had in mind was to publish the complete text of the document; but in this article he says, "I cannot, for reasons of space, here republish the whole of it, though the whole deserves republication, in view of its importance and authorship and of the rarity of Uspenskij's edition. But I select the two passages in it which are of greatest importance to the historian, translate them and add some notes on their meaning, author and historical reliability."

He then gives the two passages of the Vatican manuscript with references to the editions of Uspenskij and Kurtz.[90] He proposes several corrections and *lectiones* in the text; he also identifies the sources of some quotations. The Greek text of the passages is followed by its English translation.[91] In his *Comment*, Jenkins touches on the first passage only briefly: "The first passage (ὦ τῆς ἐπινοίας...χωρῆσαι τὸ μέγεθος) is by far the less important of the two, being merely a rhetorical celebration of the conclusion of the Peace of 927, of the repulse and death of Symeon of Bulgaria, and of the providential arrival of Romanus Lecapenus in 919, to redeem and unify the divided realm."[92] Most of the same ideas are expanded in the second passage, where the Anonymous dwells on the historical change in the way of life of the Bulgarians. "The Bulgars, says the orator, are no longer to be called 'Scyths' and 'barbarians,' but once more Christians like ourselves. God has transformed the 'wolves of the West' (Bulgars) into 'cheerfulness.'" Again, God has intervened on behalf of the Byzantines, "He has caused the new Hadad or Holofernes [Symeon] to give place to his son Peter." Here Jenkins makes an interesting linguistic observation on "the usage of the *hapax* προδιαμεθοδευσάμενος," a word "which the orator, a hardy and daring innovator, has coined to imply 'having caused to move out of the way in front of': in other words, God has removed Symeon so that Peter can take his place." Similarly it is to divine will that the ascension of Romanus Lecapenus to the throne is attributed. Jenkins agrees with the identification of Solomon with the Emperor Leo VI and thinks that Jeroboam may stand for Leo Phocas. Uspenskij was unable to suggest any identification for Jonah, whereas, in Jenkins' opinion "...there is really no mystery about the matter. As Jonah was belched up from the sea to be the salvation of Nineveh (Jonah 2–3), so Admiral Romanus rose from the sea to the throne."[93]

[89] *Ibid.*, 289.

[90] Uspenskij, "Neizdannoe cerkovnoe slovo," 67 line 8–70 line 2; 76 line 4–84 line 2 = Jenkins, "The Peace with Bulgaria," 289–93.

[91] Jenkins, "The Peace with Bulgaria," 293–97.

[92] *Ibid.*, 297.

[93] *Ibid.*

Further in the text Jenkins notes another reference to Romanus, who this time is called "Moses from the water."[94]

Speaking of the marginalia, Jenkins accepts the identification of Hadad-Holofernes as Symeon. Regarding the identification of Jonah, Jenkins remarks that in one instance some indecision is betrayed by the author of the marginal notes, for he first identifies Jonah with Constantine VII Porphyrogenitus, and then (this time correctly) with Romanus Lecapenus.

The second, and historically more important, passage of the sermon begins with a promise to explain the significance of the celebration of the peace of 927. The Anonymous turns back to the preceding historical period, namely, to the reign of the Emperor Leo VI, with a highly positive representation of this time. Achitophel, mentioned in the text, is possibly Samonas, the "trusty adviser" of Leo VI from 900 to 908,[95] while the identification of Draco and Solon, mentioned further in the sermon, remains problematical: "What specific law-givers, if any, lurk under the names of Draco and Solon," declares Jenkins, "does not appear."

In his further analysis, the explanation of the title *archon*, given to Symeon of Bulgaria, must be noted. "Symeon is here correctly styled *archon*, since at the outbreak of hostilities he was not yet crowned emperor."[96] With reference to a study by the late G. I. Brătianu,[97] he interprets the terms δῆμος and ἀποστασία as *insurrection* and *revolt*: Symeon "usurps an imperial crown and throne, the *crown that discrowned Europe*, that is, ruined the Balkan Peninsula and Thrace during the next eleven years." What is not clear in this statement made by Jenkins, is, first, the date of Symeon's usurpation of the imperial title and, second, the chronology of the Byzantine-Bulgarian wars. The first date is still controversial. Assuming for the end of hostilities the death of Symeon (27 May 927), the beginning of the war must be set—according to Jenkins[98]—at about 916, which historically is not exact.[99] Jenkins interprets the term ἀνάρρησις in its "obvious and most common meaning," i.e., as a reference to the fact that Symeon proclaimed himself emperor; he seeks confirmation of this evidence given by the anonymous author in the letters exchanged between Romanus Lecapenus and Symeon[100] and in the inscriptions on Symeon's seals.[101] In the next passage of the sermon Jenkins sees a descrip-

[94] On the Byzantine identification of the emperors in general with Moses, see A. Grabar, *L'empereur dans l'art byzantin* (Strasbourg, 1936), 237; O. Treitinger, *Die oströmische Kaiser- und Reichsidee nach ihrer Gestaltung im höfischen Zeremoniell* (Jena, 1938), 81, 130 ff.

[95] On Samonas, see R. Janin, "Un arabe ministre à Byzance: Samonas," *EO*, 38 (1935), 308–10. L. Bréhier, *Vie et mort de Byzance* (Paris, 1947), 151 ff.

[96] Jenkins, "The Peace with Bulgaria," 298.

[97] For details, see G. I. Brătianu, "'Démocratie' dans le lexique byzantin à l'Empire des Paléologues," *Mémorial Louis Petit. Mélanges d'histoire et d'archéologie byzantines* (Bucharest, 1948), 32–40; *idem*, "Empire et 'démocratie' à Byzance," *BZ*, 37 (1937), 86–111; *idem*, "La fin du régime des partis à Byzance, et la crise antisémite du VIIe siècle," *Revue Historique du Sud-Est Européen*, 18 (1941), 49–67.

[98] Jenkins, *op. cit.*, 298.

[99] Zlatarski, *Istorija*, 375: beginning of the hostilities in 914.

[100] Bibliographical references, in Moravcsik, *Byzantinoturcica*, 502–3. Zlatarski, *Istorija*, 485 ff., 830 ff., and *supra*, note 64.

[101] For details, see I. Dujčev, *Medioevo bizantino-slavo. III. Altri saggi di storia politica e letteraria* (Rome, 1971), 185 note 6.

tion, "with much corroborative detail," of the "actual crowning of Symeon as emperor by the Patriarch Nicholas Mysticus in September 913"[102] (he accepts the interpretation of this event proposed by Ostrogorsky[103]) and continues: "For obvious reasons, the utmost discretion had to be used by our orator. The transaction was so irregular and shameful that to name the principals, even though both were now dead, would have been—to put it mildly—unfortunate. Nor was it necessary to do so. The facts were known to all the audience, who would be quick to catch the allusions. Instead. the principals are referred to by a simple ὁ δέ - ὁ δέ - ὁ δέ." Here Jenkins accuses Uspenskij of having proposed a wrong interpretation and consequently of having ended in "hopeless confusion."

The new interpretation of this passage suggested by Jenkins is very interesting and worth quoting *in extenso*. Proceeding from Ostrogorsky's explanation of the events of 913, he attempts to analyze the text from a new point of view. The allusions, he says, would have been easily comprehensible to contemporaries; the pronoun ὁ δέ was used the first and the third time with reference to Patriarch Nicholas Mysticus, and the second time with reference to the Bulgarian Czar. Let us quote Jenkins;[104] "Nicholas, then, on Symeon's arrival, asks what his terms are, though in fact he knows them already.... Symeon wants the imperial crown. This has to be conceded, but how can it be made as *'unofficial'* as possible while still acceptable to Symeon? The first thing to do is to avoid the *'obeisance'* (προσκύνησις) due to an emperor from the second estate of the realm, the Roman Senate. So Nicholas takes good care that their representatives are excluded from the ceremony. He then goes to Symeon and crowns him with the black patriarchal *epirrhiptarion*, which, bunched up into the semblance of an imperial *stemma*, is wittily described by our orator as the 'helmet of darkness.' But this is not enough for Symeon. He knows that *'obeisance'* is necessary for a proper coronation, and he goes on to demand this. Nicholas has foreseen this; and he makes it perfectly clear (σαφῶς ἐρῶν) that Roman senators (who, in any case, are not present) cannot make obeisance to any but a Roman emperor. *'No,'* says he (and we are given what purport to be his exact words), 'Wear for a little the diadem which I have improvised for you, and let your fellow-celebrants do you obeisance.' This can only mean that the συνέορτοι ('fellow-celebrants') were Bulgarians, and that the title given to Symeon, or at all events understood by Nicholas to be given, was that of Βασιλεὺς Βουλγαρίας. That Symeon was *'tricked'* into accepting this is clear from the immediately following encomium on the tricks whereby the Patriarch cheated Symeon throughout his life; and also from the fact that, after his withdrawal to Bulgaria, Symeon renewed his demand for obeisance by Romans, and was again put off."[105] Here Jenkins points

[102] Jenkins, "The Peace with Bulgaria," 299.

[103] G. Ostrogorsky, "Die Krönung Symeons von Bulgarien durch den Patriarchen Nikolaos Mystikos," *IzvArhInst*, 9 (1935), 275–86.

[104] Jenkins, "The Peace with Bulgaria," 299.

[105] *Ibid.*, 299–300.

out that, although the term συνέορτοι is a *hapax*,[106] there is "no need to reject it," as Uspenskij has done, for the term συνεορτάσοντας appears in the correspondence of Nicholas Mysticus.[107]

On the basis of this term συνέορτοι Jenkins further suggests that an attempt might be made to establish "where this peculiar coronation took place."[108] According to a version of John Skylitzes and George Cedrenus,[109] which was accepted by Zlatarski, Ostrogorsky, and Dölger,[110] Symeon himself was received inside the city of Constantinople, and the ceremony of the coronation took place in the palace of Blachernae. But Jenkins recalls that, according to the "older" version of the Logothete, only Symeon's two sons were admitted in the City, while Patriarch Nicholas went out to meet the Bulgarian King at the Hebdomon.[111] In that case, it follows that the ceremony took place outside of Constantinople, with the assistance of a "mainly, if not wholly Bulgarian entourage." And Jenkins adds: "It is equally certain that Nicholas would have preferred this, for obvious reasons."[112] These reasons, of course, were chiefly those of security for the Byzantine capital. In support of this assertion, he reminds us that, when in 922 Symeon wanted to enter the City, he was given a very decided refusal, as Nicholas Mysticus reports.[113] The positive result of these meetings was, as Jenkins remarks somewhat ironically, that "Symeon goes off home, after his peaceful inthronisation over his peaceful Bulgars."

The sermon then goes on to describe the change in the relations between Byzantium and Bulgaria during the months immediately following. "This peaceable settlement was rudely overthrown by the palace-revolution of February 914, the expulsion of Nicholas from the regency, and the advent of Zoe's new '*government of eunuchs*' headed by Constantine the Chamberlain, here called '*the new Proteus*.' This government denounced the secret agreement with Symeon...and prepared for war." What comes next in the text is interpreted by Jenkins as an allusion to the war between the Byzantines and the Bulgarians in 917 and the defeat of the Byzantine army by Symeon in the battle at Achelo on August 20 of that year.[114] The first editor of the text at this point failed to grasp the meaning of this passage, and Jenkins writes: "It is hard to understand how Uspenskij...could so totally have misunderstood this very obvious allusion; the orator should indeed have written παραστησαμένους for παραστήσαντας (as, lower down, he should have written

[106] *Ibid.*, 299 note 6.
[107] PG, 111, col. 201D.
[108] Jenkins, "The Peace with Bulgaria," 300.
[109] G. Cedrenus-Joh. Skylitzes, Bonn ed., II (1839), 282 line 18.
[110] Zlatarski, *Istorija*, 364 ff. Ostrogorsky, "Die Krönung Symeons," 276. Dölger, "Der Bulgarenherrscher als geistlicher Sohn des byzantinischen Kaisers," reprinted in *Byzanz und die europäische Staatenwelt* (*supra*, note 25), 192.
[111] On the Hebdomon, see N. P. Kondakov, *Vizantijskija cerkvi i pamjatniki Konstantinopolja* (Odessa, 1886), 198 ff.
[112] Jenkins, "The Peace with Bulgaria," 300.
[113] PG, 111, col. 176A ff.; cf. Jenkins, "The Peace with Bulgaria," 300.
[114] For details, see Zlatarski, *Istorija*, 380 ff.

συνθέμενος for συνθείς), but, apart from this solecism, his reference to the campaign and its commander is as plain as words can make it."[115]

The passage which follows is interpreted by Jenkins[116] as a narration of the ascension of Romanus Lecapenus to the imperial throne. The reference to the *"Nazarenes agreeing"* in the text is explained as expressing the approval of the Byzantine clergy: "All blessings instantly followed his elevation, among which we note '*Nazarenes agreeing*,' in the Tomus Unionis of July 920."[117] The politics of the new Emperor are presented by the Anonymous as "a most versatile display of diplomatic activity" on the part of Romanus I Lecapenus. Jenkins declares that "the meaning of the awkward sentence τοῖς ποικίλοις... πολύτροπος is, the singleminded man may try any number of alternatives to achieve his aim ('*that is what versatility means*'), whereas the ποικίλοι are unstable and have no singleness of purpose."[118] Thanks to other historical sources[119] we know details of this wide diplomatic activity undertaken by the Emperor Romanus at the courts of Egypt and Bagdad, in Serbia, among the Russians, Petchenegs, Alans, Abasgians, and Magyars.

Jenkins recognizes that what follows in the sermon was correctly interpreted by Uspenskij as an allusion to the meeting of the Emperor with Czar Symeon on Thursday, 9 September 923;[120] and he is inclined to accept as a historical fact the author's assertion that it was the Bulgarian ruler who began to speak and that he made "many errors in Greek diction and grammar." The next day, September 10, having made a promise to negotiate for peace, Symeon left. But he did not keep his promise: "But as King David of old was not allowed by God to build His temple because he was a man of blood, for the same reason [the orator believes] Symeon was not allowed to do the holy work of peace-making, which has been reserved for his son Peter. Peter has come, and the treaty has been made...."

After thus recapitulating the contents of the sermon, Jenkins turns to two fundamental questions: first, that of the authorship of this work; and, second, that of the value of our text as a historical source.[121] As regards the first question, he recalls that Uspenskij had "noted some similarities in the content and phraseology of our document with those of the Letters of the Patriarch Nicholas," but had also seen the chronological discrepancy. This chronological discrepancy, says Jenkins, is "decisive against attributing the oration to Nicholas," for the sermon was composed to celebrate the conclusion of the peace between Byzantium and the Bulgarians in October 927, while Patriarch Nicholas Mysticus had died in 925, that is, more than two years before.[122] In

[115] Jenkins, "The Peace with Bulgaria," 300–1.

[116] *Ibid.*, 301.

[117] For details, see V. Grumel, *Les regestes des actes du patriarcat de Constantinople*. Vol. I. *Les actes des patriarches*. Fasc. 1. *Les regestes de 381 à 715*, Le patriarchat byzantin, Ser. 1 (Istanbul, 1932), 169–71, no. 669.

[118] Jenkins, "The Peace with Bulgaria," 301 note 14.

[119] For details, see Zlatarski, *Istorija*, 430 ff.

[120] For details, see *ibid.*, 468 ff.

[121] Jenkins, "The Peace with Bulgaria," 301–3.

[122] *Supra*, note 54. Grumel, *Les regestes*, 148.

addition to this, the Patriarch "himself is referred to, if not actually named...,
in terms which make it nearly impossible that he can have been its author."
Having thus rejected this hypothesis, Jenkins turns to the suggestion I had
offered in my correspondence with Moravcsik: "Who then was [the Author]?
The obvious person to think of is Theodore Daphnopates, the friend and
protoasecretis of Romanus I and the author of Romanus' letters to Symeon.[123]
And indeed, according to Moravcsik,[124] I. Dujčev has already made the
attribution." Here Jenkins reminds his readers that the editor of the cor-
respondence of Romanus I Lecapenus, the Greek scholar John Sakkelion,[125]
had advanced the hypothesis that Theodore Daphnopates was the author of
Books I–IV and VI of the historical work generally known as Theophanes
Continuatus. Sakkelion's suggestion is now generally accepted.[126] The Russian
scholar S. Šestakov[127] tried to analyze the style of Theodore Daphnopates
but, as Jenkins himself had pointed out in a previous article,[128] his "proofs
were not quite convincing"; he now adds: "But the evidence of our oration,
if Daphnopates wrote this too, goes far to confirm the hypothesis...." He
had already indicated that the Continuator of Theophanes wrote under the
influence of Polibius and Plutarch; "It can scarcely be accident that, in our
oration...the author says he can only explain the circumstances of the festival
by 'presenting the occasions and causes, and whence and how those went
before and these followed after.'" A similar assertion in the text of Theophanes
Continuatus is here quoted by Jenkins[129] who concludes, convincingly: "It is
pretty clear that the same hand wrote both passages; and as Daphnopates
has been put forward as the likeliest author of both these works, we can I
think safely assume that he it was."

The second question, discussed briefly by Jenkins, is that of the chronology
of our sermon.[130] He begins by raising the problem of "how reliable" this
oration is "as a source, especially for the 'coronation' of Symeon in 913."
The answer, according to him, is that "the author was a serious historian,
and second, that he was addressing an audience all of whom, from the emperor
downwards, knew the facts." He believes that the Anonymous "was certainly
familiar with the Patriarch Nicholas' letters to Symeon, and may, as a younger
man, have been a patriarchal secretary." This latter surmise is very inter-
esting; it needs, however, further proof. But Jenkins does not stop here, but
adds: "He [Theodore Daphnopates] may even, in that capacity, have gone
with Nicholas to Hebdomon and been present at the 'coronation': at least,
he purports to quote some actual words of Nicholas on that occasion."

[123] Moravcsik, *Byzantinoturcica*, 540 ff.
[124] *Ibid.*, 223.
[125] Sakkelion, Ῥωμανοῦ βασιλέως τοῦ Λακαπηνοῦ ἐπιστολαί, 2 (*supra*, note 37), 39–40.
[126] Moravcsik, *Byzantinoturcica*, 542.
[127] S. Šestakov, in *Actes du Deuxième Congrès International des Études Byzantines* (Belgrade, 1929), 35 ff.
[128] Jenkins, "The Peace with Bulgaria," 302. Cf. *idem*, "The Classical Background of the *Scriptores post Theophanem*," *DOP*, 8 (1954), 13 ff., reprinted in *idem, Studies on Byzantine History of the 9th and 10th centuries* (London, 1970), no. IV, 13 ff. See also M. Sjuzjumov, "Ob istoričeskom trudě Feodora Dafnopata," *Vizantijskoe Obozrěnie*, II (Jur'ev, 1916), 295–302.
[129] Jenkins, "The Peace with Bulgaria," 302.
[130] *Ibid.*, 302 ff.

At the end of his study Jenkins discusses Ostrogorsky's opinion on the description of the ceremony performed in 913, as given by the Byzantine orator, and says,[131] "Ostrogorsky[132] tends to cast doubt on the Chronicle's account of a 'sham' coronation, by which Symeon was tricked. He thinks that Symeon, the 'half-Greek,' could not have been so stupid as to be deceived into thinking that coronation with an *epirrhiptarion* was as good as one with a *stemma*. He believes that the 'trick' was invented ex postfacto, to invalidate a coronation that was perfectly in order." And he adds, "If we maintain this position, as we are still free to do, then Daphnopates, both here and in the Continuation of Theophanes, is merely giving the official version as it was told in 927. However, I am inclined to think there is more to it than that. The orator states that Nicholas practised his deceits on Symeon throughout his life; and adds that, on this very occasion, he cheated Symeon out of a Roman obeisance. It does not seem wholly impossible that Symeon, who had probably never seen an imperial coronation, should have accepted the presence of the Ecumenical Patriarch, his prayer of consecration, and his imposition of some sort of head-gear, however ridiculous, as a valid procedure for his own elevation."

To conclude, Jenkins' study of 1966 represents undoubtedly one of the most valuable contributions to the analysis and interpretation of the anonymous sermon. Some of his conclusions on this historical source can be considered as final. First, it is clear that the author of our document was not the Patriarch of Constantinople, Nicholas I Mysticus, as was suggested by the first editor and uncritically taken up by some recent scholars. It follows that we must look elsewhere for the author of the work. The most likely person appears to be Theodore Daphnopates. But this hypothesis can be accepted as irrefutable only after a thorough analysis of all the historical and philological arguments, as I shall attempt to demonstrate in a special study.[133] Thanks to Jenkins' insistence that the sermon was pronounced on the occasion of the conclusion of the peace treaty between Byzantium and the Bulgarians in October 927, it is impossible to ascribe this work to Nicholas Mysticus. It is now also established that the marginal notes are not the work of an anonymous, later scribe but are contemporary with the original text. Thus, the identification of the different historical personalities mentioned in the text will become easier. Very valuable, too, are the many observations on the text suggested by Jenkins, as well as his translation, which is at the same time a useful interpretation.

Two years after the publication of Jenkins' study, the Belgian Byzantinist Mrs. Patricia Karlin-Hayter wrote an article about our document.[134] She begins by remarking, "We are once more in debt to Professor Jenkins for focusing attention, this time on a known but neglected source of tenth-century

[131] *Ibid.*, 303.

[132] "Die Krönung Symeons" (*supra*, note 103), 278 ff.

[133] "Notes sur l'activité littéraire de Théodore Daphnopate," to be published shortly.

[134] P. Karlin-Hayter, "The Homily on the Peace with Bulgaria of 927 and the 'Coronation' of 913," *JÖBG*, 17 (1968), 29–39.

history. The Ἐπὶ τῇ τῶν Βουλγάρων συμβάσει is neglected because of its obscurity. J. has, with dazzling brilliance, provided the crucial chaps. 11 to 17 with a translation and commentary. The solutions proposed for some of the main difficulties do not convince me. I have not always an alternative to propose, but as I draw, from my more fragmentary one, historical conclusions which are not possible with J.'s interpretation it is up to me at least to make clear how I reach them.''

What are Mrs. Karlin-Hayter's objections to the interpretations and identifications given by Jenkins? First, the identification of Jeroboam, mentioned in the text, with the Byzantine general Leo Phocas. Mrs. Karlin-Hayter objects that "Jeroboam seems to be put on a level with Solomon, in other words to be an emperor. Same impression given by what follows, διὰ τὴν τῶν νεωτέρων βουλήν. It is the *emperor's* counselors one would expect to tear the flock. A suitable emperor is there, Alexander, Leo's brother and immediate successor accused elsewhere of superseding his brother's men by favorites of his own. This reference to the 'counsel of the young men' suggests that not Jeroboam but Rehoboam was meant. Rehoboam 'forsook the counsel of the old men, which they had given him, and consulted with the young men that were grown up with him and which stood before him' (I Ki 12,8).'' The objection is worth considering.

The second observation made by Mrs. Karlin-Hayter concerns the titles given by the Anonymous to the Bulgarian rulers. She recalls[135] that, according to Jenkins, "Symeon is here correctly styled *Archon* since at the outbreak of hostilities he was not yet crowned emperor."[136] On this assertion she notes: "Nowhere in the homily have I found Symeon called βασιλεύς. The βασιλεῖς διχογνωμονοῦντας have made peace in the person of Peter, thus, whether the author of the homily gives Symeon different ranks at different dates or not, here the Bulgarian sovereign had to be βασιλεύς.'' In addition, she points out that Jenkins accepted Ostrogorsky's interpretation of the passage on Symeon's coronation,[137] and comments: "The passage is certainly of extreme interest, and there is no need to insist on the importance of the conclusions J. has drawn. One should not, however, forget that 'extreme discretion' means that identifying what is meant may be rather a subjective process, and, secondly, that Ostrogorsky's elucidation was rejected by Dölger.''[138] Before attempting to give a better explanation of the passage in question, she first quotes it; then she proceeds to confute Jenkins: "My feeling is that the orator who, in an official oration in the presence of Romanus Lecapenus, described the patriarchal *epirrhiptarion* as a 'helmet of darkness' might find he had been too witty by half. Less sacred, perhaps, than imperial vestments, the patriarchal wardrobe was no subject for jokes except with the likes of Michael

[135] *Ibid.*, 29–30.

[136] Jenkins, "The Peace with Bulgaria," 298.

[137] *Ibid.*, 299.

[138] Dölger, "Bulgarisches Zartum und byzantinisches Kaisertum" (*supra*, note 25), 57–68, reprinted in *idem, Byzanz und die europäische Staatenwelt*, 140–58. Cf. also Dujčev, *Medioevo bizantino-slavo*, III (*supra*, note 101), 183 note 3, with additional bibliographical references.

the Drunkard."[139] Moreover, she does not agree with Jenkins that the third ὁ δέ refers to the Patriarch: "It is hard to imagine this being said of Nicholas in any circumstances..." That would be in contradiction with several passages of the homily conceived in praise of the Emperor Romanus Lecapenus. So it seems more likely that here the Emperor Leo VI is intended. "J. suggests that this sentence about honouring peace and being honoured by her applies to Symeon. Neither historically nor in the framework of the homily does he seem to me a possible candidate."[140] Moreover, the expression of the Anonymous "the [imperial] brother" is interpreted by Jenkins as indicating Symeon; Karlin-Hayter finds this interpretation "surely a little strained." However, she is not sure about the identification, for she declares: "the brother, whoever he may be, συναποίχεται leaving to the child [Constantine, by common consent] the sceptre and a regency council...." Following her suggestion, we must accept the possibility that the Emperor Alexander is meant here, and that the "child" could only be the young Constantine VII Porphyrogenitus. A's regards the expression ὑφάψας (ἐφάψας)...προσμένουσαν, she has this to say: "with or without the proposed emendations, I admit that I do not see what the author is driving at, but I can discover no element here that helps or hinders identification."[141] Her conclusion then is that the first and third ὁ δέ indicate "the same person, Leo." But she adds: "A serious obstacle to the identifications I propose would, it is true, arise if the homily said that *on Leo's death* vainglory and ambition swept into the heart of the Archon. But in fact it simply says 'Our affairs flourished once, under Leo, and all was happiness, but misfortune had to come and evil to prevail and at once the torrent of vainglory swept into the heart of the Archon.' This is slightly different."

Let us now look into Mrs. Karlin-Hayter's analysis of the text. She finds "very attractive" emending the term συνεόρτους, found in the MS, to συνόρκους, as Uspenskij proposed. Jenkins, however, accepted the reading of the MS and translates: "called for fellow-celebrants and proposed the confirmation of the covenant." To explain her interpretation of the text, Karlin-Hayter offers other considerations as well. The Bulgarian King Symeon demanded obeisance as emperor, as is evident from a letter of the Patriarch Nicholas.[142] The fact that he turned to the Patriarch with this demand permits us to assume that he had made the same demand earlier of Emperor Leo: "Leo rejected it. But at the same time he managed to prevent war breaking out. In fact it did not break out under Alexander either."

Speaking of the two studies on the problem of Symeon's coronation in 913, that of G. Ostrogorsky and that of Dölger, she has some objections to make on several points. Of the two versions describing the event—that of Symeon Logothete (Greek text and Slavic translation) and that of John

[139] Karlin-Hayter, *op. cit.*, 30.
[140] *Ibid.*, 31.
[141] *Ibid.*
[142] PG, 111, col. 57. Cf. Karlin-Hayter, *op. cit.*, 32.

Skylitzes—she finds that the latter is to be preferred as being "the most reliable" and "a coherent whole." Comparing the two versions, she emphasizes the following: It is clear, first, that "Skylitzes depends for this period almost exclusively on the Logothete" but has tried to clarify the "obscurities" and so his account appears "more lucid." In this passage, too, she says that the "broad basis is the Logothete chronicle." Paying special attention to the difference between the Logothete and Skylitzes, she comes to the conclusion that "we are not in presence of two sources but of two variants of the same source. What did [the original source] say? That *Symeon* was introduced into the palace to eat with the emperor, or *Symeon's sons*? It is, of course, impossible to give a certain answer, but I find the consistency of the earlier tradition, including the Slavic versions, impressive. And if Skylitzes is right, what happened to our older witnesses? Early enough to affect the various families of the text, Symeon fell out of the company admitted into the palace of Blachernae, through a scribe's carelessness or a deliberate altering of the text. I insist on the text, because it is a common text that lies behind both variants, and one of them merely represents a deformation of it."[143] This text is old, but not so old as to be dated with any likelihood to the time of Patriarch Nicholas. However this may be, two sure points have emerged from the previous discussion: "1. that we are not faced with two sources but with two variants of one source; 2. that one of these variants is met with exclusively in all the older families of the text [all those, at least, that are readily accessible], while the other is only represented by a very late tributary of a member of one of these families [Theophanes Continuatus]."

Having stated that foreign sovereigns very rarely were allowed to enter the Byzantine capital, especially during a period of war,[144] Mrs. Karlin-Hayter then raises the question of whether Symeon was admitted into Constantinople and wonders what hostages could be found to make him feel safe. Here she discusses the different hypotheses put forward by Zlatarski, Ostrogorsky, Dölger, and Jenkins on the subject of Symeon's coronation.[145] As "corroboratory circumstances" to Dölger's hypothesis, she notes that the "Slav Logothete twice refers to Symeon as *czar*..., thereafter reverting to *knjaz*."

After mentioning that the Slavic translation of the Chronicle of the Logothete "is not earlier than 948," Mrs. Karlin-Hayter declares that "his [i.e., the translator's] sensitivity to titulature is both overprecise and not precise enough: he should not have used the title *before* the coronation. But on the other hand, why, if he was so precisely informed, did he not make the episode a little clearer for the interested Bulgarian reader? Because, I think, for him the term *czar* had a past, sketchily apprehended rather than precisely charted."[146]

I cannot agree with this explanation given by Mrs. Karlin-Hayter. When turning to the evidence of the medieval Bulgarian translation of the Chronicle

[143] Karlin-Hayter, *op. cit.*, 34.
[144] S. Runciman, *A history of the First Bulgarian Empire* (London, 1930), 156 note 3.
[145] Karlin-Hayter, *op. cit.*, 35.
[146] *Ibid.*, 35–36.

of Symeon Logothete, especially to that concerning the ruler's titles, one must take into consideration the fact that this old Bulgarian translation dates from a later period, namely, from the fourteenth century. The translator, moreover, does not translate titles precisely but adapts his text in view of making it more accessible and comprehensible to his readers. Therefore, the evidence of the medieval Slavic translation of the Chronicle is, in this respect, only of limited value. It is also possible that it was a later copyist, and not the translator himself, who introduced certain changes in the official terminology. Thus, one must be very cautious in drawing conclusions based on these passages of the Chronicle in its Slavic translation.

As to Ostrogorsky's study, Mrs. Karlin-Hayter has this to object:[147] "It is suggested that there is a complete change in the tone of Nicolas' letters after August 913. This is perhaps a little misleading. In spite of the prayers and entreaties, the circumlocutions and confusion, and even the absence of the word *archon*, Nicolas' letter 8 is not a general lamentation on the insatiability of man, but another lesson on the impiety of trying to overthrow the order established by God and seize by violence titles and honours He has ordained for others...." After quoting several passages from this letter of the Patriarch, she concludes: "In short, one cannot prove that there was no coronation in 913, but no source says there was, only that Symeon would have liked one but got instead a benediction and a scarf laid on his head. The coronation is the imaginative interpretation of a cryptic remark, supporting evidence is doubtful while, on the other hand, there are undoubted objections to it."[148]

Thus she refuses to believe that the passage describes the coronation of the Bulgarian ruler by the head of the Constantinopolitan Church and attempts to explain the significance of the ceremony in a different way. Turning to the interpretation proposed by Dölger, she is inclined to accept that here are "essential features of an official spiritual adoption,"[149] which is to be understood as the admission into the Byzantine "family of princes and peoples"; she leaves, however, other difficulties unresolved. After quoting a long passage of Dölger's study of the event, Mrs. Karlin-Hayter analyzes certain expressions of paragraph **13** and declares:[150] "[Paragraph] **13** alludes in my opinion to relations between Symeon and Leo VI. The 'helmet of Hades' is the usual metaphoric headgear, never inappropriate to Symeon. What lies behind the allusion to the Senate escapes me." In my opinion, Mrs. Karlin-Hayter's explanation is refuted by the well-known historical evidence. She affirms: "The actual information to be drawn from this part of the oration seems to be that already under Leo VI Symeon was claiming the title of βασιλεύς and asking for προσκύνησις from Ῥωμαῖοι." After quoting the sentence that follows, Ἢ βραχὺ τιθεὶς τὸ περινοηθέν σοι διάδημα προσκυνητὰς ἔχε τοὺς συνεόρτους, she goes on to explain: "[an] opposition, as Jenkins points out, between the προσκυνηταί he could not have, the Ῥωμαῖοι, and those he could, described as his συνεόρτους."

[147] *Ibid.*, 36 ff.
[148] *Ibid.*, 37.
[149] *Ibid.*
[150] *Ibid.*, 38.

If we accept the hypothesis that Patriarch Nicholas Mysticus staged, in 913, a sham coronation of Symeon, the passage quoted by Jenkins would be clear. Also, the Bulgarian King was crowned, only briefly, not with the real imperial crown, but with a fake diadem and had as "worshippers" only those present at the ceremony, not the subjects of the Empire. The so-called "coronation" of Symeon is made to appear as a farce, or, at least, the Anonymous, together with some other Byzantine authors, tried to present *post factum* as a farce a ceremony which had actually taken place, with the intention of minimizing its real significance.

Mrs. Karlin-Hayter considers other points in the text of the sermon. She disagrees with Jenkins' translation, "denouncing the secret agreement with Symeon," which she thinks interprets too freely the Greek συκοφαντοῦντας τὰ τοῦ κράτους ἀπόρρητα; and as a matter of fact, the exact translation of this phrase is: "those who are denouncing the secrets of the Empire [or: of the Emperor]." As regards the interpretation of "those who played Jeremiah and Isaiah to him," she quotes Jer. I: 15–19 with its reference to the kingdoms of the North and the gates of Jerusalem. On the term παραστήσαντας (and also συνθείς) she notes:[151] "This would deservedly lose a schoolboy a mark, but the author not only knows Greek but writes educated Greek with all the literary Byzantine's excessive fondness for verbal tricks." She reminds us further that the Anonymous uses "irreprochably" this expression at the end of paragraph **20**, "so that a lapse so patent seems hardly possible." And she adds: "Perhaps it is, on the contrary, a piece of wordplay whose subtlety escapes us." Analyzing single terms and expressions, Mrs. Karlin-Hayter finds that "the account of the meeting between Symeon and Roman[us] is full of details that concord with the account of the chronicler."[152] As a parallel text she quotes only one passage from Theophanes Continuatus (ed. Bonn, 407 line 12ff.); but I should like to point out that the similarities are easy to explain if we accept that the author of both works—the Homily and this part of the *Continuatio Theophanis*—was one and the same person—that is, Theodore Daphnopates. She then quotes that phrase of our sermon where it is said that Symeon πολλὰ μὲν βαρβαρίζων, πλείω δὲ σολοικίζων.... This assertion of the Anonymous, she says, represents "perhaps a counterblast to the flattering term of ἡμιαργός applied to Symeon according to the Antapodosis" of Liutprand of Cremona. The contradiction between the two historical sources has been pointed out before; its explanation, however, is unconvincing. Is one to see here a rhetorical exaggeration, deliberately directed against the Bulgarian ruler, or is a different interpretation possible? Mrs. Karlin-Hayter suggests that "the barbarisms and solecisms could be moral ones: the low jokes with which Symeon began the interview" with Romanus Lecapenus, as is indicated by Nicholas Mysticus.[153] The first interpretation of this phrase, however, seems to me more likely.

[151] *Ibid.*
[152] *Ibid.*
[153] PG, 111, col. 189; cf. Karlin-Hayter, *op. cit.*, 39.

The suggestion concerning the translation of the phrase εἰ γὰρ τὸ ἐξ Αἰγύπτου παραιτεῖται σιδήριον is interesting: "For if He [God] rejects the iron from Egypt, how shall He rejoice in a bloody hand?"

Finally, let us quote the conclusion reached by Mrs. Karlin-Hayter as the result of her detailed and careful analysis: "The author of the homily has been the object of much speculation but never backed up by arguments as precise and solid as the two quotations produced by J. We can now hardly doubt that the author of books I–IV and VI of Theoph. Cont. is responsible for the homily, whether or not he was Daphnopates. J. writes: 'I thought Šestakov's proofs were not quite convincing: and I still think that, in themselves, they are not.' To them must now be added the suitability of Daphnopathes, 'the friend and protasekretis of Romanus I and the author of Romanus' letters to Symeon,' as author of the homily. J. seems to have built up a very strong case. This double identification is capital for assessing the reliability of the homily. Though differing considerably when it comes to its interpretation, I agree with J. that it is a source of a very high order, and I feel that detailed discussion can only further understanding of it."

The present study was begun some years ago; certain circumstances, however, delayed its publication. In the meantime there appeared a detailed article in Greek by the young Byzantinist Mrs. Alkmene Stauridou-Zafraka, under the title "The Anonymous Sermon 'On the Peace with the Bulgarians'."[154] This article deserves our special attention. In the introductory part Mrs. Stauridou-Zafraka endeavors to throw new light on some fundamental problems concerning the anonymous work. She begins by describing Codex Vat. gr. 483, which contains the sermon. Relying on Uspenskij and Devreesse, she offers only a few general indications. The notes made by Hase in the Bibliothèque Nationale[155] are known to her, it seems, only indirectly, through Uspenskij's reference. On the marginal glosses to the text of the sermon, she agrees with Jenkins that they were written by the copyist of our text, hence, that they date from the thirteenth–fourteenth century; they could have been copied from an older protocopy, but in no case could they have been written by the author of the sermon itself.

As to the date of this literary work Mrs. Stauridou-Zafraka believes that the correct one is the almost generally accepted date 927, when the Byzantine Empire and Bulgaria concluded the peace treaty. She discusses further the question whether the sermon was in fact delivered in public or not. According to Jenkins it was pronounced in the imperial palace, while Mrs. Stauridou-Zafraka subscribes to Uspenskij's opinion that it was delivered in one of the churches in Constantinople.

The most important problem, however, is that of the authorship of the sermon, and Mrs. Stauridou-Zafraka analyzes the four main hypotheses put forward in the studies in which the matter is discussed and in which the

[154] A. Stauridou-Zafraka (Zaphraka), Ὁ Ἀνώνυμος λόγος "Ἐπὶ τῇ τῶν Βουλγάρων συμβάσει," Βυζαντινά, 8 (1976), 345–406.

[155] *Supra*, note 7.

sermon is variously attributed to: 1. the Patriarch of Constantinople, Nicholas Mysticus; 2. the patrician Nicetas Magistros; 3. Arethas; 4. the writer Theodore Daphnopates. After a careful analysis she rejects all the suggestions made by previous scholars. The authorship of Patriarch Nicholas Mysticus is improbable because of chronological incongruity: if we accept 927 as the date of the sermon, the Patriarch, who died in May 925, could not have been its author; moreover, no convincing linguistic and stylistic analogies can be traced between the letters of Nicholas Mysticus[156] and the sermon. It was the French Byzantinist J. Darrouzès, who came to the conclusion that the author of the sermon must have been the patrician Nicetas Magistros, a close relative of the Emperor Romanus I Lecapenus.[157] The literary activity of Nicetas is fairly well known: he wrote in all probability the Life of Saint Theoctiste of Lesbos[158] and thirty-one epistles.[159] However, when about 927 Nicetas Magistros was suspected of treason, he lost the favor of the Emperor and was exiled. The author of the sermon was in all likelihood a person of importance in Constantinople toward the end of 927 or the beginning of 928, when the sermon was delivered, so he could hardly be identified with a man who at that very time was suspected of plotting against the Emperor and had fallen in disgrace. In any case, Mrs. Stauridou-Zafraka characterizes briefly the correspondence of Nicetas as being essentially different from the style and contents of our text.

Neither does Mrs. Stauridou-Zafraka find convincing the hypothesis advanced by the late Russian Byzantinist M. Šangin[160] that the author of the sermon was the Metropolitan of Caesarea, Arethas. She completely agrees with L. G. Westerink's statement that there is "*in ea [oratione de pace] nihil quod Arethae proprium sit.*"[161]

Finally she subjects to criticism the hypothesis, first proposed by me and accepted as correct by Jenkins, Mrs. Karlin-Hayter, and Westerink, that the author of the sermon was Theodore Daphnopates. After giving some biographical data on this Byzantine personage, she concludes that the arguments offered in favor of this theory are not sufficient. The comparative analysis of Mrs. Stauridou-Zafraka is restricted to analogies between the vocabulary and phraseology of the sermon and the correspondence of Theodore Daphnopates on the one hand, and the works of Arethas and the text of the so-called Theophanes Continuatus on the other.[162] In spite of the fact that the analogies with the works of Arethas are, in her opinion, more numerous as

[156] For the new critical edition of the Greek text and the English translation by R. J. H. Jenkins and L. G. Westerink, see *supra*, note 30. Cf. Stauridou-Zafraka, *op. cit.*, 351–52.

[157] J. Darrouzès, "Inventaire des épistoliers byzantins du Xᵉ siècle," *REB*, 18 (1960), 126. Cf. Stauridou-Zafraka, *op. cit.*, 352–53.

[158] BHG³, ed. F. Halkin, II, 270, nos. 1723–24.

[159] Nicétas Magistros, *Lettres d'un exilé (928–946)*, ed. and trans. L. G. Westerink (Paris, 1973).

[160] See *supra*, note 77. Cfr. Stauridou-Zafraka, *op. cit.*, 353 ff.

[161] L. G. Westerink, *Arethae scripta minora*, II, Teubner (1972), p. ix ff. Cf. Stauridou-Zafraka, *op. cit.*, 353 ff.

[162] Stauridou-Zafraka, *op. cit.*, 358 ff.

compared to those with the works of Theodore Daphnopates and "Theophanes Continuatus," she has to admit that there is no sufficient evidence for attributing the authorship to Arethas with any certainty.

At the end of her analysis Mrs. Stauridou-Zafraka comes to the conclusion that to none of the above-mentioned writers could the authorship of the sermon be ascribed. So she goes back to the first editor of the sermon, Uspenskij, who preferred to consider it an anonymous work and whose opinion Mrs. Stauridou-Zafraka shares—as indeed she clearly implies in the very title of her study.

"Within the text of the sermon," writes Mrs. Stauridou-Zafraka, "one finds only a few allusions to the author's personality; moreover, they are often obscure." If we accept as concrete and reliable the allusions in paragraph **3**, then it follows that the author of this literary work was "a member of the ecclesiastical hierarchy, that he was connected with the imperial court, and that he belonged to some literary circle."

Next, she concisely examines the contents of the sermon,[163] emphasizing the moments which are most significant from a historical point of view. The complete text is then reproduced,[164] and identifications of the quotations and allusions are given, together with the *variae lectiones* from the Vatican MS and previous editions of the text, and the proposed emendations (especially those of Kurtz and Jenkins). Compared with the text established by Jenkins and myself and given in the present edition, the divergencies are only few. As to the identification of the numerous quotations and allusions, Mrs. Stauridou-Zafraka is able to enrich here and there the indications of the previous editions, thanks especially to some more recent publications. Of particular interest is her commentary to the text,[165] which is examined from a historical and philological angle. Certain interpretations and explanations differ from, and sometimes are even the opposite of, our own.

Considering all the publications we have discussed, especially after the study of Mrs. Stauridou-Zafraka, one might well question the necessity of a new edition of the sermon. But to my mind not all problems connected with this literary work have been definitively solved; not all doubts have been cleared. To begin with, it is necessary to bring out fully the importance of our text as a historical and literary document connected with some decisive events in the life of the Byzantine Empire during the tenth century. It must be admitted that the accurate interpretation of the contents of this literary work is particularly difficult. The author of the oration does not express his thoughts in simple language, as is the case with other Byzantine writers, but resorts to allusions, images, and vague indications, which no doubt were intelligible to his listeners who were contemporaries with the events alluded to. Today's scholars flounder in the midst of the rhetorical language.

[163] *Ibid.*, 360–62.
[164] *Ibid.*, 363–80.
[165] *Ibid.*, 380–404.

The text as presented by Mrs. Stauridou-Zafraka is satisfactorily edited. But to her study, which is published in Greek, a translation of the sermon in one of the more commonly known modern European languages should have been added. This omission is redressed by the English translation made by the late Romilly Jenkins which is included in the present edition. The bibliographical data of Mrs. Stauridou-Zafraka is incomplete, various contributions on the subject were either not known or inaccessible to her. This fact must necessarily have had some influence on the author in limiting her grasp of the problems concerning the oration.

There is no need to repeat here the arguments against the attribution of the work to Nicholas Mysticus, Nicetas Magistros, or Arethas of Caesarea, for this was briefly but convincingly disposed of by Mrs. Stauridou-Zafraka. But then who among the other writers of the first half of the tenth century was the most likely author of this sermon? In all probability this writer was Theodore Daphnopates. Let us recall what we know about the main facts of his life. The dates of his birth and death are not known. What is known is that he lived during the reign of the Emperor Romanus I Lecapenus (920–44) or, rather, of Constantine VII Porphyrogenitus (913–59) and his son Romanus II (959–63), and that he occupied an important position in the civil hierarchy. During the initial years of the reign of Romanus I Lecapenus, in all probability in 925, Theodore Daphnopates was appointed *mystikos* (confidential secretary) to the Emperor, with the honorary title of *magistros*. While in this office, he wrote a number of official letters in the name of the Emperor. It is accepted by scholars that the letters of Romanus I Lecapenus addressed to the Bulgarian Czar Symeon between the years 925 and 926[166] were actually written by Theodore Daphnopates:[167] "Diktat: Theodoros Daphnopates" (Dölger); "Verfasst wahrscheinlich von Theodoros Daphnopates" (Moravcsik). We know, moreover, that Theodore Daphnopates composed some literary works. In all probability he is the author of a Life of St. Theodore the Studite.[168] He also composed a selection of the sermons of St. John Chrysostom.[169] Further, to him is attributed Book VI of "Theophanes Continuatus," which contains the history of Byzantium under the Emperor Leo VI (886–912), his brother Alexander (912–13), Constantine VII Porphyrogenitus, and Romanus I Lecapenus, and includes also the first years of the reign of Romanus II. This comprises the period from 886 to 963. He was probably also the editor of the entire "Theophanes Continuatus."[170] Some

[166] For bibliographical references, see Moravcsik, *Byzantinoturcica*, 502–3.

[167] Dölger, *Regesten* (*supra*, note 9), 74–75, nos. 606–608. Moravcsik, *Byzantinoturcica*, 502. Cf. also D. Obolensky, *The Byzantine Commonwealth. Eastern Europe, 500–1453* (London, 1971), 116: "The Bulgarian peace treaty of 927 was celebrated in an oration delivered in the same year in the palace, probably by Theodore Daphnopates, a high imperial official and the author of Romanus' letters to Symeon."

[168] *BHG³*, II, 279, no. 1755.

[169] S. Lambros, in *Neos Hellenomnemon*, 1 (1904), 186. Stauridou-Zafraka, *op. cit.*, 354. For other references on the literary activity of Theodoros Daphnopates, see Beck, *op. cit.* (*supra*, note 10), 552–53, 551, 484. Krumbacher, 151 § 3, 161, 170, 348, 367, 399, 459. Runciman, *The Emperor Romanus Lecapenus* (*supra*, note 24), 2.

[170] Moravcsik, *Byzantinoturcica*, 540 ff.

scholars even go so far as to consider him the author of Books I–IV of that work.[171] As Jenkins pointed out,[172] it is possible to find many analogies between the text of "Theophanes Continuatus" and those works whose author is beyond all doubt Theodore Daphnopates. As I have mentioned above, it is my hope to publish in the near future a special comparative linguistic study in support of the claim that Theodore Daphnopates is indeed the author of the sermon.

[171] Cf. Stauridou-Zafraka, *op. cit.*, 354 and note 45. Moravcsik, *Byzantinoturcica*, 542 ff.

[172] Jenkins, "The Classical Background of the *Scriptores post Theophanem*" (*supra*, note 128), 13 ff.; reprinted in *idem, Studies* (*supra*, note 128).

SIGLA

V — Cod. Vatic. gr. 483, fols. 43–51	Du — corr. Dujčev
Jk — corr., con. Jenkins	Ku — corr. Kurtz
Me — corr. Mercati	Us — legit, corr. Uspenskij

ΕΠΙ ΤΗΙ ΤΩΝ ΒΟΥΛΓΑΡΩΝ ΣΥΜΒΑΣΕΙ

1. Εἰρήνην ὑμνοῦμεν, εὐφράνθητε· εἰρήνην ἀφ' ὕψους,[1] σκιρτήσατε· εἰρήνην ἐπὶ τὰς πόλεις Σιών,[2] αἱ θυγατέρες Ἱερουσαλὴμ[3] συγχορεύσατε. ἀλαλάξατε συμφώνως πᾶσα πνοή·[4] ὅσοι τε χθὲς ἐτρυχό-
5 μεθα, καὶ ὅσοι σήμερον ἀνεκλήθητε· ὅτι προσέσχεν εἰρήνη τοῖς ὑπομέ-
νουσιν αὐτὴν καὶ εἶδεν ἰδοῦσα τὴν κάκωσιν τοῦ λαοῦ αὐτῆς· ὅτι εὐδόκη-
σεν ἐπὶ τὴν τῶν ταπεινῶν προσευχὴν καὶ τοὺς ἐν ἀθυμίᾳ πεπεδημένους
ἐρρύσατο. ὁ αἰθὴρ σταλαξάτω γλυκασμόν,[5] καὶ οἱ βουνοὶ ἀγαλλίασιν,[6]
καὶ νάπαι καὶ ποταμοὶ συγκροτείτωσαν.[7] ὅτι ὁ πόλεμος πεπολέμωται
10 καὶ νενίκηται, καὶ ἐπὶ πᾶν ἀνάστημα καὶ ὕψωμα γῆς κατὰ τῆς ἔχθρας
ἵστανται τρόπαια. εἴ τις φιλόνεικος,[8] εἴ τις φιλαίτιος, ἐκχωρείτω· ἀνέστη
γὰρ εἰρήνη καὶ διασκορπισθήτωσαν οἱ ἐχθροὶ αὐτῆς, καὶ κηροῦ δίκην
ἐκ πυρὸς ἐκλιπέτωσαν·[9] οὐ γὰρ μὴ θεάσηται δόξαν εἰρήνης ὄμμα βάσκα-
νον,[10] ἢ ὑπὲρ τὸν Σεδεκίαν ἀμαυρωθήσεται.[11] ὅρα μοι τὰς φαρέτρας ὁ
15 βλέπων εἰς ἄροτρα, καὶ τὰς ζιβύνας εἰς δρέπανα, καὶ πρόσθες, καὶ γὰρ
ἐν πνεύματι, ὅτι οὐ μὴ μάθωμεν ἔτι πολεμεῖν.[12] ἡ νὺξ κατὰ τὸν εἰπόντα
προέκοψε, καὶ αὕτη ὡς ἑωσφόρος λελουμένος ἀφ' ὕδατος προέκυψε τὸν
ὁρίζοντα.[13] ἐπειχθῶμεν πρὸς τὴν λάμψιν αὐτῆς καὶ τῷ φωτὶ αὐτῆς
ὑπαντήσωμεν. ὅτι ζωὴ ἐν τῇ δεξιᾷ αὐτῆς καὶ τῇ ἀριστερᾷ εὐζωΐα
20 προτείνεται, ἀπὸ διαδήματος αὐτῆς εὐφροσύνη καὶ ἡ φθογγὴ αὐτῆς
θανάτου κατάλυσις.

2. Ποῦ μοι τοσοῦτον, ὦ θεία καὶ κλήσει καὶ πράγματι,
προδιέτριβες; ποῦ μοι δίχα τῶν σῶν συνεδρίαζες; ἢ καὶ σὺ λευκοῖς
καλυψαμένη χιτῶσιν, ὡς λέγουσιν, ὅτι τὸ ἐν ἡμῖν μῖσος ἐμίσησας,
25 ἀνεπτερύξω πρὸς Ὄλυμπον;[14] ὑπὲρ τὸν ἐκ τρικυμίας ὅρμον ἐφιλήθης
ἡμῖν, ὑπὲρ τὸν ἐκ χιόνος ἀνέφελον ἥλιον. ὅσον ἐμάκρυνας ἀφ' ἡμῶν καὶ
ηὐλίσθης ἐκκλίνασα ἡ Ἀκεσίου σελήνη,[15] καὶ οὐδαμοῦ τὰ ἡμέτερα ὁ

2–3 Εἰρήνην ὑμνοῦμεν...σκιρτήσατε VMeJk: Εἰρήνη ἀφ' ὕψους, σκιρτήσατε. εἰρήνην ὑμνοῦμεν, εὐφράντητε Us ‖ 4 χορεύσατε Us ‖ 5–6 ὑπομένουσι Us ‖ 16 πολεμεῖν corr. Jk: πολέμων Us

[1] Cf. Eccl. 12:5.
[2] Num. 21:26–28; Jos. 13:10.
[3] Cant. 2:7; 3:5, etc.
[4] Ps. 65:1; 97:4; 150:6.
[5] Amos 9:13; Joel 3:18.
[6] Ps. 64:13.
[7] Ps. 97:8.
[8] Ez. 3:7.
[9] Ps. 67:2–3.
[10] Cf. Deut. 28:54–56; Sir. 14:8.
[11] Jer. 52:11.
[12] Cf. Is. 2:4.
[13] Cf. Homerum, *Il.* 5.5–6; 23.226–28.
[14] Hesiodus, *Op.* 197–200.
[15] Diogenianus Epicur. I.57; Suidas, *Suidae Lexicon* T 512 (ed. Adler, III, 541); cf. E. L. Leutsch et F. G. Schneidewin, *Corpus Paroemiographorum Graecorum* (Göttingen, 1839; reprint, Hildesheim, 1965), I, 189–90.

ON THE TREATY OF THE BULGARIANS

1. We sing of peace, and be ye glad! Of peace from on high, and do ye leap for joy! Peace upon the cities of Sion, and do ye dance together, ye daughters of Jerusalem! Let all that have breath cry aloud in unison, as many of us as were yesterday afflicted and are redeemed today: forasmuch as peace hath regarded them who waited upon her, and hath seen with her eye the tribulation of her people: forasmuch as she hath approved the prayer of the humble and delivered those that were fettered in despondency! Let the sky distil sweetness and the mountains joyfulness, let the vales and rivers clap their hands together; forasmuch as war has been warred upon and defeated, and upon every rising and elevated ground stand trophies erected over enmity. If there be any lover of strife, any contentious man, let him stand away: for peace has arisen, and let her enemies be scattered and be melted like wax by the fire: for the eye of envy shall not behold the glory of peace or that eye shall be dimmed more than Zedekiah. See with prophetic eye our quivers turned into ploughshares and our spears into sickles, and add, in spiritual exaltation, "we will no longer learn to make war!" The night, in the poet's words, is far advanced, and she, like Lucifer bathed in the waters, has emerged above the horizon. Let us hasten toward her brightness and salute her light, forasmuch as life is proffered in her right hand and prosperity in her left, cheerfulness shines from her diadem, and her voice is the doing away of death.

2. Where, o holy one in name and deed, hast thou tarried so long until now? Where hast thou sat in counsel apart from thine own? Or didst thou, clad, as they say, in white garments, fly up to Olympus, because thou hatedst the hatred among us? Thou wast loved by us above the haven from the tempest, above the sun undimmed by snow clouds. For so long as thou wast far from us and dwelledst apart like the blue moon of Akesios, and our state

Ed. Note: The reader will find a few minor discrepancies between this translation and the text. These occur because the late Romilly J. H. Jenkins finished his translation before Professor Dujčev completed his critical edition.

Ἐνδυμίων ἐξ ὕπνου[16] καὶ τῷ αὐχμῷ [ἐ]πιεζόμεϑα· μετὰ Στέντορος εἶχον
εἰπεῖν τὸ ᾀδόμενον, καὶ τῷ Κροίσου παιδὶ[17] συνεσίγησα μετὰ τοῦ ἐν
30 Δωδώνῃ χαλκείου,[18] καὶ ἰχϑύων ἀφωνότερος[19] γέγονα. καὶ γὰρ τῷ
Ἰακὼβ συνήλγησα τὴν ψυχὴν[20] καὶ ποταμοὺς δακρύων[21] κατήγαγον.
οὐ τὸν χιτῶνα διεψευσμένοις λύϑροις ἰδών, οὐδὲ τὸν ζῶντα νεκρὸν
ὀδυρόμενος, οὐδὲ πιστεύσας τοῖς ἀπατῶσιν, ἀλλὰ τοὺς πεποϑημένους
αὐτούς, τοὺς ἀϑῴους, τοὺς ἀναιτίους διατετμημένους ὁρῶν καὶ μεμο-
35 λυσμένους ἐν αἵματι. ναὶ δὴ καὶ τῷ Ἱερεμίᾳ[22] συγκέχυμαι τὸ πνεῦμα καὶ
συντετάραγμαι τὰς τῆς Σιὼν ϑυγατέρας[23] τεϑεαμένος, τὰς τιμίας, τὰς
ἀπειϑεῖς, τὰς οἷον ἀστέρας καὶ ὀφϑαλμοὺς διαστραπτούσας τοῖς πέρασι,
τὴν προτέραν περιῃρημένας εὐπρέπειαν, ἀπημφιεσμένας τὸν ἑαυτῶν
κόσμον καὶ κειμένας πτῶμα αὐτῶν τε τῶν προφητικῶν καὶ τῶν Ἡρακ-
40 λείτου τοῦ ξένου[24] δακρύων ἐπάξιον. οἴμοι ὅτι γέγονε καὶ πάλιν ἡ γῆ
ἀόρατος καὶ ἀκατασκεύαστος εἴτε τῶν ὁρώντων ἀπόντων — ἀοίκητον
γὰρ ἅπαν οἰκούμενον οὕτω τῆς ζωῆς τῷ ϑανάτῳ καταποϑείσης — εἴτε
τῆς πάλαι κατασκευῆς ἀποσκευασϑείσης τῷ παμφάγῳ πυρὶ[25] καὶ τοῖς
πέλυξιν, ὡς μηδὲ γινώσκειν ἡμᾶς ὅπη γῆς ἐσμεν καὶ ὅποι βαδίζομεν. οἷς
45 ἔτι καὶ νῦν ἐγὼ καίτοι τῆς περιχαρείας ἤδη καλῶς ἐνδημούσης σκοτο-
δινῶ καὶ ἠλλοίωμαι καὶ τοῦ πάϑους οὐκ ἐπανέρχομαι.

3. Ἡ γὰρ ὑπερβολὴν ἀνίας τὰ πραχϑέντα καταλιμπάνει·
τείχη κατηδαφισμένα, ναοὶ πυρακτούμενοι, χαρακτῆρες ϑεῖοι φλεγόμε-
νοι, ἱλαστήρια κατερρίμμένα, ἱερεῖς αὐτῷ τῷ ἐφοὺδ[26] ἀπαγόμενοι, κει-
50 μήλια ϑεῖα συλούμενα, κῶμαι καὶ χῶραι κατεστραμμέναι, καὶ ἔτι πρὸς
τούτοις πολιὰ καταικιζομένη, ἄωρος ϑεριζομένη νεότης, παρϑένων αἰδὼς
ἀναιδῶς ἑλκομένη, τὸ συγγενὲς διχαζόμενον, καὶ συνόλως εἰπεῖν, τὰ
ϑνησιμαῖα τῶν ὁσίων Κυρίου κυσὶ καὶ κόραξιν ἑλώρια κείμενα.[27] τῆς

28 post ἐξ ὕπνου lac. susp. Jk ‖ 36–37 τὰς τιμίας…ὀφϑαλμοὺς V:
τάς τε βίας τὰς ἀπειϑεῖς…ὀφϑαλμοὺς leg. Us τοῖς βιασταῖς ἀπειϑεῖς
τὰς οἷον ἀστέρας τοὺς ὀφϑαλμοὺς corr. Us ‖ 37 διαστραπτούσας V:
διαστραφείσας coni. Jk ‖ 40–41 ἡ γῆ ἀόρατος καὶ ἀκατασκεύαστος
εἴτε τῶν ὁρώντων VKu: ἀνήροτος…τῶν ἀρούντων coni. Us ‖
41 εἴτε τῶν: ἤτε τῶν leg. Us ‖ 53 ἑλώρια corr. Us: ἐλλώρια V

[16] Zenobius III.76: cf. Leutsch-Schneidewin, I, 75. [17] Herodotus I.34.
[18] Homerus, *Il.* 5.785–86; Zenobius VI.5: cf. Leutsch-Schneidewin, I, 162
et D. K. Karathanasis, *Sprichwörter und sprichwörtliche Redensarten des Alter-
tums* … (Munich, 1936), 49–50.
[19] Theoph. Cont. (Bonn. ed.), 102, 13; I. Dujčev, Iz starata bŭlgarska knižnina
(Sofia, 1944), II, 310.
[20] Gen. 37:24–35. [22] Jer. 9:1.
[21] Cf. Lam. 2:18; Dujčev, *SBN*, 4 (1935), 135. [23] Is. 3:16.
[24] The Greek philosopher of the sixth century B.C.; E. Wellmann, *RE*, VIII,
coll. 504–8: "als ewig weinenden Philosophen"; Lucianus, *Vitarum auctio* 14.
[25] Euripides, *Medea* 1187. [26] Cf. I Regn. 14:3.
[27] Cf. III Regn. 20 (21):24; IV Regn. 9:10, 36; Lucianus, *Tim.* 8.

knew, like Endymion, no awakening, and we were crushed down in squalor, then was I like one who speaks — as the proverb says — with Stentor, then was I silent as the son of Croesus with the gong of Dodona and became more voiceless than fishes. For I was grieved in soul like Jacob and shed tears in rivers. The garment I saw was defiled with no imaginary filthinesses; the dead whom I bewailed was no living man; they were no deceivers in whom I put my trust. It was my beloved ones themselves, the innocent, the harmless, whom I saw quartered and befouled with blood. Yea, and with Jeremiah I was confused and troubled in spirit at sight of the daughters of Sion, the honorable, the inflexible, their starry eyes contorted in every direction, shorn of their former modesty, stripped of their decent apparel, and lying corpses which would have moved the tears of the prophet or of the pagan Heracleitus. Alas that the land should once more lie uncared for and untilled, either because there was no one to care for it (for the whole habitation was uninhabited, so completely had life been swallowed up by death), or else because its former instruments had been ruined by all-devouring fire and axes, so that we could not even recognize in what region we were or whither we were going: at which, even now that joy has fairly come to dwell with us, I faint and turn pale and cannot put off my grief.

3. In truth, what has been done leaves behind it an excess of anguish: walls demolished, temples burnt, holy pictures devoured by fire, sanctuaries thrown down, priests in their ephods carried away, holy treasures plundered, villages and towns destroyed: nay, what is more, old age tormented, unripe youth a prey to the sickle, virgin modesty abducted without shame, families disrupted, and, in general, the corpses of the Lord's holy ones lying a prey to dogs and

παραπληξίας, τῆς σκοτομήνης, τῆς τῶν δρώντων ἀναλγησίας, τῆς
55 ἀλγεινῆς τῶν πασχόντων κακώσεως. τὸ χεῖρον ἔτι, ὅτι μὴ ἀλλογενεῖς
ἀλλοφύλοις μηδὲ ἀλλογλώσσοις ἀλλόγλωσσοι, υἱοὶ δὲ πατράσι καὶ
ἀδελφοῖς ἀδελφοὶ καὶ πατέρες υἱοῖς ἀντέστημεν, ἐπανέστημεν. τούτοις,
εἰ χρὴ κατὰ τὸν Ἀσκραῖον[28] εἰπεῖν, ἐπαχνώθη μοι φίλον κῆρ καὶ σίδηρον
διῆλθε, τὸ τοῦ ψάλλοντος,[29] ἡ καρδία μου, ὡς μὴ θέλειν ἔτι με ζῆν καὶ
60 ὁρᾶν τὴν ἡλίου φαιδρότητα· ὅτι δίχα νόσου νοσοῦμεν ἀνίατα καὶ δίχα

fol. 44

παρακοπῆς παρακόπτομεν, καὶ δίχα τῆς Αἰγυπτίων ἀχλύος | ἀχλυού-
μεθα χείρονα.[30] καὶ νῦν ὁ Ἰσραὴλ Ἰούδας καὶ Ἐφραὶμ ἐγενόμεθα,[31] καὶ
διειλόμεθα τὴν οὐσίαν ἀμφότεροι, καὶ οἱ φίλοι καὶ οἱ πλησίον ἐχθρῶν
ἀσπόνδων γεγόναμεν ἀσπονδότεροι. καὶ ταῦτα δόξης προσκαίρου καὶ
65 στεφάνου χάριν ἑνὸς καὶ τούτου περιττοῦ τινος καὶ ἀκαίρου, ὑφ' οὗ τὸ
πᾶν ἄνω καὶ κάτω δεδόνηται. ὑφ' οὗ καὶ νῦν ὁ δόλοις τε καὶ μεθόδοις
μόλις τὸν παλαιὸν ἄνθρωπον ἀπατήσας καὶ τῆς Ἐδὲν ἀποστήσας τῆς
οἰκουμένης ἀπονητὶ κατωρχήσατο.[32] τούτοις διεκόπην ὑπὲρ τὸν ἰλιγ-
γιῶντα τὸν λόγον καὶ ἡ γλῶσσά μου τῷ λάρυγγί μου κεκόλληται·[33]
70 ὅτι συνῆκα καὶ κατενόησα ἃ μὴ ὤφελε, μήτε διανοηθῆναι, μήτε γενέσθαι.
καὶ ὥσπερ τὰ ἐμφωλεύοντα τῶν ζώων ταῖς ὀπαῖς διὰ τὸν κρυμὸν
συστελλόμενα τὸ πᾶν δαπανῶσι καὶ ἐκπιέζουσιν ἕως ἠρινῇ διαυγάσει
ἡμέρα, οὕτω καὶ αὐτὸς ἔσωθεν οἷον εἰπεῖν ἐμαυτὸν κατεδήδοκα. ἐντεῦθεν
καὶ ὅ τί μοι χάριεν ἐνομίζετο καταλέλοιπα· συνόδους, συλλόγους, ὁμιλίας,
75 δημηγορίας, βασιλείους σκηνάς, ἑστίας, φιλοτιμίας, σοφῶν συνουσίας,
φιλολόγων ἐπιμιξίας, ἅπαν ὅ τι ψυχὴν διαχέει καὶ αἴσθησιν. καὶ καθὼς
ὑετῶν σφοδρῶν καταφερομένων καὶ ἀστραπῶν πυκνῶν ὑποφαινομένων
κλονεῖται τὸ πᾶν καὶ ἡμαύρωται, οὕτω πένθει καὶ στεναγμοῖς κλονού-
μενος ἐξηπόρημαι τὴν χθὲς ὡραιότητα δυσωπούμενος· τελετὰς ἁγίας,
80 ἑορτάς, ὑμνῳδίας, φωτοφανείας, ἱερέων τάξεις, αὐτὸν οὐρανὸν μιμουμέ-
νας καὶ τὰ οὐράνια.

4. Ἀλλ' οἶμαι τὸ κράτος ἀγανακτεῖν, ἐπεὶ καὶ εἰρηνικώ-
τατον καὶ λίαν φιλάνθρωπον καὶ τῶν ἑορταζομένων παραίτιον, ὡς ἐπὶ
τοῖς φαιδροτέροις ἐατέον τὰ σκυθρωπότερα. καὶ γὰρ ὑποχωροῦσιν ἡλίῳ
85 σκιαὶ καὶ εὐεξίαις δραπετεύουσι νόσοι· τῷ καιρῷ τὰ οἰκεῖα νέμειν λυσι-
τελέστερον, μηδὲ πειρᾶσθαι συνάγειν τὰ ἀντικείμενα — χωρὶς τὰ Μυσῶν

54 παραπληξίας corr. Us: παραπληπίας V ‖ 56 μηδὲ corr. Us: μὴ
δὲ V ‖ 70 ὤφελε corr. Us: ὄφελε V ‖ 76 ὅ τι mg. V ‖ 86 μηδὲ
corr. Us: μὴ δὲ V ‖ Μυσῶν corr. Us: Μήδων V

[28] Hesiodus, *Op.* 358.
[29] Ps. 104:18.
[30] Cf. Exod. 10:21 sqq.
[31] III Regn. 12:16 sqq.
[32] Gen. 3:1 sqq.
[33] Ps. 21:16.

crows! What madness! What darkness! What cruelty in the doers, what pain and suffering for the victims! Worst of all, it was not a strife of foreigner against foreigner, of one tongue against another, but we were sons opposing and rebelling against fathers, brothers against brothers, fathers against sons! At this, to quote Hesiod, "my blood runs cold"; or, as the Psalmist says, "my heart passed through the iron," so that I wish no more to live and see the brightness of the sun: forasmuch as without disease we are ailing incurably, without frenzy we run mad, and without the darkness of the Egyptians we are yet worse benighted. And now of Israel were we become Judah and Ephraem, and both were divided in substance, and friends and neighbors became more implacable than implacable foes. And all this for the sake of temporary glory and a single crown, itself one too many and untimely, whereby everything was convulsed from top to bottom, whereby, in our day, he who by deceit and practice only just succeeded in deceiving the old Adam and turning him out of Eden, has without effort triumphed over the inhabited world! At this my discourse was interrupted more than that of a vertiginous man, and my tongue clave to the roof of my mouth, for I experienced and came to know those things which should never have been thought on nor come to pass; and as those hibernating animals, pent in their holes because of the cold, spend and express all their substance until the day of spring dawns, so I too — so to say — fed within upon myself. From that time I abandoned whatever seemed pleasant to me: companies, discussions, conversations, orations, imperial ceremonies, entertainments, displays, converse with the learned and companionship with literary men — all that charms the mind and senses. And just as, when the rains fall in torrents and the lightning flashes thick, all is shaken and grows dark, so by grief and mourning was I shaken and amazed, being troubled for the delights of yesterday — the holy rites, the festivals, the psalmody, the feasts of lights, the priestly orders, that imitate the heaven itself and heavenly things.

4. But I think His Majesty begins to be annoyed, since he is most peaceable and full of kindliness and the author of the triumphs we celebrate: so that the more dismal topics must give place to the more cheerful. For shadows give way before the sun, and diseases fly before good states of health. It is better to allot its own to the time, and not to try to bring opposites together (the "terms of Mysians

καὶ Φρυγῶν ὁρίσματα[34] — καί μοι δοκεῖ καὶ λίαν εἰκότως διακελεύ-
εσθαι κἀμὲ σύμφωνον ἔχειν καὶ τοῖς ἑξῆς προθυμότατον. πλὴν ἀλλ' ὅτι
τῶν ἀηδεστέρων προδιαλαβόντων ἡδύτερα τὰ χαρίεντα· ἐπεὶ καὶ μετὰ
90 γείτονα χειμῶνα ποθεινότερον ἔαρ, καὶ Ἰωσὴφ ἡδίων μετὰ τὸν ἐλπισ-
θέντα ὄλεθρον,[35] καὶ μετὰ τὸν ἀπόπλουν, τὸ τοῦ μύθου, Τηλέμαχος,[36]
fol. 44v καὶ Ἰθάκη μετὰ τὴν ἄλην,[37] καὶ μετὰ δίψαν πηγή, καὶ λιμὴν | ἄκλυστος
μετὰ καταιγίδα καὶ χύματα. καὶ ἄλλως, ἵνα καλῶς τὸ κακὸν τεκμαιρό-
μενοι αὐτοῦ μὲν τῶν ἔργων καταγινώσκωμεν καὶ ὡς ἐνδακόντος ἔχεως
95 φυλασσώμεθα· φόβος γὰρ βοήθημα αὐτοσχέδιον, τοῖς δὲ καλοῖς ἱστά-
μεθα ἀσφαλέστερον· ἁλιεὺς γὰρ πληγεὶς νοῦν φύει, κατὰ τὴν παροι-
μίαν.[38] διὸ μὴ κωλύων ἔτι τὰ χείλη πρόδρομος ἥκω τῆς εὐφημίας καὶ
τὸ παρὸν ἐπαινέσων, καὶ τὸ ἀπὸν ἀναμνήσων, καὶ τὸ μέσον ἀπελέγξων,
καὶ τὸ ἐπιὸν ἀσφαλισόμενος.

100 **5.** Τὸ μὲν οὖν παρόν. δεῦρό μοι πᾶς ὁ τῶν θρόνων καὶ
ὁ τοῦ βήματος, οἱ τῆς ἐκεῖθεν ὑψηγορίας καὶ διατάξεως, ὅσοι τε τοῦ
κράτους πέλας καὶ ὅσοι τούτων ἐχόμενοι, πολῖται καὶ ἀστυγείτονες, αἱ
πατριαὶ τῶν ἐθνῶν, οἱ ἀνὰ πάντα τὰ πέρατα, οἱ λογιζόμενοι τὴν
ἄνωθεν πρόνοιαν καὶ τὰ ἐκεῖθεν περιμένοντες κρίματα, οἱ θύοντες τὰς
105 αἰνέσεις καί, ὡς ἐν νότῳ χειμάρρους, τὴν αἰχμαλωσίαν ἐπίστρεψον
ἐκκαλούμενοι,[39] καὶ ἔτι σὺν τούτοις οἱ ἐκτοπισθέντες τοῖς ἡμῶν ἀτοπή-
μασιν ἐν ἐσχατιαῖς ἀβάτοις τε καὶ ἀνύδροις, καὶ τῆς ἐλευθερίας καὶ
ἐξουσίας τὸν τῆς δουλείας κατακριθέντες ζυγόν, οἱ πολλὰς μὲν ἀΰπνους
νύκτας ἐγκαρτερήσαντες, κρυμούς τε καὶ ἡλίους ὑπενεγκόντες, μικροῦ καὶ
110 ἀποθανόντες ἰδεῖν ἐφιέμενοι τὴν αἰθρίαν τῆς νῦν ἀναστάσεως! Δεῦτε
λευχειμονοῦντες ἔνδοθεν ἔκτοθεν, ἀμφοτέρας τὰς λαμπάδας φαιδρύναν-
τες, τοῖς περὶ τὸν Ἰθάμαρα ἐναριθμούμενοι,[40] τῆς γερουσίας ἁπτόμενοι,[41]
Μωσέως ἡγουμένου καὶ Ἀαρὼν τῶν τιμίων, εἰς τὸν οἶκον Κυρίου μετὰ
ὁμονοίας συνίωμεν,[42] εἰς τὰς πύλας αὐτοῦ ἐν ἐξομολογήσει, εἰς τὰς αὐλὰς
115 αὐτοῦ ἐν ὕμνοις.[43] διαβῶμεν τὸ κλίτος, τῇ σκηνῇ προσχωρήσωμεν, τῷ
ἱλαστηρίῳ προσχήσωμεν, ἀκούσωμεν, τί λαλήσει ὁ τοῖς Χερουβὶμ καλυπ-
τόμενος.[44] ἰδοὺ γὰρ ἐρεῖ εἰρήνην ἐπὶ τὸν λαὸν αὐτοῦ,[45] καὶ "εἰρήνην
τὴν ἐμὴν δίδωμι ὑμῖν, εἰρήνην τὴν ἐμὴν ἀφίεμαι ὑμῖν."[46] τί τῆς φωνῆς

88 καὶ om. Us qui legit ἔχει καὶ et ἔχον ‖ 95 φυλασσώμεθα corr.
Us: -όμεθα V

[34] Karathanasis (supra, 18), 55, p. 43: cf. Leutsch-Schneidewin (supra, 15),
I, 465, no. 35.
[35] Gen. 46:29–30.
[36] Homerus, *Od.* 17.41–44.
[37] Homerus, *Od.* 13.250–51.
[38] Zenobius II.14; Gregorius Cyprius I.54; cf. Leutsch-Schneidewin, I, 35,
354; Diogenianus Epicur. I.61: cf. Leutsch-Schneidewin, II, 10.
[39] Ps. 125:4. [43] Ps. 99:4.
[40] Exod. 6:23; 37:21; Num. 4:28. [44] I Regn. 4:4; II Regn. 6:2; etc.
[41] Exod. 12:21. [45] Ps. 84:9.
[42] Ps. 121:1. [46] Joan. 14:27.

and Phrygians" lie apart); and I think it is very reasonable that I should be required to agree to this and to come with all eagerness to what follows. Not but what delights are more charming if unpleasantness has gone before: spring is more desirable after its neighbor winter, Joseph more beloved after his threatened death, and Telemachus in the story after his voyage, Ithaca after the salt sea, the water spring after thirst, and the still haven after tempest and waves: moreover, a just estimate of evil enables us to remark its works and to keep clear of it as from a viper that has bitten us (fear is a prompt ally), and to stand more safely in our time of blessings. The fisherman who was bitten found his wits, as the saying is. So I will no longer bridle my lips but come forward to be the herald of gladness and to praise the present, recall the past, convict what lies between, and make sure of the future.

5. First, for the present. Come unto me all ye who sit upon thrones or stand on the tribunal, and who thence derive your eloquence and your authority; all ye who are near to His Majesty and ye that follow after them; citizens and neighbors; the clans of the gentiles; all ye, far and wide, who regard the Divine Providence and await its judgments, ye who offer praises in sacrifice and, as a stream in the south, cry aloud "Return the captivity!"; ye who, by our offenses, were expelled from your seats into impenetrable and waterless fastnesses, and from freedom and power were condemned to the yoke of slavery; ye who endured many sleepless nights, bore chills and suns, and came near death in your longing to behold the dawn of this new resurrection! Come ye, clad inward and outward in white apparel, making bright both of your torches, ye numbered among those who are about Ithamar, members of the Council of Elders, with the noble Moses and Aaron at your head! Let us go in concord to the House of the Lord, to His gates in thanksgiving, to His halls with praise! Let us cross over the threshold, let us approach the tabernacle, let us attain the sanctuary! Let us hear what He that is hidden by the Cherubim will say! Lo, He will speak peace upon His people, and "my peace I give unto you, my peace I leave unto you."

τῆσδε μακαριώτερον, τί δὲ τοῦ φθέγματος ἁγιώτερον, τί τοῦ διδόντος
120 καὶ τοῦ δωρήματος ὀλβιώτερον. ὢ τοῦ πολυταλάντου χαρίσματος, ὢ
τῆς ὑπερμεγέθους εὐεργεσίας! δίδωσιν ὅδε καὶ ὅδε, πορίζουσι τύραννοι,
οἱ ἐπὶ σκήπτροις παρέχουσι· ἄλλοι μὲν χαλκόν, ἄλλοι δὲ καὶ ἄφθονον
ἄργυρον, λίθους, ἐσθῆτα, χρυσόν, διὰ γραμ|μάτων εὐκλείας, διὰ συμ-
βόλων προνόμια. ὅσα τῆς ὕλης, ὅσα τῆς χειρὸς τοῦ παρέχοντος· ἃ καὶ
125 βλάπτει πολλάκις ἢ ὀνίνησι,⁴⁷ καὶ μετὰ στιγμὴν οὐκέτι ἐστίν, καὶ ὥσπερ
αὖραι καὶ ὄναρ τοῖς νέμουσι [καὶ] τοῖς λαμβάνουσι συναποίχεται. οὗ δὲ
Θεὸς ὁ διδοὺς καὶ Θεὸς θεῶν καὶ ἔστι τε καὶ πιστεύομεν, καὶ τῶν ἑαυτοῦ
τὸ ἀκρότατον καὶ θειότατον, καὶ τυχὸν ἑαυτὸν κατὰ τό· αὐτός ἐστιν
ἡ εἰρήνη,⁴⁸ καὶ ὁ Μεσίας αὐτός εἰμι ὁ λαλῶν σοι,⁴⁹ καὶ ὅσα τοιαῦτα,
130 ἐκεῖ κἂν ἐπινοήσῃς κτίσιν ἄλλην τῆς νῦν ὁρωμένης καὶ νοουμένης ἄμεινω
καὶ φαιδροτέραν, οὔ τι τῆς εὐεργεσίας οὔ τι τῆς χάριτος ἐφάμιλλον
εὑρήσεις καὶ ἰσοστάσιον· ὅσῳ γὰρ ὁ διδοὺς διενήνοχε τοῦ διδόντος,
τοσούτῳ καὶ τὸ δώρημα τοῦ δωρήματος. ὅ μοι δοκεῖ καὶ ὁ ἐν πορφυρίδι
φιλόσοφος, ἐπιστάμενος κρεῖσσον, ἐρεῖν, "μερὶς ὀλίγη μετ' εἰρήνης ἢ οἶκος
135 πολύχρυσος ἀνειρήνευτος."⁵⁰ ἔτι δὲ καὶ σοφίας καὶ ζωῆς αὐτὴν ὑπερ-
τίθησι· πρὸ γὰρ εἰπών· ἡ καρδία σου τηρείτω σοφίαν ἐμήν,⁵¹ τὸ ἔπαθλον
ὡς ὑπέρτιμον ἐπαγγέλεται· ἔτη γὰρ ζωῆς. καὶ οὐκ ἔστη γε τούτῳ, ἀλλὰ
τὸ κρεῖττον· καὶ πλῆθος εἰρήνης προστεθήσεταί σοι.⁵² καὶ Ἰὼβ τῶν
πλεονεκτημάτων Θεοῦ ταύτην ὑπερθαυμάζει· θῆρας γὰρ ἀγρίους εἰρην-
140 εύειν ὑπισχνεῖται τῷ ἐκεῖθεν ἀμυνομένῳ,⁵³ εἴτε τοὺς ἐπὶ τὰ ὄρη καὶ τοὺς
βουνούς, οὐκ οἶδα, εἴτε τοὺς ἀστικοὺς καὶ τῆς ἐκεῖθεν ὠμότητος αἰνιττό-
μενος. διὸ καὶ μᾶλλον προσεκτέον καὶ τηρητέον τὸ δώρημα, ἵνα ὥσπερ
ὁ τούτου δοτήρ, οὕτως ἀΐδιον ἡμῖν καὶ τὸ δώρημα διασώζοιτο· ἀλλὰ
τὸ μὲν δώρημα καὶ ὁ διδοὺς οὕτω σεβάσμια.

145 6. Ἵνα δὲ τοῖς ὑπὲρ ἔννοιαν δεξιούμενοι καὶ προσδοκίαν
ἐν εὐκαιρίαις, ἐν θλίψεσι πλατυνόμενοι, μὴ διαμέλλωμεν, μηδὲ τὸν πάλαι
Ἰσραὴλ ἐκμιμώμεθα ἢ σιωπῶντα τὰς χάριτας ἢ φθεγγόμενον, ἀλλὰ τῆς
σιωπῆς χείρω — καὶ γὰρ τοῖς ἄλλοις θαυμασίοις κωφεύοντες τῆς τρυφῆς
ὑομένης διελοιδοροῦντο τῷ τρέφοντι⁵⁴ — αὐτοὶ τὰς φωνὰς μετὰ τῆς

126 [καὶ] suppl. Us ‖ 127 πιστεύομεν VJk: πιστεύεται Us ‖ 130 ἐκεῖ
VJk: ἐπεὶ Us ‖ 131 οὔ τι...οὔ τι VJk: οὔτε...οὔτε Us ‖
134 κρεῖσσον corr. Us: κρείσσων V ‖ 136 τὸ VJk: τί Us ‖ 137
ἔστη VJk: ἔστι Us ‖ 137 τούτῳ VJk: τοῦτο Us ‖ 146 διαμελῶμεν
V διατελῶμεν corr. Us ‖ 147 ἀλλὰ V: ἄλλα corr. Us ‖ 148 τῆς
τρυφῆς VDu: τῆς τροφῆς Us

⁴⁷ Hesiodus, *Op*. 318. ⁵¹ Prov. 3:1–2.
⁴⁸ Eph. 2:14. ⁵² Ps. 71:7.
⁴⁹ Joan. 4:26. ⁵³ Job 5:22–23.
⁵⁰ Prov. 15:16. ⁵⁴ Cf. Exod. 16:1 sqq

What speech is more blessed than this, what word more holy, what more happy than the Giver and His gift? O for the grace of much value, for the immense benefit! This or that man may give, tyrants provide, kings supply, some bronze, others abundance of silver, gems, clothing, nobilities conferred by diploma, and privileges by insignia: these gifts may harm or profit, and in a moment they are no more, and like airs or dreams they pass away with those who give ⟨and⟩ receive them. But where the Giver is God (and God of Gods He is and we believe Him to be), and gives us the most excellent and divine of His gifts, perhaps even Himself, according to the saying "He is peace," and "I am Messiah Himself that speaketh unto thee," and so on, there, even if you should devise another creation better and brighter than the one we now see and know, yet you shall not find anything to rival or equal this benefit or grace. For as Giver differs from giver, so does gift from gift. In knowledge of this I think the philosopher in the purple said "better a small portion with peace than a house full of gold where peace is not"; and he prizes it even above wisdom and life: for having premised "let thy heart keep my wisdom," he promises the reward beyond price: it is "years of life"; but he did not stop there: best of all is that "abundance of peace shall be added unto you." And Job places this above the other gifts of God, for he promises that savage beasts shall be at peace with him whom God defends — whether he means those on the mountains and hills, I know not, or whether he hints at town-dwelling beasts for their cruelty. Wherefore we must be the more careful to preserve the gift, so that, like its Giver, it may remain among us eternally. So much for the worshipful nature of gifts and Giver.

6. But now that we are graced with prosperity beyond thought or expectation and enlarged from our distresses, let us not be unmindful nor imitate Israel of old who was silent over his blessings or else uttered what was worse than silence: for they were dumb regarding the other miracles, and when their food was rained from heaven they abused their Nourisher. But let us raise our voices and our hearts,

150 γνώμης ὑψώσωμεν, καὶ μετ' εὐνοίας ἀμφότερα· καὶ τίς λαλήσει τὰς
δυναστείας τοῦ Κυρίου βοήσωμεν, τίς δὲ τὰς αἰνέσεις αὐτοῦ ἀκουστὰς
τοῖς πέρασι καταστήσεται;[55] ὅτι συνέτριψε ρομφαίαν καὶ πόλεμον καὶ
τὰ θεῖα τρυφᾶν ἡμῖν ἐχαρίσατο, ὅτι ἐπλεόνασεν ἡμῖν τὴν αὐτοῦ μεγα-
λωσύνην καὶ ἐπιστραφεὶς ἐζωοποίησε καὶ ἐκ τῶν τῆς ἀπογνώσεως

fol. 45ᵛ 155 βυθῶν ἐπανή|γαγε.[56] τίς εἰδώς, ὅποι τὰ ἡμέτερα ῥέπει καὶ ὅπη τὰ
ἐκείνου ἀνθέλκει, συλλογίσοιτο τὴν ἐν μέσῳ χρηστότητα, ὅτι τὰ παροργ-
γισμοῦ αἴτια παραβλέψας, ἐν δὲ τοῖς οἰκτιρμοῖς αὐτοῦ διαβλέψας, τὸν
φραγμὸν εἷλε καὶ διέλυσε τὸ μεσότοιχον.[57]

7. Ὢ τῆς ἐπινοίας! Τὸ γῆς καὶ θαλάττης μεθόριον, τὸ
160 μεταίχμιον ἠπειρώτου τε καὶ νηΐτου στρατοῦ, καὶ βασιλεῖς διχογνωμο-
νοῦντας διστάζοντας, οἷον τὸν Φρυγίας τε καὶ Μυκήνης ἀκούομεν,[58] εἰς
ὁμοφροσύνην, εἰς ὁμόνοιαν συνεπήγαγε. τίς τὸ πέλαγος τῆς ἀγαθότη-
τος αὐτοῦ περιλήψεται; τίς δὲ τὸν τῆς φιλανθρωπίας αὐτοῦ βυθὸν
καταλήψεται; ὅτι τὰ διαρραγέντα μέρη τῆς οἰκουμένης συνούλωσε, καὶ
165 οὕτως εἰς ὁλοκληρίαν καὶ συμφυΐαν [συνέστησεν], ἵνα μηκέτι Σκύθης
καὶ βάρβαρος, καὶ τὸ καὶ τὸ καλούμεθα,[59] χριστιανοὶ δὲ πάντες καὶ
Θεοῦ τέκνα καὶ ὠδῖνες τοῦ πνεύματος καὶ λεγώμεθα καὶ δεικνύμεθα;
τίς τὸν πλοῦτον τῆς σοφίας καὶ δυνάμεως αὐτοῦ διηγήσεται; ὅτι τοὺς
ἑσπερίους λύκους καὶ τῶν ἑῴων περιεργοτέρους καὶ θρασυτέρους τοσαύτῃ
170 μετεστοιχείωσεν ἱλαρότητι, ὡς καὶ πιστεύεσθαι φυλάσσειν τὸ ποίμνιον
καὶ τοὺς μονίους ἐπιτιθεμένους καὶ ἀπελαύνειν καὶ ἀποτρέπεσθαι. ὅτι
τὸν τῶν ζιζανίων σπορέα καὶ φύλακα, τὸν νέον Ἄδερ,[60] τὸν καινὸν
Ὀλοφέρνην[61] προδιαμεθοδευσάμενος τῷ αὐτοῦ κόρῳ τὴν διασπορὰν
τοῦ Ἰσραὴλ[62] ἀνεσώσατο. καὶ πάλιν ἐπὶ τὰς οἰκείας πηγὰς καὶ συκᾶς
175 ἕκαστος τὸ θέρος ἀμῶν,[63] καὶ τὸν ἀμπελῶνα τρυγῶν καὶ ἀνακαθαίρων
τὴν ἅλω, καὶ βαθύνων τὸ ὑπολήνιον, τῷ βραβευτῇ τῶν τοιούτων
ἐπεύχεται. τίς τὴν ἀνεξερεύνητον αὐτοῦ κηδεμονίαν ὑμνήσεται; ὅτι μετὰ
Σολομῶντα τὸ⟨ν⟩ εἰρηνικὸν καὶ φιλόσοφον τῷ Ἱεροβοὰμ τοῦ ποιμνίου
διασπασθέντος διὰ τὴν τῶν νεωτέρων βουλήν,[64] τὸν ζηλωτὴν Ἰωνᾶν

153 τὴν om. Us ‖ 161 Φρυγίας V: Φθίας Us ‖ 165 [συνέστησεν]
post συμφυΐαν fortasse ‖ 167 λεγώμεθα: λεγόμεθα coni. Jk ‖
172–73 τὸν νέον Ἄδερ, τὸν καινὸν Ὀλοφέρνην: Συμεὼν ὁ Σκύθης.
Πέτρῳ τῷ υἱῷ Συμεὼν mg. V ‖ 173 κόρῳ corr. Us: κύρῳ V ‖
178 τὸν corr. Ku: τὸ VUs ‖ 178–79 Λέοντα βασιλέα Κωνσταν-
τῖνον τὸν υἱὸν αὐτοῦ mg. V

[55] Ps. 105:2. [56] Ps. 70:21. [57] Eph. 2:14.
[58] Cf. similia: Leutsch-Schneidewin (supra, 15), I, 465 et notam 35.
[59] Cf. Col. 3:11. [61] Judith 2:4, etc.
[60] Cf. III Regn. 11:17. [62] Cf. Ps. 146:2; Is. 49:6.
[63] Cf. Prov. 4:21, 5:16, 18; Is. 36:16; IV Regn. 18:31.
[64] III Regn. 12:1–24.

both in loyal worship, and let us cry "who shall speak of the powers of the Lord, who shall make His praises heard to the ends of the earth, Who has broken the sword and battle and granted us the enjoyment of heavenly blessings, Who has multiplied his greatness upon us and hath turned and made us to live, and led us up from the gulf of despair?" Who that knows whither our state was declining and how His arm drew us back, would conceive His goodness to us meanwhile, Who has overlooked the causes of His anger and regarded us in His mercy, and dissolved the barrier and pulled down the middle wall?

7. Behold His design! The meeting point of land and sea, the battleground of land and naval forces; kings quarreling and divided as once, we hear, did those of Phrygia and Mycenae, He has reconciled in harmony and concord. Who will contain the ocean of His goodness? Who will reach the depth of His mercy, Who has healed the parts of the world that were split apart and thus brought them together in wholeness and continuity, where we are no longer called 'Scythian' or 'barbarian' or I know not what, but may be named and shown to be Christians and sons of God and travail of the Spirit? Who shall recount the riches of His wisdom and power, Who has transformed the wolves of the West, more persistent and bold than those of the East, into such cheerfulness as convinces us that He guards His flock and repels and drives away the savage brutes that molest it; Who has caused the sower and nourisher of tares, the new Hadad, the modern Holofernes, to give place to his son, and thus has redeemed the dispersion of Israel, and once more every man by his own well and his own fig tree reaps his crop and harvests his vineyard and winnows his threshing floor and deepens his vat, and offers up his prayer to the Giver of these blessings? Who shall recall His unsearchable care for us, Who, when after the peaceable and wise Solomon the flock was divided by Jeroboam through the counsel of the younger men, granted to our times the zealot Jonah, and maintained

180 τοῖς καιροῖς ἐχαρίσατο,[65] τηρήσας ἐν τοῖς μεγίστοις τὸν μέγιστον, καὶ
 χειρὶ χεῖρα κρατύνων, καὶ βραχίονι βραχίονα δυναμῶν, καὶ κινῶν καὶ
 μετακινῶν ὅπου βούλεται καὶ ὡς βούλεται, τὸν αὐτὸν καὶ βασιλέα καὶ
 πρόμαχον καὶ ἀγωνιστὴν καὶ διαλλακτήριον τὸ δέον σκοπούμενον, τὸ
 συμφέρον προμηθούμενον τοῖς πράγμασιν ἀνεστήσατο. τίς ταῦτα τῶν
185 εἰδότων ὅσον ἡ εἰρήνη καλόν, ᾗ Θέμις ἐστίν, ἐπαινέσεται;[66]; τίς τὰ
fol. 46 παρόντα κατ᾽ ἀξίαν αἰνέσεται; | τὴν παρ᾽ ἐλπίδα μεταβολήν, τὴν παρὰ
 προσδοκίαν ἀλλοίωσιν, τὴν ἀνέκφραστον ἄμειψιν, τὴν ἄπιστον ταύτην
 ἑνότητα; πόσων ἱστορίαι Πολυβίων, πόσων Πλουτάρχων παράλληλοι,
 ποίων ῥαψῳδῶν μέτρα, τινῶν εὐγλωττίαι ῥητόρων τὰ τοιαῦτα σχή-
190 σουσι διηγήματα; οὐδὲ τὸν κόσμον καὶ ἐγῷμαι, τὸ τοῦ ἠγαπημένου,[67]
 τῶν τοιούτων χωρῆσαι τὸ μέγεθος.

 8. Ἀλλ᾽ ἐπεὶ τῆς εὐφημίας οὐδ᾽ ἐφαπτόμεθα — καὶ γὰρ
 ὁρώμεθα καὶ αὐτῶν Λακώνων βραχυλογώτεροι — καλῶς ἂν ἤδη τοῖς
 ἑξῆς εὐδρομήσωμεν. ὅτι μὲν οὖν τὸ δῶρον τῆς δεξιᾶς τοῦ ὑψίστου καὶ
195 ὁ λημῶν ἂν ἐπίδοιτο· τίνος γὰρ καὶ ὅθεν; εἰ γὰρ οὐδὲ τῶν μικρῶν τι
 δίχα τῆς ἄνωθεν τελεῖται προνοίας,[68] ὅσον ἡ παγκόσμιος σωτηρία καὶ
 ἀγαλλίασις! ἀλλ᾽ ὅτι μὲν ἐκεῖθεν, οὐκ ἄδηλον. νῦν δ᾽ ὅ τι πέρ ἐστιν τὴν
 φύσιν διασκεψώμεθα, ἵνα τὸ λυσιτελὲς ὅσον καὶ οἷον συνέντες παγιώτεροι
 μένωμεν. ἔστι τοιγαροῦν εἰρήνη, ὡς ἔγωγε διορίζομαι, στάσεως προδια-
200 λαβούσης συνάφεια, ἡ περιχαρὴς ὁμιλία μετὰ σιωπὴν ἔγκοτον, φιλο-
 νεικίας καταστροφή, ὅπλων ἀπόθεσις, ἔχθρας κατάλυσις, συναίρεσις ἐκ
 διαιρέσεως, ἐκ διχονοίας ὁμόνοια, μετὰ διαφωνίαν ὁμοφωνία, καὶ ὅπως
 ἂν οἱ τῶν τοῦ Ἀρίστωνος ἀπαντλήσαντες καὶ τὸν Σταγειρίτην κατα-
 πιόντες γένει καὶ διαφοραῖς ὑπογράψαιεν. ἀλλὰ ταῦτα μὲν ἢ ὅ τι σχεδόν·
205 νῦν δέ μοι σκόπει τὸ ἐπὶ πᾶσιν αὐτῆς εὔχρηστον, σειρὰν ἐξ οὐρανόθεν[69]
 ὑπολαβὼν διὰ πάντων καθήκουσαν, τῆς δ᾽ ἐξαπτομένης τὰς αὐτῆς
 συντρόφους καὶ μύστιδας· φιλίαν, ἀγάπην, ὁμοφροσύνην, ὁμόνοιαν, ὅσα
 τῆς μακαρίας ἑταιρείας καὶ συγγενείας, ὧν ὑποστῆναί τι δίχα τῶν
 ἀμηχάνων, κἂν ὑπονοίᾳ συστῇ, τοῦ μὴ συστάντος δεινότερον††. καὶ
210 πρῶτα μέν, ἵνα τῶν θείων ἐς τὴν παροῦσαν ἀποχωρῶμεν — εἰρήνη γάρ,
 οὐ θεολογία, τὸ παριστάμενον. αὐτίκα τῶν ἀγγέλων ἡ τάξις τῆς

180–81 τὸν μέγιστον...βραχίονι: Ῥωμανόν adscr. V ‖ 185 ᾗ corr.
Ku: ἢ VUs ‖ 187 ἀνέκφραστον corr. Us: ἀνεκφραστόν V ‖
190 καὶ om. Us ‖ 195 λημῶν corr. Ku: λειμῶν V λυμεὼν Us ‖
204 ὅ τι: ὅτι Us ‖ 205 ἐπὶ πᾶσιν: τοῖς πᾶσιν Us ‖ 206 τῆς
VKu: τὰς Us ‖ 209 post δεινότερον corrupt. suppl. Jk

[65] Ion. 2:11–3:3. [68] Cf. Matt. 10:29–31.
[66] Hesiodus, Op. 137. [69] Homerus, Il. 8.19.
[67] Joan. 21:25.

him greatest among the greatest, and strengthened his hand with His own, and gave to his arm the power of His own arm, and guided him hither and thither where and as He wished, and raised him up to be, in one and the same person, our Emperor and bulwark and champion and peacemaker, mindful of our needs and devising what was profitable for our affairs? Who of those that know how fair a thing is peace will praise these things as they should be praised? Who will worthily extol our present blessings, the unhoped-for transformation, the unexpected change, the inexpressible alteration, this unbelievable union? How many Histories of Polybius, or Lives of Plutarch, what verses of rhapsodes or gems of rhetoricians, will be needed to contain such stories as these? I too imagine, with the Beloved Disciple, that "the whole world could not contain the greatness of them."

8. But since we are not yet so much as touching on the exordium (we seem to be more laconic than the Laconians themselves), we should now properly proceed directly to what follows. That the gift comes from the hand of the Most High, even the blear-eyed can see. For from whom or where else could it come? If it be true that not even small things are performed without the Divine Providence, then how great must be universal salvation and rejoicing! That thence it comes is, then, undoubted; but let us now consider what its nature may be, so that, understanding the greatness and quality of our advantage, we may be more firmly convinced of it. Peace, then, as I define it, is the composition of previous strife, the joyful converse after sullen silence, the destruction of contentiousness, the laying aside of arms, the dissolution of enmity, union out of division, harmony out of dispute, concord after discord, or however those learned in the works of the son of Ariston, or nurtured on the Stagirite, might qualify it by genus and differentia. Such then, or nearly such, is its nature. But now let us look at its universal benefits, picturing a chain from heaven passing down through everything, and the companions and initiates of peace fastened to it — friendship, love, concord, harmony, all that belong to that blessed companionship and fraternity, of which it is impossible that any one member should exist without the rest, even though in fancy one were to create for it an existence more monstrous than non-existence! And first, to come from things divine to the present matter (for peace, not theology, is now our concern), the angelic order, defending the unity of its first

πρώτης καὶ ἀνεκφράστου πηγῆς τὸ ἓν ἀμυνόμενοι καὶ διψῶντες ἀεὶ τῆς
ὀρέξεως πρός τε τὴν τῶν τοιούτων αἰτίαν καὶ πρὸς ἑαυτοὺς ἀστασίαστοι
μένουσιν, οὐχ ἧττον διὰ τὴν οὐσίαν, ἧς ἠξιώθησαν, ἢ τὴν τῆς εἰρήνης
215 φωτοχυσίαν, ἧς ἀπολαύουσι, τὸν μέντοι τῆς χάριτος ἀλογήσαντα ἴσμεν
τὴν δίκην ἀξίαν ἐκτίσαντα, ἐξ ἀστραπῆς μὲν εἰς σκοτίαν μεταβαλόντα,[70]
ἵνα κεῖται τυχὸν τοῖς ὁμοίοις ὑπόδειγμα· τί δαὶ ὁ περὶ τὸν αἰθέρα
διάκοσμος; ἆρ' οὐκ ἀεὶ διασώζει τὸ ἀστασίαστον; ὅτι γὰρ ἀμιγῆ τὰ
τοιαῦτα διαφορᾶς καὶ πέμπτον σῶμα τὸ στερέωμα λέγουσι, ξένον αὐτὸ
fol. 46ᵛ 220 πάσης | συνθέσεως[71] ἀποφαίνοντες· στάσις δὲ συνθέσεως ἔργον ὄν, εἴκει δὲ
νυξὶ μὲν ἥλιος, νύκτες δὲ ὄρθροις, οἱ δὲ τὸν ἑωσφόρον προαγορεύουσιν,
ὁ δὲ τὴν ἡμέραν ἐπάγεται, τῇ δ' ὑποχωροῦσιν ἀστέρες. καὶ τῇ τοιαύτῃ
φιλίᾳ ἀΐδιον αὐτοῖς τὸ εἶναί τε καὶ τὸ φέρεσθαι ὡραῖον, καὶ καιροὶ καὶ
χρόνοι τὸ μέσον ἑαυτῶν κατὰ μικρὸν τιθασσεύοντες, εἶτα τοῖς ἄκροις
225 οἷον δακτύλοις ὁμοειδέσιν, ὁμοφυέσιν ἀλλήλων ἐχόμενοι, χορείαν χορεύουσι
καὶ χορείαν χορῶν πάντων εὐρυθμοτέραν καὶ πλατυτέραν, καὶ ἵνα τὰ
προφανέστερα λέγωμεν, ἆρα οὐχὶ ἵππων ἀγέλαι καὶ ἑταιρεῖαι βοῶν
ἑτερογενῆ καίτοι περ ὄντα ἀναμὶξ διαιτώμενα φαίνεται; καὶ οὐ τάδε
μὲν διαφέρεται, τάδε δὲ ἀντιφέρεται, οὐδὲ ὁρίζουσί τε καὶ παρορίζουσιν,
230 ἀλλὰ τὴν πόαν ἐρέπτεται ἀδιάκριτα; ποίμνια δὲ καὶ αἰπόλια τοῖς αὐτοῖς
σηκοῖς ὁμοθυμαδὸν εἰσοικίζεται, εἶτα τοῖς τῶν ποιμένων καὶ νεύμασι καὶ
συρίγμασιν εὐείκτως ἄγεται, φέρεται, διακρίνεται. κέντρα δὲ φέρουσι
μέλισσαι — καὶ καθορᾶται γάρ — ἀλλ' οὐ τοῖς ὁμοφύλοις, οὐμενοῦν, καὶ
γὰρ εἰσὶ φιλάλληλαι καὶ πιστόταται. φαλαγγίοις δὲ τοῖς ἀλλογενέσι
235 καὶ ἀλλοκότοις κηφῆσι καὶ κοθούροις, εἰπεῖν, καὶ τοῦτο φοβοῦσαι καὶ
μόνον καὶ εἰς φυγὴν τῶν σίμβλων ἐκτρέπουσαι. τὸ φαυλότατον μύρμη-
κες μιᾷ ταμιεύοντες ἐν ὀπῇ ὁμοῦ μὲν διαπονοῦσιν, ἐπὶ τὸ αὐτὸ δὲ
συνάγουσι καὶ ὅμως οὐκ ἐρίζουσιν, οὐκ ἀμύνουσι, κοινὰ δὲ τὰ ἐφόδια
θησαυρίζουσιν.

240 **9.** Οὕτω διὰ πάντων, ὅσον διὰ βραχέων ἐρεῖν, ὁ τῆς
εἰρήνης δεσμός τε καὶ πλοῦτος καὶ ἔστι καὶ διαφαίνεται. ἄνθρωπος δὲ
τὸ θειότατον ἔργον καὶ πρώτιστον, δι' ὃν τὰ βλεπόμενα καὶ νοούμενα,
τὸ τῆς αὐτῆς χειρὸς καὶ τῆς αὐτῆς ἠξιωμένον ἐμπνεύσεως, τὸ γνώσει
καὶ λόγῳ τετιμημένον καὶ τὰ θεῖα φρονεῖν παιδευόμενον, ὁ σύνθετος
245 ἄγγελος, ὁ χαρακτὴρ τοῦ ποιήσαντος, ὁ βουλήσει δεδημιουργημένος
καὶ θαλάσσης ἄρχων καὶ κυριεύων ἠπείρου, δέον θηρσί τε καὶ κτήνεσι
τὸν χόλον ἐπάγειν ἢ κατὰ τοῦ κοινοῦ δυσμενοῦς μόνον, ὁ δὲ τῷ ἀδελφῷ

232 εὐείκτως corr. Jk: εὐίκτως VUs εὐηκόως Ku ‖ 233 καθορᾶται
V: καθορᾶτε corr. Us ‖ 240 διαβραχέων V

[70] Luc. 10: 18.
[71] Aristoteles, *De caelo* I.2–3.

and inexpressible source, and thirsting ever in longing, stays in harmony both with the Cause of these things and with itself, not less through the substance with which it is blessed than through the splendor of the peace which it enjoys: whereas we know that the angel who despised that grace paid a condign penalty and exchanged the brilliance of lightning for darkness, where he lies as a warning no doubt to those who are like him. What is the ethereal order? Does it not always preserve harmony? Because this order is unmixed with discord, they call the firmament a "fifth body" and declare that it is strange to any kind of synthesis. Strife is the work of synthesis. The sun yields to night, night to dawn, that some call Lucifer, and he leads on the day, to which the stars give place. So in this friendship is their being eternal and their motion beautiful, and times and seasons, taming by degrees what is between themselves, at last join one another with fingertips that are of one shape and one nature, and dance together in a dance that is more rhythmic and far-flung than all dances. Or, to take more obvious examples, do not the flocks of horses and herds of oxen, though different in kind, pasture indiscriminately together? There is no dispute or antipathy between them, they do not issue orders and counter orders but crop the grass without distinction. Flocks of sheep and goats dwell harmoniously in the same folds, and then obediently go, or are led, or divide, at the gestures or whistles of the shepherds. Bees, as we see, carry stings, yet by no means for use against their fellows, for they love one another and are most faithful, but against the foreign and miscreant idlers and drones, it is said, and this merely to frighten them and turn them out of the honeycombs. On the humblest level, the ants, keeping house in a single crevice, work together and unite in the same tasks; yet they do not quarrel or fight but treasure up their means of livelihood in common.

9. So through all creation — to speak it briefly — the bond and wealth of peace prevail and appear. But man, the most divine and first of works, for whom the worlds of sense and thought exist, held worthy of the same hand and the same inspiration, ennobled by knowledge and reason and educated in Divine Truth, the composite angel, the image of his Maker, endowed with will, lord of the sea and master of the land, when he should discharge his wrath on beasts and brutes or on the common foe alone, yet whets his sword against his brother and forges his arms and dons

Θήγει τὸ ξίφος, καὶ ὅπλα χαλκεύει, καὶ θώρακα περιβάλλεται, καὶ γέρρα τινάσσει, καὶ καταπέλτας ὀξύνει, καὶ εἰκονίζει τὸν Ἄρην, καὶ ὑπὲρ τὸν
250 Ἀπόλλω πηδᾷ, καὶ κατὰ τοὺς ἀραβικοὺς ὁρᾷ θῆρας,[72] καὶ ὀρνίθων τῶν ἐν τοῖς νέφεσιν ὑπεραίρεται. ἀλλὰ τούτοις ἀφόρατον τὸ κακόν, καὶ διὰ τοῦτο εὐφυλακτότερον. ὁ δὲ καὶ δόλους ῥάπτει καὶ πι|κρίας ἔσωθεν γέμει καὶ φιλεῖν ὑποκρίνεται καὶ ὑπὸ τὴν γλῶσσαν αὐτοῦ κρύπτει πόνον καὶ τοῖς χείλεσι σωτηρίαν προβάλλεται, ὑποφενακίζει καὶ τοῖς νεύμασι
255 καὶ τοῖς σχήμασιν, ἐχεμυθεῖ, ἀλλοφάσσει. τί γὰρ οὐχὶ τελεῖ; τί δαῖ οὐ σκέπτεται τῶν ἐχομένων ἀπωλείας καὶ φόνου; καὶ ταῦτα ἵνα τί; ἵν' ἐγκολπώσηται ταῦτα καὶ ἃ ἑαυτὸν αὐτίκα συναπολέσεται, ἵνα κλέος ἕξοι τὸ καὶ χλόης εὐμαραντότερον. ἵν' ἐπὶ γῆς γραφῇ καὶ τοῦτο τυχὸν κατὰ τὸν Κάϊν καὶ Λάμεχ καὶ τὴν τοιαύτην φατρίαν,[73] ἀπαλειφῇ δὲ τῆς
260 βίβλου τῶν σῳζομένων,[74] τοῖς ἐρίφοις ἀποπεμπόμενος,[75] ἵν' ἔχῃς ἀγαθὰ κείμενα εἴπῃ καὶ ἀκούσῃ τὸ ἄφρον, τὴν ψυχὴν ἀπαιτούμενος,[76] ἵνα πάθῃ τὰ Κροίσου καὶ Πολυκράτους, καὶ ἀρχόμενος καὶ οἰχόμενος.[77] ἀλλὰ τάδε μὲν Ἑλλήνων παῖδες ποιούντων τε καὶ πασχόντων, ἐπεὶ καὶ θεῶν τὸν οὐρανὸν ἐπλήσαν — ὢ τῆς αὐτονομίας! ὡς μὲν φιλοπολέμων, ὡς δὲ
265 μαχίμων, ἐριστικῶν, ἐπιβούλων, μᾶλλον ἀναπνεόντων τὸν Ἄρην ἢ τῆς κνίσσης ὀσφραινομένων ἑλισσομένης περὶ καπνῷ.[78] ὧν δὲ τὰ πρωτότυπα στάσεις καὶ μάχαι, πότε ἂν εἰρηνεύσειε τὰ μιμήματα; ἀλλ' οἱ μὲν αὐτοῖς θεοῖς καὶ οὐδενὸς ἐλαύνοντος ἀπελήλαται καὶ ἀπήλειπται· τὸ γὰρ κακὸν ἀνύπαρκτον, ἀνυπόστατον.

270 **10.** Ἡμεῖς δὲ οἱ τοῦ καινοῦ νόμου καὶ τῆς καινοτέρας ἐντολῆς μαθηταί,[79] οἱ τοῦ εἰρηνικοῦ καὶ πράου καὶ ταπεινόφρονος μύσται,[80] οἱ τῶν ἐπηρεαζόντων καὶ δυσμενῶν καὶ θλιβόντων καὶ τυραννούντων ὑπερεύχεσθαι διδασκόμενοι καὶ τοῖς φίλοις τὴν ψυχὴν τιθέναι[81] καὶ εἴκειν τοῖς ἀγγαρεύουσι,[82] καὶ ἔτι μᾶλλον, οἱ εἰδότες ὅτι ἔστιν ὁ
275 τοὺς σοφοὺς σοφιζόμενος[83] καὶ δρασσόμενος ἐντέχνους, καὶ ὁρῶν ἐν

250 ὁρᾷ corruptum susp. Jk an ὅρ[ωρ]α Du ‖ 251 ἀφόρατον V: εὐφόρατον corr. Us ‖ 255 ἀλλοφάσει V: ἀλλοφάσσει Us ‖ 257 ταῦτα: ταῦτ' ἃ corr. Ku ‖ ἑαυτὸν: καὶ ἃ ἑαυτὸν Jk ‖ συναπολέσεται Ku: συναπολήσεται Us ‖ 259 φατρίαν V: φατριάν Us ‖ 260 ἔχῃς: ἔχῃ Us ἔχω Ku ‖ 261 ἄφρων Us ‖ 264 ἐπλήρουν Us ‖ 272–73 καὶ τυραννούντων om. Us ‖ 274 ἀγγαρεύουσι corr. Us: ἀγορεύουσι V

[72] Aristoteles, *Mirabilia* 845a 24.
[73] Gen. 4:15.
[74] Ps. 68:29.
[75] Matt. 25:33.
[76] Luc. 12:20.
[77] Herodotus I.85; III.53.
[78] Homerus, *Il.* 1.317.
[79] Joan. 13:34.
[80] Cf. Matt. 11:29.
[81] Matt. 5:44; Joan. 15:13.
[82] Matt. 5:41.
[83] I Cor. 3:19.

his corselet and brandishes his shield and makes sharp his missiles and images Ares and outleaps Apollo and glares like the Arabian beasts and soars above the birds that are in the clouds. But by these antics his evil is detectable and therefore more easily guarded against. But he also concocts plots and is full of bitterness within and pretends friendship and hides his grief beneath his tongue and professes salvation with his lips, deceives by nods and gestures, holds his peace or speaks in falsehood. What does he not perform or devise to compass destruction and murder? And why does he do all this? In order to pocket the very things that will make for his own destruction; in order to get glory that withers sooner than grass; in order that he may be marked on earth, perhaps with the brand of Cain and Lamech and their crew, that he may be expunged from the Book of Salvation and be dismissed among the goats; in order that he may have riches, boast of his treasures, and listen to folly when his soul is required of him; and may, first and last, suffer the fate of Croesus and Polycrates! But these were the crimes and sufferings of the sons of the pagans, because in their presumption they filled heaven with gods who were war lovers, warriors, quarrelsome, treacherous, for ever breathing Ares or snuffing up the fat that turned about in the smoke. When the models were strife and war, how should their imitations be at peace? But these people, together with their gods, have been driven away, though there was none to drive, and abolished. For the evil was without being and substance.

10. But we, the disciples of the new law and the new commandment, the initiates of the peaceable, the meek, the lowly: we who are taught to pray for those who injure us, hate us, grieve us, and tyrannize over us, and to lay down our life for our friends, and to submit to those who lay burdens upon us, we — what is more — who know that there is One who instructs the wise and lays hold upon

κρυπτῷ,[84] καὶ ἀποδιδοὺς ἑκάστῳ κατὰ τὰ ἔργα αὐτοῦ,[85] τοὺς πολέμους
καὶ τό τε καθ' ἑαυτῶν καὶ ἀναλόγως ἀσπασόμεθα; μηκέτι, μηδαμῶς,
ἀδελφοί, ἀλλ' εἰ καὶ ποσῶς ἐκείνοις συναπηνέχθημεν — τῆς γὰρ αὐτῆς
πλάσεως, εἰ καὶ μὴ πλάνης, μετέχομεν — ἀλλ' οὖν ἐπαναχθέντες μηκέτι
280 παρενεχθείημεν. ἔστι καὶ πεσόντας ἐξανασθῆναι καὶ στῆναι τῶν οὐ
πεσόντων ἀσφαλέστερον καὶ ἀνώτερον.

11. Ἀλλ' ἐπὶ τὰ νῦν ἐπανακτέον τελούμενα καὶ προ-
δεικτέον τὰ τῆς ἑορτῆς ἐκδηλότερον· ἅπαν γὰρ ἄδηλον ἀηδέστερον.
fol. 47ᵛ ἐπεὶ δὲ τὸ πᾶν οὐχ οἷόν τε διατρανῶσαι μὴ καὶ | τὰ πρότερον παρα-
285 δείξαντας, τὰ δ' οὐκ ἄλλως μὴ καὶ τὰς λαβὰς καὶ τὰ αἴτια παραστήσαν-
τας, καὶ ὅθεν καὶ ὅπως ἐκεῖνά τε προέβη καὶ τάδ' ἐπέβη, οὕτω μοι
δοκεῖ διαθετέον εἶναι τὸν λόγον. ἤνθει τὰ ἡμέτερα πάλαι καὶ ἀνθοῦντα
προέκοπτεν, ηὔγαζε, τῆς ἀκμῆς ἐθαυμάζετο, τῆς ἐπιδόσεως ἐθειάζετο,
ζηλωτὰ πᾶσιν ὑπῆν καὶ ὁρώμενα καὶ λεγόμενα καὶ μετὰ δόξης διηχεῖτο
290 τοῖς πέρασιν, ὅτε τὸ στρατιωτικὸν ἐρρυθμίζετο Λέοντι καὶ συνεβούλευεν
Ἀχιτόφελ[86] καὶ Δράκων καὶ Σόλων ἐθέσπιζον, ὅταν αἱ μυθικαὶ μοῦσαι,
οἷον εἰπεῖν, ἐπὶ γῆς ἐγνωρίζοντο καὶ ὁ Ἄρης κατετιτρώσκετο,[87] ὅταν
εἰς πέταυρον Ἅιδου τὸ ἀφιλόσοφον, καὶ παρὰ τὸ δρυὸς σκότος ἀνομία,
κατὰ τὴν παροιμίαν,[88] καὶ αἱ Βριάρεω χεῖρες ἐζωστρακίζοντο,[89] ὅτε τὸ
295 χρυσοῦν γένος ἐπολιτεύετο[90] καὶ τὸ πᾶν εἶχεν εὐδαιμονία καὶ τῶν θείων
ἀπόλαυσις. οὕτω πως εἶχε τὰ ἡμέτερα πάλαι, συνήνθει καὶ τὰ Βουλ-
γάρων καὶ ἔσφριγε. καὶ πῶς γὰρ οὔ, υἱοθετηθέντων αὐτῶν καὶ Θεῷ
ἡμῶν καὶ ἀπομαθόντων μὲν ἤδη τὰ τῶν ἁμαξοβίων τε καὶ νομάδων,
μεταμαθόντων δὲ τὸ τῆς χάριτος εὐαγγέλιον· ἕως μὲν ἰσόρροπα τὰ
300 ζυγὰ καὶ ὁ θεῖος εὐμενὴς ὀφθαλμός, γαλήνη τὴν θάλασσαν εἶχε καὶ ὁ
πλοῦτος ἐξ οὐρίας ἐφέρετο.

12. Ἐπεὶ δὲ ὁ κύβος ἀντέστραπται καὶ ὑπερέσχε τὰ τά-
λαντα, ἔδει τε γενέσθαι κακῶς καὶ νικῆσαι τὰ χείρονα, εἴτε τοῦ καλοῦ
τὴν ἀκρώρειαν φθάσαντος καὶ διὰ τοῦτο πρὸς τὸ κάταντες ἀποβλέπον-
305 τος, εἴτε τῶν παραπτωμάτων ἡμῶν Θεῷ παρεστώτων καὶ τὸ κόνδυ τῆς
μέθης προκαλουμένων, ἵνα τοῖς δεινοῖς κραιπαλήσωμεν, φεῦ μοι τοῦ

277 ἀναλόγως Us: ἀνευλόγως V ‖ 279 ἐπαναχθέντες VKu: ἐπαναχ-
θέντας Us ‖ 290 ἐρρυθμίζετο corr. Us: ἐρυθμίζετο V ‖ 298 ἁμαξο-
βίων corr. Us: ἀμαζονίων V ‖ 302 ὁ κύβος corr. Us: τὸ κύβος V ‖
Συμεών mg. V

[84] Matt. 6:4.
[85] Matt. 23:3; Rom. 2:6.
[86] II Regn. 15:12–31.
[87] Homerus, *Il.* 5.855–63.
[88] Zenobius VI.12: cf. Leutsch-Schneidewin (supra, 15), I, 165.
[89] Cf. Theoph. Cont. (Bonn. ed.), 258, 15; Zenobius V.48: cf. Leutsch-Schneide-
win, I, 140.
[90] Hesiodus, *Op.* 109.

the cunning and sees in secret and rewards every man according to his works — shall we, in defiance of reason, embrace wars and our own destruction? No longer, not at all, brethren! But if we have been in some degree led away along with those [pagans] (for we share the same creation with them, if not the same error), yet let us be led back and be led astray no more. Those who have fallen may stand again, and to stand again is to be safe and better than those who have not fallen.

11. But we must return to the present celebration and make clearer the circumstances of the festival: for all obscurity is somehow distasteful. And since we cannot illustrate the whole without showing what went before, and this can only be done by representing the occasions and causes, and why and how those events went before and these followed after, I think my discourse should be arranged in this way. In the old days our affairs flourished, and flourishing, advanced, grew bright, were admired for their prime and extolled for their progress, and what was seen and said aroused the envy of all men and resounded gloriously to the ends of the earth: when the army was disciplined by Leo, and Achitophel lent his counsel, and Draco and Solon made our laws; when the mythical Muses (so to say) were known on earth and the War God was wounded; when ignorance was banished to the snare of Hades, and lawlessness to "the darkness of the oak" (as the saying is), along with the hands of Briareus; when the Race of Gold lived here, and all was happiness and enjoyment of divine blessings. Such was our state in the old days, and with it Bulgarian affairs flourished likewise and were vigorous (naturally, since the Bulgarians had become the adopted sons of our God and had already unlearnt the life of the wagon dweller and nomad and had learnt instead the Gospel of Grace), for so long as the scales were even and the Divine Eye was propitious, and calm held the sea, and wealth was wafted on a favoring gale.

12. But when the die fell on the other side, and the scales tipped up, and it was needful for misfortune to come and for the worse to prevail (either because good fortune had reached the ridge and therefore began to go downhill, or else because our sins came before God and cried out for the cup of drunkenness so that we might wake to

πέμπτου γένους,[91] καὶ τῆς ἀπαύστου ταλαιπωρίας. αὐτίκα γὰρ ὁ φιλο-
δοξίας ποταμός, ὁ τῆς προεδρίας τυφών, ὁ ὑετός, ἡ νιφάς — οἷα καὶ
μάλιστα τὸν Αἷμόν τε καὶ τὸν Ἴστρον κλονεῖ — τῇ τοῦ ἄρχοντος προσ-
310 ερρύη ψυχῇ, καὶ ὁ σεισμός, ὅσου καὶ οἱ ἐπέκεινα Γαδείρων ἐπύθοντο.
εὐθὺς οὖν τὸ στέφος καὶ ὁ δίφρος ἐθριαμβεύετο, στέφος ὃ τὴν Εὐρώπην
ἀπεστεφάνωσε καὶ πολλῶν ἐπὶ γῆς ἔρριψε κάρηνα.[92] Τὸ ἑξῆς ὁ δῆμος
καὶ ἡ ἀποστασία μᾶλλον, ἡ γὰρ ἀνάρρησις καὶ τ’ ἄλλα, οἷς ἡ σφραγὶς
ἐβεβήλωτο, καὶ ὠδίνετο τὸ κακὸν καὶ τὰ γεννήματα τοῦ τεκόντος
315 ἐξιδιάζεται καὶ ἀθετεῖ μὲν τὸν πατέρα, ἀθετεῖ δὲ τὸ πνεῦμα δι’ οὗ ὁ
ἀρραβὼν τῆς υἱότητος.

13. Ὁ δέ — καὶ γὰρ ὃ προήδει διαπυνθάνεται — εἴργει
τέως τοὺς τῆς συγκλήτου τὸ κράτος τιμῶν καὶ τὸν αὐτὸ χαρισάμενον,
fol. 48 ὁ δὲ τῇ τοῦ | Ἅιδου κυνέῃ συγκαλυπτόμενος[93] τοὺς συνεόρτους αἰτεῖ
320 καὶ εἰς ἰσχὺν τὴν διαθήκην προτείνεται, ὁ δ’ ἀντιτείνεται, βασιλέα
προσκυνεῖσθαι σαφῶς ἐρῶν εἰ μὴ Ῥωμαῖον Ῥωμαίοις ἀπώμοτον· "ἢ
βραχὺ τιθεὶς τὸ περινοηθέν σοι διάδημα προσκυνητὰς ἔχε τοὺς συνεόρ-
τους." καὶ τίς τὰς ἐνθυμήσεις τε καὶ προτάσεις, τίς δὲ τὰς ἐπιβολὰς
ἐκείνου ἐξαριθμήσαιτο; οἶδα, φησὶν ὁ μῦθος, "ψάμμου τ’ ἀριθμὸν καὶ
325 μέτρα θαλάσσης,"[94] ἀλλὰ καὶ ὡς εἰδέναι τὰ ἐκείνου ἀμήχανον, οἷς καὶ
δίχα σιδήρου διὰ βίου τὸν Ἄδερ ὑπεκράτει τε καὶ ἀνέστελλεν. ἀλλ’ ὁ
μὲν τὴν εἰρήνην τιμῶν καὶ ὑπ’ αὐτῆς ἔτι τιμώμενος ἀστασίαστος τοῖς
ἀστασιάστοις ἐφίσταται, καὶ τοῖς αὐτοῖς ὁ ἀδελφὸς ἴχνεσιν ἐπιβὰς συνα-
ποίχεται, τῷ παιδὶ τὰ σκῆπτρα λιπὼν καὶ ἀριστοκρατείαν ὑφάψας τὴν
330 ἥβην τῷ νέῳ προσμένουσαν. καὶ ἵνα τὰ πλείω σιγῶ, τὰς ἱερατικὰς
καὶ φιλοθέους ἐπιστολὰς καὶ τὸ συμβοσκηθῆναι λύκον μετὰ ἀρνός, τῇ
κατὰ τὸ εὐαγγέλιον εἰρήνῃ καλῶς προρρηθέν[95] τε καὶ τελεσθὲν ἐπὶ τοῖς
παροῦσι[ν ὃ] μεθεῖλκον καὶ μεθηρμήνευον αἵμασι, τοὺς συκοφαντοῦντας
τὰ τοῦ κράτους ἀπόρρητα, τοὺς Ἱερεμίας ἐκείνῳ καὶ Ἡσαΐας, τοὺς λόγῳ
335 Ζωπύρους,[96] ἔργῳ δὲ δειλοτέρους τοῦ παρακύπτοντος, τοὺς βουλεύοντας
κατὰ τῆς βουλῆς καὶ τὸ πᾶν ἑαυτοῖς ἀποφέροντας, τ’ ἄλλα οἷς ἡγόμεθά
τε καὶ ἐφερόμεθα καὶ ὡς οἱ πίνοντες οἶνον κατ’ ἀλλήλων ἐψάλλομεν
τραγῳδίαν[97] ποιούμενοι τὰ ἡμέτερα.

310 ὁ σεισμός corr. Us: τὸν σεισμόν V ‖ 315 ἀθετεῖ δὲ V: εὐθετεῖ
leg. Us ‖ 318 an αὐτῷ? Du ‖ 323 ἐπιβολὰς VJk: ἐπιβουλὰς Us ‖
329 ὑφάψας VUs: ἐφάψας Jk ‖ 330 τὴν ἥβην: τὴν ἤδη susp. Jk ‖
333 παροῦσι[ν ὃ] Jk ‖ 337 οἱ om. Us

[91] Hesiodus, *Op.* 174. [92] Cf. Homerum, *Il.* 11.500.
[93] Cf. Homerum, *Il.* 5.845; Zenobius I.41: cf. Leutsch-Schneidewin, I, 15 sqq.
[94] Zenobius I.80: cf. Leutsch-Schneidewin, I, 27.
[95] Is. 11:6; 65:25. [96] Herodotus III.154. [97] Ps. 68:13.

dreadful nausea), then, alas for the Fifth Race and for misery unceasing! For at once the torrent of vainglory, the whirlwind of ambition, the rainstorm and the snowstorm (such as especially disturbs Haemus and Danube) swept into the heart of the Archon, and the earthquake came that was felt by those beyond the Pillars of Hercules! At once Crown and Throne were led captive away, the Crown that discrowned Europe and "cast the heads of many down upon the earth." Then followed insurrection, or rather apostasy: for the proclamation came, and the other [titles] with which he profaned his seals, and the evil was born, and he appropriated the fruits of his father, and rejected his father, and rejected the Spirit in which lay the pledge of his sonship.

13. But he, after enquiry of what he knew already, excluded for that time the lords of the Senate, out of his reverence for the imperial office and for Him Who gave it. But he, hidden beneath his helmet of darkness, called for fellow celebrants and proposed the confirmation of the covenant. But he opposed this and said straight out that it was abominable for Romans to do obeisance to an emperor unless he was a Roman; "rather, wear your makeshift diadem for a little, and let your fellow celebrants do you obeisance." Who could number the devices, the expedients, the impositions of that man? "I know," says the tale, "the number of the sand and the measurements of the sea"; but it is impossible to tell the devices whereby, without force, he cunningly mastered and restrained Hadad all through his life. Well: so he, honoring peace and as yet honored by it, quietly took rule over a quiet folk, and the Brother went off by the same way he had come, leaving the scepter to the child and attaching the 'aristocracy' to the youth to whom it already pertained. I will not speak at length of the priestly and pious letters; of the wolf pasturing with the lamb, in the peace according to the Gospel that was fairly foretold and has been consummated in our own time, ⟨which they⟩ wrested and reinterpreted in blood; of the traducers of imperial secrets; of those that played Jeremiah and Isaiah to him; of those that were in profession as brave as Zopyrus but in fact more cowardly than any who wink and look aside; of those that took counsel against the Council and engrossed all power among themselves; and of the other misfortunes by which we were harried and destroyed, when, like those that drink wine, we intoned dirges against one another and turned our affairs into tragedy.

14. 'Αλλ' ἧκεν ἡμῖν ὁ νέος Πρωτεύς,[98] καὶ τοῦ παλαιοῦ
340 ποικιλώτερος, ὃς ἐπιθεῖναι λίθῳ λίθον τῷ πατρῴῳ δόμῳ μὴ κεκτημένος,
μὴ ἐπιστάμενος τὸν Χριστοῦ τοῦ μεγάλου Θεοῦ καὶ Σωτῆρος ἡμῶν
κλῆρον, τὸ περιούσιον σχοίνισμα,[99] τημελεῖν ἐπηγγέλλετο καὶ πλατῦναί
γε τημελούμενος. καὶ δὴ ἀναβάσεις ἀλλοκότους ἐν ψυχῇ διαθέμενος
καθ' ἑαυτοῦ κινεῖ τὸν ἀναγύρον[100] καὶ τοὺς παραστήσαντας τὴν ἕω καὶ
345 τὴν ἑσπέραν, οἴμοι, ἐλάφῳ τῷ γαμβρῷ παραθεὶς ἡγουμένῳ κατὰ ἐκ τοῦ
δρυμοῦ μονιοῦ διεξάγεται καὶ ἀναρρίπτει τὴν κόνιν καὶ ὑπανάπτει τὸ
πῦρ, οὗ καὶ νῦν αἱ φλόγες διαθέουσιν ἄσβεστοι.

15. 'Επεὶ δὲ πυρὶ τὸ πῦρ δυσανάλωτον, ἐξ ὕδατος
ἀναλαμβάνει Θεὸς τὸν Μωσῆν[101] καὶ ταῖς ἐπιστάταις πιεζομένῳ τῷ
350 'Ισραὴλ[102] φέρων ἐφίστησι, τὴν νομὴν σβέσαι, τὸν Φαραὼ σχῆσαι, τοὺς
τριστάτας[103] ἀπῶσαι καὶ τὸν 'Ιακὼβ οἶκον ἐπανασώσασθαι. ἐντεῦθεν
— καὶ γὰρ εἰ σιγῶμεν ἡμεῖς, τὰ ἄψυχα φθέγξεται[104] — εὐθὺς εὐνομίαι,
φιλοτιμίαι, διανομαί, βουλευτήρια, φόροι κοπτόμενοι, τὸ ἄδικον τυραν-
νούμενον, Ναζηραῖοι[105] ὁμοδοξοῦντες, τὸ ἀπερίσπαστον | βοηθούμενον,
355 οἱ τῆς ἀρετῆς ἐν τιμαῖς, ἐν ἀτιμίᾳ τὸ ἄμουσον, τὸ πᾶν ἐπὶ γόνυ κλιθὲν[106]
ἀνορθούμενον· τὸ μεῖζον, αἱ πρὸς τὸ κατεπεῖγον πρεσβεῖαι, νῦν μὲν
ἥδουσαι, νῦν δὲ στύφουσαι, καὶ τότε μὲν πτοοῦσαι, τότε δὲ θαρρύ-
νουσαι, ὑπαλείφουσαι, προσάγουσαι, πλύνουσαι, πάντα λίθον κινοῦ-
σαι,[107] ἵν' ἑνὶ τρόπῳ τὸν θῆρα προσάξωνται· τοῖς γὰρ ποικίλοις τὸ
360 μονοειδὲς ἀνήρμοσται, ὃ δῆλον κἂν μεταβάλλεται, τοιοῦτον γὰρ ὁ πολύ-
τροπος.

fol. 48v

16. Καὶ παρουσιάσας εὐθὺς προκαλεῖται τὸ κράτος. καὶ
ὦ τῆς ὑμῶν πίστεως καὶ γενναιότητος· τῇ μὲν γὰρ Θεῷ, τῇ δὲ καὶ ἡμῖν
πεποιθώς, καὶ τὸ "βούλομ' ἐγὼ λαὸν εἶναι σόον ἢ ἀπολέσθαι"[108] ἔργῳ
365 διατρανῶν, ψιλὸς κατὰ τὸν Δαβὶδ[109] στιλβουμένοις τοῖς δόρασιν ἔδυνας,

339 ὁ Κωνσταντῖνος ὁ εὐνοῦχος mg. V ‖ 343 τημελούμενος Us:
-ούμενον VKu ‖ 348 'Ρωμανὸν mg. V ‖ 350 σχίσαι Us ‖ 354 ἀπε-
ρίσπαστον VUs: ἀπερίστατον KuJk ‖ 357 καὶ τότε δὲ Us ‖ 358
πλύνουσαι om. Us ‖ 360 δῆλον coni. Jk: δήλῳ VUs ‖ 363 ἡμῖν V:
ὑμῖν Us ‖ 365 δόρασιν V: θώραξιν Us

[98] Karathanasis (supra, 18), 9, p. 23; H. Herter, *RE*, XXIII, coll. 940–75,
praesertim 967 sqq.
[99] Ps. 104:11.
[100] Zenobius II.55: cf. Leutsch-Schneidewin, I, 46.
[101] Exod. 2:5. [104] Cf. I Cor. 14:7.
[102] Exod. 1:11. [105] Dujčev (*supra*, 19), 380.
[103] Exod. 14:7. [106] Cf. Aeschylum, *Pers.* 930.
[107] Zenobius V.63: Leutsch-Schneidewin, I, 146; Diogenianus Epicur. VII.42:
cf. Leutsch-Schneidewin, I, 293.
[108] Cf. Homerum, *Il.* 1.117. [109] I Regn. 17:43–44.

14. But, well: there came among us this new Proteus, yet more various than the old, who had not one stone to set upon another for building his father's house, who knew not the heritage of Christ our great God and Savior, His Peculiar Portion. He undertook to take care of it, and to increase it by his care. And so he devised monstrous ambitions in his heart, and "moved the stinkweed against himself", and, alas, entrusted the conquerors of east and west to the command of his deerhearted brother-in-law, and moved against the wild boar in the woods, and kicked up the dust and lit the fire whose flames even now run wide and unquenched.

15. But since fire is hardly quenched by fire, God raised up Moses out of the water and brought him and set him over Israel that was pressed by her taskmasters, to quench the spreading flames, to check Pharaoh, to eject the counsellors and to redeem the house of Jacob. Thereupon (and even though I should be silent, senseless things will cry it aloud) at once came good government, largess, distribution of bounties, wise counsellors, tax relief, injustice repressed, Nazarenes agreeing, the defenseless succoured, the virtuous held in honor, the ignorant dishonored, everything that was beaten to the knee raised up; what is more, embassies were made to meet the urgent crisis, some successful, some gloomy, some daunting, some encouraging — soothing, inviting, "turning every stone," with the single aim of alluring the wild beast (for instability is out of harmony with singularity, which, though it may change shape, remains plain: that is the meaning of "versatile").

16. And when he appeared among us, he at once demanded imperial power. And oh! your faith and courage! Trusting both in God and in us, and putting into action that saying, "I will that my people be saved and not destroyed," you went, like David, naked among the shining

ὁ δ', οἷον τὸν Γολιὰθ ἀκούομεν,[110] μετὰ τῆς ἀλαζονείας ἔπεισι, καὶ τῶν ὅπλων προηγουμένων ἐπὶ τὴν φιλίαν χωρεῖ, καὶ πολλὰ μὲν βαρβαρίζων, πλείω δὲ σολοικίζων, εἶτα τὸ δέον ἀκούσας, τῇ ὑστεραίᾳ διαθέσθαι συνθεὶς ἀπαλλάττεται. καὶ ὥσπερ τὰ τῶν θηρίων ὠμότερα, ἐπὰν
370 ἀποροῦσι τοῖς βάλλουσι, πρὸς τὰ βέλη διαγωνίζονται, οὕτω καὶ οὗτος μετὰ τῆς ἔχθρας ἀποκρουσθεὶς τοῖς δρυμοῖς τὸν χόλον ἀπέσκηψε. τὸν μὲν οὖν Ἰεσσαὶ παῖδα μετὰ τὸ χρῖσμα καὶ τὴν ἐπίπνοιαν ὅμως οὐκ εἴα Θεὸς οὐδὲ θεμέλιον πῆξαι τῷ οἴκῳ[111] — εἰ γὰρ τὸ ἐξ Αἰγύπτου παραιτεῖται σιδήριον,[112] πῶς αἱμάτων χεῖρα προσήσεται; τῷ μέντοι παιδὶ τελέσαι
375 τὸ ἔργον προτρέπεται, ἴσως ὅτι τῶν τοιούτων ἀνέπαφος. οὕτω μοι δοκεῖ καὶ αὐτὸν ἐξ ἥβης τοῖς τοιούτοις ἐνασκηθέντα εἰς τὸ οὕτω σεπτὸν ἔργον οὐ παραδέξασθαι, διὸ τῷ αὐτοῦ μᾶλλον ἐπευδοκεῖ παιδὶ κατανύσαι τὸ βούλημα.

17. Ἧκεν οὖν αὐτόμολος ὅτι ἐκεῖθεν τὸ ὅρμημα. καὶ
380 ὑμεῖς τὸ πατρῷον τειχίον χερσὶ διασπάσαντες καὶ χείλεσι χείλη προσπτύξαντες, καὶ χερσὶ χεῖρα λαβόντες, ἐσπείσασθε, ἐπιστώσασθε, καὶ οἱ λόγοι μετὰ τοῦ λόγου, καὶ καλῶς ἡ διαθήκη ἐπισφραγίζεται. οὕτω χθὲς καὶ σήμερον τὰ ἡμέτερα. οὕτω κατὰ τοῦ νείκους νίκος ἠράμεθα καὶ κατὰ τῆς ἔχθρας στήλην περίοπτον ἀνηγείραμεν καὶ πεφήναμεν οἱ κατ'
385 ἀλλήλων ὑπὲρ ἀλλήλων, οἱ μετὰ τῆς ἀφροσύνης ἐν σωφροσύνῃ, οἱ τῆς διαθήκης ὁμόκληροι, οἱ ἐνεδρεύοντες συνεδρεύοντες, οἱ μετὰ τῆς ἀπονοίας ἐν ὁμονοίᾳ. καὶ ἵνα πάλιν διὰ τὸ περι|χαρὲς ἀνακυκλῶμεν ἐπὶ τοῖς αὐτοῖς, οἱ τοῦ ἑνὸς ἐνικώτατοι, οἱ διαιρεθέντες κακῶς καλῶς συναιρούμενοι, οἱ τῆς ἀληθείας κατὰ τοῦ ψεύδους, Ἱερουσαλὴμ καὶ Σαμάρεια
390 σύννομοι,[113] πάντες ἐν κοινότητι φιλαδελφίας καὶ ὁμονοίας.

18. Ταῦτα καὶ ὁ βλέπων, προβλέπων, ἑόρταζε, Σιών, τὰς ἑορτάς σου,[114] διακελεύεται, πολυανθρώπους ἄγε τὰς πανηγύρεις, πλήθουσι τὰ ὅριά σου εἰρήνης, καὶ ὁμοφροσύνης αἱ ἀγοραί σου· οὐ μὴ προσθῶσιν ἐλθεῖν εἰς παλαίωσιν,[115] ὅτι Κύριος ἐπελήψατο. ἰδοὺ τὰ ὀστᾶ
395 διεσκορπισμένα παρὰ τὸν Ἅιδην καὶ ἄνικμα σάρκα καὶ δέρμα καὶ τένοντας περιβάλλεται,[116] καὶ ὁ οἶκος Ἰακὼβ προλαβὼν ὁρᾷ τὴν ἀνάστασιν.[117] καὶ νῦν ἡ ἐσχάτη δόξα τοῦ οἴκου Κυρίου ὑπὲρ τὴν πρώτην, ὅτι εὐδόκησε Κύριος. ἄρτι μὲν αἰθὴρ καὶ τὰ μετέωρα καθαρώτερα καὶ τὸ γῆς πρόσωπον ἀνθηρότερον. ἄρτι δὲ καὶ κρῆναι πηγάζουσι ποτιμώτερον, καὶ γῆ

380 ὑμεῖς: Us: ἡμεῖς V ‖ 381 ἐπείσασθε male Us ‖ 385–86 τῆς διαθήκης [ἄκληροι] suppl. Jk ‖ 390 κοινότητι Ku: καινότητι VUs ‖

[110] I Regn. 17:4 sqq.
[111] I Par. 22:7–10.
[112] III Regn. 6:7.
[113] Cf. Joan. 4:9.

[114] Nah. 1:15.
[115] Nah. 1:15.
[116] Ez. 37:8.
[117] Agg. 2:9.

spears; and he, as we hear of Goliath, came on with his boasting, and, with his armed men before him, yielded to friendship. He spoke much in a barbarous accent and made many more errors in grammar; then listened to what he had to hear; and on the morrow departed, having agreed to make peace. And as most savage beasts, unable to come at their pelters, worry the missiles, so he, repulsed in his enmity, slaked his wrath on the forest trees. Now, God did not allow the son of Jesse, even after his anointing and blessing, so much as to lay the foundation stone of His temple (for if He rejects the iron out of Egypt, how shall He admit the hand of blood?), but commanded his son to fulfill the work, perhaps because he was stainless of such bloodshed. In the same way, I think, God did not allow him, exercised as he was from his youth in such pursuits, to enter on a work so holy; and, instead, approved that his son should perform His will.

17. And so he came unbidden, for the impulse was from God. And you broke down the middle wall that his father had built, and kissed his lips with yours, and took his hand in your hands, and made a truce with him and gave him your pledge, and promise was sealed with promise and fairly the covenant was ratified. Such are our affairs of yesterday and today; thus have we won victory over strife and reared a far-seen monument over enmity; we that were hostile are seen to be friends; we that were mad, sober; we that were ⟨without portion⟩ in the covenant are partners in it; we that sat in ambush sit side by side; we that were in desperation are in harmony. Or, to recapitulate these matters out of our excess of rejoicing: we that are of the One are most unified, we who were evilly divided are fairly composed, we that are of the truth stand against the false; Jerusalem and Samaria are allies, and all are in community of brotherly love and concord.

18. These things the seer foreseeing bids you "celebrate your festivals, O Sion, lead your thronging processions!" Your borders are full of peace, and your meeting places of concord. They shall not add that they are coming to old age, because the Lord has laid hold on them! Behold, the bones scattered in death are being clad in moist flesh and skin and sinews; and the House of Jacob beholds in advance the resurrection! And now the last glory of the House of the Lord is beyond the first, for the Lord has favored it. Now are the ether and the sky more clear, and

400　καὶ θάλασσα τὰ ἑαυτῶν ἀφθονώτερον νέμουσιν. ἄρτι δὲ δρῦς ἀληθῶς,
　　　ἄκρῃ μέν τε φέρει βαλάνους, μέσῃ δὲ μελίσσας, καὶ τὰ θρέμματα τοῖς
　　　πόκοις καταβαρύνεται.[118] νῦν ἡ ἀποικία ἐγκατοικίζεται καὶ θεμέλιον
　　　τίθησι καὶ ὄροφον ὑπερτίθησι, καὶ ἀνεγείρει τὴν γῆν, καὶ καταβαθύνει
　　　φυτὰ καὶ κρύπτει σπέρματα, καὶ ἐξελαύνει τῶν ἀγγείων ἀράχνια καὶ
405　ταῖς ἐλπίσι συντρέφεται. νῦν ὁδοὶ πλήθουσιν ὁδοιπόρων καὶ ἀμνοὶ καὶ
　　　μόσχοι ταῖς νάπαις περισκιρτῶσιν ὡς ἥδιστα. καὶ πάλιν τερπνὸς ὁλκὸς
　　　ἁμάξης ἀκούεται. νῦν τὸ γῆρας ἀποξύεται γέρων καὶ ἀετὸς ὥσπερ
　　　ἀνακαινίζεται,[119] καὶ παῖδες ἀνδρίζονται, καὶ οἱ τῆς ἥβης πονοῦσιν
　　　ἀκάματα. νῦν καὶ παρθένοι τῇ Μωσέως συνερχόμεναι Μαριὰμ λιγυρὸν
410　ᾄδουσι μέλος,[120] καὶ ἀλλήλας δεχόμεναι τὸν κατὰ τῆς ἔχθρας χορεύουσιν
　　　ἐπινίκιον. νῦν καὶ τὸ εἶναι τερπνόν, καὶ τὸ βιῶναι τερπνότερον, καὶ
　　　ἄνθρωποι κατὰ τοὺς πάλαι μακροβιώτεροι. οὕτω πάντα νεάζει, οὕτω
　　　γάννυται καὶ τὸν αἴτιον τούτων ἀνυμνεῖ καὶ δοξάζεται. οἱ τῆς Ἄγαρ
　　　μόνον οἰμώζουσι καὶ οἰμώξουσιν, οἳ καὶ μόνῳ τῷ ἤχῳ τῆς ἡμῶν ὁμονοίας
415　τὰς καρδίας ἀφήρηνται.

　　　　　　　　19. Καὶ τίς ὑψώθη τῆς εἰρήνης ἐκτός, τίς δὲ δίχα ταύτης
fol. 49ᵛ　ἀπέλιπε δόξαν, εἰ μὴ τοῖς εὖ φρονοῦσιν ἐπίψογον; | Σολομῶν ὁ Δαβὶδ
　　　βασιλεύτατος οὐχ ὅτι σοφίαν καὶ βασιλείαν ἥρμοστο, ἀλλ᾽ ὅτι Σατὰν
　　　αὐτῷ διὰ βίου οὐκ ἦν· ἀνατελεῖ γὰρ αὐτῷ πλῆθος εἰρήνης (ἀκούεις;),[121]
420　ἕως ὁ πυρσὸς τῆς σελήνης σβεσθήσεται. καὶ ἵνα τὰ πᾶσι δῆλα παρά-
　　　γωμεν, οἱ περὶ τὰς ἐμπορίας, καὶ κοινωνίας ἴσην προθυμίαν ἔχοντες οὐκ
　　　ἴσασι τὸ διάφορον. ὁδοιπόροις κουφίζει τὸν πόνον, καὶ ὀλίγον τὸ
　　　διάστημα τίθησι καὶ πρὸς ἀλλήλους ὁμόνοια. πλωτῆρες καὶ λαίλαπος
　　　καὶ κυμάτων καταφρονοῦσιν ὅταν ὁμοψύχως διαγωνίζωνται. καὶ διφρη-
425　λάται, εἰ μὴ ὁμοτρόπους ἁρμόσονται ἵππους, ποτ᾽ ἂν τοὺς ἀντιτέχνους
　　　ὑπερβαλοῦνται;[122] καὶ φάναι καθόλου, εὐδαιμονίζουσιν ἔθνη καὶ πόλεις,
　　　αἷς εἰρήνη προσεπικάθηται. ὅταν ὁ δῆμος τὸ αὐτὸ καὶ λέγῃ καὶ δια-
　　　πράττηται καὶ τὸν καθ᾽ ἕνα πείθῃ τῷ κοινῷ συμφρονεῖν ὑποδείγματι,
　　　τούτους ὑποπτήσσει μὲν εἴ τι πολέμιον, συνασπίζει δὲ καὶ Θεός· εἰ γὰρ
430　μεταξὺ δύο συμφρόνων ὁρᾶται, ὅσῳ πολυανθρώπου πληρώματος.

　　　　　　　　20. Εἰ δὲ δεῖ τι καὶ τ᾽ἀναντία σκοπεῖν — τῇ γὰρ τοῦ
　　　κακοῦ παραθέσει τὸ καλὸν ἐκδηλότερον καὶ διὰ τοῦτο καὶ αἱρετώτε-
　　　ρον — τοὺς Μήδους λάβε μοι καὶ τοὺς Πέρσας, ἔθνη τῶν τῆς Ἀσίας

401 τε om. Us ‖ 403–4 καταβαθύνει — ἀράχνια ordine inverso Us ‖
423 τίθησι καὶ: καὶ om. Us ‖ πλωτῆρες corr. Us: πλωτῆρος V ‖
424–25 διφρηλάται corr. Us: διφρελάται V ‖ 433 λάβε Us

[118] Hesiodus, *Op.* 233–34.　　　[119] Ps. 102:5.　　　[120] Exod. 15:20.
[121] Ps. 71:7.　　　[122] Cf. Platonem, *Phaedr.* 253–54.

the face of the earth more smiling. Now the springs well up with purer water, and earth and sea supply their fruits more abundantly. Now in truth the oak tree "bears acorns at its top, and bees in its middle, and the sheep are weighed down with their fleece." Now the homeless return home, and lay the foundation, and set the roof above, and turn the soil, and deepen the crop, and hide the seed, and drive out the cobwebs from the vessels, and are nourished with hope. Now the roads are thronged with wayfarers; and lambs and calves frolic in the dales most gladsomely; and pleasant it is once more to hear the turning of the wagon's wheel. Now the old man puts off his age and is renewed like the eagle, and children grow to man's estate, and the youths labor without tiring. Now virgins, going along with Miriam the sister of Moses, sing a shrill melody, and hand in hand dance the dance of triumph over enmity. Now is existence joyous, and life more joyous still, and men are more long-lived after the ancient pattern. So are all things made new and sparkling, and hymn and glorify the Cause of this. Only the sons of Hagar mourn and shall mourn, who are bereft of heart at the mere echo of our concord.

19. Who hath been exalted without peace, and who without her hath left behind a name other than odious to men of sense? Solomon, son of David, was most kingly, not because he united wisdom with kingship, but because during his life Satan was not: "there shall arise upon him abundance of peace (do you not hear?) until the torch of the moon be quenched." And — to mention examples manifest to all — those employed in trade or commerce who show an equal readiness know no dissension. Mutual concord lightens the traveler's labor and makes short his journey. Seamen make light of the tempest and waves when they strive with a common purpose. How shall charioteers, unless their yoke of horses be of one mind, ever surpass their rivals in the art? In a word, happy are those nations and cities over whom peace presides. When the populace is at one in word and deed and persuades each member to conform to the common pattern, all enmity cowers before them, and God takes their part: and if this be true of two that are like-minded, how much more true is it of a company of thousands?

20. But if we should consider the opposite condition — for good is more plain and thus more desirable if we compare it with evil — take the Medes and Persians,

ὀλβιώτερά τε ἐθνῶν ἀλκιμώτερά τε καὶ ἰσχυρότερα, οἳ τῆς εἰρήνης τὸν
435 πόλεμον προστησάμενοι καὶ τάδε μὲν αἱροῦντες, τάδε δὲ καταστρέφον-
τες, οὕτω συγκατεστράφησαν, ὡς μηδὲ πυρφόρον αὐτοῖς λειφθῆναι,[123]
μηδὲ βλαστῆσαι θαλόν, κατὰ γὰρ τὸν πεύκης τρόπον ὀλόρριζοι διεφθά-
ρησαν.[124] Πάρθους δὲ τοὺς κατὰ τὰς Πύλας ἀκούομεν παντοίων πολέμων
εἰδήμονας· οὐ γὰρ ὑπὸ ζυγὸν ἄγουσι βόας, οὐδὲ διασχίζουσιν ἄρουραν,
440 οὐδέ τι τῶν τῆς εἰρήνης σεβάζονται, ἀλλ' ἔτι νήπιοι τόξοις ἐθίζουσι,
δόρατα θήγουσι, πεζομαχίαις, ἱππομαχίαις, φυγαῖς, διώξεσιν ἐναθ-
λεύουσιν, οὐ μὴ φάγωσιν ἐὰν μὴ τῷ πολέμου νόμῳ τὴν κεφαλὴν
ἐφιδρώσωσι.[125] καὶ ὅμως τῇ Ῥωμαίων ἡττηθέντες αἰχμῇ αὐτοῖς ὅπλοις
καὶ τοὔνομα προσαπώλεσαν. τί δὲ τοὺς περὶ τὸν Νεῖλον Θηβαίους
445 διελυμήνατο; ἕως γὰρ τοῖς ὁμόροις συνέβαινον, τήν τε Χρυσῖτιν ἐπεῖχον
καὶ τἆλλα τοῦ Νείλου ἐνέμοντο, ἐπεὶ δέ πως ἐφυσιώθησαν καὶ περὶ τοὺς
γείτονας ἔσκασαν. ἴστε τὴν Καμβύσου στρατείαν καὶ τὸν ἐκεῖθεν τούτοις
ἐπιπολάσαντα ὄλεθρον, οὗ τὴν κεφαλὴν οὐκέτι διαίρουσιν.[126] ὁ μέντοι
fol. 50 τὴν ὀφρὺν Ξέρξης αἰθέριος ἐπεὶ κατὰ Λακεδαιμονίων | ἐξέμηνε, γῆν μὲν
450 ὑπερέθηκεν ἄλλην τῇ θαλάσσῃ μετέωρον[127] καὶ μηχανῇ ξένῃ τὰς μυριά-
δας ἠρίθμει,[128] ἐπεὶ δὲ τὸ ἔργον μετὰ τῆς αὐθαδείας [...], τὰς μυριάδας
ἀποβαλὼν οὐδὲ χιλιάσι τὰ Σοῦσα κατέλαβε. καὶ παρίημι τὰ Ἐτεοκλέους
καὶ Πολυνείκους τῶν Οἰδίποδος, οἳ τῆς Θηβαίων ἀρχῆς προμαχόμενοι,
ἀλλήλους ἀνεῖλον.[129] ἐῶ καὶ Κῦρον τὸν ἔσχατον, ὃς Δαρείῳ τῷ Ἀρτα-
455 ξέρχου διαφερόμενος καὶ τὴν εὐτυχίαν οὐ φέρων, τῷ δυστυχοῦντι πεσὼν
τὴν ἀρχὴν προεξένησε.[130] καὶ τὸν λίβυν Ἀνταῖον ἀφῶμεν, ὃς ἀναιρῶν
τοὺς ἐπιξενουμένους ὀψὲ καὶ αὐτὸς ἐπιξενωθεὶς Ἡρακλεῖ τῆς ξενίας εὗρε
τἀπίχειρα.[131] τίς δὲ τὸν Φιλίππου παῖδα, τὸν ἀκάθεκτον ἐκεῖνον καὶ
μαχιμώτατον οὐκ ἐπίσταται, ὃς σχεδὸν τὴν οἰκουμένην παραστησάμε-
460 νος καὶ τῷ δημιουργῷ ἐπεμέμφετο ὅτι μὴ μᾶλλον τὸν γῦρον τῆς γῆς
ἐπλατύνατο, ὡς οὐχ ἱκανοῦ τοῦ νῦν ὁρωμένου τῷ ἐκείνου συνεκτείνεσθαι
δόρατι,[132] ἀλλὰ καὶ ὃς πρὸς τῷ μηδέν τι τῆς ἀπληστίας ἀπόνασθαι,

434 ὀλβιώτερα τε mg. V ‖ 436–37 μηδὲ...μηδὲ corr. Us: μὴ
δὲ...μὴ δὲ V ‖ 437 ὀλόρριζοι corr. Us: ὀλόριζοι V ‖ 440 τόξοισι
Us ‖ 446 post ἐνέμοντο lac. susp. Jk ‖ 447 ἔσκασαν: ἐσκαιώρησαν
coni. Us ‖ 448 ἐπιπολάσαντα corr. Us: ἐπιπολώσαντα V ‖ 451
post αὐθαδείας lac. susp. Us ‖ 460: ἐπεμέμφετο corr. Us: ἐπεμ-
φέτο V ‖ 462 ὃς: ὡς Us ‖ τῷ Us ‖ ἀπόνασθαι Us

[123] Zenobius V.34: cf. Leutsch-Schneidewin, I, 134–35.
[124] Zenobius V.76: cf. Leutsch-Schneidewin, I, 150–51.
[125] Cf. Julianum Justinum, *Epit. Hist. Philippicarum* XLI.2–3.
[126] Cf. Herodotum III.1–4, etc.
[127] Herodotus VII.34.
[128] Herodotus VII.60.
[129] Aeschylus, *Septem contra Theb.* 810.
[130] Xenophon, *Anab.* I.viii.27.
[131] Apollodorus II.v.11 (Loeb ed., 222).
[132] Ex fonte incert.

nations more rich, more courageous, more powerful than any
of those of Asia, who, preferring war to peace, and choosing
the former and destroying the latter, were themselves de-
stroyed with it, so that not a fire carrier was left behind nor
a shoot to sprout: for like a pine tree they were withered
root and branch. We read that the Parthians at the Gates
were masters of all sorts of fighting: "for they harness no
oxen under the yoke, nor do they cleave the soil, nor respect
any of the arts of peace; but even as infants they practice
with bows, sharpen spears, exercise themselves in fighting
on foot and on horseback, in flight and pursuit; nor will
they eat save in the sweat of their face in warrior fashion."
And yet, defeated by the Roman spear, they lost name,
arms, and all. What destroyed the Thebans about the Nile?
For so long as they agreed with their neighbors, they kept
to Chrysitis and dwelt in the other districts of the Nile. But,
when in some way they became puffed up and were vexatious
to their neighbors, you know of the expedition of Cambyses
and the destruction that thence overflowed upon them, and
they lift up their head no more. When Xerxes in his pride
was enraged against the Lacedaemonians, he placed another
earth on high above the sea and numbered his myriads by
a strange device; but because he ⟨approached⟩ the work
with arrogance, he lost his myriads and arrived back in Susa
with not even thousands. I omit the story of the sons of
Oedipus, Eteocles and Polyneices, who, fighting over the rule
of Thebes, slew one another. I pass by the last Cyrus, who
quarreled with Darius, son of Artaxerxes (*sic*), and had no
luck, but fell and yielded his rule to the loser. Let us ignore
the Libyan Antaeus who slew his guests and at last, enter-
tained by Hercules, received the wages of his hospitality.
But who knows not Philip's son, that uncontrollable and
most warlike man, who, after conquering almost all the
world, reproached the Creator for not having given the
earth a wider circuit, since, as it now is, it was not sufficient
to measure with his spear; and who not merely reaped no

Όλυμπιάδα τε τὴν μητέρα καὶ Περδίκκαν καὶ Ἀντίπατρον τοὺς ἐπιτη-
δείους καὶ τὸ γένος ὁμοῦ καὶ τὴν Μακεδονίαν ὅλην ἀπώλεσεν, εὐθὺς
465 αὐτῷ συνδιαλυθέντος τοῦ κράτους καὶ Ἰταλοῖς προχωρήσαντος.

21. Τοιαῦτα τὰ τῆς ἔχθρας ἐπίχειρα. οὕτω τιμᾷ τοὺς τι-
μῶντας αὐτήν, οὕτω δεξιοῦται τοὺς αὐτῇ προσανέχοντας, τοιούτῳ τέλει,
τοιαύταις ἀμείψεσι. καὶ τίς εἰ μὴ Κορύβου ἠλιθιώτερος[133] οὐκ ἀποτρό-
παιον αὐτήν, οὐκ ὀλέθριον, οὐ τῆς Ὕδρας αὐτῆς,[134] Σκύλλης αὐτῆς,[135]
470 οὐ πάντων ἀτόπων ἀτοπωτέραν ἡγησοίτο; ἀφρήτωρ, ἀθέμιστος[136] καὶ
παράκοπος ὄντως καὶ κάρου καὶ παροινίας ἀνάπλεως, ὁ διχοστασίας
καὶ πολέμων ἐρῶν. πλήρεις αἱ παροιμίαι τῶν ταύτης ἀπαγορεύσεων, ὁ
προφητῶν θίασος, ἡ καινότης, ἡ παλαιότης, ἡ θύραθεν· μεσταὶ γὰρ
τῶν ταύτης κακῶν πᾶσαι μὲν ἀγυιαί, πᾶσαι δ' ἀνθρώπων ἀγοραί,
475 μεστὴ δὲ θάλασσα[137] καὶ λιμένες καὶ ὁ ἀὴρ τυχὸν ταῖς ὀρνίθων ἀντι-
θέσεσιν. ἔχθρας καὶ ἡ κλῆσις δυσώνυμος καὶ χείρων ἡ μνήμη, καὶ ἡ
ἀρχὴ ἔτι χείριστος καὶ τὸ τέλος χειρότερον· τὸ συγγενὲς διαιρεῖ, τὸ
ἀλλογενὲς οὐ προσίεται. τί οὐχὶ τελεῖ τῶν κακῶν; πατέρας ἐκμαίνει,
παῖδας ἀνάπτει, κυμαίνει δήμους, διαιρεῖ χώρας, καταστρέφει πόλεις,
480 ψυχὰς θηριοῖ, λύει τὰ σώματα. ἆρ' οὖν εἰσάμενοι ὁποῖον ἡ μάχη κακὸν
fol. 50ᵛ καὶ συμφορῶν ὁπόσων | αἰτία, οὐ καταβαλοῦμεν αὐτὴν εἰς τὸν Τάρταρον,
οὐκ ἀπορρίψομεν εἰς τὸν Κέρβερον,[138] εἰς Ἅιδου ταμεῖα, εἰς βάραθρον
ἀδηλίας; οὐ σωρὸν λίθων, καὶ θημῶνα γῆς συνεπιφορήσωμεν ἄνωθεν,
οὐ κορμοὺς καὶ ὕλην καὶ ὅ τι που κατὰ χεῖρα συνεπιθήσωμεν, ὡς
485 ἐπαναστῆναι βουνὸν καὶ ἀναδραμεῖν ὄρος πάντων ὀρέων τραχύτερόν
τε καὶ ὑψηλότερον, ἵνα καὶ πολλῶν ἀνελκόντων μαχίμων μηκέτι που
διαφαίνηται; οὐ τῇ συνεχείᾳ τῶν ἀλγεινῶν πιεσθέντες, καὶ Στυγὸς καὶ
Χιμαίρας,[139] καὶ τῶν Κύρβεως κακῶν,[140] καὶ Λαιστρυγόνων αὐτῶν[141] καὶ
τῶν Αἰγύπτου πληγῶν[142] μᾶλλον αὐτὴν βδελυξώμεθα; οὐ τὰ τῶν
490 προγόνων ἐπιμνησθέντες, οἷον τὰς πανηγύρεις ἐκείνας, τὰς ἑορτάς, τὴν
ἐλευθερίαν, τὴν ἀοχλίαν, τὰς ὁλοφώτους νύκτας καὶ ὑμνῳδίας, εἶτα καὶ
τὰ νῦν ἐπικωμάσαντα προσεπιλογισάμενοι τὰς λεηλασίας, τὰς οἰμωγάς,
τὰς καθημερινὰς μιαιφονίας, παραφυλαξόμεθα καὶ νοῦν καὶ ὦτα καὶ τὰς

463 Περδίκαν Us ‖ 468 Κορύβου V: Κοροίβου corr. Us ‖ 469 οὐ τῆς
Ὕδρας αὐτῆς, οὐ τῆς Σκύλλης Us ‖ 479 χώρας Us: χορούς V ‖
481 καταβαλοῦμεν corr. Ku: καταναλοῦμεν VUs ‖ 483 καὶ λίθων
Us ‖ συνεπιφορήσομεν Us ‖ 484 συνεπιθήσομεν Us ‖ 488 κύρ-
βεως Us ‖ 489 βδελυξόμεθα Us ‖ 491 ἀοχλησίαν Us

[133] Zenobius IV.58: cf. Leutsch-Schneidewin, I, 101.
[134] Hesiodus, *Theog.* 313. [137] Cf. Hesiodum, *Op.* 101.
[135] Homerus, *Od.* 12.222–59. [138] Hesiodus, *Theog.* 311.
[136] Cf. Homerum, *Il.* 9.63. [139] Homerus, *Il.* 6.179.
[140] Zenobius VI.77: cf. Leutsch-Schneidewin, I, 105.
[141] Homerus, *Od.* 10.80 sqq. [142] Exod. 7:1 sqq.

reward from his insatiability, but also destroyed his mother Olympias, and Perdiccas and Antipater, his friends, together with his race and all Macedonia, since his empire at once perished with him and fell into the hands of Italians?

21. Such are the wages of enmity! So does she honor those who honor her; so does she reward those who cleave to her, with such an end, with such exchanges! And who (unless he were more foolish than Korybos) would not think her hateful, deathly, more monstrous than Hydra's or Scylla's own self, more monstrous than all monsters? Unsocial, lawless, a proper madman, replete with drunken torpor and folly, is he who loves division and wars! The proverbs are full of prohibitions against strife, as is the company of prophets, the world of today and yesterday, the pagan wisdom. "Full of her evils is every street, every meeting place of men, seas" and harbors, nay, even the air is full of the quarrelings of birds. Of enmity the name is ill-omened, and the memory worse still; her beginning is most evil, her end more evil yet. She divides the family and repels the foreigner. Of what ills is she not the cause? She inflames fathers and kindles the wrath of children, convulses peoples, destroys cities, ensavages souls, dissolves bodies. When we know how evil a thing is strife, and of how many disasters she is the cause, shall we not consign her to Tartarus, cast her to Cerberus, to the regions of Hades, to the pit of obscurity? Shall we not bring to cover her a mound of stones and a pile of earth; shall we not lay above her logs and rubble and whatever lies to hand, so that a hill shall arise and a mountain be piled up more rough and tall than all mountains else, so that though many stalwarts might try to drag her up, she shall never more appear? Shall we, oppressed by continuous griefs of Styx or of the Chimaera, by all the evils of the statute book, by the plagues of the very Laestrygons and of the Egyptians, not loathe her the more? Shall we not remember our forefathers, their holidays, their festivals, their freedom, their ease, their nights brilliant with illumination and the hymns they sang, and then compare them with the rout that has now rushed in upon us, the devastation, the lamentation, the daily murders; and so keep guard over our

αἰσθήσεις, εἰπεῖν, μηδὲν τῶν ταύτης ἕως καὶ λεπτοῦ παραδέξασθαι.
495 ἀλλ' ἀνδροφόνοις μὲν καὶ τοιχωρύχοις καὶ λωποδύταις καὶ ἀκολάστοις
καὶ τῇ τοιαύτῃ φατρίᾳ, διὰ βίου τὰ πολλὰ τῆς κακίας ἀνέκφορα καίτοι
θριάμβων πόσων ἐπάξια, ἡμεῖς δέ τι τῶν τῆς εἰρήνης παρακινήσωμεν,
ἢ παραλύσωμεν, ἢ Λοκροὶ τὰς συνθήκας ἐσόμεθα, τὸ ᾀδόμενον;[143] μὴ
μηδαμῶς, ὦ φιλότης καὶ ἀδελφότης, ὅσοι τῆς σαγήνης τοῦ Λόγου καὶ
500 τῆς μερίδος τοῦ [Χριστοῦ], ἀλλ' ὅτι καὶ ποσῶς ἡλώμεθα τῷ κακῷ,
σχετλιάζοιμεν, οὕτω γὰρ καὶ δυσαλωτότεροι τοῖς ἐξῆς ὁραθείημεν. οὐκ
ἔστι τῶν ἀμεινόνων οὐδὲν ἄμεινον ὁμονοίας· τὰς σχέσεις φυλάσσει, τὰς
διαφορὰς ἀναιρεῖ, χρηστεύεται, μεγαλοψυχεῖ, ῥυθμίζει τὸν βίον, οὐχ
ὑπερτίθησιν ὅρους. τί τ' ἄλλα; Θεῷ συνάγει καὶ ἀγγέλοις τὸν ἄνθρω-
505 πον. οἶμαι λυσιτελεῖν καὶ ἐν ὕδασι διαιτωμένην αὐτὴν καὶ ἐν αἰθέρι,
ἐπεὶ συνεδριάζει Θεῷ, καὶ Θεός, ὡς δέδεικται, τυχὸν ἔνεστιν. ἐγὼ μὲν
οὖν καὶ τὴν εὐπροφάσιστον ἔχθραν καὶ ὡς ἂν εἴποι τις εὔλογον,
αὐθημερόν[144] εἰ οἷόν τε διαλύεσθαι, τῶν καλλίστων τίθεμαί τε καὶ ὑποτί-
θεμαι· ἔχθρα γὰρ αὐρίζουσα δύσλυτος. πλὴν εἰ μὴ φιλαίτιός τις ὑπὼν
510 τὰς ἀντινομίας ὠδίνει καὶ ὠδίνων γλῶσσαν δολίαν προβάλλεται — τί
δὲ δοθείη σοι καὶ τί προστεθείη σοι πρὸς τοιαύτην γλῶσσαν, ἀλλ' ἢ
τὰ τοῦ δυνατοῦ βέλη καὶ ταῦτα μετὰ καὶ τῶν ἐμπυριζόντων ἀνθράκων,
ἀκήκοας;[145] εἰ δὲ λόγου μεγάλου δίχα καὶ ὑπὲρ ὄνου σκιᾶς τε καὶ παρα-
κύψεως, τὸ θρυλλούμενον,[146] ἐπιφύεται, οὐδὲ φροντιστέον, οὐδὲ διασκεπ-
τέον τοῦτο ἐκεῖνο, ἀλλ' αὐτοβοεὶ χωρητέον | πρὸς τὴν διάλυσιν καὶ
προκαταβολῇ κἀὶ τὰς ῥίζας διατμητέον. καὶ γὰρ ἀρχομένων τῶν νόσων
κατὰ τῶν αἰτίων ἱστάμεθα, ἀκμάζοντα γὰρ πολλὰ παρέχεται πράγ-
ματα. ἐπεὶ δὲ Θεὸς τὴν μέν, οἵαν τὴν Νιόβην ἀκούομεν,[147] ἔθηκε, τῇ δὲ
συγχορεύειν ἡμᾶς ἔδωκε, καὶ δεδωκὼς συνεπελήψατο, καὶ τὸ αὐτὸ καὶ
520 νοεῖν καὶ φρονεῖν καὶ λαλεῖν καὶ ἐπιτελεῖν ἐχαρίσατο, καὶ μίαν, οἷον
εἰπεῖν, ψυχὴν ἐν ἀπείροις διένειμε σώμασι καὶ ἡμεῖς διὰ παραινέσεων
ὅση δύναμις αὐτὴν ἐπισχύσαμεν.

fol. 51 (left margin at 515)

500 [Χριστοῦ] suppl. Jk ‖ 515 αὐτοβοεὶ corr. Us: αὔτοβοι V ‖
520 καὶ φρονεῖν om. Us ‖ 522 ἐπισχύσωμεν Us

[143] Zenobius IV.97, V.4: cf. Leutsch-Schneidewin, I, 114, 116.
[144] Cf. Eph. 4:26.
[145] Ps. 119:4.
[146] Zenobius V.39, VI.28: cf. Leutsch-Schneidewin, I, 136–37, 169.
[147] Homerus, Il. 24.602.

hearts and ears and, in a word, our senses so that not the smallest trace of her shall be received among us? Even murderers, and burglars, and brigands, and lewd men and their crew preserve a lifelong secrecy about most of the evil they do, though disclosure might bring them so much reputation; and is it for us to disturb or dissolve any article of peace and become, as they say, Locrians in our covenants? No, by no means, my friends and brothers, who are converts of the Word and the portion of ⟨Christ⟩! But now that once we have been caught in the evil, let us rue the day, for so shall we be less easily taken in the future. Of the better things none is better than concord: it guards affections, destroys differences, is honorable and magnanimous, regulates life, and does not overstep its limits. What else? It leads man toward God and His angels. I think it confers benefits when it dwells in the waters and in the air, since it is throned with God, and, as has been shown, God is perhaps in it. For my part, I posit and premise that among the fairest things is to dissolve today, if that be possible, even a seemingly just or, one might say, reasonable enmity: for the enmity that endures until the morrow is hard to break. But unless there lurk a captious man, who travails to bring to birth ambiguities of law and puts forth a treacherous speech from his travail (but what will be given and added to you in respect of such speech, if not the darts of the powerful and therewithal the coals that inflame, you have heard) — but even if he insists with great reason, over and above proverbial vanity and troublemaking, even so it should not be cared for or considered, but should be instantly dismissed at the very outset and its roots severed. We take our stand against the causes of sickness in its beginnings, for when these grow mature they bring about great troubles. And now that God has set the one [enmity] like Niobe in the fable, and given us to dance with the other [concord], and lent His support to His gift, and has granted us to think and speak and act in unity, and has, so to say, distributed a single soul among an infinity of bodies, then let us too, through exhortation, strengthen this spirit so far as we are able.

22. Δεῦτε καὶ ταῖς εὐχαῖς αὐτὴν ἔτι κρατύνωμεν, αὐτοῦ
Μωσέως ἡγουμένου καὶ τῷ κατὰ τοῦ Ἀμαλὴκ τύπῳ ἱλεουμένου,[148] τὸν
525 εὐδιάλλακτον. πρόσχες ἐξ ἀΰλου κατοικητηρίου σου, Κύριε, καὶ ἴδε τὰ
χθὲς διεστῶτα συνεστῶτά σοι σήμερον. οἳ διέστημεν ἀβουλίᾳ καὶ συνέστη-
μεν εὐδοκίᾳ σου, ἔπιδε τὰ διασπασθέντα μέλη τοῦ σώματος τοῦ Χριστοῦ
σου εἰς ὁλοκληρίαν ἁρμολογούμενα. ἔπαισας καὶ ἰάσω ἡμᾶς, ἤλεγξας
καὶ ἐπιστραφεὶς παρεκάλεσας.[149] ἐπύρωσας ἡμᾶς ὡς χρυσὸν καὶ εἰς
530 ἀναψυχὴν ὑπεξήγαγες.[150] ἐξομολογούμεθά σοι καὶ τῆς παιδείας καὶ
τῆς ἀκέσεως. τίς γὰρ ἐνατενίσοι τῇ ἀβύσσῳ σου τῶν κριμάτων,[151] τὸ
δὲ πλῆθος τῶν οἰκτιρμῶν σου τίς ἐξυμνήσεται;[152] διαλλάσσεις καρδίας
ἀρχόντων, ἐν δὲ βουλῇ μενεῖς βουλευομένων,[153] ἐντέλλῃ, καὶ ὁ θαλάσσης
κατευνάζεται σάλος,[154] ἐμπνεῖς, καὶ ἀνακαινίζεις τὰ ξηραινόμενα.[155] πάντα
535 σου ὑπὲρ ἔννοιαν καὶ κατάληψιν. ἀλλ' ἔτι δοίης μηδὲν ὃ μὴ βούλει
πεπονθέναι ἡμᾶς, μηδὲ παρολισθῆσαι τοῖς πρὶν ὀλισθήμασιν, ἀεὶ δὲ
νεάζειν τε καὶ ἡβᾶν καὶ ἀκμάζειν τὰ δεδογμένα σοι σήμερον. εἷς αὐτὸς
ἐν τρισὶ συμφυής τε καὶ ὁμοούσιος καὶ ἡμῖν τοῖς σοῖς δοίης ἐν σοὶ καὶ
ἀλλήλοις ἓν εἶναι καὶ τὸ ἓν τοῦτο διαμένειν ἐπὶ σοὶ καὶ ἡμῖν ἀθάνατον
540 καὶ αἰώνιον.

527 ἔτι δὲ Us ‖ 533 μένεις Us ‖ 536 μηδὲ corr. Us: μὴ δὲ V ‖
537 νεάζειν VDu: ζεῖν Us

[148] Deut. 25:19.
[149] Ps. 71:21.
[150] Ps. 65:12.
[151] Ps. 35:7.
[152] Ps. 50:1.
[153] Prov. 15:22.
[154] Matt. 14:24. sqq.
[155] Cf. Marc. 3:1 sqq.; Matt. 8:23 sqq.

22. Come hither, and with your prayers, strengthen it yet more, with Moses himself at your head, reconciling himself to the placable one after his example against Amalek. Behold from Thy spiritual dwelling place, Lord, and see those things that were divided yesterday made one by Thee today. We who were severed by unwise council are made one by Thy favor, and, moreover, the members of the body of Thy Christ that were torn apart are joined together in wholeness. Thou hast smitten and healed us; Thou hast convicted us, then turned toward us, and comforted us; Thou hast tried us as gold in the fire and hast drawn us out into coolness. We acknowledge to Thee our punishment and our healing. Who shall look into the depth of Thy judgments, who shall extol the multitude of Thy mercies? Thou reconcilest the hearts of rulers and abidest in the counsels of councillors. Thou commandest, and the surge of the sea is stilled; Thou inspirest and revivest what was dried up. All Thy works are beyond thought and understanding. Mayst Thou give no more what Thou wouldst not we should suffer, nor may we slide in our former slipperinesses; but may Thy decisions of today ever live and flourish in youth and grow strong! Mayst Thou, that Thyself art One in Three, conatural and consubstantial, grant to us, Thy children, to be one in Thee and one another, and may this unity abide with Thee and us immortal and eternal!

290 IVAN DUJČEV

Commentary

(by line reference)

7–8: Cf. Ps. 67:7; Job 37:8.

14–15: ὁ βλέπων, i.e., the Prophet; cf. I Regn. 9:9.

16: τὸν εἰπόντα, i.e. Homer; cf. also Rom. 13:12.

17: ἑωσφόρος — Lucifer; Slavic, Dennica; see Is. 14:12.

19–21: Cf. Prov. 3:16–17.

24: The white dress is a symbol of joy; see also line 111.

28 and note 16: Endymion — see Roscher, *Lexikon*, I, cols. 1246–48; see also the Byzantine quotations by John Scylitzes and George Cedrenus, *Hist. comp.*, Bonn. ed., II (1839), 126 line 12; Leo Diaconus, *Hist.*, Bonn ed. (1828), 38 line 22; Nicetas Choniates, *Hist.*, Bonn ed. (1835), 772 line 19; Nicephorus Gregoras, *Hist.*, Bonn ed., II (1832), 1061 line 14; III (1855), 133 line 6; 208 line 14; 427 line 13, etc.

29–30 and note 18: τοῦ ἐν Δωδώνῃ χαλκείου — cf. also Kern, in *RE*, V (1903), col. 1262.

39–40 and note 25: See also Nicephorus Gregoras, *Hist.*, ed. Bonn, I (1829), 375 lines 6–9; 957 lines 2–4.

47 ff: Cf. this general description of the damages of the war with II Esdr. 1:3 ff.; Is. 24:1 ff.; 64:10 ff.; Ier. 18:21 ff.; II Par. 36:17 ff.; Ps. 77:63 ff., etc.

49 and note 26: See also *Suidae Lexicon*, ed. A. Adler (Leipzig, 1928–38), *s.v.*; *Encyclopaedia Judaica* (Jerusalem, 1971), VI, cols. 804–6.

58 and note 28: See also *Suidae Lexicon*, *s.v.* Ἀσκραῖος.

62 ff.: This is an allusion to the crisis in the Judaic Kingdom after the death of King Solomon (*ca.* 972 – *ca.* 932 B.C.), the son of David; cf. also II Par. 25:5 ff.; 28:1 ff.; Is. 11:13, etc.

67: τὸν παλαιὸν ἄνθρωπον — i.e., Adam.

69 and note 33: Cf. also Ps. 136:6; Job 29:10; Lam. 4:4.

74: σύνοδος — ecclesiastical council, assembly, meeting.

74: συλλογή — (mundane) assembly, meeting; cf. N. Skabalanovič, in *Vizantijskoe gosudarstvo i cerkov' v' XI věkě* (St. Petersburg, 1884), 138, 140 note 1.

74: ὁμιλία — homily, sermon, oration; cf. Ch. Du Cange, *Glossarium ad scriptores mediae et infimae graecitatis* (hereafter *Glossar. gr.*), *s.v.*

75: δημηγορία — public speech, harangue, oration; cf. *Glossar. gr.*, *s.v.*; Photius, *Epistolae*, ed. I. Valettas (London, 1864), § 31, p. 227.

82: τὸ κράτος — i.e., the Emperor (Romanus Lecapenus).

85–86: Cf. Photius, *Epistolae*, § 67, p. 237: Δεῖ τοιγαροῦν ... τοῖς καιροῖς ἰδίοις τὸ πρόσφορον ἀπονέμειν.

87 and note 34: Cf. also *Suidae Lexicon*, s.v., χωρίς; οὐδὲν ἧττον.

93–94: Cf. Matt. 7:15ff.

100: ὁ τῶν θρόνων — cf. *Glossar. gr.*, s.v. θρόνος — *cathedra, sedes episcopi in Ecclesia..., episcopatus, dignitas episcopi*.

101: ὁ τοῦ βήματος — see *Glossar. gr.*, s.v. οἱ τοῦ βήματος — *qui in synthrono, seu intra bematis cancellos sedent, ... dignitates ecclesiasticae*.

111: λευχειμονοῦντες — cf. Marc. 9:3; Apoc. 3:4–5; 3:18, 4:4; 7:9; 7:13–15; Act. 1:10; etc.

112: τοῖς περὶ τὸν Ἰθάμαρα ἐναριθμούμενοι — the clergy, members of the clergy, ordinary clergy.

112: τῆς γερουσίας ἁπτόμενοι — the members of the Byzantine senate; cf. C. Diehl, "Le sénat et le peuple byzantin au VIIe et VIIIe siècles," *Byzantion*, 1 (1924), 201–13.

113: Μωσέως ἡγουμένου — the Emperor Romanus I Lecapenus.

113: Ἀαρών — the Patriarch of Constantinople, Stephen II (925–27).

122: χαλκόν — i.e., copper money; cf. Matt. 10:9; Marc. 6:8; 12:41; I Cor. 13:1; Apoc. 18:12; cf. also I. Dujčev, in *Izvestija na Instituta za bŭlgarska istorija*, BAN, 3–4 (1951), 103ff. with bibliography.

128 and note 48: Cf. also Luc. 10:5–6.

133–34: ὁ ἐν πορφυρίδι φιλόσοφος — i.e., the Prophet Solomon.

145–49 and note 54: See also Ps. 77:21ff; Sap. 16:20; Deut. 8:16.

152: Cf. Ps. 75:4; 45:10; Os. 2:18.

155–58: μεσότοιχον — cf. Nicholas Mysticus, *Epistolae*, PG, 111, cols. 61, 64, 84, 108, 121, 161, 193, etc.

165: Σκύθης — the "Scythian" here signifies Bulgarian; see G. Moravcsik, *Byzantinoturcica. II. Sprachreste der Türkvölker in den byzantinischen Quellen*, 2nd ed. (Berlin, 1958), 279–83, esp. 280, § 5; I. Dujčev, *Bŭlgarsko srednovekovie. Proučvanija vŭrchu političeskata i kulturnata istorija na srednovekovna Bŭlgarija* (Sofia, 1972), 104ff.

172: τὸν τῶν ζιζανίων σπορέα — cf. Matt. 13:24ff.

173–74: τὴν διασπορὰν τοῦ Ἰσραήλ — concerning the "diaspora" (the dispersion) of the Jews, see Deut. 28:25; 30:4; Lev. 26:33; Joan. 7:35.

177ff.: Cf. III Reg. 3:11ff., 4:24ff., 5:12; Sir. 47:13ff.

203: οἱ τῶν τοῦ Ἀρίστονος ἀπαντλήσαντες — the followers of the philosopher Plato.

203–4: οἱ … Σταγειρίτην καταπιόντες — the followers of Aristotle.

218 and note 71: The same idea is found in *Teodoreto, Terapia dei morbi pagani* IV.56ff., ed. N. Festa (Florence, 1931), 252ff. This text was translated into Old Bulgarian by John Exarcha; see *Das Hexaemeron des Exarchen Johannes*, ed. R. Aitzetmüller (Graz, 1958), 19ff.; I. Dujčev, *Estestvoznanieto v srednovekovna Bŭlgarija; sbornik ot istoričeski izvori* (Sofia, 1954), 96ff.

241–42: Cf. Gen. 2:7.

244: Cf. Gen. 1:26, 5:1, 9:6; Sap. 2:23; Sir. 17:3.

245: ὁ βουλήσει δεδημιουργημένος — the Christian concept *de libero arbitrio*; cf. A. Vaillant, *Le De autexusio de Méthode d'Olympe. Version slave et texte grec édités et traduits en français*, PO, 22.5 (Paris, 1930). I. Dujčev. *Medioevo bizantino-slavo. I. Saggi di storia politica e culturale* (Rome, 1965), 266ff.; *idem.*, in *Studi Veneziani*, 12 (1970), 108ff.

246: Cf. Gen. 1:26ff.; Sap: 9:2; Sir. 17:1ff.

247: τοῦ … δυσμενοῦς — the Devil.

257–58: ἵνα κλέος ἔξοι τὸ καὶ χλόης εὐμαραντότερον — cf. Ps. 36:2; I Pet. 5:4.

267ff.: The Christian problem of Evil, i.e., *unde malum*; cf. Basil of Caesarea, *Quod Deus non est auctor malorum*, PG, 31, cols. 330–53; D. Obolensky, *The Bogomils. A Study in Balkan Neo-Manichaeism* (Cambridge, 1948; reprint: Middlesex, 1972), 1ff.; Dujčev, in *Studi Veneziani*, 12 (1970), 108ff.

268: οὐδενὸς ἐλαύνοντος — cf. Prov. 28:1.

291 and note 86: II Regn. 15:12ff.; I Para. 27:33–34.

291: Draco or Dracon, Athenian lawgiver (*ca.* 621 B.C.).

291: Solon, Athenian lawgiver (*ca.* 639–*ca.* 599 B.C.).

291: ἐθέσπιζον — θεσπίζω, *sancire*, decree; cf. Theophanes, *Chronographia*, ed. C. de Boor, I (Leipzig, 1883), 28 line 24; 93 line 18 (= Anastasius Bibliothecarius, *Chronographia tripertita*, ibid., II [1885], 103 line 6: *sanxit*); 100 line 9 (= Anastasius Bibliothecarius, *ibid.*, 106 line 14: *sanciret*); 153 line 13; 180 line 18 (= Anastasius Bibliothecarius, *ibid.*, 134 line 19: *promulgavit*); 360 lines 4–5 (= Anastasius Bibliothecarius, *ibid.*, 228 line 3: *decrevit*); 399 line 24 (= Anastasius Bibliothecarius, *ibid.*, 258 line 26: *sanxit*); Theophanes Continuatus, *Chronographia*, Bonn ed. (1838), 99 lines 9 and 16; 100 line 11, etc. Cf. also θέσπισμα — F. Dölger, *Regesten der Kaiserurkunden des oströmischen Reiches*, I (Munich–Berlin, 1924), p. 14, no. 115; p. 38, no. 313; p. 43, no. 355, etc.

297: υἱοθετηθέντων — spiritual adoption as a son, baptism; cf. Rom. 8:15, 23; 9:3–4; Gal. 4:5; Eph. 1:5; cf. Joan. 1:12; I Joan. 3:1; Nicholas Mysticus, *Epistolae*, PG, 111, cols. 85, 188, etc.

299: τὸ τῆς χάριτος εὐαγγέλιον — cf. Matt. 4:23; esp. Act. 20:24.

302: ὁ κύβος — cf. Michael Psellos, *Chronographie*, ed. E. Renauld, 2 vols. (Paris, 1926, 1928), I, 30 line 16 ff.; II, 65 lines 18–21; II, 81 lines 15–16.

303: νικῆσαι τὰ χείρονα — cf. Homer, *Iliad* I.576.

305–6: τὸ κόνδυ τῆς μέθης — cf. H. Liddell and R. Scott, *A Greek-English Lexicon*, s.v., κόνδυ — a drinking vessel; cf. Gen. 44:2; Apoc. 14:10, etc.

309: I.e., the Haemus Mountains, in Bulgarian the *Stara-planina*.

309: I.e., the Danube.

310: I.e., Gades, Gadiz, the Straits of Gibraltar.

311: τὸ στέφος — a crown, a wreath, a garland.

311: ὁ δίφρος — i.e., a seat, couch, stool, throne; cf. *Glossar. gr.*, s.v.

311: τὴν Εὐρώπην — i.e., esp. the territories of the Balkan peninsula.

313: ἡ ἀνάρρησις — *appellatio imperii*; cf. V. Valdenberg, "Les idées politiques dans les fragments attribués à Pierre le Patrice," *Byzantion*, 2 (1925), 67 ff.; *ibid.*, "Nikoulitza et les historiens byzantins contemporains," *Byzantion*, 3 (1926), 111 ff.; Skabalanovič, *op. cit.* (*supra*, line 74), 145, and 146 note 2, etc.; *Glossar. gr.*, s.v.

313: ἡ σφραγίς — here the sign of the cross.

313 ff.: See Introduction, p. 227.

318: τὸ κράτος — the Emperor (Romanus Lecapenus).

320: διαθήκην — testament; but also convention, arrangement between two parties, covenant.

324–25 ff. and note 94: Cf. also Gen. 13:16; 22:17; 28:14; Is. 10:22, etc.

326: Ader — cf. note 60 to line 172.

336: τῆς βουλῆς — i.e., the Senate.

339 and note 98: See "Proteus," in Roscher, *Lexikon*, II, cols. 3172–78.

343 and note 100: Cf. also Michael Psellos, *Chronographie*, ed. E. Renault, II (Paris, 1928), 183 line 38 and note 5.

352: εὐνομίαι — cf. Valdenberg, "Nikoulitza," 115.

353 ff. and note 105: See also F. Dölger, *Aus den Schatzkammern des Heiligen Berges* (Munich, 1948), no. 37 line 23; see also *Glossar. gr.*, s.v. ναζηραῖοι.

368: σολοικίζων — to speak or write incorrectly, coupled with βαρβαρίζειν.

371–72: τὸν ... 'Ιεσσαὶ παῖδα — Jesse, father of David; concerning Jesus' family tree, depicted with Jesse as its source, see A. Watson, *The Early Iconography of the Tree of Jesse* (London, 1934); *idem.*, "The Imagery of the Tree of Jesse on the West Front of Orvieto Cathedral," in *Fritz Saxl 1890–1948. A Volume of Memorial Essays from His Friends in England* (London, 1957), 149–64; M. Garidis, "L'ange à cheval dans l'art byzantin," *Byzantion*, 42 (1972), 32 ff. with other bibliographical indications. Concerning Jesse in general, see II Regn. 20:1 ff.; 23:1 ff., etc.

371 ff.: The analogies are between David and the Bulgarian King Symeon, between Solomon and King Peter of Bulgaria, and between the building of the Temple of Jerusalem and the conclusion of the peace between Byzantium and Bulgaria in 927. Cf. III Regn. 5:2–4: *Misit autem Salomon ad Hiram, dicens 'Tu scis voluntatem David patris mei, et quia non potuerit aedificare domum nomini Domini Dei sui propter bella imminentia per circuitum, donec daret Dominus eos sub vestigio pedum ejus. Nunc autem requiem dedit Dominus Deus meus mihi per circuitum ...'*; III Regn. 8:16 ff.; I Par. 22:7 ff.; 28:3: *Deus autem dixit mihi [David], 'Non aedificabis domum nomini meo, eo quod sis vir bellator, et sanguinem fuderis'*; etc.

380: Cf. note to line 339.

389 ff. and note 113: Analogy between the Byzantine-Bulgarian and Judaic-Samaritan enmity; cf. III Regn. 21:16 ff.; IV Regn. 13:1 ff.; Matt. 10:5; Joan. 8:48 ff.; etc.

391: ὁ βλέπων — i.e., the Prophet; cf. note to lines 14–15.

396 and note 117: Cf. Job 10:1 ff.; Is. 26:19.

413 ff.: οἱ τῆς Ἅγαρ — i.e., the Arabs.

429–30 ff.: Cf. Matt. 18:20.

435 and note 123: Cf. also Leo Diaconus, *Historia*, Bonn ed. (1828), 105 line 1 ff.; Nicephorus Gregoras, *Historia*, Bonn ed., II (1832), 839 line 16 ff.

437: ὁλόρριζοι — cf. Job 4:7; Ps. 51:7.

438: τὰς Πύλας — i.e., the Caspian Gates or Derbent, in Latin *Portae Caspiae*; see Procopius Caesar., *De bello Persico* I.10,4 ff.; I.12,2; I.16,7; I.22,5; II.10,21, ed. J. Haury, Teubner (1936), vol. I, 46 line 2 ff.; 56 line 2 ff.; 81 line 11 ff.; 115 line 12 ff.; 197 line 3 ff.; etc.

439 ff.: Cf. Ios. 7:9; I Regn. 24:22 ff., Sir. 10:15 ff.; Job 18:17.

444 ff.: Cf. Herodotus II.15; III.10; etc.

447 ff.: See Herodotus II.25 ff.

452: The capital of Persia.

452:–53 Eteocles and Polynices, sons of Oedipus.

454–55: Cyrus the Younger, son of Darius Nothus, King of Persia (*ca.* 401 B.C.), and Artaxerxes II (404–358 B.C.).

458 ff.: Alexander the Great, son of Philip II and Olympias (356–23 B.C.).

463: Perdiccas, general of Alexander the Great.

463: Antipater, officer of Philip II and Alexander the Great.

465: Italians, i.e., the Romans.

473: ἡ καινότης — the New Testament.

473: ἡ παλαιότης — the Old Testament.

473 ff.: ἡ 9ύραθεν — the profane literature.

483–84 ff.: Cf. II Regn. 18:17; Ios. 7:25–26; 8:29.

499: σαγήνης τοῦ Λόγου — i.e., a large dragnet for taking fish, a seine; cf. Matt. 13:47 ff.

504: Cf. ὑπερτίθημι — to cross, to passover.

510 ff. and note 145: Cf. also Sir. 8:10; II Regn. 22:9; etc.

518 and note 147: Concerning the Queen of Thebes, Niobe, see Roscher, *Lexikon*, III, col. 372 ff.

523–24: αὐτοῦ Μωσέως ἡγουμένου — i.e., the Emperor Romanus Lecapenus.

523 ff. and note 148: Cf. Gen. 14:7 ff.; Exod. 17:8 ff.; S. Žebelev, "Oranta. K' voprosu o vozniknovenii tipa," *Sem. Kond.*, 1 (1927), 1 ff.

526–27: Cf. Rom 12:4 ff.; I Cor. 6:15 ff.

529–30. and note 150: Cf. also Num. 31:22 ff.; Sap. 3:6; Prov. 17:3; 27:21.

537 ff.: Cf. Joan. 17:20 ff.

NOTES

NOTES ON THE ARCHEOLOGY OF ST. SOPHIA AT CONSTANTINOPLE: THE GREEN MARBLE BANDS ON THE FLOOR

GEORGE P. MAJESKA

THE MARBLE RIVERS

The floor of the Great Church of St. Sophia in Constantinople is like a sea. This is certainly the meaning of the metaphor which Paulus Silentiarius tries to convey in the turgid archaisms of his ˝Εκφρασις on the ambo of St. Sophia, where he describes the great pulpit as "a beautiful island amidst the swelling billows [which yet] does not stand in the middle space completely cut off, like an island girdled by the sea; it is rather like some wave-washed land, projected forward by an isthmus into the middle of the sea through the grey billows it projects into the ocean wave-washed on either side"[1] In other literary works, the floor of the nave of St. Sophia is described as the earth depicted in marble with "green [marble] in the likeness of rivers flowing into the sea."[2] There are four green rivers representing the rivers which flowed from paradise.[3] In less sophisticated works of Byzantine literature the two metaphors occasionally become confused, and we are told that the floor is "like a sea, ... [like] ever flowing waters of a river; for he [Emperor Justinian] called the four borders [φίνας = Latin *fines*] of the church the four rivers which went out of paradise."[4]

The existence of bands of green marble "rivers" dividing the nave of St. Sophia in Constantinople is beyond question. They are the transverse bands of green Thessalian marble, varying in width between 0.50 and 0.70 m., plotted in Van Nice's folio of architectural plans of the church.[5] These bands seem to be common to the Byzantine floor of the nave in the Justinianic church and in the large-scale repaving after the first collapse of the dome in 558, as well as in the paving repairs necessitated by the fall of the western and eastern arches in the tenth and fourteenth centuries respectively.

The first river, counting from the west, is approximately 16.75 m. from the threshold of the doors leading into the nave (fig. A). Its western edge falls approximately 2.10 m. west of the flat nave side of the western

[1] "Descriptio Ambonis," in *Johannes von Gaza und Paulus Silentiarius*, ed. P. Friedländer (Leipzig, 1912), 263f.; trans. S. Xydis, "The Chancel Barrier, Solea, and Ambo of Hagia Sophia," *ArtB*, 29 (1947), 14–15. In the second part of the metaphor the waves are the crowds of the faithful rather than the matched graining of the pavement. The conceit of the nave floor as a sea, with the matched graining of the pavement recalling waves, becomes a commonplace thereafter; cf. C. Mango and J. Parker, "A Twelfth-Century Description of St. Sophia," *DOP*, 14 (1960), 239.

[2] Διήγησις περὶ τῆς Ἁγίας Σοφίας, in *Scriptores originum constantinopolitanarum*, I, ed. Th. Preger (Leipzig, 1901), 107–8. On the tradition of depicting the sea and the earth on Early Byzantine church pavements, see E. Kitzinger, "Studies on Late Antique and Early Byzantine Floor Mosaics. I. Mosaics at Nikopolis," *DOP*, 6 (1951), 100–8.

[3] [Pseudo-]Codinus, *De S. Sophia*, Bonn ed. (1843), 144–45; cf. Gen. 2:10–14.

[4] Διήγησις, 102–3. Unlike mosaic pavements, the opus sectile floors of Early Byzantine churches have been little studied; but see H. Kier, *Der mittelalterliche Schmuckfussboden unter besondere Berücksichtigung des Rheinlandes*, Die Kunstdenkmäler des Rheinlandes, 14 (Düsseldorf, 1970), esp. 16–52. On later Byzantine church floors, see A. Frolow, "Deux églises byzantines d'après des sermons peu connus de Léon VI le Sage," *EtByz*, 3 (1945), 55–58.

[5] R. L. Van Nice, *St. Sophia in Istanbul: An Architectural Survey, Installment I* (Washington, D. C., 1966) (hereafter Van Nice, *St. Sophia*), pl. 10: Plan at Ground Level, Central Areas; cf. also pl. 1. These transverse bands also appear, of course, in photographs; see T. F. Mathews, *The Byzantine Churches of Istanbul: A Photographic Survey* (University Park, Pa., 1976), no. 31–64 et al. Pavement "rivers" in other churches are occasionally mentioned in literary sources, but usually as borders; see Frolow, *op. cit.*, 56–57.

piers. This river is the least well preserved in the church. Only 3.70 running meters of green marble at the south end of the strip (which is only about 12 percent of the original length) are preserved *in situ*; moreover, this section is a Byzantine patch replacement. The replacement pieces are, however, fitted into matched-grain Byzantine pavement flooring, and the mark of the eastern edge of the strip is quite visible in the preserved Byzantine flooring for a further 66 percent of the distance across the central nave, including the northern 2.70 m., where the line of the western edge of the strip in the matched Byzantine pavement is also preserved. The line is not carried beyond the edge of the last paving sheet within the area of the exedrae.[6]

The second river is 9.10 m. east of the first; its eastern edge is roughly aligned with the eastern side of the western piers. Of its 32.40 m. length, 11.30 m. are Byzantine (4.50 m. in Byzantine patching), and almost all of the remaining line of both edges is clearly visible in the Byzantine pavement.

The third river is 8.90 m. east of the second, and is aligned, albeit poorly, on its eastern edge with the eastern side of the bases of the columns second from the west of the aisle colonnades. Only about 13 percent of the strip is missing.

What may be taken to be the fourth of the four rivers on the floor of the Great Church is not as easily described, although, as I trace it, almost 21 percent is preserved. Following the line of this river is difficult, inasmuch as, unlike the other three, it does not cross the nave in a straight transverse line. Because of its peculiar shape, in fact, it is often seen as two separate rivers, giving the church a total of five, although literary sources are clear that there are only four.[7] Tracing the course of this river from the north side of the nave to the south one finds that the meter-size area of very extensive damage to the floor pavement at the east end of the flat south side

of the northeast pier shows evidence of the river line only to within 0.74 m. of the pier. The green marble stripe, badly chipped and damaged, runs south from the damaged area for 5.60 m., though originally the river must have begun at the pier. Lines of a further 0.30 m. of this run are preserved at its south end up to the point where replacement paving cuts off the evidence. I suggest that this line continued a further 0.50 m. before the later pavement was laid, so that the strip had the same length as its opposite member at the south side of the nave (see fig. A and *infra*). This posited extension also served as the eastern terminus of an east-west green marble band now represented by two preserved pieces of green marble. One, 2.20 m. long (with evidence in the surrounding pavement of another 0.33 m. at its eastern end), lies about 3.0 m. west of the north-south strip at the north side of the front of the nave; the other, a strip 1.35 m. long of the same green marble, appears amid smashed placage just below the level of the present pavement one m. west of the first, and separated from it by an area of replacement paving squares. I suspect that the east-west line represented by these two segments continued 1.10 m. farther west and intersected the continuation of the north-south green band which now abuts the north side of the great opus sectile plaque on the floor of the south side of the nave. This north-south band, I suggest, represents the western segment of the meandering fourth river, the northern and northeastern sections of which have just been described. Its west side is in large part traceable in the line of the Byzantine floor slabs, and the expected green marble is well preserved over a distance of 4.26 m. north from the north side of the opus sectile plaque which it intersects 0.60 m. west of the plaque's eastern edge. The preserved 4.26-m. length running north from the inlay plaque might, indeed, be all that ever existed on the south side of the nave, for the continuation of this line is difficult to trace for the next 2.40 m., after which the probable line of the green strip can again be discerned in its western edge line along the joint of the matched Byzantine pavement. The apparent 2.40 m. break centers exactly on the east-west axis of the church, and quite likely represents the placement of some part of the ambo

[6] The information on physical aspects of the floor is based on Van Nice, *St. Sophia*, pl. 10, and on Mr. Van Nice's field notes and store of information about the Great Church, both of which he has generously shared with me.

[7] See, for instance, Mango and Parker, *op. cit.*, 243; T. F. Mathews, *Early Churches of Constantinople: Architecture and Liturgy* (University Park, Pa., 1971), 97.

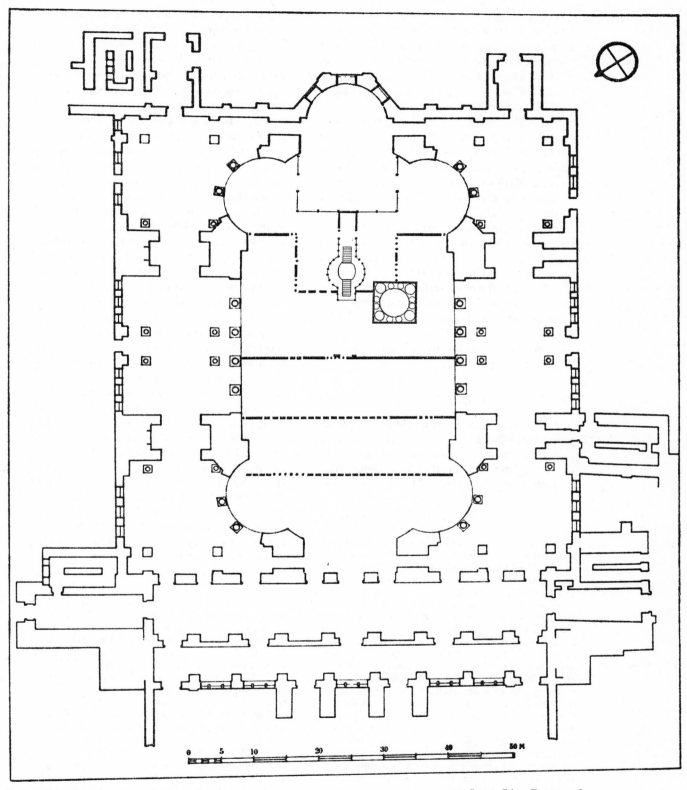

A. Constantinople,
 St. Sophia, Ground Plan

——————— Green Line Preserved
– – – – – – Line of Strip Preserved in Pavement
· · · · · · · · Conjectural Continuation of Strip

complex which we know was in this area (see *infra*). After this break, the line continues north to the point where it would have joined the northern east-west band discussed previously. The east-west green strip which one would expect to connect the comparable western and eastern segments of the fourth river on the south side of the nave is interrupted, of necessity, by the large opus sectile plaque and is visible only in the small archeological trench made in the low, stone Turkish platform which covers the Byzantine flooring near the southeastern major pier. It is, however, aligned, as one would expect from the arrangements on the north side of the nave. The area where the strip should abut the eastern segment of the river is in replacement paving, and thus one can only assume that the two strips once met. The eastern segment in the south part of the nave is preserved almost perfectly for 6.22 m., and the mark of the eastern edge is visible from the preserved section to the nave face of the southeast pier.[8]

THE LITURGICAL FUNCTION OF THE RIVERS

At first consideration it would seem difficult to explain what function these rivers served. I would dismiss the explanation suggested in the Διήγησις and in Pseudo-Codinus that they were originally designed to represent the

[8] The archeological evidence of the northern east-west sector of the fourth river is, in fact, somewhat more complex. The eastern preserved segment is only 0.40 m. wide, while other river segments in the building are 0.50–0.70 m. wide. This particular segment, however, is a fourteenth-century repair after the most recent collapse of the dome, and the narrowness of the band could easily be accounted for by the fact that its south edge abuts large uniform sheet replacement flooring, the laying of which would have demanded using a conveniently narrower green band here. The western preserved segment of this line (which is a more normal 0.51 m. wide) appears in an archeological trench, and represents an earlier floor (probably the first of the Justinianic church) over which the present floor was laid following the first collapse of the dome. A strong argument can be made in favor of continuity of decoration through the various repairs to the church floor in Byzantine times. The fourth river is traceable in Van Nice, *St. Sophia*, pl. 10; corroborated by Van Nice's field notes.

"four rivers which flowed out of Paradise."[9] These texts are quite late and read symbolism and folklore into almost everything they mention. Symbolic significance commonly comes after the fact. An esthetic explanation, upon which a symbolic interpretation could well have been made, is also not very convincing. The green transverse bands are not symmetrically arranged, despite the statement of Theodore of Andida that they are, nor, one should add, do the spaces between the rivers increase or diminish regularly in either direction to counteract optical foreshortening.[10] The most telling argument against an esthetic explanation of the rivers, however, is that they have no regular relationship to the architectural members of the building. The alternative explanation offered by the Διήγησις, that Justinian decreed that worshipers be segregated among the rivers according to their sins,[11] even in conjunction with Symeon of Thessalonica's remark that catechumens and those excluded from communion were allowed to enter the church only part way, would not seem a sufficient explanation for the complex of floor markings.[12] Symeon of Thessalonica, however, does offer specific information on these transverse lines which points to their clearly liturgical function. In describing the rite for the consecration of a bishop, Symeon notes that after the bishops appointed to consecrate their newly elected colleague have taken their places on thrones (located somewhere at the eastern end of the church), the bishop elect enters with his entourage (doubtless through the west doors of the nave) and "... crosses the three rivers marked out on the floor in

[9] See *supra*, notes 3 and 4. Curiously, at least one of the rivers mentioned in the Genesis account of the Garden of Eden is described as winding; see E. A. Speiser, "The Rivers of Paradise," *Festschrift Johannes Friedrich*, ed. R. von Kienle (Heidelberg, 1959), 476–77.
[10] Theodore of Andida, *Commentatio liturgica*, PG, 140, col. 436. The spaces between the bands, from west to east, are 9.10 m., 8.90 m., and 10.88 m. (and 8.50 m. between the western and eastern segments of the last river). See *supra*.
[11] Διήγησις, 103.
[12] Symeon of Thessalonica, *De sacro templo*, PG, 155, cols. 357–60; *De divino templo, ibid.*, 708; cf. Mathews, *Early Churches of Constantinople*, 120.

chalk, which represent the grace of teaching to which he is called," to approach his consecrators.[13] The symbolism which the Thessalonican liturgist attaches to the rivers need not detain us; symbolic significance varies with the occasion. Indeed, in a marvelously incoherent metaphor, Theodore of Andida would have it that the "strips of dark marble spaced at moderate intervals from each other like ruled lines on the floor of the Great Church are called rivers" because in entering the church [and crossing the rivers?] the bishop represents Christ appearing at the river Jordan.[14] For that matter, the fact that Symeon describes the rivers as διὰ γύψου ἐκτυπωθέντας ("marked out in chalk") should not bother us either; he is describing episcopal consecrations in general, which could be held in any church, and few churches had permanent rivers in the pavement as did St. Sophia in Constantinople. In other churches the rivers were apparently supplied temporarily by chalk lines. What is moderately clear in these texts, however, is that the rivers crossed the nave transversely, and, extrapolating from Symeon of Thessalonica's ritual directions, that the fourth river was located beyond the thrones of the consecrating hierarchs whose thrones in St. Sophia would have been near the ambo. (This text, then, seems to confirm our interpretation of the archeological evidence, and suggests that the fourth river marked off an area of the nave restricted to the clergy.) A manuscript typicon preserved at Sinai notes another liturgical use of the rivers on the floor of the Great Church in its recording of special ritual prescriptions for services in St. Sophia on the morning of the Sunday before Christmas, the Sunday of the Holy Fathers. During the singing of the λιτή after Orthros, the patriarch advances from the sanctuary "to the third river," where clerics light their

candles from his in preparation for a procession to the Forum of Constantine.[15] This text would seem to refer to the "third river" from the east since the patriarch is going from the sanctuary to the west portal of the church.[16]

At least one clear indication exists that "the rivers" served a liturgical function much more regularly than during the rather special services noted above. Symeon of Thessalonica notes that when the patriarch takes part in solemn vespers in St. Sophia he enters the nave from the narthex through the imperial doors (here τὰς ὡραίας πύλας), and when he has advanced "to the first river," he turns to the west to venerate the image of the Savior above the imperial doors on the nave side before continuing eastward to his throne.[17] The text specifies that the same ceremonial is observed when the archbishop officiates at solemn vespers in the church of St. Sophia in Thessalonica, except that in the Thessalonican ritual the archbishop stops to venerate the image over the main doors not "at the first river," as is done in Constantinople, but simply "at the river"; the smaller Thessalonican church apparently had only one.[18] Later in the same work the

[13] ...[ἐπίσκοπος] ὑποψήφιος τρεῖς ποταμοὺς διέλθων ἐπ' ἐδάφους διὰ γύψου ἐκτυπωθέντας, τὸ τῆς διδασκαλίας ἐφ' ᾧ ἐκλήθη δηλοῦντας χάρισμα... (De sacris ordinationibus, PG, 155, col. 408). The four rivers of paradise represent the four Gospels which the bishop must preach. The same symbolism accounts for the four colored bands on the bishop's cloak which are called "rivers"; see Euchologion sive rituale Graecorum, ed. Jacobus Goar (Venice, 1730), 133.

[14] Commentatio liturgica, col. 436.

[15] A. Dmitrievskij, Opisanie liturgičeskih rukopisej, I,1 (Kiev, 1895), 157, no. 286. The ceremony described apparently fell into disuse and is not recorded in other typica. Cf. J. Mateos, Le Typicon de la Grande Eglise, I (= OCA, 165) (Rome, 1962), 134–37.

[16] Dmitrievskij, loc. cit.

[17] J. Darrouzès, "Sainte-Sophie de Thessalonique d'après un rituel," REB, 34 (1976), 46–49. I have suggested in an earlier article that the image in the nave above the imperial doors of St. Sophia was of the Christ "of the Chalke Gate." See G. Majeska, "The Image of the Chalke Savior in St. Sophia," Byzantinoslavica, 32 (1971), 284–95.

[18] Darrouzès, op. cit., 52–53; cf. 46–49. See also commentary, ibid., 68–69. Darrouzès correctly concludes from the wording of this text that the cathedral of St. Sophia in Thessalonica had only one river, and remarks on the unusually long distance between the river at which the clergy turned to venerate the image and the image itself (ibid., 68). The distance in question would be approximately 5.60 m., if one accepts Darrouzès' hypothetical location of the river (ibid., 68–69 and fig. 1). (The present floor is modern, dating from after the fire of 1890, and thus offers no archeological evidence of the earlier pavement pattern.) The icon must have been displayed above the still preserved,

liturgist notes that during the celebration of solemn vespers in the church of St. Sophia in Thessalonica the lectors taking part in the procession with the censer (ἡ εἴσοδος) place their torches "on the river," while the priests venerate the icon over the main west doors of the nave and recite the prayer of the entrance before completing the procession by returning to the sanctuary.[19] The single river on the floor of the church is the counterpart of the first (or western) river in Constantinople's homonymic cathedral; since the services in the Thessalonican church are modeled on those of its Constantinopolitan counterpart,[20] one should assume that in the vesper procession with the censer in the church at Constantinople the procession also stopped at the counterpart river, the green marble strip at the west end of the nave.

From the cases just described we can determine at least one use served by the

rivers on the floor of St. Sophia in Constantinople. Like the lines on a stage prepared for ballet, the rivers served as indications of stopping places for the various magnificent processions which played such an important part in the ritual of the imperial cathedral. Infinitely more complex than the rubrics at even a large provincial cathedral, such as the one at Thessalonica which needed only one river, the choreography of the various imperial-patriarchal services in the major church of the Eastern Christian capital demanded four "stop markings" to guide the clergy in their ritual movements.

THE POSITION OF THE CHANCEL BARRIER

The peculiar line of the fourth or eastern river would certainly seem to demand some additional explanation. Its unusual configuration suggests that it delineated something; its location at the eastern end of the building immediately suggests that it marked off an area of the church normally restricted to the clergy. The marked off area would include not only the ambo and the bema, but also the area where Paulus Silentiarius tells us the choirs sang "enfolded in the arms of the columns," that is, the eastern exedrae.[21] There is also an archeological basis for suggesting a relationship between the line of the fourth river and the line of the bema's projection into the nave.[22]

continuous Byzantine cornice approximately 7.25 m. above the pavement of the nave. I see no reason to reject the river location posited by Darrouzès, but would suggest that the tradition of venerating the image above the central door from the river is not based on an appropriate distance, but rather is derived from the analogous custom followed in the Great Church at Constantinople (see *infra*), where the distance of the first river from the wall where the icon was displayed was 16.75 m. (see *supra*). However, the image at Constantinople was at least 8.0 m. above the floor (Majeska, *op. cit.*, 293–94; the top of the lintel of the imperial doors above which the image was probably displayed is 8.0 m. above the pavement, according to Van Nice's field notes), demanding that one be at some distance from the image to see it. See Mathews, *The Byzantine Churches of Istanbul* (note 5 *supra*), no. 31–59, a photograph of the area of the west wall of the nave once occupied by the image; the photograph is taken from the first river on the floor of the church. Professor Kleinbauer of Indiana University and Ms. Theocharidou of the Athens Technical University have kindly supplied me with the information on the physical aspects of the church of St. Sophia in Thessalonica used above.

The use of the word ποτάμιον for "river" in this text by Symeon of Thessalonica (Darrouzès, *op. cit.*, 53, 55) is not as unusual in this context as the commentator suggests. It is also used in [Pseudo-]Codinus, *De S. Sophia* (note 3 *supra*), 144, 149, and in the manuscript Typicon, Sinaiticus 286 (Dmitrievskij, *op. cit.*, 157). See *supra*, p. 303.

[19] Darrouzès, *op. cit.*, 54–55.
[20] Cf. *ibid.*, 47, 51.

[21] Paulus Silentiarius, "De S. Sophia," ed. Friedländer (note 1 *supra*), 237 lines 374–75; cf. Symeon of Thessalonica, *De sacro templo* (note 12 *supra*), col. 357.
[22] The best and most dependable study of the sanctuary (and ambo) of the church of St. Sophia in Constantinople is Xydis, *op. cit.* (note 1 *supra*), 1–24; see esp. 1–6 on the chancel screen and its configuration. The remaining sections of this paper draw heavily on this excellent work.

More recent studies include E. Weigand, "Die 'Ikonostase' der Justinianischer Sophienkircher in Konstantinopel," *Gymnasium und Wissenschaft (Festgabe des Maximiliansgymnasium in München)*, ed. A. Schwerd (Munich, 1950), 176–95; V. Lazarev, "Tri fragmenta raspisnyh epistiliev i vizantijskij templon," *VizVrem*, 27 (1967), 169–72 and *passim*; K. Kreidl-Papadopoulos, "Bemerkungen zum justinianischen Templon der Sophienkircher in Konstantinopel," with appendix by J. Koder, *JÖBG*, 17 (1968), 279–89; C. Walter, "Further Notes on the Deesis," *REB*, 28 (1970), 171–81.

Preserved in the pavement of the northern side of the reduced Byzantine platform which covers the eastern end of the nave is a strip 2.0 m. long of green porphyry stylobate (broken or cut at both ends, and with three square dowel holes) which runs east-west. The strip was uncovered by Dirimtekin in 1955, and clearly represents part of the base of a Byzantine chancel barrier (fig. A).[23] If the line of the stylobate were continued toward the east it would intersect the northwest angle face of the northeast secondary pier, located 5.0 m. away, approximately 1.80 m. from its southern edge.[24] This side of the pier (largely covered by the "Sultan's loge" today) shows marks of serious repair,[25] accounted for in part by the attachments of the loge, but quite possibly also by the removal of Byzantine furniture, perhaps the northeast end of the chancel barrier. The fact that the northern edge of the green porphyry stylobate is rather closely aligned with the southern edge of the northern east-west green strip of the fourth river suggests that this river reflects the lines of the chancel barrier. Since the east-west green marble strip is parallel to and aligned with the probable line of the north side of the chancel barrier indicated by the preserved stylobate fragment, and is approximately 8.40 m. in length, might that also be the length of the north side of the barrier? The dowel-drilled porphyry stylobate segment would, in fact, be included in this length. Assuming such an arrangement, the line of the front or western side of the chancel barrier would fall within a fraction of a meter (0.27 m.) of including a strip of red porphyry 2.40 m. long and 0.28 m. wide, which runs north-south and is imbedded in the pavement of the Byzantine platform exactly on the east-west axis of the church. This strip is part of a Byzantine pattern which includes similar porphyry strips running west at each end of the north-south strip; together they form three sides of a rectangle on the main longitudinal axis of the church. Filling this open rectangle is a matched pair of Byzantine paving slabs abutting each other on the east-west axis of the building.[26] This pavement pattern, lying on the main axis of the church, with its eastern end close to the projected line of the western side of the chancel barrier, quite likely represents the central opening of the chancel barrier. Unfortunately, no further clear archeological evidence seems to bear on the proposed location of the chancel barrier. The areas where one would expect to find evidence are either late patch replacements or, in the case of the space where one would logically expect to find marks of the south side of the chancel barrier, they are covered by the Turkish mimbar platform.[27] However, note should be taken of an important piece of circumstantial evidence. The placage on the angle face of the southeast minor pier, where the mimbar now stands, and where the east end of the south side of the chancel barrier here posited would have abutted, is an amalgam of repair work in replacement marble and plaster painted to resemble marble,[28] a situation one would expect had an engaged chancel screen been removed from the spot.

The hypothesis suggested above on the basis of the physical evidence can supplement and refine the theoretical restoration of the chancel barrier of the Great Church elucidated by Stephen Xydis from the literary evidence and from comparison with what is known of chancel barriers more or less contemporary with that of St. Sophia.[29] The western side of the chancel screen was approximately 15.70 m. long (cf. Xydis: 14.48–27.36 m., that is, the distance between either the inner or outer sides of the eastern minor piers). The north and south sides of the chancel barrier, of course, were equal, and 8.40 m. long (cf. Xydis: 8.70–11.60 m., based on projected intercolumnia).[30] The combined length of the three sides of the line of the chancel barrier, then, would be 32.50 m.

We know from Paul the Silentiary that

[23] Mr. Van Nice in conversation; Mathews, *Early Churches of Constantinople* (note 7 *supra*), 97. The stylobate fragment appears in Van Nice, *St. Sophia*, pl. 11.

[24] See Van Nice, *St. Sophia*, pl. 11; cf. also pl. 1.

[25] Van Nice field notes.

[26] See Van Nice, *St. Sophia*, pl. 11.

[27] See *ibid.*

[28] Van Nice field notes; cf. H. Kähler, *Die Hagia Sophia* (Berlin, 1967), pl. 82.

[29] Xydis, *op. cit.*, esp. 3–7.

[30] *Ibid.*, 6.

twelve columns formed the chancel barrier, and since it is unlikely that they were arranged in six pairs,[31] one must deal with eleven or thirteen interstices, depending on whether the eastern columns of the two sides of the screen abutted the eastern secondary piers or were freestanding and connected to the minor piers only by an entablature. Given the fact that some of the twelve columns also stood along the sides of the sanctuary, one would expect to find either five or seven intercolumnar spaces on the west side of the screen. The average intercolumniation on the west side would be 3.14 m. if there were five spaces. The intercolumniations on the north and south sides of the chancel barrier must have been similar in size to those of the west side; and, indeed, dividing the 8.40-m. length of each side into three equal segments would result in three 2.80-m. intercolumniations, but slightly less than the 3.14 m. a normal intercolumniation would have on the west side of the screen. It is, moreover, likely that the central portal was larger than a normal intercolumniation, a fact which would necessarily reduce the remaining intercolumnar spaces on the west to a width more in conformity with the size of those on the sides of the barrier. We also know from Paul the Silentiary that the side portals of the chancel screen were smaller than the great portal.[32] This would be so

in the case outlined here even if the lateral entrances were the size of a normal intercolumnar space on the side of the barrier. Such an arrangement would generously accommodate the 2.40-m. north-south crimson strip suggested as marking the threshold of the central portal, with room for the center pair of columns of the west side without their impinging on the special pavement, as archeological testimony would require (fig. B). Accepting Xydis' ratio of intercolumnia to height of column (based on the proportions of the chancel barrier in the fifth- or sixth-century basilica of Afendelli on Lesbos), the columns would be 5.36 m. in height.[33] Columns of this height would locate the pediment of the chancel barrier at approximately the height of a major revetment border which would carry on esthetically the entablature line of the screen. It is noteworthy, moreover, that on the two faces of the eastern minor piers where one could expect evidence of the barrier's attachment, the border is clearly the late repair work one would expect had the chancel barrier entablature been removed when the church was converted into a mosque.[34] The standard diameter for columns of this height would easily support a catwalk at the top for the lamplighter, in conformity with the text of the Silentiary.[35]

[31] *Ibid.*, 3; the case for double columns is presented in J. Walter, "The Origin of the Iconostasis," *Eastern Churches Review*, 3 (1970), 254–55.

[32] Paulus Silentiarius, "De S. Sophia," ed. Friedländer, 247 lines 717–19. Some comment is in order on alternative arrangements of the twelve columns known to make up the chancel barrier of the Great Church. Assuming the west side of the screen had eight columns rather than the six suggested above, the resultant seven intercolumniations would average 2.24 m. in length, which is shorter than the crimson marble strip, and would have demanded column bases on the strip; the good condition of this strip precludes this possibility. Still, as noted earlier, the central portal was probably wider than a normal intercolumnar space; if so, the central pair of column bases could have been located on the surrounding replacement pavement. Such an arrangement would, of course, demand narrowing the remaining intercolumniations still further. With eight columns on the west side, the north and south sides of the chancel screen

would be left with only two each, plus the corner columns shared with the west side. Even allowing that the chancel screen was freestanding and that between the eastern columns of the two sides and the secondary piers there was a space equal to the two intercolumniations on each side wall of the chancel screen, the spaces between the columns and the columns and minor piers would be 2.80 m., considerably wider than the intercolumnar spaces at the front of the chancel barrier. Moreover, one of these spaces in each side wall would represent a side entrance through the chancel screen, and we are told (Paulus Silentiarius, *loc. cit.*) that the side doors were smaller than the central portal, which would not then be the case.

[33] According to Xydis, *op. cit.*, 6–7. His projection of the 14.48-m.-long west wall of the chancel screen would demand six columns 4.94 m. high; by the same formula the 15.70-m. west wall here posited would have six 5.36-m. column shafts.

[34] Van Nice field notes; Kähler, *loc. cit.*

[35] Paulus Silentiarius, "De S. Sophia," ed. Friedländer, 251 lines 862–65.

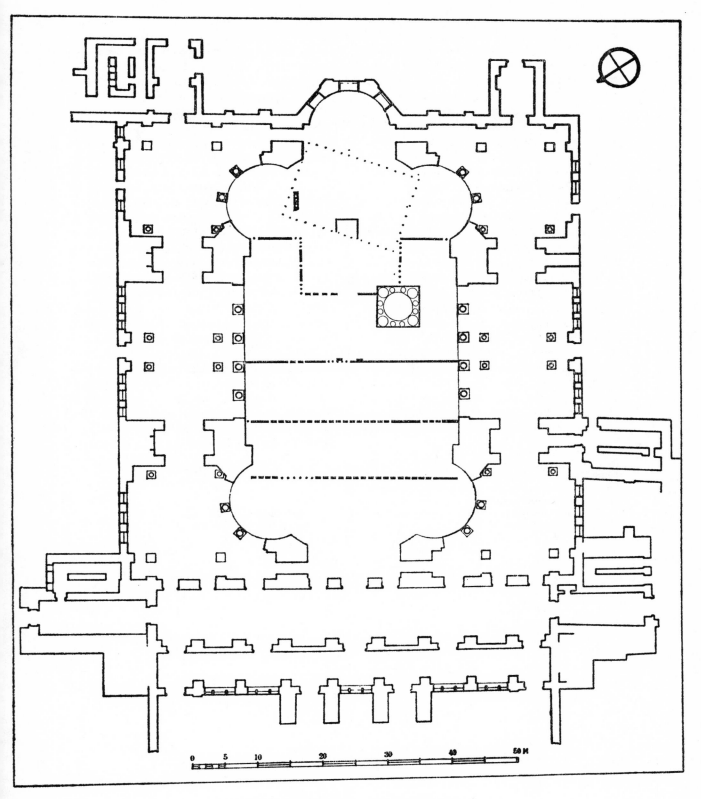

B. Constantinople, St. Sophia, Ground Plan.
The Rivers, Chancel Barrier, Ambo, and Solea

Similarly, archeological evidence in the floors of the church of St. Sophia also aids in locating the ambo-solea complex in the Great Church. Here again, combining Xydis' hypothetical reconstruction with the archeological evidence suggests a more exact placement of this permanent ecclesiastical furniture. Xydis' point that the width of the central opening in the chancel screen might approximate the width of the long narrow solea leading to the ambo is well taken. The rectangular pattern of red marble strips that we have taken as marking the central entrance of the sanctuary is, interestingly, open on the west. In exact alignment with the inset's north and south sides, and thus also on the central axis of the church, is a break in the fourth river 13.20 m. away (see *supra*). The apparently post-Byzantine replacement pavement closely associated with this break in the green marble river strip, and extending 2.60 m. west from it,[36] suggests the removal of permanent ecclesiastical furniture. Since we know from Paul the Silentiary that the ambo (and thus the associated solea, too) stood in the center of the church, but a bit to the east,[37] the repair work in the floor around the center of the

fourth river probably marks the emplacement of the western end of the ambo-solea complex. Its western end would have been approximately 7.0 m. east of the center of the building as marked by the pinnacle of the dome. The width of the solea, which extended west of the ambo to accommodate its western steps, and thus of the solea in general where it did not broaden to accommodate the ambo platform, would be 2.40 m. The solea-pathway, including the ambo, would have stretched, then, 15.80 m. from the chancel barrier (with a break at its eastern end to allow clergy to cross the nave in front of the bema).[38] Figure B adapts Xydis' hypothetical reconstruction of the ambo and solea of the Great Church to the present interpretation of the archeological evidence. Interestingly, an imaginary line continuing the suggested east-west lines of either side of the solea would intersect the centers of two small and unusual rectangular paving blocks of green marble (0.6 × 0.38 m.) carefully laid in the Byzantine pavement 8.25 m. away, along the east side of the third river.[39] Possibly it was at these markings that processions divided into two lines to move on either side of the ambo and thence, for the lower clergy at least, to the side doors of the chancel barrier.

George P. Majeska
University of Maryland

[36] Van Nice, *St. Sophia*, pl. 10. E. M. Antonides, Ἔκφρασις τῆς Ἁγίας Σοφίας, II (Athens, 1908), 50f., correctly suggested that there was a relationship between the patterns in the pavement of St. Sophia and the location of the ambo.

[37] Paulus Silentiarius, "De S. Sophia," ed. Friedländer, 258 lines 50–51.

[38] See Xydis, *op. cit.*, 23.

[39] Van Nice, *St. Sophia*, pl. 10.

BYZANTINE CHURCHES OF SELYMBRIA*

Paul Magdalino

THE title of this paper may surprise those familiar with the article in which S. Eyice in effect pronounced the funeral oration of the last Byzantine monument inside the walls of Selymbria, modern Silivri.[1] It was thanks only to preservation in the Istanbul Archaeological Museum of certain monogram capitals from this former church that Eyice was able to identify it as a foundation of Alexios Apokaukos, *parakoimomenos* and *megas doux* (d. 1345).[2] The very appearance of the building would have remained conjectural but for another chance survival—in this case, some old photographs of a hitherto unidentified ruin.[3]

There is, however, written evidence for the Byzantine churches of Selymbria, most of which has been overlooked. It is worth presenting in full, since it does much to enhance our picture of a town which was one of the main centers of the Empire during its final decline. From 1381 to 1399 Selymbria was the capital of the Thracian appanage ruled by Andronikos IV Palaiologos (d. 1385) and his son John VII;[4] then and later the powerful Leontares family were connected with it.[5] The city was one of the last places to fall to the Turks, having remained in Byzantine hands until 1453.[6]

The most important evidence is supplied by one of the lesser-known literary lights of the fourteenth century, Philotheos of Selymbria,[7] the author of a spirited pro-Hesychast *Dialogue* and several homiletic works.[8] In one of these, a laudation of Makarios, a refugee monk from Asia Minor who lived in Constantinople in the first half of the fourteenth century, Philotheos mentions something about his own life.[9] He was born at Dakibyze (modern Gebze) near Nikomedia, the son of a priest called John, and was baptized Philemon. When he was fifteen his father died, leaving him in the care of his uncle Sabbas, a disciple of Makarios. Sabbas sent the boy to a school, where he received a secondary education. Later he entered the monastic life and took the name Philotheos.

* In addition to the specific acknowledgments mentioned below, I wish to express my gratitude to Dr. Elizabeth Zachariadou and Professor Ihor Ševčenko for their helpful comments, and to the Dumbarton Oaks Center for Byzantine Studies for providing access to the previously unpublished material presented here.

[1] S. Eyice, "Alexis Apocauque et l'église byzantine de Sélymbria (Silivri)," *Byzantion*, 34 (1964), 77–104, esp. 103 note 2: "A Silivri, dans ces dernières années, à peu près tous les monuments historiques ont disparu sans distinction d'importance ni d'époque."

[2] *Ibid.*, 86–93.

[3] O. Feld, "Noch einmal Alexios Apokaukos und die Byzantinische Kirche von Selymbria (Silivri)," *Byzantion*, 37 (1967), 57–65.

[4] Ducas, *Istoria Turco-Bizantina (1341–1462)*, ed. V. Grecu (Bucharest, 1958), 83, 86; F. Miklosich and J. Müller, *Acta et diplomata graeca medii aevi sacra et profana* (Vienna, 1860–90) (hereafter Miklosich-Müller), II, 360; J. W. Barker, *Manuel II Palaeologus (1391–1425): A Study in Late Byzantine Statesmanship* (New Brunswick, N.J., 1968), 41, 51–52, 491–93.

[5] Miklosich-Müller, II, 401, 502–3; see *infra*, note 51; H. Hunger, *Johannes Chortasmenos (ca. 1370–ca. 1436/37), Briefe, Gedichte, und kleine Schriften*, WByzSt, 7 (Vienna, 1969), 127–28.

[6] Ducas, ed. Grecu, 321.

[7] H.-G. Beck, *Kirche und theologische Literatur im byzantinischen Reich* (Munich, 1959), 776–77; G. Mercati, *Notizie di Procoro e Demetrio Cidone, Manuele Caleca e Teodoro Meliteniota ed altri appunti per la storia della teologia e della letteratura bizantina del secolo XIV*, ST, 56 (Vatican City, 1931), 246–48.

[8] Philotheos' writings are preserved in two MSS: cod. Patm. 366, fol. 369 ff.; cod. Kamariotissa 51 (53), fols. 86r–109v, 302r–321v. See I. Sakkelion, Πατμιακὴ Βιβλιοθήκη (Athens, 1890), 167; A. Tsakopoulos, Περιγραφικὸς κατάλογος τῶν χειρογράφων τῆς Βιβλιοθήκης τοῦ Οἰκουμενικοῦ Πατριαρχείου. I, Τμῆμα χειρογράφων Παναγίας Καμαριωτίσσης (Istanbul, 1953), 93–98. On the *Dialogue*, Philotheos' most important work, see M. Jugie, *DTC*, XI,2, cols. 1798–99; Mercati, *loc. cit.*

[9] Ed. A. Papadopoulos-Kerameus, Μαυρογορδάτειος Βιβλιοθήκη, in Ἑλλ.Φιλολ.Σύλλ., Suppl. 17 (1886), 57–58.

Philotheos became metropolitan of Selymbria not later than 1365/66, when he issued an excommunication of Nikephoros Gregoras.[10] He was still in office in 1379/80, when he signed a Gospel Book that he had copied.[11] *Theophilos* of Selymbria is recorded as a signatory of an act of February 1389 copied into the synodal register;[12] however, a *sigillion* issued to Vatopedi in April of the same year bears the original signature of *Philotheos* of Selymbria.[13] Either Philotheos was temporarily replaced by Theophilos, or the copyist wrote Theophilos for Philotheos, which is more likely. At any rate, April 1389 is the terminus post quem for his death.

As metropolitan of Selymbria, Philotheos wrote an encomium of the local patron saint, Agathonikos, supposedly a native of Nikomedia who had been brought to Selymbria and beheaded by order of Maximianus Galerius.[14] By the fourteenth century the head was the only relic remaining in Selymbria; the rest of the body was generally believed to have been taken by the Latins,[15] although even before 1204 it is likely that most of the relics were not in Selymbria but in the saint's martyrium at Constantinople.[16] The encomium is a work of civic and personal propaganda expressing immediate concern with the Turkish danger.[17] It was probably written before 1381, since it contains no reference to the Emperor Andronikos IV who resided at Selymbria after that date.

Toward the end of the encomium is an account of some miracles performed by Agathonikos' head. This section, published below, contains interesting references to the churches of Selymbria in Philotheos' day. Mingarelli summarized but did not reproduce it in his publication of excerpts from the text in cod. Nanian. 309 (now Venice, Bibl. Marc., II, 168);[18] besides, this text, although interesting as a product of Selymbria, was copied a century after the work's composition.[19] The other manuscript containing the encomium, cod. Kamariotissa 51, is in the author's own hand,[20] and includes a "miracle" left out of the later copy, no doubt because it was considered to have been recorded for unworthy personal reasons.

[10] Miklosich-Müller, I, no. 229, p. 490; J. Darrouzès, *Le Registre synodal du patriarcat byzantin au XIVe siècle*, AOC, 12 (Paris, 1971), 57. Philotheos' closest known predecessor was one Esaias, recorded in 1355: Miklosich-Müller, I, 433.

[11] Scribal colophon in Princeton, Art Museum, cod. 57, fol. 170v; see *Illuminated Greek Manuscripts from American Collections*, ed. G. Vikan (Princeton, 1973), 196–97. I am grateful to Dr. Vikan for bringing this to my attention.

[12] Miklosich-Müller, II, 129.

[13] I am most grateful to Fr. Jean Darrouzès for this information.

[14] BHG³, 43. See H. Delehaye, "Saints de Thrace et de Mésie," *AnalBoll*, 31 (1912), 245–47; *idem*, *Les Origines du culte des martyrs*, SubsHag, 20 (Brussels, 1933), 244.

[15] PG, 154, col. 1237B–C.

[16] *Kniga palomnik' Antonija arhiepiskopa Novgorodskago*, ed. Hr. M. Loparev, Pravoslavnyj Palestinskij Sbornik, 51 (St. Petersburg, 1899), 31; trans. B. de Khitrowo, *Itinéraires russes en Orient* (Geneva, 1889), 106; R. Janin, *La Géographie ecclésiastique de l'empire byzantin*. I, *Le Siège de Constantinople et le Patriarcat Oecuménique*, pt. 3, *Les Eglises et les monastères* (Paris, 1969), 7–8.

[17] For appeal to Selymbrian local sentiment, cf. PG, 154, cols. 1232–33, 1237. Personal propaganda is evident in the fourth "miracle" ascribed to Agathonikos (see text *infra*), and perhaps in the very conception of a work celebrating a hero who, like Philotheos, came from Nikomedia via Constantinople to Selymbria; see the joint laudation of Nikomedia and Selymbria, in PG, 154, cols. 1232–33. For concern with the Turkish threat, see lines 38–39, 46–48 of the excerpt published below, and the prayer with which Philotheos concludes: ὁρᾷς γὰρ ὅσα καὶ οἶα (leg. ὅσων καὶ οἵων) νῦν τὰ ‘Ρωμαίων ἐμπέπλησται πράγματα, ἤπερ ἄλλοτέ ποτε· ὁρᾷς ὅσοις περικυκλούμεϑα κακοῖς καὶ ἡμεῖς μάλιστα οἱ ἐπὶ τὴν σὴν πόλιν οἰκοῦντες· | ὁρᾷς ὅπως τὰ τῶν πολεμίων βέλη ἐπ'αὐτῶν σχεδὸν τῶν ἐπάλξεων ἵπτανται, καὶ οὐδεὶς ὁ βοηϑήσων ἡμῖν ... (cod. Kamariotissa 51, fols. 309v–310r).

[18] G. L. Mingarelli, *Graeci codices manuscripti apud Nanios Patricios Venetos asservati* (Bologna, 1784), 536 (PG, 154, cols. 1239–40).

[19] In 1481 the scribe, a monk Gregory, dedicated this and its companion volume to the monastery of the Savior in Selymbria: A. Ehrhard, *Überlieferung und Bestand der hagiographischen und homiletischen Literatur der griechischen Kirche*, III, TU, 52 (1939), 245, 250.

[20] This is evident from the author's corrections on fols. 306v–307v, and from a comparison of the script with those of the Princeton Gospel Book, the excommunication of Gregoras (Vind. Hist. gr. 47, fol. 250v; I am grateful to Fr. Darrouzès for lending me his photograph), and the annotations and substitutions to the *Dialogue* in Patm. 366.

Istanbul, Greek Patriarchate, Kamariotissa 51 (53)=I
Venice, Biblioteca Marciana, II, 168=V

I fol. 309ʳ
V fol. 750ʳ

1 Βασιλεὺς Μανουὴλ ὁ Πορφυρογέννητος τὴν ἑαυτοῦ κεφαλὴν ἔχων
νενοσηκυῖαν ἐπὶ πλεῖστον δήτινα χρόνον, ἐπεκαλεῖτο τὸν ἅγιον εἰς
βοήθειαν· ὅθεν καὶ τὴν σεβασμίαν κάραν αὐτοῦ εἰληφώς, καὶ ἀπηωρη-
μένην ποιήσας τῇ κεφαλῇ ὥραν οὐχὶ συχνήν, ἀπήλλαξε τῆς νόσου
5 τελέως, καὶ ὑγιεινὴν ἀποκατέστησεν. Ὁ βασιλεὺς οὖν θεασάμενος τὸ
συμβὰν παραδόξως, ἀμείβεται τῷ ἁγίῳ δῶρον ἀντάξιον. Ποῖον δὴ
τοῦτο; Τὸν καθολικὸν νεὼν τουτονὶ ἀνεγείρει τὸν στερρὸν καὶ ἀδάμαντα
εἰς ὄνομα τοῦ ἁγίου, ἔτι δὲ καὶ ἐξ ἀρχιεπισκοπῆς πατριαρχικῆς προεβί-
βασεν εἰς μητρόπολιν προσηκόντως τὴν αὐτοῦ ἐκκλησίαν καὶ πόλιν.

V fol. 750ᵛ

10 **2** Ὕστερον δὲ καὶ Ἀλέξιος ὁ μέγας δούξ, ὃς ἦν εἷς τῶν Ἀπο|καύκων
καὶ κρείττων κατὰ γένος, ἀνὴρ πλούτῳ τε κομῶν καὶ δόξῃ, προσέτι γε
μὴν δραστήριος καὶ ὀξὺς λίαν, ἔτι δ'αὖ ἀγχίνους καὶ περιδέξιος τὰ ἐς
πάντα, ἔν τε βουλαῖς δηλαδὴ καὶ ἐμπειρίαις στρατηγικαῖς, θαλαττίαις
καὶ ἠπειρωτικαῖς, καὶ πολιτικοῖς πράγμασιν, ἀμειβόμενος τῷ μάρτυρι
15 διά τινα περίστασιν αὐτοῦ, ναὸν ἀνίστησιν ἕτερον κάλλιστον κατὰ τὰς
Ἄμμους, ἐν ᾧ ὁ ἅγιος τετελείωται τὸν μαρτυρικὸν δίαυλον, ὃς ἔτι
περισώζεται καὶ καθορᾶται.

3 Ἀλλὰ καὶ πρὸ βραχέος ὁ πανταριστος βασιλεὺς Ἰωάννης Παλαιολό-
γος ὁ μέγας, νόσῳ δεινῇ περιπεσών, ἡ σεβασμία κεφαλὴ καὶ ἱερὰ τοῦ
20 ἁγίου ἐκ θείας ἐπιπνοίας ἐπὶ τὰ ἀνάκτορα σταλεῖσα καὶ ἀφικομένη,
εὐθὺς ἀνερρώσθη καὶ τῆς μεγίστης νόσου ἀπηλλάγη κατὰ μικρόν. Ὅθεν
ὁ βασιλεὺς οὑτοσὶ διὰ τὴν τοῦ θαύματος, ἐνέργειαν τοῦ ἁγίου, τῷ
ἱερεῖ Ἀγαπίῳ ἐκείνῳ τῷ εἰσκεκομηκότι τὴν θείαν κάραν, τῷ κλήρῳ
αὐτοῦ συγκατήλεξε τῷ βασιλικῷ, καὶ τετίμηκεν ὡς εἰκός.

(non habet V) 25 **4** Βούλεται δ'ὁ λόγος καὶ ἕτερον προσθεῖναι διήγημά τε καὶ θαῦμα.
Τινὲς τῶν τοῦ κλήρου τοὐμοῦ τῶν λίαν φθονερῶν καὶ ματαίων νεω-
τερισάμενοι, καθ'ἡμῶν εἰς βασιλεῖς καὶ πατριάρχας πολλὰ | κατειπόντες,

I fol. 309ᵛ

καὶ λιβέλλους δεδωκότες κρύφα, ᾤχοντο ἀπιόντες, τοῦτο μὲν καὶ ὡς
ἀπαρρησίαστοι καὶ οὐδενὸς λόγου ἄξιοι ἀνθρωπίσκοι, τοῦτο δὲ καὶ
30 ὡς μάταια καὶ ψευδῆ λέγοντες, πλὴν τριῶν κεφαλαίων κρατηθέντων
καὶ ἐξετασθέντων συνοδικῶς ὡς δῆθεν ἀληθῆ ὄντων· περί τε τοῦ ἄμβω-
νος ὅτι μετετέθη διὰ τὸ τῆς ἐκκλησίας στενώτατον· περί τε μαρμάρων
ἐδαφικῶν τῆς ἐκκλησίας τοῦ μάρτυρος Ἀλεξάνδρου ἔξω τοῦ ἄστεος ὅτι
ἐν τῷ τῆς μητροπόλεως τρικλίνῳ ἐνεβλήθησαν ψευδῶς φλυαρούντων·
35 καὶ μάλιστα περὶ θείων ἱερῶν ἀργῶν κειμένων παντάπασιν, ὅτι διε-
πράθησαν δι'ἀνάγκην ὑπὲρ αἰχμαλώτων καὶ τῆς πόλεως, καὶ ὀχύρωμα
ἐγεγόνει διὰ τὴν τῶν Ἀγαρηνῶν ἐπιβουλὴν τηνικαῦτα, ἐφ'ᾧ πάλιν
ὡς ἱερὰ θεῖα εἶεν καὶ περισώζεσθαι ἔν τινι εὐαγεῖ οἴκῳ. Τούτων ἐξεταζο-
μένων συνοδικῶς πλεῖστον δήτινα χρόνον σὺν διασκέψει μακρᾷ, θεία
40 συνάρσει καὶ βοηθείᾳ, καὶ βασιλικῇ χειρί, πατριαρχικῇ τε αὖ καὶ συνο-
δικῇ θείᾳ γνώμῃ καὶ εὐθύτητι, ἐν τῇ τοῦ μάρτυρος Ἀγαθονίκου μνήμῃ,
ὦ τοῦ θαύματος, τὰ τῆς ὑποθέσεως διελύθησαν, μικρὸν πρόσθεν τὸ
θριγγίον φροῦδον γεγονός, τῆς θαλάσσης σφοδρῶς ταραχθείσης ὅτε
ταῦτ'ἐγίγνετο, διὰ τὴν τῶν βασκάνων οἶμαι ὠμότητα· πρὸς δέ, μετ'
45 ὀλίγον καὶ τὸ ἐπίνειον παρὰ τῶν Ἰσμαηλιτῶν σκυλευθὲν ὡς γεγονὸς
ἄφρακτον καθάπαξ, κατακέκαυσται καὶ ἐρείπιον γέγονεν.

11 τοῦ γένους V, δόξει IV. 13–14 post θαλαττίαις om. καὶ ἠπειρωτι-
καῖς add. πρὸς τούτοις V. 19 ἡ σεβασμία καὶ ἱερὰ V. 22–23 leg. τὸν
ἱερέα Ἀγάπιον ἐκεῖνον τὸν εἰσκεκομικότα. 31 leg. ἀληθῶν. 43 cod.
θρυγγίον.

Translation

1 The Emperor Manuel Porphyrogennetos, who had long had an affliction in his head, called on the saint for help; taking that most revered head and suspending it above his own for no great length of time, he cured this completely of the disease and restored it to health. The Emperor, considering that which had happened contrary to all expectation, rewarded the saint with a comparable gift. What was it? He raised this firm and unshakable church in the saint's name; furthermore, he fittingly promoted his church and city to the status of a metropolis from that of a patriarchal archbishopric.

2 Later, Alexios the *megas doux*, who was one of the Apokaukoi and of most worthy ancestry, a man flourishing in wealth and glory, most energetic besides and extremely sharp, keen-witted too and capable in everything—in deliberations, that is, and military operations, both on land and sea, and in political matters; he, paying gratitude to the martyr for some circumstance, erected another most beautiful church at Ammoi, where the saint had finished his race of martyrdom. This is still preserved and can be seen.

3 And a short time ago, (when) the most excellent Emperor John Palaiologos the Great[21] fell victim to a terrible illness, the most holy and revered head of the saint was, by divine inspiration, sent to the palace; and when it arrived, he immediately felt better and in a little while was cured of that formidable sickness. And thus this Emperor, because of the miraculous action of the saint, appointed the priest Agapios, who had brought the head, to the palace clergy, and rewarded him fittingly.

4 My discourse calls for another miracle story. Some of the over envious and vain among my clergy revolted, and made many accusations against me to the emperors and patriarchs, and produced libels in secret, but they were dismissed, both as little men worthy of no consideration who had no right to talk, and as speakers of falsehood and inanity. Three charges were, however, retained and examined by the synod as being supposedly true: concerning the ambo, that this was removed because of the extreme narrowness of the church; concerning marble paving-stones belonging to the church of the martyr Alexander outside the town,[22] that they were removed to the metropolitan palace (this was just lying chatter); and especially concerning holy and precious objects lying idle all over the place, that these were sold of necessity for the sake of captives and of the town,[23] and were used to pay for fortifications because of the Hagarenes' attack[24]—sold, however, on condition that they would again become sacred and holy and would be kept in some pious foundation. When these matters had been examined by the synod over a long period, with much deliberation, by divine intervention and succor, by imperial action, and by divine consensus and justice of the patriarch and synod, the affair was resolved—Oh miracle!— on the feast of the martyr Agathonikos.[25] Shortly before, the harbor wall had been destroyed, the sea then being violently disturbed, I imagine because of the outrageousness of those calumniators; moreover, a short time afterward, now that the harbor was unfortified, it was sacked by the Ishmaelites, burned, and reduced to ruin.

[21] Most probably John V, rather than his grandson John VII.

[22] No doubt the martyr of this name whose relics were venerated at Drizipara in Thrace (near modern Karistiran); cf. *BHG*³, 48–49; *Theophylacti Simocattae Historiae*, ed. C. de Boor (Leipzig, 1887), 270–71; Delehaye, "Saints de Thrace et de Mésie," 244–45.

[23] The controversial issue of whether religious property could be sold for charitable or military purposes was revived in the fourteenth century; see I. Ševčenko, "Nicolas Cabasilas' 'Anti-Zealot' Discourse: A Reinterpretation," *DOP*, 11 (1957), 151 ff.

[24] John VI Cantacuzene had already strengthened the fortress by the addition of a tower in 1346: Nikephoros Gregoras, II, Bonn ed. (1830), 762. On the walls of Selymbria, see F. Dirimtekin, "La Forteresse byzantine de Selymbria," *Actes du Xᵉ Congrès International d'Etudes Byzantines, 1955* (Istanbul, 1957), 127–29. The work of fortification to which Philotheos refers may be that mentioned by the seventeenth-century traveler Evlija Čelebi; see H. J. Kissling, *Beiträge zur Kenntnis Thrakiens im 17. Jahrhundert* (Wiesbaden, 1956), 10.

[25] August 22. Unfortunately, the surviving fourteenth-century synodal register contains no record of the proceedings.

Commentary on §§ 1 and 2

1 The emperor in question is obviously Manuel I Komnenos (1143–80).[26] Manuel spent the Easter of 1167 at Selymbria while on his way to Hungary,[27] and this may well have been the occasion on which he sought the aid of St. Agathonikos, since he was still suffering from injuries incurred during a polo game. It was at some point between 1166 and 1169 that he raised the Selymbrian see to metropolitan status.[28]

The church was evidently the cathedral, and it is therefore certain that Manuel did not build an entirely new church, but restored or remodeled an existing structure; an ambo mentioned in the third miracle was surely a survival from preiconoclastic times.[29] The building was clearly dedicated to Agathonikos, which poses a problem as far as its later history is concerned, because the cathedral mentioned by seventeenth- and nineteenth-century observers was dedicated to the Virgin.[30] Either this was a different church, or the original dedication had changed.

2 Alexios Apokaukos,[31] *parakoimomenos* (1321–41)[32] and *megas doux* (1341–45),[33] was head of the administration under Andronikos III, the main power behind the regency government of John V, and the most determined opponent of John Cantacuzene in the most disastrous of Byzantine civil wars. The fulsomeness of Philotheos' description contrasts oddly with the summary treatment of the miracle as such, and with the prohesychast and pro-Cantacuzene sentiments he expresses elsewhere.[34] It is noteworthy that he refers to Apokaukos as being of good family, when Cantacuzene and Gregoras insist to the contrary.[35] Apokaukos may have been well remembered in Selymbria; he is more than once mentioned in connection with the town, and he built his private castle at Epibates in the vicinity.[36] Possibly Philotheos had cause to be grateful to Apokaukos, a fellow Bithynian,[37] or, more likely, he chose his words in deference to living and influential Apokaukoi.[38]

It is tempting to identify the church mentioned by Philotheos with the building known to archeology as the Fatih Camii, and it is perhaps apparently unlikely that Apokaukos would have made two major pious foundations in the same provincial town. This possibility cannot be excluded, however, and on consideration may be preferable. There is no evidence that the Fatih Camii was dedicated to Agathonikos; indeed, both testimonies to popular tradition concerning the building indicate, for what

[26] For epigraphical examples of Manuel's official use of the epithet Porphyrogennetos, see C. Mango, "The Conciliar Edict of 1166," *DOP*, 17 (1963), 324; A. Van Millingen, *Byzantine Constantinople. The Walls of the City and Adjoining Historical Sites* (London, 1899), 187.

[27] John Kinnamos, Bonn ed. (1836), 265; F. Chalandon, *Jean II Comnène (1118–1143) et Manuel I Comnène (1143–1180)* (Paris, 1912), 488.

[28] H. Gelzer, "Zur Zeitbestimmung der griechischen Notitiae Episcopatuum," *Jahrbuch für protestantische Theologie*, 12 (1886), 544–47; V. Laurent, *Le Corpus des sceaux de l'empire byzantin. V, L'Eglise*, I,1 (Paris, 1963), 645–46.

[29] T. F. Mathews, *The Early Churches of Constantinople: Architecture and Liturgy* (University Park, Pa.-London, 1971), 178–79, 180 note 4.

[30] See Appendices *infra*.

[31] For prosopographical details, see D. I. Polemis, *The Doukai. A Contribution to Byzantine Prosopography* (London, 1968), 101; for Apokaukos' public career, see K. P. Matschke, *Fortschritt und Reaktion in Byzanz im 14. Jahrhundert. Konstantinopel in der Bürgerkriegsperiode von 1341 bis 1354*, Berliner Byzantinische Arbeiten, 42 (Berlin, 1971), 133 ff.

[32] R. Guilland, *Recherches sur les institutions byzantines*, Berliner Byzantinische Arbeiten, 35 (Berlin-Amsterdam, 1967), I, 210.

[33] Cantacuzene, Bonn ed. (1828–32), II, 218; Guilland, *op. cit.*, 550.

[34] I.e., the unpublished theological *Dialogue*, and the *Encomium of Makarios*, ed. Papadopoulos-Kerameus, *op. cit.* (note 9 *supra*), 55–57.

[35] Cantacuzene, I, 25, line 4; 117, lines 24–25; II, 89, line 2; Gregoras, II, 577, line 20; 602, line 19. Cf. G. Weiss, *Johannes Kantakuzenos—Aristokrat Staatsmann, Kaiser und Mönch—in der Gesellschaftsentwicklung von Byzanz im 14. Jahrhundert* (Wiesbaden, 1969), 54–56.

[36] Cantacuzene, I, 258; II, 102, 105, 141; Gregoras, II, 602–3. On the remains of the castle at Epibates (Bigados), see A. Papadopoulos-Kerameus, Ἀρχαιότητες καὶ ἐπιγραφαὶ τῆς Θράκης, in Ἑλλ.Φιλολ.Σύλλ., Suppl. 17 (1882–83), 71; Eyice, *op. cit.* (note 1 *supra*), 87.

[37] Cantacuzene, II, 89.

[38] Apokaukos married twice and had several sons and daughters, at least two of whom made noble marriages (Polemis, *op. cit.*, 101 note 13). Two Apokaukoi ranked high under Manuel II; see L. Politis, "Eine Schreiberschule im Kloster τῶν Ὁδηγῶν," *BZ*, 51 (1958), 32; J. M. Spieser, "Les Inscriptions de Thessalonique," *TM*, 5 (1973), 176–77.

they are worth, a dedication to some St. John.[39] There is also the question of the location. The name Ammoi (sands) given to the place where Apokaukos built his church to Agathonikos suggests the proximity of a sandy beach, and this is borne out by Philotheos' statement that the saint was executed by the seashore.[40] The Fatih Camii, however, lay in the center of the elevated medieval citadel.[41] Therefore, it is likely that Apokaukos' church of St. Agathonikos was a different building, and that it stood by the shore outside the walls. This interpretation would give some point to the remark that the church was still standing, which, since it is not applied to the older church rebuilt by Manuel I, can be no more than a rhetorical flourish unless it carries the implication that Apokaukos' foundation had been in danger of destruction, for instance at the hands of Turks raiding outside the walls. Drakos, writing in the nineteenth century, mentions that a church of St. Agathonikos had existed outside the citadel.

A further reminiscence of Alexios Apokaukos' patronage in Selymbria should be mentioned here. This is a note in a synaxarion of 1325, now cod. Kamariotissa 47:

† τὸ παρὸν βιβλίον ἔνι (ἔστι Ts.) τοῦ με(γάλου) δουκός, ἀπὸ τὴν σηλυβρίαν· καὶ δέδωκα (δέδωκεν Ts.) τοῦτο (αὐτὸ Ts.) ἐν τῇ μονῇ τοῦ τιμίου προδρόμ(ου), ἵνα ἀναγινώσκωσι τὰς μνήμας τῶν ἁγίων· ὅταν δὲ ἔλθη τὸ ἔλεος τοῦ θεοῦ, ἐν ὅλη τῇ κτίση, πάλιν ἐπιστρέψη ἡ βίβλος, ὅμου καὶ τὰ

ἔτερα, ἐν τῇ μονῇ τῆς σηλυβρίας, ἤτοι τοῦ μεγ(ά)λου δουκός.[42]

At the end of the codex is another note in the same hand, under the scribal colophon of 1325:

† δέδωκα τὸ παρὸν ὥσπερ δανικὸν ἐν τῇ μονῇ τοῦ τιμίου προδρόμου τῆς πέτρας, ἵνα ἀναγινώσκωσι μνήμας ἁγίων ἐν ἔτει ͵ϛϡοα', ἰνδ. ια'.[43]

These notes show that in A.M. 6971, or A.D. 1462/63, part if not all of the movable property of a monastery "of the *megas doux*" in Selymbria was transferred to the house of St. John the Baptist at Petra in Constantinople,[44] with little expectation that it would be restored to its owner before the Second Coming. In view of the fact that the transfer took place in the reign of Mehmet II Fatih, "the Conqueror," it is plausible to identify the monastery of the *megas doux* with the building studied by Eyice and the occasion as that of its conversion into a mosque. It is true that the monograms on the capitals of the Fatih Camii show that Apokaukos built this while he was *parakoimomenos*, but it is likely that he was remembered by most people in his last and highest capacity of *megas doux*, in which he seems to have caught the popular imagination.[45] It is perhaps of some significance that this foundation was a monastery, whereas that mentioned by Philotheos was termed *naos*.

One other passage of Philotheos' encomium deserves mention. Digressing at one point on the subject of the reconquest of Constantinople from the Latins in 1261, Philotheos comments that the Emperor Michael VIII started his reign well but ended it badly, as a Latin sympathizer, "so that in this town of Selys, in the monastery of Christ the all-merciful Savior, his body is to be seen lying

[39] See notes 52, 53 *infra*. The monogram on a capital, now lost, which nineteenth-century observers claim to have seen in the building, has been resolved as 'Ιω(ά)νν(ης); cf. Eyice, *op. cit.*, 89, 91.

[40] The *comes* Eutolmios brought Agathonikos from Byzantion ἐπὶ τὸν τύραννον Μαξιμιανόν, ἐν ᾧ τόπῳ διῆγεν, Ἄμμους ἐπονομαζομένῳ, ἐν τῇ περιφανεῖ πόλει Σηλυβρίᾳ δηλαδή, ἔνθα τοὺς βασιλείους οἴκους εἶχε τηνικαῦτα καὶ τὴν δίαιταν, διά τε τὸ χάριεν τοῦ τόπου καὶ εὔάερον καὶ ἐλεύθερον (fol. 305ʳ). After a long debate which, of course, the emperor lost, he ordered Agathonikos' execution, οἵ γε μὴν στρατιῶται τὸ κελευσθὲν ποιησάμενοι τάχιστα κατὰ τὴν τῆς θαλάττης ἀκτήν (fol. 308ʳ). Philotheos is more precise in this respect than any of the versions of Agathonikos' *Passio* which I was able to consult (*BHG*³, 39, 39z, 40, 41, 41a, 42), no doubt because he had the location of the church in mind.

[41] Eyice, *op. cit.*, 93.

[42] Originally published by Tsakopoulos, *op. cit.* (note 8 *supra*), 85. I have indicated where our readings differ.

[43] *Ibid.*, 86.

[44] Janin, *op. cit.* (note 16 *supra*), 421 ff. In 1462 the Petra monastery was given to the Christian mother of Mahmud Pasha, Vizir of Mehmet II; cf. the firman published in Ὀρθοδοξία, 20 (1945), 147–48.

[45] A. Xyngopoulos, Ἅγιος Δημήτριος ὁ Μέγας Δοὺξ ὁ Ἀπόκαυκος, in Ἑλληνικά, 15 (1957), 122–40.

all bloated because his heterodoxy was so far gone; and also, indeed, because of the excommunication which the most holy Patriarch Arsenios pronounced against him for having deceitfully usurped power from the son of Theodore Laskaris."[46] This passage is interesting for the information that Michael VIII's body was never removed for burial in one of the imperial or aristocratic mausolea in Constantinople, but remained in the monastery of the Savior in Selymbria, where, according to Pachymeres, Michael had reburied the remains of Basil II in 1260 and was himself interred in 1282 after his death near Raidestos.[47] Pachymeres again mentions the monastery in connection with events of the year 1299, and in a context which suggests that the house depended upon the patriarch.[48] It is probably to be identified with the patriarchal monastery which John Kalekas tried to protect in 1343 from the encroachments of neighboring communities.[49] It was still flourishing in 1481.[50]

From the above information, it is obvious that the monastery of the Savior cannot be identified with any of the others mentioned by Philotheos, or with the Fatih Camii.

There are two other mentions of local monasteries in Byzantine sources, both of the fifteenth century. Short notices in cod. 265 of the monastery of Eikosiphonissa at Kosinitza near Drama record the deaths of Demetrios Leontares (1431) and his son John (1437); the latter "was buried in the monastery of the Prodromos, in Selymbria."[51] As I have already mentioned, there seems to have been a tradition in the nineteenth century that the Fatih Camii had once been dedicated to a St. John—John the Theologian according to Stamoulis,[52] and John the Baptist (Prodromos) according to Drakos.[53] If Drakos is right, and not merely influenced by a knowledge of this note, then it is conceivable that the monastery of the Prodromos was identical with the monastery of the *megas doux*. Demetrios Leontares was buried in the Petra monastery at Constantinople,[54] where, as we have seen, liturgical books from the monastery of the *megas doux* were deposited in 1462/63.

Another Demetrios Leontares, probably John's son, recorded in 1446 that he received a book formerly belonging to the metropolitan Ignatios of Selymbria (John Chortasmenos), from Makarios, "abbot of (the monastery of) St. Marina in the same town."[55]

To summarize, Greek sources of the fourteenth and fifteenth centuries mention the following religious institutions at Selymbria: the metropolitan church of St. Agathonikos rebuilt by Manuel I, a church of St. Agathonikos built by Alexios Apokaukos, a church of St. Alexander outside the town, a patriarchal monastery of Christ the Savior, a monastery of the *megas doux*, a monastery of the Prodromos, and a monastery of

[46] Fol. 308ᵛ: ὡς καὶ ἐν τῇ τοῦ Σήλυος ταύτῃ πόλει κατὰ τὴν τοῦ Σωτῆρος καὶ πανελεήμονος Χριστοῦ μονήν, τὸ ἑαυτοῦ σῶμα κατακείμενον καθορᾶται ὀγκούμενον, διὰ τὴν προβᾶσαν τῶν δογμάτων διαφοράν, προσέτι γε μὴν καὶ διὰ τὸν προσφωνηθέντα κατ'αὐτοῦ ἀφορισμὸν παρὰ τοῦ θειοτάτου πατριάρχου Ἀρσενίου, ὡς σφετερισάμενον (leg. σφετερισαμένου) ξὺν δόλῳ τὴν τῆς βασιλείας ἀρχὴν ἐξ υἱοῦ Θεοδώρου τοῦ Λάσκαρη; also published, with slight variations, in PG, 154, cols. 1237D–1238A.

[47] George Pachymeres, Bonn ed. (1835), I, 125; II, 107–8 (Gregoras, I, 159). John IV Laskaris, whom Michael had deposed and blinded, seems by contrast to have been buried in the capital and venerated as a saint; cf. I. Ševčenko, "Notes on Stephen, the Novgorodian Pilgrim to Constantinople in the XIV Century," *SOforsch*, 12 (1953), 173–75, who discusses the persistence through the fourteenth century of Arsenite sentiments such as those expressed by Philotheos in the passage quoted above. Mercati (*op. cit.* [note 7 *supra*], 247 note 4) suggested that an encomium of Arsenios at the end of Patm. 366 may be Philotheos' work. Examination of the codex supports this idea, since the encomium is in the same hand as the *Dialogue*, which has the author's autograph annotations.

[48] Pachymeres, II, 281.

[49] Miklosich-Müller, I, no. 103, p. 232. The name of the town is given as Σηβρία—surely a copyist's error.

[50] See note 19 *supra*.

[51] A. Papadopoulos-Kerameus, Ἔκθεσις παλαιογραφικῶν καὶ φιλολογικῶν ἐρευνῶν ἐν Θράκῃ καὶ Μακεδονίᾳ, in Ἑλλ.Φιλολ.Σύλλ., Suppl. 17 (1882–83), 30; P. Schreiner, *Die Byzantinischen Kleinchroniken*, I (Vienna, 1975), 649.

[52] A. Stamoulis, in Ἑλλ.Φιλολ.Σύλλ., 6 (1872), 246.

[53] See Appendix B *infra*.

[54] S. P. Lampros, Παλαιολόγεια καὶ Πελοποννησιακά, I (Athens, 1912–23), 213–14.

[55] Vatican, cod. Reg. 6, fol. 205ᵛ; cf. H. Stevenson, *Codices manuscripti graeci Reginae Svecorum et Pii P.P. II* (Rome, 1898), 6; Hunger, *op. cit.* (note 5 *supra*), 128.

St. Marina. Whether these did in fact correspond to seven and not six, or five, different foundations, and which, if any, correspond to Christian churches visited by post-Byzantine observers, cannot be proved conclusively from the evidence available to date. There is good reason to believe that the monastery of the *megas doux* became the Fatih Camii, although its Christian dedication remains a mystery. In conclusion, I wish to draw attention to the fact that when Covel visited Selymbria in 1675, twenty-two Christian churches were remembered, of which fourteen survived. At that date, none of these churches could have been of post-Byzantine foundation. Thus, however the evidence so far collected is to be interpreted, it seems unlikely that it can allow us to identify more than a third of the total number of churches of Byzantine Selymbria.

Appendices

I reproduce here two accounts of Selymbrian churches in the Ottoman period which have been quoted *supra*, since neither is widely accessible.

A. *The Covel Papers*.[56] John Covel, chaplain of the Levant Company at Constantinople from 1669 to 1677, visited Silivri in 1675 while on a journey to Adrianople, staying in the town from 3 to 5 May. The relevant entry in his journal, British Library, Add. MS 22, 912, is quite extensive, and the first part, in which he describes the Byzantine walls, is omitted here.[57]

fol. 181ᵛ The Greekes had formerly 22 churches here within ye walls, but now (as I have said) are but ιδ, and

those most pittifull little sad holes, an ordinary chancell will make two of them; the like (I must tell you once for all) are ye greek churches now all over ye Empire (that ever I saw;) and I shrewdly suspect (out of Constantinople) that ye generality of them of old were little better, which might very well make *Procopius* keep such a stirre about Sta. Sophia; which is indeed a very fine building still, and in comparison of these I speak of, might indeed be said to tempt ye Seraphims and Cherubims to dwell there, but in good earnest it fell infinitely short of my expectations as elsewhere shall perhaps be discoursed with you. I went here to visit ye Metropolite, who was a very young man I guest him not above 25; he treated me (as this countrey breeding goes) very civilly; with cáffe, sherbet, conserve of roses and fair water as much as I would drink; he hath a pretty little house by ye Metropolitical church, which is dedicated to ye B.V. it hath been ye finest there, adorn'd with marble pillars, but now shrunk into nothing but a vestery all most. The oldest church in veiw, (and now ye best) is dedicated to St. George. The floor is finely checkered with black and white marble, it is (as to ye foundation) yet intire and I assure you it may well stand in our chappel, and almost another on ye top of it. The *Cupola* over the ἅγιον βῆμα is very good Mosaick work and about ye skirt of it is written

ᚥᚥ Τῷ ΟΙΚῼϹΟΥΠΡΕΠΕΙΑϹΙ
ΑϹΜΑΚΕΕΙϹΜΑΚΡΟΤΗΤΑΗΜΕΡῳΝ ᚥᚥ [58]

[56] Cf. F. W. Hasluck, "Notes on Manuscripts in the British Museum Relating to Levant Geography and Travel," *BSA*, 12 (1905–6), 211–12.

[57] The entry is published in a modern Greek translation; cf. Germanos, Metropolitan of Thyateira, Ἡ Σηλυβρία κατὰ τὸν ΙΖ′ αἰῶνα, in Θρακικά, 10 (1938), 128 ff.

[58] Τῷ οἴκῳ σου πρέπει ἁγίασμα, Κύριε, εἰς μακρότητα ἡμερῶν (Ps. 92 [93]:5); for a comparable occurrence of the same inscription, see the rock-church at Medeia (Midye) in Thrace: S. Eyice and N. Thierry, "Le Monastère et la source sainte de Midye en Thrace turque," *CahArch*, 20 (1970), 55. The cufic motif at either end, which Covel took to be part of the inscription, probably indicates a mid-Byzantine date.

The beginning and ending are the same, and a καλόγηρος (a papás or Monk there) would needs have it to be ὢ σῶσον; I am apt to think it might mean so (but there wants ye N,) for I find it was a word of supplication yet in the antient Amulets, commonly ascribed to ye followers of Basilides; I have a very rare curiosity of which I will give you an account amongst the rest and compare that with this. Coming out from that church on ye wall on ye right hand without, are four figures standing in a small stone about 1½ foot long; an Antient man with a young lad on his left hand holding one hand on his breast and ye other under his cheek. Opposite to him stands a Woman with a young lasse in ye same posture with ye boy. Over was wrote (ye corner being a little broken): ΟΥΝΙΟΣ ΠΡΟΒΟΣ and on ye edge of ye side to ye right hand, ΖΗ. I conclude it to have been the title to his monument by ye word ΖΗ which I have frequently met with all in monuments, perhaps it was onely an indication of their beleif of ye immortality. In another church of ye B.V. is shown ye body of a saint which they call[59] ἁγία ξένη and an old picture of ye V.M. They tell the story [that] after a great shipwrack this body was driven ashore with this picture tyed to it with an Iron chain, and though they never knew whence she came nor what she was yet they for the pictures sake sainted her, and reserved her body and ye picture as objects of devotion to ye people. There is a day set apart (Jan. 24th) in their Legend for this

saint, but there they tell another tale of her. The monastery (which I have already mentioned)[60] hath been a very pretty little/ building, but now running to ruine, there being no endowments or revenue left to repair it; there is but one old καλόγερος left, who lives only upon what few aspers he can get by ye charity of strangers.

fol. 182ʳ

B. Translated excerpts from E. I. Drakos, Τὰ Θρακικά (Athens, 1892).

p. 16 There is an undamaged Byzantine church in the citadel, dedicated to St. Spyridon,[61] decorated with paintings; I regard it as one of the wonders of the Thracian littoral. In ruins is the Byzantine church in the town dedicated to the Prodromos, which the Turks have as a mosque; painted icons are visible on the inside of the apse. This is the monastery of St. John the Forerunner, which existed in Selymbria before 1437,[62] and to the present day its environs are called the quarter of the metropolis.

p. 18 The church of the Selymbrians, dedicated to the Birth of the Mother of God, is in a sort of Byzantine style, although the part of it between the episcopal throne and the narthex was completely rebuilt in 1833 during the incumbency of

[59] The sources attesting to the cult of Agia Xeni at Silivri from 1614 to the twentieth century are too numerous to list here; for a representative sample, see Eyice, op. cit., 83 note 2; F. W. Hasluck, Christianity and Islam under the Sultans (Oxford, 1929), II, 580. It is interesting that Covel distinguishes between the cathedral and the church where the body was kept, and difficult to know how to reconcile this information with that of Drakos (infra).

[60] Fol. 180ᵛ: "Within ye castle now stands an old monastery so near ye brow of ye cliff as I am confident in very little time it will follow ye fate which ye wall have had." This was probably the monastery seen in the previous century by Pigafetta; see P. Matković, "Putopis Marka Antuna Pigafette u Carigrad od god. 1567," Jugoslavenska Akademija Znanosti i Umjetnosti, Starine, 22 (1890), 160: "Questa città fù nomata già Selimbria et è picciola. Ha un castello, le cui mura sono tutte minate, dentro al quale sono due monasteri, l'uno de frati, e l'altro di monache."

[61] K. Mavrides, Ὁ ἐν Σηλυβρίᾳ Βυζαντινὸς Ναὸς τοῦ Ἁγίου Σπυρίδωνος, in Θρακικά, 9 (1938), 37–44.

[62] Although he refers to no source, Drakos' mention of this date suggests that he knew of the Kosinitza manuscript note (see note 51 supra).

Metropolitan Ierotheos of Selymbria; the icon of the Ever-Virgin is covered with silver, and portrays her holding the Once-Begotten, while on the other side it shows the Birth of Our Most Blessed Lady—a curious thing, since all the icons of our churches and houses are painted on one side of the panel only; the locals flatter themselves in saying that this icon is one of those worked by the Evangelist Luke.

[There follows a passage discussing the importance of the icon as an object of pilgrimage, and describing the custom of the "ransoming" of the "slaves of the Virgin"—people who had themselves bound symbolically with a chain and then pledged money to the church in order to be freed.]

p. 19 The church now treasures the relic of St. Xene, whom the citizens revere as a second patron, as well as the holy head of St. Agathonikos who suffered martyrdom here in 290. On the south side of this venerable church there is a sculpture representing the Panagia and the Emperor Justinian,[63] founder of the church according to tradition, although history does record all that he built. In the courtyard are preserved tombs of the bishops Sophronios and Zacharias; adjoining the church to the south is a wooden, two-storied metropolitan residence erected in 1782. There is in the town another small church dedicated in the name of the Dormition of the Virgin, in which the three priests officiate only during the feast of the Fifteenth of August; it is at the southwest edge in the place called Paraporti, to which one climbs by a stone path as if to an acropolis. It is said that here an old woman betrayed the town on the occasion of its capture by foreigners; it is a lonely and deserted spot on summer days. The citizens say that their lovely home was adorned with almost forty churches, yet only traces or names of a few are preserved, of SS. Demetrios, Panteleimon, the Apostles, and Theodosia in the citadel, and, nearby, of SS. Agathonikos, Anne, and the Blachernae.

[63] For a more sober account of this sculpture, see Papadopoulos-Kerameus, Ἀρχαιότητες καὶ ἐπιγραφαὶ τῆς Θράκης, 74–75.

THE "HALF-CONE" VAULT OF ST. STEPHEN AT GAZA*

HENRY MAGUIRE

THE orator Choricius is well known to art historians for his descriptions of two lost sixth-century churches in Gaza, St. Sergius and St. Stephen.[1] In the *ekphrasis* of St. Stephen the attention of scholars has focused on the literary climax of the piece, an involved account of a "novel form" of wooden vault.[2] The complexity of this passage has challenged several modern writers to reconstruct the appearance of the vault, but nobody has been able to account fully for all of the clues given by the description.[3] This paper offers a new solution to the puzzle which satisfies every requirement of the text, and which is also possible in the context of sixth-century ecclesiastical architecture.

Photius, when he reviewed the works of Choricius in the ninth century, noted that this orator "surpasses himself when developing descriptions and eulogies." However, Photius also complained that "His carefully chosen diction does not always keep to the legitimate sense of the words. For sometimes through the excessive turning of his tropes he falls into a frigid phraseology, and in places he is swept into a style that is overly poetic."[4] By and large the modern critic must concur with the judgment of the ninth-century Byzantine. The style of Choricius is indeed often overly ornate and hard to follow. On the other hand, his descriptions are of surpassing value because there is every reason to believe that they were accurate, and that Choricius painstakingly observed the buildings about which he spoke. In the case of the pictorial decoration of St. Sergius, comparisons with surviving sixth-century works of art have demonstrated that Choricius meticulously recorded the iconography of the Gospel scenes, even down to such details as the gestures made by the actors.[5] Here I hope to show that for the history of architecture, too, Choricius can yield very precise and specific information once his rhetorical code has been deciphered.

The description of St. Stephen takes up almost a third of the second panegyric which Choricius composed in praise of Bishop Marcian of Gaza, who was presumably responsible for the construction of the church. Choricius probably delivered this oration after 535/36, and certainly before the death of the Empress Theodora in 548.[6] Several

* I am indebted to the many with whom I have discussed the reconstruction presented in this paper, especially Professor Slobodan Ćurčić, Professor Ihor Ševčenko, and Mr. William Tronzo. Professor Noël Duval kindly made available his photograph of Dar el Kous at Kef. I am also grateful to Miss Frances Jones who redrew my reconstruction of the apse of St. Stephen for publication.

[1] *Laudatio Marciani*, I.17–76 (St. Sergius) and II.28–54 (St. Stephen), ed. R. Förster and E. Richtsteig (Leipzig, 1929); French trans. F.-M. Abel, "Gaza au VIᵉ siècle d'après le rhéteur Chorikios," *RBibl*, 40 (1931), 5–31; English trans. R. W. Hamilton, "Two Churches at Gaza, as Described by Choricius of Gaza," *PEFQ*, 1930, pp. 178–91; and C. Mango, *The Art of the Byzantine Empire 312–1453* (Englewood Cliffs, N.J., 1972), 60–72.

[2] *Laud. Marc.*, II.41–45.

[3] A brief suggestion for reconstructing the appearance of the vault is offered by Abel, *op. cit.*, 25 note 1, 27; a more detailed reconstruction is found in E. Baldwin Smith, *The Dome* (Princeton, 1950), 38–39, to which G. Downey contributed an appendix (pp. 155–57) with an annotated translation of *Laud. Marc.*, II.37–46; the most recent discussion is by Mango, *op. cit.*, 71 note 87.

[4] Ἡ δέ γε λέξις αὐτῷ τῶν λογάδων οὖσα ἐν πολλοῖς οὐκ ἀεὶ τὸ γνήσιον διώκει· ἔσθ'ὅτε γὰρ διὰ τὴν ἄκρατον τῆς τροπῆς ἐκτροπὴν εἰς ψυχρολογίαν ἐκπίπτει καὶ πρὸς τὸ ποιητικώτερον δὲ ἔστιν οὗ παρασύρεται. Χρήσιμος δέ ἐστιν αὐτὸς ἑαυτοῦ μᾶλλον ἐκφράσεις καὶ ἐγκώμια διεξερχόμενος. *Bibliotheca*, cod. 160, ed. R. Henry, II (Paris, 1960), 122.

[5] See H. Maguire, "Truth and Convention in Byzantine Descriptions of Works of Art," *DOP*, 28 (1974), 118–19.

[6] C. Kirsten, *Quaestiones Choricianae*, Breslauer philologische Abhandlungen, VII (1894), 13–15; W. Schmid, "Chorikios," *RE*, III,

features of the church of St. Stephen emerge clearly from the description, and since they have not been disputed by previous commentators, they may be listed without further discussion. The church was a basilica with a nave flanked on each side by an aisle surmounted by a gallery.[7] At its eastern end opened an apse. Sumptuous revetments embellished the apse wall, in the center of which was a window framed in marble. Choricius says that a band (ζώνη) of the same kind of marble lay above the window; here he was presumably referring to the cornice at the top of the wall.[8] In the course of his description of the apse Choricius also says that "on either side" were images, one of John the Baptist on the spectator's left, and one of him "who holds the church" on the right.[9] Here there have been differences of interpretation, for F.-M. Abel and Cyril Mango identified the latter personage as the invisible patron of the church, St. Stephen,[10] while Glanville Downey opted for the visible patron, the building's donor.[11] Moreover, Abel and Mango placed the two figures on the triumphal arch, while Downey put them in the semidome of the apse.

Immediately after Choricius' description of the apse comes the passage on the wooden vault: "On one band (ζώνη), I speak of the highest, is placed a novel form. In geometry I have heard this called the half cone...."[12] After explaining through a mythological

reference that geometry borrowed the term from the shape of the pinecone, the orator continues: "A carpenter has cut five circles of the material given to him by his craft [i.e., wood] each equally into two, and has joined together nine of the segments to each other by their tips, but by their middles to the band which I have just called the highest. On these he has set an equal number of concave pieces of wood, which begin broad from below, but taper gradually to a sharp point, curving sufficiently to fit the concavity of the wall. And drawing together the tips of all the pieces into one and gradually bending them, he has produced a most pleasing sight. But while I have cut five circles in half, I have described the function of only nine of the segments, and am aware that you are naturally asking about the remaining part of the circle. This part, then, has itself been divided into two halves, and one being placed on one side and one on the other side of the nine, upon the two of them is placed an arch of the same material, hollowed out in front, and contributing additional beauty, an image of the Ruler of all things being painted in its center. Gold and colors make the whole work bright."[13]

In his commentary on this passage Abel suggested that Choricius was here describing the semidome over the eastern apse, which was adorned by a wooden construction with gores converging toward the top. But Abel's solution did not convince later commentators, since he did not attempt to explain the

col. 2425. The terminus post quem of 535/36 given by Kirsten and Schmid for the second panegyric addressed to Marcian is based on the eulogy of Duke Aratius and Governor Stephen. In the latter speech, delivered in or shortly before 536, Choricius praised recent constructions in Gaza, in particular the building of St. Sergius by Marcian, but did not mention St. Stephen.

[7] See especially *Laud. Marc.*, II.46–48.

[8] *Ibid.*, 37, 39.

[9] Ἔστι ⟨δ'⟩ ἀμφοτέρωθεν ὁσίων ἀνδρῶν συνωρίς, ἑκάτερος τὰ συνήθη σύμβολα φέρων, ὁ μὲν τὸ τέμενος ἔχων ἐν δεξιᾷ τοῖς θεωμένοις, παρὰ δὲ τὴν λαιὰν τὸν Πρόδρομον ὄψει. *Ibid.*, 38.

[10] Abel, *op. cit.*, 24 note 7; Mango, *op. cit.*, 70 note 84. Mango argues cogently that the absence of St. Stephen would be surprising.

[11] G. Downey, *Gaza in the Early Sixth Century* (Norman, 1963), 136.

[12] Μιᾷ ζώνῃ, τὴν ὑπερτάτην φημί, καινὸν ἐπίκειται σχῆμα. κῶνον ἡμίσεα τοῦτο καλούσης γεωμετρίας ἀκήκοα.... *Laud. Marc.*, II.41.

[13] Ἀνὴρ ξύλων δημιουργὸς κύκλους ἐξ ἧς αὐτῷ δέδωκεν ὕλης ἡ τέχνη πέντε τὸν ἀριθμὸν ἕκαστον ἴσα δύο τεμὼν καὶ τῶν τμημάτων ἐννέα συνάψας ἐκ μὲν τῶν ἄκρων ἀλλήλοις, ἐκ δὲ τῶν μέσων τῇ ζώνῃ ἣν ἀρτίως ὑπερτάτην προσεῖπον ἰσάριθμα τούτοις ἐπέστησε ξύλα κοιλάνας κάτωθε μὲν ἐξ εὐρέος ἀρξάμενα, κατὰ βραχὺ δὲ μειούμενα πρὸς ἄκρον ὀξὺ κυρτούμενά τε τοσοῦτον ὅσον τῇ κοιλότητι συναρμόσαι τοῦ τοίχου καὶ τὰς ἁπάντων κορυφὰς εἰς μίαν συναγαγὼν ἠρέμα τε κάμψας ἥδιστον ἀπέδειξε θέαμα. ἀλλὰ γὰρ πέντε μὲν κύκλους δίχα τεμών, ἐννέα δὲ μόνον τμημάτων ὑπογράψας τὴν ἐργασίαν ἐπιζητοῦντας ὑμᾶς εἰκότως αἰσθάνομαι τὸ λεῖπον μέρος τοῦ κύκλου. αὐτοῦ τοίνυν τοῦ μέρους ἐξίσης διῃρημένου καὶ τοῦ μὲν ἔνθεν, τοῦ δὲ ἔνθεν τῶν ἐννέα κειμένου ἀψὶς ἀμφοτέροις ἐκ τῆς αὐτῆς ὕλης ἐπίκειται τὰ πρόσω κοιλαινομένη συνεισφέρουσα κάλλους προσθήκην εἰκόνος αὐτῇ γεγραμμένης ἐν μέσῳ τοῦ προστάτου τῶν ὅλων. χρυσὸς δὲ καὶ χρώματα τὸ πᾶν ἔργον φαιδρύνει τοῦτο. *Ibid.*, 43–45.

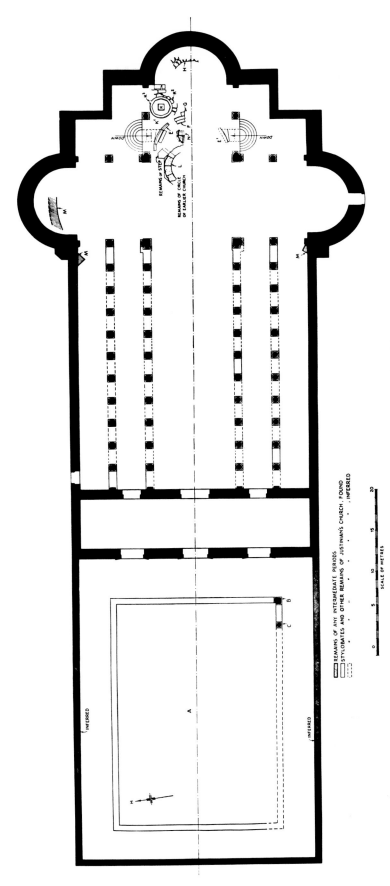

1. Bethlehem, Church of the Nativity. Plan

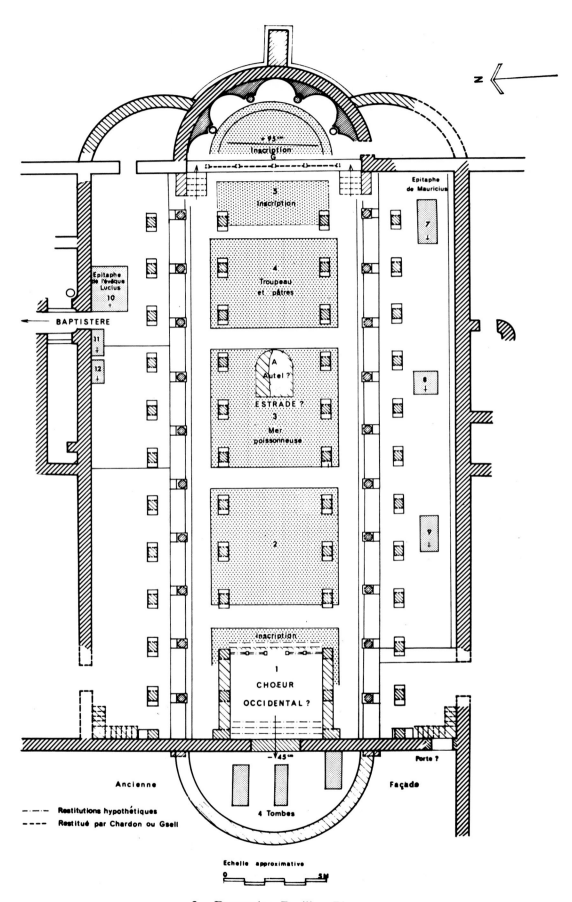

N

Inscription
G

Épitaphe
de Mauricius

5
Inscription

7

4
Troupeau
et pâtres

Épitaphe
de l'évêque
Lucius
10

BAPTISTERE

11

12

A
Autel?

ESTRADE?

3
Mer
poissonneuse

8

2

Inscription

1
CHOEUR
OCCIDENTAL?

Porte?

Ancienne Façade

—·—·— Restitutions hypothétiques

— — — Restitué par Chardon ou Gsell

4 Tombes

Echelle approximative
0 5M

2. Rusguniae, Basilica. Plan

3. Tunisia, Kef, Dar el Kous, Apse

4. Ravenna, S. Michele in Affricisco, Triumphal Arch

precise arrangement of the nine semicircles, nor of the two remaining quarter circles.[14] A detailed explanation of these features was subsequently provided by Smith and Downey, who argued that the nine half-circles formed the ribs of a dome, while the two quarter-circles indicated the profiles of two supporting semidomes. Thus, while Abel had cut the cone in half vertically to make an apse, Smith and Downey truncated it horizontally to create a wooden dome.[15] This dome "consisted of nine sections . . . whose panels were curved out like a pine cone before they came together at the top in a point." The central dome "was flanked on either side by supporting half-domes of wood which theoretically did have the vertical section of a quarter-circle." Thus Smith proposed that the church of St. Stephen was similar in plan to the Justinianic basilica of the Nativity at Bethlehem, which had an east end with three apses arranged in a trefoil (fig. 1).[16] As for the image of Christ the Ruler of all things, Downey believed this was a sixth-century mosaic of Christ Pantocrator which filled the cupola.[17]

The interpretation given by Smith and Downey should be rejected for several reasons. First, the passage on the pinecone immediately follows Choricius' description of the marble revetments of the apse wall; it is, therefore, more natural to assume that Choricius is describing the apse vault rather than any other. Second, in another passage of his *ekphrasis* Choricius lists the architectural elements which combine to make up the height of the church, but he does not include a dome. He says: "Let us now figure the height of the roof of the church from the ground. High columns, an architrave joining their capitals, a wall above it faced with marble, [a] second [row of] columns, a second layer of stones, decorated with animal figures, arched windows, all these make up the height."[18] If a cupola had been the crowning

feature of the building, it should surely have been included in such a catalogue. Third, the reconstruction of the vault as a dome involves an awkward switch from actual structural components to metaphors: the nine semicircles are to be interpreted as the ribs of the dome, while the remaining semicircle, divided into two quarter circles, has to be taken metaphorically to indicate the profile of the supporting semidomes.[19] This must be an unnecessarily complicated conceit, even for Choricius. Furthermore, it is incorrect mathematically, as it leaves out the third semidome of the triapsidal east end which Smith and Downey proposed. Finally, if the quadrants are interpreted metaphorically as the profiles of the semidomes, it is hard to visualize what Choricius means when he says that "an arch . . . hollowed out in front" was placed upon them.

The most recently published interpretation of the text, by Cyril Mango, rightly rejects the thesis that the vault was a dome, and returns to Abel's suggestion that it was the semidome of the apse. Mango further proposes that the nine half-circles were the ribs, and that since they were joined to each other by their tips "they were disposed like an accordion." However, he admitted that he was not able to account for the two wooden quadrants, nor for the "hollowed out" arch which they supported.[20]

The solution proposed here is that the wooden vault did indeed cover the apse. But if we are to account for all of the features recorded by Choricius, we must restore the vault as a pumpkin or melon dome cut precisely in half. This reconstruction can be visualized with the aid of the sixth- or early seventh-century apse of the church of Dar el Kous at Kef in Tunisia, where the pumpkin vault still stands (fig. 3).[21] At Gaza there

[14] Abel, *op. cit.*, 25 note 1, 27.

[15] Smith, *op. cit.* (note 3 *supra*), 39, 156.

[16] *Ibid.*, 39, fig. 156. For the plan, see E. T. Richmond, "The Church of the Nativity; Justinian's Alterations," *QDAP*, 6 (1936–37), fig. I.

[17] Smith, *op. cit.*, 157 note 24; Downey, *op. cit.*, 138.

[18] Τοῦ νεὼ δὲ τὸ στέγος, φέρε, συλλογισώμεθα

πόσον ὑπεραίρει τῆς γῆς. κίονες ὑψηλοί, σύνδεσμος αὐτοῖς ἐπιζευγνύων τὰς κορυφάς, τοῖχος ἐπὶ τούτῳ μαρμάροις ἠμφιεσμένος, κίονες ἕτεροι, λίθων ἑτέρα προσθήκη θηρίων πεποικιλμένη μορφαῖς, θυρίδες ἐν ἁψίδων γενόμεναι σχήματι, ταῦτα πάντα τὸ ὕψος ἐστίν. *Laud. Marc.*, II.48.

[19] Smith, *op. cit.*, 157 notes 18 and 23.

[20] Mango, *op. cit.*, 71 note 87.

[21] N. Duval, "Les Eglises d'Haïdra, III. L'église de la citadelle et l'architecture byzantine en Afrique," *CRAI*, 1971 (hereafter Duval, "Haïdra"), 161, figs. 13 and 18.

A. Gaza, Church of St. Stephen. Reconstruction of Central Apse

were nine concave segments, or gores, which rose from semicircular bases (fig. A 1) resting on the cornice of the apse wall ("the highest band") (fig. A 2), and which tapered to sharp points at the crown of the apse. The nine semicircles formed the scalloped lower border of the vault and were thus joined to each other by their tips, while at their middles they were connected to the cornice. The elements of Choricius' description which have caused most difficulty to commentators are the two quarter-circles placed on either side of the nine half-circles, and the arch which they supported. The explanation for these features is provided by another North African church, the basilica of Rusguniae, or Matifou, in Algeria. The building has been almost completely destroyed, but excavation revealed an apse with a groundplan composed of three semicircular niches flanked by two quadrants (fig. 2).[22] It seems likely that this apse was covered by a pumpkin-shaped vault with a scalloped base, as was the apse at Kef. In the vault at Matifou, then, three concave segments rose over the semicircles, while on the quadrants flanking the entrance of the apse were two curved half-segments producing

[22] For the plan, see *idem, Les Eglises africaines à deux absides*, II (Paris, 1973), 21–28, fig. 11; see also *idem*, "Haïdra," 161–64, fig. 19.

the effect of an "arch ... hollowed out in front." The apse vault of St. Stephen's basilica must have been similar, except that it had a greater number of segments. Presumably at Gaza the wooden semidome was framed by a triumphal arch of masonry, against which the two half-segments abutted (fig. A 3).

The North African churches may help us to visualize the embellishments of the lower part of the apse in the church at Gaza. At Matifou the curved segments at the base of the semidome rose above niches hollowed in the apse wall, while between the niches colonnettes supported the projecting ribs of the vault. At Kef the bases of the ribs now overhang the wall below (fig. 3), but originally they too were supported on colonnettes which were set against the apse wall.[23] A similar arrangement existed in the Citadel Church of Haïdra in Tunisia, a Byzantine building which also had a pumpkin-shaped semidome over its apse.[24] It is possible that at Gaza, also, the ribs of the vault were carried on columns, for Choricius may refer to such supports in his *ekphrasis*. After describing the marble revetments of the apse wall, Choricius remarks that "... painters ... if they should be looking for columns or beautiful plaques to copy ... will find plenty of good models here."[25] However, there is an objection to this interpretation of the text. Unless St. Stephen had a large apse, a ring of ten columns would have left little room for the central window, which Choricius specifically says was "wide and tall in proportion."[26] Because the basilica of St. Stephen boasted galleries and probably a clerestory, the apse could conceivably have been wide enough to accommodate both the ten columns and a window in its center.[27] But we can also argue that when Choricius invited painters to use the columns as models he may have had the whole church in mind, rather than the apse alone. If this was the case, the apse wall could have been adorned with an essentially flat decoration of marble plaques, while the ribs of the light wooden semidome were carried either on corbels or simply on the thickness of the wall itself.

Choricius tells us that the east end of the church displayed images, but unfortunately the orator does not allow us to decide with certainty whether these were true paintings or mosaics.[28] However, if the reconstruction of the "half-cone" vault which I propose here is accepted, it can help us to determine with more confidence the pictures' precise location. I have suggested that the opening of the apse vault at Gaza was flanked by two curved wooden gores which produced the effect of an "arch ... hollowed out in front." The image of the "Ruler of all things," which Choricius says was painted in the center of this arch, must have been at the summit of the triumphal arch against which the two wooden gores abutted (fig. A 4). To an observer looking into the apse, an image painted at the apex of the triumphal arch would have appeared to be in the center of these two gores which framed the semidome. The portrayals of John the Baptist and of the patron, which Choricius says were placed "on either side," cannot have been represented on the vault of the apse, as Downey believed, because a composition of two figures would have fitted very awkwardly onto a surface divided into nine concave segments. The two figures must have been placed on either side of the triumphal arch, flanking the picture of Christ at the top, as Abel originally supposed (fig. A 5 and 6). The arrangement would, then, have been analogous to that of the contemporary mosaics on the triumphal arch of S. Michele in Affricisco at Ravenna, where Christ the Ruler is enthroned at the top of the arch, while SS. Cosmas and Damian occupy the spandrels on either side (fig. 4).[29] Because Choricius mentions no other

[23] *Idem*, "Haïdra," 161, fig. 18.

[24] *Ibid.*, 150–52, figs. 7, 8, 12.

[25] ὥστε καὶ ζωγράφων παῖδες...εἴ που δέοιντο κιόνων εἰς μίμησιν ἢ πλακῶν ἀγλαΐας...καλῶν εὐπορήσουσιν ἐντεῦθε παραδειγμάτων. *Laud. Marc.*, II.40.

[26] ...εὐρεῖαν ὁμοῦ καὶ πρὸς τὸ πλάτος εὐμήκη θυρίδα.... *Laud. Marc.*, II.39.

[27] *Ibid.*, 48 (see *supra*, note 18).

[28] In his summary at the end of the *ekphrasis*, Choricius specifically mentions both paintings and mosaics, but he does not tell us whether the mosaics were on the walls or the floor; *Laud. Marc.*, II.53.

[29] F. W. Deichmann, *Ravenna. Hauptstadt des spätantiken Abendlandes*, I. *Geschichte und Monumente* (Wiesbaden, 1969), 220–25, figs. 211–12; *ibid.*, II, *Kommentar*, pt. 2 (1976), 38–43, fig. 1.

figures, we may conclude that the decoration of bright gold and colors which he saw on the vault of the apse was aniconic.[30]

There remains the question of why Choricius uses the term "half-cone" in his description of the vault. The gored domes of Hadrianic architecture had already been described as pumpkins (κολοκύντας) by Cassius Dio in his report of the dispute between the emperor and the architect Apollodorus.[31] Abel suggested that Choricius may have compared the semidome to a pinecone because the vault had a decoration of imbrications.[32] But as Choricius specifically calls the "half-cone" a geometrical term, it is more likely that it refers to shape rather than to surface ornament. Mango proposed that the semidome of the apse "may have been slightly pointed at the top so as to suggest the form of a cone cut vertically in half."[33] A famous letter of the fourth century lends some weight to this interpretation. When St. Gregory described to Amphi-

lochius, bishop of Iconium, the martyrium which he planned to build at Nyssa, he referred to the top of his church as a pinecone (στρόβιλος). Whatever may have been the precise shape of this superstructure, which covered an octagonal space, it is clear from St. Gregory's description that it came to a sharp point.[34] However, it is difficult to accept that the apse vault of St. Stephen was also pointed at the summit. In surviving sixth-century churches, even if the apse arches are not always true semicircles, they almost invariably have rounded tops, like that at Kef. It is more likely that the term "half-cone" refers not to the shape of the whole vault but to the shapes of its nine segments. Choricius visualized each segment, with its semicircular base, as an oblique cone which had been cut vertically in half and bent to conform to the curvature of the vault.[35]

My interpretation of the "half-cone" bears upon another difficult passage in Choricius' description of the church of St. Stephen. Referring to the two side aisles, Choricius says: "Since each of the colonnades should also have some distinction at its east end, but they should not have as much as the middle, they are adorned with the rest of the forms apart from the intricacy given by the cones which I have described."[36] Here Mango comments that "Choricius may be trying to say that the two colonnades did not have any special feature at their eastern end such as exedras covered by half domes ('cones')."[37] However, if by "cones" Choricius means

[30] To my knowledge, the only early medieval pumpkin vault which still retains traces of its original decoration covers the east apse of the crypt of St-Oyand beneath St-Laurent at Grenoble. This vault is divided into three segments which were adorned with painted stucco reliefs. The stuccoes in the central segment portrayed a cross flanked by rinceaux, while each side segment was decorated with symmetrical scrolls of foliage; see J. Hubert, "La 'Crypte' de Saint-Laurent de Grenoble et l'art du sud-est de la Gaule au début de l'époque carolingienne," Arte del Primo Millennio, Atti del II° Convegno per lo studio dell' Arte dell' Alto Medio Evo (Pavia, 1950) 327–34, esp. 330, figs. 198–99. According to Hubert the crypt was constructed at the end of the eighth century: ibid., 332. However, G. Gaillard, "Un édifice des temps barbares: la Chapelle Saint-Oyand à Saint-Laurent de Grenoble," Bracara Augusta, 9–10 (1958–59), dated the crypt to the sixth or seventh century. According to the recent investigation by R. Girard, the interior plan of the present crypt dates back to the sixth century, but the building was extensively restored in the Carolingian period; "La Crypte et l'église Saint-Laurent de Grenoble," Congrès archéologique de France, 130 (1972), 243–63, esp. 260.
[31] Cassius Dio, LXIX.4,1–2. This passage is discussed in R. E. Brown, "Hadrianic Architecture," in Essays in Memory of Karl Lehmann, ed. L. F. Sandler (New York, 1964), 55–58.
[32] Abel, op. cit. (note 1 supra), 25 note 1.
[33] Mango, op. cit. (note 1 supra), 71 note 87.

[34] τὸ δὲ ἀπ'ἐκείνου στρόβιλος ἔσται κωνοειδής, τῆς εἰλήσεως τὸ σχῆμα τοῦ ὀρόφου ἐκ πλατέος εἰς ὀξὺν σφῆνα κατακλειούσης. Ep. XXV.6, ed. G. Pasquali (Leiden, 1959), 80; translation in Mango, op. cit., 28. On the reconstruction of Gregory's church, see J. Strzygowski, Kleinasien. Ein Neuland der Kunstgeschichte (Leipzig, 1903), 74–90, fig. 63 (includes a contribution by B. Keil); A. Birnbaum, "Die Oktogone von Antiochia, Nazianz und Nyssa," RepKunst, 36 (1913), 202–9.
[35] Apollonius of Perga terms the oblique cone κῶνος σκαληνός; Conica, I, Def. I.3, ed. I. L. Heiberg (Leipzig, 1891).
[36] ἐπεὶ δὲ καὶ τῶν στοῶν ἑκατέραν ἔδει μέν τινος μετασχεῖν εὐπρεπείας κατὰ τὴν πρὸς ἔω πλευράν, ἔδει δὲ μὴ τοσαύτης ὅσης τὸ μέσον, ἄνευ τῆς ἐκ τῶν κώνων εἰρημένης μοι ποικιλίας τοῖς λοιποῖς ὡραΐζονται σχήμασιν. Laud. Marc., II.46.
[37] Mango, op. cit., 71 note 89.

the segments of a pumpkin vault his text becomes easier to understand. What Choricius says is that the side aisles are not terminated by pumpkin vaults, but since they "should also have some distinction ... they are adorned with the rest of the forms" which he had just described at the center of the east end. The implication is that the ends of the side aisles also had apses decorated with colored marble revetments but covered by plain, unscalloped semidomes.

To sum up, the *ekphrasis* of St. Stephen, complicated though it is, gives us valuable information about the east end of this Justinianic church. The basilica had three apses, of which the outer two had smooth semidomes, while the central apse was covered by a wooden vault in the shape of half a pumpkin dome. Choricius is less specific about the decoration of the east end than about its structure, but it is clear that the program of images had to be presented on the triumphal arch, since the apse was scalloped. The wooden "half-cone" vault was evidently unusual, for Choricius in the first sentence of his description terms it a "novel form"—a feature which deserved the most intricate exercise of his rhetorical arts.

Dumbarton Oaks

A STUDY OF AN ENAMEL FRAGMENT IN THE DUMBARTON OAKS COLLECTION*

ANNA GONOSOVÁ

IN 1963 the Samuel H. Kress Foundation enriched the Dumbarton Oaks Collection with a fragmentary plaque executed in cloisonné enamel (fig. 1). The fragment (12.1 × 11.2 cm.) preserves the face with halo and the shoulders of a Church Father clad in patriarchal vestment. The image has traditionally been identified as St. John Chrysostom.

The present condition of the enamel is very poor, yet even in this state its beauty and technical quality are inescapable. The gold of the background and cloisons is very thin, and the layer of enamel does not exceed one millimeter. The colors are rich and homogeneous: the complexion of the Saint, animated by its translucency, is rose; his hair, beard, and eyebrows are black; his eyes are white with black pupils; and his mouth is red. The emerald green halo is outlined in red. He wears a blue *phelonion*, a white *omophorion* with edges and crosses in red, and the characteristic "collar" in yellow.[1]

The image was set against a white background of diaper pattern with a yellow heart in the center of each lozenge, of which, unfortunately, only traces remain.

The early history of the enamel is lost in obscurity. Before it reached the Dumbarton Oaks Collection it was owned by M. P. Botkin and later by Paul C. Drey. It was exhibited twice: in Chicago in 1931 and in Baltimore in 1947,[2] where it was informally dated to the eleventh or twelfth century.

The aim of the present study is to hypothesize, on the basis of stylistic analysis, a more specific date, the place of origin, and the purpose of this enamel.[2a]

All the features of the Church Father on the Dumbarton Oaks enamel—his prominent forehead, emphatic cheekbones, receding hairline, short beard, and patriarchal vestment—are rendered in a manner so characteristic of St. John Chrysostom that there can be no doubt as to the identification. As Otto Demus clearly demonstrated in his analysis of a Palaeologan miniature mosaic icon of St. John Chrysostom in the Dumbarton Oaks Collection,[3] different portrait types

* I wish to express my gratitude to Professor Ernst Kitzinger, who brought this enamel to my attention, for his helpful criticism; and to Professor Henry Maguire, for whom this paper was originally written, and whose guidance helped me to crystallize my ideas. Also my sincere thanks to my colleagues and friends, M. Shreve Simpson, K. Patricia Erhart, William Tronzo, and Dr. Bertha Hertz, for their help in editing and proofreading this paper.

[1] C. Mango and E. J. W. Hawkins refer to a similar article of clothing as a "collar": "The Mosaics of St. Sophia at Istanbul. The Church Fathers in the North Tympanum," *DOP*, 26 (1972), 11, fig. 17. A more stylized rendering (and thus more comparable to the one on this enamel) is shown in the portraits of the Church Fathers in Hosios Lukas in Phocis; cf. A. Grabar, *The Art of the Byzantine Empire* (New York, 1966), 40, pl. 13; P. Lazarides, *Touring Byzantine Greece: Boeotia* (Athens [n.d.]), fig. 23. An almost identical type of "collar" is found on the enamel plaques of the Church Fathers on the frame of the icon of the Virgin Nicopoia in San Marco in Venice; cf. W. F. Volbach, H. R. Hahnloser, et al., *Il Tesoro di San Marco*, II.

Il Tesoro e il Museo (Florence, 1971) (hereafter *Il Tesoro*, II), no. 15, p. 22f., pl. xv,6, 9, 11.

[2] Previous bibliography: *Collection M. P. Botkine* (St. Petersburg, 1911), pl. 85; *Early Christian and Byzantine Art*, Exhibition Catalogue, The Walters Art Gallery (Baltimore, 1947), no. 527.

[2a] Dr. William J. Young of the Boston Museum of Fine Arts has performed a nondispersive X-ray analysis on the gold and enamel of the Dumbarton Oaks plaque. This analysis yielded basic data as to the composition of the gold (Au 95%, Ag 4.2%, Cu 0.4%) and the elements present in the white, blue, green, and flesh-tone enamel. Due to the lack of comparative technical data from other Byzantine enamels, it is not yet possible profitably to use the results of this analysis in determining the date of this piece.

[3] O. Demus, "Two Palaeologan Mosaic Icons in the Dumbarton Oaks Collection," *DOP*, 14 (1960), 110–19.

were developed for this saint. Demus distinguishes three portrait types: the iconic, the ascetic, and the humanistic. The Dumbarton Oaks enamel does not correspond to the iconic type, which represents St. John Chrysostom in youthful guise;[4] instead it approaches the ascetic type, which emphasizes the saint's proverbial austerity through the use of emaciated facial features, a bald head, and a sparse beard. Two mid-eleventh-century representations of St. John Chrysostom in Kiev and Ochrid,[5] as well as the Dumbarton Oaks mosaic icon mentioned earlier, are characteristic of this type.[6] The moderate rendering of the "ascetic" features in the Dumbarton Oaks image relates this enamel also to the humanistic type, in which St. John Chrysostom appears as a scholar and a theologian—a man of mature age, but not bald, with an elongated oval face and a short, full beard. This type is best illustrated by a late ninth-century mosaic of the saint in the north lunette of the Hagia Sophia in Istanbul,[7] and by a painted icon on the lid of a reliquary of the True Cross in Rome, a tenth-or eleventh-century metropolitan work.[8]

The Dumbarton Oaks enamel does not easily lend itself to stylistic inquiry. Drapery, which normally reflects changes of style with greatest accuracy, cannot be considered here, since too little has been preserved from the garment on this plaque. In the end, it is only what is left—the face and the background—which can be used in an investigation concerning the date of the enamel. Even so, by determining the place of the enamel within the stylistic progression of Byzantine enamels, it is possible to establish a more specific date than the eleventh- or twelfth-century date previously proposed.

The development of the tenth-century style is well demonstrated by several securely dated enamels: the votive crown of Leo VI (886–912)[9] and the so-called "Romanus chalice,"[10] both in the Treasury of San Marco in Venice, and the Limburg reliquary of 964–65.[11] These monuments enable us to follow the stylistic trends of the tenth-century enamels—simple but assertive drawing of human figures, structural clarity in the design, and technical excellence—from its initial phase in the votive crown up to its culmination in the enamels of the Limburg reliquary. To be more specific, the faces, oblong in most instances, are delineated by flowing curves of cloisons full of inner vibration (figs. 2 and 4). They do not yet often employ the rippling outlines seen in the hairline of St. Peter (fig. 3) or the more dynamic forms of the beard of St. John the Baptist (fig. 5), both from the "Romanus chalice," to mention only a few examples. The clarity and simplicity of the inner structure of the design is even more obvious

[4] Examples of this type are two representations in S. Maria Antiqua in Rome, dated to around 649 and to the papacy of Hadrian I (772–95), respectively (ibid., 112, fig. 24), and a third representation on a wooden diptych in the Monastery of St. Catherine on Sinai (cf. K. Weitzmann, The Monastery of Saint Catherine at Mount Sinai. The Icons, I [Princeton, 1976], 58f., pls. XXIV and LXXXVII).

[5] V. Lazarev, Storia della pittura bizantina (Turin, 1967), figs. 176 and 177; idem, "Živopis' XI–XII vekov v Makedonii," XIIe Congrès international des études byzantines, Rapports, V (Ochrid, 1961), 115, fig. 7.

[6] Demus, op. cit., figs. 22 and 23.

[7] For the most recent study and bibliography, cf. Mango and Hawkins, op. cit., 1–41, esp. figs. 17–19.

[8] Demus, op. cit., fig. 31; L. von Matt, Die Kunstsammlungen der Biblioteca Apostolica Vaticana (Cologne, 1969), 173f., fig. 89.

[9] Il Tesoro, II, no. 92, p. 81f., pls. LXXII–LXXV, CXLVIII; Venezia e Bisanzio, Exhibition Catalogue (Venice, 1974), no. 25; K. Wessel, Byzantine Enamels From the 5th to the 13th Century (Greenwich, Conn., 1967), no. 12, pp. 20f., 57f.

[10] The attribution to a Byzantine emperor Romanus is given in the inscription on the chalice. Of the four emperors with this name, the style of the enamels permits only the attribution to Romanus I Lecapenus (920–44) or Romanus II (959–63). Romanus I is favored by the majority of scholars: A. Grabar, in Il Tesoro, II, no. 41, p. 59f., pl. XLIII; M. C. Ross, "Enamels," in Byzantine Art: An European Art, Exhibition Catalogue (Athens, 1964), 395; Wessel, op. cit., no. 19, p. 71f.

[11] The inscription of the reliquary mentions the Proedros Basil, who was the illegitimate son of Romanus I and who received his title in 963. Another inscription, on the setting of the cross, mentions the Emperors Constantine and Romanus. This definitely refers to Constantine VII Porphyrogenitus and his son Romanus. Ross dates the reliquary to 964–65: op. cit., 395f.; cf. Wessel, op. cit., no. 22, p. 75f.; J. Rauch and J. Wilm, "Die Staurothek von Limburg," Das Münster, 8 (1955), 201–40.

in the drapery folds. Although the number of cloisons applied increased throughout the Middle Byzantine period, the balance between the design as a whole and its parts was maintained in the tenth century.

The setting of the cloisons of the Dumbarton Oaks plaque produces a completely different effect. The lines are drawn with greater confidence, and the inner vibration in the tenth-century enamels has been replaced by a much more decorative rhythm of undulating curves which delineate the hair and beard of the saint. In contrast to this almost playful treatment the artist has employed powerful arches for the eyebrows and mustache.

This tendency toward a more virtuoso use of cloisons is characteristic of eleventh-century enamels. In this century, the portrayal of historical personages enables us to establish a sound chronology. Key monuments are the crown of Constantine IX Monomachus, the Holy Crown of Hungary, the small enamel plaque with Michael VII Ducas (1071–78) and the Empress Maria on the Khakhuli icon,[12] and the portrait of the Empress Irene (1081–1118), wife of Alexius Comnenus, on the Pala d'oro in Venice.

The crown of Constantine IX Monomachus in the National Museum in Budapest is securely dated to the period between 1042 and 1050 because it depicts the Emperor Constantine IX Monomachus (1042–55), his wife, Empress Zoe (d. 1050), and her sister, Empress Theodora (d. 1056).[13] These three imperial portraits are represented in a schematized manner without any distinctive features. The saint at Dumbarton Oaks can be compared to the plaque of the emperor (fig. 6), for both enamels share similarly shaped beards, sunken cheeks, and mouths,

although the technical rendering of their images is quite different.

The style of the enamels on the *corona graeca* of the Holy Crown of Hungary is particularly close to that of the Dumbarton Oaks enamel.[14] Of the ten plaques, the three forming the posterior group provide a definite date for this part of the crown. They represent the Byzantine Emperor Michael VII Ducas (1071–78), flanked by his son and coemperor, Constantine, and the king of Hungary, Géza I (1074–77), whose reign sets the time limitations for the origin of these plaques. The group at the front of the crown consists of plaques with the enthroned Christ; the Archangels Michael and Gabriel; two military saints, SS. George and Demetrius; and two holy doctors, SS. Cosmas and Damian. The excellent technical quality of these enamels, their iconographic nature, and historical conditions lead to the conclusion that they were made in Constantinople.[15]

The bearded faces of the emperor (fig. 7), King Géza (fig. 8), and SS. Cosmas (fig. 9) and Damian have in common with the Dumbarton Oaks enamel an elongated nose whose tip breaks the line of the mustache. The mouths, especially that of St. Cosmas, and the eyebrows also have similar forms. But above all, the crown enamels and the plaque with St. John Chrysostom share a closely related conception of form and line. The undulating line which delineates the beards of the two holy doctors finds a close

[12] S. Amiranashvili, *Medieval Georgian Enamels of Russia* (New York [n.d.]), 101; Wessel, *op. cit.*, no. 38, p. 115f.
[13] The fragment of the crown consists of seven plaques, representing the Emperor Constantine IX Monomachus, the sister Empresses Zoe and Theodora, two dancing girls, and two personifications of virtues. The enamels were found in 1860. For the history, style, and reconstruction, cf. M. Bárány-Oberschall, *The Crown of the Emperor Constantine Monomachos*, ArchHung, 22 (Budapest, 1937), 49–96. For a brief summary, cf. Wessel, *op. cit.*, no. 32, pp. 96–104.

[14] For the complete and most recent account of the history of the Holy Crown of Hungary, cf. J. Deér, *Die Heilige Krone Ungarns*, DenkWien, Phil.-hist. Kl., 91 (Vienna, 1966); and M. von Bárány-Oberschall, *Die Sankt Stephans-Krone* (Vienna-Munich, 1974). For shorter accounts, cf. Wessel, *op. cit.*, no. 37, pp. 111–15; and P. J. Kelleher, *The Holy Crown of Hungary* (Rome, 1951).
[15] Before his usurpation of the Hungarian throne Géza I acted as an ally of the Byzantine emperor. An imperial gift decorated with enamels was then sent to Hungary in recognition of friendship and, in the eyes of the Byzantine emperor, as a sign of his sovereignty. The exact nature of this gift is the subject of scholarly dispute, which does not, however, affect the generally accepted dating of these enamels to the reign of Géza I. Cf. von Bárány-Oberschall, *Die Sankt Stephans-Krone*, 41–49, 63–76; Kelleher, *op. cit.*, 56–71; Deér, *op. cit.*, 35–88.

parallel in the beard of the saint at Dumbarton Oaks. The faces of the crown enamels are regular, with details suppressed to the minimum, but nonetheless they convey strong individual character. The representation of Géza I, in particular, is so portraitlike that one would not hesitate to see in it a true likeness.

The enamel plaques on the Holy Crown reveal the great technical and artistic accomplishment of their master. Like the Dumbarton Oaks enamel they are characterized by a balance between the whole and its details, which demonstrates that their master was well aware of the optimal artistic possibilities of the enamel technique.

The plaque depicting the Empress Irene, which is generally accepted as a portrait of Irene Ducas, the wife of Alexius I Comnenus (1081–1118), provides a terminus ad quem for a group of enamels from the lower part of the Pala d'oro in San Marco in Venice.[16] These plaques form a part of the Pala d'oro which was thought to have been ordered by the Doge Ordelaffo Falier in Constantinople and delivered to Venice in 1105–6.[17] Although

this group does not seem entirely homogeneous stylistically, and is, along with the rest of the Pala d'oro, a subject of scholarly disagreement, its dating within the first half of the twelfth century is unquestionable. The difference in style between these enamels and those from the second half of the eleventh century with which I group the Dumbarton Oaks plaque is striking. The sense of proportion and the balance between the whole composition and its parts, which were noted in the enamels from the eleventh century, disappeared by the end of that century. It seems as if the artists responsible for the enamels of the Pala d'oro were carried away in the creation of design for its own sake. The delicate equilibrium between the enamel technique and figural representation was broken, and the enamel acquired an ornamental character. This change in attitude is particularly visible in the rendering of male images. The monumental simplicity of facial forms which persisted in the eleventh-century style was superseded by a decorative interplay of lines and surfaces: the profusion of cloisons and elaborate outlines dominates the portraits of the apostles and prophets of the Pala (figs. 10 and 11).[18]

That this development had taken place still in the late eleventh century is clearly demonstrated by the difference between the plaques with empresses from the Monomachus crown and the Empress Irene from the Pala d'oro (figs. 12 and 13).[19] The former show the figures more animated and expressive, the composition more balanced, and the relationship between the body and the drapery still clearly articulated. The latter, on the other hand, consists of a series of two-dimensional patterned surfaces which represent the empress' garment but which do not have any relationship to the body underneath.

The Dumbarton Oaks enamel does not show any stylistic resemblance to the enamels from the Pala d'oro. Based on similarities with the enamels on the Holy Crown of Hungary and the enamels from the Monomachus crown, the date of this plaque can be safely established in the third quarter of the eleventh century.

[16] For the complicated history of the Pala d'oro and the controversy concerning its different phases, cf. H. R. Hahnloser, "Le oreficiere della Pala d'Oro," in Volbach, et al., *Il Tesoro di San Marco*, I. *La Pala d'Oro* (1965) (hereafter *Il Tesoro*, I), 89–101; G. Lorenzoni, *La Pala d'oro di San Marco* (Florence, 1965); J. de Luigi-Pomorišac, *Les Emaux byzantins de la Pala d'Oro de l'église de Saint-Marc à Venise* (Zurich, 1966); O. Demus, "Zur Pala d'oro," *JÖBG*, 16 (1967), 263–79; J. Deér, "Die Pala d'Oro in neuer Sicht," *BZ*, 62 (1969), 308–44; Wessel, *op. cit.*, no. 46, pp. 131–53.

[17] This information stems from the fourteenth-century Chronicle of the Doge Andrea Dandalo, under whose order the present Pala was composed in 1342–45, and it is fully accepted by Volbach; cf. *Il Tesoro*, I, 3–4; cf. also Lorenzoni, *op. cit.*, 2; de Luigi-Pomorišac, *op. cit.*, I, 14; and O. Demus, *The Church of San Marco in Venice* (Washington, D.C., 1960), 23. Hahnloser, on the other hand, considers this part of the Pala d'oro the one which, along with important trade privileges, would have been given to the Venetians after 1082 by Alexius I to thank them for their military assistance against the Normans. Hahnloser's dating is accepted by Deér; cf. H. R. Hahnloser, "Magistra Latinitas und Peritia Greca," *Festschrift für Herbert von Einem zum 16. Februar 1965* (Berlin, 1965), 80f.; and Deér, "Die Pala d'Oro," 315–20.

[18] *Il Tesoro*, I, nos. 28–39, p. 18f.
[19] *Ibid.*, pl. II; Wessel, *op. cit.*, nos. 32a, c, p. 99.

On the plaque of St. John Chrysostom the use of the patterned enamel for the background, instead of a plain gold surface, at first appears unusual, for the majority of preserved Byzantine enamels from the period under discussion are executed in sunken enamel technique. There are, however, several enamels, all quite large in size, that have patterned backgrounds, namely, an eleventh-century relief icon of St. Michael in the Treasury of San Marco in Venice (fig. 14),[20] an icon with St. Theodore in the Hermitage,[21] and a number of ornamental fragments from icon backgrounds now in various museums.[22] Thus, the extant material seems to indicate that the techniques of full and sunken enamel were used side by side during the same period.

Large-scale Byzantine enamels are rare. Among the most notable are the icon of St. Michael mentioned above, a number of enamels from the Pala d'oro (the Apostles, the Feast cycle, the Archangel Michael, and the Pantocrator),[23] and an icon of the Virgin from the monastery of Khakhuli in Georgia.[24] Only the latter exceeds the Dumbarton Oaks fragment in size: the face of the Virgin is 12 cm. long and 7 cm. wide,[25] while that of St. John Chrysostom is 9.5 cm. long and

4.5 cm. wide. Although the dimensions of these two enamels may be compared, their execution and styles are completely different. The Dumbarton Oaks enamel is technically superior to the Khakhuli Virgin, whose cloisons and enamel layers are quite heavy. Stylistically the Virgin is clearly a product of a differnet milieu.

The Dumbarton Oaks enamel, even in its fragmentary state, is too large to be considered a part of any kind of frame or reliquary. Moreover, the visual appeal of the saint, especially his frontal attitude with side glance, suggests that the enamel was part of a larger decorative program rather than an independent icon. The most common way to represent St. John Chrysostom in such a scheme would be in a group of the Church Fathers and other saints. Many examples of this composition are offered in every medium of Byzantine art. Assuming that the Dumbarton Oaks plaque was originally part of such a multifigural, presumably horizontal, composition, we must consider the type of object most suitable to this kind of decoration in enamel. The beam of a templon provides an ideal base for the extended horizontal decorative arrangement.

The written Byzantine sources are very explicit concerning the use of precious metals, enamels, and other costly materials for the decoration of church and palace furnishings. Constantine VII Porphyrogenitus' *Vita Basilii* provides, among other information concerning the building and decoration of churches by Basil I (867–86), a specific reference to a templon decorated with enamel in the church of the Savior:

> ... Indeed, the entire pavement is made of solid beaten silver with niello (*enkausis*) exhibiting the perfection of the jeweler's art; the walls on right and left are also covered with an abundance of silver, picked out with gold and studded with precious stones and gleaming pearls. As for the closure that separates the choir from the nave, by Hercules, what riches are contained in it! Its columns and lower part are made entirely of silver, while the beam that is laid on top of the capitals is of pure gold, and all the wealth of India has been poured upon it. The image of our Lord, the God-man, is represented several

[20] *Il Tesoro*, II, no. 16, pp. 23–25, pls. xvi–xviii; A. Grabar, *Les Revêtements en or et en argent des icones byzantines du Moyen Age* (Venice, 1975), no. 1, p. 21f., pl. A and fig. 1; and Wessel, *op. cit.*, no. 30, pp. 92–95.

[21] The size of the enamel is 24 × 21 cm.; cf. A. V. Bank, *Iskusstvo vizantii v sobranii Gosudarstvennogo Ermitaža* (Leningrad, 1960), no. 84, p. 123.

[22] Some are in Tbilisi and some in the Metropolitan Museum of Art; cf. Amiranashvili, *op. cit.* (note 12 *supra*), 97; O. M. Dalton, "Byzantine Enamels in Mr. Pierpont Morgan's Collection," *The Burlington Magazine*, 21 (1912), 128.

[23] The apostles have an average size of 28 × 11.8–12 cm.; the Archangel Michael is 44 × 39 cm.; the Feasts are 30.7 × 30 and 36.7 × 31.3 cm.; and the Pantocrator has a diameter of 37 cm., although its original size is assumed to be around 44 cm. Cf. *Il Tesoro*, I, no. 6, p. 10, pl. v; nos. 28–39, pp. 18–20, pls. xvii–xxii; no. 79, p. 39, pl. xlii; nos. 80–85, pp. 39–43, pls. xliii–xlviii.

[24] Amiranashvili, *op. cit.*, p. 99.

[25] *Idem, The Khakhuli Triptych* (Tbilisi, 1972), list of illustrations, no. 5.

times in enamel (*chumeusis*) upon the beam....[26]

The existence of several enamels thought to come from the beam of a templon seems to confirm the documentary evidence. The upper part of the Pala d'oro consists of seven large plaques, of which the five smaller ones with the Feasts form part of one series, while the Archangel Michael in the central quatrefoil and the plaque with the Entry into Jerusalem come from two different ensembles.[27] It is generally accepted that these enamels, which stylistically belong to the twelfth century, are a part of the loot from the Fourth Crusade. Based on the fifteenth-century tradition, these enamels were considered a part of the templon in one of the churches of the Pantocrator monastery in Constantinople, which was in the hands of the Venetians after 1204.[28]

That the effect of templon architraves decorated with precious metals and enamels was very much sought after is convincingly documented by the existence of imitations in less expensive materials and techniques. Almost the entire length of the beam can be reconstructed from the fragments excavated in the Phrygian Sebaste.[29] The marble architrave is decorated with interlaced medallions filled with portrait busts representing the Great Deesis; eighteen out of twenty-one medallions have been preserved. The decoration consists of glass paste inlay against a background where traces of ochre and gilding are preserved, giving an overall impression much like that of enamel. This visual effect is further confirmed by the striking similarity with tenth-century enamels, and supports the tenth-century attribution of the templon proposed by the excavators. Another fragment in the same technique, also from Asia Minor, shows the Apostle Philip and SS. Luke, Macarius, and Panteleimon.[30]

Recent scholarship and a sufficient number of preserved templon architraves and architrave icons enable us to reconstruct their form and iconographic program.[31] The examination of the preserved templon fragments reveals that there were several iconographic themes developed for the decoration of the templon architrave, including the Great Deesis.[32] The Dumbarton Oaks enamel would be ideally suited for incorporation in such a scheme. The iconography of the Great Deesis is very flexible; the number and selection of the saints is not based upon any strict rule. The inclusion of St. John Chrysostom, one of the four most venerated Church Fathers, in

[26] C. Mango, *The Art of the Byzantine Empire 312–1453. Sources and Documents* (Englewood Cliffs, N.J., 1972), 196; cf. also M. Chatzidakis, "Ikonostas," *RBK*, III, col. 331 f.

[27] Hahnloser, *Il Tesoro*, I, 94.

[28] The tradition that these enamels are a part of the loot from the Pantocrator monastery after 1204 goes back to 1438, when the Constantinopolitan Patriarch Joseph, while visiting Venice, identified some enamels on the Pala as coming from the monastery. The monastery had three churches and was the burial place of the Comneni. The Venetian Podestà resided there during 1204–61. Demus convincingly pointed out, however, that the patriarch's identification was based on the recognition of the portrait of the Empress Irene, who was mistaken for another Irene, the wife of John II Comnenus (1118–43) and founder of one of the churches of the Pantocrator monastery. Demus also agrees with Hahnloser that the enamels are not necessarily part of the iconostasis from the Pantocrator monastery, but could have been taken from elsewhere in the capital. Demus, "Zur Pala d'Oro" (note 16 *supra*), 273; *idem*, *The Church of San Marco* (note 17 *supra*), 27 note 90, 28; Hahnloser, *Il Tesoro*, I, 91.

[29] N. Fıratlı, "Découverte d'une église byzantine à Sébaste de Phrygie: Rapport préliminaire," *CahArch*, 19 (1969), 151–66.

[30] V. N. Lazarev, "Tri fragmenta raspisnyh epistiliev i vizantijskij templon," in *Vizantijskaja živopis'* (Moscow, 1971), 118, 133, no. 41.

[31] Major contributions to the study of the development of the iconostasis are: M. Chatzidakis, Εἰκόνες ἐπιστυλίου ἀπὸ τὸ Ἅγιον Ὄρος, in *Studies in Byzantine Art and Archaeology* (London, 1972), 377–403; *idem*, "Ikonostas," *RBK*, III, cols. 326–53; and *idem*, "L'Evolution de l'icone aux 11e–13e siècles et la transformation du templon," *XVe Congrès international d'études byzantines, Rapports et co-rapports*, III. *Art et archéologie* (Athens, 1976), 157–92; Lazarev, "Tri fragmenta," 110–36; and K. Weitzmann, "Diptih slonovoj kosti iz Ėrmitaža, otnosjaščijsja k krugu imperatora Romana," *Viz-Vrem*, 32 (1971), 142–56.

[32] The major iconographic themes used for the templon beam are the Deesis, the Great Deesis, the Deesis and the Dodekaorton, and the Dodekaorton. On the basis of the preserved material, the preference for certain themes in different periods is noticeable. This has its limitations for the purpose of dating, however; cf. Chatzidakis, "Ikonostas," cols. 336–40; *idem*, "L'Evolution de l'icone," 170f.; Lazarev, "Tri fragmenta," 120f.

such a composition is more than probable. There are several examples of the Great Deesis decorating either the beam proper, as in the case of the Sebaste inlaid architrave,[33] or the beam icons, as shown by two eleventh-century fragments of painted architraves, one in the Hermitage with three-quarter representations of the Apostle Philip and SS. Theodore Stratilates and Demetrius (fig. 15),[34] and another on Mt. Sinai with a portrait bust of the Apostle Thomas,[35] to mention a few early examples.

The Dumbarton Oaks fragment can be reconstructed with the Saint as either a bust, a three-quarter length, or a full-length figure, with the dimensions varying accordingly.[36]

Iconographically it was most likely a part of the Great Deesis; further details of the program would have been determined by the church for which it was executed. The reconstruction of a templon beam itself on the basis of this fragment alone would be pure hypothesis. It should suffice to note that there are existing parallels for each of the above-mentioned figural types.

The preceding analysis of the style and portrait type of St. John Chrysostom on the plaque from the Dumbarton Oaks Collection has revealed sufficient evidence to identify this fragment as a late eleventh-century enamel made in Constantinople. Due to the costly material, we can assume that an enamel-decorated templon architrave would have been commissioned only for the capital city, known so well for the sumptuous decoration of its churches.

Fogg Art Museum
Harvard University

[33] Fıratlı, *op. cit.*, figs. 15–18.

[34] This fragment measures 41 × 50 cm.; cf. Lazarev, "Tri fragmenta," 110f., 131 note 5; A. Banck, *Byzantine Art in the Collections of the USSR* (Leningrad [1966]), no. 227.

[35] Chatzidakis, "L'Evolution de l'icone," 164, 175, pl. XXVI,2.

[36] A three-quarter length figure would be comparable in size to the saints on the Hermitage fragment; cf. note 34 *supra*.

PLATES

1. Dumbarton Oaks Collection, Enamel, St. John Chrysostom

2. The Apostle Luke

3. The Apostle Peter

Venice, San Marco. Romanos Chalice, details

4. Limburg am Lahn, Cathedral Treasury. Limburg Reliquary, detail, The Apostles James and John the Evangelist

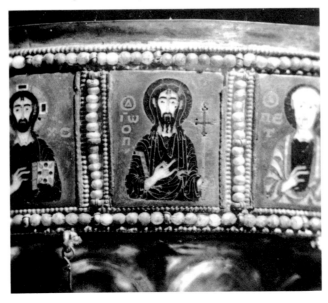

5. Venice, San Marco. Romanos Chalice, detail, St. John the Baptist

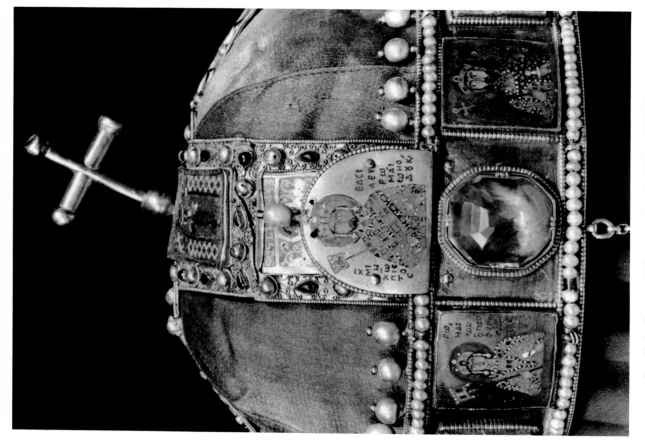

7. Holy Crown of Hungary, detail, Michael VII Ducas

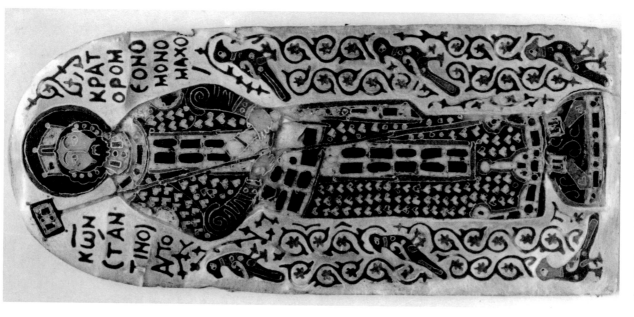

6. Budapest, Hungarian National Museum. Crown, detail, Constantine IX Monomachus

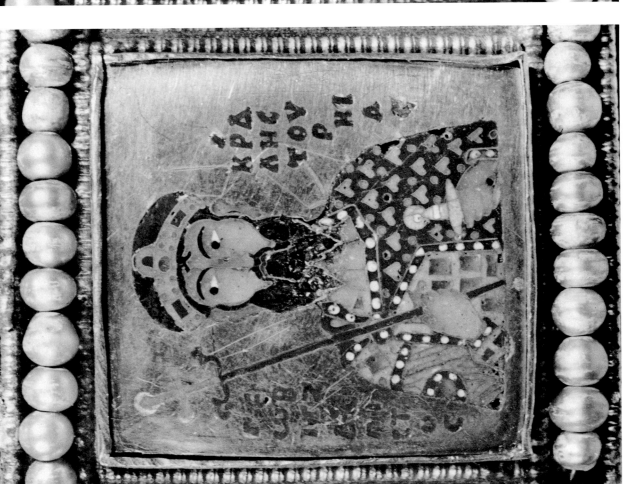

9. St. Cosmas

8. King Geza I

Holy Crown of Hungary, details

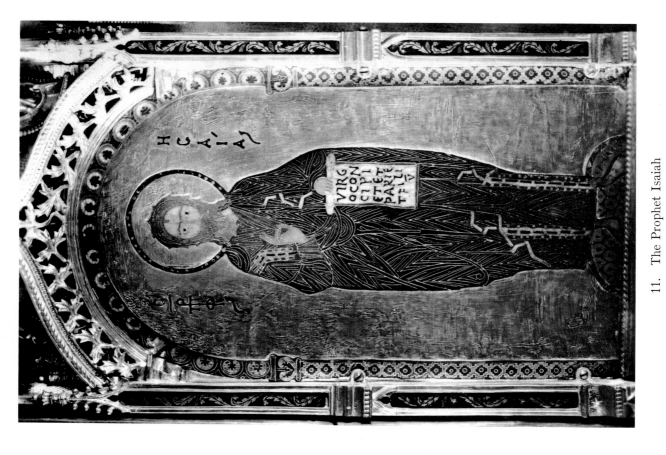

11. The Prophet Isaiah

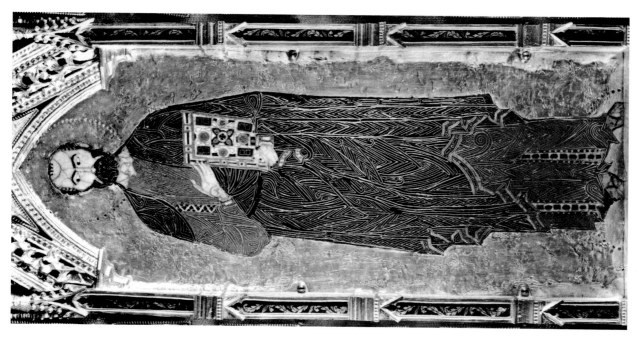

10. Apostle

Venice, San Marco. Pala d'Oro, details

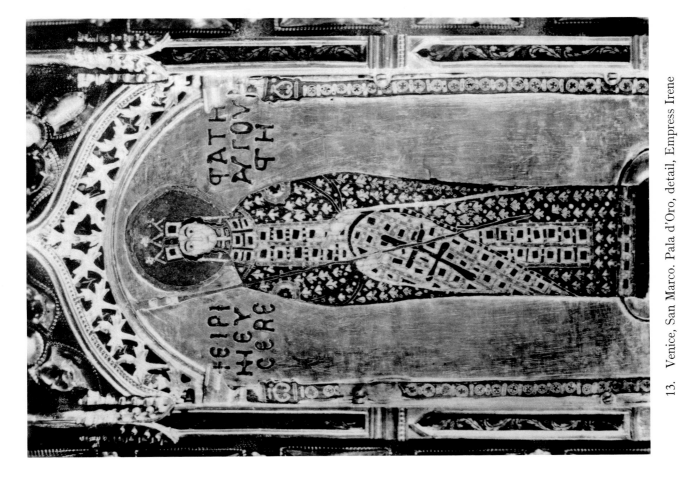

13. Venice, San Marco. Pala d'Oro, detail, Empress Irene

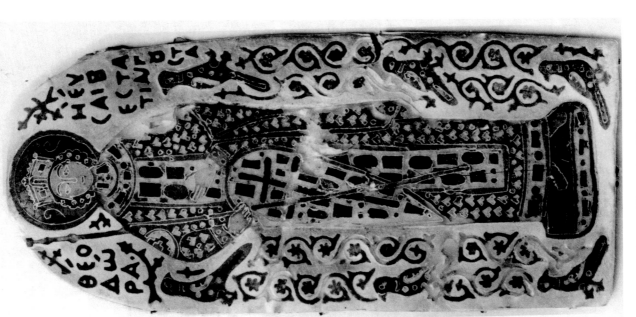

12. Budapest, Hungarian National Museum. Crown, detail, Empress Theodora

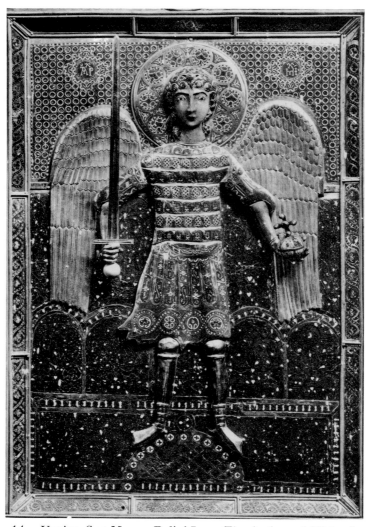

14. Venice, San Marco. Relief Icon, The Archangel Michael

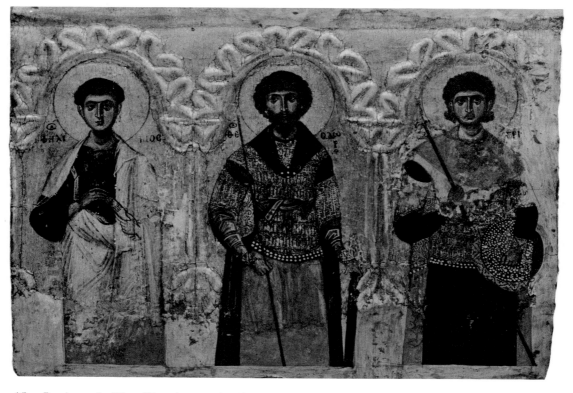

15. Leningrad, The Hermitage. Architrave Icon, The Apostle Philip and SS. Theodore Stratilates and Demetrius

LIST OF ABBREVIATIONS

Used in this Volume of the

Dumbarton Oaks Papers

AbhBerl Akademie der Wissenschaften, Berlin, Abhandlungen

ActaSS Acta Sanctorum Bollandiana

AIEtByz Association Internationale des Etudes Byzantines

AJA American Journal of Archaeology

AJPh American Journal of Philology

AnalBoll Analecta Bollandiana

AnnEth Annales d'Ethiopie, Section d'Archéologie du Gouvernement Impérial d' Ethiopie

AnzWien Anzeiger der [Österreichischen] Akademie der Wissenschaften, Wien, Phil.-hist. Klasse

AOC Archives de l'Orient Chrétien

'Αρχ.Βυζ.Μνημ.'Ελλ. 'Αρχεῖον τῶν Βυζαντινῶν Μνημείων τῆς 'Ελλάδος

ArchHung Archaeologia Hungarica

ArtB Art Bulletin

AUf Archiv für Urkundenforschung

BAN Bŭlgarska Akademija na Naukite

BCH Bulletin de Correspondance Hellénique

BHG Bibliotheca Hagiographica Graeca

BIFAO Bulletin de l'Institut Français d'Archéologie Orientale

BISI Bollettino dell'Istituto Storico Italiano per il Medioevo e Archivio Muratoriano

BJb Bonner Jahrbücher

BNJbb Byzantinisch-neugriechische Jahrbücher

Bonn ed. Corpus Scriptorum Historiae Byzantinae, ed. B. G. Niebuhr et al. (Bonn, 1828–97)

BSA The Annual of the British School at Athens

BSOAS Bulletin of the School of Oriental and African Studies

BZ Byzantinische Zeitschrift

CAH Cambridge Ancient History

CahArch Cahiers Archéologiques

CFHB Corpus Fontium Historiae Byzantinae

CIG Corpus Inscriptionum Graecarum

CMH Cambridge Medieval History

CorsiRav Corsi di Cultura sull'Arte Ravennate e Bizantina

CQ Classical Quarterly

CRAI Comptes-rendus des séances de l'Académie des Inscriptions et Belles-Lettres

CSCO Corpus Scriptorum Christianorum Orientalium

DACL F. Cabrol and H. Leclercq, Dictionnaire d'Archéologie Chrétienne et de Liturgie

Δελτ.'Ετ.'Ελλ. Δελτίον τῆς 'Ιστορικῆς καὶ 'Εθνολογικῆς 'Εταιρείας τῆς 'Ελλάδος

DenkWien, Phil.-hist.Kl. Akademie der Wissenschaften, Wien, Denkschriften

DOP Dumbarton Oaks Papers

DOS Dumbarton Oaks Studies

DOT Dumbarton Oaks Texts

DTC Dictionnaire de Théologie Catholique

'Ελλ.Φιλολ.Σύλλ. 'Ο ἐν Κωνσταντινουπόλει 'Ελληνικὸς Φιλολογικὸς Σύλλογος

EO Echos d'Orient. Revue d'histoire, de géographie et de liturgie orientales

'Επ.'Ετ.Βυζ.Σπ. 'Επετηρὶς 'Εταιρείας Βυζαντινῶν Σπουδῶν

EtByz Etudes Byzantines

FGrHist Die Fragmente der griechischen Historiker, ed. F. Jacoby, 3 vols. in 16 parts (1923–58)

FHG Fragmenta Historicorum Graecorum, ed. C. Müller, 5 vols. (Paris, 1841–70)

HJ Historisches Jahrbuch

HSlSt Harvard Slavic Studies

IG Inscriptiones Graecae (Berlin, 1873–)

IGLSyr Inscriptions Grecques et Latines de la Syrie, ed. L. Jalabert, R. Mouterde, and Cl. Mondésert, 7 vols. (Paris, 1929–70)

IzvArhInst Izvestija na Arheologičeskija Institut

IzvIstDr Izvestija na Bŭlgarskoto Istoričesko Družestvo

JAOS Journal of the American Oriental Society

JbAChr Jahrbuch für Antike und Christentum

JHS Journal of Hellenic Studies

JÖB Jahrbuch der Österreichischen Byzantinistik

JÖBG Jahrbuch der Österreichischen Byzantinischen Gesellschaft
JRS Journal of Roman Studies
JSav Journal des Savants

Krumbacher K. Krumbacher, *Geschichte der byzantinischen Litteratur* (Munich, 1890; 2nd ed. Munich, 1897)

Loeb The Loeb Classical Library
LSJ H. G. Liddell, R. Scott, and H. S. Jones, *A Greek-English Lexicon*

MAMA Monumenta Asiae Minoris Antiqua
MélRome Mélanges d'archéologie et d'histoire, publiés par l'Ecole Française de Rome
MGH Monumenta Germaniae Historica:
 AA Auctores Antiquissimi
 Ep Epistolae
 ScriptRerMerov Scriptores Rerum Merovingicarum
MittIÖG Mitteilungen des Instituts für Österreichische Geschichtsforschung

NA Neues Archiv der Gesellschaft für ältere deutsche Geschichtskunde
NC The Numismatic Chronicle
Νέος Ἑλλ. Νέος Ἑλληνομνήμων

OC Orientalia Christiana
OCA Orientalia Christiana Analecta
ÖJh Jahreshefte des Österreichischen Archäologischen Instituts in Wien

PEFQ Palestine Exploration Fund, Quarterly Statement
PG Patrologiae cursus completus, Series Graeca, ed. J.-P. Migne

QDAP Quarterly of the Department of Antiquities in Palestine

RAC Reallexikon für Antike und Christentum
RBibl Revue Biblique
RBK Reallexikon zur Byzantinischen Kunst, ed. K. Wessel (Stuttgart, 1963–)
RE Paulys Real-Encyclopädie der classischen Altertumswissenschaft, new rev. ed. by G. Wissowa and W. Kroll (Stuttgart, 1893–)
REB Revue des Etudes Byzantines
REG Revue des Etudes Grecques
RepKunstw Repertorium für Kunstwissenschaft

RIDA Revue Internationale des Droits de l'Antiquité
RN Revue Numismatique
Roscher, *Lexikon Ausführliches Lexikon der griechischen und römischen Mythologie*, ed. H. W. Roscher, 10 vols. (Leipzig, 1884–1937; repr. Hildesheim, 1965)
RQ Römische Quartalschrift für christliche Altertumskunde und [für] Kirchengeschichte

SBBerl, Phil.-hist.Kl. Akademie der Wissenschaften, Berlin, Philosophisch-historische Klasse, Sitzungsberichte
SBMün, Phil.-hist.Kl. Akademie der Wissenschaften, München, Philosophisch-historische Klasse, Sitzungsberichte
SC Sources Chrétiennes. Collection dirigée par H. de Lubac et J. Daniélou
SemKond Seminarium Kondakovianum
SOforsch Südostforschungen
SpBAN Spisanie na Bŭlgarskata Akademija na Naukite
ST Studi e Testi
StB Studi Bizantini
SubsHag Subsidia Hagiographica, Société des Bollandistes
Synaxarium CP Synaxarium Ecclesiae Constantinopolitanae. Propylaeum ad ActaSS Novembris, ed. H. Delehaye (Brussels, 1902)

TAPA Transactions [and Proceedings] of the American Philological Association
TFByzNgPhil Texte und Forschungen zur byzantinisch-neugriechischen Philologie
TM Travaux et Mémoires
TrDrLit Trudy Otdela Drevne-Russkoj Literatury
TU Texte und Untersuchungen zur Geschichte der altchristlichen Literatur (Leipzig-Berlin, 1882–)

VizVrem Vizantijskij Vremennik

WByzSt Wiener Byzantinistische Studien
WSt Wiener Studien. Zeitschrift für klassische Philologie und Patristik

Zepos, *Jus Jus Graeco-Romanum*, ed. C. E. Zachariae von Lingenthal and J. and P. Zepos, 8 vols. (Athens, 1931; repr. Aalen, 1962)
ZVI Zbornik Radova Vizantološkog Instituta, Srpska Akademija Nauka